BOGIE & BACALL

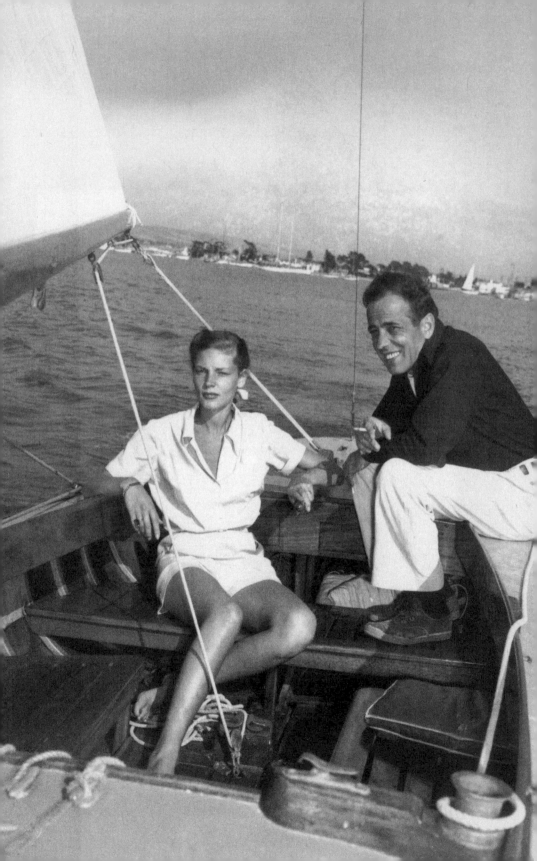

BOGIE & BACALL

THE SURPRISING TRUE STORY
OF HOLLYWOOD'S GREATEST LOVE AFFAIR

William J. Mann

HARPER

An Imprint of HarperCollins*Publishers*

HarperCollins books may be purchased for educational, business, or sales promotional use. For information, please email the Special Markets Department at SPsales@harpercollins.com.

FIRST EDITION

Designed by Elina Cohen
Title page art courtesy of Getty Images

Library of Congress Cataloging-in-Publication Data has been applied for.

ISBN 978-0-06-302639-1

23 24 25 26 27 LBC 5 4 3 2 1

FOR T.D.H.

CONTENTS

PREFACE

"Let's have the Café Flore today, shall we?" asked Lauren Bacall, grandly laying down coasters from the fabled Parisian coffeehouse. Her maid had just brought out a cozied coffeepot and a couple of cups to the table, where Bacall sat with a writer from the *New York Times*. The writer thought that Bacall spoke with "an actress's reflexive flourish." The eighty-year-old movie star was putting on a show, as she always did when she wanted to impress a visitor. They sat in her living room stuffed with priceless artwork and cheap souvenirs, such as coasters that had value only to her. Beyond them, oversized windows looked down on the cold, bare trees of Central Park. But the temperature in the Dakota, one of New York's poshest addresses, was just right.

The *Times* writer had come to interview Bacall about the release of her third memoir, *By Myself and Then Some*, which everyone expected to sell as well as her first memoir, *By Myself*, some twenty-seven years earlier. Bacall was pleased to do the interview, but when she learned that the *Times* was not planning to review the book, she became quite cross. "What the fuck is the *Times* thinking?" she asked after the writer left; she harshly blamed one of her managers for the newspaper's decision. The people who worked for her knew that she wasn't always as gracious in private as she was to important visitors. "She could be lovely, and she could also turn very cantankerous," said one of her agents, Scott Henderson. "You never knew which one you were going to get."

The problem many news outlets were having with Bacall's latest memoir and the reason that so few reviews of *By Myself and Then Some* had been published was that the new material made up only about one-eighth of the book. The rest was just a reprint of *By Myself*, which the *Times*, and countless others, had already reviewed back in 1978.

"When I have a lull in my life," Bacall told the *Times* writer, attempting to explain the reasoning behind her latest memoir, "I write, and that's fairly often." She was continually struck, she said, by the "fairy-tale life"

she had led since she was nineteen. "Who could have thought something like that could happen?" But, the *Times* writer noted, her words grew wistful. "Nothing," Bacall went on, "is ever as good as it is in the beginning."

Ah, yes, that beginning. Brooklyn teenager Betty Bacal becomes Hollywood love goddess Lauren Bacall. She teaches Humphrey Bogart to whistle and sets the world on fire. At twenty, she marries Bogart, who is twenty-five years her senior and who, in the fullness of time, will be named the greatest movie star in history. "Bogie" and his "Baby" live happily ever after, which means twelve years, during which time they make four successful, iconic films. Then Bogie dies, horribly, of cancer, and their story slips into legend, aided and abetted by Bacall herself. Her post-Bogart life is never the same, never as good.

That had been a hard, cruel truth for the young widow with another fifty-seven years of life ahead of her. "With all the great luck I had," she told another interviewer, "to have that in my life early on, you know . . ." Her voice trailed off until she found her words. "For the rest of your life, you just stumble through as best you can."

The process of stumbling through included writing three memoirs. Over the previous four decades, Bacall had invested a great deal in shaping the legend to her satisfaction. First she had trusted two friendly biographers, Joe Hyams and Nathaniel Benchley, both of whom tried to please her; she wrote the introduction to the first and had the second dedicated to her. When what Hyams and Benchley came up with didn't fully satisfy her, she started writing herself. She was all too aware that after she was gone, others would put their own spin on the stories she'd told (and not told). So she made sure to carve as many stone tablets as possible to leave behind. In the various accounts she told about herself and Bogart and their life together, Bacall could be both surprisingly candid and conspicuously disingenuous. Her candor about some things—Bogie's last illness, for one—seemed to make her a reliable narrator and distracted readers from the things she had skipped over—such as Bogie's affair with his hairdresser and the extent of his alcoholism. Bacall's crafting of the legend was always more about omission than invention. By the time she died in 2014, the mythology of Bogie and his Baby was solidly in place, and it was pretty much of her own design.

Ten years on, it's time to turn a fresh eye on their story—not to tear

their legend down, as people always fear about reassessments of their favorites' lives, but to understand how Bogie and Bacall happened, what their story meant, and in how many ways it's still relevant and reflective for today. Bogart and Bacall were among the first celebrities to become political activists, speaking out in the late 1940s when they believed American democracy was under assault. Moreover, many of our ideas about masculinity, femininity, and the expectations for men and women were encoded by Hollywood in the middle part of the twentieth century, with Humphrey Bogart and Lauren Bacall being held up as exemplars. In truth, Bacall, just nineteen when she met the forty-five-year-old Bogart and twenty when she married him, had to learn fast how to navigate not only the power differential of her marriage but the high-stakes, systemically sexist film industry that saw her as only Bogie's wife. For all her mythologizing, Bacall truly did smash through barriers to become one of the great Hollywood survivors.

There's treasure to be mined from Bacall's memoirs, to be sure, but the true mother lode is found elsewhere, in the Bogarts' recently opened personal and business files at both Indiana University, Bloomington, and Boston University. The papers of Katharine Hepburn and John Huston have also been opened since the last major Bogart biography, and several people who dared not speak out while Bacall was alive felt free to do so now (though some of them still asked for anonymity; Bacall remains formidable even in death). I am also indebted to the exhaustive research of A. M. Sperber and Eric Lax, conducted while so many important figures in Bogart's and Bacall's lives were still living and published in their excellent *Bogart* in 1997.

I was also fortunate to earn the trust of Dean Shapiro, the companion of Verita Thompson, Bogie's hairdresser, lover, and trusted friend. Thompson's papers provide us with another angle from which to view Bogie and Bacall, one that may surprise some people. There was also value in going back and reading *everything* again—interviews, letters, newspaper columns, production records, oral histories, fan magazines, studio press releases—to trace myths back to their origins and to draw connections between what was said at the start of their careers and what was said later.

Lauren Bacall and Humphrey Bogart were arguably Hollywood's greatest love story, and maybe not even so arguably. Whose story was greater? Elizabeth Taylor and Richard Burton? Too chaotic and such an

unhappy ending. Lucille Ball and Desi Arnaz? Too self-destructive. Clark Gable and Carole Lombard? Poignant and tragic but too brief. Katharine Hepburn and Spencer Tracy? Too much window dressing

It's notable that Bacall looked to Hepburn as her model for stardom. Hepburn brilliantly created a mythos about herself, and Bacall clearly took note. She watched as her pal "Katie" orchestrated a veritable cottage industry of mythmaking throughout the 1980s and 1990s (books, articles, interviews, documentary films). Bacall didn't need to repackage her life with Bogart the way Hepburn had done with Tracy. The Bogart-Bacall relationship was real; it was wonderful; it was passionate; it was complicated. But there were still lessons to be learned from Hepburn that Bacall used in writing and promoting her second and third memoirs. Like Hepburn, she delivered her story with such imperious authority that no one dared question her version of events.

But in so carefully controlling the way her life was chronicled, Bacall narrowed Bogart's story as much as she did her own. One of the few reviews of *By Myself and Then Some*, in the *Guardian*, commented that Bacall's version of Bogie tended to "blur the man himself." That does a disservice to a figure that remains such a cultural touchstone, not just the greatest movie star but a prototype for the modern American man.

Humphrey Bogart has come down to us as the supremely confident, unflappable, unpretentious, reluctant movie star, filled with integrity, strength, and disdain for phonies. That's not untrue. He did have integrity and he did have strength, and he very much disdained phonies, but he was softer than such a description would imply. He was wounded, vulnerable, and filled with self-doubt. He lived most of his life trying to overcome the emotional deprivations of his childhood. He was no tough kid from the streets, as so many people thought based on the roles he played, but rather the privileged son of a wealthy physician and an acclaimed illustrator. Yet for all his birthright, he never felt he measured up. Denied love by his parents, expelled from schools, fired by employers, he struggled with self-worth all his life. That helps explain the drinking and the rage it unleashed.

But this complex and unguarded Bogart does not appear in Betty's pages, and consequently he's largely absent from the public's memory of him as well. Instead, he is the cynical, hard-edged Sam Spade or Rick Blaine, and his legendary output of film noir classics continues to play in Bogart festivals all over the world. Yet although he brilliantly created

Spade and Rick—and Duke Mantee and Philip Marlowe and Mad Dog Earle and Charlie Allnut—from parts of himself, the characters and the man were very much not one and the same.

The real Humphrey Bogart, whom I hope I am revealing here, was gentler, more romantic, more yearning than the legend admits. In his youth, he was a Broadway cavalier, a speakeasy dandy, who wanted very much to become a romantic matinee idol. He loved the theater, he loved his craft, and he cared about becoming a better actor, pushing himself to take chances. But the wounded child within him made regular and devastating appearances over the course of his career, and his alcoholism constantly threatened everything he had achieved.

The legend holds that Bacall saved him, that with her Bogart finally found true love and contentment. There's truth in that, but as always, the truth is complicated. That Bogie and Bacall loved each other is undeniable. But in fact, Bogie had been in love with his first three wives as well, a fact deliberately obscured and sometimes denied in service to the Bogie and Bacall legend. Each time he wed, Bogie thought he'd found true love. Turns out, the cynical, hard-hearted Humphrey Bogart was a softie when it came to love. He was no philanderer. His friend John Huston, who most definitely was, often remarked that Bogie never chased his leading ladies or starlets on the lot. Instead, he fell for a woman, married her, then hoped to remain true to her. But for the legend to maintain that Bacall was his one and only, that romantic early Bogart had to be played down, and his earlier wives had to be minimized, especially Mayo Methot, whom Bacall replaced.

There is considerable misogyny threaded through the stories, columns, and interviews about Bogie's life, and much of that has been heaped on Methot, a high-spirited former child star who was turned into a monster by the chroniclers of Bogie's legend. Joe Hyams set the template for subsequent biographers to use in portraying Methot, even though Hyams hadn't arrived in Hollywood until 1951, six years after Bogart and Methot divorced. Even Sperber, using Hyams as her source, portrayed Methot as a paranoid schizophrenic. Methot was clearly an alcoholic, but so was her husband. It would be Methot, however, who was left to take the fall for the failure of the marriage. Bogie could not, even partially, be at fault. It was Methot's drinking that was out of control, not Bogart's. I hope I can offer a corrective to the way Methot's story has been told.

By 2005, when his widow began promoting her latest chapter of their story, Bogart had passed into myth. Jean-Luc Godard's *Breathless* had paid him homage. Woody Allen had built an entire play and then a movie around him with *Play It Again, Sam*. An actor named Robert Sacchi had made a career as Bogie's double, starring in *The Man with Bogart's Face* as a private investigator who has plastic surgery to look like his idol. The Brattle Theatre in Cambridge, Massachusetts, has been the nexus of a worldwide "Bogie cult" dating back to the 1950s. In 1997, *Entertainment Weekly* named Bogart the number one movie legend of all time; two years later, the American Film Institute ranked him the greatest male star (Katharine Hepburn, notably, was the greatest female).

This book hopes to reveal the man, not the myth, although the myth is hard to ignore. The fundamental mystery is how this particular actor—not conventionally attractive, with a persona honed during depression and war—was able to surpass Clark Gable, Cary Grant, Jimmy Stewart, Marlon Brando, Montgomery Clift, Paul Newman, Warren Beatty, and everyone else to become the greatest movie star of all time. "Immortality is a difficult subject," the journalist Alyssa Rosenberg wrote. "It doesn't actually make sense that Humphrey Bogart would endure as a romantic hero when the much handsomer, and much more sexually compelling Clark Gable is largely remembered for his performance in *Gone With the Wind* . . . Bogart's humor was much more bitter and clipped than William Powell's, whose performances as Nick Charles would seem to have held up better in an age that venerates irony than Bogart's bitten-off jokes."

But Humphrey Bogart embodied America in a way that few other actors managed, not in the loud, garish manner of John Wayne but with a quieter, grounding sense of history. "As an actor," one critic wrote, "Bogart's sensibility derives from the Wild West, a lawless, gunslinging world where the code of honor is no antiquated frivolity but an essential chapter in the survivor's handbook." (This despite the fact that Bogie was never all that good in western films.) Bogart was an ordinary Joe who learned how to survive and get what he wanted. He was wounded and guarded, on the borderline of ugly, but extraordinarily self-possessed. He managed to do something few actors achieved. "In a sense, his talent is narrow," *Time* magazine opined soon after he won an Oscar for *The African Queen*. "For all his technical excellence, Bogart never gets completely out of Bogart and into the character he plays. But . . . few stars can so convincingly and smoothly accomplish the trick of fitting a character to themselves. In an

odd sort of way, as a result, Bogart manages to achieve surprising range and depth while still remaining the familiar figure with whom millions expect to renew an acquaintance when they pay at the box office to see a Bogart film." That description is the heart of his appeal.

That Bogart lived according to principle and a deep-rooted set of values can be seen in the stand he took against the House Un-American Activities Committee in 1947. Along with Bacall and several others, he traveled to Washington to protest what many saw as unconstitutional infringements on freedom of speech and expression. Though Bogie and Bacall were forced to backtrack in the face of the anti-Communist hysteria that swept the country, they had revealed themselves as persons of conscience. That, too, has served their legend.

The image Bacall worked so hard to codify in the public mind was, in fact, more authentic than many Hollywood stories. She just left out some of the things that made it human. We get very little of what it was like to marry a man a generation older than she was. Love knows no age, of course, but a twenty-five-year age gap has its challenges, and Bacall tells us very little about them. But there are hints, which I bring out in this book. She is also circumspect in how she discusses her involvements with Adlai Stevenson and Frank Sinatra during her marriage to Bogie; as it turned out, Bogart wasn't the only one being emotionally unfaithful in the marriage.

Bacall is very much an equal costar in this book, a situation she never enjoyed in her films with her husband. For all her spinning of myths, her story is remarkable even without the ornamentation. Lauren Bacall was one of the great Hollywood success stories. She was lonely in her last years, a regrettable finale that I wished, when writing about it, could have been different. But what a career she'd had! Leaping from movies to the Broadway stage and winning two Tonys for the effort. Blossoming from a sultry siren into a musical comedy star, giving 200 percent of herself during both incarnations. It's not easy for a beautiful young model to grow old in the public eye. But Bacall did, without apology. She tried Botox once, hated it, and never did it again. "I think your whole life shows in your face and you should be proud of that," she said.

In 2009, five years before her death, Bacall was awarded an honorary Oscar "in recognition of her central place in the golden age of motion pictures." The little gold man had proved to be elusive. She hadn't been nominated until 1996, for *The Mirror Has Two Faces*. She hadn't won.

Still, as much as she'd wanted it, Bacall didn't need an Oscar to solidify her status. After her death, as she expected, her obituaries heralded Bogie and Bacall as "Hollywood's Greatest Love Story." All her work had paid off. The legend was secure.

What's still needed is to understand the people behind it.

PART I

HUMPHREY

1899–1935

Newark, New Jersey, Saturday, December 11, 1920

Braving the cold and the wind, the young man made his way toward the Broad St. Theatre. He was called Hump, and he was the stage manager of the play *The Ruined Lady*, for which he earned $50 a week. Hump knew he'd have extra work to do at the theater that day, as it was the end of the show's run. After their last performance, he'd have to pack up the props, hand over the books, and sweep off the stage. The company would strike the sets and call an end to the show they'd been hauling around the country for most of the past year. Hump wasn't unhappy to see the show end. It was time for a new adventure.

Humphrey Bogart was twenty years old, almost twenty-one, a milestone he'd reach on Christmas Day. When people would ask him if having a birthday on Christmas made celebrations extra fun, he would scoff at the idea. Neither occasion held happy memories for him. "I never had a birthday of my own to celebrate," he said. "I got cheated out of a birthday." For most of his young life, he'd been a drifter and an idler, and his parents did not hide their disapproval. On the threshold of adulthood, Humphrey still didn't know what he wanted to do with his life. He was a slight young man, standing barely five feet eight, with small, rounded shoulders and a petite waist, more handsome than many people would remember. Later, he'd be called craggy or weather-beaten; on occasion, he'd even refer to himself as ugly. But the young man known as Hump who made his way through windy downtown Newark was a good-looking fellow with unlined skin, intense brown eyes, and a tight smile that masked as much as it revealed.

The theater stood where Central Avenue met Broad Street. Overhead, the marquee announced GRACE GEORGE IN THE RUINED LADY. George was a top star of both stage and screen, and *The Ruined Lady* had been a smash hit all over the eastern and midwestern United States, as well as in Montreal. When the Broad St. Theatre placed newspaper ads for the show, they announced, "Monday night, An Important Event,

Grace George in *The Ruined Lady*," featuring the original company from its Broadway debut nearly a year before.

Humphrey had spent months riding on trains and sleeping in seedy theatrical hotels. As stage manager, he'd been responsible for baggage, props, scenery, pulling up the curtain and ringing it back down, collecting tickets and adding up each night's take, as well as prompting actors on their lines from the wings. "I tossed lines to actors like a keeper tosses fish to seals," he recalled. With the exception of a couple months off during the summer, he'd been working nonstop since the previous winter, and he was bored with it. He wanted to shake things up.

He got his chance when he arrived at the theater. At some point that afternoon, the juvenile lead, Neil Hamilton, who'd joined the tour only in October, announced that he wouldn't be going on. Whether that was just for the matinee or for both performances that day is unknown, but either way, the eyes of the company turned to Hump. A year earlier, when he'd taken the job as stage manager, the producer, William A. Brady, had added one more responsibility to Hump's job description: he was to understudy the male parts. A bit of a penny-pincher, Brady probably figured it was a chance to save a few dollars. And so Humphrey's next adventure was upon him.

WORKING FOR BRADY HAD BEEN THE MOST CONSISTENT EMPLOYMENT OF THE young man's life. Expelled from school, threatened with a court-martial during a brief stint in the navy, he'd spent several months burning through various jobs that his father had set up for him. "After getting out of the navy," he told a reporter in 1937, "I got a job as an inspector for the Philadelphia Railroad. I labored at that for a few weeks." When he began working in the movies, studio publicity played up his time on the railroad, implying that it had been some sooty construction job and not what it was: an office position secured by his wealthy father. As the studio's story went, Humphrey's supervisor told him that if he worked hard, he could someday become president of the railroad company. Bogart supposedly countered with the fact that there were fifty thousand employees between him and the president and promptly quit. More likely, if Humphrey's academic and naval careers demonstrated any pattern, he was pink-slipped for insubordination or lack of motivation. His next job, in

the purchasing department of S. W. Straus & Company in Manhattan, didn't last long, either.

All that changed when he went to work for Brady. The florid, flamboyant producer, the son of Irish immigrants, had gotten his start promoting prizefights, including one of the biggest of them all, between the heavyweight champ, Jim Jeffries, and his challenger, Tom Sharkey. That had been back in 1899, a month before Hump had been born. Two decades later, Brady ran one of the most successful theater companies in the world and had an agreement with Famous Players–Lasky to make movies as well. He wore expensive bespoke suits with a gold watch chain strung across his prominent belly. Once a shoeshine boy making pennies in the street, Brady had done quite well for himself. He lived in an elegant brownstone at 316 Riverside Drive, around the corner from the Bogart home at 215 West 103rd. Brady's fortune had been built on Coney Island boxing matches, vaudeville, and Hale's Tours—storefront theaters dressed up like train cars with machinery under the floorboards to jostle audiences as they watched travelogues of the Rhine Valley or the Grand Canyon. "A fine racket," Brady called it. He was an imaginative risk taker who always had a fresh scheme, and he was the most influential figure of Humphrey's early life.

They'd known each other since Hump was a boy. Brady's son, William Jr., was Hump's age. Living just minutes from each other, they were "inseparable from the time they were kids," according to their mutual friend Ruth Rankin, later a fan magazine writer. So often did Rankin see the boys running in and out of each other's homes that she thought they were kin. Brady Sr. was also a patient of Hump's father, Belmont DeForest Bogart, physician to the gentry of the Upper West Side. The Bogarts often looked down their noses at show people, but Brady had enough social clout (and the ability to provide free tickets) to be an exception.

The Bradys' home was much more stimulating for Humphrey than his own, where his mother spent most of the day cloistered in her art studio and his father, when he wasn't seeing patients, was often ill. For a young man like Humphrey, searching for something without being aware that he was searching for anything, Brady provided inspiration, as well as a strategy for survival. "There was [an] axiom this impresario of the prize ring and the theatre lived by," Brady's New York Times obituary would read thirty years later, "one he learned as a poor child on the Bowery

sleeping above a saloon. It was to fight early and often to avoid being picked on unnecessarily."

Humphrey understood the axiom. He'd engaged in his share of fist-icuffs over the years. Ruth Rankin told the story of coming upon him sometime in 1918 or 1919, laid out on a sidewalk in Greenwich Village. Rankin "picked up all [she] could find" of her friend and phoned Dr. Bogart, "who seemed less surprised than would be ordinarily indicated." Rankin figured that Hump's father had "been called before on similar occasions." As many not-so-tall young men with concave thirty-six-inch chests discover, there are times when one needs to be pugnacious to make one's way.

At some point, Hump acquired a scar on the right side of his upper lip. As always, once movie press agents got hold of a story, they spun it to fit whatever image they were building for their client—in Hump's case, the tough guy. One narrative claimed that he'd gotten the scar during his naval service, when he tried to stop a prisoner from escaping. Another version claimed that a German U-boat had fired at the ship. As Bogart (or his press agent) told it, "Why, it was all part of the fun when [a shell] hit the side of the boat and splintered it. A piece of wood lodged in my lip. That's where I got this scar."

The story is entirely false. As his military records reveal, Humphrey saw no action during his time in the navy. The escaping prisoner tale is also dubious, given the physical Hump was given upon his discharge from the navy in June 1919. Despite an extensive inventory of other scars and marks on his body, the record fails to note any deformity on his upper lip. Ruth Rankin insisted that the scar had come from that night in Greenwich Village, when Hump had brawled with a fellow over his wallet, or maybe over a girl. "He carried a souvenir from that little fracas," she wrote, "an upper lip like an awning, which blurred his speech but didn't stop him from talking. Finally, his father made a pleat in it."

Brady took care of him in more intangible ways. When he was Hump's age, he had stood weeping over the body of his father, who'd been found on a city street, dead from drink and exposure. Brady had never known a father's support, so he made sure that his own son, Bill, along with Bill's pal Hump, would be pushed and encouraged and challenged and occasionally, when warranted, praised. Dr. Bogart's attempts to direct his son's life and career had so far failed spectacularly. But Brady, by hiring

the wayward young man as stage manager, had lit something in him, inchoate and imprecise but hopeful, for the first time in his life.

Until going to work for Brady, Humphrey had absorbed the cynicism of his generation, articulated by F. Scott Fitzgerald when he had described the era's war-scarred young people "grown up to find all Gods dead, all wars fought, all faiths in man shaken." Humphrey might not have seen action in the war, but he knew the death count, had seen the stacks of coffins brought back in the holds of ships or buried overseas. His return to civilian life took place in a postwar economic decline, one that had, by December 1920, settled into a severe deflationary recession. Jobs were scarce, which exacerbated the problem of Hump never holding on to one for very long. Many of his peers surrendered to defeatism. Humphrey's chances for success seemed remote.

William Brady saved him. Brady wasn't just his employer; he was his godfather of imagination and possibility. Since Humphrey had been a boy, Brady had slipped free passes to him and Bill Jr. for plays, revues, and circuses. Humphrey would remember seeing *Oliver Twist* at the New Amsterdam Theatre and George M. Cohan singing and dancing in his eponymous theater. The extravaganzas at "the Hips"—the Hippodrome on Sixth Avenue—were particularly thrilling: *Neptune's Daughter* with its daring aquatic stunts and *Sporting Days* with its gladiators on horseback. As Bill Jr.'s boon companion, Humphrey had easy access to box seats for all of Brady's shows on Broadway. When he was eleven, he'd watched as Brady's daughter and Bill's sister, Alice Brady, seven years his senior, made her debut in the musical *The Balkan Princess*. Overnight, she became a star.

But the young Hump had eyes for someone else—"A marvelous English actress whose name I should remember but don't," he'd say a couple of decades later, recalling only that she had appeared with H. B. Warner. Night after night, Hump and Bill would sit in their high-priced box watching the beguiling leading lady with her costar. Sometimes they'd shout, "Go it, Harry!" at "very tense" moments of the drama. Had they been just a couple of kids and not William Brady's son and protégé, they would have been tossed out. But as it was, the boys had the freedom to slip backstage after the show, where Hump found himself dumbstruck in the presence of his inamorata. "I'd hold her coat for her and shake all over," he said.

By the time he was thirteen, Hump had seen Laurette Taylor in *Peg*

o' My Heart, Maude Adams in *Peter Pan*, and Alla Nazimova in *Bella Donna*. He would even recall seeing the nineteenth-century theatrical legend Sarah Bernhardt at the Palace Theatre with an opening vaudeville act featuring a young juggler by the name of W. C. Fields.

So when Brady offered him a job as stage manager for productions starring his daughter, Alice, and his wife, Grace George, Humphrey enthusiastically agreed. Seventeen years later, Bogart was still crediting Brady for getting him started on the road to success; Brady was the reason he was, by that point, a rising star in Hollywood. "Surgery I couldn't see," Hump said, eschewing his father's profession. "Ships interested me, but I was bored with the shipping business. The bond business I hated. Then I thought of Mr. Brady and the theater." He'd spent his youth in the thrall of the stage; making his living in showbiz would be a fantasy realized. "I wanted to act," he said plainly in 1937, as if it had been the most obvious and wonderful thing in the world.

But that was before the Hollywood machine geared up to remake his image. Three years later, in 1940, as Humphrey Bogart was being groomed for top stardom, he gave a very different sort of interview to a fan magazine writer. "There wasn't a drop of theatrical blood in me," he insisted. "I never played theatre as a kid, and I didn't like boys who did. They were sissies." During the Great Depression, Hollywood made sure that its male stars were all he-men and tough guys. Clark Gable, James Cagney, and Spencer Tracy had also been theater enthusiasts in their youth, but once they started their ascent, all traces of theatrical ambition had to be erased. They were presented to the public as reluctant actors, dragged onto the stage only under protest. What real man, after all, would ever dream of becoming an actor? Actors were soft. *Sissies*.

Humphrey's youthful excitement about sitting beside Bill Brady in those high-priced theater boxes marveling over Alla Nazimova or Sarah Bernhardt, therefore, had to be transformed into something else. By 1940, he would describe his adventures with Bill as "shooting the globes out of lanterns with air rifles, which our parents didn't know we had." His friend Joe Hyams, in his authorized Bogart biography, claimed the young man had also gotten his hands on a .22-caliber pistol and, while horsing around, had shot himself through the wrist—"Fortunately," Hyams assured his readers, "without doing any serious damage." How a bullet can blow through a wrist without creating serious damage stretches credulity (and there's no mention of it in the physical exam Humphrey was given

upon his discharge from the navy). But guns, secret hideouts, signals to warn of approaching cops: "That was the kind of fun I went for as a kid. Adventure stuff." It was the same stuff, pointedly, that he was going for in his movies by that time.

The Bogart legend, first promulgated in the late 1930s and early 1940s and nourished by chroniclers for the next seventy-plus years, simply could not reconcile the Broadway boulevardier of the Roaring Twenties with the cynical tough guy of midcentury. Humphrey's decision to enter the dandified world of the theater needed to be somehow explained away. It was just for the money; it was only because he "loved sleeping late in the morning." Even a more recent biographer wrote that Hump had agreed to take the job as stage manager only after both Alice Brady and Grace George had clamored for him to do so, leaving him "beset from two sides." But in fact Humphrey had required no prodding to take Brady's offer; it was the fulfillment of a boyhood dream.

THE RUINED LADY HAD GIVEN ITS FIRST TRYOUT IN BROOKLYN AT THE MAJESTIC Theater on December 29, 1919, which is the date we can mark as Humphrey Bogart's start in show business. The comedy of a woman of certain years who tricks her longtime beau into proposing marriage received generally good reviews. But the trade paper New York Clipper was a bit more measured, calling the play "more or less clumsily handled" and hampered by "technical shortcomings." At least some of those shortcomings would be the job of the stage manager to fix, so Humphrey no doubt took careful note of what was going right and what was going wrong. By the time the show rolled into Newark, he seems to have had it under control.

Much of the magic that happens during a performance is conjured up backstage: the well-aimed spotlight, the sudden cut to black, the startling sound effects, the rise of a curtain that reveals a shimmering set. That was what Humphrey was tasked with overseeing, and the twenty-year-old onetime slacker seems to have done an efficient job. If he'd fallen short, he wouldn't have been kept on for the run of the play, no matter how good friends he was with the boss's son. After seeing so much theater as a boy, he had good instincts for that sort of work. He knew when to cue an actor and how to manage curtain calls. When The Ruined Lady had opened at Brady's Playhouse Theatre on West 48th Street in New York City on January 19, 1920, its sets were praised as being "so thoroughly pleasant

they drew spontaneous applause" and its overall production as efficiently "workmanlike." Humphrey hadn't designed the sets, but he'd made sure that they were arranged flawlessly and lit effectively. Although he didn't come out to take a bow at the end of the performance, he perhaps should have. A successful Broadway opening isn't easy to pull off even for pros much more seasoned than *The Ruined Lady*'s novice twenty-year-old stage manager.

During their time on the road, Gladys George coached Humphrey on a career in theater. "Always keep working," she told him. "By constant working, you learn the business." He took her advice to heart. And now, on the show's last day in Newark, he was about to learn one more lesson, one that would set him on a path to the future.

The part Hump was stepping into was small but pivotal. Dallis Mortimer, the nephew of the protagonist played by George, appears at the top of the show; he and his sister, played by Leila Frost, deliver the show's first lines. Hump had very little time to prepare. Although he largely knew the dialogue, he had to balance his work onstage with his stage management backstage.

Just why Neil Hamilton wasn't playing the part that last day isn't entirely clear. A few years later, Hump would tell the *Los Angeles Times* that his first onstage performance had been for the matinee; in response to a press agent's questionnaire, he stated that he'd needed to fill in because Hamilton had taken ill. That certainly seems plausible enough, but as the origin story of movie star Humphrey Bogart was revised and polished, something more characteristic of his screen persona was needed. In 1940, in the same piece in which he'd turned himself into a juvenile delinquent shooting out lanterns, Bogart would declare that his first appearance on a stage had been the result of a dare. "I'd been kidding Neil Hamilton about the soft life of an actor," he said. "Acting doesn't look very hard to me," he claimed to have said. And so, on the last night of the show, Hamilton told him to go on in his place. "I took the dare," Bogart said.

The story is absurd. Hamilton would have been in breach of contract if he'd refused to go onstage. But for the Bogart legend, the story of Hump teasing a dandified thespian for being overpaid for a cushy job bolstered the myth of the manly, reluctant actor. The teasing anecdote, in fact, sounds a lot more like Hollywood's Bogie than it does New York's Hump, who had just spent a year watching how hard actors work.

The legend wouldn't be consistent, either, on the details of what happened once Humphrey made it onstage. One account called the performance only an afternoon rehearsal, though why, after months on the road, the company would need to rehearse on their last day goes unexplained. That same account also claimed that Gladys George had gotten sick, too, and so the entire performance had been canceled, thereby thwarting Hump's stage debut. The problem with that story is that none of the theatrical trades or Newark-area newspapers reported the show ending its run a day early. The cancellation of a final performance of a popular show, especially if due to the illness of a major star such as George, would have been covered somewhere. Newspaper advertisements were running for the show straight up to its last day.

When Bogart himself told the story, he didn't say that the show had been canceled. Indeed, he gave the distinct impression that he had made it through the performance (and perhaps two performances, if Hamilton had also ditched on the evening show). The experience turned out to be an epiphany for him. In Act I, his character, Dallis, is easygoing, but in Act II, when the scheming comes to a comical head, he has to deal with the repercussions, "which occur with a vengeance," according to one review. Dallis finds his aunt and her beau apparently in flagrante delicto, "leading Dallis to tell Bill he must marry his aunt." Humphrey seemed to be describing that particular exchange in his recollections: "In one scene, an actor was supposed to be mad at me, and I thought he was really mad. It was the first time I had been face to face with actors at work. I didn't realize how convincing they could be!"

His friend Nathaniel Benchley wrote, "[He'd] never been in front of an audience and was unprepared for the almost tangible electric current generated by a house full of people. He was . . . moist and shaking when the final curtain spared him—and the audience—any further torture."

Benchley's account implies that Hump wasn't very good in the part. That belief, too, seeped into the Bogart legend. Joe Hyams described the novice actor as "awful" on his first try and quoted him as saying that despite knowing "all the lines of all the parts because [he'd] heard them from out front about a thousand times," he couldn't remember a thing once he got onstage. This is a common trope in the official recounting of movie star histories: Katharine Hepburn, Bette Davis, Clark Gable, and Cary Grant, to name some of Bogart's contemporaries, were all, according to their legends, rejected and derided on their first outings.

Their talent went undetected by shortsighted managers, directors, and audiences—which made their eventual triumphs all the more impressive. In Bogart's case, the studio's reimagining of his origins had him declare "Never again!" after his supposedly disastrous stage debut. Only "to make a fortune" did that latter version of Bogart consent to becoming an actor. This is a trope that tends to be used more in the origin stories of male stars, who weren't supposed to care about such things as fame or artistic expression. Getting rich, however, was an acceptable, even admirable goal.

All of this does a disservice to the young man who strode out onto the stage of the Broad St. Theatre in Newark and did his best, and who turned out, evidently, to be competent enough for Brady to hire again within a month of *The Ruined Lady*'s closing—not just as a stage manager, significantly, but as an actor. Humphrey had never successfully committed to anything in his life for as long as he had committed to the theater—a full year, by the time of the show's closing. His experience onstage on December 11, 1920, was visceral and transformative, and it allowed him, for the first time, to imagine the possibility of a career, a vocation, a *life* for himself. For his past twenty aimless, combative, unhappy years, the possibility of being successful at anything had seemed elusive. Now he had found a way forward—although it would take him the rest of his life to unlearn the message of hopelessness that had followed him since the day he was born.

Manhattan, Monday, December 25, 1899

When Humphrey Bogart was born on Christmas Day, it's unknown whether his mother held him, and if she did, for how long. Several weeks later, she'd pose for a photograph with him in her arms, a formal portrait of the kind many upper-middle-class families took at the time to document a birth. An artist, she also drew her son at seven weeks, the baby propped in a bassinette as she stood a few feet away at her easel. But that's as much as we can say for certain about the family connection in those first few critical weeks and months of Bogart's life. All we have is what Bogart would later say about his parents and their emotional distance from him. "We were not an affectionate family in the sense that some families are," he recalled. "It was difficult for us to kiss, for instance. We were a career family, too busy to be intimate." It's also unclear whether Humphrey's father ever scooped him up in his arms or bounced him on his knee, or if so, how often. But we can surmise. "There was no affection in my family, ever," Bogart said. "The closest it came was a clap on the back."

When babies aren't held, when children are denied affection, they struggle to grow, both physically and emotionally. Their brain doesn't learn the connection between human contact and pleasure. Like many white Anglo-Saxon Protestant families of the period, the Bogarts believed that too much affection or praise could stultify their children's progress or make them weak. Much of Humphrey's care, as well as the care of his two sisters, Frances Patricia "Pat" and Catherine "Kay," who came along at regular intervals after him, was relegated to servants and nannies, who were present in both their Manhattan town house and their summer home on Canandaigua Lake in western New York State. Until the Bogart children were in their early teens, a nursemaid would meet them each day after school and escort them home, where cooks and maids saw to their dinner. "Our mother and father didn't glug over us," Bogart said. "They had too many other things to do." Though Christmas

and his birthday weren't "exactly overlooked," he remembered, "there was no to-do about it. Everyone was busy with matters of more interest and importance."

That lack of family connection provides a window on the emotional conflict that Bogart struggled with for the rest of his life. When babies fail to thrive due to lack of intimacy, they can grow up with a lingering sense of unworthiness, weighted down by sadness, rage, and an abiding sense of inferiority. Often, at a young age, they turn to drugs or alcohol to palliate those feelings. Only those with remarkable determination can break free of such a legacy.

Although not the wealthiest of families, the Bogarts were financially very comfortable at the time of their children's births and extremely conscious of their place in New York society. "We lived in a three-story brownstone house filled with horsehair furniture," Bogart later said, "maintained a legion of Irish maids to look after things, drove the newest cars on the market." In Manhattan, they lived in one of the highest-income neighborhoods of the city. At their Canandaigua lake house, they were surrounded by neighbors whose occupations were given on census records as "own income," likely indicating that they'd been born into money and did not have to work for a living. The Bogarts worked, however; worked a great deal. Dr. Bogart was a prominent physician serving at three different hospitals. His practice was successful enough for him to make the move uptown from 315 West 79th Street, where Humphrey had been born, to the West 103rd Street town house, for which Belmont paid $14,000. On the first floor of the house, he set up an office in which to see patients. His wife, one of the most successful commercial artists in the country, also worked from home, sketching and painting in a studio that was off limits to her children.

Bogart would call his mother the "busiest" in his busy family. He'd been named for her. Maud Humphrey was the daughter of John Humphrey and Frances Churchill of Rochester. Her father was the business manager for a large construction company; in 1870, Maud's parents shared a combined personal estate of $7,500 and real estate worth $6,500, enormous sums for the time. That wasn't counting the inheritance they received after the death of Frances's father, an affluent lawyer and merchant, which helped subsidize Maud's decision, at the age of eighteen, to attend the newly formed Art Students League of New York in Manhattan.

Since girlhood, Maud had shown talent as an illustrator, and the League offered a modern approach to the study of art. From the beginning, many of its students were women. In rented rooms on 16th Street and Fifth Avenue, they were taught drawing, painting, and sculpting. Maud was determined to become a recognized artist. "For over forty years," her son said, "she expended all of her considerable mental and physical energies to bring [her] name to prominence."

After a few years studying in Paris under the naturalist painter Julian Dupré, Maud returned to New York in September 1894 ready to take the art world by storm. That meant a relocation to Manhattan with her mother, to whom Maud was "devotedly attached," according to an acquaintance. (Her father had died shortly before her departure for Paris, leaving them enough money to finance their move.) Their home at 200 West 79th Street was described as "beautiful" by a Rochester newspaper reporter. There Maud set up a studio and got to work.

Her medium was watercolor, "worked so dry," her son said, "the painting seemed to be etched." Maud's sentimental depictions of babies and children were quickly snatched up by Louis Prang, considered the inventor of the modern Christmas card, and by the Frederick A. Stokes Company, which used them as book illustrations. From there it was a fast rise to the top. For Stokes, she illustrated *The Book of Pets*, a children's title with color plates, which went into several printings. She also provided watercolors for books of fairy tales and Mother Goose rhymes. By the end of the decade, Maud was one of the most sought-after American illustrators. One of her most successful works was *Sleepytime Stories*, published by the Knickerbocker Press just a month before her son Humphrey's birth.

"Her children are natural, everyday sorts of tots," one art reviewer commented. "Her work is characterized by skillful draughtsmanship, refined color and a pleasing regard for detail." Maud drew Betsy Ross, George Washington, and other Revolutionary War patriots as children, with plump, angelic faces, many of them hoisting American flags. She rendered little boys in curls wearing sailor suits and little girls at prayer wearing lace nightdresses. Only from a privileged class perspective can those images ever be described as "natural" or "everyday." One art critic contrasted Maud's work to that of Ida Waugh, a contemporary artist whose child subjects were far less idealized: "the children of the tenements, the careless waifs of the sidewalk, [the] everyday imp and angel."

With her flag-bearing toddlers and prayerful babes, Maud was codifying the way white, middle-class America wanted to see its children.

The artist often used her own offspring as her models. Maud drew Humphrey at seven weeks old—already with dark hair at such a young age—and the image was used in magazines, calendars, and advertisements. It would later be revived after he had become a Hollywood star as an amusing fan magazine contrast to his rogue image.

Maud stands out as a woman of agency and self-determination a full two decades before American women won the right to vote. She made no secret of her support for suffrage. Her marriage to Belmont Bogart was as egalitarian as it could be in the Victorian era. Their wedding announcement included the information that she was "a well-known young New York City artist," at a time when a bride was usually defined only by whose daughter she was. Her son said, "She was working when she married and she never thought of stopping." Maud was part of a movement in the arts to equalize the appreciation of women's and men's contributions. The art journal *Critic*, in profiling Maud's work, challenged the practice of distinguishing artists by gender, "as if there were a disposition to . . . divide an art by a question of suffrage."

For all her support for a woman's right to vote, however, Maud was not entirely progressive. Her son would describe her as "a laboring Tory," pointing to her "upper-stratum heritage, the times in which she lived and her own undeniable snobbishness." He described his mother as having no faith in working people and clinging tightly to her social privilege. She dressed elaborately, wearing white boots even when it rained because black boots were "plebian." People called her "Lady Maud." Her son thought the name was apt.

Maud's influence on her son was lasting. Humphrey Bogart grew up with the example of a strong, independent woman who made decisions for herself and her family and who did not need a man to support her. (At several points, Maud earned double the annual income of her husband.) "I admire her more than anyone I have ever known," Bogart said in 1949. But admiration did not translate to affection. Strong women might be admirable in the abstract, but in his own romantic exploits, he would do his best to avoid them. As his father declined due to ill health and an addiction to morphine, Bogart witnessed his mother taking over as breadwinner and custodian of the family, often belittling his father in the process. Strong women, he came to believe, were cold, judgmental,

withholding, and emasculating. That belief would hover over all four of his marriages.

Around 1910, Maud became the chief art director at the *Delineator*, a popular monthly magazine that published clothing patterns, photos of embroidery, and articles on home decor. "She set herself a nearly incredible schedule," Bogart would recall, "working at her office by day and far into the night at our home." The streetcar journey downtown every morning to the magazine's office on Spring and MacDougal Streets and then the return trip uptown in the evening also sliced considerable time out of her day, keeping her away from her family.

As a result, her son said, "she had no time for emotion, even less for sentimentality." The cherubic children of her paintings suggested a tender, dewy-eyed worldview that Bogart could not recognize in his mother. "She was essentially a woman who loved work, loved *her* work, to the exclusion of everything else," he said. Her children called her by her first name. "It was always easier to call her Maud than Mother," Bogart remembered. "'Mother' was somehow sentimental. 'Maud' was direct and impersonal, businesslike."

What made Maud so cold and distant from her own flesh and blood can only be guessed at. Her own childhood was described by one newspaper account as "an ideal family, each one engaged in congenial pursuits . . . but not unmindful of the need for praise so often bestowed." If that was true (and it might not have been, as it was part of a panegyric printed at the time of Maud's mother's death), it is the exact opposite of the way Bogart would describe his own childhood and the mother he judged "incapable of showing affection." For his entire life, he'd admire her above all others. "But," he said, "I can't truthfully say that I ever loved her."

AT NINE YEARS OLD, HUMP WAS ENROLLED AT THE TRINITY SCHOOL, NEW YORK'S oldest private academy, founded in 1709 and one of the most prestigious in the country. Trinity operated under the auspices of Trinity Church, the affluent Episcopal congregation to which many of the city's elites belonged. Located on West 91st Street between Columbus and Amsterdam Avenues, the school was a walkable distance from the Bogart home. On the last Monday of September, Hump made his way to the school, attired in the Trinity uniform of crisp blue Eton suit and beanie.

His father was a graduate of Phillips Academy Andover, Columbia, and Yale, and he intended his son's academic pedigree to be just as solid. The problem was, Hump was not a good student. At his first school, the exclusive De Lancey School on West 98th Street, he'd barely passed from one grade to the next. The full name of the institution was, in fact, the De Lancey School for Girls. It educated female students from kindergarten through college, although it also offered "classes for small boys." Might that particular small boy have been uncomfortable attending a predominantly girls' school? Was he teased about it by other boys in the neighborhood?

His grades certainly showed no enthusiasm for the educational process. His family had been "pretty discouraged," Hump said, about his chances of success in life. "Very early, my father saw I wasn't going to be a student." The answer, Dr. Bogart hoped, was Trinity. "Prepares for all colleges," Trinity's advertisement in New York newspapers declared. Certainly that was what Dr. Bogart hoped for. He understood that a good deal of shaping and molding would be needed before Humphrey could make it into Yale.

Belmont Bogart had always been an ambitious man. Serving on the staffs of Bellevue, Sloan, and St. Luke's hospitals, he'd been steered toward success by his own father, Adam Bogart, the son of a farmer in the town of Victory in western New York State. The Bogarts were an old American family, stretching back six generations to Gijsbert Bogaert, born in Schoonrewoerd, Utrecht Province, in the Dutch Republic, who had emigrated to New Amsterdam in the 1620s, just a few years after the arrival of the Pilgrims. A later ancestor, the similarly named Gisbert Bogaert, had fought in the American Revolution. Adam Bogart's father, however, had fallen on difficult times, suffering a series of financial misfortunes and hanging himself in his barn. That had sent Adam out on his own at a young age to rebuild the family's fortunes.

He did quite well for himself, first as an innkeeper and then as a lithographer, developing a process that brought the family "a great deal of money," his grandson Humphrey would recall. Adam increased his worth by marrying Julia Stiles, the daughter of a wealthy landowner from Ontario County, New York, who brought a sizable estate to the marriage. Their second son was named Belmont DeForest, his first and middle names taken from two of the state's grandest families, neither of which,

however, was in any way related to either Adam or Julia. Instead, the names reflected their social aspirations.

After his mother's death when he was just two, Belmont was raised by maternal relatives for a while before his father retook custody of him. Adam was determined that his son have every opportunity to improve his station; for all his money, Adam remained a sign maker with a shop on Park Place in Manhattan. He made sure that Belmont attended the best schools, where the young man proved to be bright and charming enough to gain his professors' mentorship. Graduating from the Yale School of Medicine, Belmont had all the connections and access he needed to establish a successful practice in Manhattan. With the city's old-money elite embracing him, his rise was swift. "My father made a great deal of money," his son would state. And, like Adam, Belmont married a woman with enough of her own collateral to cement his social status.

His father, Humphrey said, was the "antithesis" of his mother. For all of Belmont's self-awareness of his social position, he nevertheless "loved talking with truck drivers or farmers or anyone else who came along"— something that would have been abhorrent to Maud. Belmont was also an outdoorsman, an inclination he passed on to his son. Their outings at the lake house disproved Maud's contention that Humphrey was a sickly child, an idea that had grown out of an early bout with pneumonia. In fact, the boy was agile and strong. He relished the escape from the drudgery of the classroom, as well as a chance to bond with his father. "My father liked to get away from his patients into the open air," Humphrey would remember. "We went sailing, hunting and fishing together. It was a good way for me to dodge any prissying up around the house."

"Prissying up," whatever that meant, was, of course, something the Humphrey Bogart of 1949 (when he made the statement) needed to keep far away from his image. Instead, studio publicists would play up his sailing adventures, including the time he and his father had supposedly found a drowned man in the lake. But it's true that Humphrey's exploits in the great outdoors provided him a happy retreat from the stultifying Manhattan home of his parents, with its indifferent servants and irritable matriarch. Summers in Canandaigua offered him an escape and influenced how he wanted to see himself. His father, he'd say, was a "he-man," and so, therefore, he would be one as well.

For the rest of his life, Humphrey Bogart would feel most at home on

the water. The yachtsmanship he learned on his father's boat meant that by the time he was in his early teens he was an expert captain. His father gave him a one-cylinder motorboat. "I used to putt-putt around the lake all day," Bogart remembered, "exploring every watery inch of it." With his pals—the sons of bankers and industrialists—he'd zip across the lake, docking alongside the steamer ferries in the harbor so they could haul themselves up onto the deck and dive into the water. Other times the boys rode the waterfalls in the hills above the lake. In such activities, his father cheered Humphrey along.

A generation later, Humphrey's son, Stephen, would observe that his father's relationship with Belmont, "while far from perfect, seems to have been less disappointing" than the relationship he had with his mother. Still, he added, "few words of affection ever passed" between father and son. Off the water, they had little to say to each other. It wasn't just Maud who withheld intimacy from her children.

Once the summer ended and the family returned to the city, a darker side of Belmont would emerge. In public, at social functions, the handsome, successful doctor projected a friendly, cultured demeanor. "Maud and Father swept off to Delmonico's and the Lafayette and all the other fashionable places in great state," Humphrey would recall, "she beautiful in her perennial lavender and white, he tall and handsome beside her." But Hump's friends witnessed a different face of Dr. Bogart. In private, he could be gruff and grouchy due to nagging, constant pain. When he'd been a young man, a horse-drawn ambulance had toppled over onto him on a street corner, leaving him with a badly fractured leg. The bone had been poorly set and had needed to be broken again in an attempt at repair. The pain never entirely went away. Eventually, Belmont turned to morphine for palliation, wandering like a ghost through the house on West 103rd Street before disappearing, like his wife, into a closed-off room, leaving his children with their maids and cooks.

Sometimes, when his wife's migraines became intense, Belmont would also inject Maud with syringes of his morphine. She also suffered from erysipelas, a chronic skin infection, which Belmont also relieved with his syringe. Eventually both Dr. and Mrs. Bogart became dependent on the drug. Making matters worse, they also drank a great deal, especially when they were quarreling, which became more frequent once Humphrey was in his teens. Their conflicts usually centered on the downturn in the family's finances. Belmont had made some unwise

investments. His medical practice was also in decline. Probably due to his growing addiction, he began missing appointments. Maud, resentful at being forced to manage the family's finances largely on her own, berated her husband for being a failure.

Sometime earlier, Belmont had put the house into Maud's name for reasons that are unclear. But that allowed Maud, faced with the family's declining income, to lease the 103rd Street house during the summer, while they were in Canandaigua. "Real Estate Transfer" newspaper columns document several leases during that period. A deeply private person, Maud wasn't pleased with the idea of strangers occupying her house, and she let her husband know that. "We kids would pull the covers over our ears to keep out the sound of fighting," Humphrey remembered.

According to neighbors, Belmont and Maud also browbeat their staff. In 1910, they employed two Irish immigrant servants, Katherine Compton, thirty, and Mary Fulmer, twenty-six, who lived with them. By 1915, the women had been replaced by another pair of Irish immigrants, Kate O'Connor, twenty-five, and Minnie Hennessy, thirty-seven. "Our maids would invariably quit after a month or two in the house," Humphrey would recall, after Belmont would "go into the kitchen and tease them into such a state that they'd give their notice." Maud would then try to win them back, but she wasn't always successful. Despite Humphrey's lighthearted description of his father's "teasing," the behavior sounds like sexual harassment. It's perhaps not surprising that some neighbors would recount tales of the Bogart servants' lack of interest in or even cruelty to Hump and his sisters. No surprise, either, that by 1920, Belmont and Maud had no servants living with them, a reflection of both their mistreatment of their staff and their own declining finances.

In that unhappy house, young Hump didn't stand a chance. When he was a baby, he'd gripped his father's finger so strongly that Belmont had triumphantly told his friends that he'd produced a surgeon. That was likely the last moment Belmont had any faith in his son's future. His father despaired over the fact that Humphrey didn't possess the same sort of ambition and self-determination he himself had exhibited at the same age. Belmont's despair sometimes turned into rage. It was not uncommon for Dr. Bogart to take the whip to his children, especially his son. One childhood friend would forever be traumatized by the memory of what he saw one day after walking unannounced into the Bogart house. There was Dr. Bogart, holding Hump's neck in one arm and whipping a razor

strop across his back with the other. The boy made no sound and offered no resistance.

Discipline, Belmont believed, was the only answer to his son's recalcitrance. Trinity would provide that. Its rigid austerity, with each day beginning at 9:00 a.m. in the chapel, followed by a strict schedule of classes and physical training in the gymnasium, had brought generations of wayward students into line. The teachers, all Episcopal priests, wore long black cassocks with gold crosses swinging from chains around their necks as they walked. The headmaster was the thirty-nine-year-old Reverend Lawrence Cole, who, because of his pink complexion, was known as Bunny. He was not unkind, but he ran a tight ship.

For Hump, any ship that wasn't the *Comrade*, gliding across Canandaigua Lake, would be unsatisfactory. One classmate, recalling Humphrey years later, thought it was clear that the adolescent boy "wasn't happy at home." His reserve and detachment made him a target of the other boys. "His good looks and his tidiness," the classmate remembered, "plus the fact that he posed for his mother's pretty illustrations, helped earn him a sissy reputation." The boys made sure to call him "Humphrey" because they considered it "a sissy name." It certainly didn't help when his nursemaid was there to meet him after school. "We must have made life miserable for Bogart," the classmate lamented.

Consequently, Hump did his best to lie low. During wrestling matches, he wouldn't fight back, losing quickly "just to get it over with." Sometimes, when the schoolmasters weren't around, the matches took a savage turn, with bullies wrapping unfortunate boys inside a mat and then pummeling them with dumbbells. Not yet had the brawler inside Humphrey emerged. But he was there, his resentment building.

The Bogart legend, of course, could not countenance stories of a weakling being beaten by the tougher guys, and so the mythmaking began. Joe Hyams described Humphrey at Trinity not as insecure and sissified but as cool and debonair, eschewing the school beanie for a black derby (which is nonsense, as doing so would have gotten him kicked out). Hyams quoted a long stretch of dialogue supposedly exchanged between the young Bogart and the Reverend Cole, with the headmaster lamenting the "riots" the obstreperous student provoked in the classroom. Humphrey, in that telling, brazenly confronted his teachers, declaring that he could tolerate only algebra, because English, history, and economics were too "theoretical." He wanted only cold, hard facts, he insisted, sounding

like the gruff mobsters or detectives he would play in Hollywood, which was precisely the point. Stephen Bogart would repeat Hyams's story verbatim in his biography of his father, declaring that "this flouting of authority was a Bogart trademark throughout his life." It was, indeed, a trademark of the Hollywood Bogart. But not so much for the boy called Hump.

No matter how the legend was spun, there were some facts that were incontrovertible. Humphrey's marks did not significantly improve at Trinity. He managed to graduate from the lower school to the high school but ended his second year there with just a 58 percent average. If not for his father's influence, he would've been booted out. In his third year, he managed to get his grade average up to 69, but that was still a point shy of the requirement for passing, so he had to repeat the year. Despite his getting to 70 on his second try, Belmont decided that incremental change was not happening fast enough if he wanted to get his son into Harvard or Yale. It was time for a change.

In the early months of 1917, Dr. Bogart sent a letter to his alma mater, Phillips Academy, asking if they would take his seventeen-year-old obstreperous son. If Andover couldn't make a man out of the boy, he believed, nothing could.

THE YOUNG MAN ARRIVING ON THE TRAIN AT THE BUCOLIC TOWN OF ANDOVER, Massachusetts, about twenty-three miles north of Boston, was miserable on every front. For one thing, he was exhausted, having boarded the train at 3:59 a.m. in New York. On the platform, he saw that no one from the school was there to meet him. He had to navigate his own way to the campus, more than a mile away, asking for help with his heavy trunk from a lorry driver.

His father had chosen not to accompany him. It's doubtful if Humphrey would have wanted him to do so, even if Belmont had been so inclined. It was better sometimes just to keep out of his parents' way. Life in the Bogart household had never been easy, but by that point even the few things that had sustained Humphrey were gone. The previous summer, the Canandaigua house had been sold. When Maud had taken the job at the *Delineator*, she'd needed a summer home closer to the city. So Hump's beloved lake house had been traded for a cottage on Fire Island, where there was little of the communal feel of the lake. Humphrey had

pleaded desperately with his father not to sell the house, but his laments had been brushed aside.

In the weeks after his withdrawal from Trinity, life became, if possible, even worse for the teenager. For much of the spring, Humphrey was confined to his room by a case of scarlet fever, and for much of the summer he was stuck inside studying for the Andover entrance exams. He passed them, barely. But because of the wait to get his grades, he started the semester a week late. The other boys were already settling in and getting to know one another when Hump stepped off the train the first week of October, making what was always going to be a difficult adjustment even more so.

Walking for the first time onto the Andover campus, Humphrey would have been struck by the sight of army bivouacs set up on the grass, with battalions of young men training with rifles. Even before President Woodrow Wilson had declared war on Germany the previous April, bringing the country into the war that had been burning across Europe since 1914, Andover had offered its campus as a training site. "Military training is being taken up enthusiastically by the entire student body," a local newspaper reported. Any student of the high school could elect to join after-school training exercises. Some four hundred students—a majority of those enrolled—had joined the six companies that had been formed at Andover. "Three hours of each week are assigned to the company for the rest of the school term," the newspaper noted. The government donated some two hundred rifles to be used in trainings conducted by army and navy officers. A few months before Humphrey arrived at the school, Andover had sent a unit composed of thirty students to serve in the American Ambulance Field Service in France.

The maneuvers on the quadrangle fit with Principal Alfred E. Stearns's vision for the school. Stearns believed in universal military training, calling it "one of the richest blessings to American youth." He had no patience for "modernists" who would coddle and indulge students. "The early life of the average American boy nowadays," he decreed, "is devoid of everything that makes for character. Duty, responsibility and obligation, hard work and discipline are stones in the foundation of Phillips Andover Academy, and we propose to keep them there." That was precisely the ethic for which Belmont had sent his son to the school.

After finding his way to his room, Humphrey mostly stayed put except to attend classes, although he rarely participated in discussions. One

classmate, Yardley Chittick, later described him as "sullen" and "spoiled." Humphrey did not join the military exercises being held every day after classes. Neither did he take part in any athletics outside of the physical education requirement. His father, a member of the class of 1888, had been a football and baseball star, which was likely the reason Principal Stearns had accepted the younger Bogart despite his poor academic record. From that perspective, it's understandable that Chittick might have viewed Humphrey as "spoiled." But he only knew a small part of the sullen young man's story.

Andover did not offer the hoped-for epiphany for Humphrey. Returning to New York for Christmas, he carried with him a letter from Stearns complaining about his "indifference and lack of effort." Belmont apparently said little, leaving Maud to deliver the ultimatum: "If your marks don't improve measurably by the end of the next semester, we will withdraw you and put you to work." His eighteenth birthday, undoubtedly, was one of the worst of his life so far.

Belmont eventually picked up his pen to plead with his old classmate Stearns. He blamed his son's inattention to study on an obsession with a girlfriend back in New York, to whom he spent all his time writing mash notes. That might have been the girl Humphrey would call "Pickles" in interviews, describing her as his first love. But much more than puppy love was troubling Humphrey. No one, least of all his parents, understood his struggle, his doubts, his inability to believe in himself. Belmont assured Stearns that Humphrey was "a good boy with no bad habits, who simply has lost his head temporarily." The answer to the problem, Dr. Bogart believed, was the same as it had ever been. He urged Stearns to ride his son hard: "The harder the screws are put on, the better it will be for my boy."

Stearns complied, putting Humphrey on probation early in the spring semester and rescinding his off-campus privileges when his grades continued to slide. His teachers were unanimous, Stearns told Belmont, that "he has not exerted himself at all seriously." He hoped that the "catastrophe" of withdrawal could be avoided. No surprise, Humphrey became even more sullen after probation. "He lived a life of his own, like no one else's, a mystery man, actually," recalled his classmate Arthur Sircom, who observed that he was perennially "in the wrong pew at Andover." Alone among the classmates who remembered Humphrey, Sircom recognized the boy's "vulnerability." Humphrey's recalcitrance, if anyone had

cared to examine it, emerged not from malice but from anxiety and, quite possibly, depression.

A month before his class was due to graduate, Humphrey was asked to withdraw from the school, as he had failed to satisfy the terms of his probation. The plain truth was that he was being expelled. "I cannot tell you how deeply I regret our inability to make the boy realize the seriousness of the situation and put forth the effort to avert this disaster," Stearns wrote to Belmont. "I can only express the sincere hope that this will prove the turning point in the boy's life."

In Warner Bros. press releases, the reason given for Bogart's dismissal from Andover was due to "excessive high spirits" and his repeated "infractions of the rules." Nowhere did the Bogart legend prove more inventive than in describing his time at Andover. Bogart's fourth wife told Nathaniel Benchley that her husband's dismissal had come after he was "caught coming in a window after hours." In December 1940, with Bogart on the verge of movie stardom, one fan magazine insisted that he'd been kicked out after being caught by a faculty member with a girl in his room, prompting Humphrey to grab hold of the professor ("a very unpopular gent"), carry him outside, and dunk him in a fountain. It's highly unlikely that Hump, not even yet at his full adult height of five foot eight and weighing somewhere around 120 pounds, could have pulled off such a stunt. Even Hyams, who wasn't above recycling myths in his biography of Bogart, doubted the story after asking various classmates if they remembered it. They did not.

"My father," said Stephen Bogart, "apparently, would rather be thought of as a discipline case than an academic failure, and he bragged about a couple of pranks which probably never occurred." Humphrey's friend Nunnally Johnson said, "He claimed he was thrown out. He had to. Bogart couldn't say he quit or anything like that. He had to be thrown out, you know."

The truth was, Humphrey was asked to leave because he didn't fit in, or play by the rules, or care about the things he was told to care about. When Arthur Sircom saw him leaving campus with his trunk, Humphrey told him, "I'm leaving this fucking place. It's a waste of time here."

LESS THAN A WEEK AFTER ARRIVING HOME FROM ANDOVER TO FACE THE GLOWering disappointment of his parents, Humphrey hoofed his way up the

gangplank of the USS *Granite State*, moored at a Brooklyn pier. The ship served as an enlistment and training center for new recruits for the war. When the war had begun a little over a year earlier, Hump had still been suffering through his final months at Trinity. Now he was eighteen years old, a dropout from not one but two schools, with no career prospects or aspirations. "Because I loved boats and water, I joined the navy," he told a fan magazine two decades later, though he (or a studio lackey) fibbed a bit, saying he'd enlisted at the start of the war, when in fact the conflict was just about over.

Bogart's war service would prove to be quite useful to the legend. The studio promoted him as having been a wide-eyed, cocksure scamp who had been ready to sow his wild oats. "What does death mean to a kid of seventeen?" the fan magazine quoted him as saying. "At seventeen, war is great stuff. Paris. French girls. Hot damn!" Joe Hyams called him "hell bent to get into the military."

But the truth, as ever, was very different. Humphrey simply could not endure another day in his parents' house. His mother had told Stearns at Andover that the boy was going to be hired by Frank E. Kirby of Detroit, whom one newspaper at the time called "the leading marine engineer of the world." But that arrangement apparently fell through, and Hump was faced with no other practical choice but to join the navy as a seaman second class. After his basic training at the Pelham Bay Naval Training Station in Pelham, New York, he was put to work swabbing decks. Later, he worked as a clerk. That would be the extent of his military service.

To be fair to the young Hump, there may also have been other, less desperate reasons for his enlisting. His parents had drilled into him from a very young age that he was deficient, that he was not carrying his load. He internalized this guilt and shame. "I spent much of my life feeling I had let the world down," he said many years later. By the spring of 1918, he could not have missed the fact that so many young men his age were putting their lives at risk for a cause they believed to be greater than themselves. He must have observed that the casualty rate among Andover students increased every few months. Of the seventeen members of the classes of 1917 and 1918 who'd enlisted in the war, twelve had been killed in action. Many of them would have been boys Humphrey had known. So he deserves the benefit of the doubt. Maybe his enlistment was not just an act of last resort but also an attempt to do his part, to carry his load.

Still, he was certainly not a jingoistic, gung ho sailor itching to fight for freedom, even if the studio biographies endeavored to give that impression. One story had him typing up of a list of those being assigned to foreign duty and adding his own name at the bottom. Thereafter, the story boasted, he had seen "active service." Such a stunt seems unlikely to have escaped notice, and besides, the war was over by the time Humphrey received his orders to report to the USS *Leviathan*, the navy's largest transport ship, carrying 14,500 men. Hump's only "active service" came after the cessation of hostilities. That didn't stop inventive press agents from coming up with the U-boat story that had supposedly resulted in the scar on Hump's lip or many other tall tales.

In truth, the transatlantic voyages Hump took aboard the *Leviathan* quickly turned monotonous. The ship's main purpose was to transport peacetime troops back and forth from France, where Americans were helping to rebuild the country after the war's devastation. More than a dozen times, Humphrey crossed the Atlantic, but he saw very little of France (or French girls), despite the stories he'd tell.

In February 1919, he was transferred to another ship, the USS *Santa Olivia*. One night in April, when the ship was docked at Hoboken, Hump didn't return in time and the ship sailed without him. His commanding officer declared him a deserter; the wheels were put into motion for a court-martial. In fact, he hadn't deserted; he'd just missed the boat back to the ship, possibly because he was drunk. Clearly his year in the military hadn't instilled much more discipline in him than Trinity or Andover had. "They didn't know what had become of me," he was quoted as saying, "and for months I was listed as a deserter. That worried me not at all. Nothing worried me."

That's likely more studio hyperbole. The penalty for desertion was five years' imprisonment. Humphrey was no doubt plenty worried and pled his case to various navy departments. It wasn't until June that the desertion charge was changed to "neglect of duty," which brought three days in solitary confinement on bread and water.

One week after serving his sentence, Hump quit the navy. Like Trinity and Andover, it had not been a rewarding experience. "I joined the navy [and] got out from under as fast as I could," he said more candidly than usual. "The adventure was too strenuous for me, as adventure usually is." His service could have been transformative for him, but it was as if it had never happened. Bogart would express regret that the war hadn't

touched him "mentally." Rather, it had left him, he said, "no nearer to an understanding of what I wanted to be or what I was." Accepting his honorable discharge, he went back to his parents' house.

TWO DECADES BEREFT OF WARMTH, EMPATHY, COMPASSION, AND SUPPORT HAD left Humphrey guarded, resentful, obstinate, and angry. He'd internalized his parents' dissatisfaction with every facet of his life and personality, believing on some basic level that they had reason to feel as they did. But he also lashed out against their disapproval. The brawling he became famous for began in earnest after the war. His fights, however, had little to do with the incidents at hand. They were redirected opposition to his parents' low opinion of their deficient son. Only by fighting, Hump believed, could he get what he wanted. Problem was, he had no clue what that was.

Certainly he didn't want the world his parents had built for themselves. Part of the Bogart legend would be his absolute intolerance of class pretension; people who cared about such things, he said, were "phonies." This part of the legend is true. During his childhood, when his father would proudly show off his name in *Who's Who in New York City and State* and his mother would boast of the family's listing in *Dau's Blue Book*, the young Humphrey was not impressed. Why should he find worth in the accomplishments of a family that berated and belittled him? He had dutifully marched through the rites of passage expected of young men of his class—Trinity, Andover—and hated every moment of them. Part of the unworthiness he felt came from believing that he could never measure up, not only in his parents' eyes but in the eyes of the society they so prized. There were expectations for young men of the upper classes—degrees, awards, lucrative positions, club memberships—and he was not fulfilling them. Classmates such as Chittick and Sircom were already making good on the promise of their rank, Chittick heading to MIT, Sircom to Yale. Bogart, meanwhile, after being almost drummed out of the navy, was perennially unemployed.

Yet for all his resistance to it, Bogart's privileged social status was inextricably a part of him. His caste, as one biographer would put it, had been set at birth. After the war, he'd had a comfortable home to return to on the Upper West Side, while many veterans were scrambling to make a living and keep a roof over their heads. He never had to haunt

employment offices, press ball bearings on an assembly line, or worry how he'd pay his rent. He'd be known for making a lot of noise, then and later, against snobs and affectation, but on another, deeper level, he was very aware of his social status and, in fact, valued it.

Years later, he would pontificate on the idea of "class." Sid Luft, the husband of Judy Garland, was, in Bogart's opinion, garish; to Luft, class meant driving a Rolls-Royce. Holding forth on the topic at one party, Bogart seemed to feel obliged to defend the exclusivity of his birthright against such grasping parvenus. "You can't buy it," he declared, referring to class, "and you can't acquire it like a suntan." Sid Luft didn't have class and he never would, Bogart declared; "I know what I'm talking about because I was born with it. I've had it all my life." His friend Katharine Hepburn, springing from blood as blue as his, would make a similar observation in 1991, recalling how she was "old Hartford and very socially OK" and lamenting the fact that "socially OK" was no longer something to be prized. "Nobody," she complained, "knows what that means." But Bogart did.

Following his discharge from the navy, Humphrey made his way through his series of unfortunate employment experiences—the brokerage, the railroad—leaving him apathetic about the prospects of a career. To distract himself, he lived the life of a playboy, one more perk of his class. His chum Stuart Rose, who was dating Humphrey's sister Pat, was the son of a wealthy banker, also hailing from the Upper West Side. Rose taught Hump how to ride a horse, finding his student quite apt. "His body was coordinated beautifully," Rose would remember. Their equitation, however, was largely for show, as they'd trot through Central Park on Sunday morning in expensive riding dress. With Rose and other society friends, Humphrey became a regular at fancy balls and cotillions, such as the one thrown by the Phi Beta Sigma sorority, Zeta chapter, in May 1919 at the Bossert Hotel in Brooklyn. In the newspapers the next day, the name Humphrey Bogart appeared near the top of the list of the fifty tuxedoed, enameled, well-born young men who had danced with the sorority sisters.

Humphrey wasn't always so stilted. Bill Brady, Jr., gave him entry to theatrical parties at the Greenwich Village apartment of the actor Kenneth MacKenna and his brother, the scenic designer Jo Mielziner. Although Prohibition was now the law of the land, the liquor still flowed at private parties such as those as well as in the speakeasies popping up all

over town. At the El Fey Club on West 47th Street, Humphrey cheered for the sultry hostess, Texas Guinan, until the premises were shut down by the vice squad. The best bootleg joints, however, were found in Greenwich Village. Hump's friend Ruth Rankin wrote about going to the Kit Kat Club with him, with Bogart joking that her skimpy costume was "two beads and a buckle." He himself was dressed as a Spanish toreador. Their friendship was not romantic or sexual, or if it was, it didn't remain so for long; Rankin had a fiancé, who sometimes accompanied them on their adventures. "We did the Village regularly," Rankin said, "which was known as 'slumming.' The Village was more fun than any place in those halcyon days."

Most nightclubs were segregated by race, even when black performers were on the bill. But that wasn't the case in Harlem, where Humphrey and his friends also frequently partied. They took in Andy Preer's orchestra at the Cotton Club on 142nd Street and Lenox Avenue and Gladys Bentley's revue at Harry Hansberry's Clam House on West 133rd Street. Bentley, dressed in top hat and tails, sang risqué songs and flirted with the women in the audience.

Humphrey often found himself staggering home just before dawn. Rankin recalled, "I was not the only girl he had permanently in wrong with her family on account of those three o'clock in the mornings." She also recalled the fights Hump had gotten into. The problem was that he simply could not "suppress his joy in the fact that he has no tact and an unholy habit of not minding his own business." He was "a pretty arrogant, fresh kid," but Rankin wasn't overly concerned. "We were convinced that any man who could dance that well and put up a good fight, on any provocation whatever—or none—had a great future."

When Rankin told that story, Humphrey Bogart was being heavily promoted as a movie villain, so the pugnacity fit the studio's desired narrative. But enough other people recalled his hot head to give credence to the stories. The resentment Hump had kept bottled up for so long, spurred on by alcohol, was finally erupting. He couldn't have pulled it back even if he wanted to. As he told his friend Nunnally Johnson years later, he took pleasure in needling a foe "just to the point where he's going to slug you, then you stop," and he didn't always know when to stop. "I have a mean streak in me," Bogart admitted. Nathaniel Benchley, writing forty years later, observed, "There are still those who go white with rage at the mention of his name."

Sometimes the combativeness took a cruel turn, such as the time, much later on, when Bogart, at Romanoff's restaurant, reacted hostilely to a man he believed to be masquerading as a marine. To Bogart's mind, the man was simply too effeminate to be a real marine, and his suspicions seemed confirmed when the man, as Benchley described it, "flounced out [of the restaurant] as though he were walking on springs." Bogart rose from his seat, snarling, "Let's go get him." They didn't—but his rage showed that even after almost three decades, the memories of being taunted, of being made to feel less than a man by his parents, his teachers, his classmates, his naval officers, were still raw—so much so that he would want to "go get" a man who had done him no wrong. That need to prove himself, to show he was no sissy or milquetoast, went back very far and would remain with him all his life.

As 1920 approached, Humphrey's fuse was constantly being lit. Fisticuffs were a way of life. "Everyone dislikes me on sight," he said. "There's something about my face which annoys most people—something about the cast of my head or the look in my eye." Perpetually resentful, he burned every bridge he crossed. He shared his generation's ennui about the world and their place in it. "It didn't look as if he would be anything," said Ruth Rankin, "but an awfully naughty boy from a nice family who thought the world was his oyster." Or at least, he thought the world *should* be his oyster but was perpetually being proved wrong.

And so, at last, he turned to William Brady and asked for a job.

ONE OF THE FIRST JOBS HUMPHREY DID FOR BRADY WAS TO TAKE OVER A FILM called *Life* being shot at the showman's motion picture studio, World Film, in Fort Lee, New Jersey. The assignment sounded like a lark, but Hump knew nothing about movies. Silent movie cameras were big and bulky, and movie actors, with all their exaggerated expressions and mannerisms, were like nothing Hump had experienced in the theater. After a few days of bumbling, Hump was sidelined and Brady himself took over. The movies were not yet ready for Humphrey Bogart. Neither was he ready for them.

But as a stage manager, he found his niche. After his success with *The Ruined Lady*, he was put into a new show that was being developed called *Dreamy Eyes*. He would both act and assist in stage management. His salary was doubled to $100 a week. "He had the beginning of a career

just tossed in his lap and took it all in stride," said Ruth Rankin. Finally, there was something he was good at. Finally, he woke up with some motivation each day.

But could he sustain it? Humphrey had no idea what the rest of his life would look like as he marked his twenty-first birthday that Christmas. But he did know that something was different. The turning point in his life had not, as his former principal had presumed, been his expulsion from Andover—or any other experience in which he had been expected to see the error of his ways. The turning point, instead, had come on that stage in Newark on the night of December 11, 1920, when, terrified and exhilarated, he'd pushed himself beyond his comfort zone and finally become a valued part of a team. At long last, he could glimpse a way forward.

William Brady knew that something was wrong with his new show even before its first tryout at the Majestic Theatre in Brooklyn. *Dreamy Eyes* was too long, and its name was being derided by Broadway wags as childish. Still, its lead actress, Faire Binney, was a movie star—a minor one, but that didn't matter: theatrical audiences flocked to buy tickets whenever a picture player was in a show. Brady took his seat beside his daughter, Alice, and hoped for the best.

Some rows behind him sat Stuart Rose, who'd brought Dr. Bogart to see his son, Humphrey, in his first billed performance. Also with them was Pat Bogart, whom Rose was planning to marry. Looking down at their programs, they saw Humphrey's name at the bottom of the cast listing. Playing a character named Subi, a Japanese manservant, the novice actor had been subjected backstage to the stereotypical "Oriental" makeup of the period: a slight yellow tint to his skin, exaggerated black makeup around his eyes, possibly a braid of hair attached to the back of his head. His part was small but intended to be memorable.

Rehearsals had begun in early April; the premiere was held on Memorial Day. Earlier, Rose had marched in a parade up Riverside Drive with forty thousand other veterans. With so many marching from 74th Street to 92nd Street, the parade lasted three hours, which meant that Rose had to hustle to pick up Pat and Dr. Bogart and get to the Majestic Theatre on time. Humphrey had not been among the marchers, although he would have been welcome to participate as a navy veteran. But that morning he'd been busy running through a dress rehearsal for the evening premiere, and he was likely perfectly fine with that.

Dreamy Eyes was the lighthearted tale of a young woman from Menominee, Michigan, played by Binney, who takes on the big city of New York. Subi works as a valet for her aunt and pops into and out of scenes to deliver droll observations. When Humphrey first appeared onstage, wearing a trim-fitting white jacket and carrying a tray, the three

people who had come to see him watched carefully. He delivered his line, got a laugh, and then exited stage right. Rose wasn't impressed, but Belmont turned to him and whispered, "The boy's good, isn't he?" Dr. Bogart seemed almost awestruck that his shiftless son had finally committed to the job at hand.

Over the next few weeks, the play was trimmed and renamed *The Teaser*. Brady made some other changes as well, including among the cast. By the time the show opened on June 8 in Stamford, Connecticut, the part of Subi was played by Allen Atwell. Perhaps Rose was right and Belmont wrong about the quality of Humphrey's performance. But as it turned out, Brady brought his young protégé back to the show for its opening in Asbury Park, New Jersey, during the third week of July. By the time *The Teaser* opened at Brady's Playhouse Theatre on Broadway a week later, Bogart was gone again and Atwell was back in the part.

It's possible that the casting shuffle wasn't because of any dissatisfaction with Humphrey but rather because he was needed elsewhere. Alongside the development of *The Teaser*, Brady had been building a play for his daughter, Alice, called *Drifting*. The show had been struggling through tryouts in Brooklyn and elsewhere since the previous April. Although Humphrey cannot be pinpointed in published cast lists until later in the year, it seems very likely, especially knowing how fond Alice Brady was of him, that he was transferred from the one show to the other near the end of July. *Drifting* opened in Atlantic City, New Jersey, on August 7.

As both actor and stage manager, Humphrey had his hands full, and he found himself in a clash of wills with Brady. In Atlantic City, he didn't like being overruled by Brady on when to raise the curtain, so up and down the curtain went, leaving the audience bewildered. Clearly not yet ready for Broadway, the show limped over to Asbury Park for further try-outs. Finally, Brady called a halt, putting *Drifting* on hold in late August.

Humphrey's conflict with the producer did not derail his stage career. During the fall of 1921, he toured with Alice Brady in a midwest road show of her Broadway smash *Forever After*. What role he played is unknown, as no cast lists for the company have yet surfaced, but it was evidently not an insignificant part, as a couple of years later, a critic in Wilkes-Barre, Pennsylvania, would "pleasantly remember" him in the play. The *Forever After* tour ran through several theaters in Pennsylvania and Indiana. How long Humphrey was in the show is unknown. He may have been idle for a time that fall; he'd later recall periods when he had

been unemployed for a season. That was because, he said, he was becoming "fussy" about which parts he took.

Humphrey was beginning to think of himself as an actor. His name had now appeared in enough published cast lists to be recognized, if not by the general public, then by theater managers and Broadway aficionados. "I liked the challenge of stepping into new characters," he said, looking back, which was a sea change for a young man who had, so far, been loath to challenge himself.

On January 2, 1922, Humphrey Bogart, freshly twenty-two, made his Broadway debut at Brady's Playhouse Theatre in the rewritten *Drifting*. The play was another "Oriental" drama, but this time Bogart played an American sailor who comes into contact with "one of life's derelicts," a euphemism for prostitute, played by Alice Brady. Humphrey's part was small, but he had several lines of dialogue to memorize. The rewrites of the script seemed to have been successful, as *Drifting* garnered mostly good reviews; the New York *Evening World* called it "the best acted melodrama of the season." Although Bogart was not singled out in the reviews, a critical and commercial hit such as *Drifting* could launch his career.

The show closed briefly when Alice Brady became pregnant but reopened on January 16 with a new actress topping the cast. Helen Menken was an up-and-coming star, most recently seen in the short-lived Shubert production *The Mad Dog*. *Drifting* might launch her, too, to the sort of height she'd been seeking since her stage debut at age fifteen. An elegant, graceful actress with a serious face, Menken was just a few weeks older than Bogart, and, like him, a New York native. The child of immigrant, deaf parents, Menken had learned early how to express herself through facial expressions and body language. Producers pegged her as someone to watch.

Humphrey was once again helping out backstage. *Drifting* had eight complicated Chinese dock sets that needed to be assembled and broken down several times during the performance. One night, before Menken went onstage, one of the props fell over on her. Scared but unhurt, she spun on Humphrey and cursed at him. Since very little was required to provoke the Bogart temper, he shoved her. "I guess I shouldn't have done it," he admitted many years later. With justification, Menken shoved him back, then turned on her heel and "ran to her dressing room to cry."

At the height of Humphrey's fame, that story would be told with an ugly sexist spin. A reporter from the *Saturday Evening Post* wrote that

after Menken had "turned loose" her "fine, fiery temper on the harassed Bogart," the young actor did "what every other man would have liked to do under the circumstances." Taking hold of her "pretty white shoulders," he "whirled her roughly around and planted a firm, hard kick on her der-riere." Menken, the reporter assured his readers, "was utterly bedazzled" and fell in love with him in that moment. The old trope of a woman gladly submitting to a violent man was not yet exposed as a lie in 1952, when the *Post* writer described it. Yet although Menken was unlikely to have been "bedazzled," somehow or other, the passion of the moment did lead to other, more pleasant physical interactions, and soon the pair decided that they were in love. Here the romantic, sentimental side of Humphrey Bogart revealed itself for the first time. Within a few months, he had asked Helen to marry him.

THE MAGNIFICENT MUNICIPAL BUILDING AT CENTRE AND CHAMBERS STREETS, just a few years old in 1922, rose thirty-four stories into the sky of down-town Manhattan. Humphrey Bogart and Helen Menken needed to go only as high as the second floor, however, where the marriage license office was located. At the desk of the city clerk, they applied for and received a license allowing them to wed. Both were twenty-two years old.

Their romance had intensified during *Drifting*'s run. After closing on Broadway the last week of January, the show went on tour, wrapping up in March at Philadelphia's Adelphi Theatre. Humphrey was promptly transferred to Brady's latest offering at the Playhouse, *Up the Ladder*, tak-ing over for one of the original actors, but he continued to see Helen. It was while he was playing in *Up the Ladder* that the news of the marriage license became public.

The Bogart legend would struggle to fit Helen Menken into its narra-tive. She would be portrayed as "relentless" in her pursuit of Humphrey, giving the impression that she'd dragged him downtown against his will to take out the license. Stephen Bogart would say that his father regret-ted the action "a matter of hours" after the license was issued. Various accounts claimed Humphrey complained bitterly to Bill Brady, Jr., that he didn't want to marry "that girl," to which Bill supposedly replied that if he didn't, he'd never work onstage again. It's difficult to see why that would have been the case, since Humphrey had a good relationship with the Bradys, who would've had no reason to fire him just because he

had broken off an engagement. Meanwhile, although Helen was better established than her fiancé, she was not yet a powerhouse in theatrical circles, someone who, scorned, might have blacklisted Humphrey with managers and producers.

But the Bogart legend, which attempted to tidy up his life retroactively, required that Humphrey be shielded from the Menken episode, which eventually turned tumultuous. Given that the marriage did not take place immediately after getting the license but rather a considerable time later, it was easy to portray him as reluctant to tie the knot and therefore blameless for the relationship's eventual deterioration. He had seen the dangers ahead, the legend implied, and would never have proceeded if he'd had his way. It was all Menken's fault.

The evidence, however, suggests two young people infatuated with each other. "Denial was made that the wedding has taken place," noted the *Evening World*, "but reports say the young people have been house hunting." The discovery of the marriage license by the press was likely not a random act. Actors knew what good publicity could do for their careers, and getting married was always beneficial. Perhaps a well-placed call by Brady's office to newspaper editors alerted them to the license. Humphrey certainly would have enjoyed the sudden notice he was being given. "A romance of the stage was disclosed yesterday by the discovery of a marriage license issued to Humphrey Bogart, now playing in William A. Brady's *Up the Ladder* . . . and Miss Helen Menken, recently a costar in the Brady production of *Drifting*," reported the *New York Herald*. Despite the fact that he'd played only bit parts at that point, Humphrey's name was listed first in the announcement, and, for the moment at least, it was he who was the employed actor, not Helen. The *Daily News* called them "both well-known stage folk." It was the most ink Humphrey had gotten since starting out in the theater.

Bogart was not some henpecked, hesitant husband-to-be. He was an ambitious young actor who understood how the marriage could assist his rise. That he appears also to have been in love with Menken was icing on the cake. They were clearly sexually drawn to each other, given how frequently they resumed their affair over the years. But Menken was also highly acclaimed as an actress with potential. The syndicated critic James W. Dean predicted that Menken would eventually be recognized as "one of the greatest actresses of the decade." Critics such as Alexander Woollcott had taken a shine to her. Humphrey would

have understood—and welcomed—the benefits of attaching himself to Menken.

Indeed, years later—but before the legend began hardening—Bogart would himself attribute any premarriage jitters not to himself but to Menken. "Helen didn't want to marry me because she was wise enough to know about theatrical homes where husbands and wives are separated continually," he told a reporter in 1937. More likely, Menken's doubts about getting hitched may have arisen after a closer examination of her fiancé's habits. The actress Louise Brooks recalled Humphrey during that period as "a slim boy with charming manners" but one who drank until he passed out. "If he was abruptly shaken awake, he would say something rude and sometimes get socked for it," she said.

Bogart was already a serious drinker by the age of twenty-two. Drinking to excess was part of the culture of the Roaring Twenties, with Prohibition making nights on the town both glamorous and dangerous. Although he was still a bit player, he moved with a high-profile theatrical crowd, his upper-class social status facilitating his rise. He wasn't some former chauffeur or salesclerk struggling to find a foothold as an actor but a member of the sort of society the theater world wished to emulate. Humphrey's friendships with Bill Brady, Jr., Kenneth MacKenna, and Jo Mielziner were now supplemented by connections with other up-and-comers. John Cromwell had played with Humphrey in *The Teaser* and *Drifting* and perhaps others; he was also beginning a directing career that would eventually take him to Hollywood. Cromwell was frequently at Bogart's side during his speakeasy crawls.

There was also Louise Brooks, just starting her trajectory to stardom, who recalled seeing Humphrey at places such as Tony's, a popular Broadway watering hole on West 52nd Street, "drinking steadily with weary determination." He was soon passed out at his table. When that happened, friends sometimes had to carry him home. Likely it was only Maud who witnessed her unconscious son being carried through the door. Belmont, his practice having declined, had taken a job as a doctor on ocean liners, sailing primarily to South America and returning home every few months. But surely he was kept apprised of his son's shenanigans by his disapproving wife.

Onstage every night in *Up the Ladder*, Humphrey was playing the same sort of sophisticated libertine he played on the streets of New York. The play was a cautionary tale about "the younger generation's fast pace

and fondness for liquor and jazz." Until then, Bogart had played servant and transient roles, but with *Up the Ladder*, he was cast to type: a flaming youth of the upper class who caroused and carried on, rejecting parental expectations. Charles Darnton, a critic for the *Evening World*, shuddered at the "tipsy youngsters and dubious scheming" in the play. Like many other shows, *Up the Ladder* was trying to have it both ways: condemning the hedonism of the younger generation while also reveling in their exploits to gain box-office receipts.

Humphrey was flush with success, even if he'd yet to play a significant part. Brady raised his salary to $200 a week. "Money?" Humphrey asked, looking back. "It grew on trees." *Up the Ladder* closed at the Playhouse on June 17 but toured for the next several months, so Humphrey likely remained employed, possibly managing the stage as well. But as the summer stretched out ahead of them, there was still no wedding for those two "well-known stage folk," Bogart and Menken. In fact, one more reason had now emerged to delay tying the knot: Helen was poised to take a career leap that would lift her to the heights while leaving her fiancé far behind.

THAT FALL OF 1922, HUMPHREY FOUND HIMSELF AT THE PLYMOUTH THEATRE IN Boston. He was appearing in the touring company of a play Grace George had directed on Broadway. The play was *The Nest*, written by Paul Géraldy of the Comédie-Française. On Broadway, Humphrey's part had been played by his friend Kenneth MacKenna. George may have hired Bogart only when the show went on the road.

The Nest was another story of young adult children disregarding the values and norms of their parents and following the siren song of the permissive new generation. As Max, Humphrey was once again playing himself, the estranged son of disapproving parents, preoccupied by wine, women, and song. Though the play contained satire, it was essentially serious, the first time Humphrey had been cast in a play that was not, at its heart, comedic. That night in Boston, as he strode across the stage, the audience observed a young man confident in his ability. "Mr. Bogart, as the cad," observed one critic, "was fairly satisfactory in a disagreeable role." Though that sounds like faint praise, the critic made a point of lifting him above the other supporting cast, whom he deemed

merely "acceptable." In time, of course, Humphrey Bogart would make a specialty of disagreeable roles that audiences found highly satisfying.

The Nest concluded its Boston run on September 16, and the actors disbanded. Humphrey went back to New York to await whatever Brady or George might offer next. Meanwhile, Helen wasn't waiting for anything. She was fast becoming the name on everyone's lips as she prepared to open in a highly anticipated new play produced by John Golden called *Seventh Heaven*. She'd been cast in the play's earliest tryouts a couple of years earlier but was reengaged in April 1922, soon after *Drifting* ended. For much of the summer, she'd been on the road with *Seventh Heaven*. At each stop, the show made more money. Traveling all over the Northeast left her with little opportunity to see her fiancé or make plans for marriage.

As *Seventh Heaven* dominated the talk of the upcoming season, William A. Brady announced, on October 5, the cast of his upcoming Playhouse production *Swifty*, a melodrama about a prizefighter. Humphrey had a sizable role this time, that of yet another upper-class cad. Curiously, some notices of his casting referred to him as "Humphry Ward." It's possible that for a brief moment, Humphrey considered the idea of taking a stage name, perhaps giving him some distance from his parents. By the time the show premiered on October 16, however, he was back to being Bogart. Humphrey played Tom Proctor as a more boorish version of his part in *The Nest*; both roles were versions of his own playboy self. The *Brooklyn Times* called Tom Proctor "a young roué of the city pavement." Humphrey had found his niche on the stage.

Swifty was largely panned by the critics. Alexander Woollcott, in the *New York Herald*, described the play as "three heavy-fisted acts which have been put together with a little less than the decent minimum of theatrical skill." Humphrey was the antagonist of the piece, a rich kid who seduces and ruins the prizefighter's sister. Some critics thought he did a swell job: Bogart deserved "full praise" for a "fine performance," wrote the *Brooklyn Daily Times*, and the *New York Tribune* praised his "excellent bit of work." But Woollcott delivered a stinging rebuke of the young actor that would go down in history, thereby distorting the truth of the critical consensus of both the play and Humphrey's part in it.

In his preview of the play the day before its opening, Woollcott had conspicuously not included Humphrey's name in the cast, despite the

significant role he was playing. In his review the day after the premiere, Woollcott once again chose not to identify him, referring to his character only as "a young sprig of the aristocracy." He didn't much like the play overall, but he reserved his greatest scorn for "the young man who embodies the aforesaid sprig." His performance, the critic wrote, was "what is usually and mercifully described as inadequate." In part due to Woollcott's damning judgment, *Swifty* closed on November 4 after three weeks.

Conversely, *Seventh Heaven* had opened on October 30 at the Booth Theatre to rapturous reviews. The story of a young waif adrift in Paris who finds love with a sewer worker who later marches off to war, the play was a cathartic tale of love and hope. HELEN MENKEN SCORES SUCCESS announced the New York *Daily News*; its critic, the influential Burns Mantle, described Menken as "taking each of the big scenes in her even and pretty teeth and literally shaking the drama out of it." John Corbin of the *New York Times* wrote, "Not since Duse has an actress possessed these qualities in a measure so abundant." Woollcott waited to have the last word. *Seventh Heaven*, he declared, was "irradiated by the dazzling performance" of Helen Menken. "One of the morning-after reviews opined that never before had a young actress owed so much to her playwright. It would be nearer the truth to say that never before had a middle-aged playwright owed so much to his actress."

It's difficult not to consider Woollcott's two reviews, of Bogart and Menken, together, coming as they did just a couple of weeks apart. The critic had become quite friendly with Menken. His refusal even to use Humphrey's name feels personal and petty, and he used the caustic putdown of his performance as the review's punch line. It's quite possible that Woollcott was responding to stories that the actress had told him about her fiancé's carousing while she was on tour. Woollcott liked to think of himself as a maker and breaker of actors. It's obvious which of the couple he was making and which he intended to break.

The mixed reviews of Humphrey's performance in *Swifty* reverberated beyond Broadway into the Bogart home. Maud was waiting, newspapers in hand, when her son awoke the next morning. "So, you wanted to be an actor, eh?" she said. "I will read you the reviews." Her patience with her wastrel son seemed to be at an end. There is no record of Belmont's reaction.

Humphrey was now approaching twenty-three. So when, that fall,

Maud sold the house on 103rd Street, he did not accompany his parents to their new home. "The breakup of the Bogarts" he'd call that moment; his sisters, too, were pursuing their own lives, Pat with Stuart Rose and Kay heading toward a modeling career. Maud claimed she had sold the house because "all the better people" were moving to the East Side; the place she chose was on 56th Street near the river. In truth, the Bogarts' relocation was a downsizing move made necessary by the family's declining income. The fights between his parents, the pressure they put on him to succeed, and the hostility which his mother expressed toward his acting career, made life in the family household intolerable to Humphrey. "I found myself wanting independence," he said, "so I did not go home to live again." Instead, he took rooms in a series of theatrical hotels.

Another split occurred that fall. As Helen's star soared, Humphrey's doubts about the marriage may have grown. He'd been raised in a family where the wife had been the top breadwinner and had often belittled her husband for his inability to live up to her standards. Humphrey feared the sort of diminution his father had endured and failed to grasp that it was Belmont's weakness that was the issue, not Maud's strength. If Helen had reservations about tying the knot after observing her fiancé's dissolute lifestyle, it's possible that now, as his bride-to-be became the toast of Broadway, Humphrey had his own misgivings about the match. The couple drifted apart. Their names were no longer linked in the press. Reporters stopped inquiring about their marriage plans.

They still saw each other occasionally, however, when they happened to be in the same place at the same time, because the physical tug between them remained strong. If it hadn't been, Helen Menken would likely have faded from Bogart's life at that juncture, their engagement merely a footnote to his story. As it was, Menken would have a significant return role to play.

Brooklyn, New York, Monday, August 31, 1925

At the conclusion of *Cradle Snatchers*, the new play at Werba's Brooklyn Theatre, the cast members took their curtain calls to thundering applause. The show's headliner was the ebullient Mary Boland, forty-three, a two-decade veteran of the stage best known, up until then, as comedic support. That night, however, all the signs were pointing to *Cradle Snatchers* being her breakout hit. The show had opened a month earlier in Stamford, Connecticut, and the applause had been as enthusiastic there as it was this night in Brooklyn. Of course, in a week's time, Broadway audiences and critics would make the final determination of the play's success.

But optimism was high. The entire cast was being praised by the critics, including the young man who played Boland's Latin gigolo, the twenty-five-year-old Humphrey Bogart. Taking his bows, he basked in the cheers and whistles, a rather new experience for the young actor. Hired by producer Sam H. Harris the previous spring, Bogart had originated the part of Jose Vallejo. Working with Harris had proved to be very different from working with William A. Brady. Polite and soft spoken, Harris had none of Brady's bombast. But quietly and deliberatively, he had scored a long list of box-office successes, often in partnership with George M. Cohan or Irving Berlin. Harris had a knack for recognizing star potential. Mary Boland had it. And so might this new up-and-comer, Humphrey Bogart.

In the three years since the ignominious closing of *Swifty*, Humphrey had struggled to maintain a foothold in the theater. He may have fallen out with Brady briefly after *Swifty*. During rehearsals for that show, the producer had driven Humphrey hard, forcing him to do scenes over and over. When Bogart had spotted Brady pretending to fall asleep, intended as a comment on his protégé's acting, he had erupted. A scuffle had ensued, with Bill Jr. having to pull his friend off his father. Earlier clashes between the two had occurred as well, momentary but always dramatic.

"He fired me forty times," Bogart admitted. Perhaps Brady felt that the young actor's temper needed a little cooling off before he put him into another show. No doubt the mixed reviews Humphrey had gotten for *Swifty* didn't help.

It's not surprising that he rebelled against Brady. Despite all the producer had done for him, Brady was still a father substitute. Emotionally scarred by his parents, Bogart would find it difficult throughout his life to trust authority figures. Both consciously and unconsciously, he'd test them and sometimes push them away. When Brady reacted in anger to something Humphrey had done, it may have summoned old memories of his father's whip. When the producer mocked his acting by pretending to fall asleep, it may have elicited the same feelings he'd experienced from his mother's belittlement. Humphrey's childhood demons still had the power to pull him down.

Harris had first entered Bogart's life when he had cast him in a revival of the play *Nice People* in the fall of 1922. In that play, Humphrey had taken the part of Scotty Wilbur, another member of "the younger set, intoxicated with pleasures and marked by a daring and looseness." He was now typecast as the idle playboy, the sort he'd later describe as walking onto the stage in white shorts with a racquet over his shoulder, asking "Tennis, anyone?"—even though he never uttered the phrase onstage. He carried on with his upper-class cads in the comedy *Scrambled Wives* for the Warburton Players and in *Mary the Third*, produced by Lee Shubert. "Humphrey Bogart does well as a visionary young ass," one critic judged after the play's tryout in Hartford. At least his asses were now visionary instead of debauched. By the time *Mary the Third* opened on Broadway, Humphrey was no longer in the cast. Instead, he was put into another Shubert-sponsored revival called *Steve*, which opened far, far away from Broadway in Sheboygan, Wisconsin.

Despite its provincial locale, *Steve* was a very-high-profile production, being staged by Laura Hope Crews, a prominent actress and director on Broadway, and starring Eugene O'Brien, a top Hollywood leading man, who was playing a version of himself in the show. *Steve* drew plenty of press because of Crews and O'Brien, but it remained a road show designed to make money in the hinterlands; there was no discussion of taking it back to New York, where it had last played in 1912. It may have seemed to Humphrey that he'd never get back onto Broadway.

Still, when the show moved to Buffalo, the newspapers took notice

of him, not so much for his acting but for his looks and debonair appearance. As publicity for the show, the cast attended soirees at the Palais Royal restaurant and were feted by local socialites. One columnist appeared more smitten with Bogart than with movie star O'Brien: "Mr. Bogart is most attractive," she reported, "and at Mrs. Becker's tea at the Garret Club wore a blue serge suit, spats, and a red and black tie. He is very dark and attended Andover preparatory school." It was the first personal publicity Bogart received as an actor, so he was probably feeling a little heady as the tour wound its way through the Midwest. But he knew the show was a dead end. Before *Steve* ended its run in Chicago in July, Humphrey had departed, looking for a way back to Broadway.

He turned up at Brady's office contrite and rueful. That was how he'd presented himself to his father after the Andover expulsion and no doubt other times. Brady, fortunately, was in a forgiving mood and gave him another chance, casting Humphrey in a small part in *The Clean-up*, a comedy starring Hazel Dawn that previewed in Long Branch and Asbury Park before closing just a few weeks later. For the rest of the summer and into the fall of 1923, Humphrey remained at loose ends.

He was never at his best when idle. Ruth Rankin recalled that he would drink heavily and stay out all night whenever he was out of work. Closing in on twenty-four, Bogart had to wonder, in the few moments of clarity between his drunken blackouts, if he was ever going to make a sustainable living in the theater.

Things started to change in October when he landed a part in a new comedy, *Underwrite Your Husband*, produced by Rosalie Stewart, one of the few women working as producers on Broadway. The show opened at the Irving Theatre in Wilkes-Barre, Pennsylvania, on October 15, 1923. The production reunited Humphrey with Faire Binney and gave him his first appearance opposite Mary Boland. He played "the usual youthful lover," according to newspaper reports; one critic called him "a pleasing young chap." His stock was on the rise again.

The last week of November, the show opened at the Klaw Theatre on West 45th Street, its name now changed to *Meet the Wife*. For the first time in more than a year, Humphrey was back on Broadway. *Meet the Wife*, a marital farce of the kind Cecil B. DeMille was turning out in Hollywood, was a major hit, Humphrey's most successful show yet. He was earning more money than ever before, was secure in a long-term engagement (the show ran for seven months), and was increasingly getting

noticed. Critics praised the entire cast, especially Boland and her costar, Clifton Webb, but many also singled out Bogart's portrayal of a reporter: the *Daily News'* Burns Mantle called him "the sort newspapermen are pleased to admit to the fold."

But here we get our first glimpse of the self-sabotage that would intrude upon Humphrey's success at various points in his life. He was not the first, and certainly not the last, actor with low self-esteem to engage in self-destructive behavior that merely reinforced his opinion of himself. One night in the spring of 1924, Humphrey turned up drunk for a matinee, missing cues and leaving Boland to ad-lib her way through the scene. At the end of Act II, he took off his makeup and went home, despite the fact that he was needed for Act III. When he showed up for the evening performance, the stage manager reprimanded him. The deep-seated rage flared, and Humphrey slugged the manager in the jaw. Mary Boland exploded. "Get this, Bogart," she vowed. "You'll never work in another play with me."

Why he wasn't fired on the spot is a mystery. Possibly he survived because by the end of *Meet the Wife*, he'd become quite popular with audiences, especially women. His near-black hair, dark eyebrows, and intense eyes, preserved in photos from the period, gave him the appearance of a Latin lover despite being a quintessential WASP. Humphrey wasn't tall, but he'd learned to "think tall" from the actor Holbrook Blinn, who also stood about five foot eight; lifts in his shoes aided the illusion. One newspaper called him "the latest heartthrob on the stage for America's girls."

Yet while his nascent matinee idol status kept him in the play, there was also another reason: his own determination. When he sobered up, Humphrey would spend several months containing his misbehavior and getting down to business. He was intent on becoming a success in the theater—the only thing, except for sailing, that had ever given him any satisfaction. "The needling I got about my acting in those days made me mad," he would tell his son. "It made me want to keep on until I'd get to the point where I didn't stink anymore."

When *Meet the Wife* closed in the spring of 1924, Humphrey joined up with several of his pals for an ambitious drama, *Nerves*, written by John Farrar and Stephen Vincent Benét. The story follows a group of Yale students from their carefree campus existence to the trenches of World War I. Bill Brady, Jr., was the director, Kenneth MacKenna was one of the stars, Jo Mielziner was the set designer, and Brady Sr. produced. It

was a happy homecoming for Bogart, but it didn't last. *Nerves* closed in a matter of weeks.

But once again, critics had noticed him. As the Yalie turned dough-boy Bob Thatch, Humphrey was "both dry and fresh, if that be possible," the *New York Times*' critic remarked. Another critic said he "stood out" among the cast, which may have been awkward, since several of them were his friends. The *New York World*'s Heywood Broun concluded that he gave "the most effective performance" in the show. It would appear that Humphrey no longer "stank."

In short, he had learned how to act. "You can't just make faces," he'd muse about acting. "If you make yourself feel the way the character would feel, your face will express the right things." There was so much he was learning, such as how to open a door on the stage, how to hit his marks, and what to do with his hands. "All of these things," he said, "you get to do them instinctively."

By late 1924, Humphrey found himself busier and making more money than ever. Five hundred dollars a week kept him in blue serge suits and spats and allowed him to run up tabs at all the top speakeas-ies. He lived in a series of ever-grander hotels, hopping from place to place so often that enumerators for the city directories and censuses never caught up with him. No longer was he ever unemployed. In Octo-ber, he joined a road show tour of *Meet the Wife* through Iowa, Indiana, and other midwest states. Mary Boland, who'd also returned for the tour, apparently put aside her grudge against Bogart for the good of the show.

Humphrey was so busy during that period that he sometimes ap-peared in two shows at the same time. In November, he opened in Stam-ford, Connecticut, in a comedy produced by Herman Gantvoort and written by Barry Conners called *Fool's Gold*, which then moved to Phil-adelphia, just in time for him to hop back into the cast of *Meet the Wife* during its own run in the City of Brotherly Love. The following February, he double-dipped again, appearing in *Hell's Bells* (the newest iteration of *Fool's Gold*, which opened on Broadway at Wallack's Theatre on Janu-ary 26) and Grace George's *She Had to Know*, which opened on Broadway just a week later. "Humphrey Bogart, the juvenile in *Hell's Bells* and a character in *She Had to Know*, is one of the few young actors appearing in two Broadway shows at the same time," observed the critic of the New York *Daily News*. He continued in the same manner when he took a part

in William A. Brady's *Ostriches*, which opened at the Comedy Theatre on March 30, while he was still performing in *Hell's Bells*. Humphrey would finish up his part in *Ostriches* every night and then run up Broadway one block, makeup still intact, and jump into *Hell's Bells*. He loved every minute of it, managing, for the time being, to keep his self-defeating habits under control.

When he was finally at liberty, several offers came his way. "I had a choice between a Joe Cook show and a little play called *The Cradle Snatchers*," he said. "My wisdom and my inclination said, 'Pick the Cook show. It has a big name for a star, it's a musical, and it will probably run a long time.' I still don't know why I picked the other. All I know is that the Cook show died on its tryout, never even got to Broadway, and *The Cradle Snatchers* ran two years." He appears to have been referring to *How's the King?*, which Joe Cook was producing. Humphrey's memory was correct: the show fizzled after a few previews. But *Cradle Snatchers*, a sex comedy that began tryouts in July, would give the world a Humphrey Bogart his Hollywood fans and friends would never recognize.

ON THE NIGHT OF SEPTEMBER 7, 1925, THEATERGOERS QUEUED UP OUTSIDE the Music Box Theatre on West 45th Street hours before the evening's presentation was set to begin. The humidity did not deter audiences from attending the Broadway premiere of *Cradle Snatchers*. Mary Boland, the star, was now one of the leading comediennes of the stage, and she had chosen Humphrey Bogart to play her young lover, no matter how angry she'd been at him during *Meet the Wife*. The story concerned three middle-aged women who, weary of their husbands, take much younger lovers. Humphrey, in long sideburns and jet black, slicked-back hair, was a "young lounge lizard," one critic observed, who posed as a Spanish osteopath to intrigue Boland. Brash and grandiloquent, Bogart declaimed from the stage, "Am I not Don Jose Vallejo, the matador, whose two strong arms have choked the breath out of the bulls in the rings in Barcelona?" Theatergoers ate it up. "The first night audience . . . received [the play] with gales of almost hysterical laughter," reported the *New York Times*. And the women in the audience squealed for Jose Vallejo.

Critics were just as appreciative. Humphrey's gigolo, according to the New York *Daily News*, was "freshly played." Amy Leslie, in the Chicago *Daily News*, waxed poetic: Humphrey, she wrote, was "as young

and handsome as Valentino, dexterous and elegant in comedy [and] as graceful as any of our best actors."

Just like that, Humphrey Bogart became a romantic idol. "All the old women in the audience thought because I played such a part, I must be such a guy," he remembered. "I wish I saved the notes that came to the theatre." He did save Leslie's review comparing him to Rudolph Valentino, flashing it in front of friends "to show what a romantic fellow he was in those days," remembered Nunnally Johnson.

That early iteration of Bogart would, of course, become another stumbling block in the construction of his legend. The salty, craggy, irascible Humphrey Bogart of Hollywood would never have cavorted in a cape with slicked-back hair and pronounced himself a great lover. From the late 1930s onward, he and his studio publicists did their best to downplay those early roles. His image as a new Valentino, he claimed, had been thrust upon him against his will. "I'm allergic to glamour," he protested. He'd been coerced, he insisted, to "model one of those pansified neckcloths and the swishiest new model of hair wave," which made him "very much in demand at all the musicales and tea-fights."

At the time, of course, Humphrey was all for anything that might take him to the top, although there was always that insecurity about his manhood and masculinity underneath. He was terribly self-conscious of the elevator shoes he wore when performing opposite taller leading ladies. But he strapped them on because he wanted to be a star. He did what he needed to do. Later, he would distance himself from "fancy men" such as Vallejo who dressed elegantly, wore makeup, or spent too much time slicking their hair. But in truth that was what Humphrey Bogart was in 1925. He moved comfortably enough through the nightlife of Greenwich Village and Harlem with all the fancy men who populated the clubs. Once he went to Hollywood, however, any hint of deviance or effeminacy in his past needed to be eradicated.

Still, there's no getting away from the fact that it was his flamboyant performance as the dandified Jose Vallejo that made him a star—not quite a leading man yet but a recognizable featured player actively sought out by producers. *Cradle Snatchers* ran for an astonishing thirteen months, passing its one-year anniversary in September 1926 before going out on tour in October. Humphrey Bogart, the Valentino of the stage, had secured his Broadway bona fides. That iteration of himself deserves to be remembered, no matter how much it would later be erased.

Manhattan, Thursday, May 20, 1926

In Helen Menken's swank Gramercy Park hotel, in front of more than a hundred guests, an Episcopal priest opened his book to begin the ceremony. After four years, Helen and Humphrey Bogart were tying the knot. The day was bright and sunny, with the view of the park below revealing the vibrant greens of spring. "Everybody in the theatre was there," remembered Stuart Rose, who provided the only firsthand account of the wedding. Now married to Pat Bogart, Rose was serving as Humphrey's best man.

Missing from the ceremony was Belmont; the family explained that he was in Peru, but that was a fabrication. Belmont had, in fact, arrived back home from South America several weeks earlier, according to passenger manifests. Did he disapprove of the marriage? Was he too ill or too strung out on morphine to attend? Regardless, Maud was there, along with Helen's parents, Frederick and Mary Meinken. Like the Meinkens, the family priest, John Kent, the rector of St. Anne's Church, was deaf, communicating with both sign language and voice.

Rose, clearly unaccustomed to hearing deaf people speak, would describe the wedding to Nathaniel Benchley as a "macabre performance" and "almost obscene." Helen, Rose reported, fled the room in tears after the vows were exchanged, embarrassed by the priest's speech. "She got hysterics and refused to meet the press. I had a hell of a time calming her down." What's actually obscene is Rose's description of the event and his interpretation of the bride's distress. Helen had grown up with deaf parents; she had never hidden that fact of their lives, and in fact, when the wedding date had been set, she had "hastily . . . summoned [Reverend Kent] by telephone" to make sure her parents would be able to follow the ceremony, as reported by the *Daily News*. She would've known exactly how the service would unfold. Running from the room in embarrassment makes little sense and does not match her character.

When we remove Rose's bias, we can consider the possibility that

the ceremony may in fact have been lovely and gracious, with its elegant setting and distinguished guests. Later on, of course, it would serve the Bogart myth that his first three marriages had all been ill omened. But the press at the time was decidedly upbeat. There was no report of any stress, no mention of the bride abruptly exiting the scene, which surely would have been reported if it had happened. Though reporters did note the fact that both the Meinkens and the priest were deaf, they did so respectfully. The photo the *Daily News* snapped that day of the beaming newlyweds also debunks the story of Helen's being too distraught to meet the press.

But if Rose is correct that Helen showed some anxiety afterward, perhaps there was another reason for her tears. After all, she had resisted marrying Humphrey for a long time. Why had she finally agreed? "I've been so frightfully occupied, you know, I just haven't found the time to marry," she told reporters after the ceremony. Now, however, after nearly two years of high-flying success, she suddenly had the time. She was unemployed. Her only income that spring of 1926 came from selling beauty tips to newspapers. Her only theatrical prospect was a vaudeville sketch, a steep comedown from the days of *Seventh Heaven*. Bogart, meanwhile, was appearing nightly in a big, flashy role in the season's biggest hit.

The couple was still fond of each other, and their sexual passion remained undiminished. But their decision to wed was undoubtedly tied to their careers. By May 1926, Helen evidently decided that the marriage might help her, which wasn't so different from the reason Humphrey had initially been enthusiastic about their engagement. Yet if Helen's motives for the marriage seem apparent, what were Humphrey's? He didn't really need Helen's help in his career anymore. Most likely, his age influenced his decision; he was now twenty-six, and family members and colleagues were asking when he might get hitched. Just a few months earlier, Bill Brady, Jr., had married the actress Katharine Alexander; Humphrey knew he'd have to follow sooner or later. He'd been brought up to believe that young men of his class and status at some point needed to find a suitable match and get married.

Still, the chroniclers of the Bogart myth would keep pushing the narrative of the reluctant bridegroom; Nathaniel Benchley wrote that Humphrey had tied the knot "against his wishes." But the marriage was entered into willingly. It probably didn't hurt that Humphrey could now reasonably assume that he'd be the big shot in the marriage; he had no reason to

fear becoming his father, eclipsed by his wife. Indeed, for the first three months of their union, Helen remained out of work while Humphrey brought home the bacon from his ongoing role in *Cradle Snatchers.*

Their marriage was a precarious balance of ego and expectations. The newlyweds took a place in the tony East Side neighborhood of Turtle Bay, where Menken attempted to transfer her ambition from the theater to her marriage. "I tried to make my marriage the paramount interest of my life," she remembered. "Although my career was a success, I was willing to give it up and concentrate my interests on a home." She was, of course, rewriting history a bit there, since her career had stalled and she had no immediate prospects of getting it moving again. Perhaps what she was trying to do with her spin was to justify those early months of her marriage, when she'd stayed home every night waiting for Bogart to return after he took his curtain calls. "I was deeply interested in acting," she told a reporter, "but managing a home was something greater."

The problem was that Humphrey didn't always come home to his waiting bride after the theater. "I had planned to make a home for my husband," Helen insisted, "but he did not want a home. He regarded his career as of far more importance than married life." Humphrey seems to have expected his unemployed wife to be indulgent of his lifestyle, grateful that her bills were being paid by his salary. But Helen was neither indulgent nor grateful. Their fights grew in frequency and vitriol. "We quarreled over the most inconsequential things," Humphrey complained. He didn't appear to grasp why his wife might be unhappy that his nights of drinking and carousing had continued after the marriage much as they had before.

In August, however, the dynamic between them shifted. Helen was offered the lead in an American adaptation of Édouard Bourdet's play *La Prisonnière* by the prestigious producer Gilbert Miller. Called *The Captive* on Broadway, the story concerned a young woman conflicted by her attraction to another woman. Moralists condemned Miller's decision to stage the play before it even opened. "Women's organizations and ministerial associations may try to halt the production or emasculate it," warned one report around the time of Helen's casting. The president of the Colonial Dames of America vowed to "prevent such an affront to American womanhood" from making it to the stage. Helen couldn't have missed the outcry. But she accepted the role anyway, with Humphrey's encouragement.

If he was still worried about his wife overshadowing him, Bogart probably didn't see *The Captive* as much of a launchpad to stardom. Several theater owners had refused Miller's request to stage the play, most notably Abraham Erlanger, the proprietor of the largest chain of legitimate houses in the nation. There was skepticism about how long such a production could survive. Humphrey may have seen it as providing a temporary respite from Helen's nagging (as he saw it) but surely not a long-term success that might rival his own career. After all, who would pay five bucks to see a show about lesbians?

As it turned out, droves of people would. *The Captive* opened at the Empire Theatre on September 29, 1926, to a packed house; the audience would grow every night from then on, with tickets being difficult to obtain. Reviewers praised the direction, the script, and Menken's performance, even if many of them added a coda to their accounts: the subject was offensive and immoral, more suitable to "the clinical laboratory" or "the province of pathologists." But that didn't dampen the box office. Although the ads never used the word "lesbian," nor was it uttered in the script, the subject matter was plainly understood by most critics. "Lesbian love walked out onto a New York stage for the first time last night," declared the *Morning Telegraph*. And it was precisely that fact that brought in the crowds.

For her part, Menken didn't play the role with much sympathy. Wearing ghastly white powder on her face, she saw her character as struggling with "a collection of sins." She'd seen "girls like Irene," she told an interviewer, "pathetic beyond all description." Yet her discomfort with the part didn't stop hundreds of young women filling the house every night. They sent the star mash notes at a rate of fifty per day; many left bracelets and other gifts for her. On a pretext of safeguarding the honor of the city's young women, the police began monitoring the show. One officer reported that 70 percent of the audience on a Saturday night was under the age of twenty-five, with women accounting for more than 60 percent of those present. "Groups of unescorted girls in twos and threes sat together," the police report read.

Within a few weeks, the moral panic was in full force. "To believe that such stuff does not at least pique curiosity on the part of susceptible young women is to believe more than I, for one, am capable of," declared the influential critic George Jean Nathan. "If all the ladies present were not weakened, they were at least made curious." Newspapers owned by

William Randolph Hearst mounted a campaign to force the mayor to close the show.

This was not the sort of publicity Menken had hoped the show would get. It likely unnerved her husband as well, as innuendoes about Helen's own sexuality spread. "What sort of woman is Helen Menken really?" asked one columnist. For someone as sensitive about appearing to be a red-blooded man's man, that kind of scuttlebutt had the power to make Humphrey very uneasy. After all, if the wife was degenerate, what did that make the husband?

Despite the rising censure, the box office remained high straight through Christmas and into the new year. But on the night of February 9, immediately after the first act, the entire cast of *The Captive* was arrested backstage and escorted by police out to a long line of waiting taxis, which conveyed them to night court on West 54th Street. The police had also shut down two other plays that evening, one of them *Sex* by Mae West, who was also hauled into court. Menken and her costar, Basil Rathbone, were the first presented to the magistrate. They were charged with contributing to a common nuisance and presenting obscene exhibitions and held on $1,000 bond. Gilbert came up with the bail money so Helen didn't have to spend the night in jail. Small comfort. The next morning her face adorned the front page of the New York *Daily News* flanked by police officers as she was being led into court.

It's bewildering that previous Bogart biographers have ignored this clearly disruptive event in their subject's marriage. It may be because, at least in the case of the two biographies sanctioned by the fourth Mrs. Bogart, there was a desire to distance Bogart from such sordidness. But it may also be because, in the contemporary media coverage of *The Captive*'s raid and Menken's arrest, there was absolutely no mention of the star's husband. It was as if Menken wasn't even married, which only further associated her with her character. Usually in such cases, the accused's spouse would rally in support, but Humphrey was nowhere to be found. It's true that he wasn't in town at the time of the raid and arrest: in December, three months after *The Captive* opened, he'd gone on tour to Chicago with *Cradle Snatchers*. Still, it's odd that reporters didn't bring him into the story, given the prodigious coverage they'd given to the marriage just the previous spring. If they did reach out to him for comment, Bogart evidently declined. The only word from Humphrey would come six months later, after the charges had been dropped, when

he described himself to a columnist as "the husband of Helen Menken and proud of it."

In fact, the marriage was all but over. Soon after *The Captive* was shut down, Menken visited Bogart in Chicago. If she was seeking solace, she didn't get it. They fought fiercely; it's hard not to see *The Captive* as being a point of contention. Helen's divorce suit alleged that while she was in Chicago, Humphrey threw a telephone at her in his hotel room. The couple separated.

After a London tour of *Seventh Heaven*, Menken's mind was made up. For a second time, she boarded a train to Chicago, where Humphrey was once again touring in a show. There, in superior court, she filed for divorce, alleging cruelty and adding that Humphrey had told her he no longer loved her. "I hate the idea of coming to a divorce court," she told the judge. "I wanted a chance to make a home with my husband. But Mr. Bogart wouldn't give me one. He said it would interfere with his artistic success." The divorce was granted on November 18, 1927. Humphrey was ordered to pay her $2,000, which Helen said he owed her.

Bogart's up-and-coming Broadway career took a hit from the headlines over the divorce. He wrote to Lyman Brown, a theatrical agent, lamenting his depiction as "an old meany" in Menken's divorce suit. "I have tried my very best to keep my mouth shut and be discreet," he wrote. "Do you suppose the publicity and the divorce will hurt me in a business way?"

Brown's reply is unknown, but in fact, the forces around Humphrey Bogart, then and later, made sure that the publicity didn't stick. Bogart had become one of the good old boys of the Great White Way, liked and embraced by men in power: directors, producers, agents, actors. With the aristocratic John Halliday and the dignified Paul Harvey, he played bridge every night at the Music Box Theatre before they all hurried to their respective plays. Bogart's latest booster was Guthrie McClintic, an influential producer, as well as the husband of Katharine Cornell, maybe the biggest star on Broadway. Such powerful friends weren't going to let some bad publicity bring him down.

The failure of the Menken marriage was perhaps inevitable. Humphrey had had no idea of the notoriety Helen would accrue during the scandal of *The Captive*. When the two had said, "I do," he'd been on the rise, and he'd perhaps failed to grasp that his wife's ambition was as strong as his own. He seemed to take a lesson from the marriage. As he

told Joe Hyams some years later, "I had had enough women by the time I was twenty-seven to know what I was looking for in a wife the next time I married." In other words, he would steer clear of strong, independent women from then on.

WHATEVER FEELINGS HE WAS EXPERIENCING AFTER THE DIVORCE, HUMPHREY doused them with alcohol. By the late 1920s, his drinking had escalated to the point where he sometimes was unable to speak his lines and an understudy had to take over, according to Ruth Rankin. "Once he hit his stride on the stage, he also hit his stride as a drinker," Rankin recalled. "It's a wonder he made it to his curtain call." For all his erratic behavior, his influential friends continued to protect him. Bogart was now a member of the Players Club, the Gramercy Park private social organization that welcomed bankers, industrialists, and prominent journalists as well as actors, with the membership vetting process making sure that not just anyone could join. One needed breeding, connections, and a reputable lineage to join the Players. The goal of the club, at least in the 1920s, was less about theatrical camaraderie than it was about fortifying a privileged social class within the largely proletarian world of Broadway. George S. Kaufman said that other clubs were for "actors trying to be gentlemen," but the Players were "gentlemen trying to be actors."

It was a woman, however, who'd become Bogart's most frequent companion in New York's nightlife. Sometime in April or May, just around the time of his official separation from Menken, Humphrey had run into a former costar, Mary Philips. They'd met during the short run of *Nerves*, and Humphrey had been greatly affronted when Philips had gotten more audience reaction than he did during a scene. She was supposed to walk off the stage while Humphrey launched into a speech, but it was *how* she walked that he objected to. "Philips was putting too much of what he called 'that' into her walk," Stephen Bogart recalled. After the final curtain, he upbraided the young novice for trying to upstage him. "You can't do that," he barked at her. Philips just laughed at him for being ridiculous.

Sometime in the spring of 1927, the two former antagonists ran into each other and decided to go for a drink. Unlike Menken, Philips was happy to go out carousing with Bogart and never scolded him if he stayed out too late, usually because she was with him. When he told Menken

that he was no longer in love with her, it was likely because he was now in love with Philips. Mary had no qualms about regularly knocking down shots and dancing the Charleston at speakeasies all throughout the city. She was a woman, Bogart thought, whom he might actually enjoy having around. The only problem was, his pal Kenneth MacKenna had his eye on her, too.

After the long tour of *Cradle Snatchers* finally ended in May 1927, Humphrey was cast in *Baby Mine*, produced by John Tuerk and starring Roscoe "Fatty" Arbuckle, the three-hundred-pound former movie star who'd been felled by scandal six years earlier and banned from the screen. Everyone knew what had led to Arbuckle's downfall: too much carousing and drinking. He was known for having one of the best bootleg cellars in Hollywood, and cocaine was pervasive at the parties he threw. When a woman died at one of those parties, Arbuckle was charged with rape and manslaughter, although the evidence was never convincing; after two mistrials, a jury finally acquitted him. But he was blacklisted by the movie studios, and his career never recovered. Working with Arbuckle, whose films he'd enjoyed as a boy, Humphrey had an up-close view, if he chose to see it, of the dangers of overindulgence. How much he learned from Arbuckle's story remained to be seen.

Baby Mine was hyped as the comedian's comeback, but despite the enthusiastic cheers of the opening-night audience on June 9, 1927, Arbuckle garnered tepid reviews, with most critics feeling that his on-screen charisma did not translate to the stage. Bogart, playing the husband in the dated farce (*Baby Mine* had first been presented in 1910), fared much better. "Humphrey Bogart gives the best performance of the cast," Burns Mantle adjudged. So when the show closed in a matter of weeks, Humphrey emerged unscathed.

Guthrie McClintic soon snapped him up to replace Roger Pryor in the hit Broadway show *Saturday's Children*, the Pulitzer Prize–winning play by Maxwell Anderson. On August 2, 1927, Humphrey stepped onto the Booth Theatre stage opposite Ruth Gordon, whose character tricks his character into marriage. Although the play is comic in tone, Anderson was exploring the shifting meanings of love and happiness, and *Saturday's Children* gave Bogart a chance to show off how much he'd learned about acting. Given that he was a replacement actor, New York critics didn't get a chance to weigh in on his performance, but when the show went on

tour in the fall, Bogart was called "excellent" by the *Detroit Free Press* and "exquisite and credible" by the *Chicago Tribune*.

It was while he was in Detroit that Humphrey gave a revealing interview. On the surface, the questions posed to him were about the plot of *Saturday's Children*, in which the woman engineers the marriage proposal. But his answers hint at his own worldview. "Men hate to have women interfering in their affairs like that," he said. "It hurts their ego. I like women who are soft and feminine." That was clearly a burn on Menken, but there were warnings for Philips and any other woman who might come into his life. Men, he said, "would suffer from an inferiority complex" married to a woman "capable enough to do the proposing." A woman who took the reins in a relationship only "made herself look foolish," he declared. "The girl must be clever about it, because men don't like to think they are being managed."

If we take him at his word, what he was saying was that the problem lay with men and their fragile sense of masculinity. Yet it was women, he insisted, who had to learn to live with that and adjust their plans accordingly. The man was not obliged to change a damn thing.

Bogart's attitude toward women was generally shared by the men at the Players, puffing on their cigars and sipping their Scotches, protected in their brownstone sanctum from the interference and management of women. Humphrey fit right in with them all: Kaufman, John Barrymore, Eugene O'Neill, Alfred Lunt. He'd make a career out of that sort of bonhomie, the backslapping privilege of the old boys' club. But his career could still be challenged by the fears and insecurities of the young man who lived beneath his tough skin.

6

The *Chief*, the streamliner from Chicago to Los Angeles, clattered across the Mojave Desert. From his window, Humphrey Bogart could watch the cacti and baked orange earth of Oro Grande and Victorville speeding by. He was nearing his destination. The journey had taken fifty-eight hours, give or take, and had passed through some spectacular scenery in Colorado and New Mexico, though Humphrey had probably been out cold at that point. As he awakened to the conductor's announcement that Los Angeles was coming up, he was very likely hungover. The *Chief* was famed for its convivial club car, and despite the grip of Prohibition, enterprising travelers always found a way to imbibe, even if the conductor did his best to play headmaster.

Around nine in the morning, the train pulled into Los Angeles' La Grande Station. Humphrey stepped out into the warm, sunny morning. The high for the day was predicted to be 80 degrees. When he'd left New York, the temperatures had been hovering nearly twenty degrees lower. The weather wasn't the only thing that would have gotten his attention as he debarked from the train. La Grande Station was fanciful, as befit the city where dreams were made, with onion domes and Moorish arches shaded by palm trees. Humphrey found himself in a whole new realm.

He was met by Kenneth MacKenna, who'd come out to Hollywood a year or so before on a Fox Film Corporation contract and had already made a handful of pictures for the studio. Humphrey, too, had been brought out by Fox. According to one story, told yet again by the often unreliable Stuart Rose, Humphrey had made the three-thousand-mile cross-country journey thinking he was being brought out to play the lead in *The Man Who Came Back*, the talkie remake of a successful 1924 silent picture. But the anecdote is just more of Rose's embroidery. Charles Farrell, then one of the top stars of the screen, had been announced for the lead in late April, well before Humphrey had boarded his train in New York; his Fox contract had been announced in the trades on May 10.

Rose also gave himself the credit for Bogart's Fox contract. As the studio's East Coast story editor, he claimed to have arranged a screen test for his brother-in-law. Rose also asserted that MacKenna, as well as others of Bogart's acquaintance, had also believed they were getting the lead in *The Man Who Came Back*. The story, as Rose told it, was set up to be a joke on Humphrey, with MacKenna delivering the cold, hard truth to him right there on the train station platform. Movie publicity tends to concoct tales of less-than-impressive Hollywood arrivals for actors who then go on to become big stars.

Yet there may have been, in the early spring, at least some glimmer of hope on Bogart's part that he'd been tapped for his first movie lead. The gossip maven Louella Parsons had announced that he'd been cast for *The Man Who Came Back* in her column of April 4 (though she didn't say as the lead). "There is no juvenile on Broadway with more admirers than young Humphrey Bogart," she wrote. She hailed Winfield Sheehan, the head of Fox, for his foresight in hiring the young actor, as "any play in which young Bogart appears is sure to go over big." *The Man Who Came Back* would be just the first of his film successes, Parsons predicted. "Fox picked out a good one when they picked out that lad."

The column reads like a promotional "plant" supplied by a canny agent or publicist to build up a client. Yet even with that in mind, Parsons gives us a glimpse of Humphrey's standing in the spring of 1930 and thereby debunks Rose's taking of all the credit for his brother-in-law's start in motion pictures. Bogart was a big enough stage star that he would not have needed anyone to pull strings to get him a screen test. Just a couple of years into the sound revolution, Hollywood was importing nearly every actor from Broadway who knew how to speak, given that many of its own stars had failed the microphone test. In fact, Bogart's first job on his Fox contract was to serve as voice coach for Farrell in *The Man Who Came Back*. He wrote to Stuart Rose, "What the hell am I doing here being paid $750 a week to coach a very nice fellow named Charles Farrell to play a role he can't play because he can't talk?"

Bogart was a very different man in a very different world than he'd been just two years earlier. For one thing, the previous fall, the stock market had crashed and the economy along with it. Fortunes had been lost, jobs were getting scarcer by the day, and industries were operating on deficits. Broadway attendance sagged. The movies, buoyed by the novelty of sound, managed to keep chugging along, although there would be

some losses in the next few years. Moreover, Bogart's "juvenile" appeal, so praised by Parsons, was diminishing now that he had hit thirty. He needed to segue into a mature leading man, and he hoped that Hollywood could help him do that.

Humphrey was also different in a more personal way: he was married again, something that had once seemed unlikely. It was remarkable, in fact, that MacKenna was willing to meet his train, given that Humphrey had stolen the woman MacKenna had hoped to marry himself. Mary Philips did not accompany her husband on his sojourn to Hollywood. She was appearing nightly in George M. Cohan's *The Tavern* back in New York at the Fulton Theatre. Philips's demurral of Bogart's request to join him, despite the fact he now had the money to support her, had echoes of Menken's prioritizing her career over his. And that, in turn, echoed his parents' marriage.

By now, the union between Maud and Belmont had utterly collapsed. They'd left 56th Street for Tudor City, the recently constructed residential skyscraper complex on the southern edge of Turtle Bay, the first such structures in the city. They had taken two flats, one for her and one for him. Humphrey would call his parents' lives at that point "complicated." Belmont was largely bedridden; the once strapping outdoorsman who'd taught his son to sail was nowhere to be found. Maud cooked him breakfast and dinner every morning and evening, but in between and afterward she returned to her own apartment, leaving him to the care of hired nurses. "There was no formal separation between Father and Maud," Humphrey said. "There was never even the thought of divorce. They just couldn't stand being together for long."

Humphrey still blamed his mother for his father's degradation. After Menken, he'd been determined not to marry another woman with whom he might feel competitive and therefore lose his power. He'd thought that Philips had been the perfect choice. Now, two years later, at the dawn of his Hollywood career, he hoped he hadn't made the same mistake twice.

IN THE BEGINNING, THE MARRIAGE TO PHILIPS APPEARS TO HAVE BEEN BLISSFUL. Humphrey could be surprisingly romantic when he fell in love. "Love is very warming, heartening, enjoyable, a necessary exercise for the heart and soul and intelligence," he said. "If you're not in love, you dry up." That was what had happened to his parents: they were dried up and unhappy.

Humphrey did not want it to happen between him and Mary. At the start of their married life, there seemed to be no worry of their drying up. She was his companion through the city's nightlife and could knock back as many shots of gin as he did. Bogart was the more established Broadway name, and indeed he would help his wife get parts in his own plays. There would be no competition as there had been with Menken.

Mary had been born in New London, Connecticut. Her early Broadway publicity described her as a member of Connecticut's society elite. Indeed, in one article, headlined FOOTLIGHTS DRAW SOCIETY GIRLS, Mary was paired with another up-and-coming Connecticut ingenue, Katharine Hepburn. Mary's New England blue blood was emphasized; she was "a determined young lady with a shrewd sense of business judgment inherited from a long line of Yankee ancestors who settled in Connecticut."

Yet Mary's family tree was in fact far less patrician than Hepburn's. She had been born Edna May Phillips on January 23, 1900, making her just about a month younger than her husband. Her mother, Anna Hurley, hailed from an Irish Catholic immigrant family, and her father, Charles Phillips, came from a long line of railroad workers. She'd been educated at the Academy of Our Lady of Mercy, Lauralton Hall, in Milford, Connecticut, run by the Sisters of Mercy. At age eight, little Edna May recited the poem "A New Santa" at her school's Christmas pageant; her path to the stage seemed set, at least for her. Her father died in 1907 after being electrocuted while working on the railroad. Her mother took her daughter first to New Haven and then to Hartford. Both cities were frequent stops on the Broadway tryout circuit, and publicists would claim that the future Mrs. Bogart had been an inveterate theatergoer in her youth, "learning about the theatre from a gallery seat" in her hometown playhouses. When she set her sights on a stage career, Edna May re-created herself as Mary Philips, dropping one *l* from her name and one year from her age. Leaving convent school virtues behind, she took the train to New York at the tender age of eighteen to go on the stage.

"With the intrepidity that youth sometimes has," one early publicity release read, she walked into a rehearsal for the show *Apple Blossoms* and asked to see the stage manager. So struck was that gentleman with the pretty teenager that he summoned the producer, the powerful Charles Dillingham, who immediately put her into the chorus. There is certainly much more to that story, but that's how it was told. For the next eight

years, Mary was rarely out of work. It wasn't until *Two Girls Wanted* (1926), however, in which she played an acid-tongued, middle-aged spinster (when in fact she was only twenty-six), that she received significant notice from the critics. It was during that period that she reconnected with Humphrey.

Mary came across as worldly and tough. She was often cast in "hard-boiled" parts, and she was frequently described that way in the press. Publicists eventually tried to feminize her, insisting that she disavow the trend of women wearing slacks "and such other masculine tomfoolery." But Philips had to be tough if she was going to run around with Bogart to all hours of the night. They were married on April 3, 1928, less than six months after Bogart's divorce, at Mary's mother's apartment in Hartford, followed by a honeymoon in Atlantic City. "Mary is a mixture of New England and Irish," Bogart told the press, suggesting that he knew more about her heritage than they did, "and she furnishes just the sort of balance I need. Marrying her is probably the most wonderful thing that could happen to me."

The hard-boiled Mary found her sentimental new husband "a strangely puritanical man with very old-fashioned virtues [and] class as well as charm." "Puritanical" is not the first word that comes to mind when considering Humphrey Bogart; his Puritan forebears would have had something to say about all that alcohol and carousing. But to Philips, growing up within a family of railroad workers, Bogart's taste and manners, instilled at home and at Trinity and Andover, likely struck her as very proper and respectable. It didn't matter if he'd pass out drunk at the end of the night; what mattered was that he knew which fork to use at dinner, pulled her chair out for her, and never cussed around women.

They were together almost constantly. After *Saturday's Children* was given encore runs on Broadway and in Brooklyn, finally closing in May 1928, Bogart turned his attention to summer stock and planned to take his wife with him. He and Mary were signed by the Cort Jamaica Theatre in Queens to appear in a weekly repertoire of Broadway hits, among them *Rain*, *White Cargo*, *An American Tragedy*, and *Abie's Irish Rose*. The only company member, however, who received billing in the minireviews the Brooklyn newspapers gave such summer offerings was Shirley Booth, so we don't know which, if any, of the plays the Bogarts were in. The one cast list that was published was for the mid-June production of *Cradle Snatchers*, and neither Humphrey nor Mary was in it. (He would have

been resistant, in any event, to reviving Jose Vallejo; in the press, he was still being ribbed as "the Argentinian osteopath.")

The Cort Jamaica season ended in July. In August, Bogart and Philips starred together in *The Dawn of a Tomorrow* at the Lakewood Theater on Wesserunsett Lake in Madison, Maine. Working together may indeed have felt like "the most wonderful thing" for the newlyweds who were, essentially, still on their honeymoon. They also optioned a comedy by a pair of unknown playwrights in the hope of both producing and starring in it, but the project never came to pass.

Their togetherness continued into the new Broadway season. Guthrie McClintic cast husband and wife in *The Skyrocket*, another story of a married couple unhappy after they strike it rich, only to rediscover equanimity when they lose it all. The show closed after ten performances. Then came a bit of a dry spell for the Bogarts. As the coffers decreased, they resorted to vaudeville, appearing at Proctor's Theatre in Yonkers, New York, in a skit called *Three Rounds of Love*. It was Mary who got the next big break. In April 1928, she was cast in George M. Cohan's *Gambling*, which turned out to be a massive success, rolling through hit previews to its Broadway premiere on August 26. Critics were enchanted, singling Mrs. Bogart out for praise. "Mary Philips is a delight as Mazie, a hard-boiled golddigger," one reviewer wrote. "Miss Philips threatens to stop the show on several occasions."

Humphrey had experience with a wife getting all the notices while he struggled just to get cast. If he'd hoped he and Mary might have a productive professional partnership, he quickly realized that it would be a challenge. The problem was, as he neared his third decade, Humphrey's juvenile swagger increasingly belied his face. The delicate beauty, dark eyes, and full dark hair had been abraded by years of alcohol, tobacco, and fistfights. His face was sunken, with hollow cheeks and bags under his eyes. The hair hadn't yet begun to recede, at least not by much, but he would never again be compared to Valentino. Bogart's only hope to survive as an actor was to transition out of juvenile roles. Making that leap, however, was never easy, and the process was only complicated by a sharp downturn in Broadway profits in early 1929. *Variety* reported that "legit business" had dropped by 50 percent. Insiders blamed a rough winter and "loud squawks from the brokers." That fall, of course, things would get much, much worse.

Alice Brady, as she'd often done before, threw Humphrey a lifeline

by casting him as a replacement actor for the final weeks of her hit show, *A Most Immoral Lady*, produced by her brother and Bogart's pal, but the show closed in April, just as Mary was taking off in *Gambling*. Humphrey was back to waiting for the telephone to ring, hoping to hear from his new agent, Mary Baker. What he did to while away the hours was, of course, drink.

Stuart Rose told a story from that period that, even allowing for his tendency to embellish, rings true. Humphrey approached him with a problem: he loved Mary, he said, but he was impotent. How long he'd been troubled by that condition isn't clear, but it's not hard to imagine why he might have been so afflicted, with his self-esteem, always tenuous, plunging as his career declined and with his wife on the upswing. Rose insisted that Bogart regained his virility soon after, but it's perhaps significant to point out that the risk for long-term erectile dysfunction is linked to chronic heavy alcohol consumption. Men who are dependent on alcohol have a 60 to 70 percent chance of suffering from sexual problems. Bogart's drinking was taking a toll.

For some, it's difficult to see alcohol as a problem when there's no arrest, incarceration, lawsuit, or hospitalization and when the alcoholic keeps a job. But the problem can still be acute. Bogart's "life was one extended hangover," Joe Hyams observed. Humphrey was a high-functioning alcoholic; he got jobs, he learned his lines, he did the work, he banked his salary. But alcohol still controlled both his life and his relationships. Philips, unlike Menken, enabled the problem by partaking herself. In between their times under the proscenium arch, the Bogarts drank until they passed out. It's no surprise that Humphrey couldn't perform in bed. His fourth wife would remember his telling her how much he had drunk in those lean years. He'd skip lunch in order to have enough money to order drinks at "21," the fashionable speakeasy on West 52nd Street, when he hit the street in the evening.

Hyams also claimed, and other biographers have repeated the story, that Mary made Humphrey more serious about his craft, but there's no real evidence to support this. As his drinking companion, she likely did the opposite. Her own drinking was prodigious. She was right by his side lifting glasses of gin or bourbon, laughing uproariously, and could quickly turn belligerent when anyone told them to quiet down. They both seemed headed for a crash.

Humphrey once more spent the summer of 1929 with the Lakewood

Players in Maine, although this time Mary did not come along. She was on the fast track to Broadway with the box-office bonanza *Gambling*. Her husband, meanwhile, did his best to please the summer audiences, which often included parents with screaming children. He mugged his way through the facile mystery *Cock Robin*, and the comedy *Upstairs and Down*, playing his typical cad, except this time with an Irish accent.

His career needed a jump start. Humphrey had worked very hard for the past ten years to secure himself a place in the theater. He cared about his craft and had found a degree of fulfillment and personal satisfaction on the stage. Now, the loss of his youth and good looks, sped up by drink, meant that there might no longer be a place for him as an actor. If so, he truly had no idea what else he might do. Except for sailing (and drinking, of course), acting was the only thing he knew how to do.

He appeared to get a break when he returned to New York in July. Broadway was largely dark during the summer, but producer David Belasco took a chance with a frothy comedy, *It's a Wise Child*, which previewed at the Jamaica Theatre on July 29 and then opened on Broadway at the Belasco Theatre on August 7. Brooks Atkinson of the *New York Times*, musing over "the heat and the humidity and the apathy of Summer in town," noted that when *It's a Wise Child* premiered, "the public and the ticket brokers sat bolt upright." Humphrey was once again in a certified hit, and his income rose accordingly. He was not, however, the star, just another juvenile not mentioned in most reviews of the show. Despite *It's a Wise Child* running for a year on Broadway, the show did nothing to launch Bogart on a new, very much needed career trajectory— although the steady paycheck was appreciated, especially after the Wall Street crash a couple of months after the premiere.

Humphrey didn't stay with *It's a Wise Child* for its full run. He signed his Fox contract the first week of May 1930, and he set out almost immediately for the West Coast. Winfield Sheehan, Fox's newly minted studio chief, had been in New York for the past several months, so it's likely he met personally with Bogart or at least had seen him onstage in *It's a Wise Child*. Whether Sheehan was impressed with the thirty-year-old actor or was simply collecting as many actors with speech training as possible is unknown.

Humphrey very much wanted to be a movie star, for the fun and the glamour and the fame, but also for the money. His parents were struggling, his sister Pat suffered from mood swings, and Kay was, like her

brother, a heavy drinker and seemed unable to land either a sustaining career or a relationship. More and more, Humphrey felt a family responsibility.

He also wanted, with his increased salary, to support Mary and allow her to be the stay-at-home wife he believed he needed. Mary had other ideas. From *Gambling*, she'd moved directly into two other Cohan shows, *The Tavern* and *The Song and Dance Man*. Not only was she happy in her work, she had likely also fallen out of love with her husband by that point. When she rebuffed Humphrey's request to follow him to Hollywood, she made a telling remark: they were "a modern couple," after all, and didn't need to be together all the time. In fact, they should both feel free to sleep with whomever they wanted—an endorsement of polyamory decades ahead of its time. Humphrey wasn't enthusiastic about the idea. "We were so modern," he recalled. "Too modern. I was to go out with other girls. She was free to see who she wanted. She was fine, not jealous a bit. But I wanted her to be jealous. And ashamed to admit it when we were both so modern." And so Humphrey headed west alone.

HUMPHREY BOGART LOVED HOLLYWOOD. FROM THE MOMENT HE ARRIVED, HE loved the sunshine, the swimming pools, the golf courses, the blue skies uninterrupted by skyscrapers, the fragrant orange blossoms. "Nothing could make him leave," remarked Elena Boland, one of the first movie journalists to interview him. "What he didn't get on Broadway, he has here: and what he misses in Hollywood, he has already had on Broadway—so everything is balanced and compensated one way or another." At first, the newly hired studio contractee lived in hotels, but once he started earning a salary, he secured a small house at 2639 Canyon Drive in Whitley Heights, just below Griffith Park, with a view of the iconic HOLLYWOODLAND sign. His hope was that Mary would join him there.

It may have been Humphrey's first time in Hollywood, but he'd already made two films, short subjects shot back in New York. The first had been written by the humorist Rupert Hughes and distributed by Paramount in June 1928, at the dawn of talking films. The working title was *Twinkling Toes*, but by the time of its release in October the studio had renamed it *The Dancing Town*. It was part of the "Great Stars and Authors" series that was shown in between features to feed the demand for motion pictures with sound. In that instance, the "great star" was

Helen Hayes, who'd made a splash on Broadway in *Coquette* and other plays. Humphrey had just a cameo in the twenty-minute picture, as a man standing by himself at a dance. The job gave him a few extra dollars in his pocket, and he likely never thought about it again.

He'd made the second film not long before he'd come out to Hollywood, sometime in early January 1930, and that time he'd had more to do. At the Vitaphone Studios in Flatbush, Brooklyn, he found himself playing (no surprise) the cad, a married man romancing the star, the musical comedy actress Ruth Etting. The film was called *Broadway's Like That*, part of a series of "Vitaphone Vodvils" (vaudeville for film). He was paid $200 for his time. Unlike his first short subject, this one still exists, a grainy little novelty that suggests what Bogart may have been like on Broadway in the 1920s. Sitting across from Etting, wooing her, teasing her, moving in for a kiss, all with great flair and finesse, may have been the way he'd played Jose Vallejo. The director, Arthur Hurley, had originally intended for Mary Philips to play the part of the wife who uncovers her husband's scheme. But Mary either declined or was too busy, and the part was given to Joan Blondell.

Bogart's first weeks in the movie colony, to his dismay, were spent teaching Charles Farrell how to orate. But by early June, the studio cast him in his first feature film, *Sez You, Sez Me*, directed by Irving Cummings. Cummings had been in Hollywood since 1909, first as a popular actor and then as a director; he'd been nominated for an Academy Award for *In Old Arizona*, one of the biggest hits of the previous year. So Humphrey was working for someone who knew the system quite well. They became friendly, raising a glass (or two or three) after the last cut of the day. The star of the film was Victor McLaglen, who'd soared to fame in the film of *What Price Glory?* in 1926. "Sez you, sez me," in fact, was a catchphrase from that film. McLaglen played a blustery, bellowing soldier of fortune who competes for the attentions of a pretty señorita with a rich young man, played, of course, by Bogart. At heart, the film was a comedy, but it also had to be a jungle adventure, and it failed at both attempts. The studio had little faith in the picture; completed by early summer, it would sit on the shelf for several months before it was released.

After a short break, Humphrey was put into the cast of *Up the River*, the new film by the up-and-coming director John Ford, who'd just signed his own contract with Fox. Production began in early August, when its star, Spencer Tracy, arrived in Hollywood. Tracy was another Broadway

import, having scored a major hit in *The Last Mile* that past winter. He had left the still running show in late July to take the deal with Fox but insisted he needed to be done by September, when he would be taking *The Last Mile* on the road. The shooting schedule for *Up the River*, therefore, had to be brisk. Though it was intended to be a crime drama, Ford made the decision to layer on some satire, which Humphrey had difficulty adjusting to. "To me it was a wise move [to add the satire]," he told Elena Boland, "but . . . there are several serious episodes [which] to me destroy the real flavor of satire."

He played a convict serving out his time for various crimes, but he was soft and kind and the scion of a wealthy family who did not know he was in prison. It seemed that all those polished Broadway roles wouldn't quite allow him to be cast as an authentic tough guy right away. When a new crop of inmates arrives at the prison, Bogart, as Steve, welcomes them and treats them humanely. The other inmates, however, jeer the newbies, still in jackets and ties from their sentencings, their hair combed, their manners gentle and frightened. One longtime convict (William Collier, Sr.) gripes, "They wouldn't have allowed guys like that in here in my time. You know what we woulda called 'em in my day? A sissy. There were *men* in those days." Steve is visually linked to the well-mannered arrivals by the shirt and tie he wears to work in the prison office. Ford intended that Bogart stand apart from the roguish Tracy, who's quick with his fists and often cruel. When Bogart interviews a new female inmate, played by Claire Luce, he is lit by a romantic spotlight, his teeth and eyes sparkling. Ford saw him as the picture's love interest, its romantic lead, even if Humphrey resisted the idea.

"He just can't warm up to the idea [of being the love interest]," Elena Boland observed. Bogart told her, "I want to be a real person with all the foibles and weaknesses that everyone has." He didn't want to play the bad guy who is reformed and refined by the end of the picture; he wanted to stay bad. "In movies," Bogart complained, "the code seems to be that if one is bad in the beginning, he either has to end up regenerated or else die." He was referring to the Motion Picture Production Code, adopted in March of that year. Although the Code would not be strictly enforced for another few years, Bogart's description precisely expressed its stipulations.

In a few years, this sort of antiromantic, antiheroic image would come to define the Humphrey Bogart persona. But at that point, with

his screen identity still developing, the complaint feels authentic to the man himself and not merely a publicist's spin. After all, throughout his life, Bogart made sure to emphasize his difference from pretty boys and sophisticated men. It's easy to imagine him watching *Up the River*, cringing when the "sissy" remark was made just before he drifts on-screen wearing his tie and offering a gentle word to a new inmate. He would have preferred to be a ruffian like Tracy, who had managed to successfully promulgate that image off-screen as well. John Ford projected a similar "he-man" image as Tracy, which meant lots of braggadocio and jokes about women bouncing around their sets—although it's unclear how much of the swagger was true.

Postproduction wrapped on *Up the River* by the end of September, and the movie was released on October 10. Humphrey was right to call Ford's decision to spotlight the comedy in the film "wise." *Up the River* might have been just another turgid prison melodrama but instead turned out to be a delightful farce, with prisoners breaking out of (and into) jail at will and the kindly warden allowing them all to play in the climactic baseball game. It's as if the prison were in fact a college, with pretty coeds in the adjacent dorm (or penitentiary, in this case).

Humphrey saw his photograph splashed across the nation's newspapers, which was surely exciting for his friends back east (when the picture played in Canandaigua, the local newspaper noted that Bogart had been "for many years a summer resident at Seneca Point"). But it was Tracy, as the he-man, who got credit for the film's success. It was a movie about men for men. Edwin Schallert of the *Los Angeles Times* noted that *Up the River* had "roused no end of mirth, especially, one might say, from the masculine portion of the audience." Tough-guy Tracy was the studio's new star.

About a week after *Up the River* was released, *Sez You, Sez Me* finally came out, although with a name change: *A Devil with Women* (one trade report contended that "devil" and "woman" were the two sexiest words to entice audiences into the theater). The film's long gestation period revealed the studio's dissatisfaction with it, which *Variety* picked up on in its review: "This film, made some time ago, looks like a slice which Fox intended to use as a sequel [to Victor McLaglen's earlier films] but flopped." Once more, Humphrey was the cultured rich boy, playing off a costar with far more machismo. In the part, Bogart was "okay," according to the *Variety* reviewer, but the action he had been given was "silly"

and made little sense. "He's supposed to be the nephew of the richest power in the country and walks through jungle spots and other mysterious country as a lark, just to nag McLaglen." *A Devil with Women* did nothing to boost Humphrey's Hollywood ascent.

In some ways, in the first year of his movie career, Humphrey Bogart was more in line with the leading men of the previous decade, such as Ramon Novarro, John Gilbert, Nils Asther, and Rudolph Valentino, to whom he'd been compared. They were stars who projected sophistication, style, and a somewhat ambiguous sexuality, reflecting the social and gender rule breaking of the 1920s. The new crop of male stars who arrived with the introduction of sound, however, expressed the hardscrabble realities of the Great Depression: Tracy, Cagney, Gable, Paul Muni. Bogart wanted very much to join their ranks, both on-screen and onstage. But a decade of playing rich cads in tennis shorts seemed to have typed him indelibly.

He made up for it by playing the bad boy on his own time. For his first Hollywood hit, he couldn't have asked for more like-minded comrades than Ford and Tracy; Bogart would later recall "the many nights" of drinking with his director and costar, with whom he had "trouble keeping up." (One suspects that he rose to the occasion like a pro.) The *Hollywood Reporter* spotted him at the Trocadero and other nightclubs. One boisterous party that Humphrey attended was thrown by Dimitri Tiomkin, a Russian émigré composer of movie scores, and his wife, Albertina Rasch, an Austrian ballerina now working as a choreographer for Metro-Goldwyn-Mayer. Their home at Sunset Boulevard and Fairfax Avenue was decorated with a Russian motif, an orchestra played Russian music and waiters served caviar. Though the guest list included many reputable industry leaders, the presence of some of Hollywood's party set—the screenwriter and director Edmund Goulding, the actress Lilyan Tashman, Louise Brooks, and Bogart's pal Kenneth MacKenna—suggests that the revelries weren't all that sedate. Indeed, the newspaper item reporting the party noted that it had lasted "until a late hour." Mary Philips was there, too, on a visit to her husband, and she was never one to go home early.

Yet Humphrey gave a curious interview in the fall of 1930 to a reporter from the Consolidated Press, in which he complained about how boring Hollywood was compared to New York. "Where are the wild Hollywood parties?" he asked. "I've hunted the darn town over from the hills

to the boulevard, and not a wild party have I seen, heard, or attended yet." He'd been told that "wild Hollywood parties simply spring out at you from behind every palm tree." That seems like artful deflection. The interview is clearly tongue in cheek and possibly a move on Bogart's part to ingratiate himself with the studio honchos. With the Motion Picture Production Code weighing on the industry and the fear of reformer-led boycotts looming, industry leaders very much wanted to distance Hollywood from the hedonistic reputation it had earned during the previous decade. "Wild parties went out with the silent movies," Bogart said, almost as if he were reciting studio talking points. "Actors have to work too hard today to make whoopee at night. You can't raise the dickens until 4 a.m. and speak your lines correctly at nine next morning." Except that he had done just that on Broadway for many years. Still, Winfield Sheehan would have appreciated his new employee's words, even if those in the know were amused by the irony.

In fact, Humphrey was already making a name for himself in Hollywood as a two-fisted drinker and rapscallion. Those "wild parties" weren't really so hard to find; in fact, they sometimes happened right in his own home on Canyon Drive. The screenwriter Nunnally Johnson, who'd soon be hired by Fox, told Nathaniel Benchley that Humphrey liked to think of himself as Scaramouche, the impish character of the Italian *commedia dell'arte*, needling people and provoking fights just for the fun of it. He usually, of course, had a few whiskies in him by that point. "He was a disputatious fellow," Johnson said in another interview, stirring up trouble between people, then "leaving them to fight it out." Calling Bogart "maddening," he said, "It would have been all right with me if somebody punched him."

That exact scenario would play out during his film *Body and Soul* in 1931. Charles Farrell had the lead in the picture. Possibly still holding a grudge against him, Bogart hassled and goaded the star until they nearly came to blows. Humphrey was cocky, despite the fact that Farrell was over six feet tall and a former boxer. "I can lick you," Bogart declared. Only when Farrell's full height cast a shadow over his five-foot-eight frame did Bogart back down. He likely hadn't wanted a fight at all; just getting Farrell steamed up was satisfying enough.

Whether Humphrey had been drinking on that occasion is unknown, but as it was after the film was finished, it's certainly possible, especially if there had been a wrap party. Most friends would always insist that

Bogart never drank when working, although he often showed up on set with a hangover, which affected his acting, just as it had on Broadway. Joe Hyams wrote that whenever he *wasn't* working, Humphrey was drinking, which might provide some insight into the story Nathaniel Benchley told about a day on the links. Finding himself and a golfing partner stuck behind a very slow-moving party, Humphrey asked if they could play through. One of the men ahead of him asked who the hell he thought he was asking such a thing. As ever when provoked, Bogart lashed back: "My name is Humphrey Bogart [and] I work at Fox. What are you doing playing a gentleman's game at a gentleman's club?" As it turned out, the man was a Fox executive. The story may be apocryphal, given its cute punch line, but it certainly feels real enough, especially if Humphrey and his pal had downed a few cocktails prior to their game.

Bogart's career on the stage had been a fairly steady rise. He'd started out as a juvenile, and by the time he was called to Hollywood, he'd moved into playing leads. His drinking had irked producers from time to time, but never enough for them to expel him. Protected by the old boys' club, he was also young and handsome; the women in the audience liked him very much. But now Bogart wasn't quite so young or handsome, and the men in power in Hollywood were very different from the power brokers on Broadway. Their focus was always the bottom line. No matter how well bred an actor might be, if he dragged out production by drinking or carousing or his antics became fodder for the gossip columnists, he was quickly shown the door.

Alcohol continued to be the quickest way to muster the self-esteem and courage that Bogart so profoundly lacked. But it had also become a physical need: his body went into withdrawal when he didn't drink. Humphrey's addiction threatened everything he'd worked for over the last decade. Thanks to William Brady, he'd found a path forward after a directionless youth, but that had been a full ten years earlier. His situation now was very different. If he expected, based on the quick success of *Up the River*, to experience in Hollywood the same sort of precipitous rise he'd enjoyed on Broadway, he would prove to be sadly mistaken.

Madison, Maine, Monday, July 6, 1931

Humphrey stepped off the *State of Maine* express train at Skowhegan and boarded the trolley that would take him to his wife. He knew the route well, having been a part of the Lakewood Players for some time now, although he'd missed the previous year because he'd been making movies in California. On this trip, however, he was no longer the same man he'd been before. The swagger was gone from his step. He hadn't expected to return to Maine.

A month or so earlier, Fox had canceled his contract. Pictures that featured Humphrey were still in theaters across the country; *Body and Soul* was, at that very moment, playing at the Park Theatre in Bangor, about an hour's drive from Skowhegan. But Hollywood credits didn't impress the stage actors of the Lakewood summer stock company. Most of them were seasoned players, such as Thurston Hall and Harland Tucker, who'd made their share of films and then returned to the stage. Like Humphrey's, their parts had been in support of the lead and hadn't generated much publicity. Unlike him, however, they hadn't expected to become movie stars, so traipsing once more to the woods of Maine in summer did not feel like a comedown as it did for him.

There was also the conflict that Bogart was facing with his wife. Approaching the sprawling theater with its white-columned portico, Humphrey may have recalled the exchange he'd had with Mary in New York just a couple of weeks earlier. He'd left Hollywood in the middle part of June. He had been hoping to lie low for a while and lick his wounds. After seeing Mary in her hit play *The House Beautiful* on one of its final nights, Humphrey, according to newspaper reports, wanted to take his wife on "an extended vacation." Facing both a professional and personal crisis, Bogart was apparently looking to Mary for support. He seems to have been genuinely trying to rekindle their marriage with a second honeymoon. It was an uncharacteristically vulnerable position for him to be in, and he made no effort to hide it. He and Philips had loved each

other once, and in the beginning, their partnership had been rewarding both onstage and off. Humbled by his Hollywood experience, Humphrey seemed to be trying to recapture that early magic between them.

But Mary told him plainly that she had no intention of taking off with him. Her notices for *The House Beautiful* had been superlative, praising her versatility as an actress. Convinced her career was going places, she wasn't keen on risking producers forgetting about her if she went gallivanting on a two-month jaunt with Humphrey. Besides, she had accepted a place with the Lakewood Players again for the summer. Mary suggested that her husband join her.

Arriving at the theater, Humphrey greeted the company, many of whom he knew from previous summers, being "welcomed back after two [sic] seasons of absence," as reported in the *Bangor Daily News*. Director Melville Burke found a small part for him in its first production, *Just to Remind You*, a lighthearted comedy. Next up was another small part in *Zoom*, which starred James Bell. In both plays, Mary was billed above Humphrey. He moved up a notch for *Bird in Hand*, playing the son of an English baronet who ends up with the girl. Finally, in late August, Humphrey won a lead role in *Michael and Mary*; he and Edith Barrett, later the wife of Vincent Price, played the titular characters. But for the final offering of the summer, *The Last Warning*, Bogart was merely described as being among "others in the cast." Still, the play, set in a haunted theater, was probably great fun for the actors to perform, with its "clutching hands, sliding panels, ghostly apparitions [and] doors that open and shut without human touch."

Humphrey seems to have been pleased enough with the season. Maybe, in fact, coming to Maine hadn't been a bad idea, and maybe here he could find the equanimity he sought. Soon after his arrival, he began exploring the idea of settling down in Maine. The local newspaper reported that he was planning to purchase a lakefront lot on which he'd build a house for himself and his wife the following summer. Memories of the house in Canandaigua, sailing across the waters of the lake with his father, some of the few happy occasions of his childhood, likely guided his thinking. Perhaps at that moment, as the momentum of his acting career ran out, Bogart contemplated a simpler life. He could become Thurston Hall or Harland Tucker, more or less steadily employed on the New York stage during the winter and spring and then spending the summer on a crystal lake in Maine surrounded by rolling hills and

mighty evergreens. It might actually be a relief to give up his ambition to become a star.

Sitting at the lake in late September, Humphrey would have noticed how the light had changed. The days were no longer quite so long. From his earliest efforts with Brady, he'd been determined to pursue a life as an actor. Acting was the first professional thing he had ever done well, the first endeavor that had brought him acclaim. As the years had gone by, he had only wanted it more, becoming fussier and more discriminating about parts. By the time he had gotten the call from Hollywood, he had been ready to take his career to new and different heights. Yet the last few years, even before he had gone west, had largely left him wanting. On stage and screen, he was still playing the same sort of parts he'd been associated with for a decade: young, urbane, usually supporting the lead. So it's quite believable that he'd consider settling down to a new way of life. If only his wife would agree. It's tempting to believe that the ambitious Philips was the one to squelch the idea of settling down, as after the summer of 1931 there was no more talk of owning a house in Maine.

"IT WAS ALWAYS A STRANGE THING TO SEE MY NAME ON THE MARQUEES OF theatres as I'd drive by," Bogart would say many years later. It was no doubt particularly difficult that summer and fall, seeing his name in movie ads and recalling his hope and optimism of a year before. Soon after the February release of *Body and Soul*, the production in which Humphrey had nearly provoked Charles Farrell into a fight, it had become clear that his fate was sealed. In the film, Bogart played a bomber pilot who is killed while in the air, so his partner (Farrell) has to take over and drop the bombs himself—although he gives the credit to his dead comrade after he lands. Bogart disappeared before the end of the first act, and reviewers mostly shrugged at his performance (Mordaunt Hall of the *New York Times* called him "earnest") or else completely ignored him.

Things only got worse. After *Body and Soul*, Bogart was loaned out (never a good sign) to Universal for *The Bad Sister*, in which he played a con man who swindles his girlfriend's father. It was his first true villain role on-screen, and he performed it with a suave, sinister charm, a harbinger of the movie star he'd become. Yet no one seemed overly impressed; Mordaunt Hall didn't even mention him. Then came a small part in *Women of All Nations*, reuniting him with Victor McLaglen, playing

the last-billed part of Stone. But upon (or soon after) the film's release in spring 1931, all of Humphrey's scenes were deleted; existing prints today do not include him. His part was apparently seen as superfluous by the front office, a rather telling perspective on his early film career.

Despite all that, he soldiered on, obligingly making the publicity rounds. The studio assigned him to *A Holy Terror*, a murder mystery wrapped in a western cowboy melodrama. Humphrey felt completely inadequate. "I was too short to be a cowboy, so they gave me elevator shoes and padded out my shoulders," he remembered. "I walked around as though I was on stilts and felt like a dummy." One of several villains in the picture, he did a better job than he gave himself credit for. He was intense and menacing and handled horses expertly. But no one seemed to notice. Not long after finishing *A Holy Terror*, his contract was canceled. There was nothing left to do but head back east and follow Mary to Maine. After such a bruising experience, Humphrey may have indeed been content to settle down by the lake. But one has to wonder for how long that would have satisfied him.

After the Lakewood season, the Bogarts returned to New York. Things continued to look bleak. No offers were forthcoming. Heading toward his thirty-second birthday, with the Great Depression worsening, Humphrey was understandably anxious. Making it worse, at least from an ego perspective, Mary had gone on tour with *The House Beautiful* along with James Bell, with whom they'd played all summer at Lakewood. Humphrey faced the real possibility that his wife would be the sole breadwinner, and that, of course, would never do.

He had limited options. Given the economic downturn, there were simply fewer shows being produced. Since 1929, Broadway had seen a 19 percent decrease in productions, and by 1932 that would drop further, to 26 percent. Humphrey had saved little from his time in Hollywood. There was every reason to fear that he would have to return to auditions and casting calls or find other work to support himself.

Late that fall, he was saved, at least for the moment, by a call from Dwight Deere Wiman, a partner of Bill Brady, Jr., who was producing John Van Druten's newest play, *After All*, a story about adult children coming to appreciate their parents—hardly material Humphrey had any experience with. Forgoing previews, Wiman believed that Van Druten's name would guarantee success. *After All* opened on December 3. The reviews were withering. Brooks Atkinson thought that the play took "an

unconscionable time to prove a truth that is obvious." And although he observed that the actors were "better than [Van Druten's] characters," he failed to mention Humphrey, who played the rather bland Duff Wilson, the lover of the family daughter. The show barely made it through two weeks. Good thing Mary was still getting a paycheck on the *House Beautiful* tour, which took her across the Midwest.

But then, just in time for Christmas, Hollywood wanted him back. That was likely the work of his new agent, Mary Baker, who was a neighbor of his, along with her husband, Melville. Columbia Pictures was looking for a last-minute replacement for Donald Cook, who had been set to play the male lead opposite Dorothy Mackaill in *Love Affair*. "Following telegraphic negotiations," as one columnist put it, "Humphrey Bogart was persuaded to board a plane and rush to Hollywood."

It's doubtful that he needed much persuasion. On December 22, he flew out of New York, arriving the next day in California. Upon his arrival at the studio, he was given "a royal welcome," which must have felt pretty darn good after his ignoble departure. Columbia was grateful to him for coming so quickly, as the studio wanted to complete its current schedule just after the first of the year. "None of the companies are anxious to have an over-production for 1932," a reporter observed. "That, in the opinion of all, is because of the Depression."

For the moment, Humphrey's financial fears were abated, but his contract was for just six months. He had until the spring to convince the studio to renew it. *Love Affair*, thankfully, seemed to be just the ticket. Second billed and with plenty of screen time. Bogart plays a working-class aviator who teaches rich girl Mackaill to fly; they fall in love, but he balks at marrying above his class. Eventually they end up together after Humphrey flies to the rescue of his ladylove in a thrilling (or so the studio hoped) finale. *Love Affair* was shot in about five weeks, after which he was put back onto the publicity treadmill.

This time, he was being built up as an athletic, manly hero with an eye to making him a star. A fan magazine disclosed that he and Kenneth MacKenna were regular squash players at the Hollywood Athletic Club, where they were considered "champeens." Another fan publication gushed over his "broad shoulders and tapered torso," which was likely the first and last time Humphrey was praised for his physique. A wire report went out claiming that Dorothy Mackaill had nearly swooned when she had met him, thinking he was the "perfect image of a stalwart leading

man." Columbia seemed to be taking its lead from an earlier bit of press coverage when Humphrey had been compared to John Wayne, Joel Mc-Crea, and Richard Cromwell, other emerging he-man stars. "The increasing prominence of these four gentlemen is one of the healthiest movie signs," the story had gone. "Their importance signifies the death of the screen sheik. The Latin type, who plastered his hair mercilessly and looked killingly at helpless females, seems finished. There is a demand for the silent, strong-man characterization." The irony of this, obviously, was that Bogart had gained his first acclaim by playing a Latin lover.

While he waited for the film's release, Humphrey stirred up a bit of publicity that was clearly not orchestrated by the studio. His name was linked with Ethel Kenyon, an actress in western pictures. Though a romance with a pretty young thing was usually an ideal hype for an actor aiming for leading-man status, there was a big problem: Humphrey was married. Studio execs, and the church ladies and reformers they feared, weren't likely to countenance the sort of open marriage Bogart had with Philips. Walter Winchell, the doyen of New York gossip columnists, was the first to report the news, telling his readers that Bogart and Kenyon were "Cupiding." He also made a point of referring to Kenyon as a "divorcee." Another report described the couple as "always together and lovey-dovey."

Hollywood in 1932 was facing increasing calls for censorship and the "cleaning up" of the movie colony's morals. If the studios wouldn't enforce the Production Code, reformers argued, maybe the government should step in to do so. Federal control was something all movie moguls dreaded. They'd spent two decades amassing fortunes and did not want to lose them. So reports of married actors taking up with divorcees were taken very seriously.

Columbia appears to have squelched the rumors, as there were no further reports of a dalliance with Kenyon. Yet curiously, around the same time that Winchell broke the story, Humphrey was admitted to the hospital. The official explanation was that he "got up too soon after a bad attack of the flu," which necessitated his being taken to Hollywood Hospital, where he would remain "until he is entirely well." Though the report may well have been true, "the flu," similar to appendicitis and exhaustion, was a common explanation to cover up other sorts of situations. His old pal Ruth Rankin later revealed the truth: the studio's new leading man had been throwing his fists around at a nightclub and ended up

hospitalized. "There he was, bandages and all," Rankin said, describing her visit to the hospital. "It seemed like old times." Humphrey quipped that she ought to see the other fellow. On top of the adulterous stories about Kenyon that were swirling about, studio execs may have started to wonder if Bogart was more trouble than he was worth.

There was also his disappointing turn in *Love Affair*. Very little of the film's prerelease publicity mentioned Humphrey, as was usually the case when building up a new star. The studio's dissatisfaction with his performance may also be inferred by the fact that for his follow-up picture, he was loaned out to Warner Bros. to make *Big City Blues* for the director Mervyn LeRoy. The part was tenth billed, and Bogart reverted to type as a big-city swell. So much for his promotion as the strongman hero.

Once *Love Affair* was released in early April 1932, the handwriting on the wall was clear: Bogart's film career was doomed. The film was barely reviewed. And when *Big City Blues* was finally released in the fall, reviewers completely ignored Humphrey.

Bogart's second attempt at a movie career had gone as badly as the first. His contract at Columbia was not renewed. "I like Harry Cohn," Humphrey would say of the Columbia chief. "He was honest enough to tell me I was so terrible he had no further use of me." Bogart faced a real dilemma: Hollywood clearly didn't know what to do with him, and Broadway seemed largely to have forgotten him since the days of *Saturday's Children* and *It's a Wise Child*. Even the Bradys had nothing for him. So rather than head back east, he accepted an offer from the Belasco organization to appear in its stage production of *The Mad Hopes*, starring Billie Burke, at its eponymous theater at Hill and Eleventh Streets in downtown Los Angeles.

In the play, Burke played her usual featherbrained society woman and Bogart the young man "who arrives for a visit and stays to put the financial tangle of the Hope household in order." When the show opened on May 23 in front of "the smart set of Hollywood," critics gushed over Burke's performance. They also liked the supporting cast, which included, beside Bogart, Rex O'Malley and Peg Entwistle (who a few months later would achieve tragic infamy by jumping from the HOLLY-WOODLAND sign to her death). The *Hollywood Citizen-News* thought that Humphrey "stood out" from the other supporting players, but Edwin Schallert, the chief critic for the *Los Angeles Times*, was more measured in his praise. "Humphrey Bogart was competent in most respects," he

wrote, but there was "latitude for making more of a portrayal." The show closed on June 4. The playwright, Romney Brent, had dreams of Broadway. Some members of the Los Angeles cast, such as Rex O'Malley, were asked to stay on. Humphrey, however, was not rehired.

While her husband was appearing in *The Mad Hopes*, Mary Philips joined him at the home that was supposedly both of theirs. She'd been cast by First National for a small part in the upcoming Loretta Young picture *Life Begins*, a drama set in a maternity ward. Her part was so small that she wasn't even credited in the final picture. But just as Humphrey was wrapping up the play, she was cast in a more substantial part in Paramount Pictures' adaptation of Ernest Hemingway's *A Farewell to Arms*, directed by Frank Borzage. It was a top-of-the-line picture from one of Hollywood's most powerful studios, far more prestigious than anything Humphrey had done on-screen so far.

But screenland threw him one more chance. Not long after *The Mad Hopes'* closing, Mervyn LeRoy, his director on *Big City Blues*, contacted him about doing a Warner Bros. melodrama called *Three on a Match*. The role was no strong, silent hero, but neither was it a city slicker or a "weak-willed youth." Instead, Humphrey would play a gangster. He jumped at the opportunity.

Humphrey had played villains before. There'd been all those cads on the stage, the wealthy conniver in *A Devil with Women*, the swindler in *The Bad Sister*, and the crooked cowboy in *A Holy Terror*. But those characterizations had largely been situationally villainous. The part in *Three on a Match* was something new entirely, an amoral thug who provided the muscle for a gang of racketeers. Humphrey had at least been charming in *The Bad Sister*; in the new film, audiences would look in vain to discern anything redeemable about him.

Bogart doesn't appear until nearly halfway through the picture, but he makes a vivid impression the first time we see him. As Harve, he's called "the Mug"; he's the mob boss's tuxedoed henchman, the most dapper of the bunch. He's utterly ruthless toward anyone who gets in his way, and that includes a little boy, whom Harve decides needs to be killed. He also terrorizes the boy's mother, played by Ann Dvorak. His dialogue is sardonic and heartless throughout. Made before the Production Code was enforced, *Three on a Match* does not shy away from violence, sex, and drug use. At one point, Bogart makes fun of Dvorak's cocaine addiction by rubbing his nose. Loathsome and terrifying he is, yet we can't take our

eyes off him. He's the personification of evil. *Three on a Match* reunited Humphrey with Joan Blondell, with whom he'd made his second movie short, *Broadway's Like That*, and Bette Davis from *The Bad Sister*.

A *Farewell to Arms* was released not long after Bogart finished *Three on a Match*. He attended the premiere with Mary, who'd played Helen "Fergie" Ferguson, the jaded confidante of the star, Helen Hayes. The part was small but telling, and the columnists promoted Mary Philips as an up-and-coming star, much as they had done for Humphrey not so long before. But now he was wise to Hollywood's ways. He knew that as the Depression intensified and bottom lines were all that mattered, studios would be disinclined to take chances; if a player didn't score after a couple of pictures, he or she was let go. Now almost thirty-three, Humphrey had concluded that he would never be a movie star. Not even waiting for *Three on a Match* to be released, he made his way back to New York, his head held low. On September 3, Bogart flew east, convinced that he'd never return to Tinseltown.

When reviews for *Three on a Match* came out a month later, it's unknown if Humphrey even took the time to read them. But others did. The *Hollywood Filmograph* called him "impressively sinister," and the *Brooklyn Daily Eagle* judged him as "impressive in a brief role." Humphrey's portrayal of Harve was also noticed by the producer Arthur Hopkins, who a few short years down the road would have cause to remember just how good Bogart was at playing bad.

Manhattan, Monday, November 26, 1934

At the height of the Depression, many of the theaters along Broadway slumbered in darkness, their marquees bare, their lights turned off. But this day, in one of those deserted, forlorn structures, a group of actors was defying the gloom and doom, assembling for the first day of rehearsals for a new play. Written by the noted playwright Robert E. Sherwood, the play was about the death of dreams and the thin line between good and evil. Its cast was eclectic, from Charles Dow Clark, whose career on Broadway stretched back to 1902, to the silent film star Blanche Sweet to the up-and-coming ingenue Peggy Conklin. The star of the show was Leslie Howard, one of the biggest names of both stage and screen. Howard, however, wasn't present that first day of rehearsals; he was in the middle of the Atlantic, sailing from England to New York on board the SS *Europa*. But standing on the bare stage, script in hand, was one other key member of the cast: Humphrey Bogart, now on the cusp of thirty-five.

Bogart had been signed only a few weeks earlier. The producer, Gilbert Miller, had worked with him on *The Skyrocket*, and Sherwood was Humphrey's occasional drinking buddy. But it was Gilbert's coproducer, Arthur Hopkins, who had ultimately given Bogart the nod. Sherwood had recommended Humphrey for the small part of Boze Hertzlinger, the former football player turned diner cook who tries to woo Conklin. But Hopkins, upon consideration, had another idea for Bogart, namely the much larger part of Duke Mantee, a desperate, unrepentant gangster on the run. Hopkins had seen Humphrey play hard and ruthless onstage and on-screen, particularly in *Three on a Match* and the more recent *Midnight*. "He thought of more than Bogart's masculinity," wrote the critic John Mason Brown. "He thought of his driven power, his anguished dark eyes, the puffs of pain beneath them, and the dangerous despair which lined his face." And so Hopkins cast Humphrey Bogart in *The Petrified Forest* because he wore his pain and despair plainly on his face.

In the two years since his ignominious return from Hollywood, Bogart had lived with little else than pain and despair, blotted out regularly for a few hours or days by a bottle of bootleg gin. It was his "lean and hungry period," as he'd later describe it. "I thought I'd gone as far as I could go," he'd remember, "and figured I'd just eke out a living on the stage, playing character parts for the rest of my career." Stardom, after all, rarely came to anyone after thirty-five. Once acting had brought him joy and hopes for success and allowed him to dream big about the future, but now that was gone. Acting had become a way to pay the bills. He had no reason to think this play was going to do any more for him than any of the others over the past couple of years, except, hopefully, to run long enough for him to pay his back rent and catch up on his bar tab at Tony's.

He and Mary had found a place at 434 East 52nd Street, near the river. It wasn't a very glamorous apartment, but the neighborhood was fashionable, which allowed them to keep up appearances. Both of their careers had stalled. In his first months back in New York, Humphrey had bombed out repeatedly. *I Loved You Wednesday* had opened in October 1932, but Bogart had been unhappy in the part, and the critics once again had largely overlooked him. Besides, the play had premiered just as banks across the United States had been closing. On opening night, "there were ten people in the house," Bogart later recalled. He'd left the show after a few weeks to join the cast of *Chrysalis*, produced by the prestigious Theatre Guild. For seemingly the three thousandth time, he had been cast as the cad. The show closed after a couple of weeks. After that, it had been a long, bleak, penurious winter.

Things weren't much better for Philips. *A Farewell to Arms* had come out in December 1932 to great reviews but had not led to anything else for Mary, whose part had been cut down to just a few minutes of screen time. She had been onstage in *Black Sheep*, a show that had opened and closed the same month, and had then gone missing from Broadway for several months.

To make ends meet, Humphrey had picked up some money as the house chess player at a local arcade. He loved the game, in part because his father had taught it to him. (Years later, at his suggestion, *Casablanca* would open with him playing chess.) Later on, the legend would declare that Bogart had played chess in the arcade only for fun, but in those destitute years, he would have been only too glad to take the cash if offered to him. There were days, his friend the author Louis Bromfield recalled,

"when sometimes he didn't know where his next meal was coming from." Stories abound, most of them likely with some basis in fact, of Bogart and Philips pooling their money with neighbors to attend shows or even to buy groceries. The bromide of *The Skyrocket*, in which their characters had learned that it was better to be struggling than to be rich, now rang pretty hollow.

Bar tabs were racked up, with owners finally having to cut him off. Bogart's membership in the old boys' club was threatened. At some point, he penned a letter to the Players Club asking for its indulgence in the matter of his unpaid dues. "I have not been paying other bills and neglecting my club," reads the missive still preserved in the Players Club archives. "The simple truth is that I have not been paying any bill as I have, temporarily, no money. So, if you will be gentle with me, I'll appreciate it." He promised "to make at least a partial payment" as soon as possible. The club appears to indeed have been gentle; Bogart's membership would run unbroken throughout the 1930s.

He still had friends in high places who continued to look out for him, people such as Robert Sherwood, John Cromwell, and, of course, all of the Bradys. By early 1933, there were also Lawrence Langner and Theresa Helburn, two of the cofounders of the Theatre Guild. Helburn had been friendly with Belmont and Maud during their better days, which had likely helped Humphrey's being cast in *Chrysalis*. Now the Guild was looking for another project and hoped to cast him. The upper classes tended to look out for their own.

But no matter how often Bogart's powerful friends bailed him out or intervened on his behalf, they couldn't reverse the downward trend on Broadway or fill the theaters back to their pre-Depression numbers. In early March 1933, Humphrey opened in the comedy *Our Wife* at the Booth Theatre. The show closed after a few days. Philips, meanwhile, did a little better that spring in swelling the family finances, being cast in *Both Your Houses*, which ran for about a month and a half. In May, Helburn and Langner came through with a part for Bogart in the Theatre Guild production of *The Mask and the Face*, written by Somerset Maugham, which reunited him with Shirley Booth. Yet despite its prestige, *The Mask and the Face* closed one month later.

That summer, Bogart and Philips went their separate ways in summer repertory. Humphrey appeared in *Tourists Accommodated* at the Cape Playhouse in Dennis, Massachusetts, halfway up Cape Cod, while

Mary joined the Berkshire Players at the Stockbridge Theatre. For *Love Flies in the Window*, she played opposite Katharine Alexander, otherwise known as Mrs. Bill Brady, Jr., and in August, both of their husbands came to see the show. Humphrey, and possibly Brady, showed up three sheets to the wind. During his visit, "he was drunk a good deal of the time," recalled Edith Oliver, later a drama critic at the *New Yorker* and at the time an aspiring actress of twenty. Yet Oliver insisted that Bogart had always been charming "and entertained the company with hilarious stories about Hollywood." Nathaniel Benchley, to whom Oliver told the story, made sure to stress that point, declaring that "nobody from the period" remembered Bogart "as anything but a gentleman."

That's difficult to believe, given the number of fights Humphrey got into. He was indeed charming, even when drunk, but there was a belligerence, too, causing a sense among some people, including, perhaps, his wife, that his drinking was getting out of hand. Oliver recalled what appears to have been exasperation on the part of Philips, who, after witnessing her husband's behavior, made an offhand comment about finally agreeing with Carrie Nation, the temperance activist who'd attacked saloons with a hatchet around the turn of the century.

Bogart's marriage to Philips had now endured for five years. He appears to have remained in love with her even as the marriage declined. Philips's assertion of polyamory and her disinclination to stay by his side in Hollywood had hurt, but he returned to her time and again, and except for Ethel Kenyon, there had never been any reports about dalliances with other women. When he was in love, wrote Louise Brooks, he waited for the object of his affection "the way the flame waits for the moth." Despite everything, he believed that Mary would be by his side for life.

It helped, of course, that Mary remained his partner in crime. Despite her comment about Carrie Nation, she remained happy to toss back shots with her husband at nightclubs and speakeasies. Both of them tended to sober up when they were working, but there were now many weeks or months between jobs, with Humphrey playing chess with strangers in arcades. No doubt more than a few of them smelled alcohol on his breath. His friend and agent, Mary Baker, said he was "worried about money for the first time in his life." Bogart had witnessed his parents' fortune disappear; now all of the money he'd earned during the heyday of his Broadway career, as well as the rush of income that had come during his brief stopovers in Hollywood, had likewise evaporated. "He kept beating

on producers' doors with all the other out-of-work actors," Baker said, trying his best not to give in to his fear that "his acting career was finished."

If Humphrey thought he had hit rock bottom, however, he had no idea of how bad things were about to get.

THE POSTER PROPPED OUTSIDE THE ROXY THEATRE ON WEST 50TH STREET between Sixth and Seventh Avenues in early March 1934 bannered the names of some familiar movie players: Sidney Fox, O. P. Heggie, Henry Hull. In smaller type, further down, was another name, one not so familiar to moviegoers but recognizable to certain Broadway aficionados: Humphrey Bogart. The film was *Midnight*, and it marked Bogart's return to the silver screen after an absence of more than a year. It's unlikely, however, that Humphrey put much stock in it.

Midnight had been a very different sort of filmmaking experience. The previous November, Helburn and Langner of the Theatre Guild had secured Bogart's services for a screen adaptation of *Midnight*, their successful 1930 play. The Guild occasionally collaborated on film productions; this time its studio partner was Universal. The picture was shot at the old Edison Studios in the Bronx at Decatur Avenue and Oliver Place, a facility that dated back to 1908. Once again Humphrey was playing opposite Sidney Fox, who'd previously been at his mercy in *The Bad Sister*. This time, however, he got his comeuppance from Fox: she plugs him and gets charged with murder.

During production of the film, the news arrived that the final three states had voted for passage of the Twenty-first Amendment, which ended fourteen years of Prohibition. Humphrey, naturally, was jubilant. He and Philips went out on the town to celebrate with Mary Baker and her husband, Melville, all of them dressed to the nines—"A white thigh and tails evening," as they'd describe it. Promenading down Lexington Avenue, heading to the Waldorf for dinner and more cocktails, spending money they didn't have, the foursome evoked Maud and Belmont whisking off to Delmonico's and "all the fashionable places" in their "great state," as their son described it, before their world crumbled. The quartet ended up at Tony's, their usual haunt, to keep the party going well into the morning.

But the celebration was hollow. There was little cause to celebrate. *Midnight* was released in March. There is no record of any premiere gala. Whether Humphrey ever footed it over to the Roxy to see it is unknown.

Burns Mantle gave it a rave review but failed to mention Bogart. Most other reviewers did the same. *Midnight* was a prestige picture, based on a play and paced like a play; it was not the sort of rapid-fire melodrama the Hollywood studios put out. It did well enough in New York but died in the hinterlands, usually playing as the second feature of a double bill. No one had really expected it to be a smash, and it wasn't.

But Humphrey was good in it: tough, sneaky, not entirely unsympathetic. The producer Arthur Hopkins caught the film and, remembering the similar *Three on a Match*, offered him a part in his new play *Invitation to a Murder*. In this rather clichéd mystery replete with trapdoors, sudden disappearances, and a faked death, Humphrey played one of several murder suspects. Like so many before, the play lasted only about a month.

Bogart's plan had been to join Philips at Lakewood in Maine for the summer, although no record exists of him appearing in any of the productions that season, despite having been announced as part of the company in May. Instead, he went solo, trekking to Cohasset, Massachusetts, and appearing in *The Shining Hour* in July. His costar was Edith Barrett, with whom he'd previously appeared at Lakewood; she may have gotten him the part. In August, toward the end of the season, Mary joined her husband, and together they starred in *Minick*, by Edna Ferber and George S. Kaufman, and *Mary Tudor*, by Victor Hugo. Philips played the queen and Bogart her "rascally" (and fictional) lover, Fabiani, who ends up without his head.

On the night of *Mary Tudor*'s closing, Humphrey, Mary, and a few other actors, including the young Broderick Crawford, drove to nearby Hingham to celebrate. Cohasset was rather sleepy; Hingham was the closest thing to civilization for this group of New Yorkers. Still, downtown Hingham was just a square bounded by a few shops and restaurants, a park, and a church. After the eatery they'd descended on closed for the night, the actors tumbled out into the square to continue their merrymaking well into the early hours of the morning. Officer Oscar Beck fielded calls from several citizens whose sleep was being disturbed by the noise from the square. A little before 4:00 a.m., Beck, a rookie in his midtwenties, approached the group and asked them to quiet down. He was met with catcalls and insults. Humphrey appears to have led the revolt, rushing at Beck before more officers showed up. Mary was right behind her husband, and when Beck pointed his finger at her, she bit it, evidently still thinking she was Mary Tudor.

Arrests came swiftly: Mary for disturbance and unruly conduct, Humphrey for breach of peace and public intoxication. When Broderick Crawford put up a fight after the handcuffs were brought out, he was arrested, too, and charged with breach of the peace. All three were hauled down to the station, where they were booked and released, likely through the intercession of the South Shore Players.

That incident, despite being written up in the *Boston Globe*, would be erased from the Bogart legend. Benchley didn't mention it; neither did the army of fan magazine writers who were charged in the late 1930s and '40s with making him a star. Hyams did acknowledge the altercation, though he treated it all rather lightheartedly, presenting Mary's bite as boisterous rather than criminal, and he made no mention of the charges brought against Humphrey. But they were serious offenses. On August 29, 1934, Judge Daniel A. Shea of the Second District Court fined Bogart $50, gave Crawford a fifteen-day suspended sentence, and kept Philips's offense on file. Their actions went beyond just youthful hijinks. Crawford might have been only twenty-three, but Bogart and Philips were now in their midthirties; Humphrey would turn thirty-five in just a few months. His alcoholism was spiraling out of control.

Things only got worse when he returned to New York. Bill Brady, Jr., secured him a small part in a show he was promoting, *Good-bye Please*, produced and staged by Edward Mendelsohn, mostly as a way for his old friend to pay his bills. But just before rehearsals began, Humphrey got word that his father was very sick. He rarely visited his parents; time spent with them was never rewarding. But he made his way to his father's bedside. Belmont was pale, drawn, and largely uncommunicative. He may have suffered a slight heart attack or stroke due to his seriously high blood pressure. What was only suspected then but has since been documented is that opioid abuse, such as Belmont's decades-long morphine addiction, can significantly exacerbate cardiovascular problems. So can alcoholism, with which Belmont also struggled. It's tempting to wonder if, looking down at the shell of the man who'd been his father, Humphrey saw himself, if he had any glimmer of awareness that he was repeating his father's mistakes. At that point in his life, it was unlikely. He'd hardened himself against his parents. They were very different creatures. There could be no comparisons.

Belmont was taken to the Hospital for the Ruptured and Crippled at 42nd Street and Lexington Avenue. Humphrey was now overcome with

emotion. "It was only in that moment," he told Joe Hyams, "that I realized how much I really loved him and needed him and had never told him." Happier memories must have flooded back to him: sailing on the lake, hiking through the woods, learning that his father had said, "The boy's good," after seeing him for the first time onstage. On the morning of September 8, it was clear that Belmont had only a little time left. "I love you, Father," Humphrey managed to say. Belmont heard him, he believed, because he thought he saw a smile. Then, as Humphrey told it, his father breathed his last.

Humphrey would never forget his mother's reaction when he took her the news. "She doubled up momentarily as if she had had the wind knocked out of her," he recalled, after which she quickly straightened up and declared, "Well, that's done." Her son had never understood her; and never was that truer than at that moment. "I have never been able to figure," he said, "if she meant that everything was a step forward or whether she felt that a chapter in her life was finished." Belmont was cremated at the Fresh Pond Crematory and his ashes placed in its columbarium, adjacent to the Mount Olivet Cemetery in Queens.

Humphrey's father's death came barely a week after his arrest and court fine. He knew that his role in *Good-bye Please* had been bestowed on him out of pity. It was meager, of no consequence, the sort of part taken by actors either on their way up or down. What was more, Humphrey was now saddled with paying his father's $10,000 worth of debts; his mother and sisters could not help him. His wife was out of work; the financial pressures were overwhelming. Mary Baker described him as "desperate." Although he was bumped up in the cast of *Good-bye Please*, replacing William Harrigan, he eventually dropped out of the play entirely or was fired. "I thought my career was over," he remembered. "I thought I'd never have any money again." Robert Sherwood believed that he might actually have been suicidal at this point. Whether he was or not, Bogart was in a very bad place. This would be the nadir of his career.

It was in such a context that Sherwood put his name forward for a small part in *The Petrified Forest* and Arthur Hopkins, observing Bogart's ragged face and recalling his coiled performances, saw something more in him. Long gone were the delicate features and soft eyes. Instead, when Hopkins looked at him, he saw a man who was guarded, wary, calculating, and terrified. That wasn't what the young Bogart had been, the one who'd sashayed onto the stage in tennis shorts or made the girls

in the balcony swoon. This was an entirely new incarnation, a bundle of bitterness and self-defense.

Humphrey had long been hot tempered and quick to lash out, but he'd also been charming and funny. Enough of that charm remained now to temper his hotheadedness, just as had been the case with John Dillinger, on whom Duke Mantee had been based. Before being machine-gunned to death by federal agents in Chicago less than three months before rehearsals for *The Petrified Forest* began, Dillinger had led a national crime spree with bravado and bluster, winning the hearts of down-trodden Americans. But he was also a ticking time bomb. When backed into a corner, he shot to kill in cold blood. That was the sort of man Bogart was assigned to play. His earlier villains had been milquetoasts compared to Mantee. But Humphrey was different now. He understood desperation and what it drove men to do.

ON NOVEMBER 27, FRESH OFF THE BOAT FROM ENGLAND, LESLIE HOWARD SHOOK hands with the cast and crew of *The Petrified Forest*, offering wishes for a successful collaboration. Howard was handsome, elegant, dapper, and dignified. His posh accent seemed to accentuate all his best qualities. He was forty-one years old and had been a star on both sides of the Atlantic for nearly a decade in films such as *A Free Soul* and *Of Human Bondage*. He typically played well-behaved men full of conscience and character. When it came time to shake hands with Bogart, Howard could have been staring at his exact foil. Every element of the one man was the polar opposite of the other. Perhaps that was the reason why they liked each other immediately.

Sherwood's script was bare bones and simple: A disillusioned drifter on an aimless journey across the desert arrives at a roadside diner at the edge of the Petrified Forest. There he meets the proprietor's daughter, a starry-eyed young woman who dreams of moving to France to find her long-lost mother and become an artist. She shows the drifter her paintings and reads him poetry. But a black-hearted gangster fleeing the police shows up with his gang and takes everyone in the diner hostage. The drifter engages the gangster in conversation, toasting him as "the last great apostle of rugged individualism." The two share a sort of epiphany about life and their places in it, each of them trapped by fate and unable to do anything about it. Something close to respect and understanding

passes between the two men. As police draw closer, the gangster decides to flee. The drifter gets an inspiration: he takes out his life insurance policy from his bag and amends it right there, making the proprietor's daughter his beneficiary. His life has come to a close, he realizes. There is nothing more for him. The money will enable the young woman to live her dreams. The drifter asks the gangster to kill him before he goes, saying "It couldn't make any difference to you . . . they can hang you only once." The gangster, understanding, fulfills his request. The chemistry and rapport between Bogart and Howard made the outrageous situation believable and sincere.

Had Bogart played the smaller part of Boze, as Sherwood had first suggested, his character would have had to exhibit courage, selflessness, and noble purpose: at one point, Boze takes a shot at Duke Mantee in order to free the hostages. But those weren't the qualities Humphrey was called on to display. He was the mysterious, unfathomable outsider. He needed to project amorality, malevolence, and danger but with a measure of humanity and humor. Bogart embodied all of those characteristics to some degree and found it easy to slip into the character. "I just started thinking like Duke Mantee," he would later explain.

After three weeks of rehearsals, *The Petrified Forest* opened for try-outs in Hartford, followed by two weeks in Boston. Burns Mantle caught the show during those previews and let his New York readers know that something special was on its way. Howard's "baiting of the gangster and the patience of the gangster in listening," he wrote, "would, with a less finished approach, seem so much hokum drama." Mantle seemed surprised that Bogart, "of all people," could give such "splendid support as the gangster," recalling, no doubt, his series of playboy lovers.

But Bogart had thrown off all he'd learned about acting over the past decade. Louise Brooks thought that once Humphrey had grasped the idea that he, like Cagney, Tracy, and others, might achieve success with a more naturalistic style of acting, "he went about contriving it with the cunning of a lover." Critically, he also understood that the most effective naturalistic acting required, as Brooks put it, some "eccentricities and mystery," which would allow the audience to both admire and puzzle over the character. Bogart, quite shrewdly, restructured the way he practiced his craft.

Variety reported that *The Petrified Forest* broke records in Boston, hauling in "an excellent $14,000" in its first week. Boston, the trade paper

noted, "gasped at the blunt profanity," which was "unprecedented" there, "but hardly a novelty on Broadway." The second week in Boston brought in $20,300, "the best in town." But the play's fate would be decided when it opened at the Broadhurst Theatre on West 44th Street on January 7, 1935.

For Bogart, "that opening night meant everything," remembered Louis Bromfield, who was in the first-night audience. "Not only was he down to his last nickel, but he was so discouraged that if the play flopped and he made no impression, he was ready to give up acting forever." That might be a bit of an exaggeration, but Bogart no doubt felt the pressure. "He was putting everything into this chance of showing that he was the excellent actor he knew he was."

As it turned out, he was successful in the effort. Brooks Atkinson called *The Petrified Forest* "a roaring Western melodrama with a few artful decorations of thought, sentiment and humor," adding, "Humphrey Bogart does the best work of his career." It was Howard's show, and he dominated the reviews, but critics and theatergoers were fascinated by Bogart's naturalistic portrayal of Duke Mantee. *Variety* even ran a bit on "Bogart's Beard," assuring readers that it wasn't stage makeup but a four-day growth of whiskers, which he maintained "by using a Number 3 barber clipper." Bromfield recalled that in the advance of the show's first previews, Bogart had "sacrificed his good looks by cropping his hair so short that his head appeared to be shaved." For an actor whose diminishing youthful looks had once augured a career crisis, it was a bold move, demonstrating Bogart's determination to up his acting game.

Thanks in large part to Humphrey, *The Petrified Forest* was a gigantic hit. In its first week on Broadway, the show earned $22,000; by the end of its second week, it had become "that rare phenomenon," one scribe wrote, "a genuine smash hit . . . the biggest dramatic success in several years." To cash-strapped producers and managers, not to mention actors, it was a gift from Heaven. Humphrey hadn't been in a smash since *It's a Wise Child*, and he'd hardly been noticed in that one. None of his previous stage successes had enjoyed the massive critical acclaim that *The Petrified Forest* was getting, and much of it, for the first time, was directed at Bogart. "There is something authoritative about Duke Mantee, the killer, as played by Humphrey Bogart," *Variety* noted, "who sits with his back half-turned to the audience most of the time, a sub-machine gun in his lap." With only the right side of his face visible for the much of the

proceedings, Bogart managed to leave an indelible impression on theater-goers. It was that dangerous authority that would define his new persona, that would eventually yield the Humphrey Bogart of modern legend.

He didn't yet know that it would work out that way. All he knew was that he was in a hit, that he could pay his bills and his father's debts, and that maybe the show could help him get regular parts as gangsters in other shows. But as it turned out, *The Petrified Forest* changed everything. There had never been any guarantee that Humphrey Bogart would become a star; in fact, the likelihood, given his appearance, his drinking, and his temper, was low. Bogart was as unlikely a star as they came, especially now, in the second half of his thirties. Had he not been cast in *The Petrified Forest,* how easy it might have been for him to sink even deeper into despair, lost in his grief and regret. How easy it might have been for the name "Humphrey Bogart" to become obscure, that of some secondary stage actor from the 1920s and 1930s, forgotten by all but the most avid theater buffs. But that was not what happened.

The Petrified Forest made Humphrey a different man, one who glimpsed his own potential. He was no longer haphazardly bouncing from job to job. He was no longer clueless about how to proceed. He was no longer even Humphrey, even if that would be the name lit up in lights for the next twenty-three years. Only a few friends from the old days still called him "Humphrey." He'd become Bogie, what his father had sometimes been called. "Bogie" was rougher, less refined, more seasoned, more lawless—like Duke Mantee and the actor who played him. And if the name evoked a bit of the Bogeyman, that wasn't so bad.

But the battle was yet to be won. Bogie still had not exorcised the feelings of inadequacy and lack of worth that he'd been dragging along since childhood. He would regret that his father hadn't lived to see him make a success of himself, dying on the eve of his big breakthrough, and that regret would weigh on him. The drinking would escalate, even in the glow of success. The self-sabotage did not completely abate. Louise Brooks, his old pal from pre-Prohibition days, still saw Bogie at the clubs drinking himself to oblivion. One night, well into the run of *The Petrified Forest,* she spotted him at Tony's in a booth with Thomas Mitchell, another heavy-drinking actor. When Mitchell left, Humphrey remained on his own, "drinking steadily, with weary determination," Brooks said. His head drooped to his chest and finally to the table. "Poor Humphrey," she said to Tony. "He's finally licked."

PART II

BOGIE

1935–1943

9

everly Hills, California, Monday, January 6, 1936

At their theater on Wilshire Boulevard, the assembled brass of Warner Bros. welcomed their guests to an exclusive preview of their upcoming production of *The Petrified Forest*. Considerable buzz surrounded the film, and studio chief Jack Warner was feeling upbeat. He'd initially been concerned over the sad ending of the Broadway play, because Hollywood preferred happy fade-outs, so he'd asked the director, Archie Mayo, to shoot two endings to be shown to a few trusted observers. "The reaction of the chosen few to the sad ending was so satisfactory," wrote one journalist, "the other was discarded without a showing." That night in Beverly Hills, the audience saw the gangster kill the drifter, just as he'd done onstage nearly two hundred times.

The preview was a hot ticket in screenland. "The colony literally stormed the gates" to see the picture, the *Los Angeles Times* reported. Leslie Howard was there with his eleven-year-old daughter, although they made "a quick getaway" as soon as the lights came up. But the actor who'd played the gangster stuck around afterward to shake a few hands. Still heady that he'd been cast in the film at all, Bogie had attended with the actress Josephine Hutchinson and her husband, James Townsend, feeling, perhaps, a bit like a fifth wheel. But his wife wasn't around to accompany him. Mary had returned to New York after a brief Christmas visit to begin rehearsals for a new play called *The Postman Always Rings Twice*.

If Bogie was feeling at all awkward that night in Beverly Hills, the situation changed the moment people began congratulating him on his performance. Big Hollywood stars such as Kay Francis, Paul Muni, and Joe E. Brown laid on the accolades. The critic from the *Los Angeles Citizen-News* rushed back to the newsroom to type up his review for the next day, praising "the striking performance" of newcomer Humphrey Bogart. Of course, Bogie wasn't exactly a newcomer, but it was the first time that most of Hollywood had heard of him.

Every indication was that Bogart's third try at the movies would be the charm. But so much could still go wrong. Even the fact that he stood shaking hands at the Warner Beverly was a small miracle, given how long it had taken for the studio to hire him; they'd only agreed after Leslie Howard had insisted. Bogie couldn't get past the feeling of being second choice, tapping as it did his lifelong sense of inadequacy. "You worry they maybe would've preferred someone else," he said. He had no trust in the men in the front offices. He knew how routine it was to build up an actor one day, then boot him out the door the next. Bogie would still have to prove his worth to the moneymen.

His original contract, dated October 2, 1935, had been the standard freelance boilerplate for one picture, $750 per week and "round-trip railroad transportation from New York plus a lower berth." Once the film was shot, Warner Bros. had signed him to a conditional twenty-six-week contract at $550 a week. Although plans were immediately made to pair him with James Cagney in the upcoming *Over the Wall*, the new contract was no guarantee of employment. Much as he'd experienced under his earlier Fox and Columbia contracts, Bogie could be terminated if Warners became dissatisfied with his work or the profitability of his films. But if he did well, the studio would renew his contract for another twenty-six weeks at $600, and if he kept on doing well, he'd eventually be renewed for a year at $1,750 a week. That meant he had a lot riding on the next six months.

He was up for the fight. Bogie had far more cachet this time around. *The Petrified Forest* had been one of Broadway's few certifiable hits of the 1934–1935 season, at a time when the odds of a show becoming a hit were five to one (in pre-Depression days, the odds had been three to one). Jack Warner himself had seen the show in its first month, cabling the studio that he wanted the property. It took half a year to close the deal. Warner Bros. eventually paid $110,000 for the rights. With Leslie Howard owning 50 percent of the play, the studio had to concede to the star's wish to take the summer off even though it would have preferred to start shooting immediately. The play could have continued on Broadway for several more months if not for Howard's determination to spend the summer in Scotland. *The Petrified Forest* closed on June 29, 1935, with Howard graciously calling Bogart out at the final curtain call to share in the applause.

The Bogart legend would maintain that from the start, Howard told

Warner Bros. he wanted the same Duke Mantee he'd had on the stage. That's not supported by the evidence. It's possible that Howard recommended Bogie to Jack Warner, but once the deal was signed, the actor was off on holiday, leaving the studio to complete its plans on its own. It was clear that Warner had no intention of casting Humphrey Bogart or Peggy Conklin, two unknowns as far as Hollywood was concerned. Almost immediately after the deal was signed with Howard, the casting of Bette Davis as the proprietor's dewy-eyed daughter was leaked to the press, shattering Conklin's dream of movie stardom. As for who would play Mantee, no one was saying.

For Bogie, that meant a return once more to Maine and to the Lakewood Players, where Mary was already ensconced for the summer. One columnist reported that she was awaiting her husband's arrival "like a bride"—almost certainly untrue, as the couple had grown only further apart. In their ongoing competition, they had pulled roughly even, with Philips appearing in one of the only other hits of the season, *Anything Goes*, although in a less featured part. Around that time, she also admitted to Bogie that she had fallen in love with another man, the actor Roland Young, with whom she was about to appear in *A Touch of Brimstone*. Bogie's return to Lakewood may have been, at least partially, an attempt to save his marriage. He cheered her on from the audience on the opening night of the season, but a month later Philips left the company to join the Cape Playhouse on Cape Cod. So much for feeling like a "bride."

On his own, Bogie appeared in several Lakewood productions that summer, including *Ceiling Zero* in August, which Mary, accompanied by Maud and Pat Bogart Rose, returned to see, and *Rain*, the notorious play by John Colton based on Somerset Maugham's story of a South Seas prostitute, who, at Lakewood, was played by the famous burlesque dancer Sally Rand. Bogart had the supporting part of Dr. MacPhail. For the last show of the season, Bogie played the jealous Gabriel in Dorothy Bennett's *Fly Away Home*, set in the seaside town of Provincetown, Massachusetts. *Fly Away Home* closed the second week of September 1935. Although no one knew it at the time, it was the last time Humphrey Bogart would ever act on a theatrical stage.

His attention was now focused on making sure he got the part of Mantee in the movie version of *The Petrified Forest*, which was scheduled to start shooting that fall. Rumor was that Edward G. Robinson, who'd seen the play around the same time as Jack Warner, was being considered

for the part. Perhaps to counter such talk, a story went out that Bogie had been cast by Arthur Hopkins in the upcoming play *Paths of Glory*. The fact that the casting was not reported in *Variety* but only in the popular press suggests that the story was a plant. Even if Bogie had agreed to do the play, no doubt he would have dropped out if he had suddenly received a cable from Warner Bros.

But his hopes were dashed when, during the third week of September 1935, the studio officially announced Robinson's casting. Robinson, the star of such films as *Little Caesar* and *The Man with Two Faces*, was bankable in ways Bogart was not. Combined with Howard's drawing power and the rising acclaim for Bette Davis, the studio figured its $110,000 investment would translate into major dividends.

Bogie was crushed. Blanche Sweet, who had played the wealthy woman in the stage production of *The Petrified Forest* and who had also been replaced by a more current Hollywood player for the film, remembered the disappointment they had both felt. "Bogie was devastated," she said. "That was what the picture industry had become. Not about who was the best for the part but who would get the most publicity and bring in the most money."

But worse was yet to come. Just days later, on September 26, Bogie's closest and oldest friend, Bill Brady, Jr., relaxing at a summer cottage in Colts Neck, New Jersey, fell asleep while smoking a cigarette, setting his bedding on fire. The flames quickly spread, their heat so intense that the bungalow was burned to its foundation. Only a few charred bones were left of the carefree, enterprising young producer. For a moment, investigators considered foul play, as a revolver was found in the ruins with its bullets discharged. But then it was determined that the heat of the fire had likely caused the bullets to explode. Friends told police that it wasn't the first time Bill had caused a fire with his cigarettes.

The funeral was held on September 28 at St. Rose of Lima Church in Freehold, New Jersey. Bogart was in attendance, grieving with Brady Sr. and Grace George, who, as surrogate parents, had been far more nurturing to him than his own father and mother had. Bill had been like a brother; this, in some ways, was his true family. (Alice Brady and Katharine Alexander were both in Hollywood, shooting a picture, preventing them from rushing back east, although Alexander arrived in time for the funeral.) After the solemn high Mass, Brady Sr., now seventy-one, placed his hands on Bogie's shoulders and told him how happy he was that Bill

had lived to see his success in *The Petrified Forest*. "I always knew one day you'd be a great actor," the veteran showman told him, as Bogart would later recall. Brady seemed to have forgotten the battles they'd fought and the critical barbs he'd tossed at Bogart. But his words were no doubt sincere and ones that Bogie had never heard from either of his real parents.

Returning to New York, he was at a low ebb. Things might not have been as bad as a year earlier, when his father's death had coincided with the apparent death of his theatrical career. In the interim, he'd accomplished his astounding success in *The Petrified Forest*, securing himself a place, if he wanted it, on the American stage for some time to come. Problem was, he no longer wanted it—or at least, he did not want it as badly as he wanted a movie career. Warner Bros.' casting of Edward G. Robinson in the part Bogart had created, followed by his best friend's death, would have made the fall of 1935 feel not that dissimilar to the fall of 1934.

One night Bogie showed up at the 52nd Street studio of the sculptor Henrietta Kaye, who'd played with him in the short-lived *Chrysalis* a few years before. "He was quite plastered," Kaye remembered, "but on his feet." Bogie had never made a pass at her, and he did not do so that night, either. Kaye got the impression that he was estranged from his wife and needed someone to talk with. "The reason I'm getting mush-headed," he told her, "is because Eddie Robinson is going to play my part." It had happened before, he lamented: *Cradle Snatchers*, *Hell's Bells*, *Saturday's Children*, and *It's a Wise Child*, among others, had all been made into films without him. "They buy them," he grumbled to Kaye, and "Bogart is left out in the cold."

But sometimes it's true that it's darkest before the dawn. Unbeknown to Bogie, Warner Bros. was having trouble nailing down the contract with Robinson. Leslie Howard was not happy to share top billing with the actor, which Robinson's contract demanded. Neither was the studio happy at the prospect, as it wanted to pitch the movie as a reunion between Howard and Bette Davis, who had costarred in the *succès d'estime* of 1934, *Of Human Bondage*. Whether Robinson backed out or the studio broke off negotiations is unclear. It's also unclear when, in the midst of the conflict, a telegram arrived from Howard, saying plainly NO BOGART NO DEAL. Given his 50 percent ownership of the property, the actor pretty much had the last word. And so it was then, at the eleventh hour, that Leslie Howard went down in history as the savior of Humphrey Bogart's

career. Bogie would be forever grateful to him, going so far as to name his daughter, born some years later, Leslie Howard Bogart.

Louella Parsons broke the news of Bogie's casting on October 1. "Humphrey Bogart is returning to Hollywood after an absence of three years," she reported. "Bogart left here absolutely disgusted with movies, saying he felt his place was on the stage." He was returning now, the columnist told her readers, at "the request" of Warner Bros. to play "the character he so successfully created on the stage."

Bogie arrived in Los Angeles on October 10 on the same train as Leslie Howard. Almost immediately, Howard commenced location work in Cantil, California, standing in for the Arizona desert. Bogart didn't report for his first day of shooting until October 26, and his welcome at the Burbank studio was inauspicious. He had, of course, worked at Warner Bros. before, on both *Big City Blues* and *Three on a Match*, but no one remembered him until the actor Lyle Talbot, who'd shared the screen with Bogie on both pictures, set them straight. They could "save Jack Warner some embarrassment," Talbot told the front office, by rustling up some stills from the earlier films.

THE OFFICIAL WORLD PREMIERE OF *THE PETRIFIED FOREST*, THREE WEEKS after the sneak preview in Beverly Hills, was held not in Los Angeles or New York but at the Orpheum Theater in St. Louis, Missouri. It was, after all, a picture about people, ordinary people, salt of the earth and unpretentious. By opening in middle America, Warner Bros. reminded the public that it was a studio devoted to depicting the struggles of everyday Americans. It wasn't glossy like MGM or Paramount; the stories it told were realistic, gritty, unglamorous, *real*. From his first day at the studio, Bogart absorbed the straightforward, unaffected style, carrying it with him throughout his career, using it as the basis of his public image. If MGM had bought the rights to *The Petrified Forest*, we probably wouldn't have had Humphrey Bogart, movie star.

In St. Louis, the film caused considerable excitement. The Orpheum was closed the day before the premiere so the theater could be "staged with all the trimmings." When it opened its doors on January 31, "a line a block long weathering subzero weather" was already waiting to be admitted. Box office was equally as strong once *The Petrified Forest* opened a week later in larger markets, and the reviews were smashing. Just as

on Broadway, Howard was praised to the skies, but reviewers also noted the extraordinary performance of Bogart. Philip K. Scheuer of the *Los Angeles Times* thought he was "outstanding . . . as the simian killer; he keeps things earthy." Frank S. Nugent of the *New York Times* thought he was "more like Dillinger than the outlaw himself." The *New York Herald Tribune* declared, "Bogart provides a brilliant picture of a subnormal, bewildered, and sentimental killer."

The image Bogie seared onto the screen was unlike anything that had come before. He was compared to James Cagney in the trailer for the film: "Humphrey Bogart," the subtitle read, "the most terrifying character since the Cagney of *Public Enemy*." But in fact, Bogie was quite different from Cagney, who had been kinetic, twitchy, and impatient in the earlier film. Bogart in *The Petrified Forest* is coiled like a snake, watching, waiting, observing, not reacting, utterly unknowable. In gangster pictures starring Cagney or Edward G. Robinson, we learn their stories, their traumas, their pain. Duke Mantee, as well as many of Bogart's later screen characters, was inscrutable, the pain and trauma only implied by the look in his dark, haunted eyes.

So different was Bogart from any other screen personality that Jack Warner didn't quite know how to use him. What mattered, however, was that he be used *somewhere*, since he was now a salaried employee and needed to start earning his pay. There was talk of casting him as Napoleon in the upcoming production of *Anthony Adverse*; he was "just right for Bonaparte," Warner Bros.' publicity declared. The part was minuscule, however, and went to Rollo Lloyd. Then came an idea to team Bogie with Bette Davis in *The Public Enemy's Wife*, which was eventually made with Pat O'Brien and Margaret Lindsay. The studio finally settled on *Two Against the World*, directed by William McGann, a B-picture regular. Bogart played a shady radio producer in the rather confusing fifty-seven-minute melodrama. He got top billing this time, a first for his movie career, but the other players were all second string. A B picture such as *Two Against the World* was a significant comedown from the prestige of *The Petrified Forest*. The *New York Times* cited it as an example of Hollywood's penchant for "quantity over quality."

That disappointing turn of events was tempered somewhat by the fact that *Two Against the World* was released *after* Bogie's next picture, despite having been made before it. Therefore, the first time audiences saw Bogie after *The Petrified Forest* was in *Bullets or Ballots*, a step above

a B picture if not quite an A, directed by the midlist director William Keighley. Bogie was teamed with his former rival Edward G. Robinson and fellow tough guy Barton MacLane in a story of racketeers and an undercover cop, based on the real-life exposés by the journalist Martin Mooney. Studio publicists had a field day promoting the "screen's three baddest 'bad men'"—Robinson, MacLane, and Bogart—as the "triple threats" of *Bullets or Ballots*. The *Film Daily*'s critic saw a preview of the film and called it "easily one of the most important crime pictures that has come to the screen."

The mainstream press was more measured in its appraisal. Most of the attention went to Robinson as the undercover cop, although the *San Francisco Examiner*'s critic made sure to point out that Bogie played "the blackest menace" of the film, moving stealthily "with a ready gun at his hip" and speaking "between his teeth, slowly and deliberately." Indeed, his portrayal of "Bugs" is almost demonic—Duke Mantee stripped of even the smallest vestige of humanity. Utterly disdainful of societal moral codes, Bugs smirks as he watches a newsreel claiming that crime doesn't pay. When he assaults leading lady Joan Blondell with an unwanted kiss, he gets a very convincing slap across the face, but he just laughs. Eventually, Robinson and Bogart kill each other off, the forces of good canceling out the bad, or perhaps the other way around.

Even if the reviews were modest, *Bullets or Ballots* was a money-maker, being held over for a third week at the Strand Theatre in New York, and that was ultimately even more important than critical acclaim. He hobnobbed with some of the industry's biggest names at the premiere of *Anthony Adverse*, the film he'd been considered for, rubbing elbows with Fredric March, Gloria Swanson, Norma Shearer, Irving Thalberg, Marion Davies, Myrna Loy, Errol Flynn, Cary Grant, and, most important, Jack Warner, who appreciated his players supporting the studio's films even when they weren't in them. Despite the flop of *Two Against the World*, Bogart was holding his own. The *Film Daily* had named his performance as Duke Mantee as one of the best of the season. From all appearances, Bogie should have been quite content with the way his movie career was progressing by the summer of 1936.

Except he wasn't. He'd been around that rodeo before, and he could see that the pictures he was being cast in were not going to take him very far. "Probably more gangsters and more gangsters," he replied when asked by a reporter what sorts of roles he expected he'd play. "They have a way

of casting you as to what they think is your type." A few years earlier, he'd had the same realization about the roles theatrical producers were giving him to play on the stage: he'd been stuck playing juvenile playboys until he had aged out of consideration. Now he was stuck playing the taciturn accomplice to either the film's hero or its villain. And he saw no way out unless he did "something drastic about it," probably a reference to James Cagney's strike against Warner Bros. for not abiding by the terms of his contract.

Bogie may have also been privy to the plans of Bette Davis, whom he admired. Unhappy with the quality of films she was put into after *The Petrified Forest*, Davis would, by the spring of 1936, stage a strike against the studio. She would eventually take Warner Bros. to court. Yet Bogie, however much he might grumble, was not the type to take such "drastic" action, not with the memory of his lean years still fresh in his mind. Bogart "knew the score," observed Mary Astor, a later costar. "Go along with it, keep quiet, and collect your dough." Bogie wasn't about to bite the hand that fed him, at least not yet.

That meant, of course, that he was forced to continue playing in whatever the studio gave him. For his third film, he was cast in *China Clipper*, another B picture, in which he played second fiddle to Pat O'Brien. The film's inspiration was Charles Lindbergh's historic flight across the Atlantic, though in this case, the pilots traverse the Pacific. The *Brooklyn Daily Eagle* thought that Bogart was "wasted in a role that offers little opportunity for his peculiar talents."

From there he went immediately into *Isle of Fury*, directed by Frank McDonald. Though Bogie once more had top billing, the film suffered from an extremely facile script. Playing a pearl diver in the South Pacific alongside Mexican actors wrapped in sarongs playing Polynesian natives, Bogart began to grumble, requesting better dialogue. No one took time for rewrites, however, on a lot that prized efficiency over eloquence. When, on the day before the July 4 holiday, McDonald kept the crew working for fifteen hours straight, Bogie had had enough. He demanded that the unit manager explain why they were being kept so late. To the front office, the unit manager reported, "Humphrey Bogart has been making it rather difficult."

Even though his renewal option was coming up soon, Bogie's patience was at its end and he didn't back down. When, after the holiday, he was informed that they'd once again be working late, he outright refused—for

a time. Though he made a big scene storming off the set, he soon backed down. He couldn't afford to follow the lead of Cagney or Davis, who'd risked their salary and security by walking out. That was one thing Bogie couldn't yet bring himself to do.

ON SUNSET BOULEVARD, FROM BEHIND EXOTIC PALMS AND BLAZING BIRDS OF paradise, rose the Garden of Allah hotel, one of Hollywood's fabled addresses, with its red-tile floors and colorful Circassian walnut finishes. The Spanish-style structure and the 2.5 acres it stood on had once been the home of the outré silent film actress Alla Nazimova, who, past her prime by 1936, still resided in one of the bungalows as a tenant. The pool had been designed to resemble the Black Sea in honor of Nazimova's Russian motherland.

Thirty bungalows covered in bright red bougainvillea surrounded the pool. Both temporary and long-term residents were welcomed at the Garden of Allah, all of whom chose the place because of its bohemian reputation. In its restaurant and around its bar, which was open all night, congregated actors, artists, musicians, and writers. On certain nights, the clientele was drawn from Hollywood's lesbian demimonde, with Marlene Dietrich swimming nude in the pool. Affairs were conducted in the open; married couples swapped room keys; the sharp, bitter odor of opium cut through the sweet fragrance of gardenias. For people who had never visited, such a place was hard to imagine. "I'll be damned if I'll believe anyone lives in a place called the Garden of Allah," Thomas Wolfe wrote to F. Scott Fitzgerald, who, in a year's time, would take up residence there himself.

This was where Humphrey Bogart, too, decided to settle when he came west for the third time. He'd likely been to the Garden of Allah before; he knew what went on there. Cut off from his New York friends (Kenneth MacKenna had given up the movies to head back to Broadway) and still grieving Bill Brady, Bogie was on his own; the fraternity of the Players Club, which had sustained him through highs and lows, was gone. It was necessary, therefore, to find a new support system. He joined the exclusive Lakeside Golf Club, a male-dominated space where he could play a few rounds and knock back some whiskies with like-minded, up-and-coming actors. But where he lived would be even more crucial in setting up his social network.

No doubt Bogie had learned that the humorist Robert Benchley, a friendly face from New York, had taken a bungalow at the Garden of Allah. Stories abounded of Benchley being carted in a wheelbarrow from room to room in a quest to find more gin. It was a place where Bogie could feel right at home. The Garden of Allah became his new Tony's— even better, because when he got falling-down drunk, he didn't need to be poured into a cab; he was already home.

He'd moved into the hotel around the time his contract was signed; his start work record from Warner Bros., dated January 6, 1936, confirms his residence. That was just after Mary had ended her Christmas visit and returned to New York. For Bogie, hotel life, with its easy camaraderie and convivial imbibing, was far preferable to living (and drinking) by himself, as he'd often found himself doing during his first adventure in Hollywood in the house on Canyon Drive. But he remained lonely. Every indication suggests that he still cared for Mary and did not want the marriage to end, swayed by the memories of their early, happy days.

He'd become used to the distance from his wife, however, as it had gone on for some time. He'd also forgiven her for the affair with Roland Young, even if Philips felt that forgiveness wasn't necessary, as she'd given permission to Bogie to have his own affairs. But he appears not to have taken her up on it. There may have been dalliances with women outside the limelight that went unreported, but the lack of sexual interest expressed toward Henrietta Kaye was not an isolated incident. One night, soon after the release of *The Petrified Forest*, Louise Brooks received a call from a mutual friend asking her to join her and Bogart for a drink. Brooks had seen Bogie the night before at the Garden of Allah in Robert Benchley's bungalow, "leaning against a sofa with a glass of Scotch and soda in his hand." He had appeared depressed to her. Now came this invitation, apparently from Bogie himself. "Coming from anyone else," Brooks wrote, "the invitation would have meant that two bored people wanted company. Coming from Humphrey, it was nothing less than a declaration of love." Yet when Brooks arrived, Bogart "retreated slowly into gloom and silence and Scotch," leaving Brooks alone with their friend. In the cab ride home, she mused, "He could only love a woman he had known a long time." It's an observation that sheds light on why he tried so hard to hang on to his wife.

"I can tell you one person who was a romantic at heart," Gloria Stuart, an actress and friend, recalled. "That was Humphrey Bogart." Stuart

had observed firsthand Bogie's loneliness after Philips had departed for New York. She and her husband, the screenwriter Arthur Sheekman, frequently accompanied Bogie to nightclubs. "He was one of the few who really wanted to find one wife and be true to her," Stuart said.

Still, her use of the word "romantic" is slightly misleading. Bogart was never the sort of man to woo his paramours with flowers, champagne, and candlelight. But he did subscribe to the notion that marriage made a man complete, that it was something every man should strive for, and that a supportive, docile wife was the key to the marriage being successful. Had his mother been less domineering, he still believed, her own marriage would have been happier. But although the relationship between Bogart's parents was certainly not something he wanted to emulate, at least as far as he knew, they had been faithful to each other, despite the problems between them. Bogie's fidelity to Mary followed that example.

But his commitment was about to be tested. The novelist Eric Hatch and his wife had recently come out to Hollywood from New York, renting Charles Farrell's house in Beverly Hills. Bogart had made the Hatches' acquaintance at least by February 1936, when he had accompanied Mary and Melville Baker to the Screen Actors Guild Ball and Hatch and his wife had been at their table. Given that they were all golfers and imbibers, a friendship was struck. Eric and Constance "Gertie" Hatch adored their Scotch and enjoyed being on the scene, rather like Bogie and Mary in the beginning. Bogie seems to have felt a kinship with them.

At some point that winter or spring, Eric Hatch invited Bogart to his house for a private party. Among the guests was a vivacious thirty-two-year-old actress whom Bogie remembered vaguely from New York. She'd been friendly with Helen Menken and had worked for both William Brady and Arthur Hopkins, so they'd met on several occasions, even if they hadn't known each other well. The actress's name was Mayo Methot. Bogie was fascinated by her. For the rest of the night, he never left her side. Everyone noticed the attraction.

Over the next few weeks, Bogie and Mayo met often at the Hatch residence, because inviting her to the Garden of Allah would have caused gossip, which Bogie abhorred. But it wasn't just Bogart who was concerned about appearances; Methot was also married. Her husband was Percy T. Morgan, Jr., an oil tycoon. Their budding friendship needed to be kept secret.

Knowing Bogie's somewhat puritanical views about sex and marriage,

it's quite possible that his relationship with Methot started off platoni-
cally. They would have shared a common gripe about the roles they were
being given to play; it was the post–*Petrified Forest* period in which Bogie
was churning out such drivel as *Two Against the World*. Perhaps they
talked about acting and ambition. But their flirting intensified. "They
made it very obvious they were attracted to each other," said Gloria Stu-
art. "It could get embarrassing."

Still, it's unlikely that Bogart had gone looking for an affair, and he
most certainly did not want to end his marriage. That went beyond any
lingering feelings for Philips. Recalling his concern over whether the di-
vorce from Menken would hurt his career, no doubt he had the same fear
now. Hollywood continued to strain against the shackles of the Produc-
tion Code, with every film script being subjected to the censor's red pen.
Not surprisingly, marriage was all the rage in the film colony during the
immediate post-Code period, with many formerly footloose and fancy-
free players tying the knot to project the appearance of domestic confor-
mity. Bogart hadn't worked so hard to get this far to risk a scandal. His
contract renewal time was coming up.

Yet there's no doubt that he was enchanted with Methot. "He found
her at a time of lethargy and loneliness," Louise Brooks remarked. Mayo
was everything Mary had once been: playful, hard drinking, quick to
laugh, devoted to him. When he fell in love, Bogie went all in. He and
Mayo met at the Hatches' house or at other friends' houses or in studio
dressing rooms, laughing like kids playing hooky from school.

They had a great deal in common. Both were on their second mar-
riage and feeling increasingly dissatisfied in them. Both were frustrated
with the sorts of roles they were playing. Both were past the age when
people usually became stars. And both, significantly, could drink every-
one else under the table. "The bottle is what they had most in common,"
said Gloria Stuart.

"They were irresistible to each other," said M. O'Brien, a Portland
friend of Methot from later in life. "They each thought they had finally
found the perfect partner." Problem was, they'd discovered only their
commonalities; the differences would take a little longer to manifest
themselves. But for the moment, Methot occupied Bogie's mind and
heart. She changed the narrative of his life. Even as he headed toward
forty, what he was learning from Mayo was that there was still a lot more
he could accomplish. In some ways, it's fair to say that he felt reborn.

MAYO METHOT WAS BORN ON MARCH 3, 1904, IN CHICAGO, MAKING HER A LITTLE more than four years younger than Bogart. Her first name was Isabel; her middle name, Mayo, was the last name of her paternal grandmother's mother. Her father was John D. Methot, or Captain Jack, as most people called him. The master of cargo ships sailing back and forth from the West Coast to Japan, China, and the Philippines, Captain Jack was a bit of a rogue, with a tattoo on his right arm and a sailor's salty language. When he married Mayo's mother, Beryl Evelyn Wood, he was still married to someone else, which meant a hasty remarriage to Beryl ten years later when it all came out. In the meantime, their only child, Mayo, was born.

From the time she was very young, Mayo accompanied her father on his boat along the Columbia River near Portland, Oregon, to which the family had relocated soon after Mayo's birth. She learned to love the water, absorbing the mechanics of sailing, something else she'd have in common with Bogart. But she was most at home on a stage. When she was eight, her mother auditioned her for the Heilig Theatre's upcoming production of *The Awakening of Helena Richie*, a soggy melodrama typical of the period. Mayo played a boy, "the wistful little waif David, who awakens the soul of Helena Richie." The local reviewer called Mayo "a wonderfully temperamental child actress." While Bogart was enduring boring lessons and the taunts of his classmates at the Trinity School, Mayo was emoting before the footlights and basking in the applause of her audiences. She also had a mother who believed in her and encouraged her, perhaps the greatest difference between herself and Bogie.

Beryl Methot, called Buffie by everyone who knew her, proved indomitable in pushing her daughter forward. Mayo's rise was swift on the stages of Portland. Often the showstopper, with her blond curls and saucerlike eyes, she was soon a regular part of the Baker stock company, playing in saccharine plays such as *Mary Jane's Pa*. The local press dubbed her "Little Miss Portland Rose." So popular was she that, at nine, Mayo accompanied the local advertising club to a Baltimore convention, where she presented President Woodrow Wilson with roses. "I was very much charmed with little Miss Mayo Methot," Wilson wrote to Oregon's governor, extolling her "delightful grace and simplicity." In 1915, the city named a dahlia after her.

But Mayo wanted more. "If I can't be a second Sarah Bernhardt," she declared precociously to the press, "I won't be anything." In 1916, she

played the title role in *The Little Rebel*, the story of a young Southern woman during the Civil War who falls in love with a Northern soldier. Mayo was only twelve, but by theatrical standards of the period, she was practically all grown up.

M. O'Brien said that Mayo's formative years were often stressful, with "lots of fighting between her parents." A report in the *Oregon Daily Journal* gives some evidence of the stress. When she was fourteen, Mayo was riding with her father in an open automobile after a performance. A teenage boy on the sidewalk, George Abdie, the son of Syrian immigrants, blew kisses at her. Jack slammed on the brakes and jumped out of the car, slapping the young man so hard across the face that he broke his jaw. Mayo's reaction to that, watching from the car, can only be imagined. Abdie pressed charges against Jack, who was found guilty of assault by a municipal judge and fined $100. Mayo's volatile temper as an adult and her proclivity to throw punches may have had their roots in some childhood trauma. If so, that would have been another point of congruence with Bogie.

Mayo was never going to be content with fame confined to the borders of Oregon. That might explain her sudden decision, at seventeen, to step down from the Baker stage and marry John Lamond, a cinematographer of movie travelogues. Her new husband was two years older than she. What Mayo wanted was to be a movie actress, and Lamond had been hired by a film distributor to make little scripted playlets from his travelogues. Mayo would be his leading lady.

In *And Women Must Weep*, released in March 1922, Mayo was a woman waiting for her husband to return from the sea. Several more travelogue films followed, but Mayo grew restless. That fall, she and Lamond left for New York. "It is her ambition now to get into production work on Broadway," her hometown paper reported, "and, failing that, she expects to turn again to her first love, stock, meanwhile maintaining a happy home in the metropolis."

Mayo's only offer, however, came from W. K. Ziegfeld, the brother of the famous impresario Flo Ziegfeld, who offered to hire Mayo for his newly formed India Pictures Corporation. That would require her to relocate to the Indian subcontinent, as the films were intended for that market. Clearly, breaking into the movies was going to be a lot harder than becoming the Baker company's leading lady. She landed the small part of a maid in William A. Brady's upcoming comic play *The Mad Honeymoon*.

The role was so small, however, that she worried she was going backward in her career. Wiring her mother for advice, Mayo received a quick reply: "Take it and make all you can of it."

George M. Cohan spotted her and cast her in his new play *The Song and Dance Man*, which, after an extensive preview tour, opened in New York in December and ran for four months. Mayo was in her first Broadway hit. In the prominent role of the daughter, she won the audience "almost exclusively with the eloquent expression in her pretty eyes," according to Burns Mantle. In the fall of 1924, Mayo took over a part in the comedy mystery *The Haunted House* at George M. Cohan's Theatre. She was just twenty years old.

Around that time, her marriage to Lamond ended. Any heartache she might have felt, however, was at least partially assuaged when she landed a plum role in *The Deacon*, a critical flop but an audience smash about a rascally card shark. One critic called Mayo "lovable." The play ran for four months, her second hit.

For the next four years, Mayo worked steadily on Broadway, building up a reputation as a dependable character actress. She landed few leads during that period, instead usually playing tough-broad supporting parts, but her reviews remained solid. After her performance in *All the King's Men* in February 1929, one critic judged, "Mayo Methot handles her emotional scenes with both art and warmth and makes the woman very real."

She'd also become a familiar presence at the city's watering holes, yet another opportunity for her to run into Bogart. Her apartment at 325 West 45th Street was a frequent gathering place for show people. Mayo was known as a good-time girl, as free-thinking women were called in 1929. She had lots of like-minded friends. Her drinking was prodigious, and her appearance showed it. She was still, as one writer would remark, a "vital person with yellow hair and blue eyes," giving "the effect of sunlight dancing into a room"—a quality that no doubt facilitated Bogart's attraction to her. But she was also putting on weight, gaining an undisguisable double chin. Looking older than her twenty-five years, Mayo seemed destined for a career as the wisecracking best friend of the leading lady.

But then her fortunes rose. She was cast in *Torch Song*, which opened to critical raves on August 27, 1930, at the Plymouth Theatre. Arthur Hopkins was the producer, playing a similar role for Methot as he would

for Bogart, boosting her career at a critical moment. Mayo had one of the two leads, a torch singer named Ivy, who falls in love with a drummer. So successful was the show that it went on a West Coast tour immediately after its Broadway run ended, and the Los Angeles critics were no less enchanted. "In a part that would tax the patience of Job and the art of Duse, Mayo Methot holds *Torch Song* to a grand, high level," observed the *Los Angeles Evening Post-Record* of her performance at the El Capitan Theatre.

Appearing in Los Angeles had the added benefit of putting her before the eyes of Hollywood producers, many of whom were in the audience the first night. "Reservations have been made by many important motion picture folk to see Miss Methot's characterization of the blues singer," reported the *Los Angeles Evening Express*. With press releases calling her "one of New York's most popular young stars," Mayo's turn on the El Capitan stage was in effect an audition for the studio chiefs. She even got to sing for them.

It worked. Not long after the show closed, Mayo realized her long-held dream to be a Hollywood film star when she was offered, and accepted, a job from the producer-director Roland West. They made one film together, *Corsair*. Then came a contract with Columbia Pictures, where she played the titular character in *Murder of the Nightclub Lady*. She may have crossed paths with Bogie during that period, as their time at Columbia overlapped.

Mayo had remarried by now. Her new husband was Percy T. Morgan, Jr., a wealthy young man far above her in social class. His family was not, as some publicists would assert, connected to the J. P. Morgan dynasty in New York. Still, Percy's father had been the president of the General Petroleum Company in San Francisco and a cofounder of the California Wine Association. When Percy took Mayo home to meet his mother (his father had died some years before), they stayed at the family's sprawling Tudor Revival mansion in Los Altos. Mayo was eyed suspiciously by Percy's status-conscious family. When the couple married in late 1931, Mrs. Morgan chose Mayo's matron of honor for her, selecting a family cousin.

Now that she was supported by a rich husband, Mayo didn't need to keep working, but she hadn't lost her drive. She made thirteen pictures in four years, bouncing from Columbia to RKO to Warner Bros., almost always as the second or third female lead. In 1935, she headed back to

Broadway for what turned out to be her last stage production, *Strip Girl*, at the Longacre Theatre, playing a burlesque dancer and winning raves. Her Broadway laurels brought her back to Hollywood, although she still found herself far down in the cast lists. Her husband had become controlling and wanted her to retire from acting, but Mayo refused, spending time with friends without him. And then one night early in 1936, she became reacquainted with Humphrey Bogart.

When exactly Bogie and Mayo took the next step and became lovers is unknown, but it was almost certainly by the early spring of 1936—a rather portentous time, as it turned out, as it was also when Mary Philips decided to return to Hollywood—and her husband.

Hollywood, California, Sunday, April 26, 1936

Waiting for the telephone to ring, Bogie grew increasingly distraught. His wife's flight from New York had been scheduled to land in Los Angeles several hours earlier, but no plane had touched down and no radio communication could be made with it. He'd already been anxious about Philips's arrival because of his dalliance with Methot, but his concern for his wife was genuine. He would be devastated if she, like his friend Will Rogers, died in a plane crash. In 1936, airline accidents were not unusual, and tracking and monitoring systems were still rudimentary. For Bogie, the night was long and probably sleepless. But in the morning his fears were relieved when the phone finally rang. Mary's delayed plane had landed. She soon joined her husband at the Garden of Allah.

Bogart and Methot had been playing a dangerous game, but all that would have to stop now. At one party not long before Philips's arrival, Louise Brooks had learned that the furious Percy Morgan was on his way over, causing Bogie and Mayo to panic. As they had tried to leave through the back door, Mayo couldn't find her shoes. Bogie had turned savagely on Brooks and accused her of hiding Methot's shoes. The reason isn't entirely clear, but the incident does reveal the explosive anger that could still erupt, especially when he was drinking (and no doubt he'd had a few that night). It also revealed how terrified he was of scandal. Although Bogie and Mayo had managed to flee before Morgan arrived, it had been a close call. Next time they might not be so lucky. And now Philips was on hand to make things even more complicated.

The fear of scandal was very real that spring and summer. The popular leading lady Mary Astor's affair with the playwright George S. Kaufman had been exposed during her child custody case against her ex-husband. The case had drawn headlines all around the world. For the church groups and civic reformers, what made the Astor scandal even more objectionable was the fact that both parties were in open marriages, further proof to them of Hollywood's immorality. Although Astor's boss,

Sam Goldwyn, refused to fire her, others caught in similar situations might not be as fortunate, and there were plenty of other actors, directors, and producers whose private lives would outrage the reformers if revealed—Bogart and Philips, for example, whose polyamorous marriage wasn't so different from Kaufman's and Astor's. "Hollywood is afraid," wrote the columnist Paul Harrison. "No one wants to suffer the remotest association with scandal." Harrison went on to list several celebrities who, when asked, had declined to offer Astor their support. Bogie did not want to find himself with the same pariah status.

Some biographers would later imply that Philips's relocation from New York to Los Angeles at that moment was because she'd heard rumors about Methot and wanted to save her marriage. This comes across as more window dressing of the Bogart legend: two women fighting over a man was always good copy. But even if Philips did know about Methot, she had, some time before, given her husband free rein in extramarital activities. She'd certainly indulged in them herself. Philips did not appear to be the possessive type.

In truth, her haste in flying out to Hollywood had more to do with her career than with her marriage. On Broadway, she had been starring in *The Postman Always Rings Twice*, the racy drama adapted from James M. Cain's novel. The play was a personal success for her. For the first time in years, Mary was playing the romantic lead and not the fast-talking sidekick. Burns Mantle called the play "renewed proof of Mary Philips' intuitive artistry." It struggled to find an audience, however; by early April, box office was still "not up to expectations." So when the announcement came the third week of April that the show might close, no one was surprised. When *Postman* finally went dark on April 25, the closing had been "anticipated."

This rather detailed postmortem on *The Postman Always Rings Twice* is relevant because it debunks the myth that Mary abandoned her play and jeopardized her career to win back her man. The origins of this myth may derive from a contemporary report that asserted, "Mary Philips is leaving *The Postman Always Rings Twice* to rejoin her husband Humphrey Bogart in Hollywood." Yet the report came just days before the end of the show, and Philips continued in the cast until the end. If *Postman* hadn't closed, it's unthinkable that Philips, as ambitious as she was, would have boarded that plane for California.

What she was hoping for, finally, was steady employment in motion

pictures. Mary Baker was her agent as well as Bogie's, and she'd been pitching Philips to studio producers. In very short order, she won her client a contract. The offer came from none other than Irving Thalberg of MGM, who wanted Philips to appear in his upcoming production of *Maytime*, the popular Sigmund Romberg musical. Edmund Goulding was set to direct; Mary was slated to play the comic foil to Frank Morgan. Appearing in a big-budget Thalberg production at the Tiffany of studios was a far cry from appearing in *Isle of Fury*, the programmer Bogie was making at the time.

With his wife's return, Bogie faced a dilemma. As drawn to Mayo as he was, he still wasn't ready to end his marriage. Reportedly, at the eleventh hour, he pleaded with Philips once more to give up her work. "This is the first time I've ever really been able to support you," Hyams quoted Bogie as saying. "We could never afford to have children before. Stay here and let's start a family." This may be more mythmaking, once again exculpating Bogart for any of the problems in the marriage (inasmuch as he was the supportive husband to the restless wife) and, for good measure, providing a less embarrassing explanation for their lack of children than impotence. Still, the anecdote does reflect how he felt: he wanted a wife who would take a back seat to him and his career. To his mind, that was the natural order, with the husband supporting the wife, unlike the warped model of his parents. So it's not inconceivable that he may have made one more plea to Philips to retire, even if he couldn't have truly believed that she'd take him up on it, especially not after her success in *Postman* and her contract with Thalberg.

Unsurprisingly, the Bogarts were miserable in their renewed cohabitation. Philips's admittance into the august club that was MGM no doubt rankled her husband. Moreover, he missed the fun nights out with Mayo. It's no surprise, therefore, that Philips soon flew the coop again, agreeing to another season of the Lakewood Players before shooting started on *Maytime*. Meanwhile, their various publicists did their best to conceal any hint of discord. Though Mayo's problems with her husband were reported, there was silence about the Bogarts. Mayo was, in fact, linked with the orchestra director Paul Lannin, possibly to keep the spotlight off Bogie. He was now an investment Warner Bros. needed to protect.

As all the private drama was unfolding, the studio assigned him to the second lead of *The Great O'Malley*, playing an honest family man who runs afoul of a by-the-book policeman (Pat O'Brien). Tragedy ensues,

but it's all patched up sentimentally by the end. Although the film's tag-line was WHEN A HOT-HEADED IRISH COP COMES TO GRIPS WITH A COLD-BLOODED KILLER (despite Bogie's character being nothing of the sort), the picture was a snoozer. Once again, Bogart resented the studio's putting him in inferior pictures that were stalling his career. That was hardly protecting their investment to Bogie's mind.

But good news arrived in early August 1936: Warner Bros. handed him a starring role in *Black Legion*, based on the actual Black Legion of Michigan, a white supremacist organization convicted of kidnapping and murder in 1935. *Black Legion* would be unlike any film Bogart had yet made: dark, political, and far more controversial than even *The Petrified Forest*. "Three hits in three times up . . . wins Humphrey Bogart the starring role in Warners' timely 'Black Legion,'" crowed the *Film Daily*. (That's typical studio hype, as only *The Petrified Forest* and *Bullets or Ballots* had made significant money.) *Black Legion* was an important film, and the Warner Bros. publicity department was already gearing up for a big rollout. Archie Mayo, the director of *The Petrified Forest*, was to direct, and production was set to begin in late August. At last, Bogie seemed on track for stardom. But his private world was about to unravel.

Philips had returned from Maine to start shooting *Maytime*. In early September, however, Irving Thalberg died of pneumonia and production was halted. The new producer, Hunt Stromberg, decided to scrap the existing footage and recast most of the parts. Mary was one of those who got the boot. The studio promised to find her another picture, but nothing was forthcoming. Both Bogarts were frustrated, impatient, and resentful not only of the studios but of each other. Philips had had enough of Hollywood and wanted to go back to New York. As disappointed as he might be about it, Bogie had to realize by now that divorce was inevitable. The trick would be to make it as inoffensive as possible to Hollywood's morality police.

For the moment, Bogart and Philips kept up appearances. In October, a syndicated columnist asked Bogie what his favorite subject was, and he said, "my wife." The couple attended dinner parties together at the homes of the author Irvin Cobb and the actor Charles Butterworth, events that were covered in the press. But a chasm had opened up between them. Some chroniclers would tell stories of Philips discovering Methot at the Garden of Allah and causing a scene, although there is no evidence of it. Ferocious battles were not, in fact, what was wearing the Bogarts down,

but rather a glacial coldness. In November 1936, there was a report that they were taking a holiday to Mexico together; perhaps it was as a last-ditch attempt to patch things up. Border records do not corroborate the trip, however, and in any event, there would be no reconciliation.

It was in that state of mind that Bogie showed up every day on *Black Legion*'s soundstage. His real-life resentments and frustrations come through in his portrayal of Frank Taylor, a hardworking husband and father who comes to believe that the system is rigged against him and joins a vigilante group. Such contentious material was rare for the studios of the 1930s, which preferred to tell uplifting stories with happy endings.

Warner Bros., however, was one of the few companies to tackle social issues. Jack Warner was concerned about rising white nationalism, which was targeting not only African Americans but Jews and immigrants from southern and eastern Europe. In the script by Abem Finkel and William Wister Haines, Frank Taylor is passed over for a promotion that is given to a Polish immigrant. Radicalized by racist and nativist radio programs, he accompanies a coworker to a meeting of the Black Legion, a "secret patriotic society," where members in hoods with eye slits and crosses on their chests make him swear an oath of loyalty. (The Ku Klux Klan would sue Warner Bros. for copyright infringement, but the case was dismissed.) Originally the part of Frank Taylor had been intended for Edward G. Robinson, but the studio had worried that Robinson, a Jew born in Bucharest, Romania, looked too "foreign." What it needed was a "distinctly American-looking actor," and the blueblood from New York, Humphrey Bogart, was just the man.

Bogie threw himself into the part. The script lacked the poetry of *The Petrified Forest* but was still a powerful study of how good men go bad. Frank Taylor was Bogie's first complex character since Duke Mantee, and he intended to bring everything he'd learned about acting to the task. He knew how to project discontent, as he lived with the feeling every day, but it took more work to portray Frank's frenzied, desperate hysteria. Yet even there Bogart could draw on his lived experience: he'd felt desperate several times in his life and may have been feeling that way during pro-duction, given the frustrations at home. Although the script doesn't make it clear, there's a sense that Frank has always felt deficient, ineffective, unappreciated. The Black Legion turns him, finally, into a man, although it's a perversion of maleness. Bogart conveys the transformation power-fully in the scene after he's gotten his gun: he cradles it by his side, posing

in the mirror, grinning at what he sees. The phallic nature of the weapon as Frank flexes his masculinity can't have been an accident; Bogart gives it all the power and pathos it needs. Somehow, it passed the censor.

What Bogie didn't have experience with, however, was the realities of the average workingman. He's less convincing in the early scenes portraying his simple, happy home life with his wife and son. But from the moment Frank swears his oath to the Legion, Bogart comes alive. He is fervent, feverish, and not a little bit mad. His laughter after a raid on a Polish family is chilling in its ferocity. He's Duke Mantee unhinged. Emotions—shock, grief, terror—ricochet after he shoots his best friend to death. This is not the typical Hollywood protagonist who, despite his misdeeds, is redeemed by the end. No redemption was possible for Frank Taylor. Yet we do not hate him; we pity him. That is Bogart's greatest achievement in the part.

Reviewers were impressed when the film was released in January 1937. Frank Nugent praised Bogie for his "perfectly rounded character study." Bogart, he wrote, "has handled a difficult assignment flawlessly." Ada Hanifin in the *San Francisco Examiner* thought Bogart's "gradual disintegration of character . . . to a drunken, terror-stricken failure adds impressive height to his dramatic stature." The *Los Angeles Citizen-News* boldfaced its praise: "Bogart, an extremely fine actor, gives an outstanding performance [making] the psychological changes of the character clear and logical."

But critical praise doesn't always translate into lucrative box office. "Despite that it was given a strong publicity campaign, *Black Legion* is faring very mildly," *Variety* reported. In its first week in New York, the picture made less than $20,000—"Very disappointing," the trade paper judged. All across the country, exhibitors were seeing the same lack of enthusiasm. Industry observers blamed it on a "lack of cast strength" (Bogart was not yet a big name) and "women's dislike of films that smack of cruelty and brutality." Indeed, several accounts noted that *Black Legion*'s audiences consisted mostly of men; that sort of gender gap will sink a film fast.

There may also have been other, more political reasons that kept moviegoers away. In many places, especially in the South and Midwest, militia members and Klan sympathizers weren't keen to pay good money to watch folks like themselves be beaten by the system. Left-leaning patrons may have stayed away for the opposite reason. As Frank Nugent

wrote in a "second thoughts" review of the film a week after its release, "It is ironic and tragic that we cannot praise Hollywood for its courage without mocking it for its cowardice." He called out the studios for halting production on a film of Sinclair Lewis's *It Can't Happen Here* for fear it would offend the German and Italian Fascist regimes. The studios had also destroyed the negative of *The Devil Is a Woman* because Spanish nationalists had been upset about the portrayal of the Civil Guard. For all its strengths, *Black Legion* never really confronts the status quo: Frank is mostly alone in his prejudices at his job; the Legion henchmen are small-time hoods, not a well-connected network of powerful players; and the local police haven't been infiltrated by racists and nativists.

Still, the film was in many ways a political awakening for Bogart. Apolitical for most of his nearly four decades, he had never contributed to any political party. He was not found on California voter lists until 1940. But his friends were largely liberals: John Cromwell, Bill Brady, Gloria Stuart, Louise Brooks, the producer Hal Wallis. Robert Benchley was a Republican but often voted Democrat, especially after Franklin D. Roosevelt was in the White House. Mayo was a Republican, but her family was Democrat; by now Bogart had likely met her grandmother and aunt, who were living in Los Angeles. His research for his role in *Black Legion*—reading about the Michigan militias, their encroachment into the state assembly, and the xenophobia that drove them—also gave him a new worldview. Never overtly prejudiced against anyone, except possibly effeminate men, Bogie found the white nationalist and nativist philosophies repugnant. Once again, despite his upper-class origins, he knew what it was like to be singled out and made into the "other."

Not surprisingly, then, once production wrapped on *Black Legion*, Bogie made his first political contributions. He didn't give to a politician or a party, a fact that would prove useful for him a few years down the road, but rather to workers whose plight he could empathize with. In September 1936, newspapers were filled with stories of the abuses endured by lettuce workers in Salinas, California, who'd gone on strike for better pay and working conditions. The exposés by Paul C. Smith, the executive editor of the *San Francisco Chronicle*, entitled "It Did Happen in Salinas," riveted the nation's attention on the strike. Smith alleged that "sinister fascist forces" were controlling the local Salinas authorities. The situation became so dire that it drew the attention of Frances Perkins, the secretary of labor under President Roosevelt.

Hollywood was also paying attention. When the California Federation of Labor began raising money for the striking workers, the Screen Actors Guild followed suit. Gary Cooper, Boris Karloff, James Cagney, and other notable names contributed. Bogie, just weeks after exposing "sinister fascist forces" in *Black Legion*, sent a check for $1,000, which wouldn't have been easy on his salary and therefore speaks to his convictions. He knew what it felt like to have virtually no rights as an employee. Around the same time, he also donated to the American Newspaper Guild in support of reporters at the *Seattle Post-Intelligencer*, who'd walked out when management fired several journalists sympathetic to labor.

In both strikes, the Communist Party of America was a major supporter and benefactor. The Communists claimed credit for getting the Teamsters Union on board. Support for the strike, therefore, was being branded by right-wing politicians as support for communism. That association was made clear when the Communist newspaper *Daily Worker* printed the names of nineteen donors in gratitude, including those of Cooper, Karloff, Cagney, and Bogart. But in 1936, that did not carry as much danger as it would a few years later. The Communist Party of America was a legal political entity, running its own slate of candidates in national and state elections.

Bogart's strong identification with the message of *Black Legion* no doubt made its lack of success even more disappointing. Everyone at the studio had predicted big things for the film, as well as for Bogie. He'd been put onto the fast track to stardom, with photo shoots, ad campaigns, and interviews with columnists and fan magazines. All of that now ground to a halt. Estranged from Philips and kept apart from Methot, Bogie licked his wounds alone, bottle and shot glass at hand. He had a contract, at least for the time being, something many actors would kill for, and he was making better money than he had on the stage. But the repeated unflattering comparisons to Cagney, Tracy, and Robinson were wearing him down: Why could they bring in the box office when he couldn't? Ambition still burned in his gut, but it was slowly being drowned by the steady flow of booze.

DRIVING WESTBOUND ON SUNSET BOULEVARD, BOGART TURNED RIGHT ON HORN Avenue. Today every square foot of the area is developed, overlaid with asphalt and concrete, but in 1937, large tracts of green plateaus and stone

outcroppings marked the gradual ascent of the Hollywood Hills. Bogie had decided to purchase a home at the corner of Horn and Shoreham Drive. (His official mailing address over the years would alternate between the two streets.) Today it's the site of the high-rise Shoreham Towers apartments, but when Bogie pulled his car into the driveway, the front yard was landscaped with flowers and fruit trees. Built in the mid-1920s, the Spanish-style adobe hacienda was positioned high on a ridge, affording dazzling views of the city below and the sparkling Pacific beyond. Not yet had office towers and residential developments risen to impede the unbroken panorama of sun, sky, mountains, and ocean. Staring up at his new home, Bogart had every reason to feel that he'd finally arrived in Hollywood. He might not be among the top moneymakers in town, and possibly he would never be. But at least he had a movie star home.

Despite the box-office failure of *Black Legion*, Warner Bros. had taken up the option on his contract, so Bogie had decided to put some of his money into real estate. Philips had left Hollywood for New York, her MGM contract terminated. The press had called it "an amicable separation" for the couple, though it also disclosed that husband and wife had "not been getting along for some time." Yet instead of discouraging him about settling down, Mary's departure may have motivated him. He needed some stability in his life, and a house could give him that. Perhaps, too, hope still lingered, consciously or not, that a lovely home in the verdant Hollywood hills might lure her back.

But it was Methot who helped him decorate and buy furniture. They could meet there now, behind the cascade of bougainvillea that covered the house, without fear of discovery. Together they assembled a menagerie of dogs, cats, and birds. Bogie became an avid gardener, tending to the tropical plants and palm trees.

Late 1936 and early 1937 was a time of reckoning for Bogart on several levels. His marriage was at its end, he was closing in on forty, and his family was falling apart. His sister Pat's mental illness had worsened, and her husband, Stuart Rose, unable to cope, had left her. Pat sued for divorce on the grounds of adultery. The divorce was finalized in June 1937, with Rose obliged to pay Pat $35 a week plus $10 a week for the support of their daughter, Patricia. Not long after the decree, Rose remarried (for which he'd had to petition the court for permission) and he and his new wife had a second child. Despondent, Pat moved into an apartment of her own but was soon "off again," Bogie wrote to his sister Kay in early

1938, and was spending time in a sanitarium, where she was "being very well taken care of."

Bogie felt a special responsibility toward Pat. The closest in age to him, Pat shared with her brother many happy memories of New York, especially during Bogie's first years on the stage. They'd also been through the fire together, surviving their difficult childhoods and bearing similar scars. "Please do your best to assure Mother there is nothing to worry about," Bogie requested of Kay, "and also cooperate with her in straightening out Pat's affairs as regard her apartment. See that it is kept rented and the rent paid by the tenant." If it couldn't be rented, Bogie would allow the lease to lapse.

Kay had her own issues. Despite having gotten married, she seemed no closer to settling down; her drinking was as bad as ever. If Bogie was a functioning alcoholic, Kay was unable to hold a job. Her husband, Geoffrey Harper Bonnell, was a colorful figure in New York society, the grandson of the founder of the Harper publishing house. But he was best known for his marital musical chairs. Divorcing his first wife in Mexico, Bonnell neglected to tell her about it and married someone else. The first Mrs. Bonnell sued and got the Mexican divorce voided, while the second received an annulment from the court, although lawyers scratched their heads about how one can annul a nullity. The drama landed on the front pages of many newspapers and led to calls for the reform of divorce laws. Bonnell was not the sort of husband Bogie believed could get Kay to settle down, but he was civil to him.

The problems did not end with his sisters. Since her husband's death, Maud had been working as a commercial artist for the Stone-Wright Studio, an ad agency on Fourth Avenue in Manhattan (today Park Avenue South). There she toiled without credit, the name Maud Humphrey no longer meaning much. Although she retained her regal stature, she was becoming forgetful. Bogart remembered calling his mother one day and learning that she was on strike, although she had no idea why. "Nobody came to work this morning," she said. "So I was lonely and just went down to be on strike with the rest of them." He decided that Maud, now close to seventy, should move to Los Angeles. He set her up in a large, swanky apartment complex at 8221 Sunset Boulevard, where many movie people were her neighbors. Only a six-minute drive separated mother and son— along with, of course, a lifetime of incompatibility.

Maud's visits to Bogie's house would be rare. But when she was there,

her son likely took some pleasure in observing his mother's late-blooming pride in his career. He liked telling one particular story: "She was parading down Hollywood Boulevard like a dowager duchess when suddenly a sound truck went by, blaring an ad for a picture I'd made." The truck's loudspeaker boomed, "Who is the vilest fiend in history? Who is the monster whose laughter rings as he kills? Go to the Warner's Theatre and find out!" (The picture sounds like *Black Legion*.) From Schwab's drugstore, her most frequent hangout, Maud called Bogie and furiously described what had happened. "They have to advertise the film," Bogie explained. His mother replied, "But they might have mentioned your name!"

JANE BRYAN, NINETEEN AND NEW TO HOLLYWOOD, WATCHED WITH FASCINATION the exchanges between Humphrey Bogart and Mayo Methot on the set of *Marked Woman*—the way they spoke to each other, looked at each other, got angry with each other, and made up with each other. Bryan, along with Bogart and Methot, had supporting parts in the picture, which starred Bette Davis and was being directed by Lloyd Bacon. Everyone on the set knew that Bogie and Mayo were involved romantically, and to Bryan, their connection seemed incongruous. Not to her were the couple's commonalities obvious; what she saw was a foul-mouthed woman and a polite, soft-spoken gentleman. When Bryan blushed at the salty language bandied about between Methot and Lola Lane, another actress in the cast, Bogie told them to "pipe down," that they were being "too far out" in their conversation. According to Bryan, Methot didn't take her boyfriend's words kindly and launched into a tirade. It wasn't the first or the last contretemps Bryan witnessed on the set. "It was cataclysmic," she recalled years later. "They were poison to one another."

Bryan, of course, was not privy to the side of Bogart that could keep up with Methot when it came to curses and epithets. She had apparently never seen him fly into a rage or flail about angrily while drunk. The Bogart she experienced was the one who'd been brought up by parents who'd prized their place in *Dau's Blue Book*. She also hadn't observed Bogie and Mayo out with their friends, laughing raucously and finishing each other's sentences, or back on Shoreham Drive, making passionate love.

Despite all the stories that would be told, in the beginning the pairing of Bogart and Methot was a love match. It seems likely that Bogie was

instrumental in getting Mayo cast in *Marked Woman*. Her standing in
Hollywood was plummeting. In *Mr. Deeds Goes to Town*, her part had
been so small that she hadn't even been credited. The fact that she was
given a sizable part in *Marked Woman* suggests that she had a guardian
angel assisting her.

Part of the reason for Methot's falling out of favor with the studio's
brass was her appearance: she'd gone from cherubic Kewpie doll to care-
worn showgirl. Once very pretty, as portraits from her Broadway days
confirm, she now showed the signs of late nights and heavy drinking.
In *Marked Woman*, her double chin is impossible to miss; her eyes, once
her best feature, are weary. Indeed, the studio had likely cast her spe-
cifically for her run-down looks: her character is the oldest of a group of
"hostesses" (the Code didn't allow use of the word "prostitute"), and at
one point she is insulted by the gangland pimp who runs the joint: "Kind
of old, aren't you? I need young dames here." The line must have stung
Portland's Rose.

The cruel truth is that Bogie's face, too, showed the ravages of drink
and despair. But that's never been as much of a problem for men as for
women. Though Bogie might not have had matinee idol appeal, he could
still be cast as villainous tough guys; aging prostitutes weren't as much
in demand. In *Marked Woman*, Bogie was playing against type as the
righteous district attorney, looking to put the mob out of business and
serving as a sort of de facto love interest for Davis. He's awkward and not
very good in the part; he was never memorable when playing stiff and
straitlaced. Cagney and Robinson could go back and forth convincingly,
playing both heroes and villains, but at least so far, Bogie hadn't mastered
the art of heroics. He claimed to be satisfied with always playing the
heavy; "In fact, I like to play those parts," he told a reporter. "It means
I have a greater chance to act, to show why a man turns out to be bad."

Still, it looked as if he had a hit in *Marked Woman*, at least based on
the first week's tallies. In New York, the picture pulled in a whopping
$42,000 at the Strand Theatre. It did well in other big cities as well. Out
in the hinterlands, however, audiences largely stayed away; there, the box
office "faded to poor," according to *Variety*, which blamed the losses on
the picture's being "too sordid and heavy" for the "femme" clientele.

Immediately after *Marked Woman*, Bogart went into *Kid Galahad*,
his fifth film with Bette Davis. Davis by now had become one of Warner
Bros.' most bankable actors, and in *Kid Galahad* she was teamed with

Edward G. Robinson for maximum impact. Bogie was billed third, but his part as a prizefight-throwing gangster didn't really merit his billing. He had little screen time, and audiences had seen it all before. Although *Kid Galahad* opened strong, as *Marked Woman* had, its attendance quickly fell off. Two weeks after its release, *Variety* reported that the picture's grosses were "not as big as expected."

A similar fate awaited Bogie's next film, *San Quentin*, set at the famous prison and shot before *Marked Woman*. The Los Angeles premiere of *San Quentin* brought in $9,500, which *Variety* called "plenty good," but a week later the take was less, a pattern that soon spread across the country. Once again, Bogart was less convincing in the scenes in which he decides to go straight than he is playing the mad criminal hell-bent on taking out Pat O'Brien.

In none of those three films was Bogie the star, so the responsibility for their failures shouldn't rest with him. But that truth didn't insulate him from the fallout over the films' unsatisfactory grosses, especially *Kid Galahad's* and *San Quentin's*. He hadn't been in an unqualified hit for more than a year. With memories of the *Black Legion* debacle still fresh, it was clear that he had failed to win the confidence of the industry. Another starring role seemed unlikely. He had his supporters, but the moneymen couldn't have been very keen on him.

That became painfully obvious in February 1937, when the Academy Award nominations for the previous year were announced. The name Humphrey Bogart was missing. Despite all his accolades for *The Petrified Forest*, Academy of Motion Picture Arts and Sciences voters did not select his performance as being worth a nomination. It was the first year supporting players were nominated, which might have given Bogie a shot at the gold, but he was overlooked. None of the other nominees, though good, had delivered the sort of textured performance that Bogie had in *The Petrified Forest*. Some critics called foul. "Undoubtedly, the best supporting performance by any actor during the year was Humphrey Bogart as Duke Mantee," the critic from the *Chattanooga Daily Times* judged. Bogie's absence was bemoaned by several other publications as well. But then as now, Academy voters often considered other criteria besides excellence of performance when determining their choices: loyalty to the industry, seniority, personal stories, and, frankly, how much money actors made for their producers. There was no need to reward Bogart at the moment, as he hadn't lived up to the hype of a year before.

There may have been other considerations as well. During the first week of February, just before the Academy made the announcements, various media outlets reported that Bogie was being divorced by his wife. "Although both have confided the fact to friends, neither wanted to discuss their troubles yesterday," columnist Read Kendall wrote in the *Los Angeles Times*. "Those who are close to the couple declare it is a matter of incompatibility and nothing else." That last bit was probably engineered by Bogie's agents or the Warners publicity team to forestall scandal, because talk about the affair with Methot was all over town. But just days later, Walter Winchell said in print what people were whispering about: "Humphrey Bogart, being unraveled from Mary Philips, will marry Mayo Methot, who just started abrogation proceedings against Percy Morgan."

Not for another couple of months, however, did Bogart officially confirm that he and Philips were divorcing, admitting to the journalist Harry Brundidge in April that the stories were correct. Although he said nothing about Mayo, it was while *Marked Woman* was in theaters; seeing the lovers together on the screen certainly seemed to confirm the reports.

And then suddenly, in the spring of 1937, Bogie found his luck starting to change. Not long after being snubbed by the Academy and in the midst of all the talk about his divorce and impending remarriage, he was called into Jack Warner's office. The studio chief had news for him: he was being loaned out. Rarely were contract players happy about such a move. But in this case, the borrower was Sam Goldwyn, the most successful independent producer in Hollywood, and the part was Hugh "Baby Face" Martin, the killer in the film adaptation of Sidney Kingsley's long-running Broadway play *Dead End*. Bogie was delighted by the opportunity to further prove himself as an actor, though he wasn't pleased that the loan-out, though netting Warners a bundle of money, wouldn't bring him any more than his usual salary.

It was, nevertheless, a big break, and Bogie knew it. Goldwyn had originally wanted James Cagney for the part, but he was still suing Warner Bros. and Goldwyn had no desire to wade into that mess. The producer had then turned to George Raft, but Raft had objected to the unsympathetic nature of the character. In the Broadway production, in which Martin had been played by Joseph Downing, the killer had showed a conscience and awareness of the cycle of poverty and violence he was trapped in, allowing audiences to commiserate with him. Sympathy for criminals, however, wouldn't fly in Hollywood under the Production

Code. So Goldwyn approached his third choice, whom he'd seen not only in *The Petrified Forest* but also in *Black Legion*. Indeed, as Harry Brundidge reported, Bogart's "sensational role in *Black Legion* won him the coveted role in *Dead End*." Bogie had none of Raft's qualms about playing an unredeemable psychopath.

Goldwyn, the outsider, was taking a chance on Bogie that the rest of the industry appeared unwilling to do. With production set to start in May, Goldwyn's publicists turned their attention to rebranding Bogart. He could no longer be seen as a third-rate Cagney; he needed to be presented as a star of the same stature so audiences wouldn't feel they were being cheated out of somebody better. Accordingly, several sit-down interviews were arranged for Bogie at the Lakeside Golf Club in Burbank. Harry Brundidge took pains to point out that his conversation with Bogart was constantly being interrupted by the likes of Clark Gable, Spencer Tracy, Edward G. Robinson, and Bing Crosby, "who wanted to have a drink, discuss their golf scores or organize a bridge game." A piece in the *New York American* called Bogie "the new Cagney" and, like Brundidge, played up the reflected glory of his high-powered friendships. *Silver Screen* called Bogie "the most exciting newcomer to Hollywood in years," despite the fact that he'd been kicking around the place for half a decade. Several pieces in the spring of 1937 called Bogie "tall, dark and handsome," which, except for "dark," was stretching the truth.

He was also sent over to CBS Radio, which broadcast Shakespearean adaptations from the Music Box Theatre in Los Angeles. Humphrey Bogart doing Shakespeare might seem incongruous today, and it probably did at the time as well, but as Hotspur in *Henry IV* (a combination of Parts I and II), he was well cast: the ambitious, privileged son of a noble family who, like most of the actor's screen roles, is unsympathetic throughout and winds up dead. As surviving audio reveals, he's actually quite good, keeping up with actors such as Walter Huston, Brian Aherne, and May Whitty, who had at least some Shakespeare under their belts. Hotspur's death speech, one of the most celebrated in Shakespeare's work, enabled Bogie to express depths he didn't get to on-screen. His performance is impressive, especially for an actor who hadn't read a lot of Shakespeare or been in Shakespearean repertories. Though few critics reviewed radio plays at the time, the *San Francisco Examiner*'s Ada Hanifin declared that Bogart "was cast to advantage."

What we see here in early 1937 is the first coordinated campaign to

build Humphrey Bogart's image. Goldwyn's publicity went so far as to declare him, without any basis, as a star of the first rank. Brundidge used Maud's cutting remarks after Bogie's first negative Broadway review as a way of showing just how far the actor had come since then. He assured his readers, "Now he's a top flight film player." Even if he wasn't yet.

Bogart welcomed the publicity. Despite his advancing age, being cast in *Dead End* had revived his dreams of stardom. No doubt he took all the ballyhoo with several grains of salt, as he'd been promised big things before and they mostly hadn't materialized. He knew that the star-making machinery could grind to a halt as quickly as it had begun, as it had with *Black Legion*. Besides, the publicists building him up worked for Sam Goldwyn. At the end of the picture, Bogie would be going back to Warner Bros., which had a history of ignoring the successes its players achieved on loan-out. What happened when he returned from *Dead End*? He had no idea. So for the time being, he concentrated on the new picture. Its success would be no guarantee of his, but if it failed, he would surely be sunk.

Calabasas, California, Tuesday, November 29, 1938

The dark gray smoke rolling down from the hills above the Warner Bros. ranch made it difficult for cinematographer Ernest Haller to see his actors. The company had trekked up to Calabasas to shoot some final location scenes for Warners' much-anticipated production of *Dark Victory*. But forest fires raging north of Los Angeles were now getting too close for comfort, with the actors coughing and weeping. Just a day before, the flames had destroyed the hotel owned by Fox executives Joseph Schenck and Darryl Zanuck in Arrowhead Springs, and since then the conflagration had rapidly spread east. Finally, the director, Edmund Goulding, suspended production until further notice, and cast and crew piled into cars to head back to Hollywood.

The scenes that were shot at Calabasas were between the star, Bette Davis, and the actor playing her stable master, Humphrey Bogart. For Bogie, it was quite the departure. "Bette Davis and Humphrey Bogart are playing a love scene in the stable tack-room of *Dark Victory*," the syndicated columnist Paul Harrison reported. "Bogart actually has a sympathetic role this time: he doesn't even carry a gun or get shot." After so many gangsters, villains, killers, and psychopaths, Bogie was playing the romantic. Even though the groom's love for Davis goes unrequited, Goulding was directing Bogie as a Byronic hero: brooding, rough, and conflicted but at heart gentle, idealistic, and deeply in love. And from all reports, Bogart had been giving quite the performance until the fires shut everything down.

By now Davis was a top star, having far outpaced Bogart, her castmate in *The Bad Sister*, her first picture and his third. *Dark Victory* was their fifth teaming, but only now were any romantic sparks allowed between them. Unaccustomed to playing romantic figures, Bogie was awkward in rehearsals, especially when he was supposed to move in for a kiss. He was mindful of the edict that a star's face should never be blocked. When Goulding expressed dissatisfaction with the scene, Davis told Bogart to

lean forward more when he kissed her. "But if I do," he countered, "I'll completely cover you from the camera." To Davis, such things didn't matter, and she insisted that he "do it the natural way." Bogie complied. Davis told Bogart that he was superb in the scene and would be quite an asset to the picture.

Of course, even with the advance positive word on Bogart's performance, the public would have the final verdict on whether he merited the promotion to romantic hero. Filming resumed on the Burbank lot, and by early December the completed film was sent to the editors, with a release planned for early 1939. Would the public accept Duke Mantee as a love interest?

Bogie's big break in *Dark Victory* could be traced directly back to the break he'd gotten in *Dead End* eighteen months earlier, although it had taken some time before he'd been able to reap the dividends of that success. In *Dead End*, he hadn't been a romantic character at all. As "Baby Face" Martin, he had seethed with resentment and revenge, with the script by Lillian Hellman adhering to the Hays Office's edict not to sympathize with murderers. Yet with the assistance of the director, William Wyler, known for his skill with actors, Bogie transcended Hays's restrictions. The words he speaks in the film and the actions he takes are evil, but his eyes, expressions, and body language manage to make the character something more than just a two-dimensional villain, thereby circumventing the censors. Talking with a childhood pal (played by Joel McCrea) who'd gone on to school, Baby Face cannot completely hide his regret and envy. Even more powerful is his scene with his mother (played by Marjorie Main), whose grief and anger at her lawless son are heartbreaking. Bogie responded to Main's histrionics by underplaying, making crystal clear Baby Face's anguish and sorrow over his mother's rejection.

Wyler directed the film with a precise balance of action and emotion. Baby Face dies during an intense gunfight that took five days to shoot. McCrea, his clothes wet and dripping with theatrical blood, pursued Bogart through the labyrinthine set for the first four days, with flashes of ammunition provided by the sound and lighting engineers. Wyler called for multiple angles of the scene, including a crane shot from above. Bogie was required to climb the sets, run down dark alleys, and look manic. On the fifth day, McCrea finally shot his quarry, with Bogart tumbling from the facade of a tenement onto the floor of the set,

reportedly without the use of a stuntman. Baby Face was dead, "killed from every possible camera angle," as one observer said.

When *Dead End* was released, critics were rapturous about both Bogart and the film. Considerable praise went to the sumptuous production design, with its waterfront slum marked by depth and detail. Key to the film's success were the naturalistic performances of the "Dead End Kids," the same young actors who'd played the juvenile criminals in the stage version. But it was Bogie who got the lion's share of the reviews. Kate Cameron from the New York *Daily News* wrote that Bogart "dominates the scene whenever he is present." Norbert Lusk at the *Los Angeles Times* called Bogie's "the most striking performance" in the film, praising his "masterpiece of subtle acting." The novelist and journalist Graham Greene declared *Dead End* to be "the finest performance Bogart has ever given."

Bogie was at last coming into his own as a film actor. The Humphrey Bogart the world remembers—the hard-boiled antihero of *The Maltese Falcon, Casablanca,* and *The African Queen*—made it all look so easy, but in fact he had spent a long time mastering his craft, first on the stage and then adapting those skills for the movie camera. He'd been acting now for seventeen years, longer than Cagney, Tracy, and Davis, as well as many other stars far bigger than he was. Despite his problems with self-esteem and alcohol, he remained committed to becoming the best actor he could be. And critically, by the time of *Dead End*, the men in suits in the studio boardrooms were finally starting to recognize that.

But the problem was just as he feared: Warner Bros. simply put him back into programmers when he returned to the studio. There was a gap of several months between the completion of *Dead End* in the spring of 1937 and its wide release in September, and although it would become one of the top pictures of the year, racking up $50,000 just a few days into its New York run, no one knew that in June. So according to the usual pattern, Bogie toiled through several substandard pictures that gave him little further chance to shine. In *Stand-In*, he's third billed below Leslie Howard and Joan Blondell, playing, ironically, an oblivious movie producer. The film would turn out to be a flop, but we do get to see Bogart deliver a comic drunk scene, which, if the reports of his friends are any indication, was much lighter and less antagonistic than his real-life benders. Then there was *Men Are Such Fools*, in which Bogie again played third fiddle, only this time to stars (Wayne Morris and Priscilla Lane)

who were a couple of notches below Howard and Blondell. Directed by Busby Berkeley, who was out of his element in nonmusical pictures, *Men Are Such Fools* flopped even harder than *Stand-In*.

The worst of the three, however, was *Swing Your Lady*, a "hillbilly musical," directed by the pedestrian Ray Enright. Set in the Ozarks, the top draws were "America's hillbilly favorites, the one and only Weaver Brothers and Elviry," as the trailer for the film heralded. For the sheer indignity of appearing in the picture, Bogart's new, powerful agents, Myron Selznick and Leland Hayward, were able to finagle a raise in his salary to $1,000 a week. Bogie would call *Swing Your Lady* the worst picture he'd ever made, and it would be difficult to quibble with his assessment.

In the long lead-up to *Dead End*'s release, Bogie was treading water, trying to stay afloat until the Goldwyn picture demonstrated what he could do with a good script working with a capable director. "Bogart's got the Warners scratching their heads," the *Exhibitors' Herald* quipped. "Is he hero, villain, monster, or matinee idol?"

Bogie's worries during this period weren't only professional. Just weeks before *Dead End* was released, Mary Philips's divorce suit became public, and it wasn't pretty. Bogie, as he'd feared for some time, would finally have to stand before the public and await its judgment.

AT THE LAKESIDE GOLF CLUB, BOGIE SAT FIDDLING WITH HIS WRISTWATCH AS A reporter from one of the news services peppered him with questions. Was it true what his wife had told a judge? Bogie wouldn't answer. The press was making hay of each new unflattering detail revealed in court by Mary's lawyers. "Humphrey Bogart, gun shooting bad man of the movies," reported the *Chicago Tribune*, "had one big fault in real life, actress Mary Philips testified today. He forgot to come home at night." The reporter at Lakeside wanted to know where Bogart had gone if he hadn't gone home. Bogie tried to shift the conversation to talk about other things, such as his desire to captain his own boat. But the reporter pressed, so Bogie finally said, "Mary deserved better than me."

Both he and his handlers at the studio were understandably concerned about the impact the divorce would have on the sorts of roles he would be given. Mary's suit certainly did not encourage the idea of Bogie as a romantic leading man. In addition, she claimed that Bogie had told her he no longer loved her and that he "preferred life as a single man."

When the divorce was granted a few days later, Bogie was left looking like a heel.

It was a sad end to a relationship that had started with such companionship and collaboration. Bogie and Mary had acted opposite each other in joint projects on Broadway, on tour, and in summer stock. They'd shared a group of friends and the love of a good time. But as soon as Mary began actively pursuing work separate from her husband's, the marriage had faltered. Bogie was still convinced that his wife's career should be subordinate to his. In the end, that makes him more to blame for the marriage's failure than Mary, no matter how hard he had tried to keep it going. But Mary certainly shared some of the blame, becoming attached to other men in the polyamorous arrangement she'd imposed on her husband. When she charged that Bogie hadn't come home at night, she was giving the impression that he had been tomcatting around town, when in fact it seems that Philips was far more prodigious in her bed-hopping than he was.

Even more hypocritical was Philips's claim that Bogie had told her that he no longer loved her. Though that was a frequent charge in divorce suits, it was Mary who had told her husband that she was in love with another man. The fact was that Bogie had feelings for her until the end. As a sign of those feelings, he agreed to pay all the income tax Mary owed for 1937. He also agreed to pay her $75 a week as alimony until such time as she married again.

The claim that he "preferred life as a single man" has been used by some chroniclers to substantiate the myth that he did not want to marry Mayo Methot. His agent Mary Baker would give interviews years later insisting that Bogie had had no intention of marrying again after Philips, giving the impression that Mayo had coerced him into it. But here again it appears that facts were being retroactively molded to fit a later narrative. Humphrey Bogart, according to the legend that emerged, could never have truly loved any woman before his fourth and final wife came along. So his three previous wives had to somehow be explained away.

But Mayo was more than just a friend with benefits. Sheilah Graham, who usually knew what she was talking about, reported a day after Philips's suit became public, "Humphrey Bogart will marry Mayo Methot just as soon as his divorce is absolute." In interviews, Bogie began referring to Mayo as "my best girl," hardly what one would expect from a man who didn't consider the relationship serious. Methot was, in fact,

everything Philips had once been and everything she had never been. With Mayo, Bogie had found another partner in crime, a fellow bon vivant who could keep up with his drinking. But also, more important, Mayo had put her own career aspirations second to Bogie's, becoming a vocal and relentless booster of his acting talent. At a dinner with Tay Garnett, the director of *Stand-In*, Mayo let her frustrations fly. "Why can't the best actor in the world get to play anything but heavies?" Garnett recalled her shouting. "And what the hell are you going to do about it?" Neither from Philips nor from Menken had Bogie ever received such full-throated support and advocacy.

Mayo made it her mission to make her boyfriend into a star, cornering executives, directors, and columnists. "Mayo Methot is a one-woman publicity team for Humphrey Bogart," Sheilah Graham remarked. That took energy that Mayo could have spent on her own career, which had plummeted into unbilled bit player territory. Instead, she focused on advancing Bogie's prospects, and people took note of her passion. "Except for Leslie Howard," Louise Brooks wrote, "no one contributed so much to Humphrey's success as his third wife, Mayo Methot." Bogie's new girlfriend and soon-to-be wife made him believe once again in the possibility that he could still become a star, an idea he was losing faith in. "He met Mayo and she set fire to him," Brooks observed. By the early part of 1938, Bogie was publicly acknowledging that when his divorce was final, he'd marry Mayo.

They fought as passionately as they loved, but that seemed to be part of the appeal for them both. To one fan magazine reporter, Bogie declared that he "adored" Mayo because she had the "guts" to tell him when he was wrong, "Mayo is a frail-looking person, as feminine and attractive as any woman could possibly be," he said, "yet she has more strength and honesty and directness than most men." His best girl "could pack a good wallop," he revealed, stroking his chin. "It still hurts." But slugging him, he insisted, was "the only possible way of handling a certain situation, and Mayo had the courage to do what she knew was right. Which is another reason I admire her so greatly."

The marriage took place on August 21, 1938, just ten days after the divorce with Philips was final. On August 13, Philips had married her old flame and Bogie's pal Kenneth MacKenna, thereby extinguishing her ex-husband's alimony payments before they'd even begun. After that, Bogie reasoned that it was safe to tie the knot with Mayo. The couple

exchanged their vows at the home of Melville and Mary Baker. Shei-
lah Graham caught up with Bogie shortly before the ceremony. "Are you
looking forward to it?" she asked him. "You dumb dope," he replied. "You
don't think I'd get married if I wasn't." After all, he told Graham, he'd
had a whole year to think it over, and here he was about to slip a ring on
Mayo's finger. Bogie's statement should serve as the final word on the
myth of the reluctant bridegroom.

It's been the tendency of most writers, influenced by later events, to
portray the marriage as doomed from the start. Bogie's jocular anecdotes
about his wife packing "a good wallop" served as the basis for charac-
terizing Methot as unstable and vituperative, the very archetype of the
shrewish wife. Every book and article written about Bogart since the
1960s has depicted Mayo in this way. But what those writers have been
doing, consciously or unconsciously, is layering problems from later in
the marriage onto its beginning. Their reasons for doing so have already
been discerned several times: the fault for the marriage's collapse could
never be Bogie's, and he could never truly have been in love with any wife
until he married his fourth. Yet there is scant evidence of problems in the
marriage, or Mayo's combustibility, in 1938 or 1939.

Tales of a row immediately following the wedding ceremony, for ex-
ample, arose only in 1966, based on the testimony of just one person,
Mary Baker. Bogie's first biographer, Joe Hyams, had reason to consider
Baker a reliable source; she'd hosted the wedding, after all. Baker de-
scribed a wild party with liquor flowing and the character actor Mischa
Auer parading around naked. It's certainly quite believable that the wed-
ding of Bogart and Methot included prodigious drinking. But we should
remember that Baker was also Bogie's agent, with a lifelong vested inter-
est in protecting his image. The wedding, therefore, needed to foretell
the problems that would occur later, as well as provide a stark contrast to
his next, much more respectable wedding. When Hyams presented the
row as fact, however, it slipped into legend.

Bogie's second biographer, Nathaniel Benchley, also interviewed
Baker, who provided him with further details of the quarrel: Bogie, in
a huff, had taken off for Mexico with Baker's husband, leaving his hys-
terical, drunken bride alone on their wedding night. Benchley at least
acknowledged that no one else present at the wedding recalled such a
tempest. And perhaps significantly, no records of Bogart crossing the
border exist during that period.

The lack of corroboration for the row suggests that Baker may have been exaggerating a minor kerfuffle. The reality is, during their first two or three years of marriage, Bogie and Mayo were devoted to each other. She remained his chief booster, getting right up into the faces of producers to lobby for him. She believed in Bogie as few others had ever done, and that would have meant something to a man who had spent four decades trying to disprove the verdicts of his parents and teachers and studio bosses. Among Mayo's personal papers were found several notes from Bogart, carefully preserved, that attest to his feelings: "My darling angel," he called her at one point. Another time: "I've thought of you all day, darling." Finally: "I love and I love you. Bogie."

He was grateful to Mayo for running the household efficiently, managing the finances, and working with their financial adviser, Morgan Maree, on investments that paid off handsomely. Moreover, Mayo had been the one who'd facilitated Bogie's change of agents from Leland Hayward, who spent little time on clients unless they were big stars, to the more egalitarian Sam Jaffe, for whom Mary Baker was now working. By the end of the 1930s, a team was in place to take Bogie to the top, and much of the credit for that should go to Mayo. She had provided the kick to his career that it needed.

Mayo also took his mother off his hands. Maud was sometimes invited to parties on Shoreham Drive, arriving just as her son always described her: regal, a bit aloof, impeccably dressed. But she was increasingly fragile, living with recurrent illnesses that left her vague and unfocused. One of Bogie's friends found her "jittery . . . a little out of it." When a butterfly flitted past her in the garden, she screamed in terror. With his painful childhood always close to the surface, Bogie found he could not bring himself to give his mother the sort of support and solace she had denied him. The best he could do was pay her bills. But Mayo, who'd had a much stronger relationship with her own mother, was up for the task. Maud liked her and trusted her. "Mayo loved [Bogart's] mother," said her Portland friend and caregiver. "They had a certain connection. Mayo often took her out or went to sit with her."

Best of all, Mayo could make the old woman laugh. To a reporter, Mayo described a time when she and Bogie "couldn't agree on anything" during one of Maud's visits. The senior Mrs. Bogart watched with some amusement as the couple bickered, contradicted each other, and threw up their hands in frustration. The next morning, Mayo called her

mother-in-law and told her, "I shot Bogie this morning. What does one do with a body?" Maud laughed, Mayo said; "She understood what I meant perfectly."

Mayo also lent support when, a few months after their marriage, Bogie got word that his sister Kay was in intensive care in New York. She'd been ill for about three weeks before her appendix, compromised by alcohol, had ruptured. Her husband had rushed her to Gotham Hospital. Dr. M. S. Rohde spoke to Bogart via a long-distance phone call and, according to his testimony, was told by the actor "to do everything necessary and spare no expenses." Sadly, Kay died of peritonitis after surgery. "She was a victim of the speakeasy era," her brother mused after her death. "She burned the candle at both ends, then decided to burn it in the middle."

Bogie wired his brother-in-law $504.30 to cover the costs of Kay's care. Two days later, he wired him an additional $250. But it wasn't long before invoices from the Gotham Hospital began piling up on Morgan Maree's desk, stating that only $300 had been paid on the account. Bogie told the hospital that Bonnell was responsible, but the widower had disappeared. Collection agencies demanded payment, with Maree insisting that they needed to track down Bonnell. After remaining unresolved for two years, the issue came to a head when Dr. Rohde claimed that Bogie had promised during that long-distance telephone call to be responsible for the payment, a promise Rohde said could be backed up by Bogart's mother, who'd been privy to the conversation. The last demand for payment came on May 31, 1940. There are no further statements on the matter in Bogie's files. It seems likely that he stopped resisting and paid the bill. A long-drawn-out legal fight would have made him look stingy, even if his brother-in-law had stiffed him.

Whether Bogie took any caution from how Kay had died is unknown. It seems unlikely. He'd come of age in the speakeasy era as well, and he still drank as hard as he had back then. There was no change in his behavior after his baby sister's death.

WEARING A NATTY SERGE BLAZER OVER A CRISP WHITE SHIRT AND BROWN pleated trousers, Bogart welcomed a journalist to his home on Shoreham Drive. They sat on the terrace with the awe-inspiring view of the valley as Mrs. Bogart brought out trays of hors d'oeuvres. They discussed his latest picture and his love of sailing. Bogie smoked a pipe, watching as

the rings of smoke ascended toward the sky, completing the picture of the distinguished, thoughtful movie actor.

Bogie's third marriage coincided with the buildup of his career that would, several months later, culminate in *Dark Victory*. The miserliness of the studio execs toward him had softened after the success of *Dead End*, and they had decided to aggressively boost Bogart up the ranks. He had finally been signed to a year's contract at $1,100 per month. Although well below the $1,750 he'd been aiming for, it was a move in the right direction. By continuing to do his job without complaint, Bogie had won the studio's respect, which was half the battle. Jack Warner knew that his star was a brawler and hard drinker, but he was rarely late to the set and always delivered a credible performance, even when stuck in a clunker. He wasn't a troublemaker like Cagney or Davis, going on strike, filing lawsuits. He might grumble, but he showed up for work. Once again, his social class may have helped him, just as it had a number of times during his career. Warner once remarked approvingly that Bogart had "breeding," something he wished more actors had. To the largely immigrant, rags-to-riches movie producers, social class was everything.

The seven films Bogie made between the disastrous *Swing Your Lady* and the successful *Dark Victory* were a mixed bag, but we can nonetheless discern a gradual rise in stature for the actor as he solidified the favor of the higher-ups at Warner Bros, even if they remained unsure how to use him. *Crime School* reunited Bogie with the Dead End Kids, but this time he played an upstanding cop, which meant he exhibited none of the nuance and pathos of Baby Face Martin. In *Racket Busters*, he was once again a criminal and playing the leading role, but the story of a racketeering truck driver was less than compelling. *The Amazing Dr. Clitterhouse* was more profitable, possibly because Edward G. Robinson was the star, but Bogart shone as the gang leader "Rocks" Valentine. For the next Dead End Kids picture, the phenomenally successful *Angels with Dirty Faces*, Bogie played a shady lawyer but had to forfeit all of the fun gangster shenanigans to James Cagney, the star. Still, three out of the four were financially successful, which counted for a great deal in the front office.

Even more promising was Bogie's next film, *King of the Underworld*, in which he once again played a gangster and, at least according to the billing, was the star of the picture. Bogie's costar, Kay Francis, had been bumped down to second place after a dispute with the studio. (Francis's ex-husband Kenneth MacKenna was now Bogart's ex-wife's new

husband, a tidbit the press gleefully pointed out.) As the mob boss Joe Gurney, Bogie is 100 percent unadulterated evil, with none of the shading of *The Petrified Forest, Black Legion,* or *Dead End.* Still, the director, Lewis Seifer, produced an action-packed sixty-seven minutes with a suspenseful ending. *King of the Underworld* proved to be a smash when it was released in January 1939. It was Bogie's first box-office success with his name above the title.

Yet still, the studio hadn't figured out the formula on how to make Bogart a bona fide star. *The Oklahoma Kid,* for which Bogie once again ceded top billing to James Cagney, was a hit, further establishing him as a top name. But Bogie never played comfortably in westerns—he looked a little silly in a cowboy hat—and certainly Cagney had the more textured part. His next picture, *You Can't Get Away with Murder,* his last before *Dark Victory,* was a box-office flop, with Bogart, once more irredeemable, fatally shooting Billy Halop, one of the beloved Dead End Kids. It was not exactly the way to win leading man material.

Still, Bogart had enough hits under his belt by that point to stay on the good side of the studio brass. In fact, when he was cast in *Dark Victory,* it was the extraordinarily profitable *Angels with Dirty Faces* that was playing in the nation's theaters. Once he was cast in *Dark Victory,* the studio-driven publicity campaign ratcheted up. The studio needed to prepare audiences for a very different sort of Bogart in his new picture. Warner Bros. saw something in him, even if the brand remained undefined.

Reporters began beating a path to his door. They went to his house, they went to the studio, they went to the Lakeside Country Club. Dora Albert from *Modern Screen* met him at the club, where she found him wearing white checked trousers and a blue sport shirt. The pipe wasn't in sight, but he gave every appearance of the country squire. Gesturing around the club, with the blue sky outside the windows and the sunlight streaming in, he observed, "It's pleasant here, isn't it?" At one point, Mayo came bounding in and appeared suitably affectionate, even deferential, toward her husband.

In another interview, Sara Boynoff of the *Los Angeles Daily News* explained away Bogart's well-known "mean streak" as simply "a refusal to conform to conventional expectations. . . . He refuses to render lip-service unto Hollywood and its 'art.'" Bogart's publicity had to walk a careful line. He needed to be presented as leading-man material, but he must not appear *too* cultured. Real men, remember, weren't supposed to

care about acting, and putting quotes around "art" was a subtle way of getting that point across. He had no regrets about leaving the theater, Bogie told Boynoff. "I think that few actors are so valuable that they can afford to sacrifice their responsibilities to starving in a garret for their art," he said.

Yet the truth was that by the late 1930s, Bogie was driven by a desire to finally, once and for all, prove himself as an actor. Since his earliest days with William Brady, he'd been motivated to prove his worth to his parents, his teachers, his friends, his wives—and he'd made a lot of advancement in that direction. But by 1939, he'd moved the goalposts even farther ahead. He was dissatisfied with being a second-string George Raft, of never being seen as in the league of Cagney, Robinson, or Tracy. He wanted to be a star.

Starting in 1938 and escalating during 1939, around the time of *Dark Victory*, we can observe the careful, nuanced strategy that Warner Bros.' press agents employed in the promotion of their contract player. Stories of Bogie's drinking and carousing were already current, so the advice from the publicity department (routinely given to an actor before an interview) was to distance himself from the snooty elite, even if some of them (Eric Hatch, Robert Benchley, others) were his pals. "I have a few friends and I go to parties occasionally," he told Sara Boynoff. "But I hate phonies. I can't stand the pretty boys with the toothpaste grins and I don't like the little girls who suddenly become stars and then rent big houses and give parties with gold plate services and butlers in black silk pants."

Given the middle ground he occupied between tough guy and leading man, Bogart had to be seen as antithetical to the image of the too-glamorous, too-self-absorbed movie star. Boynoff gave the impression that he possessed no pretentious desire to be a star—despite the fact that he did, very much. The press insisted that Bogart's only ambition was "to play golf in the lower 70s." The studio was doing its best to make clear that the "ordinary Joe" Humphrey Bogart was the real deal. If the only way to become a star was to pretend he didn't want to be one, Bogart was fine with it.

The next goal was trickier: to convince the public that he could be romantic. The fan magazine *Motion Picture* was likely encapsulating various studio press packets when one of its columnists reported, "There are heavies who are in the heavy sugar. The ones who can qualify as

romantic menaces"—namely, the columnist wrote, Basil Rathbone, Brian Donlevy, and Humphrey Bogart.

But lest Bogie come across as too gallant, the studio image makers used his reputation as a belligerent to balance things out. During a visit to New York in the spring of 1939, he apparently got into some fisticuffs in the lobby of the hotel where he was staying with Mayo. Here is the way *Motion Picture* reported the episode: "There's a disturbing male element who resent actors. [A group of hecklers] shouted, 'So you're a tough guy, eh?'" Bogie took the bait and began throwing punches. Mayo insisted that she and her husband were booted from the place. (Significantly, they took refuge at the friendlier Algonquin, where Dorothy Parker, Robert Benchley, and other sophisticated roués held court.) The point of allowing the story to make it into print was to reinforce the idea that Humphrey Bogart was different from other actors. The trope of the effete (read dandified, effeminate, homosexual) actor was already deeply ingrained in the popular imagination, and so the studio, aware of that while building up a property such as Bogart, had to keep providing evidence that he was not any of those things.

Another public relations campaign attempted to position Bogie as a sportsman, an effort Louise Brooks found rather odd. "Humphrey, according to his biographers," she wrote, "played golf, tennis, bridge, chess. He sailed, he read books! [But] the only thing I ever saw him do was sit and drink and talk to people." Studio flacks may have been exaggerating his athleticism to boost the masculine image they were trying to create, but there's no question that Bogie golfed and loved to sail. In late 1938 he set off on a rented yacht for a three-day cruise to Catalina with Mayo, Gloria Stuart, Arthur Sheekman, and others. Bogart was a competent captain, the lessons learned so long ago from his father unforgotten. But three hours out, the yacht's compass broke and they found themselves stranded by fog. When the fog finally lifted, the motor conked out and they had to row to the island, where their rescuers didn't arrive for several hours. *Motion Picture* reported, "The Hollywoodsmen vowed, when they finally got back to the mainland, that their next all-water party would be in a bathtub."

WHEN *DARK VICTORY* WAS FINALLY RELEASED, BOGIE WAS RIDING HIGH. HARRY Mines in the *Los Angeles Daily News* applauded the "frankly sexy" scene

between Bogart and Davis, one that "never steps beyond the boundaries of good taste." Archer Winsten in the *New York Post* was impressed that the menacing bad guy of the screen was just a stablehand in this film "with a thick but not phony Irish brogue," likely picked up from the succession of Irish housekeepers during his childhood. "After a while," Winsten continued, "you stopped expecting him to whip out a rod. You accepted him as a horse trainer. That's acting."

Bogie might have drawn even more acclaim if his final scene hadn't been deleted after the previews. In the finale that's become famous, Davis, realizing that she will soon die, closes herself off in her room; the camera blurs over her face and fades to black. Originally, the ending showed Davis's horse winning the championship and Bogie stroking the animal, tears running down his face. Though the preview audiences preferred the fade-out on Davis, those who saw Bogart's closing scene praised its emotional sincerity, an effect he'd achieved with the help of Goulding. A crying Bogart, however, may have been too much for the studio chiefs to accept.

So strong was Bogie's position after *Dark Victory* that he was quickly cast in Davis's follow-up picture, *The Old Maid*. Hal Wallis announced his casting on February 22, 1939. Edmund Goulding, once again directing, coached the actor for the pivotal part of Clem Spender in the adaptation of Edith Wharton's Civil War novel. "Humphrey Bogart is wearing a highly pleased smile these days because by a sudden turn of motion picture fate he has become a great lover," wrote the columnist Alexander Kahn. As Clem, Bogie was the love interest not only of Davis but of Miriam Hopkins as well. When Hopkins spurns him, Davis consoles him; later, Clem is killed in the war but not before leaving Davis pregnant with his child. Bogie told Kahn that he found the part a "blessed relief" from all the "prison, gangster and gambler roles" of the past. "It's been so long since I've had the chance to make love to a woman on the screen that I had to go back and read the exploits of some of the great lovers of literature," he said—no doubt hyperbole, but without question it was a major change of pace for him.

But then, as tended to happen whenever Bogart was on the upswing, everything fell apart. A few weeks into shooting, Goulding and Wallis realized that they'd made a mistake. A studio memo dated March 20, 1939, revealed that Bogie was likely to be recast. He was simply not convincing as the charming rogue who captures the hearts of two powerful women.

On March 22, Wallis fired him, replacing him with the stolid George Brent. Bogie was deeply embarrassed and out of a job that he'd enjoyed. His "highly pleased smile" disappeared.

Days later, adding insult to injury, the studio dispatched Bogie to Kansas for the gala premiere of *Dodge City*, intended to burnish the stardom of its current top leading man, Errol Flynn. While on the train, several of the Warners contract players began drinking heavily, Bogie and Mayo, not surprisingly, among them. According to the testimony of Bob Wallace, a journalist covering the trip for United Press, Mayo grew jealous of her husband's attentions to some of the younger actresses and went after him with the broken end of a Coca-Cola bottle. Again, this is a story told decades later, after the image of a dangerous, unhinged Methot had become standard in Bogart biographies. But if it's true that the actors were drinking heavily on the train, maybe things did get out of hand. Mayo drank as much as her husband, and she doesn't seem to have been a "fun" drunk. Maybe she did throw a Coke bottle, broken or not, at him. Regardless of the actual nature of the incident, when the studio's publicity department got wind of the antics of its players, its reaction was horror. Thankfully, Warners dodged a bullet: according to Wallace, a memo was sent to the top brass assuring them that the actors had all been "protected" from the press. No one, thankfully, wrote about the company's misbehavior.

What's clear is Bogie's reputation as a brawler hadn't disappeared. Incidents such as the train brouhaha and the scuffle in New York may have left Warner Bros. executives wondering how long their luck would hold out. He was sometimes ejected from Hollywood nightspots after squabbling with the doormen. "If I feel like going to the Troc [Trocadero] wearing this coat [not a very new one] and moccasins, that is the way I go," he told a reporter around that time. "If I want to make a jackass of myself in front of every producer in town, that's my business."

M. O'Brien recalled a story that Mayo told of another contretemps Bogie had been involved in not long after *Dark Victory* was completed: "stinking drunk," he had relentlessly badgered another actor at a Hollywood nightspot until the actor had thrown a punch at him. Badgering, as Bogie would admit, was his usual modus operandi, and he usually withdrew from the fight once he'd gotten a rise out of his opponent. But that night, fists flew both ways. In any event, the studio fixers once more persuaded the press not to run a story about it.

All of this might explain a curious profile penned by Gladys Hall for *Motion Picture* in late 1939 or early 1940 (for publication in the April 1940 issue). It's a hodgepodge of mixed messaging. Hall was one of the studios' most cooperative journalists, always eager to spin a story that would please the moguls and ensure her continued access to the stars. Nonetheless, she was a decent writer and often produced some genuinely interesting profiles, but in this particular case the task was apparently beyond her skills. Entitled "Bogey Man," the piece used the alternative spelling of Bogart's nickname to conjure up a child's nightmare. But the point of the piece was precisely the opposite. In a joint interview with Mayo at the house on Shoreham Drive, Bogart's reputation as a tough guy is consistently undercut by anecdotes from his wife that position him as a soft touch. Although Bogie meekly protests, Mayo always has the last word. Her husband avoids fights, she says, because he always gets beaten up. She calls him "sentimental"—the same description that had been denied in earlier publicity—and even "sort of fussy." He plays croquet, of all things, Mayo reveals, although she makes sure to distinguish Bogie's routine from the "sissy" version of the game; he likes "hazards, sand-traps, hills, bunkers and such," she declares.

In that interview, Hall seemed to tear down everything that had come before in Bogart's publicity and then, confoundingly, to build it back up. He's a softie, a pacifist, a bit of a fussbudget. But then Hall added that Bogie ate only steaks and chops. He never said "I love you" to a woman. Instead, he told Hall, "A good slap on the . . . can go deeper than any words." (The magazine used ellipsis points in place of, apparently, the word "ass," but the effect was still achieved.) "Bogey Man" seemed to want to have it both ways: Bogart wasn't a brawler or a bully, but he was still a man's man, a regular guy, and he wouldn't mind being more like his screen persona. Hall ended the piece with Bogie vowing, "One of these days I'm going to do in real life what I've often done on the screen. I'm going to take a swipe at some bloke, shove his cigar down his throat . . . dust my hands and say, 'Take him away.'"

There is so much to unpack in this one profile. It's hard to read the piece and not think of the real-life swipes that Bogie was taking at other blokes during that period. If one of the fights made it into print, with Bogie charged with disorderly conduct or drunkenness, any thought of promoting him as a romantic hero would be over. When he had been arrested in Hingham, he'd been a minor Hollywood player; now he was

the object of a major studio buildup. "Bogey Man," then, appears to be a line of defense against the rumors about his drinking and unpredictable temper.

The appearance of "Bogey Man" in April 1940 cannot be separated from the barely contained public disasters of the previous year. The fact that the studio heads agreed to allow such a confusing profile to make it into print suggests that they wanted to get ahead of any potential bad press. It also provides a possibly different lens on why Bogie was canned from *The Old Maid*. If Mayo's friend is correct, and the incident at the nightclub took place not long after *Dark Victory* had wrapped, there may have been some second thoughts at the studio about continuing the campaign to make Bogie a romantic hero. Hal Wallis and Jack Warner may have figured that the safest course would be to cut him loose from *The Old Maid*, because who knew when he might erupt again. Such stories wouldn't be as harmful to a villain or a rogue than they would be to a romantic leading man.

Bogie's alcoholism had always been a threat to his career, but he'd largely kept his addiction separate from his work. By 1940, however, as he entered his fourth decade, the drunken brawls and recklessness were starting to encroach onto his professional life and reputation, thereby jeopardizing his move up the ladder. A large reason for the change was the fact that he was now matched, whisky by whisky, by his wife. Mary Philips had also kept up with Bogart's drinking, but at a certain point she'd turned her attention to her career. Now Bogie had a wife who stayed home and put her career second to his, just as he'd always wanted. But his drinking only increased. The problem was that Mayo didn't just tolerate his drinking, she made it worse by her own participation.

WHETHER BOGIE'S INCREASING MISBEHAVIOR AND NEAR-MISS PR DISASTERS caused Warners to slow down his star buildup cannot be proven, but the number of profiles and mentions of the actor decreased markedly in the period from mid-1939 to late 1940. A clue to the studio's unhappiness might also be found in the picture Bogie was assigned soon after his dismissal from *The Old Maid*. It was *The Return of Doctor X*, a sequel to a 1932 picture in which Lionel Atwill had played the titular character. In the new film, Doctor X is brought back from the grave, a hybrid

zombie-vampire who sustains himself by drinking human blood. It was certainly a far cry from Bogie's sensitive, romantic groom in *Dark Victory*.

Bogart had reason to be worried. Players being assigned to horror films was rarely a good sign; it usually meant that the studio saw them as genre characters, more appropriate to B pictures than a major release. Bogie stewed over having to make "this stinking movie," as he called it. To one writer, he quipped, "If it had been Jack Warner's blood" Dr. X was drinking, "I wouldn't have minded so much." The fear was that the part, originally intended for Boris Karloff, could type him as a macabre actor. Indeed, when the film was released in November 1939, the *Los Angeles Daily News* remarked, "Humphrey Bogart joins the frightwig club fraternized by Messrs. Karloff and Lugosi." At the moment, that may have seemed to be Bogie's future.

For all the film's absurdities, however, Bogart performed competently, even with his pasty white makeup and the silver streak in his hair, not unlike that of the Bride of Frankenstein. He's genuinely creepy a few times, appearing out of the darkness and scaring the pants off people. Most reviewers treated the film kindly, seeing it as fun and humorous. The *Los Angeles Daily News* called it "a well-knit melodrama that fulfills its purpose in providing effective macabre entertainment." But in a period when horror films were in decline, *The Return of Doctor X* flopped at the box office; *Variety* called it "a no-dicer." For Bogie, that was probably just as well.

Meanwhile, against all odds, his agents weren't giving up on the idea of stardom. Just before *The Return of Doctor X* opened, reports appeared in newspapers across the country about the voluminous fan mail Humphrey Bogart was receiving from three "different strata of the American scene." The first group consisted of "convicts and ex-convicts . . . thanking him for making 'people understand us better.'" The second set of letter writers was made up of "children and youth-movement leaders," who thanked Bogart for his portrayals proving that "crime does not pay." Finally, he heard from women "attracted to the peculiarly sadistic roles" that he tended to play. "The combination of the three," the report declared, made Bogart "one of the most popular stars in the letter-writing firmament."

That was obviously a press agent's plant to propagate the idea of Bogart's wide appeal. What Bogie's dogged team—Sam Jaffe, Mary Baker, and Mayo—was undertaking—what they refused to give up on—was

some of the most unlikely star-making in Hollywood's history. Bogie was forty years old, ten or more years older than the newest up-and-comers, people such as James Stewart, Tyrone Power, Van Johnson, and Errol Flynn. Any matinee idol looks that he had once possessed were now gone for good. But still he was being positioned for stardom, a goal he continued to want very much.

"He was ambitious," Sam Jaffe recalled. "He was sincere about getting parts. He wanted to go forward." Jaffe saw his client's potential, which he identified as a "striking combination of intelligence and sexual energy." Plus, he had that "breeding" that always impressed first-generation immigrants such as Jaffe. "I was one of the few that felt that he could be a leading man," he said, and so he laid out a road map to make that happen.

The first step, no doubt to Bogie's frustration, was to continue slogging through a succession of monotonous supporting parts assigned to him by the studio. He needed to remind Jack Warner of his obedience, reliability, and skill. In July 1939, he started work on *The Roaring Twenties*, directed by Raoul Walsh, another gangster picture with Cagney top billed. Though Cagney rightfully dominated the reviews, at least some critics noticed Bogart as well. Mildred Martin of the *Philadelphia Inquirer*, after praising the top liner, remarked, "Humphrey Bogart is only a step behind him with his performance as the double-crossing trigger man." But it was no matter; the film was a bust. For his next assignment, *Invisible Stripes*, he was fourth billed behind George Raft, Jane Bryan, and a newcomer, William Holden, for whom insiders were predicting stardom. Holden was almost twenty years younger than Bogart. Not surprisingly, Bogie didn't care for his costar. He resented Holden's billing and the reckless way he rode a motorcycle in one scene with Bogie in the sidecar. He called him an "S.O.B." His opinion of the younger actor never changed. *Invisible Stripes* also failed at the box office.

Bogie needed a hit, even if he wasn't the star. He got one with *Virginia City*, a Civil War western directed by Michael Curtiz as a follow-up to his smash success, *Dodge City*. Shooting commenced immediately after *Invisible Stripes* wrapped; Bogie had maybe a week to learn his lines. Once again, he's far down the cast list, but Warner Bros.' latest moneymaker, Errol Flynn, who'd also topped the cast in *Dodge City*, ensured that the crowds would come. In this one, Bogie's the leader of a gang of "banditos" who takes on both good guy Flynn and bad guy Randolph Scott. His wagon train fight with Scott, according to the film's press releases,

took fifteen days to shoot, used 22,000 rounds of ammunition and 1,500 horses (none was hurt, or so it was said), and "purposely destroyed property worth $37,500." When *Virginia City* was released in March 1940, it was one of the studio's biggest hits of the year. Though Bogie was far from the leading player, he was part of a big, profitable studio success, and that mattered.

Yet for all of Jaffe's lobbying, Warner Bros. still didn't know what to do with Bogart. They'd tried to make him a brooding romantic figure, but that hadn't worked out. They'd tried to play off his bellicose reputation to turn him into a diabolical villain, but after *The Return of Doctor X* he was back to playing the same second-rate gangsters and connivers he'd been inhabiting since *The Bad Sister*. Even as Bogart dutifully reported to the soundstages, studio execs scratched their heads over the best approach to take with this most idiosyncratic of actors.

While Bogie was toiling in those pointless parts, Warners received a couple of interesting requests for his services. The first came from Universal, which wanted him for the forthcoming Mae West–W. C. Fields picture, *My Little Chickadee*, promising Bogart "the best part in the picture" (save for those of the two stars, presumably). That was likely the part of the Masked Bandit, eventually played by Joseph Calleia, which would have taken Bogie back to the days of Jose Vallejo. Whether Bogart could have made the transition to villainous comedy is debatable, but he never got the chance to try. The casting director, Steve Trilling, replied to Universal that Warners' "plans for Bogart were too uncertain at the moment" (an understatement), but he asked Hal Wallis if should pursue the idea further. Wallis said no.

The other offer was more intriguing. Director Lewis Milestone was interested in Bogart's playing the part of Lennie, the mentally challenged farmhand, in the film adaptation of John Steinbeck's novella *Of Mice and Men*. Sam Jaffe knew that it could finally elevate Bogart to the big time. It would be an important picture, and Lennie was already an iconic character. Indeed, Bogie might have been impressive in the part. Although he wasn't big and hulking the way Lennie was supposed to be, he could be lumbering and menacing while still conveying the instinctive humanity of the character. But the studio was holding Bogart in reserve for the film *It All Came True*, a bizarre musical comedy gangster picture, in case George Raft refused it. "Should Raft definitely work out for . . . *It All*

Came True, do you want to try to effect the most advantageous loanout for Bogart?" Trilling asked Wallis. The answer was apparently another no, as Lon Chaney, Jr., would go on to play Lennie to enormous acclaim. Meanwhile, Bogart trudged over to the set of *It All Came True* after Raft, as predicted, refused the part.

"They gave him nothing," Sam Jaffe grumbled decades after the fact. "He was being constantly mistreated . . . belittled." No doubt that treatment stirred deep resentment in Bogart, evoking the same old sense of rejection from people in power for not being good enough. Indeed, there is evidence that Warners had decided to simply maintain the status quo by that point, keeping him playing the same stock characters. Why invest big money in a forty-year-old actor with a face like a bulldog's? In the studio's view, certain roles were "Humphrey Bogart parts," as George Raft revealed in a letter to Jack Warner in October 1939. He reminded the studio chief that he'd been promised he'd never be given parts (read, secondary) "that Humphrey Bogart should play."

Unaware that the studio had apparently given up on him, Bogie kept jumping through hoops. The next was *Brother Orchid*, an Edward G. Robinson vehicle and another comedy crime picture. WE'D LIKE YOUSE TO MEET BROTHER ORCHID the movie poster read; the payoff is that the once-devious crime boss becomes a devout monk. This time the formula worked, and the picture was a success. Bogart, however, played it straight as a more stereotypical gangster and was barely mentioned by reviewers. He'd now done six pictures since *Dark Victory*, most of them flops, and in those that had made money, he'd been relegated to the background. He was right back to where he had been before *Dark Victory*, collecting a mediocre paycheck for mediocre work.

But all that was finally about to change.

FOR A FEW DAYS DURING THE MIDDLE PART OF APRIL 1940, THE CALIFORNIA STATE Police blocked off a section of State Route 1, or the Roosevelt Highway as it was often referred to then, so that a film crew from Warner Bros. could shoot some footage of freight trucks racing past each other. The director, Raoul Walsh, was there to supervise the shots, which would end up filling less than two minutes of screen time, but the actors playing the truck drivers, George Raft and Humphrey Bogart, were safely back

in Los Angeles. Their scenes behind the wheel would be shot later, on the studio lot, and intercut with the location footage. The film was *They Drive by Night*.

Bogie's latest assignment had started off not so differently from the previous six films he had made for Warners. Once again, he was far down the cast list, behind Raft and Ann Sheridan and even the newcomer Ida Lupino, which likely irked him as much as William Holden's billing in *Invisible Stripes* had done. The role he was playing, at least according to early press releases, was also familiar. "Humphrey Bogart, Warners' most consistently working sneerer, gets another villain role," one columnist reported. "This time he wrecks George Raft's peace of mind in *They Drive By Night*." Other items referred to him as the "heavy."

But something seemed to change once the cameras started turning. "Bogart's role is to be imbued with much sardonic humor," reported the *Los Angeles Times*. Indeed, Bogie is far from being a villain or a heavy in the picture. As the long-haul trucker Paul Fabrini, he displays a quick temper and indeed some dry, sardonic humor, but he's honest, level-headed, and devoted to his wife. Paul drives rigs up and down the California coast with his brother, played by Raft—whose peace of mind does indeed get wrecked but not because of any villainy on Paul's part. Instead, Paul loses his right arm in an accident for which Raft feels responsible. That becomes the motivating event that leads Raft into collusion with the unhinged Lupino and eventually gets him charged with murder. In the second half of the film, Bogie played Paul with his right arm strapped down to his side, over which he wore a jacket with an empty sleeve. He's the most sympathetic character in the film, something he'd never been before.

In some ways, Paul Fabrini was the culmination of Bogart's publicity over the past year. The contradictory profile described in "Bogey Man" had been confusing, with Bogie portrayed as both a decent all-around guy and a hotheaded rascal. But that's exactly what he is in *They Drive by Night*. Walsh appears to have sensed that Bogart could handle a more nuanced approach, and the result was one of the most naturalistic performances the actor had yet given. Looking back, Bogie would see the picture as a turning point. "Until *They Drive By Night*, I had about five pictures in a row where I could have read you off most of the dialogue before I even saw a script," he said. The film took seven weeks to shoot, wrapping at the end of May. Just as with *Dead End* and *Dark*

Victory, the advance word was that Bogart was terrific in his small but important part. But Bogie surely recalled how those two films had failed to change anything.

Behind the scenes, however, a shift was taking place regarding Bogart's position at the studio. Paul Muni, Warners' current most celebrated tough guy, had recently ripped up his contract in a dispute with executives. George Raft, the studio's second most celebrated tough guy, was growing argumentative over his parts. In the midst of all that, Hal Wallis was trying to produce a script called *High Sierra*, a crime drama written by the young screenwriter John Huston set in the Sierra Nevada mountain range. Muni had been its intended star, but Wallis had hedged his bets by showing the script to Raft as well. In the meantime, the studio also decided to take a fresh look at Bogart, perhaps to take up the slack left by Muni's departure. Sam Jaffe's hectoring seemed at last to be paying off.

Bogie very much wanted the part in *High Sierra*. Before Muni's departure but while rumors swirled that it was imminent, he'd cabled Hal Wallis, I NEVER RECEIVED AN ANSWER SO I'M BRINGING IT UP AGAIN AS I UNDERSTAND THERE IS SOME DOUBT ABOUT MUNI DOING IT. Wallis did not reply. But Bogart's name was being bandied about in executive meetings, since Raft, too, was being obstinate. Resentful at playing the heavy all the time, Raft had convinced himself that he was a romantic leading man, making him resistant to appearing in *High Sierra*.

Some stories have Bogie, at that point, snookering Raft into turning down the part by commiserating with him over the studio's treatment. Whether the stories are true or not, Bogie was determined to star in *High Sierra*. He saw the part of the gangster Roy "Mad Dog" Earle far differently than Muni or Raft did. Earle was indeed a crooked thief and gang leader, but Huston's script makes clear that he wants to go straight, that his conscience troubles him. That was quite the meaty challenge for an actor, and Bogart hankered after it. Huston later said that only Bogie understood the depth of the part. Raoul Walsh, remembering his work on *They Drive by Night*, was also enthusiastic.

Muni was still being called the star of *High Sierra* in press reports up through July 11, 1940. But on July 14, Louella Parsons broke the news that he'd refused the part. Over the next couple of days, Wallis tried to get Raft on board, but the actor adamantly refused. So on July 19, Parsons revealed that the studio had decided to go with a very different leading

man. "Suddenly Warners have discovered Humphrey Bogart," she wrote, "and from now on he is going to be one of their top men, and rightly, for Bogey is a swell actor."

The decision to cast Bogart was probably made on July 16, as on the seventeenth an extraordinary memo was sent within the Warner Bros. publicity department. "I want you to give the utmost concentration to the building of Humphrey Bogart to stardom in as quick a time as possible," S. Charles Einfeld, the director of studio advertising and publicity, wrote to Martin Weiser, who masterminded promotional campaigns. "Bogart has been typed through publicity as a gangster character. We want to undo this." Bogart, he said, was "one of the greatest actors on the screen today," and he cited *The Petrified Forest, Dark Victory,* and *They Drive by Night* as evidence. "The fellow is a master of technique and can do anything. In *Dark Victory,* he showed a type of sex appeal that was unusual and different from that of any other actor on the screen today." Einfeld instructed Weiser to "sell Bogart" both romantically and as "a great actor." Jack Warner wanted the country to be flooded with Bogart photos, profiles, and column items in the lead-up to *High Sierra.* "This is one of the most important jobs you have before you in the next few months," Einfeld told Weiser. "I know I can count on you."

As the doyenne of the gossip corps, Parsons was naturally the first to get the studio's plan, and she eagerly played ball, opining what a "swell" actor Bogart was. A couple of weeks later, she also published what she claimed to be a letter from a reader: "Now that Humphrey Bogart is a star, I hope Warners don't polish him out of his lisp." The item served two purposes: first, it established that Bogart was already a star (even though *High Sierra* hadn't been shot yet), and second, it reminded the public that he was a regular guy with an unpretentious way of talking; no studio could polish up a guy like that into a fancy-pants matinee idol.

And so began the most expansive publicity campaign Bogart had ever received. In the weeks after Weiser got his marching orders, the number of photographs printed of Bogie, usually with Ann Sheridan from *It All Came True,* spiked in newspapers and magazines. Items appeared that pushed the "ordinary Joe" narrative, with Mayo revealing that her husband took apart toasters and alarm clocks and then reassembled them to pass the time. There was a bizarre story of Bogart's buying a red-and-gilt circus wagon that had once held a lion, intending to use it as a cabana on the beach. Such far-out exploits were part and parcel of studio

promotional campaigns; just a few years earlier, Katharine Hepburn had been handed a gibbon and told to be seen around town with it.

The most critical piece of the star-making campaign was, to use Einfeld's phrase, the "undoing" of Bogart's gangster image. Obligingly, *Motion Picture* published an item on the new star's perspective on lovemaking. "Bogart, having apparently nothing else to do," the writer observed, "has been conducting some research, and pops up with an analysis of Where to Make Love, as applied to certain types of romancers." Among his recommendations were transatlantic liners; airplanes ("for the light-headed ones"); country lanes (for the "youngsters"); and, to show just how romantic he could be, he added, "A hammock beneath the maples" for "those who want the world to go by."

Another fan magazine devoted a whole feature to the star's ascent, entitling it "The New Bogart" and succinctly described the challenge ahead: "Now that he is a star, Bogie faces the horrid duty of living up to his new eminence and living down his past in gangster parts." The actor is presented, of course, as being resistant to the whole "star" identity and clueless about the publicity buildup until a friend tells him, which is malarkey. The piece also followed Einfeld's talking point in promoting Bogie as a great actor. For his upcoming role in *High Sierra*, he had seen beyond Roy Earle's gangster background and recognized "a splendid chance for what every actor loves most: a solid character role."

In the midst of all that, *They Drive by Night* was released to tremendous box office and critical acclaim. In hindsight, the part of Paul Fabrini was an excellent segue between Bogart's old image and his new one, although no one could know that at the time.

Bogie was aware that some star buildups just didn't take. The public had declined to embrace the Ukrainian-born Anna Sten despite Sam Goldwyn's relentless promotional campaign. George Raft, for all his determination, had never taken off as a romantic leading man. In the summer of 1940, Bogie was no doubt realistic about his prospects. He'd gotten his hopes up before; he knew how things worked in this town. But it was the closest he'd ever gotten to stardom, with a major studio campaign behind him and an upcoming starring role in an important picture. Mayo and Jaffe kept telling him that all their work had paid off and by the same time next year he'd be riding high. Still, by the time *High Sierra* came out, Bogart would be forty-one. His age had only become more conspicuous. Among the top box-office stars that season were

the teenage Mickey Rooney and Judy Garland, the twenty-four-year-old Van Johnson, the twenty-five-year-old Tyrone Power, the thirty-one-year-old Bette Davis, and the thirty-two-year-old Gene Autry. Though some of his contemporaries—Cagney, Gable, Tracy, Gary Cooper—still made the list, they'd all been stars for more than a decade, having started in their early twenties. Nonetheless, Bogie's team had high hopes.

That is, until the night of August 14, when the Los Angeles DA's office released the news that Bogart was being investigated as a Communist. No doubt Bogie felt as if he'd just been sucker punched. Of all the obstacles he might have imagined could detour him on the road to stardom, that surely had not been among them. His support of the striking lettuce workers four years earlier, a sincere, impulsive expression of generosity, had suddenly become controversial in the growing anti-Communist hysteria of the period. The crisis was real. Bogart's long-held dream of success might be snatched away just as it was about to come true.

Hollywood, California, Wednesday, August 14, 1940

It was late, close to midnight. The delegation from the studio showed up with little warning, just a phone call to confirm that Bogie was at home. When the execs arrived on Shoreham Drive, their faces were grim.

Just hours earlier, the office of District Attorney Buron Fitts had released transcripts of a grand jury testimony naming Bogart, James Cagney, Fredric March, and several other Hollywood actors, writers, and craftsmen as Communists. The accuser was John L. Leech, a housepainter and formerly an American Communist Party "chief functionary," as the newspapers described him, who'd given sworn testimony to Fitts. For the people named, the news was potentially catastrophic, both personally and professionally. The DA planned to share the grand jury's findings with Representative Martin Dies, Jr., the chairman of the House of Representatives Special Committee on Un-American Activities, who was opening his West Coast hearings in a matter of days.

As the Communist candidate for Los Angeles' 17th Congressional District in 1934 and 1936, Leech, along with his wife, had been a local party leader for much of the decade. Although he had lost both of his races, he had garnered 1,634 votes in 1936, a 400 percent increase over his tally two years earlier. In the depths of the Depression, the Communist cause seemed to be winning over some hearts and minds. Party stalwarts such as the Leeches were convinced that a Communist revolution was imminent. That same year of 1936, John Leech had assisted with the fundraising for the striking lettuce workers. The American proletariat, the Communist Party believed, was uniting.

But then something had happened to dim Leech's view of the party to which he'd once devoted his life. Whether his change of heart was due to disillusionment with communism or because of legal action threatened by government officials is unknown. Yet whatever the reason for his cooperation, he was sufficiently motivated to serve as the star witness in the 1938 deportation trial of the Australian-born labor leader Harry

Bridges, claiming that he was a dues-paying Red. That effort failed, but Leech was now a known quantity; the Communist newspaper *Daily Worker* called him a "professional witness," implying that he was paid by the government to testify in their prosecution of suspected Communists. Indeed, it appears that Fitts approached Leech, not the other way around, sometime in the first half of 1940. The district attorney, who was currently being sued for assault during an illegal raid, was up for reelection that fall. Accusing some Hollywood names of being Reds was certain to bring him considerable, and more favorable, coverage. Fitts convened a grand jury to hear Leech's testimony.

On August 9, five days before the explosive charges were officially released, word leaked that the actor Lionel Stander was among those being accused. Stander, who'd played prominent character roles in *Mr. Deeds Goes to Town* and *A Star Is Born*, attempted to speak to the grand jury to clear his name, and the press got wind of it. Hollywood was left wondering who else was being investigated. That may have been the first tip-off for Bogie that something was brewing that might include him, but he likely still believed that a couple of donations to American workers couldn't be construed as subversive. But the far Right had likely been suspicious of Bogart for some time, especially after he had proudly declared in a high-circulation fan magazine that he was a "liberal Democrat" who thought that President Roosevelt was "a grand guy."

After a likely restless night, Bogie awoke to bold headlines on the front page of the morning newspaper: HOLLYWOOD NAMES CITED IN RED INQUIRY. GRAND JURY TRANSCRIPT DESCRIBES ALLEGED LINKS WITH COMMUNIST PARTY. In other newspapers, Bogart's photograph, along with those of other top names being accused, accompanied the headlines. Leech, according to the *Los Angeles Times*, had provided "a broad picture of communist activities in Southern California," claiming that Bogart and several of the others had taken part in "study groups" organized by the Party. Bogart had been committed enough, Leech said, to contribute $150 a month to party coffers for several years.

That, of course, had been during a period of financial struggle for Bogie, when he was footing the bill for his sisters and mother and not getting any help from Warner Bros. It's very unlikely that he could have afforded that much for that long even if he had wanted to. Was Leech confusing Bogart's contribution of $1,000 to the Screen Actors Guild to support the striking workers? If so, how did he know about it? Or was he

exaggerating his testimony, making faulty assumptions, or just plain lying because he was being paid per each person he named?

The studio issued a statement from Bogart. "I have never contributed money to a political organization of any form," he declared. "That includes Republican, Democratic, Hollywood Anti-Nazi League or the Communist Party." Though he was technically truthful in his statement, donating to a trade union for a specific cause does carry political implications, and the grand jury could see that. He went on, "Furthermore, I have never attended the school mentioned nor do I know what school that may be." The substitution of the word "school" for "study group" may have been deliberate to make Leech's charges appear absurd. Bogart concluded, "I dare the men who are attempting this investigation to call me to the stand." Fighting words from one of Hollywood's most menacing leading men.

Others also offered denials, but only Samuel Ornitz, one of the founders of the Screen Writers Guild, called out the obvious political posturing of the DA. Ornitz had testified privately to the grand jury, and though he couldn't reveal what he'd said to it, he laid out the facts as he saw them to the press on the day the news broke: "It is sad that Mr. Fitts elected to prey upon and slander innocent people just before the election." Many of those being accused, Ornitz pointed out, were supporters of Fitts's opponent, John F. Dockweiler.

Congressman Dies, who arrived in Los Angeles that same day, August 15, was a big, brawny Texan, just thirty-nine years old (young for the halls of Congress) and "ambitious and cocksure," according to the *New Republic*. He had made a name for himself as a fiery antagonist to President Roosevelt, a fellow Democrat, investigating what he perceived to be socialist initiatives within Roosevelt's New Deal. Dies had argued for the establishment of a committee to investigate "un-American" activities. Congress had agreed, but largely because of the actions of the right-wing Black Legion, making the accusations against Bogart particularly ironic. Yet Dies spent very little time on right-wing extremism, choosing instead to target labor unions, pacifist organizations, and groups advocating progressive policies. He knew who made up his base. In his possession, Dies had a telegram from the Ku Klux Klan assuring him that every Klansman was behind him and his committee.

On his first official day in Los Angeles, Dies extended an invitation to those named in the grand jury investigation to attend a special

hearing to be held in his suite at the Biltmore Hotel. "Very grave charges have been made against some people in Los Angeles," he declared. "If substantiated, they should result in criminal indictments." By inviting those accused to come forward, he was giving them the chance to avoid subpoenas. One way or another, he intended to get their testimony. What was at stake, Dies said, was the security of the United States, as the charges suggested "possible espionage and sabotage."

Bogart was the first to accept Dies's invitation. On the morning of Friday, August 16, he arrived promptly at the Biltmore to give his testimony and face Dies's questioning. The production of *High Sierra*, which had just gotten under way, was halted; the daily log noted, "Bogart absent this morning, appearing before the Dies Committee." With him was Morgan Maree, his accountant, who was prepared to assure the committee that Bogie had never made a donation to the Communist Party. The facts, Bogie believed, were on his side.

What he didn't know, however, was that the Federal Bureau of Investigation had been keeping a file on him since 1936—and that Dies had access to it. During the Bureau's investigation into the Screen Actors Guild after its fundraising for the labor union, Bogart's name had turned up on a list of actors with "strong CP leanings," according to his FBI file. Significantly, the allegation predated Leech's testimony, as he had been running for Congress as a Communist at the time. So that means that someone else had also fingered Bogart as a Red some years before Leech. That may have been Rena Vale, a stenographer for several different screenwriters who was a member of the Communist Party from 1936 to 1938; she later turned informant, naming Lucille Ball, Gale Sondergaard, and others. During questioning, Bogart was asked if he knew Vale, raising the possibility that it was she who had named him. His reply to Dies was a terse "Never heard of her."

Elsewhere in his FBI file, Bogie was described as one of several "subversive thinkers" in Hollywood. Leech would corroborate, and elaborate on, those charges to Fitts's grand jury. Besides being a regular donor to the Party, Leech claimed, Bogie was a frequent attendee of gatherings at the home of Paramount chief B. P. Schulberg, whose son Budd, a screenwriter, would "read the doctrines of Karl Marx" to his guests.

It's perhaps good that Bogart was unaware of the contents of his FBI file when he took his seat opposite Dies in the congressman's hotel suite. If he'd known that the accusations went back four years, he might have

become rattled. Instead, he was calm and deliberative. Dies, in his usual white suit and bow tie, began by asking Bogie if he knew Leech. He replied that he did not. Dies then gave him a chance to respond to Leech's accusations. "I'd say they were 100 percent untrue," Bogie said; "they couldn't be more ridiculous or absurd because I've never been a member of any party or contributed one cent to any organization except the community chest, Army, actors' organizations"—among them the Screen Actors Guild, which had given his money to the lettuce workers' union, though Bogie didn't mention that.

Dies pushed on with his questioning: "Do you know of any communistic activities in Hollywood among the actors and screenwriters—of your own knowledge?"

BOGART: Of my own knowledge, no; I don't. I couldn't honestly say I know because I don't know whether they're communistic activities, or liberal activities, or activities of misguided people. I know of no communistic activities in Hollywood; no.

DIES: Do you know any Hollywood actor who is a Communist?

BOGART: I couldn't say he is a Communist unless I saw a card.

DIES: No; unless you had some reason to believe by conversation that such person sympathized with the Communist Party of the United States?

BOGART: Not to my knowledge; no.

Up until that point, Bogart's testimony had been forthright but also judicious. He had said just enough to not appear evasive but he also gave the committee nothing useful. That changed, however, when he offered, completely unsolicited, a personal opinion. Though he might not know for sure if any of his fellow actors were Communists, he told Dies, "I have suspicions." Fortunately, Dies did not ask Bogie to put names to those suspicions, and it's unlikely that Bogie would have done so even if he had. But by disclosing voluntarily that he had "suspicions," Bogie was signaling, truthfully or not, that he shared the committee's conviction that American Communists posed a danger to the nation and that he

supported the targeting of citizens based on their political beliefs. It was, plain and simple, a survival tactic. Unlike some later witnesses, Bogie did not stonewall or argue with his inquisitors; many of those later witnesses found themselves blacklisted or imprisoned. Bogart had to come across as being just as concerned as the Dies Committee was about Communist subversion. At the same time, he also had to maintain he was completely unaware of the same.

If any Hollywood people were involved in subversive activities, Bogart told Dies, they were "dupes." If any of the names being accused in the papers participated in Communist-sponsored events, they "didn't know what they were getting into." Any Communist agents in Hollywood, he insisted, were not under contract to the major studios. He admitted to having been approached "3 or 4 years ago" by "one of the Hollywood 'pinks'" who asked if he could leave a book with him to read. Bogie told the committee he had refused.

Leech had made two specific accusations against Bogart. The first was that he had seen the actor's name on donor lists put out by the party. That seemed disproven by Maree's testimony, which followed Bogart's, and the financial ledgers he submitted as evidence. The second charge was that Bogie had attended a private meeting with the Communist candidate for president, Earl Browder, during a campaign stop in Los Angeles. The meeting, as Leech testified after being recalled by the committee following Bogart's testimony, had been held at the home of the director Frank Tuttle, best known for Bing Crosby musical comedies. "I was present at the home of Mr. Frank Tuttle, the director, at the meeting organized for Earl Browder in 1936," he declared. "Mr. Bogart was present. I definitely recall this instance."

Dies seemed to accept the possibility that Bogart had attended the Browder meeting, even though the actor had just finished testifying that he'd been only dimly aware of the gathering. "I'm not sure," Bogie had said, "but I understand somebody entertained Browder out here and there were a lot of people present at that party." Leech was adamant that Bogart had been one of them, repeating his claim several times, but Dies dismissed any significance to it, getting Leech to admit that not everyone at Tuttle's house had been members of the Communist Party.

There were flaws in Leech's testimony, even if Dies did not appear to catch them. Frank Tuttle, who'd later admit to being a Communist, had not been in town when Browder had arrived for his political rally. On

August 1, he'd left for a trip to England, as documented in ship passenger records, and had not returned to the United States until August 17. Browder had begun his campaign travels on August 2, meaning that he couldn't have arrived in Los Angeles before the fourth or fifth, when Tuttle was in the middle of the Atlantic Ocean. Of course, Leech had never claimed that Tuttle had been present at the meeting, only that it had been held at Tuttle's house on Rockcliff Drive. Since Bogie recalled having heard about the gathering, even if he claimed not to have been there, it's likely that the event did take place, perhaps after Browder's rally on the ninth. Tuttle's wife, Tatiana, a naturalized US citizen born in Russia who shared her husband's politics, had not accompanied her husband to England. Perhaps she or someone else had hosted the event.

Dies chose not to delve into all those details. After Bogie finished his brisk thirty-minute testimony, the committee chairman assured him, even before Leech was brought back for more questioning, that they had no reason to believe he was ever a Communist. "So far as the committee is concerned," Dies said, "it has no evidence that would even remotely involve you in any subversive or un-American activity." Just why Dies seemed eager to exonerate Bogart is unclear. It's possible that Warner Bros. influenced the situation with promises of financial contributions to committee members; it was, after all, an election year, and it was shaping up to be tighter than the last one. It's also possible that Dies was trying to undercut District Attorney Fitts, a Republican, by discrediting the grand jury testimony. Finally, it's also possible that once again Bogie's class status assisted him. His concluding statement to the committee might be telling: "My family were born American; I've been born an American; I've been always a loyal citizen; I have great love for my country." Evoking his white Protestant heritage was certainly not going to hurt his cause, especially when one considers the disproportionate number of Jewish and foreign-born actors, writers, and directors who were eventually blacklisted.

To be sure, Bogart was not a Communist. No doubt he was being truthful when he said he had never read the material left for him by the "Hollywood 'pink.'" As a supporter of labor, he may have held some sympathy for the Party, at least early on. But if he attended the Browder meeting, which took place during the production of *Black Legion*, he was likely motivated by intellectual curiosity sparked by the role he was playing. He was not yet a joiner, although that would later change.

Yet Bogart's biographers have largely taken the position that Leech's accusations were simply bald-faced lies by a witness whose testimony had been discredited in previous cases. In so doing, they have accepted the premise of the Dies Committee that merely being sympathetic to communism was, ipso facto, subversion against the United States. Therefore, Bogart's chroniclers, at the time and for decades afterward, needed to distance him as far as they could from the Party. They needed to make clear that he had never tolerated pinkos, that he was no socialist, that he wasn't red, only red, white, and blue. And they made that case despite the truth of Bogart's labor sympathies and his lifelong friendships with socialists and "pinkos." The country had been going through the Great Depression. Bogie had seen inequities that capitalism wasn't fixing fast enough. Had the times not been so fraught, with reactionary politicians criminalizing freedom of assembly and expression, that should have been the thrust of Bogart's testimony to the Dies Committee: there was nothing wrong with being willing to listen to Communist ideas. But the dangers were too great. He was not going to let the accusations ruin him, or his big break.

Following the hearing, Bogie swaggered out to meet the waiting press, transforming seamlessly from the cooperative witness into the rogue he played on-screen. He was an actor, after all, and a good one. "Snarling in his best 'menace' manner," as one reporter observed, Bogart announced that he was suing "this screwball, what's his name?" Someone asked if he meant Leech. "Yeah, that's the screwball I mean." Turning to a waiting Warner Bros. publicist, possibly Martin Weiser, he remarked, "Why, they were getting wires from all over the country about boycotting pictures, weren't they?" The publicist nodded his head "vigorously," according to the *Los Angeles Times*, hinting at the conversations being held inside the studio. If these accusations weren't handled correctly, Warners knew, *High Sierra* might be dead from the moment it was released. But Bogie did what he needed to do with his performance for the press. DEFIANT BOGART TAKES ON CONGRESS declared one headline.

Immediately after his press conference, Bogie hurried back to Burbank and got into costume. Raoul Walsh called "Action!," and Bogart became the fearsome but conflicted Mad Dog Earle. The crisis was averted. He was back on track for stardom.

The experience left him bitter, however. A few months later, he described it as "the worst blow I have ever had in my life." The exoneration

wasn't enough to assuage him. His lawyers demanded that District Attorney Fitts also clear him of any suspicion, asking that Fitts "cooperate with us in protecting the innocent while endeavoring to prosecute the guilty." The DA never offered Bogart an exoneration or offered an apology, however; across the carbon of the lawyers' letter to Fitts was scrawled "No reply."

Despite his brush with ruin, Bogie would not be intimidated into silence. Just a couple of months after testifying, he took steps that he might never have taken if he hadn't had his run-in with Dies. For the first time, he registered to vote in Los Angeles; he chose the Democratic Party and immediately signed onto President Roosevelt's reelection campaign. He hadn't been a political activist before his testimony. But he became one now.

ON SEPTEMBER 19, A MONTH AFTER BOGART'S VINDICATION, THE GOSSIP columnist Hedda Hopper reported that he and Walsh had driven up to Lone Pine (elevation 3,727 feet) to shoot exteriors for the climax of *High Sierra*. Bogart approached the scenes with real excitement. Mad Dog Earle would climb the sheer rock faces of the Sierra Nevada and tumble down from them to his death. The press was told that he was doing his own stunts, a surefire selling point for any star worth his salt. Yet although Walsh got some footage of Bogie scrambling over rocks, scaling a mountainside wasn't the easiest task for a man over forty who drank and smoked too much. When it came time to shoot Earle's death scene, a stuntman took the ninety-foot slide to the bottom of the mountain, landing facedown just as Walsh had instructed him. As he'd endured a couple of awkward bounces along the way, the stuntman offered to do it again. The director said there was no need. "It's good enough for the twenty-five-cent customers," Walsh quipped.

The location shooting took several days under the blazing sun. Bogart liked the director, who was tough as nails, wore an eye patch, and shared shots with him. He was also building a friendship with the screenwriter, John Huston. The two had a great deal in common: the same ambition, the same sense of humor, and the same skill with a bottle.

Despite the camaraderie on the set, production of *High Sierra* turned sour as they headed toward the finish line. As ever, Bogie's problems were with the studio higher-ups, who seemed to be reneging on their promises

to him. The early press releases for *High Sierra* had placed Bogie at the top of the cast list; he was, unquestionably, the star of the picture. But then, on September 20, he found himself in second place behind Ida Lupino in press releases and trade paper ads, despite her significantly smaller role. Hal Wallis had his reasons. "Don't you think we ought to reverse the billing on *High Sierra*," he wrote in a memo to Jack Warner, "and instead of billing Bogart first, bill Lupino first? Lupino has had a great deal of publicity on the strength of *They Drive By Night*, whereas Bogart has been playing leads in a lot of B pictures, and this fact might mitigate against the success of *High Sierra*." Warner agreed. Unstated, but impossible not to consider, was the fact that Bogart had just been accused of being a Communist and Lupino had not.

Ida Lupino was a recent émigrée from Great Britain, where her pictures were promoted as starring "the English Jean Harlow." She was fiery, intelligent, beautiful, and very young (twenty-two). She and Bogie had barely met on the set of *They Drive by Night*, having no direct scenes together. Many years later, Lupino would tell one Bogart biographer that she had been "delighted" when she had been cast opposite him in *High Sierra*. She'd also claim that Bogart had never mentioned the change in billing to her. She described their relationship as close, even flirtatious. Working with Bogie, Lupino insisted in 1991, had been "absolutely heaven and peaceful for me." Any stories of conflict between the two, she made clear, were untrue, and the biographer took her at her word.

The record tells a different story. Whatever happened between the two of them on the set of *High Sierra* was serious enough for Lupino to refuse to work with Bogart again. In 1945, she'd reveal in an interview that she and Bogart had not spoken for two years after the filming of *High Sierra*. She made no mention of that in 1991 and instead tried to make nice. But the evidence found in contemporary newspapers and studio records seems convincing. Louella Parsons revealed after the picture was finished that there had been "plenty of temperament" between Lupino and Bogart, with Lupino "threatening to walk out." Just days after the film's release, one casting director complained in a memo to Jack Warner about "the problem of convincing Lupino to play with Bogart" in another film. A couple of months later, Bogart accused the studio of giving Lupino so much authority that she was now "casting

pictures." To Sheilah Graham later that summer, he placed the blame squarely on Lupino for refusing to play opposite him and thereby causing him to lose a job.

When she told her version of the story half a century later, Lupino had every motivation to smooth things over and describe her experience with Bogie as heavenly. By 1991, Humphrey Bogart had become an American institution, everybody's favorite movie star, the wisecracking tough guy and family man—"Saint Bogart," as Louise Brooks ironically called him. Lupino's fame hadn't weathered the years as well, despite her having gone on to become one of Hollywood's few women directors. At seventy-three, she wasn't about to bad-mouth one of the great American heroes. Instead, she basked in Bogart's reflected fame, giving the impression of flirtation and camaraderie instead of hostility and resentment. So strong had the Bogart legend become by 1991 that to do anything other than play along with the established narrative would have been self-destructive.

We cannot know exactly what transpired between them. But it appears that once the billing was reversed, Bogie took out his resentment, at least in part, on his young costar. Lupino did acknowledge in 1991 that he'd become unhappy "toward the finish of the picture," which was when the change in billing occurred. Bogart's anger could manifest in scary ways, especially to a somewhat green twenty-two-year-old. And if he was drinking, his fury would have been even more intense. A few years later, to an interviewer, Bogart would admit to having given Lupino "a verbal battering," though he didn't explain why. The battering was clearly traumatizing for the young actress. Production records reveal that she called out sick on September 20 and 21, just as the new billing was sent out to the trade papers.

Mercifully, filming was completed by the end of September, and everyone went their separate ways. Bogart was slated for a new film, *Carnival*, a remake of his earlier picture *Kid Galahad*. The studio had just increased the film's budget, as it was "building up Humphrey Bogart following his recent work in *High Sierra*." But his attention was more focused on the presidential election, which some observers thought might be tighter than in years past. In his first overtly political act, Bogart agreed to be listed, along with a couple hundred others, in a full-page ad in the *New York Times* placed by the organization Hollywood for

Roosevelt. On November 5, Franklin D. Roosevelt comfortably defeated Wendell Willkie for an unprecedented third term.

BOGIE'S GOOD FEELINGS ABOUT THE ELECTION, HOWEVER, WERE UPENDED by more family troubles. Pat had recently been released from the Los Alamitos Sanitarium after a series of incidents. Growing more unpredictable following her ex-husband's remarriage, Pat had come west, where Bogie had set her up in a small house not far from him. Although this relocation necessitated Pat's daughter going to live with her father and his new wife, Bogie hoped that being away from New York would steady Pat's nerves. His sister carried as much rage as he did. Shortly after her arrival in Los Angeles, she was arrested for smashing the windows at the Peggy Lou Beauty Salon at 7619 Sunset Boulevard. Her case was taken up by the Psychopathic Department of the county superior court. She was placed on probation in the custody of her brother and a psychiatrist she was required to see regularly. Bogie paid the proprietor of the salon $27 for the damages, which released both Pat and him from "any and all claims and demands . . . growing out of damage to and destruction of property."

For a few months, Pat seemed to find her footing, taking comfort in the home Bogie had found for her. Much as she had been with Maud, Mayo was solicitous toward Pat; she and her mother, Buffie, helped the unhappy woman set up her new place. "It's my idea of heaven," Pat wrote to her brother about the house, "so quiet, so little, so peaceful." She was grateful to Bogie and Mayo for all they'd done. "Much love to you both and to my sweet Buffie," she ended her letter.

Pat was, however, becoming an ever-greater financial burden, especially since Stuart Rose had stopped sending his monthly alimony checks. Once again, a brother-in-law had foisted his wife's care onto her brother. Bogie dashed off a letter to the man he'd once considered a friend. "As you know, Pat relies on those checks to pay her rent and to keep herself going," he wrote. Pat was facing a "zero hour," he said, and they were doing everything they possibly could "to pull her through this dangerous time." Rose had insensitively written to Pat about his new wife and baby; she'd found the letters "extremely upsetting," her brother wrote. Bogie demanded that the alimony checks be paid on time with a minimum of personal communication.

To help cover Pat's care, Bogie appealed to the studio for help. One of his agents wrote to Jack Warner, "A very heavy expense has descended upon him because of his sister's very serious illness." To no one's surprise, Warner denied him any financial assistance. The agent made another appeal. "I do wish that you could see your way clear to reconsider this matter," he wrote. But Warner wouldn't budge. Bogart, left to cover Pat's housing and medical needs whenever Rose was delinquent, never forgave his boss.

In the summer of 1939, Pat was stable enough to visit her daughter in New York. But while she was spending time with some old friends in Connecticut that fall, something occurred that caused a psychotic break. Just what happened is unclear, but her former mother-in-law found the situation serious enough to alert Bogie. It appears that Carlton Palmer, a wealthy man about town and lecturer on art, got Pat drunk at a party thrown by friends in Westport. "I cannot and never will condone the actions of Mr. Carlton Palmer," Bogie wrote to one of Pat's friends. "He has known Pat and Stuart for years and has known the situation. He knows how bad drinking is for her and how bad any unnecessary disturbances or excitement is for her, and yet he permitted both of those things to happen. As far as I am concerned, he is an unmitigated swine." Just as he had done with Kay, Bogart appeared not to see parallels between Pat's drinking and his own.

Bogie brought his sister back to California "very quickly," he wrote to her friend, committing Pat to the sanitarium in Los Alamitos. Though it was wrenching for him to commit her, the sanitarium was "private and very pleasant," he assured Stuart Rose. "There are horses for her to ride when she gets better and good doctors." By now, Bogie had lost faith in "high-priced psychiatrists." Pat, he said, had been "psychoanalyzed almost out of her mind." What she needed, he told Rose, was to be kept from harm and allowed to rest, and "eventually and inevitably," he believed, she would "come back to normal."

Pat was released from the sanitarium in the middle part of 1940. Once again finding her a place to live, Bogie assumed almost all her expenses, as Rose had once again defaulted on his support. Writing to his former brother-in-law, Bogie reported that while in the sanitarium, Pat had "undergone an operation [that] the doctors feel will affect a permanent cure of her trouble." This sounds very much like a partial lobotomy, an abhorrent practice but common at the time for treating mentally ill

patients. Bogie was optimistic that Pat was "ready to take up her life" and said that Rose needed to support her in the attempt.

Within a few months, sadly, Pat was back in the sanitarium and her former husband remained delinquent. That infuriated Bogie, especially since Rose had recently been hired as an editor at the *Saturday Evening Post* and was reportedly making $10,000 a year. Bogie threatened legal action if he did not pay his back alimony. Rose was finally taken to court and forced to make up some of the debt, although he remained irregular in his payments for the rest of his life.

More family strain was to come. That fall, Maud, already failing, developed pneumonia. It became clear to the doctors that it was the end. A year and a half earlier, she had been diagnosed with rectal cancer. The malignant tumor had been too large to operate on due to her age and her existing endocarditis. In October, she developed an intestinal obstruction that caused considerable pain. Blood and fluids accumulated in the lower parts of her body. Just as her husband had once done for her migraines, nurses injected her with morphine to palliate the pain.

She remained at home, in her apartment on Sunset Boulevard, with Mayo in constant attendance. Maud bore her final illness with all the same stoicism she'd always displayed. There were no tearful deathbed scenes, no healing of past grievances, no regrets or apologies, no last-minute expressions of love. Maud "died as she lived," her son would say, without complaint or self-pity. She expired at 5:20 in the afternoon on November 22, 1940, the day after Thanksgiving. Her obituaries made passing mention of her work as an artist, but most were headlined HUMPHREY BOGART'S MOTHER DIES. Showing how little mother and son knew each other, when Bogie was asked the names of her parents for her death record, he had no idea.

Maud wasn't entirely devoid of sentiment, however. To Mayo, she left a locket in the shape of a heart that had been in her family for generations. "Here is my heart," Maud wrote to Mayo. "but I had the initials changed to M.M.B. from M.H.B. so now it is your heart." Mayo cherished the locket for the rest of her life.

KLIEG LIGHTS SWUNG ACROSS HOLLYWOOD BOULEVARD ON THE NIGHT OF JANUary 21, 1941, illuminating the buildings and lighting up the sky. Crowds packed in tight around the beaux arts Warner Hollywood Theatre with

the radio tower on the roof. The marquee bannered the reason for all the excitement: IDA LUPINO, HUMPHREY BOGART IN HIGH SIERRA. Cheers erupted every time a celebrity entered the theater, waving to the throngs. Inside, there was hushed excitement. Scattered applause greeted the title when it was flashed on the screen. But once the last reel had finished its journey through the projector, the cheers in the theater became raucous, with hoots and whistles and calls for the director and stars. The same scene was repeated in New York a few days later, where *High Sierra* premiered at the Strand and immediately outperformed *They Drive by Night*, the last top moneymaker at the theater. In Los Angeles and New York as well as elsewhere, *High Sierra* was held over for several weeks.

Warner Bros. had spared no dime in promoting the picture. At the start of January, the company had added $150,000 to its advertising budget, targeting eight cities across the country with twenty-four-sheet displays. In a two-page spread in various publications, *High Sierra* was touted as the picture that would "skyrocket" both Lupino and Bogart "to Top Star Ranks." The two lead characters were described in ways the studio marketing department believed would resonate with the public. Lupino was "the taxi dancer and killer's companion [who] deep down [was] just another woman whose hungry heart yearned for one man." Bogart was the "enemy of all that is decent and good, defiant of every law on earth—except the High Sierra." But this diminishes the depth of the characters as Huston wrote them. Lupino's Marie Garson has much more agency than the advertising suggests. She isn't just pining for a man; she's looking for a better, more honorable future. She ran away from home to find it and then from the gang she'd gotten caught up with. The only reason she finds herself with Mad Dog Earle's posse is that she refuses to go back to a life of prostitution and subservience.

Meanwhile, Bogie's Roy "Mad Dog" Earle is not the enemy of "all that is decent and good." Though he's a lawbreaker, he dislikes the media's moniker "Mad Dog." In fact, he is rational and at times thoughtful. He wrestles with his crimes and, like Marie, longs for honor and civility. Huston had told Hal Wallis that he admired the source novel by W. R. Burnett but that too many adaptations of Burnett's work had lacked the author's "strange sense of inevitability that comes with our deepening understanding of his characters and the forces that motivate them." Huston was determined to maintain those qualities in his script. Right at the start of the picture, he has Earle, recently released from

prison, watching with affection a group of kids playing ball. Earle is kind to simple folk, such as the old man whose truck he hits, as well as the old man's disabled granddaughter. In many ways, he is the original antihero, of the sort that would come to dominate the American screen in the 1960s and 1970s: belligerent to systemic inequities in society to the point of breaking laws but still searching for a place of integrity and justice.

Those character attributes were what made *High Sierra* such a tremendous box-office success. Huston wrote and Walsh directed a story of many dimensions, and the players did justice to their roles. As it turned out, Bogart and Lupino had excellent chemistry, likely because their scenes together had been shot before the change in billing. It makes their feud even more regrettable since they could have done more good work together.

Critics adored the picture. Bosley Crowther at the *New York Times* thought that Bogie "plays the lead role with a perfection of hard-boiled virility," accurately discerning Earle, not Marie, to be the lead character. Edwin Schallert declared that "*High Sierra* reinstates Humphrey Bogart in his most potent type of portrayal, the ruthless lawbreaker—but with extenuating circumstances." As in his other most successful portrayals— Duke Mantee, Frank Taylor, Baby Face Martin—Bogie as Earle allows the audience to perceive the self-conflict that tears at him. "Bogart carries his role straightly, forcefully and with admirable conviction all through the production," Schallert concluded. The only player who received as warm a critical reception was Pard, the scrappy little dog whose real name was Zero. (Zero was not, as many accounts have claimed, Bogie's dog in private life but rather came from the kennel of James "Rennie" Renfro, one of Hollywood's foremost casting agents of animals.)

No doubt Bogie was pleased by the film's grosses and glowing reviews. But he knew he still hadn't secured his career. Although *Carnival*, its title now changed to *The Wagons Roll at Night*, gave him top billing, it was far inferior to *High Sierra*. Shot in the last weeks of 1940, the picture was directed by Ray Enright, who had had the dubious distinction of directing Bogie's least favorite film, *Swing Your Lady*. The script, which returned to the original source material by exchanging the boxing world of *Kid Galahad* to the circus world, had been banged out by the unremarkable Fred Niblo, Jr., whose position at the studio was largely due to being the son of the director Fred Niblo, Sr. Flipping through the pages

of Niblo's script, Bogie would have quickly discerned the lack of nuance that Huston had so memorably brought to *High Sierra*.

Moreover, his part as an unscrupulous circus manager was trite and predictable, offering Bogart little more to do than scowl and boss people around. The only possible reason he had been assigned the picture as his follow-up to *High Sierra* was that the studio was still hedging its bets; *Sierra* had not yet been released, its box office and reviews were still unknown. It's also worth considering the lingering aftermath of the Communist allegations. At the end of 1940, Warners didn't know what the public's response to a Bogart picture would be; that would have to wait until the release of *High Sierra*. If it was hostile, the inconsequential *The Wagons Roll at Night* could be given a limited release and allowed to disappear. So much for the studio's commitment to "building up Humphrey Bogart," as it had announced it was doing just the previous month.

Bogie was understandably grumpy during production. Once again, he took out his frustrations on a younger costar. Eddie Albert, thirty-four and eternally boyish, had to climb into a lion's den with several big cats pacing around its perimeter. Outside the cage, men with rifles stood ready to shoot if any of the cats pounced. Knowing Albert's terror, Bogie thrust a cane through the bars of the cage to provoke the lions. Albert, recalling the incident many years later, called Bogart's actions "playful," but they also fit the mean streak that many people, including Bogie himself, described. Albert said Bogart got his comeuppance, however, when one of the lions lifted its tail and shot a blast of urine at his prized LaSalle automobile. It had to be repainted. "He was quite irritated," Albert recalled.

Once filming was done, Bogie and Mayo took off for New York. The studio had arranged for them to perform together in a skit that would run several nights at the Strand Theatre in between the film screenings. Personal appearances by Hollywood luminaries were great marketing opportunities, especially outside Los Angeles, where the public rarely got glimpses of the stars. The skit staged by Mr. and Mrs. Bogart opened with some clips of his "killer-diller roles," as one Brooklyn newspaper called them, and then proceeded with some banter between the couple that "sets out to prove what a charming fellow he really is." Mayo sang a couple of numbers, accompanied by Ozzie Nelson and Harriet Hilliard, making it "a happy family foursome." The reviewer wrote that Bogart "succeeds admirably" in engaging the audience and "should make a lot of good friends."

It was a pleasant sojourn for the Bogarts and one they both needed. Just a month past Maud's death, Bogie was still feeling grateful to his wife for watching over his mother and handling the funeral arrangements, as well as for her continued nurturance of his sister Pat. This was a happy period for the Bogarts, despite what later writers would imply. He had grown very fond of Mayo's mother, Buffie, who was everything that Maud had not been: warm, funny, irreverent. Alerted to an upcoming visit from his mother-in-law, Bogie would buy several cases of her favorite beer, which they'd drink together. In one of his life insurance policies, he made Buffie a beneficiary along with Mayo and Pat. Those details simply do not corroborate the accounts of a marriage already beginning to disintegrate.

That shouldn't imply that they didn't spar. The tempestuousness between the Bogarts was, in fact, endearing to the public. The columnist Dora Albert wrote, "Remember *Private Lives*, the story of two people who fought like wildcats, but who couldn't be happy away from each other? That's Humphrey Bogart and Mayo Methot." The term "Battling Bogarts," which would become a major trope of the Bogart legend, originated as an affectionate epithet bestowed on the couple by the press. Their squabbles made good copy. Bogie and Mayo played up and exaggerated their banter for comedic effect. Their battles would eventually become more serious, but for the moment, Mr. and Mrs. Bogart enjoyed a happy visit to New York.

ONCE *HIGH SIERRA* WAS AN UNQUALIFIED HIT, BOGIE EXPECTED THE STUDIO to live up to the promises it had made him. His next picture, he resolved, needed to be as important as *High Sierra* had been, helmed by a top director and writer. No more *Wagons Roll at Night*. He believed he'd found the perfect property: *Gentle People*, written by the highly regarded Robert Rossen and based on the play by the novelist and playwright Irwin Shaw. The director would be Anatole Litvak, an acclaimed director on a par with Raoul Walsh. The part would be yet another racketeer, but the project had "class" written all over it, with its genesis in the distinguished Group Theatre.

While still in New York, Bogie heard a rumor that Warners was considering him as the star of *Gentle People*. He cabled the studio, SEEMS LIKE A GOOD IDEA, IS THERE ANY TRUTH TO THE RUMOR OR CAN'T YOU

TALK? Although he was not given official confirmation, it was Bogie's name that was on the production budget that went out on January 31, 1941, giving a clue as to what the studio was thinking. But there was a fly in the ointment: Ida Lupino had already been cast, and everyone knew her feelings about Bogart. Moreover, she would be paid $40,000 to Bogart's $16,500. It's unclear if Bogie knew of the disparity, but he was anxious enough to go straight to the top, wiring Jack Warner: IT SEEMS TO ME THAT I AM THE LOGICAL PERSON ON THE LOT TO PLAY GENTLE PEOPLE. I WOULD BE GREATLY DISAPPOINTED IF I DIDN'T GET IT.

Warner would not have appreciated the implicit threat in Bogart's telegram. But it was Lupino who ultimately put the kibosh on Bogie. With good reason, he would blame her for the loss of the part, even if, in some ways, she was justified in the ultimatum she gave the studio. Why should she have to work with a man who had browbeaten her? On the same day that Warner received the wire from Bogie, he approved a press release naming John Garfield as Lupino's costar. *Gentle People* would be released late in the year under the title *Out of the Fog*. It received mostly negative reviews, so perhaps Bogie was well out of it.

Still, he was both humiliated and enraged. The studio appeared to have given up on making him a star. Once again, he felt deceived and disrespected. Other actors might have bolted at that point, but Bogie still wasn't ready to take such drastic action. He accepted an assignment to star opposite George Raft again, with Walsh returning as the director. Marlene Dietrich would be his leading lady. The film was titled *Manpower*, and Bogie seemed appeased. But Raft, who was often dismissive of Bogart's talent, likely because he felt threatened by him, told Sam Jaffe that Bogie wasn't right for *Manpower*. So when Bogie reported for a wardrobe test the first week of March, he was distrustful and paranoid. When he encountered Mack Gray, George Raft's stand-in, words were exchanged and tempers flared. It's a wonder that punches didn't fly, at least as far as we know. Bogie went home to stew.

Stories spread fast in Hollywood, and it wasn't long before Bogart learned that Gray had given Hal Wallis his version of the story and that Raft had demanded that his costar be fired. On the morning of March 6, Bogie approached Raft at the studio to ask just what he'd said to tick him off. There was a tussle. Louella Parsons called it a "one-punch feud." Probably emboldened by a couple of shots of whisky, Bogie sent Hal Wallis a telegram: DEAR HAL, I AM SENDING YOU THIS WIRE BECAUSE I AM

EXTREMELY UPSET AND WANTED YOU TO KNOW THE TRUE FACTS. . . . ANY
REMARKS AND ACCUSATIONS BY MACK GRAY WHICH WERE ATTRIBUTED TO
ME ARE COMPLETELY AND ENTIRELY UNTRUE. Referring to Raft's demand
that he be fired, Bogart concluded, I FEEL VERY MUCH HURT BY THIS BE-
CAUSE IT'S THE SECOND TIME I HAVE BEEN KEPT OUT OF A GOOD PICTURE
AND A GOOD PART BY AN ACTOR REFUSING TO WORK WITH ME.

But that was the reality: people were refusing to work with him.
Raft was a bit of a prima donna and may have been envious of his former
costar, but to claim that Bogie was the only injured party, as he was at-
tempting to do in his cable to Wallis, is illogical, especially where Lupino
was concerned. It's possible that Raft and Gray, both rather truculent
themselves, had instigated the most recent altercation, but there's plenty
of evidence of Bogart hurling insults at those who angered him. It was
certainly not helpful for an actor's position at the studio that two other
actors in succession had drawn the line at working with him. Wallis
gave no reply to Bogart's telegram, at least nothing written. Instead,
the producer took up the matter with his boss, and Warner made the
decision to side with Raft. Though often a problem to the studio, Raft
did bring in more money than Bogart did. Later that day, word was sent
to Shoreham Drive that Bogie was off the picture. He was to await his
next assignment.

For the next month and a half, Bogart was at leisure. That spring was
warm in Los Angeles, and he took off for Balboa Island in his new thirty-
foot cruiser. He had long wanted a vessel of his own. A few years earlier,
responding to a question about his chief goal, he had replied, "To own a
boat." It didn't have to be "a big, super-colossal yacht," he said, "just one
size larger than a dinghy." His cruiser was no yacht, but it was no dinghy
either. The boat became Bogie's pride and joy. "Humphrey Bogart has
a sense of humor," Louella Parsons noted. In a nod to his brawl with
Raft, she said, "he's christened his new boat, and named his cat and dog,
'Sluggy.'" It also would become his nickname for his wife.

Bogie was back on dry land by March 13, when he received a script
for a western drama written by Charles Grayson, a recent arrival at War-
ner Bros. The title of the script was *Bad Men of Missouri*. Bogart would
later say that he could tell the quality of a project by its title, so he prob-
ably had serious reservations about that one from the moment he opened
the envelope. Sam Jaffe informed him that the studio had assigned him
to the picture and he was to report to work on March 17 to meet with

the director, Ray Enright, with whom Bogie had just worked, not all that happily, on *The Wagons Roll at Night*.

Reading through the script, Bogart was horrified. It was a trite, derivative story of bandits and gunfights. His horror turned to outrage, and he pondered what to do. If he refused to make the film, he'd be put on suspension and his paycheck would be forfeited. If he made the film, he would be conceding that his career would forever remain at the whim of the studio. This wasn't just about stardom anymore. After *High Sierra*, he wanted parts that had layers and contradictions. Although he enjoyed being recognized and applauded, his reason for wanting to rise in Hollywood was to take charge of his work. It was one part ego, another part a sense of fairness. Cagney had that freedom; so did Raft. For Bogart, this was about his craft. He knew he had talent. He'd proven that many times. Ever since *The Petrified Forest*, he'd consciously worked at becoming a better actor. That's a fact often missed in the telling of Bogart's story. His talent is usually made to seem as coming so easily, but that does a real disservice to the commitment he brought to the effort.

Four days later, on the date he was supposed to return to work, Bogie made the move he'd resisted for the past five years. He sent the script back to the studio, along with a note: "Are you kidding—this is certainly rubbing it in—since Lupino and Raft are casting pictures maybe I can." He and Mayo packed their bags and took off for Balboa Island on *Sluggy*.

When the casting director, Steve Trilling, got the missive, he phoned Bogie's house and was told that he was "on his boat." Ringing the Balboa marina, Trilling left word for Bogart to call the studio as soon as possible. But the marina official told him that Bogart's return was "indefinite."

Failing to reach Bogart, Trilling went straight to Warner. The studio chief decreed that if their errant actor refused the assignment, he would be suspended. He would also be taken to court for breach of contract. Trilling typed a memo to Roy Obringer, the studio's attorney: "Mr. Warner requests that you immediately wire Bogart, legally notifying him to report tomorrow morning at 10:00 a.m. for wardrobe, advance preparation, etc., at my office, and if he should fail to do so, take the necessary steps to place him on suspension."

The next day came and went, and Bogart never showed up. That was unlike anything he'd ever done before. Part of his ascent at Warner Bros. had been due to the fact that he was seen as reliable, a team player. This was the sort of antic Bette Davis and James Cagney had tried to pull,

and they had lost their cases in court. Yet both had bounced back even stronger. Bogie was wagering that he would, too. Warners' bad guy was no longer playing Mr. Nice Guy.

The suspension began shortly before noon on March 18. Bogie remained on the water, likely feeling for the first time in many years the sort of relief that comes from detaching from the grid. Seagulls soared, warm breezes rocked the boat gently. The briny fragrance was a tonic. Friends may have joined him and Mayo. There would certainly have been plenty of booze on board. In the morning, Bogie often fished from the side of the boat for their dinner.

But by the start of April, he'd grown worried. What might a legal case against him look like? He might be financially comfortable enough to lose his paycheck for a few weeks, but what if a court assessed him thousands of dollars in damages? His sister Pat was once again in the sanitarium, and Morgan Maree's ledgers reveal that Stuart Rose was still in arrears in his alimony payments. What would happen to his sister if Bogie suffered a financial crisis? Perhaps feeling he'd gone too far, he brought the boat back to shore. On the morning of April 2, he appeared at the studio, ready to make amends. But Obringer, after consultation with Warner, informed him that the suspension would continue until Dennis Morgan, the actor who'd replaced him in *Bad Men of Missouri*, had shot his last scene. Bogie's response to the rebuff is unknown.

As always, he had friends pulling for him, and the publicity department, possibly Charles Einfeld himself, appears to have stepped in. They reported to Obringer that if Bogart was not put on payroll before *Bad Men* wrapped, they would be in breach of contract themselves, not with Bogart but with Louella Parsons. Sometime before, the studio had committed Bogart to appearing on Parsons's radio program. "Morgan will not finish . . . until about a week later than Bogart is to do the radio show," Obringer wrote to Warner. "This means that you would have to put Bogart on payroll a week earlier." Parsons wanted an answer that very day, as she planned to make the announcement of Bogart's appearance on the show that evening. Warner agreed, and Bogie did the show.

Although he was no longer on suspension and the threat of a legal suit had evaporated, Bogie was left cooling his heels for the next two months. No assignment was forthcoming. Was the studio still punishing him? It would be against its financial interests to do so, as Jack Warner did not like paying people when they weren't working. But it's possible that he

wanted to scare his disobedient actor into never pulling another stunt like that one. Bogie was left with nothing to show for his effort.

The self-doubt and anxiety that surely kicked in during this moment meant more alcoholic benders, more carousing, and increasing disagreements with Mayo. The release of *The Wagons Roll at Night* did little to help Bogie's mood. The film flopped, as he no doubt had expected, and critics savaged his performance. "Mr. Bogart is badly hampered in a ridiculously fustian villain role," judged Bosley Crowther of the *New York Times*.

But just a couple of weeks later, things again took a turn. Whether it was a turn for the better or the worse was unclear, but at least it was a turn.

GEORGE RAFT WAS AT IT AGAIN. HE WASN'T HAPPY WITH THE LATEST PICTURE assigned to him by the studio and dictated a long letter in response to Jack Warner denigrating the project. It was "not an important picture," he declared, and he reminded the studio chief that he'd been promised he would not be required "to perform in anything but important pictures." Already ads in the trades were bannering Raft's name above the title of the picture. But Warner had had enough. He took Raft off the picture. There was another actor who'd be very happy to take the part.

The picture was written by John Huston, who was also set to make his directorial debut on the project. Already, at the age of thirty-four, Huston was a larger-than-life figure. The son of the beloved character actor Walter Huston, he stood six feet two and had had bags under his eyes since he was a young man, exacerbated by late nights of drinking. He'd been a painter in Paris and a cavalryman in Mexico. He had also published stories and been hired as a screenwriter by Universal in 1932. Twice, while driving drunk, he had injured two actresses, one fatally, for which he had been charged but acquitted by a coroner's jury. The tragedies hadn't stopped him from drinking, but they had sent him to London and Paris, where he had lived for a while as a drifter, overcome by guilt. Now he was back, itching to get his life back on track.

Huston hadn't wanted Raft as the lead. He'd lobbied hard for his drinking buddy Bogart. Warner wanted the proven track record of Raft, despite how much richer the studio had become after *High Sierra*. But then the letter from Raft arrived on the studio chief's desk. That was

June 6. That same day, the studio offered the part to Bogart. It didn't take him long to accept.

Sheilah Graham reported on the casting. "I've been on a little suspension," Bogie admitted. "I would have liked to do *Manpower* but George Raft didn't want me. Then I was up for the John Garfield part in *Out of the Fog*, but Ida Lupino didn't want me. Then they offered me *Bad Men of Missouri*, but I didn't want me for that. But anyway, that's how I've had a beautiful vacation." Another reporter remarked, "He has been on his boat for weeks with Mrs. Bogart, and he has a suntan that is so perfect for the camera he won't have to wear makeup."

The cameras started rolling on his new picture in the middle of June. The script was even better than Huston's for *High Sierra*. There was danger, surprise, mystery, humor. And Bogie was, without any doubt about it this time, the star.

The name of the picture was *The Maltese Falcon*.

Burbank, California, Thursday, July 3, 1941

John Huston strode onto a soundstage on the Warner Bros. lot prepared to shoot the penultimate scene of *The Maltese Falcon*. All the film's leading actors were present: Bogart, Mary Astor, Peter Lorre, Sydney Greenstreet—all seasoned professionals, hitting their marks and finding their light, fully conscious of what they needed to accomplish in this pivotal scene. Huston had written the byzantine script of *Falcon* so that the audience learns the details of the plot only when the lead character, the private detective Sam Spade, learns them himself. Throughout the picture, most everyone else on-screen knows more than Spade does. But in this scene, he, along with the audience, finally figures it all out: the murders, the motives, the layers of lies, the crazy international hunt for a golden statue of a bird. No scene would be more important than this one.

Sam Spade was the creation of the detective-fiction writer Dashiell Hammett, a former Pinkerton private eye. Spade had first appeared in the September 1929 issue of *The Black Mask* magazine in the first installment of a serial that had concluded in January 1930. Later that year, Alfred A. Knopf had published *The Maltese Falcon* as a novel. In that first edition, Hammett described Spade as "a dream man in the sense that he is what most of the private detectives I worked with would like to have been and, in their cockier moments, thought they approached." For Hammett, a private detective should not be "an erudite solver of riddles in the Sherlock Holmes manner; he wants to be a hard and shifty fellow, able to take care of himself in any situation, able to get the best of anybody he comes in contact with, whether criminal, innocent by-stander, or client." It would seem that Bogart was born to play the part.

The Maltese Falcon had been made twice before by Warners. Ricardo Cortez had played Spade in a successful 1931 adaptation, and Warren William had taken the part in 1936, although the film, called *Satan Met a Lady*, had bombed. Huston had an idea of what was needed to revive the project at that particular moment in time, when the threat of war against

Germany loomed around every corner. It could not be a glossy Hollywood production, paced predictably and lit with bright artificial light pouring down from catwalks. Rather, it would need to feel natural, real, gritty, claustrophobic, ominous.

Those same traits needed to be embodied in the film's leading man as well. From the start of production a month earlier, Huston had been delighted with Bogart's performance as the cool, detached, egotistic Spade, who had just enough integrity to make him, barely, the hero. Bogie knew exactly what was needed to bring Spade to life. "Practically no direction was required," Huston claimed, and that's quite believable: Bogie had been building up to that paradoxical character, the bad guy with a conscience, for the past five years. "He was forever surprising me with how good he was," Huston said. "It's instinctive. That really superb kind of timing—not many musicians have it."

Bogart did not fit Hammett's description of Spade. The detective was supposed to stand more than six feet tall and have a hooked nose. Other attributes, however, adhered more closely. Hammett wrote that Spade had "the look of a rather pleasant Satan," and that seems apt, especially if one recalls *The Return of Dr. X.* And for all his height, Spade's shoulders, like Bogie's, were rounded and sloping, making his clothes seem ill fitting. Bogie was "no movie hero," Mary Astor wrote. "He wasn't very tall, vocally he had a range from A to B, his eyes were like coal nuggets pressed into his head and his smile was a mistake that he tried to keep from happening." Except for the height, Astor could have been talking about Hammett's Sam Spade.

John Huston considered the off-screen Bogie "not particularly impressive." But when he faced a camera, he was transformed. "Those lights and shadows composed themselves into another, nobler personality," the director observed. "The camera has a way of looking into a person and perceiving things that the naked eye doesn't register."

At the start of shooting, Bogart made a couple of false moves in his characterization. Perhaps to make up for his physical shortcomings, he "adopted a leisurely, suave form of delivery" that replaced his "usual brisk, staccato manner." Apparently, he had Huston's agreement on that. But Hal Wallis wasn't happy. He argued that *Falcon* needed "a punchy, driving kind of tempo," and if Bogart wasn't able to return to form, "we are going to be in trouble." So Bogie went back to being Bogie, and an entire genre of film was born as a result.

The Maltese Falcon has been called the first film noir. Whether it technically was or not, there's no question that it was hugely influential on subsequent directors developing their own stories. Noir is defined by a mood of fatalism, pessimism, desperation, and menace, fitting for a country on the verge of war. But those characteristics were also ones that Humphrey Bogart had a good deal of experience with, both on-screen and in his own life. He was the ideal noir hero: belligerent, wounded, lonely, a chip on his shoulder.

Nearly all the characters he'd played on-screen so far had had some degree of those attributes, though he himself was probably the best manifestation of them. He'd felt socially alienated from a very young age, and despite his membership in the old boys' club, he still often felt left out when the best films, opportunities, and money were being passed around. At forty-one, he could still feel like the luckless student at Trinity, missing out on the semester's grade requirement by just one point. It's perhaps fortunate for the noir genre that Bogie went into the role weary and resentful of how long it had taken him to get there. That would, after all, be the essence of noir antiheroes going forward. The cynicism of pre-stardom Humphrey Bogart helped define the genre.

But stardom was now within reach. As the crew gathered on the set to shoot the penultimate scene, there was a sense of things coming together. After several weeks of shooting, the actors and their director had come to trust each other, developing the rapport necessary for what Mary Astor called "the whip-cracking speed of individual scenes [and] the fountains of words." Huston kept them on their toes and schedule, achieving an apparently effortless efficiency. Astor, having survived her scandal, basked in the fellowship she found from cast and crew. They took long, liquid lunches at the Lakeside Country Club, and when other film crews asked why they weren't hurrying back to set as they were, Astor would smugly reply, "We're ahead of schedule."

Huston had directed the film like a stage play, in sequence and shot mostly in real time. Astor thought that approach helped Bogart find the character. "He'd had theatre experience," she said. "People from the theatre—they never come unstuck in a scene. They know their job. There isn't any vagueness about what the scene is all about. [Bogie] knew his job."

The scene going before the cameras on July 3, however, would test them all. It was certainly the most technically challenging. "One solid

sequence of thirty-five pages of script and every member of the [main] cast in it," as the producer, Henry Blanke, described it to Hal Wallis. Moreover, it was to be shot, for the most part, in one continuous take. In the finished film, the scene would begin at the one-hour, fifteen-minute mark and run for the next thirteen and a half minutes, an eternity in movie time. Eschewing too many cutaways and inserts, Huston intended to rely on moving cameras to make the thirteen and a half minutes feel speedy and engrossing. To accomplish all of that, the director asked for an extra day to rehearse the scene, a highly irregular request. Blanke reminded Wallis that it was Huston's first film and what he was attempting was ambitious. The request was granted.

The cast and crew who assembled on July 3, therefore, were primed and ready to go. Huston called "Action!," and Bogart and Astor entered stage left to find Lorre and Greenstreet waiting for them, along with Elisha Cook, Jr., who played Greenstreet's henchman. The scene unfolded without a hitch, with the actors, cameramen, and director on top of their games. Bogie had worked with many directors, among the best in the business. But he was in awe of what Huston was doing. "You put this in somebody else's hands," he told Astor, "you know what they'd do to it." Huston might be new at the job, but he had his company's trust. Describing the atmosphere on the set, the gossip columnist Robbin Coons observed that although "an old-timer can fend for himself," a fledgling director—"If he's a right guy"—is bolstered by his "crews' and players' extra-best efforts."

Bogie was elated. It was the sort of filmmaking he'd been waiting for, fighting for. Not since his days on the stage had he felt so much a part of a team.

When shooting finally wrapped in the second week of July, Jack Warner knew he had a very important property on his hands. The studio press office began hyping the film even before it made it to the editing room. One writer, probably acting on a tip from the studio that Bogart's work in *The Maltese Falcon* was first rate, told her readers that the role was "the same that George Raft turned down, same being a role that calls for acting"—a burn that was made to order for Raft.

The syndicated columnist Virginia Vale enthused over Bogart's "first detective role—sort of a relief from gangsters." She cheered the fact that he could now play love scenes: "Gangsters can't have true loves under the producers' code." Mary Astor, according to Vale, had gushed that she

hadn't been kissed like that since Douglas Fairbanks, Jr., had planted one on her in *The Prisoner of Zenda*. As Astor would reveal in her memoir, however, that was pure PR hokum. Just as in *Dark Victory*, Bogie was awkward and self-conscious when it came time to kiss his costar. Five takes were needed for him to get it right; the production records reveal "NGA" (for "no good action") repeated five times. But to the folks in publicity, inside the studio and out, that fact was irrelevant. Humphrey Bogart was now a star, and stars could kiss.

YET BOGIE STILL DIDN'T FEEL LIKE A STAR. DESPITE ALL THE ADVANCE HYPE from *The Maltese Falcon*, he feared that the studio would once again go back on its promises. He was immediately cast in *All Through the Night*, reuniting him with Peter Lorre. But the picture was another George Raft reject, which had to sting after all the conflict earlier in the year. Moreover, *All Through the Night* was a comedy, and Bogart hadn't fared well in comedies in the past. After reading the script, he told Sam Jaffe that he didn't think the project would be any good. He'd worked with the director, Vincent Sherman, on *The Return of Dr. X*, and that probably wasn't the most encouraging sign, either. Until the fall, when *The Maltese Falcon* would be released, either solidifying his rise or destroying it, Bogie existed in a sort of limbo.

Jaffe took up the matter with Steve Trilling, asking that he let Warner know Bogie's concerns. "A story should be prepared for which they have Bogart in mind and no other actor," Jaffe wrote. "It seems for the past year he's practically pinch-hitted for Raft and been kicked around from pillar to post." There was no definitive reply. It was clear that Warner was waiting to see the reviews and, more critically, the take from *The Maltese Falcon* before he took any further steps to promote Bogart as a star.

In the meantime, Bogie went into production of *All Through the Night*. Jaffe reported to Trilling that "everything [was] pleasant" on the set, although Bogie remained unhappy. And when Bogie was unhappy, a pleasant mood could not be long sustained. He drank heavily. Mary Astor thought Bogie was "angry with the world," which was why he blew his top "violently and often." The drinking was getting worse. Mayo later told her friend M. O'Brien that Bogie was involved in many "drunken rows" around the time of this picture that "the studio had to cover up." Bogie's alcoholism threatened everything he was on the verge of achieving.

"Bogart picked fights with everybody, on the set and off," Vincent Sherman remembered six decades later. "He would come in hungover. He was angry and mean to everyone." In 1924, Bogie had allowed his drinking and belligerence to endanger his part in *Meet the Wife*, his first real Broadway success. In 1939, his misconduct may have slowed his momentum after *Dark Victory*. The pattern was repeating itself now, at another crucial moment.

"When he was drunk," Mary Astor recalled, "he was bitter and smilingly sarcastic and thoroughly unpleasant." That observation sheds light on a story she told about the making of *The Maltese Falcon*. The men on the set were always ribbing and teasing one another. "Just to get in on the act one day," Astor wrote, "I made the mistake of piping up with some kind of naïve smart-crack and the kidding was turned on me unmercifully." She did her best to smile and take it for a while, but finally the teasing became more than she could handle. "Tears started popping, and I whimpered, 'I just can't keep up with this.'" Bogie "laughed his head off" at her discomfort, Astor recalled. Although she told the story in a lighthearted way, it's hard to read it as such. Knowing Bogie's mean streak, one has to wonder if he took pleasure in making her cry, especially if he'd been drinking. He liked Astor and respected her, but even his friends sometimes bore the brunt of his savagery. Astor recalled Bogart trying to console her, but what she described is cringeworthy. "You're okay, baby," Bogie said. "So you're not very smart—but you know it and what's the hell wrong with that?" Astor was, in fact, one of the most intelligent and articulate actors in Hollywood. A group of men ganging up on the only woman in the room and making her cry wasn't lighthearted fun.

In September, Warners ramped up its publicity for *The Maltese Falcon*. For some reason, the East Coast publicity team wasn't as jazzed about the picture as their counterparts in Los Angeles; perhaps they saw it as just another gangster picture starring Humphrey Bogart. The *Falcon*'s producers, therefore, asked Jack Warner to give the New York office "a slight goose" to ramp up promotional efforts for the film. That was critical, since the marketing plan called for opening in New York to build up word of mouth before a wide release. With everyone holding their breath, the premiere was set for the Strand Theatre on October 3.

On October 4, they all exhaled in relief. "*The Maltese Falcon*," declared Bosley Crowther in the *New York Times*, "which swooped down onto the screen of the Strand yesterday, only turns out to be the best mystery

thriller of the year, and young Mr. Huston gives promise of becoming one of the smartest directors in the field." Bogart, the critic judged, "hits his peak" as the "shrewd, tough detective with a mind that cuts like a blade." The picture "enjoyed a powerful weekend at the Strand," *Variety* reported; it would rack up $38,000 in its first week. Over the next several weeks, similar receipts came in from Philadelphia and St. Louis. When *Falcon* opened in Chicago, the take was comparable to New York's and the pseudonymous reviewer Mae Tineé of the *Tribune* hailed Bogart's transition into a "very good guy, albeit a hard-as-nails one."

But it was the Los Angeles opening that finally convinced Jack Warner that he had a major hit on his hands: *The Maltese Falcon* enjoyed the biggest opening in months at the local Warner theaters. The first-week receipts totaled $33,205. The critical consensus was just as enthusiastic. "*The Maltese Falcon*, I venture to say," wrote Philip K. Scheuer in the *Los Angeles Times*, "is the finest detective-mystery movie ever turned out by a Hollywood studio." Scheuer went on, "You've never seen a detective like Sam Spade . . . not above a shady deal or two" but exhibiting "honesty and directness which compel your attention." Spade, he judged, "has what it takes," adding, significantly, "Humphrey Bogart has what it takes, too."

He sure does, right from his very first scene, looking dapper in his office and years younger than he had in *High Sierra*. There's nothing leisurely about his performance, so Wallis's directive had been a good one. Spade's dry sarcasm, his one-liners, and his smooth but cynical way with women instantly made him a new kind of screen hero. For all the trouble he'd had with the kissing scene, in the final take Bogie is full of confidence, his hands clamped on Astor's cheeks as he moves in. The scene is crackling and electric. Even his height didn't seem like a problem this time. Though he had a few inches on Lorre, Huston shot the fight scene from below to make Bogie seem even bigger. And against Greenstreet, Bogart comes across as lean and hard; for the first time in a while, his clothes fit him perfectly. He is stellar.

His final speech to Astor, revealing that he might love her but can never trust her and that there are higher, nobler reasons for him to turn her over to face the gallows, is the most powerful piece of acting, complex and layered, that Bogart had yet done on the screen. The way his eyes shine and his jaw trembles, the way his voice grows hard and rapid, reveal the talent that had been waiting so long to emerge.

Bogie may have experienced some schadenfreude when reading

George Raft's admission to a reporter that he'd "pulled a boner" by refusing *The Maltese Falcon*. The accolades kept pouring in, and the studio gave him a raise. Bogart was now a star, his name above the title in the ads for *Falcon*. For more than two decades, he'd imagined this future for himself, though at times it had seemed an impossible dream. But now that he'd achieved it, the question remained: Would it make him happy?

ON DECEMBER 7, 1941, AT 7:02 IN THE MORNING, AN OAHU RADAR STATION detected unidentified aircraft heading toward Hawaii. The report was disregarded because it was believed that the aircraft were US B-17 bombers arriving from California. At 7:40, the aircraft closed in on Oahu's Pearl Harbor, bearing the unmistakable insignia of Imperial Japan. At 7:55, bombs were dropped. Firestorms ripped through the harbor. At 8:10, the USS *Arizona* exploded, killing more than a thousand Americans on board. The attack went on for nearly two hours. Much of the naval fleet docked in the harbor was destroyed, and 2,403 servicemen and civilians were left dead.

By the time the Japanese pilots headed back to their aircraft carriers in the Pacific Ocean, it was twelve noon in Los Angeles. Radio stations cut into regularly scheduled programming to report the surprise attack. The death count was not yet known, but sources were confirming high casualties. By the time the afternoon papers bannered the attack on their front pages, most people in the country had heard the news. Bogart, who'd just finished production on *All Through the Night*, listened to the reports crackling from his radio. He knew he had to do something.

A year earlier, sitting before Martin Dies, he'd had a taste of what totalitarianism might look like: the policing of thought, the demand for loyalty tests, the trampling of constitutional rights. In Germany, Spain, and Italy, dictators had overturned democracy, and the totalitarian regime in Japan stretched back centuries. Those reactionaries envisioned a world of strongmen and clampdowns, and if they had to commit genocide to achieve control, they would do so, as demonstrated by what was happening in Germany.

Even before President Roosevelt declared war against Japan in a joint session of Congress the next day, Bogie was on the phone with friends from the Screen Actors Guild and the Fight for Freedom Committee. The latter organization had been formed in direct opposition to the

isolationist America First Committee, spearheaded by the aviator hero Charles Lindbergh. In the months before the attack on Pearl Harbor, the FFC had been planning a rally in St. Louis, the center of America's heartland, to call out American noninterventionists "with equal doses of patriotism and barbed wit." After December 7, however, the event became a war rally and the guest list suddenly mushroomed to include Burgess Meredith, Melvyn Douglas, Linda Darnell, Allan Jones, Carole Landis, Phil Silvers, Carol Bruce, Humphrey Bogart, and Mayo Methot.

The rally was scheduled for December 10. When the Bogarts arrived at the Municipal Auditorium that afternoon, they were struck by the size of the crowd that had already assembled for the 8:30 show. Eventually, nine thousand people would pack the auditorium, some paying 45 cents for admission and others $25. The money would be used by the Fight for Freedom Committee to continue its anti-Fascist campaign. More headliners had been added to the roster in the past day. Wendell Willkie, the Republican candidate for president who'd just lost to Roosevelt, rose in support of his former opponent's declaration of war. Sergeant Alvin York, a hero of the First World War currently being portrayed by Gary Cooper on the screen, exhorted the country to fight for democracy. Todd Duncan and Anne Wiggins Brown, the original stars of the George and Ira Gershwin opera *Porgy and Bess*, performed "Summertime" and "I Got Plenty o' Nuttin'." As black entertainers, they were sometimes forbidden to perform alongside their white counterparts, but in St. Louis the crowd cheered them and other performers embraced them.

Bogie took part in a patriotic skit with emcees Douglas and Meredith, but it was Mayo who drew the heartiest applause. Walking out onstage toward the end of the program, which had gone on for more than three hours, she turned on that old Portland Rose charm. She recited Walt Whitman's poem "Europe, the 72nd and 73d Years of These States," with its final line, "Liberty! . . . I never despair of you." Mayo could still emote; the cheers went on and on, much as they had in her youth.

The rally had succeeded in achieving its goals. "What emerged," reported a local writer, "was a four-hour program of pageantry, speeches and nightclub vaudeville, which, if it did anything, conveyed that America was girding for war with a reasonably high heart."

Once war was declared, the mood in the country quickly shifted from fear of communism to fear of fascism. But the Red-baiters were still out there. Bogie had to know that his work with the Fight for Freedom

Committee, with its alliances with labor unions and other progressive movements, would further solidify the perception of some people that he was a socialist. His willingness to stand up and be counted, no matter the danger it presented, came from principle. He had become more political over the past year and more willing to take risks. If he hadn't believed so strongly in what he was doing, he would never have gone to St. Louis. But he was also predisposed to take such a stand, since he had a history of acting on impulse and letting the chips fall where they might.

BOGART AND METHOT LEFT ST. LOUIS BY TRAIN THE DAY AFTER THE RALLY, heading for New York. The city felt very different with so many young men in uniform and many more lining up at recruiting stations. But in some corners, life went on as usual. Bogie and Mayo could be found at one of their old haunts, "21" or Tony's, which was still open on 52nd Street even if its cachet had faded since the Roaring Twenties. The Bogarts drank until the wee hours of the morning.

The press kept up its coverage of the "Battling Bogarts," gleefully covering their battles as if they were Punch and Judy. Many of the accounts of the Bogarts' battles were obviously tongue in cheek, approved by the studio and likely by the couple themselves, because of the great publicity it gave them. The stories read like scenes from slapstick comedies. In one, Mayo throws her highball at Bogie. "He never troubles himself to duck," one magazine writer reported, "but sits calmly in his chair while the glass whizzes by, uncomfortably close to his valuable face." As the glass shatters on the wall behind him, Bogie coolly quips, "Sluggy's crazy about me because she knows I'm braver than George Raft or Edward G. Robinson." The anecdote is essentially a vaudeville sketch, in which everyone understands that the two combatants actually adore each other. The trope of the Battling Bogarts provided journalists with an endless supply of jokes and anecdotes, many of which were likely made up.

Yet behind the comical headlines, real trouble was beginning to brew. With the success of *The Maltese Falcon*, Bogie was now triumphant. Warner Bros. had rewarded him with a new *seven-year* contract at $2,750 a week. Finally he could enjoy some sense of financial security. But Mayo didn't feel secure. She had pushed for Bogie's success for years, but now, with her husband a top star, she increasingly felt redundant. Bogie had needed her before; now, plainly, he didn't. Conscious of her fading looks

and also, reportedly, her lack of children, Mayo felt that she no longer had any leverage to hold on to her husband. One syndicated columnist hinted at the troubles between them: "When Mayo Methot speaks, [Bogart] listens. She gave up a career for him. So she works at keeping their marriage together. Once, the girls let Bogart alone. But now the style in men has changed. The big, strong, homely boys are in the lead and so Bogart is way out there, leading the field." It was one thing for Mayo to feel confident in their marriage when Bogie was just a character villain, entirely another thing after he became a romantic star. An assistant to Hedda Hopper would remark, years later, that Mayo had come to resent the fact that she "gave up her career to be just Mrs. Bogart."

Ironically, despite his success, Bogie wasn't feeling any more contented than his wife was. The success of *The Maltese Falcon* and his newly won contract had not quelled his self-doubt. Four decades of low self-esteem were very difficult to overcome. All of that meant that whenever the couple argued, a whole set of issues was triggered between them. "Mayo liked to complain about the unfair treatment they got and I think sometimes it set [Bogart] off, as if maybe she was saying out loud what he was feeling inside," said Mayo's friend M. O'Brien. Mary Astor's observation that Bogart's dissatisfaction with his life and career "made him contemptuous and bitter" suggests why his wife's diatribes could so provoke him. When Mayo railed against the studio for its treatment of Bogie (*All Through the Night* was an unworthy follow-up to *The Maltese Falcon*, for example), it only made her husband grumpier and more pessimistic. Mayo was no longer offering ideas for a path forward, merely bewailing the unfairness of the system, no doubt for herself as well as for Bogie.

As their individual neuroses rose to the surface, real conflicts and arguments, not the sorts of comical antics the press described, became more frequent. In the aftermath of *The Maltese Falcon*, Bogie felt a growing discontent in his marriage that may explain what happened at some point in 1942. Whether during the post–Pearl Harbor trip to New York or on another trip back east soon after, Bogie cheated on his wife. It was likely for the first time.

At 49 East 52nd Street, in a seven-story brownstone that had once been a home of the Vanderbilt family and, a little later, the Juilliard Graduate School, a soap opera called *Second Husband* was broadcast on the CBS radio network. The actors stood in front of microphones in soundproof studios reading their scripts. The star of the show, playing the

glamorous but conflicted Brenda Cummings, was Helen Menken. Now forty, Menken had retired from the stage and found new fame on the popular five-days-a-week soap. Whether by accident or design, Menken and Bogie reconnected. More than a decade had passed since their acrimonious split, and now only the good memories remained, as well as the sexual attraction. Menken was still a striking woman, with a slim figure and titian-colored hair. They began an affair.

Like Bogie, Helen had remarried. Her husband, Henry T. Smith, was a respected optometrist currently serving as an officer in the US Army; he'd been part of the army reserves since the end of World War I. *Second Husband* had been written with Menken in mind, so perhaps Brenda Cummings's conflicts with her husband about pursuing an acting career had some basis in fact; Helen's last Broadway show had come soon after her second marriage. Whatever the situation with her husband was, Menken seemed ready and eager to take up with Bogie again. Sex had been the one thing, after all, that they'd never had problems with.

For Bogart, the affair was completely out of character. Even when Mary Philips had given him the freedom to sleep around, he had rarely, if ever, taken advantage of it. John Huston called him "morbidly faithful" to his wives. Many of Bogie's male friends were dogs when it came to sex, using their power and prestige to seduce as many women as possible. Huston had affairs with numerous women, even hooking up with Mary Astor during the filming of *The Maltese Falcon*. Yet though "the ladies liked Bogie," Huston said, "he was not a ladies' man." Nathaniel Benchley said that "sex was low on his list of hobbies."

The reconnection with Menken, therefore, was not just about sex. What Bogie looked for in women was an emotional connection that went beyond the physical. If he didn't feel safe with a woman, he stayed far away, fearful of the emasculation he'd witnessed his father endure and for which he blamed his mother. Bogart responded to women who possessed the traits Maud had lacked: warmth, a sense of humor, nurturance. It's not surprising, therefore, that his first extramarital affair (at least that we can be sure of) was with a woman he already knew and already trusted. With Helen, impotence likely wasn't a problem.

But for the moment, he wasn't seeking any change in the status quo. He didn't want a divorce from Mayo, much as he hadn't wanted one from Mary Philips. He still had feelings for his wife. In March 1942, he surprised her on her thirty-eighth birthday with "a gold necklace that must

weigh a ton," the columnist Jimmie Fidler gushed. Given the timing, of course, there may have also been some guilt behind the gilt.

THE DIRECTOR MICHAEL CURTIZ, CALLED "IRON MIKE" AROUND THE STUDIO, was finally ready to call action on the first scene of Bogart's latest picture. It was May 25, 1942. In his heavy riding boots, Curtiz clomped around the set, barking out orders in his thick Hungarian accent. He knew very little English; to become fluent, he believed, would take away time from planning his pictures, of which he had made many, including three Errol Flynn blockbusters. Curtiz thought little of actors, seeing them as being not much different from props. He was known to berate his players in full view of the company. Bogart had seen him in action on the sets of *Kid Galahad* and *Angels with Dirty Faces*, but he'd largely escaped Curtiz's invective because he hadn't been the star. Now his name was above the title: HUMPHREY BOGART IN CASABLANCA.

The scene had taken several hours to set up because of the very specific lighting that the cinematographer, Arthur Edeson, needed to set the ominous, shadowy mood of the picture. The actors had just learned their lines, since the writers, the brothers Julius and Philip Epstein, along with Casey Robinson, had finished them only the day before. Even as Curtiz called "Action!," the actors did not have a full script. The Epsteins were still banging away at it. It left the entire company, except perhaps the director, anxious and pessimistic.

The scene being shot was a flashback that would be inserted into the middle of the picture, set in the Parisian café La Belle Aurore. Bogart is first seen in midshot, standing at a bar beside a silver replica of the Eiffel Tower. Behind him, somewhat out of focus, are Arthur "Dooley" Wilson, at a piano tinkling a few bars from the old Rudy Vallée song "As Time Goes By," and Ingrid Bergman, standing beside him, listening. Very little direction had been provided to the actors, largely because the script had yet to be finished. Curtiz told Bogart to be buoyant and irreverent and Bergman to be distracted and anxious. The Germans were about to occupy Paris, Curtiz explained. Bogart, as the American expatriate Rick, should be confident that they'll get away. Bergman, as the European Ilsa, should be unsure, struggling with a secret.

That was not a lot for the actors to work with. The dialogue, as Casey Robinson admitted, was flowery, but it was necessary "to get over to the

audience in 50 feet [thirty-three seconds] an intense love affair between two people." Bogart and Bergman did their best. Rick clinks glasses with Ilsa and says, "Here's looking at you, kid," as Ilsa's eyes glisten with tears. "With the whole world crumbling," she says, "we pick this time to fall in love." They kiss, and that's basically the extent of the scene.

Both Bogart and Bergman were extremely unhappy that first day of shooting. The script was arriving in dribs and drabs, Curtiz was uncommunicative, and the studio refused to provide a suitable budget. The next day there was a tempest in the front office, with Hal Wallis scolding Edeson about how long he'd taken to set up the lights and informing him that he'd need "to sacrifice a little on quality, if necessary." Among the top brass of the studio, there was little confidence in the picture, an attitude that had been set early on by the screenwriter Robert Buckner, who had told Hal Wallis that the play on which the film was based was "sheer hokum melodrama" and that "this guy Rick" was "two-parts Hemingway, one part Fitzgerald, and a dash of café Christ."

Bogart had met his costar, who was being loaned to Warner Bros. by Selznick, only a few weeks before production began. The actress Geraldine Fitzgerald, who'd been briefly considered for the part of Ilsa, recalled a conversation she'd had with Bogie and Bergman in the studio commissary at the time. "They thought the dialogue was ridiculous and the situations were unbelievable," she said. They both wanted out.

For Bogie, *Casablanca* was another unworthy follow-up to *The Maltese Falcon*. He also felt little chemistry with Bergman. "I kissed him, but I don't know him at all," the Swedish actress later remarked. Bogie may have had personal reasons for feeling uncomfortable with Bergman. In scenes with her, he had to strap three-inch wooden platforms onto his shoes, since his costar, topping five foot nine, was at least an inch taller than he was. It was his first time, as a romantic hero, that he hadn't measured up to his leading lady; Bette Davis was five foot three, Ann Sheridan five foot five, Ida Lupino five foot two, and Mary Astor five foot six.

He'd been surprised by the critical and commercial success of *All Through the Night*, which, through an accident of timing, had become the ideal uplifter after Pearl Harbor. The story of a shady Broadway producer (Bogart) who infiltrates and exposes a group of German agents with good old American ingenuity, the film is a breezy mix of farce and gangster shoot-outs. Having become more adept with comedy over the past few years, Bogart delivers a double-talk scene with William Demarest that

is a masterpiece of comic rhythm. Calling Bogie "that ever-resourceful facer of situations," Bosley Crowther concluded that he played his part with "cool and calculated perfection." *All Through the Night* racked up an impressive $48,000 in its first week at the Strand in New York and did well in other cities, too; *Variety* reported that the film had made "a zooming 21Gs" in Pittsburgh.

Bogie had next been cast in another gangster picture, *Escape from Crime*, later retitled *The Big Shot*, with a script that was even less inventive than that of *All Through the Night*. Worse, it was yet another castoff from Raft, a fact that rankled Bogart no end. Released while *Casablanca* was in production, *The Big Shot*, the story of a gangster looking for redemption, was merely another example of Warner Bros.' nostalgia for "the Golden Age of crime," according to Crowther. But Bogart, "with his patient fatalism and his sense of the futility of it all, is able to impart a certain dignity to an otherwise silly role."

Finally, the studio realized that what it needed was a reunion of the *Maltese Falcon* team. John Huston was tapped to direct Bogart, Mary Astor, and Sydney Greenstreet in *Across the Pacific*, the story of a spy, Rick Leland, who foils a plan by the Japanese to bomb the Panama Canal. The original script, written in the fall of 1941, had rather prophetically used Pearl Harbor as the intended target of the Japanese attack. After December 7, the script was hastily changed, with Bogie quipping "Let's hurry up and get this thing over with before the Canal goes too." Leland is very much Sam Spade in a military setting. Greenstreet is once again the villain, but Astor this time turns out to be completely innocent, which makes for a happy fade-out but a rather sparkless romance with Bogart. For the most part, *Across the Pacific* was a happy reunion but one, Astor said, that was "minus a script." Still, the film did quite well, posting what *Variety* called "mighty takings" ($55,000) in its first two weeks at the Strand. After screening a preview in Washington, DC, the studio head wired S. Charles Einfeld, REACTION OF AUDIENCE CONVINCES ME BEYOND A SHADOW OF A DOUBT THAT HUMPHREY BOGART IS ONE OF OUR BIGGEST STARS . . . THE EQUIVALENT TO CLARK GABLE.

So he was a star—but a star without script approval, meaning that when the outline for *Casablanca*, based on an unproduced play called *Everybody Comes to Rick's*, was sent his way, Bogie had to accept the part despite any misgivings he had.

Casablanca is the story of an American, Rick Blaine, who operates a

nightclub in Vichy-controlled Morocco. Nazis, Resistance fighters, and refugees all come to Rick's, exchanging secrets and planning escapes. Among them is Ilsa Lund, Rick's lost love, who arrives with her husband, the Resistance leader Victor Laszlo. Aware that Victor is being tailed by German agents, Ilsa hopes that Rick can help provide them with safe passage to the United States. But as love blooms anew for her former flame, she decides that she will stay with Rick and let Victor go on alone. Rick's left with a dilemma: heart versus conscience.

Bogie was pleased that the film reunited him with Lorre and Greenstreet. But as production proceeded through the spring and into the summer, the cast's spirits remained low. Even with the script now finished, they still lacked faith in the story, and rewrites were frequently being handed to them. "I had no idea where it was going," Bogie later said. He especially didn't buy the ending, where Rick, until that point entirely self-serving, nobly sends Ilsa away to freedom in the United States instead of keeping her with him, as she desperately wants. At one point, Bergman complained to the producer, Howard Koch, "How can I play the love scene when I don't know which one I'm going off with?"

The writers, too, understood how important it was to get the ending right. "There is a danger that Rick's sacrifice in the end will seem theatrical and phony," read an assessment from Koch, "unless, early in the story, we suggest the side of his nature that makes his final decision in character." Some suggested that Rick knock Ilsa out so she could be dragged away; others wanted to jettison the sacrifice entirely and permit Ilsa to stay with Rick. Curtiz and the producers clearly understood that both approaches would be even worse than what they had now.

Relations with their director were another source of frustration for the company. "Mike drove most of his actors crazy," said Lee Katz, Curtiz's longtime assistant. "He was from the European school, full of dolly shots and twisting cameras"—so much so that he tended to watch the cameras instead of the actors. Bogart often seethed over Curtiz's directorial decisions, which perhaps gave more punch to Rick's sarcastic asides.

By the middle part of July, open warfare had broken out between star and director. Already a week behind schedule, they were about to shoot the climactic airport scene. Before the cameras started rolling, Bogart got into a shouting match with Curtiz and refused to continue. Just what set off the fight is unknown, but it was serious enough for Hal Wallis to intervene to end the standoff. The airport ending had to be gotten right,

with Rick sending Ilsa away without appearing to be out of character. But for the moment, no one agreed on how to proceed.

A study of the various versions of the script reveals that much of the setup for Rick's selflessness had already been accomplished well before the end of the shoot, despite later reports that it was all done at the last minute. Koch, whose script doctoring would lead to a writing credit, had come up with a scene between Rick and Captain Louis Renault, played by Claude Rains, that would establish Rick's innate sense of honor and duty. In the film, Renault points out the sentimentality hidden under the café owner's cynical shell by revealing that he had once run guns to Ethiopia and fought for the Loyalists in Spain, all to defeat fascism. There was also the scene, enlarged and emphasized by Koch, of Rick fixing the roulette table so two young married refugees can win enough money to get out of Casablanca. In so doing, he also rescued the wife from, it is implied, having to sleep with Renault to gain their freedom.

Such revisions would make Rick's sacrifice believable. But cast and crew were still left without the exact mood and dialogue for that all-important climactic scene. Casey Robinson, who would not be credited on the final film, came up with the solution. Rick was "not just solving a love triangle," he wrote, but "forcing the girl to live up to the idealism of her nature, forcing her to carry on with the work that in these days is far more important than the love of two people." The entire weight of the film now rested on Bogie and his final speech to Bergman.

The scene was shot near the end of production. Predictably, star and director clashed again when it came time to shoot it. More hours were lost due to their disagreements, noted on the production log as "story conference between Mr. Curtiz and Mr. Bogart." At last they came to some understanding and Curtiz signaled to Edeson to start the cameras. Rick tells Ilsa to leave with Victor. She objects, but he says, "The problems of three little people don't amount to a hill of beans in this crazy world. . . . Here's looking at you, kid." They had no idea of how iconic that scene would become. Curtiz simply called "Cut!," and that was that—although Bogie was called back a few weeks later to record the dialogue for the film's actual ending. He tells Claude Rains, who's become an ally, "Louis, I think this is the beginning of a beautiful friendship"—another iconic line, this time written by Hal Wallis.

The production of *Casablanca* had been largely an unhappy experience for Bogie. He'd remained edgy all through the shoot and never

trusted the material. Once more, anything could set him off, and he was quick to fight. It wasn't just on the set that he vented his frustrations. His altercations with Curtiz mirrored the fights he was having at home. His relationship with Mayo was becoming more fraught. Dorothy Parker would quip, "Their neighbors were lulled to sleep by the sounds of breaking china and crashing glass." The lightheartedness of the earlier tales of the Battling Bogarts was becoming darker. A Warners publicist would remember observing a domestic squabble between the couple around that time that ramped up in intensity the more the two drank. Finally, Mayo, unsteady on her feet, fell backward, becoming wedged between the sofa and the wall. As she lay there helpless, Bogie screamed at her.

Humphrey Bogart was now a top movie star, on the cusp of his greatest successes. He was growing more respected by his peers every day and had won a contract most actors only dreamed about. But he wasn't happy. His marriage was in crisis and he had no idea how to fix it. How could he be empathic to Mayo's pain when he felt so much pain himself? Professional success, as it sadly turned out, was not enough to erase a lifetime of self-doubt and resentment.

14

Burbank, California, Late August 1942

Ann Sheridan had just left the set of her new film, *King's Row*, when she ran into a pal, a freelance wig maker who was making the rounds of the soundstages. Sheridan invited the young woman to join her at a wrap party for another film on Warner Bros.' Stage 14. "Warners ground out so many films in those days," Sheridan's friend would remember, "that there always seemed to be a wrap-up party in progress." The fête was for *Casablanca*, Sheridan explained. Humphrey Bogart and the other stars would be there. The young wig maker was happy to tag along.

She was Vera Peterson, called "Verita" (little Vera) by her friends, and she was a dark brunette with crystal blue eyes. A native of Arizona, she told her friends she was Irish on one side and Mexican on the other. She was twenty-four years old and married, unhappily, to a draftsman in the art department at Columbia.

Once inside, Peterson was impressed that the studio had gone all out for the event. "It was set up on a huge soundstage, with L-shaped tables, catered food, an open bar, and a dance orchestra," she recalled. The party was in "full swing" when she and Sheridan arrived. Studio chief Jack Warner was sharing a table with Michael Curtiz and the producer Henry Blanke. Blanke waved Sheridan over. He also knew Peterson, having met her with Sheridan at the Max Factor Hollywood Make-up Studio. The two women took seats at the table. The chair next to Peterson was empty.

That was the moment Humphrey Bogart arrived. Noticing Blanke and Sheridan, both friends of his, the star headed over to the table. "I watched him approach," Peterson wrote forty years later in a memoir, "and was intrigued to see he was staring directly at me." The thought crossed her mind that she might be "the evening target for his notorious needling," a trait that was well known throughout the industry by now. But she was "too young and stupid," she wrote, "to be insecure and too thick-skinned to fear any barbs" he might lob her way.

Bogart's first words were directed to Blanke. "Where'd a creep like

you find such a good-looking broad?" he asked, indicating Peterson. Sheridan introduced them. Bogie took the chair beside the young brunette. "[He] gave me his undivided attention for the rest of the evening," Peterson recalled. "I was flattered. And I was delighted to discover that, unlike many in Hollywood, he didn't talk about himself or his pictures or his acting. He wanted to talk about me." The liquor flowed freely. Eventually they got up to dance.

Though the ghostwriter of Peterson's memoir seems to have invented some dialogue and condensed some timelines, Peterson told her last partner, Dean Shapiro, that the book was, in its essence, an accurate account of what she remembered. Even if not in her actual words, the sentiments and observations in the book reflect her beliefs. Peterson gives us a different picture of Bogie than other writers do. On the dance floor, she recalled, "Bogie started getting amorous, kissing my cheek as we danced." She had to ask him to stop, which he did, since she was concerned about the studio execs watching them.

It's true that Bogart wasn't Huston or Errol Flynn, hitting on every female who passed by. He wasn't the sort to view a wrap party as an opportunity to "score," as so many of his contemporaries did. Yet when we recall Bogart's initial meeting with Mayo, we see essentially the same behavior. Feeling increasingly abandoned and mistreated by his wife, Bogie's amorous attention to Mayo on that first night had drawn the attention of others, paralleling the scene Peterson described on the dance floor of Stage 14. By that point, too, Bogie had already broken his marriage vows once in his dalliance with Helen Menken, so breaking them again with someone else might have been easier for him to do, despite his inclination to fidelity.

The next day, the pair met for lunch at a restaurant across from the studio in Burbank. Peterson offered a telling anecdote of Bogie at that moment. He asked her if he had been out of line or insulted her in any way the night before. It suggests that he'd had enough to drink that some parts of the evening were blacked out. But he was also likely genuinely concerned. Always loath to come across as a roué or as the sort of cad he'd once played on the Broadway stage, Bogie thought of himself as a gentleman (even if Mayo sometimes had reason to disagree). Peterson assured him that although he hadn't been "a perfect gentleman," he'd been a gentleman all the same.

The infatuated couple began seeing each other once or twice a week.

They met at Peterson's modest house on Roselli Street in Burbank. Bogie called his inamorata "Pete," choosing the nickname himself, instead of "Verita," the name she was called by most everybody else. "Pete" would be private to them. He'd show up at her house in his Jaguar in full view of the neighborhood. "It was craziness," Pete remembered. "We were both married and had everything to lose by getting involved in an affair. But here I was in my little house on a little street with barking dogs and nosy neighbors, with Humphrey Bogart, whom the world could recognize from a mile away, standing on my front porch in broad daylight and ringing my doorbell."

Their affair was a well-guarded secret, but a few colleagues did clue into what was going on. Sam Jaffe, who was also the source for the affair with Menken, admitted to A. M. Sperber that he had known about Peterson, or at least he had been "aware that there was such a girl" in his client's life. The publicist Bob William also learned of the affair, understanding that Peterson was "Bogie's girl." Nita Rodrigues, a young hairstylist Peterson would mentor in the 1950s, was also privy to the relationship. She remembered spying them sitting together on the set of one of Bogie's films, away from all the hubbub. "They were holding hands," she said, "Verita's head on his shoulder." But due to the efforts of publicists such as William and deferential chroniclers, the romance would remain largely unknown until Peterson wrote about it forty years later.

Pete was young and starry-eyed when she met Bogart. Deeply unhappy in her marriage, she was susceptible to the attentions of a wealthy, famous man. Her life had not been easy. She had been born Vera Gray Ellis in 1918 in Willcox, Arizona; her mother had died of septicemia about a week after her birth. Her father, Joe Willie Ellis, was a ranch hand on the family cattle farm. They lived on arid, sparsely populated land encircled by mountain ranges. Work on the farm was hard, long, and dirty. Pete would try to upgrade her origins a bit in her memoir, insisting that her grandfather was a famous surgeon instead of a cattle farmer.

Her claim of being of Irish and Mexican descent isn't borne out, either, by the birth and marriage records of Arizona. The Ellises had come to the state by way of Texas, and the family's roots were in Missouri, Virginia, and Kentucky, not Ireland. Her mother, Vera Juanita Ball, had been born in Missouri, not Mexico; her parents had also been born in Missouri. But the middle name "Juanita" may hint at some Mexican heritage farther back. In any event, Pete would always feel a close connection

to Mexico. Growing up in the southeast corner of the state, she was only an hour's drive to the border. A large Mexican community lived in Cochise County, and Pete became fluent in Spanish. She would make several trips to Mexico throughout her life.

In the summer of 1934, shortly after graduating from high school, the sixteen-year-old Vera entered the Miss Arizona beauty pageant. In her memoir, she made sure to point out that she had done so on her own, suggesting that her determination to get past those mountains began quite early. The contest, she wrote, was "exciting"; it might also give her the boost to break free of her hometown. The *Arizona Daily Star* listed her among the contestants of the Miss Arizona pageant in Tucson in June 1934. The event was sponsored by Fox's West Coast Theatres chain. The winner and first runner-up would receive "a week's trip to Los Angeles and a weekend stay at the beautiful Lake Arrowhead resort." A movie fan since the age of eight, Vera very much wanted to leave her family's cattle ranch and head to Hollywood.

Vera didn't win the contest, nor was she a finalist. But she'd "come to their attention," she wrote, and somehow made it to Hollywood anyway. The last notice of her in the *Arizona Daily Star* local news columns was on July 25, 1935, when her grandmother hosted a swimming pool party in her honor. Perhaps the gathering was to wish Vera good luck on her move to Hollywood. How she made her living in the film colony over the next few years is unknown. But by 1939, at the age of twenty-one, she'd landed a contract with Republic Pictures, a low-budget studio known for its westerns. She'd been hired because of her looks—photos reveal a striking beauty—and because she knew how to ride a horse.

A career as an actress, however, wasn't to be. While shooting her first picture, Vera fell from the saddle and broke her arm. Republic abruptly terminated her contract. Despite her disappointment, she decided to remain in Hollywood, where "there were always grand parties to go to," she remembered, "and I attended them all while I had the chance." She made "many valuable social contacts" in Hollywood and elsewhere during that period, she wrote.

One of those contacts brought her into the wig-making business. The company's hairpieces were assembled from hair obtained from European nunneries and held together by the finest French lace, which was the preferred foundation for wigs and toupees. During the war, quality hairpieces were hard to find, but Vera's business had an abundant inventory.

She convinced her partner that the movie studios would be the ideal market for their wares. Her gamble paid off, and soon she had contracts with Warner Bros. and other companies.

Sometime in 1940 or 1941, at the age of twenty-two or twenty-three, she married Robert Peterson, about ten years her senior. Peterson had been hired by Columbia to help design sets. By the time of the wrap party for *Casablanca*, Robert and Vera Peterson had been married for less than two years. That was enough time, however, for Mrs. Peterson to realize that she'd made a mistake. Although not naming her husband in her memoir, she called him "a good man" but one who was also a loner and often cold. "He was a workaholic, too. . . . I was simply a convenience for him." She'd tell her last partner, Dean Shapiro, that she suspected that Peterson was gay. Marital relations between them became practically nonexistent. So when Bogart showed some passion for her, it's no surprise that Pete responded enthusiastically.

For Bogie, Pete was just what the doctor ordered. She had her own money and her own business; she would never be dependent on him or in competition with him. She had confidence, which Mayo had lost, intelligence, and independence. There was no harping about where Bogie had been or what he'd been doing; they were simply happy during whatever time they could find together. And critically, Pete could keep up with his drinking—always a prerequisite for Bogie in finding a mate. "She could trade cuss word for cuss word and shot for shot with him," said Dean Shapiro. "She liked to drink, he liked to drink. They did a lot of crazy things together."

Bogie got the studio to hire Pete to make his toupees. They had become necessities as his hairline kept retreating farther back on the top of his head. An aging star needed to present the illusion of youth. Making Bogie's toupees meant that Pete was often on the set with him and sometimes alone with him in his dressing room. It didn't take long for her to fall in love. She believed that Bogie was in love with her, too. According to Pete's memoir, Bogart declared his love for her early in their relationship, insisting that what they had would never die. Whether or not Pete was embroidering the past a bit, it's clear that she was more than a dalliance for him. She served as a ballast for Bogart during the tumultuous last years of his marriage to Mayo. Before he'd met Pete, he'd been trapped between the stress of the studio and the stress of his home life. He'd been surly, pessimistic, and combative. He didn't exactly lose those

traits now, but he did find a measure of stability and tranquillity during his visits to the little stucco house on Roselli Street.

REFLECTING HIS NEW STARDOM, BOGIE WAS CAST IN THE STUDIO'S EPIC WAR picture *Action in the North Atlantic*, taking on the kind of role Gable and Cagney had heretofore embodied. Another piece of propaganda, this time the studio's intent was to valorize the supply convoys of the merchant marine. *Action in the North Atlantic* was directed by Lloyd Bacon, who'd directed Bogart in several earlier films. It's filled with exciting, well-filmed battle scenes, often between German aircraft and the US merchant marine, a masterwork of miniatures and aerial photography. Finally, Bogart was having the wartime experience at sea that he'd missed out on during the First World War.

Despite all that, the script was predictable, giving Bogie very little to work with, which always made him irritable. It was no longer enough just to cast him in the starring role of a big-budget picture. He'd become determined to expand his range as an actor, and *Action in the North Atlantic* didn't give him an opportunity to do that. It's notable that at the moment he'd finally achieved the success he'd long sought, some of Bogie's vaunted professionalism seemed to erode. On the set of *Action in the North Atlantic*, he frequently didn't know his lines. Another actor in the film, Dane Clark, finally blew his top at Bogie, a risky move for a young player just starting out. Bogart argued that the dialogue was so terrible that he couldn't speak the lines.

A. M. Sperber pinned the blame for this on Mayo, writing that for the first time, Bogart's "domestic turmoil was having an effect on his work." But there's also the specter of his impulse for self-sabotage to consider, which frequently appeared just when things seemed to be finally going his way. In any event, he was drinking more than ever, often with Pete beside him.

During one of his regular visits to Pete's house and the consumption of too many "smashes of loudmouth" (the term they used for Scotch and soda), the couple was discovered in the shower together by Pete's husband. Pete stepped out of the shower and held the door closed behind her. Her husband didn't recognize the man behind the frosted glass. The scene was chaotic, with voices, including Bogie's, being raised. Instead of making apologies or excuses for cuckolding Peterson, he went on the offensive,

accusing him from inside the shower of being a neglectful husband. Pete would later write that she hadn't been sure "how much of [Bogart's reaction] was booze," but alcohol had often unleashed his rage in the past.

Eventually Robert Peterson left, "apparently overwhelmed by the absurdity of it all," Pete surmised. When he returned later that night, his wife revealed the identity of the man who'd been in the shower. She pleaded with her husband not to expose Bogart and ruin his career with scandal. To her relief, her husband never breathed a word. A few weeks later, on December 11, 1942, Robert Peterson enlisted in the army, putting his career on hold. He would serve for the duration of the war, through November 1945, seeing action in Europe and rising to the rank of staff sergeant. It's unknown how often he returned to see his wife or whether he did so at all.

The ethics of sleeping with a woman whose husband was on active duty for his country are dubious, but Bogie had already done the same thing with Menken. In that, he was certainly not behaving like Rick Blaine, giving up Ilsa to the freedom fighter Victor Laszlo. Rick, however, was a survivor; Bogie was never convinced that he was.

In the late fall of 1942, the Allies invaded German-occupied North Africa, liberating the territory. At Warner Bros., the immediate thought was to film a short epilogue to *Casablanca* showing the landing of the Allies. Hal Wallis nixed the idea, though he did agree that they should release the film as soon as possible to "take advantage of this great scoop." The release dates of *Casablanca* and *Yankee Doodle Dandy* were summarily switched, allowing the former to hit theaters first. Jack Warner remained unsure about the ending. But a preview of the picture on November 12 convinced him it worked. Wallis cabled that the reaction to the picture had been "beyond belief."

Casablanca finally opened on November 26 in New York. Anticipating a great demand for the film because of the Allied victory in North Africa, Warners engaged in a bit of price gouging at its theaters, raising admission prices by close to 50 percent. As the studio hoped, the crowds weren't deterred by the higher cost. In its first week at the Hollywood Theatre on West 51st Street, *Casablanca* raked in $37,000—"The highest ever scored at the theatre," according to *Variety*. The trade paper predicted that the picture would go on to "take the b.o.'s [box offices] of America just as swiftly and certainly as the American Expeditionary Forces took North Africa."

Variety was right. When the film opened elsewhere around the country, the returns were more than anyone involved had ever imagined. In February, after two months of steadily rising receipts, the ecstatic Hal Wallis called *Casablanca* "a goldmine" and advised that the studio should "milk it until we get all the gold." *Casablanca* would go on to become the seventh-highest-grossing film of 1943, the first time a Bogart picture had made it into the top ten.

The critical acclaim was just as enthusiastic. The *New York Times* deemed *Casablanca* a "rich, suave, exciting and moving tale" and identified Bogart "as the cool, cynical, efficient and super-wise guy" with "a core of sentiment and idealism inside." The actor had mastered the amalgamation of his previous sinister characters with his current heroic ones. "Conflict," the reviewer judged, "becomes his inner character."

This is the essential formula of Bogart's stardom. From here on, his characters would all have both angels and devils sitting on their shoulders, with the angels usually winning but not always. His characters would be guarded, distrustful, skeptical, and vulnerable despite their veneer of cynical self-assurance. That was what established Humphrey Bogart as one of the great American movie actors.

And never was that star presence on better display than in *Casablanca*. Bogart gets the big entrance reserved for top stars. We don't see him for a full nine minutes. Then we get a glimpse of his hands. He signs a paper "OK, Rick," and the camera slowly moves out to finally reveal him, resplendent in his white tuxedo and cloaked in a haze of cigarette smoke. He's playing chess by himself (Bogart's idea, given his love of the game). We know who Rick is even before he speaks. Throughout the picture, Bogart is never rattled, but audiences can discern his inner conflict. In the final, iconic two-shot of Rick and Ilsa, Bogart is steady and resolved, yet his whole being trembles with the doubt, sorrow, and regret he also feels. He's so convincing and powerful in that scene that the story of his lack of faith in the ending seems almost a ruse, as if he were leading us on. He knew what he was doing all along. Or at least, he made it look that way.

THE CREW FILMING A SCENE ON THE WARNERS BACK LOT PARTED TO ALLOW A caterer to wheel a large sheet cake toward the star of the picture and his wife. For a moment, Bogie and Mayo weren't sure what was going on. But

they broke into smiles when they read the inscription on the cake: HAPPY FIFTH ANNIVERSARY TO MR. AND MRS. BOGART.

The date was Saturday, August 28, 1943. Mayo was on the set that day to shoot an uncredited cameo in her husband's latest picture, *Conflict*, directed by Curtis Bernhardt. It's unclear what part she played, but it may have been the woman in the pawnshop, whose face is not seen, or, perhaps more likely, the policewoman who masquerades as Bogart's wife and leads him on a wild-goose chase, whose face is also never glimpsed. Who proposed the idea for the cameo and who ordered the cake are unknown. But Bogie seemed pleased to have his wife on the set. Before slicing the cake, he extolled Mayo's charms, which, he made sure to point out, included a strong right hook. Rubbing his chin for effect, he basked in the crowd's laughter. Even in a tender moment, he knew that the crew expected to catch sight of the Battling Bogarts, and after twenty-three years as an actor, he knew how to please his audiences.

His smiles belied the tensions in the marriage, however, not to mention his dissatisfaction with the picture. Instead of *Conflict*, a noirish thriller, Bogie had hoped to be working on *Passage to Marseille*, the story of a French Resistance fighter. But there he was, glowering his way through a melodrama about a man who murders his wife—on their fifth anniversary yet. Bogart's objections to the script may have arisen over its echoes of his own life. It wasn't just the coincidence of the anniversary. The original draft by Arthur T. Horman contained dialogue that hit very close to home. The wife of Bogie's character vows that she'll never let him go: "I'll make the rest of your life as miserable and hopeless as you've made mine!" Bogart successfully lobbied for the removal of the dialogue.

Still, enough similarities remained to make filming uncomfortable at times, especially when Mayo was on the set. Bogart didn't hate Mayo the way Richard Mason, the character he played in *Conflict*, hated his wife. But the problems between the Bogarts had grown, exacerbated by their drinking and by the imbalance between them as a result of Bogie's stardom. The slapstick violence of the start of their marriage was no longer an act, many of those who knew the couple would claim. Neither side pulled punches any longer, many witnesses attested. But how much of the picture they paint is accurate?

Eighty years on, one thing is clear: there's no getting away from the inherent misogyny in the stories of the Bogarts' battles. Among the worst of the tropes is that the fights were foreplay for sex. Henrietta Kaye,

Bogie's artist friend from New York, told a biographer that the brawls between the Bogarts must have had "something to do with their sex life because they were obviously hung up on each other." Mary Baker, once again doing her best to set the tone, asserted, "Their fights usually ended up in bed." That idea may have originated from an interview Bogie gave soon after the marriage. "I love a good fight," he said. "So does Mayo. We have some first-rate battles." The two of them, he declared, were like "a couple of cats on a back fence." But extrapolating from that statement a sexual component to the quarrels is quite the leap; worse, it trivializes and makes light of potential domestic violence and comes close to condoning it by alleging that both parties liked it.

Moreover, the accounts almost always place the blame for the physical assaults on Mayo. Mary Baker insisted that the only times Bogie got rough with his wife were "when Mayo forced him to be." Mayo, in the view of Baker and others, was the instigator, drunk and out of control, smashing her husband over the head with whatever she could find. It's an offensive old motif that holds women ultimately responsible for any violence against them. Mayo as the perpetrator of the violence defines these stories. The screenwriter Allen Rivkin recalled seeing Bogie and Mayo arguing on a pier as they waited for a gambling ship. According to Rivkin, the argument ended with Mayo pushing Bogie into the water, almost like a Three Stooges sketch. The novelist Niven Busch reported spotting the Bogarts at a café in Laguna Beach. When Busch heard a slap, he assumed that Bogart had struck his wife, but when he turned around to look, he saw that it was just the opposite: Bogie had been knocked off a barstool and was spread out on the floor, Mayo looming over him.

Approached by biographers decades later, these witnesses seemed eager to ascribe the worst of intentions to Mayo right from the start. Take, for instance, a story told to A. M. Sperber by a producer's assistant who'd worked on *High Sierra*. Mayo sent a floral wreath adorned with condoms to the set, a gesture that the assistant described as a threat from an unhinged wife. (Mayo was reportedly jealous of Ida Lupino.) The wreath seems just as likely, however, to have been a joke between the Bogarts, and because people weren't in on the joke, they ascribed rancor to Mayo's motives. Her friends said she often played pranks like that.

That Mayo sometimes smacked her husband is undeniable, but that is only one side of the story. The truth is that with all the rage

and resentment Bogart carried inside, he was not averse, on occasion, to striking his wife.

Sober, Bogart was gentlemanly, if somewhat patronizing, in his interactions with women, the way Jane Bryan had experienced him on the set of *Marked Woman*. But when he was drunk, all bets were off. "Sober, Bogart was great," said Allen Rivkin. "Drunk, he was a dirty bastard." Gloria Stuart described a night at the nightclub Slapsy Maxie's on Wilshire Boulevard when Bogie had objected to something Mayo had said and warned her if she said it again, he'd "clip" her. As pugnacious as her husband, Mayo had repeated her words, and Bogie, according to Stuart, had "pushed her into the next table, really whammed her."

John Huston, defending his pal, insisted Bogie only took action after his attempts to placate his wife had failed, but Mayo was "always taking center stage," instead of, presumably, remaining silent in the background. Huston was also known to refer to Mayo as looking and acting like "a bull terrier though not quite as pretty," which tells us a great deal about the sort of misogyny that colors these anecdotes about her.

But for the Bogart legend, Mayo, like his two earlier wives, had to shoulder the blame for the marriage's troubles. Bogie was just out for some innocent fun one night, Mary Baker said, but when he got home, the crazed, jealous Mayo stabbed him with a knife. According to Baker and the biographers who would follow her lead, the problem wasn't Bogie's boozing around town but how miserable Mayo made him, forcing him into it. Of course, for the mythmakers, it was necessary for Bogie to be miserable at that point in the story, since his true love was waiting to rescue him just a few years down the road.

Yet despite the conflicts, the marriage had endured. Even at the time of their fifth anniversary, they were still taking off for days at a time, alone, on *Sluggy*, with Mayo assisting her husband in dropping anchor and pulling it back up; she even took the wheel occasionally. "Aboard the cruiser, the Bogarts lead a clear-eyed, ruddy-cheeked life," one writer observed. Also, as often as they could, they flew out to Malabar Farm, Louis Bromfield's country house in Lucas, Ohio, where, for a few days or a week, they were free of problems and pressure. When they'd had to cancel Christmas plans due to overtime shooting on *Action in the North Atlantic*, Bromfield had sent them a picture of the farm with a note: "We miss you both very much . . . everyone here sends much love and more and more success to you both—our favorite couple." Not

to Bromfield were they the Battling Bogarts who disrupted every gathering.

Bogie could even wax sentimental about his wife. While making *Conflict*, he reflected to a reporter about the first time he'd laid eyes on Mayo, when she had been appearing in one of her Broadway shows. "She was fetching," he remembered. "I thought the guy playing opposite her was lucky." Some years later, he revealed, he'd spotted her in a box above his table at a Screen Actors Guild dance at the Biltmore Hotel. "She wore a stunning red gown and looked very, very interesting," he recalled. He went on tell the reporter that, on an impulse, he had taken hold of the bronze figure that ornamented the railing of the box and vaulted up beside her. That last bit might be some embroidery on Bogie's part, imparting a bit of Douglas Fairbanks to his image. But the sentiment it reveals tells us something about the passion he'd once had for Mayo and, significantly, about his feelings at the time of their fifth anniversary. In August 1943, despite the increased quarrels and physical violence, divorce was not on the table.

The couple had also appeared happy during location shooting for Bogie's last picture, *Sahara*. Another wartime adventure, the film was shot in various sandy, arid stretches of southern California and Arizona, which stood in for the Sahara Desert. Bogart made the picture on loan to Columbia, his first time back to the studio since completing *Big City Blues* in 1932, in which he'd been little more than a walk-on. It was also his first time at any studio other than Warner Bros. since *Dead End* in 1937. The production of *Sahara*, directed by Zoltan Korda, was a stew of testosterone; there was not a single woman in cast or crew. That meant Mayo stood out among the hundreds of men around her, all sweating in 90-degree heat. Sandstorms irritated eyes and coughing fits were common, so the company wore goggles and face masks; the adobe dust had "a very injurious effect on the lungs," according to one reporter on the scene.

On her own initiative, Mayo set up a canteen at the hotel where the company was staying. She proved a delightful and effervescent hostess, flirting with the boys and singing a few tunes. So popular did the canteen become that servicemen from the nearby US Army base started showing up. They dubbed Bogie "the mayor of Sahara, California" and Mayo "the mayor's wife." Away from the studio and the Hollywood newshounds, the Bogarts seemed to enjoy being together, much as they did when they

were able to get away to Louis Bromfield's farm. On the set, Mayo took good care of Bogie, keeping thermoses on hand filled with "ice-cold martinis." They also pulled pranks together, such as the time they stowed away in the back seat of costar Bruce Bennett's car as he and his wife set off for a day trip to Mexicali. As Bennett described it to A. M. Sperber, a couple of miles into the trip, up popped Bogie and Mayo, breezily inquiring "Where are we going today?"

Being on location with Bogie, going on vacation with him, sailing with him on *Sluggy*, meant that Mayo had her husband to herself. She didn't have to worry about him straying; he was always in view. He was her entire life. In the beginning, Mayo's devotion to Bogie had been touching; now, as her husband reached new heights with almost every picture, her constancy began to feel a little sad. Without a career or ambitions of her own, everything she said and did concerned Bogie. The only status she had left was as Mrs. Humphrey Bogart. His wife's dependence could weigh Bogie down. He felt anger, exasperation, guilt. According to Pete Peterson, it was clear that Bogie loved Mayo. The problem was that her "little idiosyncrasies," which he'd once found delightful, were now "exaggerated grotesquely." Mayo's unpredictability, so appealing five years earlier, now left her husband wary.

His own demons only made the situation worse. "There was something in him that made him needle people, provoke them," Peterson wrote, "and his wife [was] awfully sensitive to such provocation." Bogart made no attempts to curb his drinking, despite the rage it incited. Sam Jaffe said that at one point, in a fit of pique, Bogie cruelly told Mayo about the affair with Menken, which must have been shattering for her. And then there was the very strange story about the doors of his house. The Associated Press described him as having a "self-indulgence [for] knocking down doors." Mayo is quoted as saying that she'd just ordered a new living room door, the third in less than a year. Buying new doors, she explained, was simply part of the household routine. Bogie, she remarked casually, "knocks 'em down." When the writer expressed surprise, Mayo said, "It's very simple. He doesn't like doors. He's a very impatient man. We're always putting up new doors at our place. Bogie despises confinement of any kind."

In the Associated Press's telling of it, the story is comical, but the actor Patrick O'Moore, who'd appeared with Bogart in *Sahara*, revealed the darkness at the heart of it. He recalled a night on Shoreham Drive when

Mayo had locked herself in her room. When a couple of gunshots were heard from inside, Bogie smashed the door down to find his wife crying on the bed, the bullets apparently embedded in the wall. Later, he took O'Moore down to the basement, where twelve doors of the exact same size and style were stacked together. "Bogart said they put a new door in at the rate of one every other week," O'Moore told Joe Hyams.

Whatever the exact pathogenesis of the doors story, it reveals a marriage unraveling. By 1943, it was obvious that the Bogarts' union was in trouble. Though they attempted to hide that fact on the set of *Conflict*, their friends saw what was happening. Even during their mostly happy sojourn to the *Sahara* location, fissures had been evident. Bruce Bennett picked up on the deep unhappiness Mayo kept hidden under the smiles she wore at the canteen. "She was a talented actress in New York," Bennett said, but "she couldn't get started here, couldn't make the grade." Had Mayo established herself as a popular character actress instead of retreating into the role of Mrs. Bogart, it's possible that the marital troubles wouldn't have been as severe. Or perhaps, given the quick tempers and alcoholism of both parties, the disintegration of the marriage was inevitable.

IT WAS, AT LEAST IN PART, BECAUSE OF THE SIMILARITIES TO HIS CRUMBLING marriage that Bogart had tried so hard to get out of making *Conflict*. Jack Warner threatened to replace him in *Passage to Marseille* with the French actor Jean Gabin if he didn't do *Conflict* first.

Bogie had dug in his heels. "This is personal between you and me, Jack," he told the studio chief. Their telephone conversation, taped and transcribed, is extraordinary evidence of Bogart's anger. "I am more serious than I have ever been in my life," he declared. He would gladly go on suspension, he declared. Warner warned him if he did so, he'd regret it. Bogart snapped back, "Turn your dogs on me." The phone call ended with Warner telling Bogie, "Goodbye and good luck." The recalcitrant actor could "stew in his own juice," Warner told Steve Trilling after he hung up. Suspension it was.

Bogie had been counting on the studio backing down. His attorney, Martin Gang, had advised him that although refusing to obey a direct order from the studio was, indeed, a breach of contract, it was not grounds for the studio to sue him. "It is my opinion that the contract is entire,"

Gang wrote, "that the employer cannot sue for damages for breach of the contract on one particular clause of the contract." He cautioned that although that was just a legal theory, the studio was unlikely to test it: "I don't think Warner Bros. will ever let it get that far because their lawyers will be just as fully aware, as we are, of the possibility inherent in the situation."

A few weeks later, however, Bogie appeared to lose faith. He phoned Trilling to say he'd do the picture. His turnaround had come, most likely, from the same fear that had surfaced some weeks after his first suspension, fear that maybe he'd gone too far. "He came back into the fold only after Warner had hinted that he would let him die of anonymity rather than meet his demands," a reporter observed. Risking his entire career on a slender legal theory wasn't the best odds, Bogie appears to have concluded.

Humphrey Bogart was a bankable star. That year, he would make the top ten list of box-office draws for the first time. But there were new tough guys turning up every few months, younger and more handsome than Bogie. His old nemesis William Holden had emerged as a popular leading man at Paramount and was now serving as a second (later first) lieutenant in the army air force, making patriotic films used for training and propaganda. Gregory Peck, Ray Milland, Brian Donlevy, and Van Heflin were other up-and-comers who could play the sort of antihero roles Bogart had established. Always insecure about his success, Bogie likely figured that playing the game was better than risking oblivion.

He may have been motivated by something else as well. When he called Trilling agreeing to do the picture, he'd just learned of the death of Leslie Howard, shot down on June 1 in an aircraft over the Bay of Biscay by the German Luftwaffe. Bogie credited Howard with his film career, frequently citing him as a mentor. Howard had not been a belligerent man. He could tussle with producers and stand up for himself, but without the acrimony that existed between Bogart and Warner Bros. Perhaps Bogie realized that life was short and haggling over details was rarely time well spent. If so, he often forgot it in the years ahead.

Conflict was completed by early July, although it would not be released for another two years due to a copyright issue over the original story on which the script had been based. But when it finally made it to the screen in the summer of 1945, the picture received largely positive reviews, with Edwin Schallert praising its "subjective melodrama." The

audience saw the action through Bogart's eyes, which made him "an interesting figure, even slightly sympathetic," despite the murder he has cold-bloodedly committed. Bosley Crowther called the film "cool and calculated," "with considerable melodramatic grit." Bogart, he wrote, "carries the whole thing . . . appropriately callous and cold, brutish without being sulphurous." The actor demonstrated that even in this return to villainy, he could still convey conscience and regret and win a measure of sympathy.

He eased into *Passage to Marseille* upon the completion of *Conflict*, joining his *Casablanca* costars Claude Rains, Peter Lorre, and Sydney Greenstreet (Greenstreet had also played, to great effect, in *Conflict*). The narrative turned out to be confusing, even for the actors, with the action taking place in a flashback within a flashback within a flashback. For some viewers, that was made up for by the exciting flying sequences, showing the Free French Air Forces dropping bombs on Nazis. Bogart is suitably defiant as the French Resistance fighter Jean Matrac, but his love scenes with Michèle Morgan lack intensity. The reviews were mixed on the picture's release, and *Passage to Marseille* made less money than *Conflict* would the following year, an ironic turn of events given how hard Bogart had fought for the former over the latter.

The fall of 1943 saw the release of *Sahara*. In a brilliant marketing move, Warner Bros. engineered its world premiere to take place at Camp Campbell, Kentucky, the base of the 4th Armored Corps, a division of the US Army that was soon to be sent overseas to join the Fifth Army in the Italian campaign. In an open-air bowl near the base, some forty thousand soldiers and civilians saw the film, promoted by Warners as "the largest single audience in motion picture history." With a launchpad like that, *Sahara* easily soared to the top of the box office in both big cities and the provinces: in Cincinnati, for example, *Variety* proclaimed the film "a smash," earning a "dandy" fifteen grand in the Queen City. *Sahara* continued doing big business straight through Christmas. Critics raved over Bogie's grim, desert-baked character.

But he seems to have grown uncomfortable playing war heroes when some of his colleagues—including Clark Gable, James Stewart, David Niven, his pal John Huston—were actually fighting with the Allies. Ever conscious of his image, he would not have wanted to be perceived as slacking in his patriotism; Lew Ayres's career had taken a hit when he had announced that he was a conscientious objector. Although he'd

dutifully registered for the draft, as required by law, in February 1942, Bogie was too old to be called up for service. But so was Gable, who was just a couple of years younger, and he'd enlisted on his own accord. Yet in truth, Bogie's discomfort wasn't just about his image or maintaining his brand. As Allied casualties mounted and as the memory of Leslie Howard's murder by the Nazis continued to haunt him, he appears to have genuinely wanted to do something more for the war effort than simply making propaganda pictures. He'd enlisted in the Coast Guard Auxiliary as a junior commander in Flotilla 21, but he mostly just stood watch when called to relieve enlisted personnel. He wanted to make a bigger, more worthwhile gesture to support the troops. And he had just the idea for how to do it.

THE SUN BAKED DOWN ON THE CASBAH, THE ANCIENT CITADEL OF ALGIERS, and the mosques and markets that surrounded it. The colorful scarves and headdresses of the merchants stood out against the stark white buildings; the pungent fragrances of cumin and coriander wafted through the air. Bogie and Mayo, dressed in army fatigues, followed a guide provided by the United Service Organizations, who regaled them with the Casbah's more than one thousand years of history. As they passed a doorway, a woman, garbed in haik and veil, spotted them. Suddenly she rushed toward the Americans, cocking her arms as if holding a tommy gun and shouting the Arabic equivalent of "rat-a-tat-tat."

If Bogie and Mayo were startled, they would have been calmed by the laughter of the guide and the woman herself. The fame of Humphrey Bogart had reached even there, a fact that must have astonished him. During that same stroll, according to a United Press stringer, a boy called him "a blankety blank gangster," though whether the youth intended it as a compliment or a rebuke, the writer didn't say.

The Hollywood couple was in Algiers with a USO troupe entertaining Allied troops along the Mediterranean and behind the battle lines in Italy. Bogie had convinced Jack Warner that the trip would do everyone good; to make his departure from the studio less expensive, he scheduled his contractual four-week vacation as part of the tour. It was his first overseas trip since those convoys back and forth to France after the First World War.

He and Mayo had begun their journey in New York, getting their

vaccinations, seeing a few Broadway shows, and putting away a few drinks with old pals. They had also polished up their act, an expansion of the routine they'd performed in St. Louis. Accompanying the Bogarts would be the comedian Don Cumming and the musician Ralph Hark, members of the Hollywood Victory Committee and USO veterans. Bogie would do a gangster bit with Cumming, tell some jokes, and banter with his wife, who'd sing a few songs accompanied by Hark.

Unbeknown to the couple, other preparations were being made as well, some two hundred miles away in Washington, DC. Hearing rumors (unfounded) that Bogart might also visit Russia on the tour, officials reopened his FBI file. Three years after the Dies Committee had cleared him, doubts apparently still lingered about the actor's loyalty. If Bogart had subversive tendencies, it was felt, he should not be roaming freely through war zones. Inquiries were made, records were examined, and in the end the Bureau came to the exact same conclusion as Dies: "Allegations that the Subject has been connected to the Communist Party did not appear to be founded on fact." Bogart's "only fault," the Bureau concluded, "was his violent temper and quarrels with his wife."

Warner Bros. publicity boasted that the tour was 35,000 miles long, "more mileage abroad than any previous Hollywood excursionists, including Jack Benny and Bob Hope." That figure seems inflated when the trip is plotted out on a map, but it sent the right message about Bogie's willingness to meet his patriotic obligations. Their first stop was in Dakar, Senegal, where they performed on an outdoor stage and were cheered by thousands of troops, who later serenaded them with a rendition of "As Time Goes By." In Casablanca, cheeky GIs asked Bogie, "Where's Rick's?" Even with two shows a day, the company's morale was high. Mayo wrote to her mother in Oregon that they were often cold (temperatures in North Africa could dip into the low forties in December and lower in January) with no heat or hot water in the hotels and on the bases where they stayed. But they were having a ball. "We have good warm clothes," she told Buffie, "and we sleep in long underwear. You should see us."

The travel was arduous. The Bogarts, Cumming, and Hark dubbed themselves the "filthy four." The only alcohol they could find was a cognac that Mayo complained to her mother tasted like "fried oil," but she added, "We drink it." In North Africa, the unhappy Mayo came back to life. She was like her old self, effervescent and ready for each new adventure. She

and Bogie were comrades in arms trekking through the desert together and putting on their shows. "It's very muddy, rainy, and cold," Mayo wrote to her mother, "but we are in real soldier clothes and warm and feeling swell. You should see your daughter in her real soldier suit."

For the first time in a very long while, Mayo felt equal in the relationship. Onstage, she flashed the charisma that had made her a child star three decades earlier, singing songs from her Broadway hits. She was rewarded with the applause and whistles of the young GIs. Not here was Mayo the frumpy, scowling wife. Bogie, according to various press reports, was impressed with, even touched by, Mayo's resilience. She never grumbled, never failed to do her best on the stage.

It was left to John Huston, many years later, to sound the only false note about Mayo's time on tour. Meeting up with the USO in Italy, Captain Huston of the Army Signal Corps spent some time with his chum Bogie. He was in the audience when Mayo belted out "More than You Know," which she'd popularized in the show *Great Day* in 1929. Huston claimed to A. M. Sperber that Mayo had been drunk, singing off key. "She had no voice," he said in 1987. "She had nothing much of anything." The sheer mean-spiritedness of that remark is both stunning and telling. There is no contemporary evidence to support Huston's story but plenty to dispute it. Numerous reports from the tour described GIs whistling for Mayo and calling for encores.

Bogie was certainly pleased with his wife's efforts. During the tour, their squabbles were few and far between. Their spirits were high, and warm feelings prevailed. To Mayo's letters to Buffie, Bogie regularly attached postscripts: "All our love, pal." The couple spent New Year's Eve together drinking the fried oil. "We made our own fireworks," Mayo wrote to her mother, a wink that their legendary sex life hadn't ended. She seemed to be wishing that the tour would never end and they'd never have to return to their old lives. "We have had a million laughs," she told Buffie, "and I have never enjoyed anything more in my life."

The end of the trip was less buoyant than the beginning. Most of the troops in Africa had seen little action and suffered few casualties. But in Italy, just a few miles from enemy lines, the soldiers, many in their early twenties, bore the signs of trauma as they filed into the auditoriums. Many were on crutches or wore arm slings. To those shell-shocked men, jokes fell flat. Mayo's lilting tones didn't arouse any emotion. The blank stares of the men unnerved Bogie. Still, one group of soldiers did

serenade the actors with a few bars of "White Christmas," bringing Mayo to tears and choking Bogie up.

The stress of the last few weeks finally got to them. It was inevitable that the Battling Bogarts made at least one appearance. After practically "distilling themselves" drinking with a group of paratroopers, the couple squabbled and Mayo locked her husband out of their room. As Bogie attempted to break in, he was apprehended by a colonel, whom he told to go to hell. As a guest of the army, he was called to account. "I didn't mean to insult the uniform," he said during a hearing. Looking at the colonel, he said, "I only meant to insult you."

Mostly, though, it was a happy time. Mayo wrote to Buffie that both she and Bogie felt good about their efforts to boost morale. "It has been quite a rough trip and quite a grind," she said, "but the boys have appreciated it so much, it was more than worth it. I wouldn't have missed it for anything."

On January 6, 1944, word went out from Burbank that Humphrey Bogart's next picture would be *To Have and Have Not*, based on the novel by Ernest Hemingway and produced and directed by Howard Hawks. Jack Warner cabled the William Morris Agency's Abe Lastfogel, the agent overseeing the USO shows, in New York, with a threat to withhold other top actors if Bogie didn't return on time. Just why Warner was already making threats is unclear. The agreement with the studio had allowed Bogart ten weeks off. With a departure at the end of November, the ten weeks would have run through February 4. If Warner demanded a return to work in mid-January, it would have been he who was in breach of contract.

Looking at the sequence of events, it appears that Bogart was not deliberately overstaying his furlough from the studio. Because of limited flight options, he arrived in New York on an American Export aircraft from France on February 8, packed like a sardine into an airbus full of soldiers (Mayo was one of only two women on the flight). When the exhausted and jet-lagged Bogie did not immediately return to the studio, Warner pounced. Not unreasonably, the actor and his wife hoped to spend a few days in New York to rest up. But telegrams began flying from coast to coast. In a cable to Lastfogel, Warner called Bogart's request "uncalled for." He'd wrangled a pair of first-class train tickets on the 20th Century Limited, not a simple task in wartime, and he expected Bogie to be on it when it departed on February 10. Bogie told Lastfogel what he could do with the tickets. HE ABSOLUTELY REFUSES TO LEAVE, the agent

wired the studio. In the end, as usually happened, Bogie gave in. At the assigned date and time, Bogie and Mayo reported to Grand Central Station with their luggage. It really wasn't worth another suspension.

As he steamed across the country, catching up on his sleep, Bogie could feel good about himself and his career, no matter how angry Jack Warner could still make him. His USO tour had been a success, and he'd been nominated as Best Actor for *Casablanca* by the Academy of Motion Picture Arts and Sciences. There had been high expectations that he'd get the nod and every reason to think that he might win. When he arrived at Union Station in Los Angeles, Bogart praised the servicemen he'd met, warned against the glamorization of war, and professed to be eager to return to work.

It wasn't *To Have or Have Not* he was thinking about, however. Instead, he hoped to set up a passion project, the story of an actor touring army camps in wartime. Bogie had been so inspired by his experience during the past ten weeks that he wanted to document it, share it with the world. It would have been his first time as a producer of his own film, an achievement several of his peers had already accomplished. But the studio shot down the idea as soon as he brought it up and instructed him to spend his time learning the script for *To Have and Have Not*.

At the start of 1944, Bogie stood at a crossroads. Nominated for an Oscar, among the top ten box-office draws in the country, he had more power than he gave himself credit for, but the old demons of fear and self-doubt kept him from using it. If he'd wanted to flex his muscle, he would have insisted on a week of rest in New York instead of dutifully boarding the train west. He might have thrown his weight around more to fight for his USO picture. He needled people and threw punches in nightclubs because he didn't feel he had the power to do so in his professional life. He knew Jack Warner's determination to get him to the set was less about money than control. Without such control, the entire foundation holding up the studio system would collapse. If Bogie wasn't able to take back some of that control, he would risk feeling like a chattel the rest of his life.

With muted enthusiasm, he met with the studio about *To Have and Have Not*. He was told two things. He needed to learn the script immediately, as production would begin the following Monday, and his leading lady had just been cast. She was someone he'd met in passing on the set of *Passage to Marseille*, though Bogie had only a vague memory of her. The young actress's name, he was informed, was Lauren Bacall.

PART III

BETTY

1924–1944

Manhattan, a Weekday in October 1941

A pack of aspiring actors gathered outside the Walgreen's drugstore on West 44th Street and Broadway, smoking cigarettes, sharing gossip, and inquiring about jobs. In the basement of the drugstore, Leo Shull, a struggling but enterprising playwright, mimeographed a daily tip sheet he called *Actors Cues*, which the would-be thespians grabbed at a dime apiece. One young woman, a newcomer to the drugstore hangout, was reading *Actors Cues* with a ferocious intensity. Her name was Betty, and she'd just turned seventeen. Ever since the eighth grade, she had wanted "so desperately to be someone." She had determined that she was going to be an actress—or, more accurately, a star.

But Betty had a lot to learn. She was still familiarizing herself with the names of the important Broadway playwrights and producers. At the Walgreen's soda fountain, she peppered the more seasoned hopefuls with questions: "Show me Max Gordon. What does George S. Kaufman look like? Where can I see Brock Pemberton or John Golden?"

She was taller than most girls her age, slim, blond, with long legs. The child of a single mother who worked various jobs to keep her fed, clothed, housed, and educated, Betty had felt powerless for most of her seventeen years, yearning, she wrote, "to have my own identity, my own place in life." Now, as she blossomed into a young woman, she realized that she might have more power than she thought. Marching down into the Walgreen's basement, Betty cajoled Shull into letting her hawk copies of *Actors Cues* on the street. It wasn't for the money; she wanted the tip sheets as an excuse "to meet and talk to anyone" who might help advance her career. Just down the block from the drugstore was Sardi's restaurant, the famed gathering place of theatrical movers and shakers. Clutching a handful of tip sheets, Betty made a beeline for it.

It was outside Sardi's that Betty noticed Paul Lukas coming through the door to the restaurant. Lukas's face she recognized. The star of the Broadway smash *Watch on the Rhine*, his photo had appeared in all the

local newspapers, which Betty read religiously for theatrical updates. This was her opportunity, and she went for it. "I brazenly cornered him," she recalled. Lukas did not attempt to flee. He smiled, took a copy of the tip sheet, and inquired if Betty was an actress. When she replied that she was (a bit of an overstatement at that point), Lukas asked if she'd like to see his play. Betty was ecstatic. "Come around backstage," Lukas told her. He'd make sure she got a seat.

Lukas may have been merely being gracious to a charming young-ster. But he might also have been intrigued by a pretty face, as many men have been, both before and since. Lukas was forty-seven. He'd been married to the same woman for more than a decade. Mrs. Lukas lived on the West Coast while her husband largely remained in New York, racking up accolades on Broadway. The marriage was not a happy one. In that context, it's certainly reasonable to consider whether Lukas's offer to the young woman was just kindness or kindness tinged with interest. Likewise, it's just as reasonable to consider that perhaps Betty was not so oblivious to her charms as she'd later imply in her memoir. "Brazenly" cornering a world-famous actor suggests more than a modicum of confi-dence and agency. Indeed, she was known as "the Windmill" among the kids at Walgreen's because of "her swinging walk," chasing after every male celebrity who walked by.

Betty Bacal was going to be Somebody. "My dream was to star in a Broadway hit, to be another Katharine Cornell," she said. She wondered *when* the dream would materialize, not *if*. So, eager to hasten that day, she made her way to the Martin Beck Theatre and gave her name at the stage door. She was led up to Lukas's dressing room. "He remembered me, got me a seat, and asked me to come around afterward," she said. She bolted backstage right after the last curtain and "felt privileged to be allowed into his dressing room."

She wrote those words nearly forty years later as she shaped her story for posterity. No hint of hanky-panky or even flirtatiousness emerged in her telling of it. "He was friendly and easy," she wrote of Lukas. "[He] sat me down, asked me about myself, what I had done, what I wanted to do." She clearly charmed him, as after that night, she had carte blanche back-stage. Over the next few months, she could often be found in Lukas's dressing room, seeking advice and sympathy from her wise, solicitous mentor. The star allowed her to watch the show as many times as she wanted, and he'd listen to the frustrations she poured out in his dressing

room. Paul Lukas, Betty said, was her "first important friend" in the theater.

He wouldn't be her last. Not long after meeting Lukas, she learned that John Golden was casting for a second touring company of his hit Broadway play *Claudia*. She "trapped" Golden (her words) outside Sardi's and asked if she could audition. "He said yes I could and would I come to his office the next morning." That, of course, is not a typical scenario. Major producers such as Golden, who at the moment had two shows running on Broadway and several shows on the road, did not normally make time for would-be actors they met on the street. Golden had been around Broadway since before the First World War; he had a theater named after him on 45th Street. But at sixty-seven, he hadn't lost his eye for talent—or, apparently, for pretty young women. When he learned that Betty hadn't seen *Claudia* (she couldn't afford it), he gave her tickets to a matinee and invited her back to audition afterward—again, very unusual accommodations for a young woman lacking an agent or experience. Moreover, Golden gave Betty an escort through the theater in the person of Fred Spooner, one of his press agents. "A warm, friendly man who had been around the theatre for years," Betty described him. "It was the beginning of another friendship."

Spooner sat with her during the matinee. He was a font of theatrical lore, and Betty no doubt pumped him for everything he knew. Spooner had managed the publicity for the show *Mamba's Daughter*, starring Ethel Waters, for which he'd been praised for the "brilliant advance build up" of its Chicago tour. He was now planning the promotion for Golden's next production, *Little Dark Horse*. Forty years old, a Milwaukee native, Spooner was separated from his wife. His assignment to escort an attractive young woman for the day may not have been an entirely unwelcome chore. "I made Fred laugh," Betty wrote. "My innocence and wild, blind dedication must have appealed to him. For no other reason than that, he helped me."

A man who knew a thing or two about publicity buildups was a very good friend to have. After she gave her reading to Golden, Betty took a stroll with Spooner along West 44th Street. Looking up at the marquees, she confessed to her new friend her dream of seeing her name up in lights. Spooner assured her that management was clearly interested and "not just being polite." The next day, Betty gave a second reading and the day after that a third. With both Golden and Spooner apparently pulling

for her, she was encouraged. She rushed over to the Martin Beck Theatre to tell Paul Lukas what was happening. Once again, the actor made time for her, advising her not to get her hopes up too high but to concentrate on the scenes she had been given to read. "Be simple," he said.

Betty would later say that the part she was being considered for was the lead, the one Dorothy McGuire had won acclaim for on Broadway. If that's so, she was almost certainly being led on by both Golden and Spooner. It's inconceivable that a major producer would consider an unknown teenager with absolutely no credits to lead a tour of one of Broadway's biggest successes. Betty wasn't even yet a member of the Actors' Equity Association. If they truly had her read for the lead, they were being manipulative. The job they finally offered her was as an understudy. In her memoir, Betty gave the impression that she was being asked to understudy the lead, but again, that seems highly unlikely.

No matter what she was being offered, however, the unavoidable question is whether she was expected to offer something in return. As it transpired, she never had to find out. She turned down the job on the advice of Paul Lukas, because it would keep her away from New York for a year. Her dreams of success couldn't wait that long. But, as she had already proved, she would have any number of guardian angels ready and willing to help her along.

BETTY HAD BEEN IN A HURRY SINCE THE AGE OF THIRTEEN, WHEN SHE'D FIRST seen Bette Davis, her idol, up on the screen. She had managed to graduate from high school in three years so she could start pounding the pavement. Her yearbook photo, which gives a good idea of how she looked as she started looking for work, bears no resemblance to the image the world would come to know. The hair flips up girlishly at the ends and the smile is broad, revealing the imperfect teeth. The sultriness that would come to be associated with her is nowhere to be glimpsed. Betty was fifteen when she sat for that photo, but she looks even younger, standing out from the more mature girls around her. What comes through in the photo is not sensuality but exuberance and her utter belief in herself and the certainty of achieving her ambitions. In that, she could not have been more different from the man who, in less than five years, would be her husband. By fifteen, Betty was pursuing her goal with a single-minded sense of purpose. Bogie, at the same age, had

been struggling through Trinity, oblivious to his future, unconscious of any ambition or dreams.

By her own admission, Betty thought a lot about fame and very little about the war that seemed to be coming closer to them every day. She had no brothers who might have been drafted, and her father had been absent from her life since she was eight. If her mother and uncles worried about what was happening to European Jews, their fears never filtered down to Betty. She had no cause for fear. She'd grown up among a thriving Jewish community in Brooklyn and Manhattan; many of her classmates had been Jewish. Being Jewish had always just been a given for her, like being right-handed. Nothing would stand in her way. After all, a good number of the most successful theater people Betty read about were Jews: the producer Max Gordon, George S. Kaufman, Lee Shubert, Richard Rodgers, Oscar Hammerstein, Irving Berlin, George Gershwin, Lillian Hellman.

There weren't as many openly Jewish actors, however. Only the most dedicated theatergoers knew that John Garfield had formerly been Julius Garfinkle. Sylvia Sidney and Lillian Roth didn't go to great length to hide their identities, but Metro-Goldwyn-Mayer made sure to publicize the glamorous Hedy Lamarr, then starring opposite Clark Gable, as strictly Gentile—Hungarian born but a shiksa nonetheless.

It wasn't until Betty started modeling in the spring of 1941 that she came face-to-face with reality. Needing the money and hopeful of being spotted by a producer, Betty spent days looking for work up and down Seventh Avenue. She'd been advised that the only worthwhile fashion houses were between 530 and 550 Seventh; "you could squeeze in 495," Betty recalled, but "anything below that was tacky." She finally landed a job at the David Crystal fashion house, located at 498, so she'd just barely made the grade. Always conscious of image and appearance, she worked hard to learn the moves and poses necessary for modeling clothes for potential buyers. She thought she had found her groove until one of her fellow models, an older California brunette named Audrey, asked, "What are you?" Betty replied casually, "I'm Jewish." Audrey was surprised: "You don't look it." It wasn't long before Audrey revealed what she'd learned to the other girls: "Can you believe Betty is Jewish?" A few days later, Mr. Crystal called Betty into his office and informed her that she wouldn't be needed for the following season.

Betty was devastated. She felt she was being singled out for something

that was merely an abstract for her. All her life, her Jewishness had sim-
ply been a part of her. She had never questioned it or worried about it.
Now, suddenly, things were different. "I resented being Jewish," she said
of the moment. The memory of it stayed with her for the rest of her life.

Still, she carried on with aplomb. "I was acting the part of a self-
assured girl on the go," she said. In the summer of 1941, Brooklyn news-
papers announced that George Abbott was looking to audition "a large
cast of young people" for his upcoming production of *Best Foot Forward*,
a musical by Hugh Martin and Ralph Blane. Betty immediately learned
a song, "Take and Take and Take," from the 1937 musical *I'd Rather Be
Right*, and practiced a dance routine to go along with it. "Naturally, I
thought I'd be a wow at the audition," she recalled. She found herself in
"the midst of beautiful, mature girls, wearing high-heeled shoes, bathing
suits, leotards—experienced, grown-up, and stacked." Betty, who still
looked about twelve, feared she might be out of her league. But she went
through the audition nonetheless, her knees shaking as she tap-danced
on the stage.

"I recall her audition," said Miles White, the show's costume designer.
"No one knew who she was back then, of course, but she came in deter-
mined. She was very young and very pretty. Her dancing was off and her
voice barely registered, but she gave it her all. After she became famous,
I realized who that spunky little charmer had been."

After she'd sized up her competition, Betty could have turned around
and gone home. But she didn't. No matter that she wasn't given a part
in *Best Foot Forward*; she had put herself out there. "My audition was no
good," she wrote. "But at least I'd done it."

To make some money, she took a job as an usher (or "usherette" in
those days) for the Shubert chain of theaters. Her uniform consisted of a
white collar and white cuffs worn with a black sweater. She learned how
to stack programs and give them out as the audience filed in. She learned
how to say "Tickets, please" and direct people to their seats. She loved
being able to watch plays, for free, from the back of the house, and she
was thrilled to be in the theater before and after the show. "I was part of
it," she said. "No longer just a spectator."

In the fall of 1941, either just before or just after Betty's encounters
with Paul Lukas and John Golden, she was ushering at the Imperial The-
atre on West 45th Street when *Let's Face It*, starring Danny Kaye and
Eve Arden, was onstage. Betty adored the show. "Ushering at a musical

really lifted me off the ground," she wrote. "I'd had no idea how differ-
ent it would be." She wanted to dance down the aisles but figured the
Shuberts wouldn't have approved. Kaye, Betty thought, was absolutely
"marvelous," and she wanted to meet him. "So, what did I do?" she wrote
in her memoir. "I went backstage after the show one night [and] knocked
on his dressing room door."

Kaye was still washing off his makeup when he answered, presum-
ably wearing a T-shirt or less. Still, he invited Betty inside. He asked her
to tell him a little bit about herself. She replied that she was an aspiring
actress who was ushering until she could get a break on the stage. "I ner-
vously told him," she wrote, "how good I thought he was."

Kaye was only recently married to his wife and still a few years away
from an affair with his costar Arden, during which the Kayes would sep-
arate. So perhaps he can be cleared of suspicion for having nefarious
motives for inviting Betty inside. Still, it's not so hard to imagine the
thirty-year-old actor finding the young woman in a tight black sweater
standing outside his door attractive. Had she been an old charwoman,
would he have invited her in? Possibly he would have. Possibly Kaye—
and Lukas and Golden and Spooner—had only the noblest intentions
when they responded to Betty's entreaties. But it's also possible that there
was something more going on, and it seems quite likely that, if so, Betty
was aware of it.

Though she may have felt like a child at her audition for *Best Foot
Forward*, she was not perceived that way by others. By the time she was
sixteen, she stood at nearly her adult height of five foot nine. Puberty
had worked wonders for her. She had long, shapely legs, and although
she was a bit flat-chested, her lips were full and her eyes were hooded—
"Bedroom eyes," they were often called. Yet while her smile was beguil-
ing, her teeth were not perfectly even. That just conjured up an enticing
mix of maturity and innocence, which was a potent allure for many men.
And Betty Bacal, it seems, was beginning to understand that.

In her memoir, Betty would profess to having been clueless about
what those powerful men saw in her and why they were so attentive
to her dreams of success. "The men I had met in the theatre who had
lecherous reputations never displayed them to me," she wrote. But that
was for posterity, history turned into what she wanted it to be. In truth,
Betty was way smarter than that. She was "a Dead End kid, a kid off the
streets," who had "heard everything, seen everything," according to one

of her compatriots at the time. Betty was far more savvy, confident, and resourceful than her future husband had been at her age, or really at any age. Surely she knew the reasons Paul Lukas invited her into his dressing room and Fred Spooner took her on a stroll, even if nothing untoward occurred. And if John Golden had been playing with her, she would have caught on quickly enough. Maybe that was the real reason she turned down the job.

She also knew exactly why Burgess Meredith, then a popular actor on Broadway and nineteen years her senior, had sidled up to her one night and asked her out. Betty was on a cloud. Despite her mother's objections, they would stay out late at Greenwich Village nightspots. Later, Bogart would be convinced that "Buzz" Meredith had been Betty's first lover. Both denied it, but "Bogie didn't believe him," Betty would say.

It's absurd to think, as Betty tried to imply, that she didn't know she had sex appeal. A blind item about her in *Esquire* around this time was written by the esteemed critic George Jean Nathan: "The prettiest the-atre usher—the tall slender blonde in the St. James Theatre, right aisle, during the Gilbert and Sullivan engagement—by general rapt agreement among the critics." So the men of Broadway had noticed her and were talking about her. Betty knew whom Nathan was writing about. She seems to have appreciated the item, as she'd quote it in her memoir.

For a woman who wanted to succeed in an industry dominated by men, every weapon in her arsenal needed to be at her disposal. A month after the item was printed, Betty wrangled an introduction to Nathan at Café Society in Greenwich Village. He invited her to join him at his table with the playwright William Saroyan, an experience few struggling actresses could have hoped for. The next day Nathan took Betty to lunch at "21." She had never been in such a grand restaurant. "A world I knew nothing about," she wrote, but that now, in no small part because of her looks, she had access to. She shouldn't be faulted or judged for using them.

Yet at the same time, she was awkward with boys her own age. There were no teenage sweethearts for her. One friend said that she'd shown some interest in a "personable New York Communist named Sam" but could never find anything to talk about with him. She sometimes "blitz-krieged" young men she wanted to meet, one of her girlfriends said; she'd do the same with the older men of Broadway.

During the Gilbert and Sullivan production that Nathan mentioned,

Betty developed "a tiny crush" on Hans Züllig, the principal dancer in the ballet *The Green Table*. She was ready, she wrote, "to enlarge [the crush] at the slightest provocation." Züllig was twenty-seven years old, a Swiss national, polite, and soft spoken. Betty made sure to speak with him whenever she could, and finally Züllig asked her to dinner. She happily accepted and went home gushing to her mother. Betty appears to have imagined that a romance was possible with the international star. No spark was lit during the date, however, to Betty's great disappointment, but she had proven yet again that when she put her mind to meeting a man, she was rarely unsuccessful.

She knew how the world worked. In her seventeen years, she had learned a great deal about human nature. She and her mother had faced deprivation, struggle, and humiliation, and not a day went by when she didn't feel the sting of her father's rejection, even if she never spoke of it. But through it all, Betty had learned something else as well: she'd learned how to survive.

16

Bronx, New York, Tuesday, September 16, 1924

Betty Bacal made her first appearance one hot evening at Lebanon Hospital, the closest place her mother could get to after she went into labor at a nearby movie house. She was given the name Betty Joan Persky (the spelling "Perske" appears to have been a later affectation on her father's part). Her mother was Natalie Persky, *née* Weinstein-Bacal; hyphenated surnames were not uncommon in Natalie's native Romania. Betty's father was William Persky. He was twelve years older than his wife.

Whether William rushed to the hospital when he learned of the blessed event or Natalie left after giving birth and returned to the home she shared with her husband on Ocean Parkway in Brooklyn is unknown. What we do know is that the marriage was unhappy. "I recall having recurring nightmares at one point in early childhood," Betty wrote in her memoir, "when I would awake in tears in the middle of the night having heard footsteps down the hall." Her nightmares grew out of listening to her parents argue and absorbing the tension between them. "From the start, Mother knew the marriage was a mistake," Betty remembered.

William Persky had once been a man with a sense of purpose. Born in Rahway, New Jersey, he'd grown up in Brooklyn, where his father, Hyman Persky, a Russian Jewish immigrant, had worked as a tailor. Hyman later moved the family a hundred miles upstate to the town of Fallsburg, where he bought a stretch of farmland; he expected everyone in the family to work the fields, including his wife, Rebecca, known as Betsy. William had no desire to follow his father's agrarian ambitions, however. Securing himself a position at a Fallsburg pharmacy, he learned the skills he needed on the job. By 1917, he'd moved back to the city, working as a druggist for the Dorb Drug Company at 3181 Broadway. William was tall, slender, blond, and handsome. His daughter would get both her looks and her ambition from him.

He met Natalie Weinstein-Bacal while visiting his parents in Fallsburg, where summer hotels drew people from the city eager for some

fresh mountain air. "I fell in love with her there," William would remember. He introduced her to his parents. His mother told him, "She's a nice girl, Bill, but she won't make a good wife." But the young man wasn't listening. "Love is blind," he said.

By 1922, William, now thirty-three, had opened his own drugstore at Broadway and Chauncey Street in Brooklyn. An active member of the Broadway Merchants Association, he appeared to a be a man on the rise. That same year, he married Natalie; they resided on St. John's Place in the Prospect Heights neighborhood of Brooklyn. But their honeymoon quickly faded. Just eight months after his marriage, William Persky's carefully built world came crashing down.

On July 9, 1923, two detectives from the special deputy police commissioner's office began tailing a twenty-seven-year-old woman by the name of Leonora Stoffregen on a tip from her husband, an employee of the city's Department of Public Works. Frederick Stoffregen described his wife as an addict who was receiving large quantities of morphine on a regular basis. He couldn't get her to reveal where she was obtaining the narcotics. On Saturday, July 14, after five fruitless days of surveillance, the detectives finally observed Mrs. Stoffregen enter a pharmacy at Broadway and Chauncey. Following her inside, one of them stepped into a telephone booth and the other began flipping through a phone book, pretending to be looking for a number. They had a clear view of Stoffregen as she approached the counter. The proprietor, William Persky, greeted her.

Just how long Persky had known Stoffregen is unknown, but the fact that he waited on her was noted by the detectives as unusual, since he had clerks to interact with customers. It was clearly not Stoffregen's first visit to the store. The subsequent investigation would reveal that Persky's pharmacy held her prescription from a Dr. Everett Winter of 240 Hull Street, Brooklyn. The detectives watched as William handed the young woman a small package. When she turned to leave, the detectives produced their badges and asked to see what was in the package. The woman complied, whereupon William was asked to produce the prescription. As it turned out, Dr. Winter had prescribed sixteen quarter-grain morphine tablets; William had given Stoffregen ninety-six. They were both arrested on the spot.

We don't know the reason Persky was supplying Stoffregen with surplus morphine. The possibility of their having an affair is reasonable to

consider, given how paranoid William would become of Natalie having affairs of her own after the newspapers revealed his association with Stoffregen. Whatever his motivations for his illegal activity, however, all of his work in building a career for himself over the past ten years was now in ruins.

WOMAN AND DRUGGIST HELD UNDER DOPE LAW. ARREST DRUGGIST ON MORPHINE CHARGE. The headlines appeared in all the Brooklyn newspapers. In those days, the borough could feel like a small town, if not in numbers then in the sense of community. Word spread quickly of William's arrest. He was arraigned, along with Stoffregen, in front of a magistrate at the city courthouse on Gates Avenue. Both were held on $500 bail ahead of a hearing on July 24. William likely spent at least one night in jail.

If his family was hoping for a quick resolution, they were disappointed. The case dragged out for three months, with the magistrate not setting a trial date until October 9. During that time, William was not allowed to continue operating his drugstore. He and his wife found themselves financially strapped and publicly humiliated. The case appears to have been settled without a trial. Perhaps William pleaded guilty and accepted a short jail sentence or probation. In any event, he was back home by New Year's, and Natalie was soon pregnant with Betty.

It's worth noting that Everett Winter, the doctor who'd prescribed the morphine to Stoffregen, was later arrested by federal drug agents in a spectacular raid of his Brooklyn home. Winter was convicted for the illegal distribution of morphine and heroin and sentenced to Leavenworth Prison. Upon his discharge, his license to practice medicine was revoked. Had Persky been colluding with the doctor in a wider drug fraud? Had he provided evidence against the doctor, explaining his light punishment? Maybe he was just a hapless stooge in the whole nightmare. But no matter the truth, the scandal would have lingering effects on his as-yet-unborn daughter, even if she might never have known the details of it.

FOR NATALIE, THE ORDEAL MUST HAVE BEEN EXCRUCIATING. HER FAMILY, A CLAN on the rise, was horrified. Natalie's eldest brother, Albert, was a successful businessman; her next brother, Charlie, was in law school; her youngest brother, Jack, planned to follow in his footsteps; and her sister Renee's

husband was already a successful lawyer in private practice. To them, the shame their brother-in-law had brought on the family was unforgivable. They had all worked hard and played by the rules. They did not want William Persky's crimes to reflect on them—or their sister or niece.

Their parents, Max and Sophie (*née* Jaspovic) Weinstein-Bacal, had been born in Iași in the Moldavian region of Romania, a city redolent of the country's past, stretching back to the fourteenth century. Iași was also the center of a thriving Jewish community that celebrated and preserved Yiddish culture. Still, an undercurrent of anti-Semitism in Romanian society dating back centuries meant that Jews were not considered citizens. The government of King Carol I tolerated pogroms and the forced emigration of Jews, particularly in the countryside.

Max Weinstein-Bacal, a wheat farmer, kept his head low, supporting his wife and their three young children: Renee, born in 1900; Natalie, born in 1901; and Albert, born in 1902. (Sophie must have been weary; she'd been pregnant for almost her entire married life.) In the winter and spring of 1903, a drought settled in over much of eastern Europe, with newspapers reporting, "The wheat is suffering badly from lack of rain." The dry spell continued for a year. In her memoir, Betty wrote that her grandfather had been "wiped out." The economic pain was worsened by anti-Semitism, as Jews were denied government loans. Max and Sophie knew they had to make their way to "the promised land" of America, as their granddaughter Betty called it.

After selling their silver and jewelry, the family set off walking, their possessions on their shoulders and backs, toward the capital, Bucharest, about 250 miles away. There they boarded a train for Berlin, nearly a thousand miles away, crammed into the cheap cars reserved for the poor. Sooty and foul smelling, the car had barely enough space to turn around in, and chamber pots were passed around among the travelers. They sat and slept on the floor. Natalie was just two years old; her younger brother, Albert, possibly hadn't yet learned to walk.

On July 20, 1904, the Weinstein-Bacals boarded the SS *Deutschland*, sweltering in the stultifying heat of steerage. The transatlantic voyage took eight days. In New York, the first-class passengers greeted family and newsmen on the pier, while those in steerage were herded onto a ferry that would take them to Ellis Island. At the processing center, Max gave his name to the inspector, who seems to have heard only

the first part; there were a thousand passengers to process that day, and "Weinstein-Bacal" took an awfully long time to write down.

With the little bit of cash he still had, supplemented by a loan from United Hebrew Charities, Max Weinstein started a pushcart business on Spring Street in lower Manhattan. The muckraking photojournalist Jacob Riis described the scene in his landmark book *How the Other Half Lives: Studies Among the Tenements of New York*. "The tenements grow taller, and the gaps in their ranks close up rapidly as we cross the Bowery and, leaving Chinatown and the Italians behind, invade the Hebrew quarter," Riis wrote. "Pushing, struggling, babbling, and shouting in foreign tongues, a veritable Babel of confusion. . . . There is scarcely anything else that can be hawked from a wagon that is not to be found, and at ridiculously low prices. Bandannas and tin cups at two cents, peaches at a cent a quart, 'damaged' eggs for a song, hats for a quarter."

Max had found a way to support his family. But the memory was a shameful one for some in the family. "One family fact that Mother always hated—the pushcart," Betty revealed. "Never tell anyone about that," she was instructed. But it was the pushcart that had enabled Max and Sophie to move, around 1906, to the Bronx, where there was fresh air, trees, and streams. At 1512 Washington Avenue, Max opened a cigar and candy store; the family lived above it. Sophie ran the store; Renee helped out after school. Within walking distance were several synagogues, and the Bronx Tremont Hebrew School was just a couple blocks up Washington Avenue.

In time, the Weinsteins became respected members of the community. By 1920, they'd moved to a better address on the Grand Concourse, with Max branching out into selling toys and ladies' hats, a profession he groomed his eldest son, Albert, to take over. Within a few years, Renee had married the promising young lawyer, William Davis, who, despite his name, was the son of Russian Jewish immigrants; the newlyweds lived with Max and Sophie while Davis set up his practice. Both of Max and Sophie's younger sons, born in America, were planning on becoming lawyers, and Natalie, after working as a secretary, had married a successful pharmacist who owned a drugstore. The Weinsteins had achieved the American Dream—through the all-American attributes of grit, determination, and hard work.

But then came the news of William Persky's arrest and, not long after

that, Natalie's announcement that she was pregnant. Every dream, it seemed, might become a nightmare.

NATALIE WEINSTEIN PERSKY WAS NOT EXACTLY PRETTY, BUT WHEN SHE LAUGHED her face lit up, lovable, affable, beautiful. Laughter, however, was in short supply at the Persky house in the months and years following Betty's birth. Natalie was still young, only twenty-two, but her daughter would remember her mother feeling trapped and hopeless. Natalie very much wanted to leave her husband, but her parents couldn't support her and the new baby.

Betty gave Natalie a reason to keep going. "Her eyes shone when she looked at me," Betty said. After her daughter's birth, Natalie could no longer simply accept her fate and continue in a marriage with a man she despised. She had to find a way out. She began saving money—nickels, dimes, the occasional dollar bill—stashing it in jars, drawers, anywhere her husband couldn't find it. She wouldn't let him touch her again. She saw to it that there would be no more children of their unhappy union.

Over time, Betty absorbed her mother's animus toward her father. When she had been very young, as she grudgingly admitted in her memoir, she had loved him. William would remember taking her out to a restaurant when she was three. She had wheedled him into getting ice cream for dessert. When the ice cream had come to the table, Betty had looked up at him and said, "I get anything I want, Daddy." That resolve would serve her well through life.

But Betty had no such memories of him. She could not remember "any great display of affection" from her father. "I don't say it never happened," she'd write. "I only say it is not remembered." Instead, what memories survived were frightening. An image of her father threatening her with a cat-o'-nine-tails was seared onto her mind. She'd also seen him strike her mother, accusing her of infidelity. "He was a man who invented jealousies," Betty wrote. If she was ever told of her father's arrest, she never spoke of it, unless she was alluding to it when she said, "His history was unsavory and spoke for itself."

Persky, however, remembered happy moments with his daughter, watching her playact in her mother's clothes, an actress from the start. "She liked nothing more than a chance to put on a long-tail dress, high-heel slippers, and make believe," he told a reporter a couple of years after

Betty had gone to Hollywood. By the time Betty was a toddler, William had found a new career for himself, selling X-ray machines to doctors, and moved his wife and daughter to a new home on Ocean Avenue. A man should not be judged by one mistake, perhaps, but just how many mistakes Persky made, we can't be sure. Still, he appears to have done well in the medical supply business, maintaining his earnings throughout the Depression.

But Natalie wanted out. On a day in June 1930, she asked William to take Betty, age five, to a summer camp, which he did before leaving for a three-day business trip. When he returned home, his wife, his daughter, and their belongings, even the pots and pans, were gone. The superintendent had a message from Natalie. "Your wife told me to tell you she's not coming back to you," the man reported to William. Betty would insist in her memoir that she'd felt no emotions when her mother had taken her away from their home on Ocean Avenue. "I don't remember reacting in any way at all," she wrote. Her early memories of life with her father were repressed for the rest of her life.

William said that the last glimpse he'd had of his daughter was when he had dropped her off at camp in the late spring of 1930. In contrast, Betty said she had seen her father on Sundays until she was eight, or 1932, and that in the beginning she had looked forward to their times together. He had given her a gold watch once, which she had treasured, but then, she said, he had taken it back. Her last memory of William, she wrote, was during a visit to his parents, who eventually became just "shadows in [her] mind." That evening, the little girl had watched as her father drove away. "His car took him out of my life forever," Betty wrote. The memory hints that she may have felt more emotion about his departure than she wanted to admit.

Her father's abandonment of her, Betty implied, had been sudden and unexpected, wholly a decision on his part. Uncle Jack tried to find William "so that he might contribute" to his daughter's support, but he couldn't be located. It was left to Natalie, with help from her family, to provide Betty with food, clothing, and an education. That became the official narrative told in the Weinstein family. William was dead to his daughter. Soon after going to Hollywood, she was asked about her father. Betty cut the interviewer off. "We don't talk about him," she said.

After Betty's memoir came out in 1979, however, William, aged eighty-nine, strenuously refuted the stories told about him. "Everything

that Betty wrote in her book about me is what her mother told her happened," he insisted to a reporter for the *Los Angeles Times*. "She didn't know anything except what her mother put into her head." He had not abandoned his daughter, he insisted; he had been prevented from seeing her by the Weinstein family. He denied having taken back the gold watch. And he most definitely had not left his wife and daughter penniless. He had sent money to Natalie for years, he said—and in 1979, he still had the canceled checks made out to her to prove it. The newspaper ran a photo of William with two handfuls of checks.

Still, whatever money Natalie received from her husband was not enough, at least not to provide the advantages she hoped to give her daughter. Max Weinstein had died in 1929, and Sophie had moved with Charlie to 253 West 89th Street in Manhattan. Not long after, Natalie and Betty moved in with them, making for rather cramped quarters. It was the only way to afford rent.

Charlie was now working as a labor attorney for the New York State Mediation Board at 366 Broadway. His income was growing but not enough to support his young niece, at least not to his sister's expectations. Natalie believed that Betty was gifted and needed to attend the best schools. No matter that at home Betty had to share a bedroom with both her mother and her grandmother, she would attend the prestigious Highland Manor in Tarrytown with the daughters of wealthy bankers and businessmen.

Paying for it, of course, wasn't going to be easy. Betty would always describe her mother as a secretary during that period, but in fact, at least for a time, Natalie worked as a domestic. The 1933 city directory for Manhattan records her as a "maid"; this is clearly her, as her brother and mother are reported as living at the same address on 89th Street. If Betty was aware of her mother's employment, she never spoke of it in public. In fact, she told a story of her mother employing a maid herself, someone who could watch over Betty while Natalie was at work. (Why that would have been necessary with Sophie present in the apartment was not explained.) It was one thing for Betty to embrace the pushcart as a symbol of how high their family had climbed; it was another to envision her intelligent, proud mother as a domestic worker. Yet Natalie's work should not be seen as demeaning but rather as evidence of how much she believed in her daughter's potential and how much she was willing to do to help her achieve it.

She could have saved a considerable bit of money, however, if she'd enrolled Betty as a day student at Highland Manor. About an hour from Manhattan by train, the school provided bus service from Yonkers (about a half-hour trip by subway from 89th Street), so commuting would have been possible. But that wouldn't do. As a day student, Betty would have been seen as different, a step down from the other girls.

Most of her classmates were Jewish. Highland Manor's principal, Eugene H. Lehman, was himself the son of Jewish immigrants; he'd taught English literature at Jewish Theological Seminary and biblical literature at Yale, his alma mater. That was the environment in which Natalie wanted Betty to grow up, with other girls like her, a generation or two from their families' pushcart beginnings, their eyes firmly set on the future. Highland Manor could polish her for success in the wider world. In its advertisements, Highland Manor boasted that "correct English and how to use it" was "the foundation work of every class." That could provide a reeducation for a young girl, moving her away from the broken English of her family. In addition to correct English, the school promised "exceptional advantages in the study of French," a mark of sophistication at the schools for Gentile girls. Significantly, Betty would later send her own daughter to a French-speaking school so she could learn Continental customs.

The Weinsteins, like so many others, were doing everything they could to assimilate into American society. In 1933, assimilation was still considered the fastest way for immigrants to succeed. But there was a definite class bias to the approach. Principal Lehman may have been the son of Jewish immigrants, but his parents had come from Germany, and German Jews sometimes looked down on their eastern European, Yiddish-speaking counterparts. Lehman drew headlines in 1930 for refusing admission to a highly qualified young woman because he disapproved of her parents' business, which, though legitimate, was something Lehman disapproved of. Some people thought that his real objection was to the parents' parvenu status and Yiddish-inflected English. The principal's views had considerable influence on his students. All her life, Betty would remain class conscious, mindful of a social standing that was fundamentally fragile.

At Highland Manor, she justified her mother's belief in her intelligence. Her marks were so good that she was allowed to skip a grade, something that would distinguish her dramatically from her future

husband. Betty was happy at the school, where she was known as a tom-boy. She "climbed trees, fell out of them, not a bit femme," she recalled. She was a good athlete, playing volleyball and basketball, and also excelled at swimming.

But her true passion was revealed in the theatrical opportunities the school offered. "There were weekly dramatic programs," she remembered, "sometimes plays, sometimes musical recitals, dances." She especially loved dance. During her last year at Highland Manor, she performed a scarf dance onstage. "I felt as though I were really performing," she wrote. "Had the stage all to myself. I felt really good." She was a regular Isadora Duncan. She decided she would be a professional dancer as well as an actress.

That ambition may have made her family uneasy, at least at first. Going on the stage was not considered reputable for girls from good families. A decade later, her uncle Charlie would reminisce about how he "took [Betty] in" when she was just ten and "so pretty, so unspoiled." He recalled introducing her to "Paul Windels," whose identity he did not elaborate on in his letter to Betty but who was clearly someone she knew. It appears that Charlie was referring to the son of a colleague, also named Paul Windels and also an attorney. By the time of Charlie's letter to his niece, Windels Jr., three years older than Betty, had just completed his law degree. Had Betty's family once hoped for a union with a family such as his?

But in ninth grade, Betty wasn't hankering after lawyers. Her mind had turned defiantly toward the stage. That may have been part of the reason Natalie decided to withdraw her from Highland Manor and enroll her in Julia Richman High School, a girls' school in Manhattan much closer to home, allowing them to keep a better eye on her. Julia Richman, named for New York's first female district superintendent of schools, was a public school, meaning that it was free. That likely made the change even more appealing to Betty's family. But if they were hoping the new environment might tamp down her theatrical ambitions, they would be proved wrong.

THE BOXES WERE PACKED, AND BETTY'S UNCLES WERE LUGGING THEM DOWN the stairs. The family was moving to an apartment five blocks south on 84th Street and West End Avenue. Betty was likely a bit apathetic about

the relocation; she'd say she didn't recall "any special home" when she was young. One apartment seemed much like the other. Down West End Avenue, the family carried their belongings on their backs and pushed carts ahead of them, which for Sophie may have evoked memories of her journey through Romania and her first years in New York. Like most immigrants, they were always just a moment away from their past.

The new apartment had one advantage, as Betty soon learned. Once again, Charlie had his own room and Natalie and Sophie shared another one, but now there were glass doors separating another space: "a tiny room for me," Betty fondly recalled, "the first time I would have a room to myself." A girl just entering puberty deserved some privacy. She had a canary she named Pete who one day flew out the window, breaking her heart. (Her feelings were soon assuaged by the adoption of a cocker spaniel she named Droopy.) The apartment was fragrant with her grandmother's kreplach and stuffed cabbage. The old woman would sing to Betty, inserting her name into old Romanian songs. Sophie was the only one in the family who went regularly to temple; she made sure the dishes were changed properly for the holidays.

Around that time, Natalie's divorce from Persky became final. She took back her maiden name, at least the "Bacal" part. Her brother Jack, who was a bit of a swell, went by "Jacques Bacal." Betty decided that she, too, preferred the name, as it made her feel like a part of the family. It also suited her ambitions: "Bacal" was an exotic last name for a dancer, like Pavlova, Nijinsky, or Karsavina. But Betty didn't want to be a classical dancer; she wanted to be a star who danced, like Adele Astaire and Ginger Rogers. Her idol, however, was Bette Davis, who didn't dance but burned up the screen in fiery roles. Davis was currently playing in *Marked Woman* with Humphrey Bogart, which Betty made sure to see. She devoured all the movie fan magazines and kept watch for any celebrity sightings in Times Square.

From an early age, Betty wanted to make something of herself, an unsurprising goal for a little girl abandoned by her father. She looked to her uncles, especially Charlie and Jack, for inspiration. They knew interesting, important people. Charlie now worked as assistant corporation counsel for the newly elected mayor, Fiorello La Guardia, and proved to be a crusading presence in court. Fighting against racketeering in 1934, the twenty-eight-year-old attorney got into a physical altercation with court attendants after clashing with a judge he viewed as corrupt. Charlie

also outraged his mother by falling in love with an Italian Catholic, Rosalie Rubino, who worked as a child welfare advocate for the city. "It had never happened in our family before," Betty wrote. Rosalie, she said, was "beautiful, brilliant, and I adored her." The same couldn't be said of the mothers of the groom and the bride, who sat on either side of the aisle, Betty recalled, "neither of them looking to one side or the other."

Uncle Jack was also a lawyer, though in private practice. As befit his professional name, Jacques Bacal, he was the glamorous uncle, regularly sailing off to the Caribbean and returning with a bronze glow. He knew actors and playwrights. Jack arranged for Betty and a friend to meet Bette Davis while she was in New York. (Betty was a nervous wreck, and her friend fainted; Davis was indulgent if a bit taken aback.) In 1940, just as Betty was nearing the end of high school, Jack married (for the second time; the first had ended in divorce) Vera Apter, an immigrant from Poland. Betty was starstruck by another new aunt, beautiful and fashionable, much as she wanted to be.

That same year, Betty, her mother, and her grandmother moved again, this time lugging their stuff two blocks north to 86th Street. Now that Charlie was married, Natalie felt it was only proper to find a place for themselves. She'd secured a position as a brokerage secretary that paid a decent wage, a small miracle at the height of the Depression, and could handle the rent on her own. It helped, of course, that she was no longer paying for Highland Manor.

Julia Richman may have been free, but that didn't mean the school couldn't offer the molding of character that Natalie so prized for her daughter. When Betty was a senior, the city Board of Education launched a cooperative education program aimed at helping students find success postgraduation. Tested at Julia Richman and two other schools before going districtwide, the program focused on the personal traits students would need to get hired for jobs. That meant "the teaching of poise, manners, neat appearance, good English, and the ability to get along with others." The board had agreements with several employers to allow students to alternate between schooling and job experience.

Of course, Betty did not see herself as a stenographer, teacher, or switchboard operator. At Julia Richman, her grades declined precipitously as her attention turned toward dramatics. When she graduated, she was 459th out of a class of 884, so just slightly above average. "Tardy too much," a faculty member jotted on her permanent record. "A nice

girl, but talks too much," wrote another. Betty had only one interest, and it had nothing to do with English, math, or bookkeeping. So it's possible that she got the school to give her an internship more to her liking. In her memoir, she'd write of attending classes at the New York School of the Theatre on Saturday mornings. Since she didn't mention any financial burden the classes caused, simply that her mother agreed to her taking them, it's conceivable that they fell under the school's cooperative education plan.

At the school, Betty signed up for courses in dance and drama. She was in her glory. At the end of the semester, the students performed famous theatrical moments for the public. Betty learned Act IV, Scene 3, from *Romeo and Juliet*, memorizing her lines on her crosstown bus ride to Julia Richman, and sometimes during her classes when she was supposed to be studying other things. Finally, "the day came and my moment with it," Betty wrote. "And the shaking started."

As Betty would demonstrate time and again, her fear did not paralyze her. Out in the audience sat her mother, her grandmother, her uncles, and their wives. "I pray thee," she emoted, "leave me to myself tonight/ For I have need of many orisons/To move the heavens to smile upon my state/Which, well thou know'st, is cross and full of sin." She brought the vial of poison to her lips. "Farewell! God knows when we shall meet again." Juliet died, and the audience applauded. "It must have been awful," Betty wrote. "But what mattered was that I had done it, and that meant I would continue." The applause turned out to be addicting.

If Natalie had hoped that her daughter's interest in the theater was a passing phase, she grudgingly accepted its permanence after her performance as Juliet. "I'd rather have you try almost anything else," she told Betty, "but if your heart is set on it, I'll help all I can."

Betty wanted to speed through school and get going on her acting career. She had a small circle of friends, but she seems to have vexed her teachers with her theatrical obsessions. "When you graduate 800 girls a year," an administrator wryly told a reporter in 1945, "you only remember the very good ones and the very bad ones." He paused. "I remember Betty very well."

For all her impatience with her studies and her teachers' chagrin over her lack of school spirit, Betty was well served by Julia Richman. Many of Betty's classmates were immigrants or the children of immigrants, like herself; the names printed alongside hers in her graduating class were

Jewish, Irish, Italian, Greek, Russian, Scandinavian, and more. Several black girls also graduated with Betty. One young woman by the name of Tanya Rodkevich penned an essay that was picked up and carried in newspapers across the country in December 1939. "I, too, am an American," the young woman wrote, "although my ancestors hold no share in the glory of American history. My parents were Europeans who migrated from their native land to escape the changes a revolution had brought. I am to begin a new generation in this country. I shall be the first American ancestor to my descendants and, as future citizens, they will play a part in the history of this nation." The message was clear: Betty had every right to expect as much success in America as any white Anglo-Saxon Protestant girl did.

But the threat of war loomed over everything. When Betty graduated in June 1940, Principal Michael H. Lucey delivered a message to the seniors. "Wars and rumors of war!" he wrote. "That seems to be the keynote of the busy world in which many of you are about to take an active part." Lucey encouraged his "dear girls" to seek satisfaction not from "heroic, spectacular roles" but instead from "the quieter ones of routine and duty."

Betty had no patience for routine. The little rhyme printed beside her yearbook photo read, "Popular ways that win, may your dreams of an actress overflow the brim." She was defiantly and unapologetically going after the spectacular roles her principal warned against. "Graduation at last," she wrote, "and the beginning of the pursuit of my destiny."

She lost no time getting started. At one point, Natalie had hoped she'd go on to college, but Betty insisted that the only higher education she needed was from the American Academy of Dramatic Arts on 57th Street, adjacent to Carnegie Hall. The academy stressed "self-discovery" and "the study of life," Betty recalled, "as that was what acting was all about." She was taught how to move, how to fall, how to apply stage makeup. In pantomime, she learned to use every part of her body to express emotion. She was taught fencing, voice placement, breathing, projection. She had to write monologues and perform them.

Through AADA's connections, Betty and some other students landed jobs at radio station WEVD, funded by the *Jewish Daily Forward* newspaper. They would be part of the stock company for a radio program called *Let's Playwright,* broadcast at 10:00 p.m. on Thursdays. The show reached at least as far as Pennsylvania. Several newspapers ran her photo,

announcing "Betty Bacal plays leading roles in *Let's Playwright* program on WEVD." Betty's voice, as revealed in a surviving broadcast, was considerably higher pitched than what we would later come to know. In the February 6 broadcast "All the World's a Stage," she sounded nothing like the smoldering siren she'd become on the screen. Betty appeared in several more episodes before *Let's Playwright* ended in May 1941.

During her last months at AADA, Betty developed a crush on a fellow student, a young man with blue eyes and a cleft chin by the name of Kirk Douglas, who was nearly eight years her senior. They went out a few times. Betty fell hard for him, imagining the two of them together "on the stage, off the stage, doing everything for each other." One day she discovered that Kirk was still in love with a former girlfriend (who later became his wife). "In retrospect," she wrote, "from then on, almost every man I have been attracted to has belonged to someone else or wanted to belong to someone else."

More disappointment awaited. For her final exam play, Betty was asked to perform a scene from the Broadway comedy *The Silver Cord*, which had starred Laura Hope Crews. She was shaking as usual as she strode out on the stage of the Carnegie Lyceum. The audience would judge her performance. A great deal was riding on how well she did. Natalie had told her that unless she could get a scholarship for a second year, she would not be continuing at AADA. She simply couldn't afford it. So Betty's only hope was to impress the judges. Although the marks on her final performance were good enough to allow her to continue, they did not convince the administration to give her a scholarship. Betty's formal dramatic education had come to an end.

And so she ended up at Walgreen's drugstore, handing out *Actors Cues*, chasing down producers, and knocking on leading men's doors, steadfastly refusing to surrender her dream.

Manhattan, a Weekday in Late November 1941

Betty knew she had to act fast. That was Max Gordon (she knew exactly what he looked like by now) coming down the street. She bolted after the producer, "practically dog-trotting" to catch up with him, as one fan magazine writer would later describe it. This was an opportunity she couldn't let slip by. She'd read that Gordon was looking to assemble a road company of his successful play *My Sister Eileen* that would tour over the Christmas season. Catching up with him, she panted, "I'm Betty Bacal, Mr. Gordon, and I'm sure that I'd be a real asset to your road company. I've had lots of experience, and I'm a very good actress and—"

The producer turned to observe the teenager through his round spectacles. He smiled. "We have a reading this afternoon at two," he told her. "You report." Betty was beside herself with excitement.

That was the way the story would be told, nearly identical to Betty's experience with John Golden and *Claudia*. Auditions, of course, were normally set up by agents, and busy producers weren't likely to risk losing time by auditioning someone they'd just met on the street. Broadway loves to tell stories of unknown actresses being plucked from chorus lines and turned overnight into stars, but if that ever really happened, it was an extremely rare occurrence, and Betty, according to her memoir, had just been given *two* such breaks in a matter of months. Yet we shouldn't rule out the other through line in her narrative: Betty was a very pretty, very passionate, fawning young woman who was drawn to older men and had already proven her ability to charm them.

She showed up at the Biltmore Theatre on West 47th Street at two o'clock as required. In her memoir, she'd recount reading for the part of Eileen (once again, the lead!) and being asked to see the play that night and come back the next day, a replay of her account of *Claudia*. "Hopes rose," she wrote. "I saw the play, loved the part . . . and didn't get the job." Thirty-some years earlier, however, before all the legend building, she'd told a somewhat different story to the fan magazine

writer Barbara Flanley. In that version, Betty had "read the lines hang-
ing onto the back of a chair which was practically in the wings." Gordon
asked her to please move to center stage, but still Betty clung to the
chair. "What else could I do?" she asked Flanley. "I was perspiring. I
was shaking so I could hardly hold the script, my knees were wobbling,
and if I'd let go of the chair I'd have fallen flat on my face." Which was
precisely the reason big producers didn't often audition inexperienced
actors.

She may also have tried for a part in *The Walrus and the Carpenter*, a
comedy that opened in November 1941. The playwright was Noel Lang-
ley, who'd also written for Hollywood (*The Wizard of Oz*). Betty's letters
would reveal a friendship with Langley, thirteen years her senior, around
that time; she called him by his first name. If there had been some in-
terest in the play, however, it didn't pan out. Betty did not appear in *The
Walrus and the Carpenter*, but she remained close with Langley, even
after he enlisted in the Royal Canadian Navy.

It was Betty's modeling work, as low paying as it was, that enabled her
to buy the hats and shoes she needed for auditions. The Walter Thornton
Agency secured her a gig in the February 1942 issue of *Harper's Bazaar*,
for which she was paid $28.70 for a back-of-the-book shot. She was also
refunded $1.95 for a pair of stockings. "Betty must have done a fine piece
of acting to get the management to reimburse her," her uncle Charlie
wrote to her mother.

It was during this period that Betty and her mother moved yet again,
this time heading downtown to Greenwich Village. They lived at 75 Bank
Street, at the confluence of Bleecker and Eighth Avenue. In the Village,
the orderly grid of streets and avenues suddenly vanishes, replaced by
twisting roads and narrow lanes based on the old carriage and cattle
passageways of the city's agrarian past. Life in the Village suited Betty.
"I really loved it," she told an interviewer. "Get up, put on slacks, take
my little dog for a walk. Lots of cute little places to go to." Though the
neighborhood's bohemianism was somewhat tamed since its heyday in
the Roaring Twenties, it was still a place where artists, musicians, and
actors roamed the streets and expounded on art in sidewalk cafés. "I
wanted to be as serious and committed as they were in my goal to be-
come an actress," Betty said.

But then what everyone had been fearing finally happened: the Japa-
nese attacked Pearl Harbor on December 7, 1941, and the United States

was at war. Still not personally affected by the calamity (she'd never had any boys as classmates, and her uncles, given their ages, weren't likely to be drafted), Betty accompanied her mother out of the suddenly chaotic city and spent the holidays in Miami Beach. They stayed at the Cromwell, a high-rise hotel on Ocean Drive at 20th Street, directly on the beach. There was also an outdoor swimming pool. Temperatures there soared into the eighties as New York suffered through a cold spell. "No doubt now that you're luxuriating in the sands of Miami Beach you will condescend to read the letter from your bankrupt brother who is freezing in almost zero temperature," Charlie wrote to Natalie. He was looking after Droopy while mother and daughter were gone. Betty's beloved cocker spaniel seems to have missed her. Charlie wrote that he "occasionally . . . irrigates the rug in excitement when strangers visit us."

Charlie appears to have been going through a financial squeeze during that period, referring to himself as bankrupt and asking Natalie to wait before depositing some checks he sent to her. It's possible that the drop in the Dow Jones Industrial Average (by more than 10 points) in the weeks after the Pearl Harbor attack had put some of his investments at risk. But the economic uncertainty didn't derail Natalie's plans to take Betty to Miami. Her daughter was feeling discouraged, so that gave her a reason to spoil her a bit (not that Natalie really needed a reason). Still, as the days went by, Natalie was feeling the pinch, so they found a smaller, less expensive hotel. Betty went inside to inquire about rooms. The proprietor asked her religion. When she told him she was Jewish, he said, "Sorry, no rooms." Betty was stunned, and Natalie was furious. "But we had each other, so the hell with it," Betty recalled. Without nondiscrimination laws, that was really the only response they could have. If nothing else, it may have given the Bacals more clarity about the anti-Semitism and xenophobia at the heart of the war raging overseas.

For all of Betty's blithe indifference to the war so far, she began to realize the seriousness of the situation when she returned to New York. The city was suddenly bereft of young men. Those she did see were in uniform. Her favorite fan magazines were filled with stories of actors heading off to war. Her former beau Kirk Douglas had joined the navy. Her cousin Marvin, the son of her uncle Albert, had registered for the draft; he'd soon be called to serve in the army. Broadway attendance fell off, so Betty wasn't ushering as many theatergoers to their seats as in the past. For her, the war was now inescapable.

The Stage Door Canteen, an entertainment venue for servicemen on their nights off, opened below the 44th Street Theatre in March 1942. Betty signed up as a volunteer for Monday nights. "I was to dance with any soldier, sailor or marine who asked me, get drinks for them, listen to their stories," she said. When one sailor grew sweet on her and asked if he could write to her after he was shipped off, Betty was moved. She tried to remain lighthearted but felt the awful weight of the young man's future. "I didn't know what to say to him," she remembered. "War was a fiction to me, not a reality. I didn't really understand what it meant—how could I?" She described her Monday nights at the Canteen as "sweet and sad" at the same time.

The Canteen gave her a chance to watch performers she might otherwise never have gotten a chance to see in person: Alfred Lunt and Lynn Fontanne; Helen Hayes; Judy Garland and Johnny Mercer singing Mercer's songs. More than ever, Betty wanted to join their ranks.

She continued chatting up influential older men. "I followed my Danny Kaye pattern with Vincent Price," she wrote. Price was appearing in *Angel Street*, and Betty was ushering. After the show, she rapped on his dressing room door. Price was removing his makeup, but he allowed the starry-eyed young woman to enter and listened as she poured out her ambitions. "He was warm and gentle," Betty recalled. But if she was looking for a theatrical mentor, she wouldn't find one among actors. What she needed was a powerful producer, a John Golden or Max Gordon. So far, she hadn't had much luck.

But then her luck seemed to change. In February 1942, she believed she might finally have met the man she'd been looking for.

A CACOPHONY OF LAUGHTER, EXCITED CHATTER, AND STAGE DIRECTIONS BEING shouted over the din bombarded a visitor backstage at the Longacre Theatre on West 48th Street. The visitor was a reporter for United Press, and he'd come to observe the final rehearsals for the new musical melodrama *Johnny 2×4*. The producer was Rowland Brown, a well-known movie writer and director. Word on the street was that Brown's new theatrical company, Brown Presentations, would transform Broadway, offering shows with a Hollywood flair. *Johnny 2×4* was the story of a speakeasy during the Prohibition years. Its producer intended for it to be a stage

version of a gangster picture, the sort that James Cagney and Humphrey Bogart had made famous.

Brown wasn't just producing; he was also the playwright and director. He had a lot riding on the show. He'd burned some bridges in Hollywood, walking off sets and turning down jobs, and he was seeking to reinvent himself on the Great White Way. His pockets were deep. Rumors had long swirled that he had friends in the mob. Brown had brought an inside knowledge to his gangster pictures, usually providing a stinging rebuke of American capitalism in the process. He'd written for such stars as Cagney, Spencer Tracy, and Constance Bennett. His most recent film was *Johnny Apollo*, with Tyrone Power and Dorothy Lamour. Among his most successful pictures was *Angels with Dirty Faces*, starring Cagney and Bogart.

The United Press journalist commented on "the sea of extras, mostly of the feminine persuasion, gathering around the producer, hoping to be thrown a bit of business to do on the stage." He didn't give their names, but one of them was Betty Bacall (she'd added an *l* because people kept rhyming her name with "cackle"). As soon as Betty had learned of the large cast being assembled, she'd hightailed it to the theater to audition for Brown. He had given her a couple of walk-on parts. Betty was over the moon. It would be her Broadway debut.

Brown would have seemed like a deity to Betty. An avid moviegoer, she'd seen most of his films. The producer was forty-two years old, handsome, bearish, and roguishly charismatic. He was also in the process of a divorce. No wonder the female extras made such a fuss over him. Certainly there were enough of them. The cast was the largest Broadway had seen in some time: thirty-nine actors, twenty-nine extras, and six musicians; Eugene Barr quipped in *Billboard* that curtain calls "looked like rush hour at Walgreen's." Brown was hiring pretty newcomers right and left, securing them Equity contracts so they could become part of the repertory company he hoped to establish. He would end up marrying one of the young women he hired for the show.

Rehearsals took place the last two weeks of February and the first week of March. Betty found herself, at last, on a stage, taking direction, being a part of a company where everyone had each other's backs. "The whole experience was magical," she remembered. It didn't matter that she had no lines and that Brown was paying her only fifteen dollars a

week. "It was Broadway," she wrote, "and I'd be behind the footlights—
other girls would be leading people to their seats, and they'd be coming
to see *me* for a change." Brown had given her a few things to do. In the
second act, she made an entrance walking down a staircase with gentle-
men on either side of her. In the third act, she would be onstage as the
curtain rose, dancing a jitterbug with a partner. "I felt I had been singled
out," she said. "I wasn't merely a walk-on."

Brown decided to forgo the expense of out-of-town tryouts and in-
stead set up a preview in New York for active-duty servicemen who hadn't
yet shipped out. "He regards them as an excellent general cross-section
and will utilize their reactions as a barometer," *Variety* reported. The
GIs must have liked the show since the company continued to steam
ahead, "with extravagant care and a good deal of confidence," according
to Burns Mantle. Although Betty had been part of the previews, she
didn't sign a contract with Brown until March 12; possibly the company
needed to wait until her Equity card, for which she had paid $50, was
issued. Her contract stipulated that she'd be paid "on Saturday night of
each week."

On March 16, Betty received congratulatory telegrams backstage as
if she were the star of the show. "Headlines in the near future," wrote one
friend. "Bacall gets Oscar. Davis collapses." Natalie, Charlie, and Rosalie
were there for opening night; Jack and Vera brought Sophie a few nights
later. Betty remembered standing in the wings on that first night, watch-
ing two of the leads, Barry Sullivan and Evelyn Wycoff, waiting for the
cues to enter. She knew at that moment that she was right, "that being an
actress was the best possible choice in life."

Just, perhaps, not in this particular show. *Johnny* 2×4 was savaged
by most of the critics. "A hack's dream," Brooks Atkinson wrote. The
reviewer from *Variety* called it "a tawdry and rather dated bit of hokum
melodrama containing innumerable extraneous musical numbers." Burns
Mantle at least seemed sympathetic: "It must be pretty disappointing for
a Hollywood playwright to work himself into a perspiration, if not a fever,
over a new play idea and then suffer the experience of exposing both the
play and himself to the chilling draughts of Broadway and its critics."

The company's morale sank, although for Betty there may have been
a bit of consolation in the fact that her name had been printed in *Variety*
(under "Also in the Cast"), the first time she had been publicly recognized
as being part of the theater. Some kind words also came from George

Jean Nathan. In the same issue of *Esquire* in which he ran the blind item citing Betty as the prettiest theater usher, he also named *Johnny 2×4* as "the best atmospheric dramatic production" of the Broadway season. Perhaps he had noticed that same pretty usher jitterbugging at the top of Act III.

The show ran for just eight weeks, then spent three weeks on the subway circuit through the boroughs, after which Brown pulled the plug—on both the show and his Broadway ambitions. "It was my first theatrical heartbreak," Betty wrote, "but not my last."

Her heart was mended by the spring, however, as she chanced upon another strategy to grab the attention of producers. The president of Betty's modeling agency, Walter Thornton, was sponsoring a series of local contests to select a candidate to vie for Miss New York City, who would then go on to the national Miss America pageant in Atlantic City. Since Betty was now living on Bank Street, Thornton had her compete in the Miss Greenwich Village contest, which was held on May 24 during a carnival and block party in Sheridan Square. "There were no bathing suits, thank God," Betty wrote. "I do remember walking onto a raised platform, smiling nervously in my high-heeled shoes and my pretty chintz dress." She'd lied about her age to enter, since contestants had to be at least eighteen and she still had a few more months before reaching that milestone. When her name was called, she rushed up to accept the award from the comedian Ole Olsen and held it up over her head, with photographers snapping away. Thanks to Thornton's clout, the photo of the beaming Betty and her award, flanked by Olsen and himself, ran in dozens of newspapers across the country.

Betty did not go on to compete for Miss New York City, so she never made it to Atlantic City, where there definitely would have been a bathing suit contest. If she had gone on, she might have become the first Jewish Miss America, beating Bess Myerson by some three years. It's likely her age stopped her; national pageant officials weren't likely to be as accommodating as Walter Thornton. Betty may have held on to the title, however, at least until June 9, when "Miss Greenwich Village 1942" and two other beauty contest winners competed with male lifeguards on a radio quiz show billed as "The Battle of the Sexes."

But the contest had already served its purpose. Casting agencies throughout the city clipped her photo from the newspaper. Her profile was now considerably higher than just a few months earlier. Once again,

it was her appearance that singled her out. Betty was fine with using her looks to get noticed. But she wanted the chance to prove she had something more.

ROWLAND BROWN HAD BEEN A BUST AS BETTY'S PATRON, BUT THAT DIDN'T mean she stopped looking for one. Just days after winning the contest, she read that her old friend Max Gordon was casting *Franklin Street*, starring Groucho Marx and directed by George S. Kaufman. So Betty did what every young, inexperienced actor did: she called the producer and asked for an audition.

Of course, most young, inexperienced actors didn't have such access. But Miss Greenwich Village was not like most, and Gordon, apparently, hadn't forgotten her audition for *My Sister Eileen*. "Max Gordon always gave me access to himself and his office in the Lyceum Theatre," Betty wrote, and so she proceeded, yet again, without any help from an agent or manager, to read for a part in a major upcoming show. When she learned that Kaufman was in the lobby of the theater, she made a mad dash downstairs and interrupted a conversation he was having to introduce herself. As Betty told it, Kaufman was "caught unaware" by her "hammerhead approach" but told her that "there might be something" for her; she should come by the following week and "see what happens." To which an obsequious Betty replied, "Oh, thank you, Mr. Kaufman, I'll be there, you won't be sorry."

If that sounds like every stage door and chorus line movie ever made, that's because it is. By the time Betty wrote her memoir, fifty years after the fact and with a legendary Hollywood career in between, she knew how to tell stories: she knew the tropes and themes audiences responded to and recognized. After all, it had happened to Peggy Sawyer and Esther Blodgett in *42nd Street* and *A Star Is Born*, so it would be easy for the public to believe that it had happened that same way to Betty Bacall.

In her memoir, she presented herself as a plucky, wide-eyed kid willing to take risks and elbow her way forward. It's not that she wasn't those things. But the stories she tells feel as if something is missing. There's no implication that her looks, her beauty queen status, had anything at all to do with the access she was being given to these powerful older men. Instead, she tells us, "For one as insecure as I was, I sure had no

compunction about running up to strangers and brazenly introducing myself. I was damn lucky all my strangers had class!" She might have added that she was also lucky that they were all heterosexual, middle-aged men, many of them known for cheating on their wives. (The married Kaufman's affair with Mary Astor had made national headlines.) They weren't the type to avert their eyes from an eager, pretty girl.

In no way does this suggest that Betty was willing to sleep with those men to get ahead. There is absolutely no evidence to support that idea, and given her upbringing, there's every reason to believe she would never have considered going that far. (Natalie had warned her, "Never give anything away. No man really wants that.") In fact, one story, buried in her correspondence and not mentioned in her memoir, reveals that no matter how much she might have been willing to ingratiate herself with potential benefactors, there was a line she wouldn't cross.

During rehearsals for *Johnny* 2×4, Betty and a friend had somehow come to the notice of Walter Pidgeon, the Hollywood leading man then starring in *Mrs. Miniver* and *How Green Was My Valley*. He was in New York to promote a Defense Savings Bond drive, staying at the Waldorf-Astoria. When Pidgeon invited the two starstruck teenagers up to his suite, they agreed, but once there, they had second thoughts. "He chased them around, leering," reads a note attached to a letter from Betty to her mother about a year later. Just who wrote the note is unknown, but it was part of Betty's personal papers. The note goes on to say that the girls "were horrified because he seemed so old to them." (Pidgeon was forty-five, only two years older than Betty's future husband and younger than Paul Lukas, George Kaufman, and Max Gordon.) The columnist Dorothy Kilgallen had apparently heard some stories about Pidgeon during that same trip, writing that he was "leaving a trail of swooning females" wherever he went. Clearly, not all the men Betty encountered had, to use her own word, "class."

Yet although Betty had her limits, she could still flirt. She could still present herself in ways that she knew would get attention. She hints at that strategy in her memoir. As she prepared to introduce herself to Kaufman, she slouched "to look smaller, younger." Given the part she played later in Hollywood, as one-half of the movies' greatest love story, she may have felt compelled to downplay her flirtatious nature at the start of her career. But it's the elephant in the room in her memoir. Every door she knocks on is opened. Every audition she requests she gets.

George Jean Nathan writes about her and says that there's "rapt agree-
ment" among the men in his circle that she's the latest It girl. Yet Betty
never admits to any coquetry. The truth is, although she may have been
insecure about many things, her sex appeal was not one of them.

At her audition, Betty was confident that "Max Gordon would help
to get me a part." But still she was trembling. She worried whether the
impression she'd made on Kaufman was "positive and appealing." Ap-
parently it was, because after Betty's reading, the director gave her a
few pointers and asked her to read again. Then he asked her to read for
another part the next day. The waiting was agony. Betty started praying:
"Please God, let me get one of the parts . . . let it be the beginning,
please, please." Finally Kaufman told her she'd be playing the role of
Maude Bainbridge, a dreamy, poetry-quoting, aspiring actress. "My first
speaking part in a Broadway show, produced by Max Gordon, directed by
George S. Kaufman," she exulted—a part she had won with only a single
walk-on credit in a notorious flop on her résumé. Gordon himself made it
a point to come down and congratulate her. "See," he told her, "I told you
I'd find something in one of my plays for you."

Betty was deliriously happy. "It wasn't so bad to be a little Jewish girl,
now was it?" she mused. "As a matter of fact, it was the best possible
thing to be." This raises the possibility that it wasn't just her looks that
appealed to the men who had hired her but also her heritage. Gordon was
a Jewish immigrant from Poland; Kaufman was the son of Jewish immi-
grants from Germany. It's not unreasonable to consider that their support
of Betty wasn't just because they found her nubile, charming, and pretty
but also because they saw her as one of their own, trying to succeed in a
business that could often be brutally anti-Semitic.

By the time rehearsals started on August 15, Groucho had dropped
out of *Franklin Street*, replaced by Sam Jaffe (not the same person as the
Hollywood agent). One of the show's writers was Arthur Sheekman, who,
with his wife, Gloria Stuart, was part of Humphrey Bogart's inner circle
in Hollywood. Stuart was charmed by Betty as she watched her rehearse.
"She was darling," Stuart said. "Very ambitious and talented and very
good in the play." It wasn't difficult for Betty to play dreamy. Maude may
have lacked her gumption, but she shared her daydreams and aspirations
for success. *Franklin Street* focused on the colorful characters of a drama
school on the eponymous street in Philadelphia. The schedule had the
play previewing in Wilmington, Delaware, moving on to Washington,

DC, and then to Boston before finally opening on Broadway at the Royale Theatre.

But cracks began to show right away. Jaffe wasn't working out. Days before the Wilmington premiere, he was replaced with Reynolds Evans. Betty didn't shed a tear for Jaffe, who'd once grabbed her hands while she was curtsying to his character and kept her there for several beats. "All I cared about," Betty said, "was that the play must continue." She stuck close to Kaufman, whom she wanted "to be around . . . as much as possible," she said. "I worshiped him." She had every faith that he would make the show a smash.

The day *Franklin Street* opened in Wilmington, September 16, was Betty's birthday. She took it as a good omen. Her eighteenth birthday was far happier than her future husband's had been. A flurry of telegrams waited for her backstage at the Playhouse Theatre. Congratulations from her friends, uncles, and aunt piled up; even Droopy sent a wire. Uncle Charlie wrote, "Just continue as you are and you will be a lovely star." From Mother and Grandma came the message "May this be one of the happiest birthdays and the beginning of a brilliant future."

On opening night, Betty walked out onstage, spoke her dreamy line while staring out into space, and the audience laughed. She was unprepared for that; she thought she had read the line wrong. But Kaufman assured her later that the laugh had been appropriate and she had done well. The show itself, however, didn't please him as much. Betty sensed that the cracks were getting larger. "It was clear even to innocent me that there were problems," she wrote.

The critics agreed. William P. Frank of the Wilmington *News Journal* summed it up: "In as few words as possible, *Franklin Street*, despite its ace director and its excellent, hard-working cast, is not a very good play." The reviewer spotlighted several members of the cast he thought had been excellent; Betty was not among them, a fact she was surely sensitive about.

Downcast but unbroken, the company made its way to Washington, where they opened at the National Theatre on September 21, 1942. A few things had been tweaked, a few scenes restaged, but to little avail. "The comic pranks," judged Andrew R. Kelley of the *Evening Star*, "lack invention and enough rollicking situation to sustain a full evening of exaggerated fun." Kelley also singled out some of the cast for good marks, but again, Betty wasn't included. (Only one review mentioned her, Betty

recalled, although she didn't provide the name of the paper.) On the same day as the Washington reviews came out, Max Gordon announced that *Franklin Street* would be withdrawn. There would be no Broadway premiere. "I burst into tears," Betty wrote. "It had never occurred to me that this might happen."

Devastated, she went looking for George Kaufman to console her. But he was nowhere to be found. To a radio reporter, she gushed about how good it had been to work with Kaufman. The director was told about the broadcast and wrote Betty a note, although he called her "Peggy": "Probably you know that the show is stopping this week until it gets fixed. All regrets." For all her worship, she clearly hadn't made the impression on him she thought she had. For Kaufman, closing a show out of town sometimes happened; it wasn't the end of the world. But Betty's world had just fallen out from under her.

During her brief stay in the nation's capital, Betty likely didn't know that her father was living just a couple of miles away from the National Theatre, on Connecticut Avenue north of the Adams Morgan neighborhood. Now spelling his last name Perske, he was making a good living as a salesman of medical equipment. He'd remarried; his wife, Sally, had also been a Weinstein, though unrelated to Natalie. William likely had no idea, either, that his daughter was performing in the city, unless he read the fine print of newspaper cast lists. Betty spent her last days in DC looking for someone to console her, when her own father was just down the road.

BETTY PASSED THROUGH THE LAST MONTHS OF 1942 IN A FUNK. HER GRAND-mother kept telling her she should get a job as a secretary and start banking some money. Her mother was more encouraging, but there was little reason for optimism. Betty kept in contact with her patrons. She paid a visit to Gordon, who apologized for the way things had worked out. She shouldn't wait around, however, for *Franklin Street* to be fixed. Everyone was moving on. Not long afterward, Betty heard that Kaufman was starting on another play for Gordon, *The Doughgirls*. So of course she went straight to the theater to speak to him, but he was unavailable. Doors weren't opening for Betty as quickly as they once had. She sent Kaufman a note, telling him that he was hard to reach and asking if there was a part for her in the new play. "Dear Betty Bacall," Kaufman replied,

this time at least getting her name right. "I'm not so hard to reach as all that. . . . There's nothing near your age in the play, so there's nothing I can do. But there ought to be another play *some* time, and I'll always try hard. . . . Cheer up. It can happen any minute." They were nice words, but Betty probably wasn't feeling them.

For solace, she turned to a new friend, an English writer who introduced himself as Timothy Brooke. It's unclear how Betty and Brooke met. He's a shadowy figure, possibly using a nom de plume, as no record definitively identifies him. All we have is Betty's memory of him: "a good deal older than I . . . very tall, very thin, very charming." Brooke's main claim to fame was that he was friends with Evalyn Walsh McLean, the owner of the Hope diamond. He also had connections to New York café society, including Mabel Mercer, whom he took Betty to hear sing at Tony's. Had the timing been a few months earlier, they might have spotted Humphrey Bogart and Mayo Methot at the bar. Betty was aware of the "growing attachment" Brooke had for her, even if there was "no attraction on [her] part." Still, she was receptive when he suggested that she meet Nicolas "Niki" de Gunzburg, an editor at *Harper's Bazaar*. Brooke was convinced that Betty could become a top model. The fashion world wasn't her first love, but at that point, she was up for anything. And so "started the chain of circumstances that would reshape my life," she wrote.

Gunzburg, born in Paris in 1904, was a larger-than-life aesthete, Oscar Wilde returned to life except with lots more money. Descended from a Byelorussian Jewish family that had controlled banks in St. Petersburg and Paris, Niki had blown most of his fortune on outrageous days-long parties for Europe's bohemian elite. All he had left of his inheritance was the title of baron, bestowed on his family in 1871 by Louis III, Grand Duke of Hesse. In 1934, as tensions had mounted in Europe, Niki had come to America, hoping to reinvent himself (and fill his coffers) in Hollywood. He'd already appeared in one film, Carl Theodor Dreyer's *Vampyr*, Denmark's answer to *Dracula*, playing the hero who fights off a vampire. Baron Niki didn't make any films in Hollywood but became one more émigré living off his name and reputation in the status-conscious movie colony. He took rooms at the Garden of Allah, likely crossing paths with Humphrey Bogart, who probably thought of him as a phony. But Niki did make at least one lasting friend, the actor Erik Rhodes. They were soon in a relationship.

With neither of them getting much traction in Hollywood, Niki and

Erik moved to New York, where, just before the United States entered the war, Gunzberg was hired to join the fashion staff of *Harper's Bazaar*, his style, reputation, and title having preceded him. Diana Vreeland, who worked alongside him, always called him "baron." A year later, Niki agreed to meet with a promising new model on the advice of his friend Timothy Brooke. Taking one look at Betty Bacall in the amber light of Tony's, the baron insisted that she come by his office the next day.

At the Hearst offices near Columbus Circle, Gunzberg presented Betty to Vreeland, who was sitting at a desk in a grand office, dressed all in black with pale white skin, red lips, and long red fingernails. She'd been an international socialite before *Harper's Bazaar* editor in chief Carmel Snow, dazzled by her style, had hired her for the magazine's fashion staff. Vreeland wrote a column called "Why Don't You?," filled with often outrageous fashion suggestions, such as "[Why don't you] rinse your blond child's hair in dead champagne to keep it gold, as they do in France?" The column lent itself to parody, but Vreeland's clout at the magazine soared.

"Very direct in manner and speech," Betty described her. As she watched, the intimidating fashion editor stood up regally from behind her desk to shake Betty's hand. Then she cupped the young woman's chin in her palm and turned her face right and left. Finally, after much scrutiny, Vreeland announced, "I'd like Louise Dahl-Wolfe to see you."

Dahl-Wolfe was one of the best fashion photographers in New York, and she spotted Betty's potential immediately. She took a series of photos of the eighteen-year-old with very little makeup, in natural poses. Other photographers photographed her as well over the next couple of days. In one photo, Betty was shot from above, her chin downward, her eyes looking up under her hooded eyelids. It was a pose that would eventually be dubbed "the Look." The little girl with the big smile and flipped-up hair had disappeared. In her place was a lithe young woman with cascading tawny blond locks, a triangular feline face, high cheekbones, vaulted eyebrows, slanted green eyes, and a "vaguely Slavic" look, as one reporter described her. This new creature never smiled but kept her lips pursed, sensuously and seductively.

In the middle part of January 1943, Vreeland asked Betty to stop by her office. She wanted to show her the February issue before it hit the stands. On a two-page spread on blouses, Betty was identified under one photo as "the young actress, Betty Becall." The typo must have stung,

even though Betty glossed over it in her memoir. But it was too late to go back to press. Still, the issue was tremendous publicity for her. *Harper's Bazaar* had a nationwide circulation. Who knew who might take a glance at her photo and note her name?

After so many false starts, Betty was cautious about getting her hopes up. Though she seemed to be in solid at *Harper's Bazaar*, with further modeling gigs scheduled, she didn't really enjoy the work. "I was never terribly good at 'hold it,'" she said. "They'd say, 'Hold it!' My God! I'd start moving away, it made me so nervous." What she really wanted was for some producer to notice the word "actress" before her name and inquire who this "Betty Becall" was.

In fact, over the next few weeks, several producers did indeed pause at Betty's two-page spread as they flipped through the February *Harper's Bazaar*. She didn't know it yet, but the heavens were finally smiling on her; her moment had come. Betty had spent the past three years search-ing for a powerful father figure to take care of her, to make her dreams come true. She had brought all her sexiness and youthful charm to woo those men. It turned out that she needn't have bothered. Her big break came not from any of the heterosexual men she had pursued but rather from a woman and a gay man who had pursued her.

The California Border, Tuesday, April 6, 1943

Morning sunlight was just starting to filter through the windows of the *Chief* when the conductor announced that they'd just crossed into California. Almost certainly, Betty was awake, dressed, and alert, ready to meet her destiny, as she considered the trip to be. "A sense of unreality" permeated it all, she would remember. Gazing out of her window, she would have taken in vistas of sagebrush, cacti, and burnt umber earth, with snow-capped purple mountains lining the horizon. It was a world like none she had ever known.

For the past three days, following a stopover in Chicago, the *Chief* had been Betty's home. At her side since departing New York was a bespectacled thirty-three-year-old composer by the name of Earl Robinson. They were both clients of the same agent, Charles K. Feldman, although Robinson had been with Feldman for some years and Betty for just a matter of weeks. The agent had asked Robinson to keep an eye on the eighteen-year-old model, as it would be the first time she'd traveled so far on her own. Betty seems to have depended on her chaperone, as her letters to her mother spoke affectionately of him.

She'd remember a disorienting mix of homesickness and excitement during the trip across country. Her three years of struggle to break into show business had felt interminable at the time, so the trip had felt in some ways long overdue. But in fact, her rise had been remarkably swift. One day, she'd been hanging out with the kids outside Walgreen's with nothing more urgent than that day's *Actors Cues*. The next, she'd been set down into an adult world of high stakes and considerable risk.

Around 8:30 a.m., the *Chief* steamed into Los Angeles' Union Station. After a torrential rainstorm the day before, puddles still glistened on the platform. Betty gathered her few belongings and accompanied Robinson down the steps. An assistant from Feldman's office was there to collect them and take them to her hotel. Despite the blue skies she'd expected being partially obscured by fast-moving gray clouds, she was

dazzled by the city around her. She'd seen palm trees in Florida, but nothing could have prepared her for the sweet, intoxicating fragrance of orange blossoms, which had just opened in the last week or so, suffusing nearly every corner of the city.

Betty's dreams of stardom were coming true, or at least they might be if she could live up to what was expected of her. The photos in *Harper's Bazaar* had done the trick. Diana Vreeland had called to tell Natalie that they were getting inquiries right and left—not from theater producers but from Hollywood. Both Columbia and Myron Selznick were interested in screen-testing her. There was also an inquiry from Howard Hawks, an independent producer-director known for an eclectic body of work that included *A Girl in Every Port, Scarface, Bringing Up Baby, His Girl Friday,* and *Sergeant York.* Unlike the inquiries from Columbia and Selznick, Hawks was considering putting Betty under personal contract, which might be preferable to a regular studio contract with its lack of guarantees.

That Betty had come to Hawks's attention at all is a marvel. A lieutenant in the aviation section of the US Army Signal Corps during the First World War, Hawks wasn't the sort to sit around flipping through the pages of *Harper's Bazaar.* Instead, it was his young and fashionable wife, Nancy "Slim" Gross, who'd chanced upon Betty's photos and showed them to him. In many accounts, it's said that Betty was on the cover of the magazine, but that achievement didn't occur until the March 1943 issue, so what Slim would have seen was the photos taken by Dahl-Wolfe and others during the first photo shoot, including the one that would launch "the Look." The March cover photo, however, did provide Hawks with confirmation of Betty's appeal just as he was making his decision on the offer. In that shot, she's dressed in a black winter coat and white hat, carrying a red purse and standing rather glumly in front of an American Red Cross blood donor site. Her lipstick matches the color of her purse and the Red Cross sign behind her.

Like most origin stories of Hollywood's stars, the story of Bacall's beginnings would take on mythic features. There's the young, inexperienced kid winning an all-expenses-paid trip to Hollywood so a big producer can make her a star. There's the one-in-a-million chance she was given, something young women all across the country fantasized about. The fates, according to the Bacall myth, had smiled upon her, with Slim Keith seeing her photograph at just the right moment when her husband was looking for an actress.

By 1966, the Bacall legend was being described as "a scene straight out of a B late-late-show about moviemaking." A chronicler for the *Saturday Evening Post* asked his readers to imagine Howard Hawks "storming about his living room in a dither," unable to find a girl to play opposite Humphrey Bogart in an adaptation of Hemingway's *To Have and Have Not*. "'Where on earth am I going to find a girl for the part?'" Hawks cries. His wife has the answer. "Listen, sweets," she says, "you could take any girl and make a star out of her." She lifts a random magazine, which just so happens to have Betty Bacall on the cover. "How about this girl right here?" Hawks instantly realizes that he's found the girl he needs, signs her to a contract, and gets busy "training her to be a movie actress."

There's always some truth in the legends Hollywood tells about itself. Slim Keith did see Betty's picture and found it compelling enough to show her husband (even if the picture wasn't on the cover). Hawks did offer her a contract sight unseen. But the contract wasn't for *To Have and Have Not*, which wasn't yet on Hawks's radar, and it wasn't for any kind of career buildup. It was only for a screen test. And the director had absolutely no intention of bringing her to Hollywood until he'd seen the test. That's one fact that, until now, has never been made clear.

"My secretary made a mistake," Hawks insisted. "When I asked her to find out about the girl, she sent her a ticket to bring her out here. I didn't want her out here at all." The actual sequence of events, according to Hawks, went this way. After seeing Betty's photo, he asked Charlie Feldman, one of the biggest agents in town, representing not only Hawks but also Claudette Colbert, Joan Bennett, Charles Boyer, and many others, to make some inquiries. Feldman called *Harper's Bazaar*, which passed him on to Natalie. At the time, early February 1943, Betty was in Florida on a fashion shoot for the magazine, so Natalie asked her brother Jack, who had become the legal counsel for *Look* magazine, to weigh the various offers that had come in. As Betty remembered, "Jack felt we should move very carefully on all this. He . . . knew that I'd be so hysterical that I might accept the first offer made."

Jack was inclined to take Columbia's offer of a year's contract. Betty agreed, and after returning to New York, prepared to meet with the studio's East Coast reps. But Feldman happened to phone just at that moment. Betty wrote that he was "very articulate about Hawks and very persuasive." According to her version of events, Feldman and Hawks then "arranged transportation and I was out there three days later."

In fact, it didn't happen quite that fast. Betty was back from Florida by mid-March at the very latest but didn't depart for California until April 3. According to Hawks, he expected Betty to have a screen test done in New York. When exactly she learned that the producer had not intended for her to get on a train and travel three thousand miles to meet him is unknown. It may have been before she left and she went anyway, or she may have learned about it later. Either way, there must have been some embarrassment. She made no mention of it in her memoir, allowing the legend to stand.

She did quote a letter Uncle Jack had sent to Feldman before her departure. "I entrust Betty to your care," Jack wrote. "She's only eighteen and doesn't know anyone in California. If her mother accompanied her, she'd have to leave her job—which she can't afford to do, especially in view of the fact that Betty might soon be back here for good." Accordingly, Feldman asked Earl Robinson to look after her.

No matter what the legend would tell us, Betty began her journey west with no guarantee of stardom, no commitment from Hawks to take her to the top. There was no movie waiting for her on the other end, no long-term contract, no fanfare. There was only a slightly annoyed producer who hadn't expected to entertain a kid with nothing but a couple of photo shoots on her résumé. That might be why Bacall could get a bit testy when interviewers tried to pin her down on the details of her discovery. "Oh, how boring," she interrupted an oral historian from Columbia University in 1971 after he asked her about Hawks's bringing her to California. "I just think it's so boring because it's been said so many times. It would just seem to me that if that's not known by now it will never be known."

In 1971, Bacall seemed determined to hold on to the perspective of the starry-eyed girl who'd boarded the train west in 1943. Eighteen-year-old Betty had been convinced that a glorious future awaited her at the terminus of her trip. Of course, that glory did come, but looking back, we can see how risky the enterprise really was. Betty's blind faith kept her going. One of the last things she did before leaving New York was to send George Kaufman a friendly update about her trip to Hollywood. She may have also been subtly making the point that although Broadway hadn't wanted her, the big screen beckoned. That can be gleaned from Kaufman's reply. "Just a note, Betty," he wrote, "to tell you how pleased I am, and I hope you get that part soon." The playwright then assured her

that, yes, he did the "know the difference between Howard Hughes and Howard Hawks."

FELDMAN'S ASSISTANT DROVE BETTY AND ROBINSON TO THE CLAREMONT HOTEL on Tiverton Avenue in Westwood. "It's clean, and kind of cute," Betty wrote to Natalie, "but terribly out of the way." Still, as she pointed out, John Payne ("you know, that cute young actor") was staying there, so maybe their lodgings weren't so bad.

The cold fact, however, was that Betty was paying for the hotel herself. Hawks may have inadvertently paid for her train fare, but he wasn't springing for her accommodations. Feldman appears to have wired her some travel money, but Betty's bill would be paid with the traveler's checks that she had brought with her. Feldman did get a car for her and Robinson, however, "which of course Earl will drive," Betty assured her mother.

That evening, she met her new agent for the first time at dinner. Along with him was the talent scout Robert Ritchie, who'd discovered Hedy Lamarr. Betty was no doubt dazzled by sitting with two of Hollywood's major power brokers, but she was also a pro at relating to influential older men. Her flirtatious mode likely clicked in fast. Feldman asked her questions about herself, and she asked him questions right back. "Guess who Charlie handles?" Betty wrote later to Natalie. "Yup—Pidgeon. God, spare me!" There was lots of laughter and flattery all around the table. Betty returned to the hotel that night spellbound.

The next morning, she gave her mother a detailed update. "Charlie is a darling, a perfect angel," she wrote. "Don't tell this to anyone, but Charlie adores me. He thinks I'm wonderful—vital, alive, refreshing, full of fire, intelligent, and a few other things. And these, sweetie, are direct quotes. He'll do everything possible for me." For all her bravura, her innocence comes through. There's no awareness that agents always greeted new clients this way, that indeed most everyone in Hollywood spoke in hyperbole. Still, she projected strength to Feldman, which surely impressed him. When he offered to advance her some money, perhaps to help cover the hotel bill, Betty refused. "I told him I didn't need it," she reported to Natalie, "but if and when I do, I'll tell him." After all, she said, "we made a bargain and I'd like to stick to it as much as I possibly can."

For all his praise, however, Feldman was vague about when her screen

test would take place. "Charlie thinks I should have my teeth fixed first," Betty wrote home. The delay in the test might also have been because Hawks was scrambling to set it up, having not expected to do so in Los Angeles.

Betty's letters to her mother are filled with name-dropping and grand expectations, but at the end of the day, she was a teenager a long way from home. "Send all my love to our little offspring [Droopy]," Betty wrote her mother. "My love to Grandma. Tell her I'll write when I can. Bestest love from the bestest daughter to the bestest mother."

On April 7, Feldman escorted her to her first meeting with Hawks. Arriving at the Brown Derby restaurant on Wilshire Boulevard, the one shaped like a derby hat, Betty, the avid movie fan, would have known all the stories about the iconic place. Its founder, Herbert Somborn, had been the husband of Gloria Swanson. John Gilbert had once gotten into a fistfight with a writer there. Marlene Dietrich had caused a scene when she had been refused service for wearing pants. And countless movie deals had been struck at the Derby's tables. Now it was Betty's turn.

She and Feldman waited for Hawks to arrive. "I was very nervous and Charlie knew it," Betty recalled. "After a few minutes, a very tall man with close-cropped gray hair and broad shoulders came in." Feldman leaned in to Betty and whispered, "There's Howard." Introductions were made. Betty found Hawks "very imposing." He "spoke very deliberately," she said, "asked me a few questions. Said he'd liked the pictures in *Bazaar*, wanted to know if I'd had any acting at all." She told him the little she had done. Truth was, it was remarkable that she was sitting opposite a major Hollywood producer at all. But she held her own. Hawks seemed to like her. When Feldman asked about her teeth, Hawks said she was fine the way she was.

At least, that was how Betty told the story. Hawks had a different memory of that first meeting. "This very eager girl arrived," he said. To him, she was just a "little girl with a gabardine skirt and sweater" with a "little high voice, talked way up here like this." (He gave a demonstration of a squeaky voice to the interviewer.) "She had a high nasal voice and no training whatsoever." The next day at the office, Hawks told his secretary to arrange a tour of the studios for her. "She's so eager to see pictures and get into pictures and everything, let her see things. Give her about a week and send her home."

Betty's voice was the biggest problem. The radio broadcasts from a

year earlier corroborate Hawks's description. Moreover, Betty spoke with an obvious New York accent and specifically a Brooklyn Jewish accent. That wasn't what Hawks had counted on when he had seen her sultry photos in *Harper's Bazaar.* "The only women I have in a picture are rather sophisticated," Hawks finally told her. "They haven't got a voice like you've got. You can't read the lines that we have." Unfazed, Betty remained in her hotel for the next ten days. No studio tour, no going out at night. When Natalie worried that Betty was getting bored, her daughter assured her she was not. In fact, she was working on her voice.

"How do I change my voice?" Betty had asked Hawks. If he didn't like it, she'd fix it. He told her it was a matter of learning to speak from the diaphragm. She should follow the example of Walter Huston, he said, who'd deepened his voice by projecting his lines "as though he were speaking to the upper gallery of a theatre." For those ten days alone in her hotel room, Betty did just that, likely keeping her neighbors awake with all the projecting she was doing. About a week later, she returned to Hawks's office with "an entirely different voice," he said, "an amazing voice." She spoke deeper and lower, at a languid pace, most (but not all) of the New York tempo smoothed out.

Hawks's timeline matches what we find in Betty's letters to Natalie. On April 15, she's idle and clueless about her test. On April 21, the test has been set. Hawks was digging around for scripts. He decided on scenes from *Claudia,* which Betty already knew, and *Kitty Foyle.*

As she prepared to go before the cameras, Betty was settling into her new California lifestyle. Feldman invited her to his home to meet his wife, Jean Howard, a photographer, society hostess, and former Ziegfeld girl. Howard gave Betty a pair of navy shoes, something she believed a new actress needed. Betty gushed to Natalie, "She only has about eighty pairs of shoes and that's no exaggeration. You've never seen anything like it." She spent Passover with her new friends at Feldman's parents' home. "A real Passover dinner," Betty gushed. "It's the first I've had in years." She had found a cocoon of support and encouragement. "Charlie said he will do everything humanly possible for me," she wrote home. "And I know that Howard likes me loads." Meanwhile, the sunny skies and warm weather had been very easy to get used to. California, she said, was "truly God's country." As for her hometown, she wrote, "The thought of New York truly repulses me."

Yet for all that, she was still anxious. She knew that there was no

guarantee beyond her screen test. Natalie was eager to quit her job and move to California with her, but Betty had to keep reminding her mother that she could only do her best to make that happen. Everything hinged on the screen test. "I have no insides left," she told Natalie. Over and over, she practiced her lines in her new voice. She worried that she didn't have enough clothes. She asked Natalie to send her a black belt, "and you know I can use some underwear." But that, she wrote, "can wait until I find out what's what with my career." She asked both Natalie and Droopy to pray for her.

At last the day for the screen test arrived. Early on the morning of Friday, April 23, more than two weeks after Betty's arrival in Los Angeles, a studio car took her over the mountain to the Warner Bros. studio in Burbank. Betty was sent to hair and makeup, where she had to wait until Ann Sheridan was finished; "tests came second to actual filming," she explained. She also encountered a flirtatious Dennis Morgan, whom she described to Natalie as a "wolf." With butterflies in her stomach and her heart pounding in her chest, Betty was escorted to Stage 12. She was surprised by how many people were needed to shoot a simple test. A cameraman, dozens of assistants, guys up in the rafters swinging the lights around, even stand-ins. And, of course, the director. Giving Betty a kiss on the cheek, Hawks asked, "How do you feel?" She told him honestly, "Terrified."

She'd practiced the scene the day before with her screen test partner, a young actor named Charles Drake, who'd appeared in several films, usually unbilled, including *The Maltese Falcon*. "It was strange to read a scene with a complete stranger," Betty wrote. "I was trying to impress him, impress Howard." So when Hawks called "Action!" on the test and the camera started rolling, she knew what to expect. But that wasn't enough to quiet her nerves. She'd gotten sick the night before with all her worry, and she prayed that wouldn't happen now.

It didn't. "My test was more fun, Mommy," Betty wrote to Natalie. They shot from 9:00 to 1:30, broke for lunch in the commissary (where Betty spotted Errol Flynn "and dove under the table"), and resumed shooting from 2:00 to 4:00. "And I loved every minute of it," she assured her mother. "I had a dressing room, a stand-in, a hairdresser and make-up man, an 11-page scene, and Howard as a director. I had what every star has." Hawks thought she had done well and told her it would be ready in a few days, when a final decision would be made.

To her credit, Betty understood how unusual her situation was and how few dues she'd paid to get there. "I was really a very lucky girl," she told her mother. "What I had only one out of ten thousand girls get." But her ultimate success would depend on more than luck. She'd been given a rare opportunity, but when the time came and she faced the camera, she met the challenge head-on. She might have faltered, blundered, goofed up. But she didn't. She accomplished everything she needed to do. She projected sensuality and authenticity. It wasn't a starstruck teenager that came through in the rushes but the awakened Claudia learning to trust her own power.

Betty saw the test on April 28. "It's the weirdest feeling to see yourself move around and talk," she wrote to Natalie. "I didn't think it was exceptionally good. I didn't look beautiful." But Hawks and Feldman thought the test was "excellent," and that was what mattered. Hawks put Betty under contract. She'd done what she'd come out there to do.

"I'm the first girl Howard has ever signed personally," Betty told her mother. "Charlie says I'm his protégé."

She was Cinderella at the ball, but there was a darker side to the proceedings she tried to ignore. In her letters to Natalie, Betty wrote only warm words about Hawks and Feldman. But both men were known within the industry for their wandering eyes when it came to young women. That was especially true of Hawks. His longtime secretary, Meta Wilde, called him "cold and ruthless" and described icy silences and compulsive womanizing. He'd left his first wife for the much younger Slim after carrying on with her for some time. William Faulkner would later say that he wouldn't want to be a dog, horse, or woman around Hawks. Although Betty knew how to handle randy older men, her friend Joyce Gates, with whom she'd appeared in *Franklin Street* and who was also in Hollywood for a screen test, hinted at some tension. "She was careful," Gates said. "And very scared."

Betty would later write of someone on the set encouraging her to visit Hawks in his private office. "He'd like it," she was told. But Betty stayed as far away as possible. "I was so frightened of him. He was the old gray fox, and he always told me stories of how he dealt with Carole Lombard and Rita Hayworth, how he tried to get them to listen to him and they didn't, so . . . their careers took much longer to take off."

There was something else that disturbed her. After spending a good amount of time at Hawks's palatial home on Moraga Drive, she noticed

that Feldman was the only Jew ever invited to dinner or parties. She'd done her best to ignore the anti-Semitic remarks that peppered Hawks's speech, which left her wondering if he knew she was Jewish. It's likely that he did not, at least in the beginning. He'd delegated to Feldman the task of finding out about Betty's background. It had been Feldman, after all, who'd dealt with Betty's family, and although both Natalie and Jack were Bacals, which did not sound Jewish, Feldman had also worked with Uncle Charlie, who still went by the name of Weinstein. "She had a dilemma about being a Jew, with Hawks, in among that bunch of anti-Semites," said Jules Buck, a cameraman and later producer, who was dating Joyce Gates. "She had the guilts about that."

Betty knew that if she spoke up, she'd likely destroy any chance she had. Still, Hawks's words were deeply disturbing. At night, his face flashed before her. "What did he really think?" she fretted. "And the Jewish business? If I was asked, I'd have to tell the truth."

But could she really? How does one balance ambition and integrity? She would have to wait a while longer before she had the answer to that.

THE APARTMENT ON SOUTH REEVES DRIVE IN BEVERLY HILLS WAS JUST FOUR rooms, but it came furnished and had its own private entrance, and the rent was only $65 a month. In New York, the same setup would have gone for more than double that, if it could have been found at all. When Natalie arrived on May 19, Droopy at her side, Betty had the place all set up, clothes in the drawers, fresh flowers on the tables. It wasn't much, but it was clean and convenient to Feldman's office. One of his assistants lived in an adjacent apartment, "and if it's good enough for him," Betty said, "it is certainly good enough for me. I don't have to put on a show for anyone."

The contract from Hawks had been agreed to, if not yet signed. Betty sent it to Jack to look over and also asked Natalie to describe it to Fred Spooner. All agreed that the contract, which gave Betty $100 a week and opportunities for promotion, while Hawks had an exclusive option for seven years, was fair. Since Betty was still a minor, however, her mother had to sign for her. If Betty had any concerns about being under Hawks's yoke for that long, she made no mention of them. If she wanted to be a movie star, she'd have to put up with Hawks, as she put it, "Svengali-ing" her.

Her dreams of Broadway evaporated in the sunshine of Hollywood.

Soon after Hawks had offered her the contract, Betty asked for an honorary discharge from Actors' Equity. She had no plans to do any stage work and didn't want to keep on paying her dues. Hawks had apparently been willing to carve out "a play clause" for her, but Betty didn't think it was necessary. "If and when something regarding a play should come up, I'm sure I can discuss it then," she told Natalie.

There was talk of having Betty play a tough Russian girl in a proposed war film called *Battle Cry*; nothing came of it, and the film was never made. For all her mentors' enthusiasm during her first month in Hollywood, after the contract was signed, they seemed to disappear. Records in Feldman's file reveal that he continued to misspell Betty's name as "Becall," perhaps a legacy of the *Harper's Bazaar* error. There are also records of Betty's calls going unanswered.

Yet that didn't appear to diminish her enthusiasm about her future on the big screen. Before Natalie joined her in California, Betty's letters to her were filled with both childlike wonder and an increasing sense of entitlement. "Please without fail get me a couple of things in Loehmann's," she wrote before her mother left for California. "I don't want to spend a lot of money when you can get something cheaper. Would love something in cyclamen or shocking pink. Get me something stunning for $20 or $25, size ten, and a navy box coat, size sixteen. Please, Mother, I'm counting on you. Don't disappoint me—and if you do, don't yell at me when I spend $50 on a dress and $100 on a coat." On another occasion, she asked for "one or two summer prints, something terribly smart," because she had worn everything she owned "fifty times" already.

It's important to remember the enormous pressure women felt about their appearance, with the expectation that they, far more than men, should always appear on the cutting edge of style. That was true in most places, but in the fishbowl of Hollywood, it could be especially intense. As a young, hopeful actress, Betty was determined to make an impression however she could and whenever she could. With hundreds of girls being groomed for stardom, she knew that not everyone could make it. She would have to stand out.

Perhaps not surprisingly, she could be somewhat mean about perceived competitors. Feldman had also brought another model and hopeful actress, June Vincent, out to Hollywood. Ohio born and four years older than Betty, Vincent was tall, blond, and Anglo-Saxon, as "all-American" as they came. Betty seemed particularly focused on her as a rival.

"Haven't met June Vincent as yet," she wrote to Natalie, "but I've seen her and think she's a mess. So does everyone in Charlie's office." Later, she said, perhaps attempting to be somewhat more gracious, "June Vincent is a terrific actress, I am told. Not pretty but different looking. Which is the important thing. Hope she clicks for her sake." Photos of Vincent disprove Betty's judgment of her looks.

Despite her professional inactivity, Betty was still being talked up in Hollywood. On May 19, the same day Natalie arrived to join her daughter on South Reeves Drive, *Variety* asked, "Could actress Betty Bacall be slated for screen stardom? Howard Hawks nabbed her for fast buildup, right off 44th Street, too." It was a canny plant by either Feldman or Hawks's publicity team and reassured Betty that she hadn't been entirely forgotten.

She'd also become a familiar sight on Moraga Drive in the mountains above Brentwood, not so much to see Hawks but to see his wife, Slim, who was just twenty-six and therefore closer in age to Betty than to her husband. Many similarities between the two women revealed themselves. Both had been raised by strong, divorced mothers. Both had immigrant grandparents (in Slim's case, from Germany and Ireland), and both had sprung from humble beginnings: Betty's family had started with pushcarts, Slim's with canning fish. Both also had a background in modeling, fashion, and charming older men. Slim had first been spotted at sixteen by William Powell, twenty-five years her senior, who had introduced her to William Randolph Hearst, half a century older, who had introduced her to Clark Gable and Ernest Hemingway, comparatively her peers at sixteen and eighteen years older. Slim was everywhere, turning up at Hollywood soirees and in society and gossip columns. A metaphorical bidding war arose for her hand, with Hawks winning the prize in 1941.

For a brief period, Slim had harbored some ambition to become a screenwriter and had worked on a western script with Winston Miller for Walter Wanger. But her marriage to Hawks had ended that. What Slim soon learned, and what Betty was just becoming aware of, was the deep current of misogyny that colored Hawks's worldview. Women existed, in his films and in his life, for a man's gaze and a man's purposes. No wife of his was going to have a career. And so Slim became the premier society hostess and fashion trendsetter of the film colony.

Slim dressed Betty for a portrait sitting that Hawks had arranged. "She had great personal style," Betty recalled. "I was led back to her

bedroom, which was gigantic." Slim had even more shoes than Jean How-
ard did. "Handbags on hooks," Betty itemized, "open shelves filled with
sweaters, a room-sized closet filled with clothes of all descriptions, an
enormous bath. Did kings live any better than this?"

Betty did her best to follow Slim's example. "Betty really emulated
Slim," said Hawks's third wife, the TV actress Dee Hartford, who had
known both women. "She *became* Slim." Betty borrowed Slim's clothes,
asked her advice on new purchases, and affected her walk and manner of
speaking. Both had low, husky voices, in both cases acquired. "Mannish,"
the third Mrs. Hawks said, "striding around with these great clothes and
able to say four-letter words trippingly." The coy, virtuous Betty of New
York, who never uttered an oath, was replaced by "a Hollywood broad
with attitude," as one writer referred to her just a few years later. The
change can be discerned by comparing the photos Louise Dahl-Wolfe
took of her and those snapped by John Engstead, the studio portrait pho-
tographer Hawks had engaged. In both sets of pictures, there are versions
of "the Look," with Betty's face downcast and her eyes looking up. In the
Dahl-Wolfe series, there is innocence and vulnerability, but Engstead's
photos, though undeniably glamorous, are tough, aggressively sexy, and
a tiny bit arrogant.

WALKING ALONGSIDE HER MOTHER, BETTY TOOK THE STAIRS UP TO THE ARCHED
entrance of the red sandstone Superior Court in downtown Los Angeles.
She was almost certainly terrified. She had been so close, but now her
dreams threatened to crumble around her. On June 9, Judge Joseph W.
Vickers had withheld approval of her contract with Hawks pending a
review of the producer's ability to pay her. Although it's not referred to
explicitly in the legal summary of the case preserved in the Warner Bros.
archive, Betty's age might also have been an issue. At eighteen, she was
still considered a minor in legal matters, and Vickers may have wanted
her mother to affirm the deal, which would explain why Natalie was
summoned to appear in court along with her daughter and Hawks. The
judge had given Hawks a week to provide financial statements. Betty had
to wonder if her mentor was one of those wheelers and dealers who were
always cashless, juggling accounts to pay their bills. After all, he'd never
given anyone a personal contract before; he'd always worked with a studio
on players. Betty had no idea what might go down.

Inside the courtroom, Hawks's attorney handed the judge reams of financial statements. As Vickers perused the documents, Hawks himself assured the court that he was worth between $700,000 and $800,000 and could easily afford the $100 a week he'd promised Betty. The judge then asked Natalie to step forward to verify her satisfaction with her daughter's arrangement with the producer-director. Natalie replied that she had given her consent. As Vickers flipped through the statements, everyone waited anxiously. Finally the judge issued his verdict. He would approve the contract, providing that Betty invested 10 percent of her earnings in war bonds and another 10 percent in a trust fund that she could claim at the age of twenty-one. That meant her $100 a week was down to $80. But what mattered was that her career could proceed.

Back in New York, Uncle Charlie had different concerns. Ever since Betty had gone west, most of the people he'd heard about from her and Natalie had been men—older, more experienced, more powerful than the young niece he'd bidden goodbye to. There were Feldman and Hawks, of course, but also Earl Robinson and Dennis Morgan, both of whom Betty appeared to be sweet on or at least curious about. Lately the news had been filled with stories of her being feted by Cole Porter and the restaurateur Michael Romanoff, both decades Betty's senior. Surely Natalie had described for Charlie the makeover by Slim Hawks, whose history with older men was clear to anyone who read the fan magazines, which Charlie had started doing. Betty's examples in New York—Paul Lukas, George Kaufman, Burgess Meredith—may also have been seen as a prologue to her time in California. And Uncle Charlie was worried.

A letter arrived for Natalie just a day or so after the court hearing. Living up to his whimsical style, Charlie penned it in rhyme. But as amusing as the letter was, it carried a strong message:

I see that musical wiz Cole Porter
Receives a great many visits from your daughter
And as if she doesn't have enough
She was to visit Romanoff.

A few lines down, he made his point clear, using the example of Oona O'Neill, the eighteen-year-old daughter of Eugene O'Neill who'd just married the fifty-four-year-old Charlie Chaplin:

Tell Betty not to pull an Oona O'Neill
Who certainly must be a heel
Young and beautiful in her prime

She wears a watch that can't keep time
She marries a guy of fifty-four
Who must be a sexual bore
She marries a very brilliant mind
Which dazzled her into being blind.

Betty was clever and savvy about dealing with men, but she was also playing a dangerous game, especially as the stakes got higher. Society might give its blessing to May-December romances (so long as they were between an older man and younger woman, never the other way around), but that didn't mean the families of the girls in question didn't have serious concerns. "Marry for love my pretty one," Charlie concluded his poem, "Marry young and for fun."

Perhaps Charlie had written the letter in response to worries that Natalie had expressed to him. A pattern in Betty's relationships had become clear to her family. The youngest man she'd ever had eyes for was the eight-year-older Kirk Douglas. About her preference for older men, Betty made no attempt to hide or apologize. "I must have been born too late," she wrote a few years later in *Look* magazine, "or they were born too early, or my nose was to the grindstone too young in life and I missed some of the good young ones, but I find the men alive in the world today that capture my imagination were all born at the turn of the century."

Yet for all her trust in her nineteenth-century producer, the summer dragged by without any word from Hawks. Betty had no idea what her first picture would be or whether she'd be playing a lead or a supporting role. She banked her $80 a week, and Natalie took a secretarial job to help make ends meet. What kept Betty busy were the rounds of social engagements that Feldman set up for her. There were gala evenings at Cole Porter's house on Rockingham Avenue, where movie stars mingled with "soldiers who had no place to go," as Betty described them. "I became a regular," she wrote. "I had marvelous times in that house." Despite being a regular, she seemed to have no clue, at least in the beginning, that many of those soldiers stayed around Porter's pool after all the women had gone home for some fun and games with their circumspectly gay host.

There were other parties thrown by the doyenne of hostesses, Elsa Maxwell, where Betty met Evalyn Walsh McLean (and gaped over the

Hope diamond). At one of Maxwell's parties, she was introduced to Robert Montgomery, "one of my heroes," she said. The thirty-nine-year-old actor flirted with her, walked her to her car, a 1940 Plymouth coupe (by that time Betty was driving herself), and asked for her number. She gladly complied, but when Montgomery took the number, he quipped, "Too easy." The ungallant comment seems to have stuck with Betty. In her memoir, she wrote, "It never occurred to him that I might be an innocent virgin who hadn't a clue to what he had in mind." That sounds very disingenuous given her history, but she had every right to be irked by Montgomery's boorishness.

On September 16, Betty turned nineteen, and Elsa Maxwell threw her a party with a cake and a guest list that included McLean, Hedda Hopper, Sir Charles Mendl, and Jean Howard, among others. Maxwell gifted her with gold earrings. Hopper gave "the delightful child named Betty Bacal" a plug in her column the next week. "She's the perfect little minx type," the columnist reported. "Yet our Hollywood wolves howl in vain." How different Betty's life had become since her last birthday, spent in Wilmington, Delaware, in a play that was about to close, working with mostly unknowns. Now she spent her days with the owner of the Hope diamond and a knight bachelor of the United Kingdom, not to mention movie stars and producers.

Finally Hawks called with a part in mind for her—or actually a couple of parts. Betty would test for them both, he'd decide which role she was best suited for. Neither was a leading role, but both were in the same picture, an adaptation of Ernest Hemingway's novel *To Have and Have Not*, which meant that it would get considerable attention. Hawks wanted Humphrey Bogart as the star. Betty would admit to being a bit disappointed that her costar wasn't going to be Cary Grant, whom Hawks had also thought to pair her with. But it was a part in a prestige picture. Betty was more than ready to make her debut.

On a day in October, Hawks brought Betty over to Warner Bros., where Bogart was making *Passage to Marseille*. Betty recalled the enormity of the soundstage, a world of high ceilings, echoing chambers, and red lights flashing above doors that, for all her social whirls in screenland, she had yet to really penetrate. During a break in shooting, Bogart came out to see them. He shook hands with Betty. "There was no clap of thunder, no lightning bolt, just a simple how-do-you-do," Betty recalled.

The star was slighter than she'd imagined after seeing him twelve feet tall on a movie screen. "Nothing of import was said," she wrote. "We didn't stay long." She left the meeting still mooning over Cary Grant. And Bogie, who was about to embark on an extended USO tour of Italy and North Africa with his wife, promptly forgot the young woman he'd met briefly that day at the studio.

Beverly Hills, California, Sunday, December 5, 1943

Betty and her new best friend, "Junie" Vincent, were getting drunk on port. A torrential downpour pounded against the windows of Betty's apartment on Reeves Drive, but the two young women were warm and dry and increasingly giddy as they refilled each other's glasses. Now that she was about to appear in a major picture with a big-name star, Betty apparently found it easier to be friends with Vincent, whose first assignment had been a B picture with Ozzie and Harriet Nelson. The two women also seem to have genuinely liked each other once they had dropped their reserve. With Natalie back in New York to see family and a new beau, leaving her daughter to her new life and her "total preoccupation" with it (Bacall's words), Betty needed a friend to confide in more than ever.

Their night had begun with dinner at a restaurant Betty called "None-Such," and then, holding tight to their umbrellas, they hurried to the Elite Theatre in Beverly Hills, on Wilshire Boulevard at the corner of Doheny. The Elite was a second-run storefront theater, and the feature that night was *Casablanca*, which had first come out a year earlier. Betty had seen the film in New York, and although she remembered her aunt Rosalie being smitten with Humphrey Bogart, Betty's reaction to the leading man had been much less enthusiastic. Now that she was about to appear opposite Bogart, however, she decided to give the picture a second look.

This time, her response was very different. The man up there on the screen was going to be acting with her in a short time. "I died all through it, watching Bogie," Betty wrote to Natalie.

To Have and Have Not was scheduled to start shooting as soon as Bogart returned from his USO tour. *The picture*, in Hawks's and screenwriter Jules Furthman's recalibration of Hemingway, was the story of a lone-wolf, professedly neutral American expatriate who has to save a Resistance fighter from the forces of Vichy France. If that evokes *Casablanca*, that was the point. Hawks and his producing partners at Warner

Bros. saw *To Have and Have Not* as a much worthier follow-up than *Passage to Marseille* had been, and they expected it to be far more successful.

Betty was clearly excited to be playing opposite a star of Bogart's magnitude. Watching him on the screen and imagining herself in Ingrid Bergman's place must have been heady for the nineteen-year-old. But it's important to point out once again that she was not drawn to him, except, perhaps, as one more influential older man who could help her. Betty would repeatedly take pains to make clear that Bogie was not her cup of tea. "I thought he was a good actor, but I never palpitated over him like many a lady did," she said. "He was not the prince on the white horse that I had imagined." In fact, she may at that point still have been interested in Dennis Morgan, though, possibly to appease her uncle Charlie, she was trying to hold him at bay. "Saw Dennis at the commissary on Thursday," Betty wrote to Natalie. "Said a few words to him, that's all."

For the first time, she signed the letter "Lauren." Hawks had decided that "Betty" wasn't sexy enough for the "little minx type" they were promoting. One day at the studio, Hawks told her that her name would henceforth be Lauren. "He wanted me to tell everyone when the interviews began that it was an old family name, had been my great grandmother's," Betty recalled. "What invention!" But Hawks and Warner Bros. (to whom the producer had to sell 50 percent of Betty's contract) had an awful lot riding on Lauren Bacall. After testing for both roles for which she was being considered, Betty learned that she'd won the main female part of Bogart's love interest. After seeing her test, Bogie ran into Betty at the studio and told her that they'd have fun making the picture. She couldn't wait. A year earlier, she'd been depressed, convinced that her career had fizzled. Now she was getting ready to appear in a picture everyone expected to be a smash.

Yet although she segued comfortably into the new way of seeing herself, she never did embrace the moniker "Lauren." She dutifully used the name and repeated Hawks's fiction in the interviews that started after the first of the year 1944. But she didn't like the name and didn't use it herself, nor did her friends. After that one letter to her mother, Betty stopped signing her name as Lauren, except, of course, on eight-by-ten glossies.

The big question at the moment, at least for the studio, was whether Betty would sing in the picture. Her character, Marie, who is trying to finagle a way back to America from Martinique, sings in a nightclub at

one point to earn some cash. There was considerable doubt about Betty's voice among the film's producers. Would her voice have the resonance and depth needed for the scene? Certainly Betty wasn't a trained singer. Accordingly, the casting director, Steve Trilling, wrote to an assistant, "Be sure that we get a good singing voice to dub for Betty Bacall. We should make tests with Lynne [*sic*] Martin [a singer on the Warners payroll] and others, even though it costs a few dollars extra, and J.L. [Warner] would like to hear the voice finally selected." Betty thought she could do it herself, but no one was listening.

Meanwhile, she continued pestering her mother for more clothes. "Please buy me some flannel slacks [a fashion trend Slim Hawks had popularized] and send them out to me immediately with a girdle," she wrote. "Go into Blackton's [on Fifth Avenue] and see if you can get anything out of the guy." After all, she had an image to maintain. One day at the Warners commissary, she sat opposite her "love" Bette Davis. "She glared at me," Betty Bacall told her mother. "Maybe she thought I looked familiar. Ha! Ha!" The minx-in-training apparently didn't want to revive memories of the starstruck kid back in New York.

The Bacall publicity machine began in earnest on March 7, 1944, when the first studio-drafted press release was published in papers belonging to the North American Newspaper Alliance. "When producer Howard Hawks spotted Lauren Bacall's high cheeked face and tall, lithe figure in a fashion magazine ad," the report read, "he wrote to the publication asking her identity and whereabouts. Miss Bacall, told about it, didn't wait to reply. She boarded the first available train and answered Hawks' inquiry in person." The statement went on to say that Miss Bacall "must be a high-powered prospect, even without previous acting experience," since she had been chosen over the studio's "much-prized" Dolores Moran as the female lead, relegating Moran to a supporting role.

A day or so later, production began on *To Have and Have Not* on Stage 12 of the Warner Bros. lot. Accompanied by Hoagy Carmichael, who'd play the pianist in the picture, Betty recorded two songs that Marie was supposed to sing. Although the studio made hay of that, releasing a statement that "newcomer Lauren Bacall" would sing her own songs, Jack Warner wasn't yet convinced. At some point, he had Andy Williams, then a young background singer at MGM, record the songs so that his vocals could be dubbed over Bacall's voice. So completely had Betty changed her voice that it was a man Warner turned to for the recording. Hawks

was against the idea of dubbing Betty, however, arguing that even if her voice wasn't perfect, it fit the character of Marie, who did whatever she needed to do to survive. Not until nearly the end of production would a final decision be made about Betty's singing.

And so, her warbling done, Betty Bacall reported to the set for her first day of filming, the fulfillment of her dreams of the past four years. "First-day jitters are observed on Stage 12 at Warner Bros.," the columnist Harold Heffernan reported. "A lovely young newcomer is facing the camera for the first time. It's the debut of Lauren Bacall, former New York model, as leading lady for Humphrey Bogart in *To Have and Have Not*." Heffernan was on the set to observe Hawks talking quietly to Bacall before the first take. "She really doesn't have much to do in this introductory scene," the columnist wrote. "Just walk out of a door into a hallway, see Bogart, and ask, 'Have you got a match?'" Bacall got "through it with what appears to be superb assurance," Heffernan wrote. Hawks okayed the take. While the crew set up the next shot, Bacall turned her eyes to her costar. Slipping the unlit cigarette "between her lips with trembling fingers," she asked Bogart, "Have you got a match?"

The game was on, even if neither of them really knew it yet.

THE FIRST THING HAWKS NOTICED WHEN BETTY STEPPED IN FRONT OF THE camera was her insolence. The precocious, crafty New Yorker came through in her very first take. This was no innocent ingenue, just off the bus from Peoria. This was Betty Bacall from Brooklyn, and she knew how to handle men and get them to do things for her. "We noticed a kind of funny little insolence about Bacall that was attractive," Hawks remembered. He turned to Jules Furthman and said, "Wouldn't it be fun if we could make a girl more insolent than Bogie?" Bogart was "the most insolent man on the screen," Hawks said. But this dame could not only hold her own with him but, if Hawks had anything to say about it, could sometimes outwit him.

Hawks gave himself credit for having discovered Bacall's insolence. He told a story about how she would come to his house for parties and never be able to get a ride home, leaving the producer to shuttle her back to Reeves Drive. "I don't do too well with men," Betty supposedly told him, despite all the evidence to the contrary. Hawks asked her how she dealt with men. "I'm as nice to them as I can be," she replied. Hawks

asked her to try a different tack. "Try insulting them and see what happens." According to the story, Betty got a ride home at the next party after asking one man where he'd gotten his necktie; when he asked why, she said, "So I can tell people not to go there." Hawks finished off his story by claiming that the man was Clark Gable. Hawks's publicity people were quite ingenious at storytelling.

The director may have encouraged her insolence, but the attitude came naturally to Betty. A woman didn't spend the better part of four years cajoling and flirting with men without learning how to handle them. Sometimes a bat of the eyelashes would do; other times, a wry comeback did the trick. Betty didn't become the Lauren Bacall of legend in a sudden transformation engineered by her producer-director. Hawks could claim credit for the name, but not for the persona. The agency was entirely Betty's. Publicity for *To Have and Have Not* claimed Betty had "had very little to do with her own success and was plucked from nowhere by an accident of fate." In fact, Betty brought to the creation of her screen image everything she'd learned, experienced, and endured from older, powerful men in audition halls, on provincial stages, in dressing rooms, and in hotel suites.

The "superb assurance" that came through to the camera did not erase her vulnerability, however. On the set, Betty was nervous, her head and hands trembling. After a few takes, she realized that she could control her quivers by keeping her head down, almost to her chest, with her eyes looking up at Bogart. "It worked," she recalled, "and turned out to be the beginning of 'The Look.'" Actually, "The Look" had already been created in the February issue of *Harper's Bazaar* and reappeared in Betty's first photo shoot for Hawks. For the legend, however, it worked better to date it to Betty's first time in front of the camera. She knew full well what that pose did for her. "An insinuating pose" *Life* magazine called it, in which her "rather Slavic eyes gaze obliquely and suggestively from beneath wicked-looking eyebrows."

After a few days of shooting, Betty wrote to Natalie, "The picture is as wonderful as ever. In fact, even more so. Howard seems very pleased. Hope it continues."

What Betty didn't tell her mother was how leery of her director she'd become. Though she appreciated his guidance on the set, his insistence that she not fraternize with the crew disturbed her. He instructed her to sequester herself in her dressing room between takes. "He wanted me

in a cocoon," Betty wrote, "only to emerge for work." Meanwhile, Bogart could "fool around to his heart's content," Betty complained, but that was because "he was a star and a man."

Even more troubling for Betty, Hawks's anti-Semitism became undeniable once the picture started shooting. One day in the commissary, he complained of the noise level in the room after Leo Forbstein, the studio's musical director, walked in. "Jews always make more noise," he grumbled to Betty, who felt her face turn white. "Howard," she said, "had very definite ideas about Jews, none too favorable, though he did business with them. They paid him—they were good for that." Yet she said nothing in response. "When the time came, what would happen would happen," she reasoned, "but I had no intention of pushing it."

What made it all bearable was Bogart. The actor, twenty-five years her senior with nearly fifty movies under his belt, was a kind and reassuring presence. Seeing how nervous Betty was, he tried to joke her out of it. "He was quite aware that I was a new young thing who knew for nothing and was scared to death." He never pressured her or took liberties. "He was not even remotely a flirt," Betty said. "I *was*, but I didn't flirt with him." She'd met his wife on the first day of shooting. Bogie had seemed protective of her. There were no heart palpitations between Bogart and Bacall. Not yet.

During the first weeks of shooting *To Have and Have Not*, Bogie and Betty were pals, kidding each other, making dry asides about the people who irritated them. "We rolled our eyes over the same sort of pretentious snobs," Betty said. They shared a similar dry sense of humor. He called her "Baby," not so much as a nickname but as part of his usual parlance. "He addresses men as 'junior' and women as 'baby,'" noted a writer from *Life* magazine.

When it was announced that Bogart's name would be above the title and Betty's below, Natalie objected in a letter to her daughter that the star was being unfair. But Bacall would tolerate no criticism of Bogie. "You make me so goddamn mad," she wrote to her mother. "What the hell difference does it make? As long as when the public sees the picture, they know that I'm the one playing opposite Bogart." For good measure, she added, "Bogie has been a dream man. We have the most wonderful times together. We kid around—he's always gagging—trying to break me up and is very, very fond of me." As for her own feelings: "I'm insane about him."

That suggests she may have started to have feelings for her costar. But she had feelings for someone else, too: One day in April, Hawks brought Paul Lukas, now working on the Warners lot, to see Betty in her dressing room. Almost at once, Betty's interest was rekindled. "He looks wonderful and we had a gay afternoon," she reported to Natalie. "Between Bogie and Paul, I was a wreck." That's the first indication we have that Betty's feelings for Bogart were beginning to blossom beyond friendship, even if at first she was torn between him and someone else.

Around the same time—three weeks into the picture, Betty recalled—something happened to clinch her feelings. At the end of a long day of shooting, Betty sat in her dressing room combing her hair. Bogie popped his head in to say good night. "We were joking as usual," Betty wrote, "when suddenly he leaned over, put his hand under my chin, and kissed me." It was an impulsive move, she said: "He was a bit shy—no lunging wolf tactics." Bogie fumbled a pack of matches from his pocket and asked if she'd write her phone number on it. "I did," Betty wrote. "I don't know why I did, except it was kind of part of our game."

It was a game that Betty Bacall was very good at. But even she, with all her imagination, smarts, and ambition, could not have foreseen her future. The dreams she'd carried with her for the past decade would be nothing compared to what was about to come.

PART IV

BOGIE AND BABY

1944–1957

Los Angeles, Thursday, March 2, 1944

To keep back the usual throng of movie fans standing ten deep in front of Grauman's Chinese Theatre, security guards had had to rope off a passage through the forecourt for the stars attending the sixteenth annual Academy Awards. Greer Garson, Charles Coburn, Jennifer Jones, and Rosalind Russell made their way toward the entrance of the theater, and the crowd cheered each in turn. Every few minutes more celebrities arrived, limos pulling up at the curb, spectators' necks craning to see who stepped out of the car. A huge roar erupted when Humphrey Bogart, in a natty pin-striped suit, and his wife, Mayo Methot, arrived. Methot wore gardenias in her hair and a full-length mink coat. Cameras popped, newsreels whirred. The fans went wild.

Bogart had been nominated for Best Actor for *Casablanca*. It was his first nomination, after being snubbed twice for *The Petrified Forest* and *The Maltese Falcon*. He would later insist that he hadn't been expecting to win that night. Even if that was true, there was likely some tiny hope in the back of his mind. Winning an Oscar would be the affirmation he'd long been seeking. He and Mayo took their seats and applauded the performers who took the stage, including Lena Horne, Edgar Bergen and Charlie McCarthy, and Ray Bolger. As it was wartime, the stage was packed with men and women in uniform, arranged as a backdrop on a ten-tiered bleacher. At the end of the ceremony, a giant American flag descended from the rafters.

When, toward the end of the night, George Murphy announced the winner for Best Actor, it wasn't Bogart. Paul Lukas had beaten him to the gold, winning for the film adaptation of his stage success *Watch on the Rhine*. There was some consolation in the fact that *Casablanca* took both Best Screenplay and Best Motion Picture. But Bogie was likely vexed by the way Jack Warner elbowed Hal Wallis aside so he could collect the latter award himself.

He might have lost the Oscar, but the annual Quigley poll had

included him among the top ten box-office stars for two years in a row. Though he had come in at number seven, the amount of fan magazine attention he got was higher than that of many of those above him. *Life* declared Bogart to be "the most popular motion-picture actor in the U.S." in 1944.

In many ways, Bogie had achieved what he'd been looking for when he'd been in his twenties, even if back then he'd had only the vaguest idea of just what that was. By the start of 1944, basking in the glow of a very successful tour supporting the troops, Bogie was at his peak. As his mail demonstrated, few stars generated the sort of passion his fans had for him. Against all odds, the struggling, cynical, homely, second-rank bad guy of the 1930s had become, less than a decade later, the greatest of stars.

But if he'd once imagined that would bring him happiness, he was mistaken. In early 1944, there was still plenty for Bogart to feel dissatisfied about. For one thing, he wasn't sure about the new picture with Howard Hawks, which began shooting soon after the Oscar ceremony. The story had never excited him, and he found the script to be rambling. Of course, he had felt the same way about *Casablanca*, and look how that had turned out. But *To Have and Have Not*, to Bogie's mind, was a pale rip-off of the earlier film. There was very little that was original in Jules Furthman's script, although William Faulkner, brought in to fix things up, managed to endow the script with some effective mood and characterization. Bogart admired Faulkner; he believed he could make a difference on the film. But that didn't change the fact that *To Have and Have Not* was, at its heart, a second-rate *Casablanca*. Once again, Bogie rued his lack of contractual script approval. This time, he'd also be flying without his usual supporting crew of Rains, Greenstreet, and Lorre.

But his biggest concern was the director, who was also the producer of the film. Hawks would carry more authority than Bogie was used to from directors, with even Jack Warner, at least nominally, being his equal. Bogie had no doubts about Hawks's ability as a director. He was one of the best. Still, nagging fears about Hawks's autocratic tendencies simmered under the surface. "I wasn't sure I trusted him," Bogie said plainly.

Once filming got under way, he also didn't like the way the director controlled the inexperienced leading lady, Lauren Bacall, sending her to her dressing room between takes. The young woman waited on his every word and seemed in awe of the director or perhaps frightened of him.

Hawks did nothing to assuage her nerves, despite *To Have and Have Not* being her first film. Feeling compassion for her, Bogie attempted to fill that void. He joked with her, made her feel at ease, helped her find her light and hit her marks. Bacall was a very pretty young woman, but at nineteen, she existed in a world far outside his own. She hadn't even been alive when Bogie had first stepped onto a stage in Newark, New Jersey.

Bacall (Bogie quickly learned that she preferred to be called Betty, not Lauren) was playing a drifter with whom Bogie's character, Harry Morgan, falls in love. Unlike Ingrid Bergman's Ilsa in *Casablanca*, however, Bacall's Marie Browning isn't integral to the plot. She doesn't make things happen and plays a very limited role in the rescue of two French Resistance fighters, which was the backbone of the film's story line. She's only there to give Morgan a love interest and to sex things up a bit. In the end, Morgan escapes Vichy-controlled Martinique with her.

But the plot was far less important than the love story. *Casablanca* had managed to have both an exciting, suspenseful plot and a heart-breaking, satisfying love story. *To Have and Have Not* wasn't so lucky, so Hawks wisely shifted the emphasis to the relationship between Morgan and Marie. Everything hinged on audiences becoming invested in their love affair.

To help it along, the relationship between the leads was deepened and expanded. Someone suggested that they have pet names for each other. It was decided that Morgan would call Marie "Slim," in homage to Mrs. Hawks, and Slim would call Morgan "Steve," a nickname Hawks had been given by his wife. Finding the chemistry between Bogart and Bacall would be essential.

Bogie was aware that his leading lady looked to him for cues on how to act. "Bogie had a lot of power," said Joy Barlow, an extra on the film. "He had a lot of know-how about cameras and angles." The neophyte Bacall watched him closely, especially when he objected to the script on her behalf. "Is that really necessary?" he'd ask Hawks. "Could we eliminate this?" Barlow noticed that Bogie sometimes would even "block himself out to get her right."

He'd been doubtful when Hawks had suggested making Bacall as insolent as he was. "Howard, you've got a fat chance of doing that," Bogie said. But the director wasn't deterred. "She is going to walk out on you, leaving [you] with egg on your face," Hawks insisted. Bogie laughed but conceded, "I wouldn't want to bet that you're not going to do it."

He was convinced after seeing Bacall's screen test. Playing opposite the studio contract player John Ridgely in Bogie's part, Betty had been given dialogue that established her character. The scene itself was not in the script. In the test, she seductively tells Ridgely that if he needs her to just whistle. Bogie was floored when he saw the scene, with all its raw sexual power and double entendre. He and Hawks agreed that it should be in the film.

Four weeks into production, the director shot the scene for real. With the cameras rolling, Bacall turns back before leaving Bogart's room. "You know you don't have to act with me," she says. "You don't have to say anything, and you don't have to do anything. Not a thing. Oh, maybe just whistle. You know how to whistle, don't you, Steve? You just put your lips together and blow." The chemistry between them combusted.

"The way they did that scene," said Dan Seymour, who played the Vichy policeman Captaine Renard, "we knew things were happening [between them]." That's the impression given by most chroniclers. For the Bogart and Bacall legends, dating the commencement of their romance to that iconic, well-remembered, and often quoted scene proved to be irresistible. Bogie and Bacall fell in love at the same moment as Steve and Slim did.

For once, the legend may have some truth. The whistle scene was shot around the same time as Bacall was writing to her mother about being a wreck with both Bogie and Paul Lukas around. So even if the scene wasn't the catalyst for the romance, it likely does reflect the budding attraction between Bogart and Bacall.

Still, Bogie remained guarded. If he had romantic feelings for Betty, they were likely filed away as transient and unobtainable. He'd never chased after his leading ladies, after all, which set him apart from many of his peers. He was also notoriously faithful to his wives, at least up until recently, when, in the worsening situation with Methot, he'd been seeing both Helen Menken and Pete Peterson. Some might argue that given those relationships, he'd become comfortable with a little adultery on the side and therefore set his sights on Bacall. But that doesn't sound like Bogie. Menken and Peterson were mature, nonthreatening figures with whom he could relax and be himself. The pressure was off the performance. Bacall, however, was a nineteen-year-old beauty with big dreams. Bogie had very little experience with younger women (twenty-five years separated him from Bacall). It's hard to imagine him suddenly

pursuing a teenager whose expectations of him were likely going to be sky high.

The final reason for Bogie's unhappiness in the spring of 1944 was his rapidly deteriorating home life. All the good feelings from their USO tour evaporated once Bogie and Mayo were back home and their old routine began again. Photos and newsreels of the Oscar ceremony reveal the tight smiles and underlying tension between husband and wife. For solace, Bogie continued to retreat to the refuge Pete Peterson offered in her little house in Burbank. He often showed up unexpectedly in the middle of the night. Many a night they stayed up talking and drinking loudmouths until dawn. Sex was not always part of it. But Bogie's anxiety over his wife, his guilt, and the strangulating sense of responsibility he felt for her were always present.

With Mary Philips, Bogie had resisted the idea of divorce for many months before finally becoming amenable to it. The same thing occurred now with Mayo. For so long, he'd been unwilling to think about ending the marriage, partly because of his fear of what Mayo might do to herself. But Pete remembered the topic of divorce coming up during their late-night talks and, inevitably, about what might happen afterward. "Bogie always said we'd make a perfect couple because we were so much alike," Pete wrote. Bogie would "needle" her about divorcing her husband if he divorced his wife. No promises were made by either of them, but the idea of divorce and remarriage had now been spoken out loud.

And then, one night on the set, he kissed his young costar in her dressing room. He even asked for her number. All we can be sure about Bogie's motivation for doing so is that he was desperately unhappy, seeking affirmation and consolation wherever he could. Kissing a costar wasn't part of his usual playbook. But something about Betty Bacall seems to have made him take a chance.

WATCHING BOGIE ACT, BETTY WAS SPELLBOUND. THE ON-THE-JOB TRAINING WAS revealing to her all the nuances, details, and practical realities left untaught by the Academy of Dramatic Arts. The technique she'd use for her entire career—her fundamental understanding of her craft and style— was forged on Stage 12 while observing Bogart in the spring of 1944. "Bogie's approach to work was always totally professional," she said. "He did not take himself too seriously, I mean, to the point of too much. He

didn't over-analyze. That was not the kind of actor he was. He wasn't one to delve, delve, delve deeply into a thing." But that shouldn't imply that he wasn't serious about his work. "He was never kidding around before a scene," Betty recalled. "He was concentrating on what he had to do. He had tremendous respect for the profession of acting, and he could not bear people that did not have equal respect for actors, such as Jack Warner. He thought it was a profession to be proud of."

Bogart's attention to his craft dated back to his days on the stage. Though he didn't often opine about acting technique, on the occasions he did so, Betty listened. "There's an awful lot of bunk written about acting," Bogie said. "But it isn't easy. You can't just make faces. If you make yourself feel the way the character would feel, your face will express the right things." Acting was about getting inside a character: how he or she walked, opened a door, held one's hands. The best actors understood that philosophy, he said, citing his top three: Spencer Tracy, Clifton Webb, Jimmy Stewart. Yet in truth he was easily their equal.

Betty couldn't have asked for a better acting mentor. Bogie was patient with her. He was willing to show her how things were done. The hero worship she'd once held for Hawks was transferred over to Bogart. By the time of the whistle scene, they were in complete symmetry, their dialogue easy and natural. No surprise that Betty was so quickly smitten.

Bogart was different from the men she had known in New York. She had chased them down on the street or finagled her way into their dressing rooms, but Bogie, for all his friendship and support on the set, remained off limits. Their flirtations ended when Hawks called the final "cut" of the day. Betty found herself unable to press her advantage the way she'd done with her mentors back east.

Was she falling in love with him at that point? It's hard to say, but we should remember that when an older man showed interest in her, she latched on, wanting to see him as often as she could. That, of course, was impossible with Bogie, who went home every night to his wife. But then had come the kiss. What did he mean by it? He started calling her at 11:00 p.m. just to talk. The met for lunch at the Lakeside Country Club. Suddenly it seemed that Bogie might be seriously interested in her. Still, Betty dared not think too much about it.

He was, after all, a married man, and his marriage was a cherished part of Hollywood lore. The Battling Bogarts still made for great copy. "There are just two moods in the Humphrey Bogart–Mayo Methot home

life," the columnist Jimmie Fidler wrote as *To Have and Have Not* got under way, "happy and scrappy." Everywhere Betty looked, she would have seen evidence of a tempestuous but well-entrenched marriage that wasn't going away. Warner Bros. had just released a short with Bogie and Mayo promoting the American Red Cross. In newspapers and magazines and on the screen, Americans saw a couple that might be hot-tempered but were nonetheless devoted. Fidler wrote that their fans should take inspiration from the Bogarts' "scrappily enduring" marriage. Despite their famous brawling, the columnist reported, the "Bogarts' system works."

Just as *To Have and Have Not* wrapped, *Life* ran a major profile of Bogart. The piece, by George Frazier, a highly regarded journalist, agreed that the Bogarts' marriage was uniquely successful. "Both are unpretentious and their pleasures simple and childlike," he wrote. "Whatever free time they have is spent aboard their cruiser, *Sluggy*." Mayo, interviewed along with her husband, told Frazier that they had been saving their money: "In five years we're going to retire and become beachcombers. That is, if Pa can keep his hair and teeth that long." Betty would have gotten the impression of a marriage, for all its irregularities, that had no danger of ending.

Still, the connection between Betty and Bogie grew. Betty remembered him sitting in her dressing room "with the door open," talking with her about all sorts of things. She'd cheer for him when he played chess on the set, standing as close to him as possible. "Physical proximity became more and more important," she wrote. In one scene, on Bogie's urging, Betty ran the back of her hand up his unshaven face and then gave him a playful slap. "It was a most suggestive and intimate bit of business, much more so than writhing around the floor would have been," Betty wrote. It also allowed them to conduct a little foreplay in plain sight.

Hawks was growing uneasy about the relationship between his two stars. Lauren Bacall, after all, was his discovery. She was to take her marching orders from him and nobody else. He collared Bogie and told him not to get serious about Bacall: "Take her downtown and get a room with her—that's enough." Bogie's reply has gone unrecorded, but it's hard to imagine his not wanting to punch Hawks in the nose.

One night near the end of production, Hawks summoned his protégée to his house. As Betty would recount, the director-producer coldly upbraided her. In her memoir, she quoted what he said at length, although it seems unlikely she could have remembered his words verbatim after

thirty-five years. Still, this is the version she gave of Hawks's tirade: "When you started to work, you were marvelous, paying attention, working hard. I thought, 'This girl is really something.' Then you started fooling around with Bogart." Hawks told her that she meant nothing to her costar, that he was just using her. If she persisted in the dalliance with Bogart, she would be "throwing away a chance anyone would give their right arm for." Hawks threatened to wash his hands of her and sell her contract to Monogram, the lowest of the so-called Poverty Row studios. Betty began to sob. All her dreams could be gone in the blink of an eye. Through her tears she promised that she would do as he instructed.

Hawks's insecurities and his tendency to bully are revealed plainly in that story. The rumor was that he had been planning to make a move on Betty himself. Certainly, he had the reputation for doing so with other actresses, and it's not an improbable theory. But it seems likely that it was mostly about ego. Hawks was threatened by Bogart's influence over "his creation," as Meta Wilde called Betty. "He trained her and gave her the right to a career," as his secretary described his attitude toward her. Hawks had enjoyed playing God to Betty. Now he could feel her deification of him fading away. That would never do for a narcissist like Howard Hawks.

Despite her fears, Betty confided to Bogart about what had happened. He reassured her that Hawks would never send her to Monogram, that she had become too valuable with all the buildup she'd been given. "He just can't stand to see your attention diverted from him," Bogie explained. "He's jealous."

Yet Hawks, for all his petty cruelty, may have had a point when he said that her costar was using her, even if Bogie's intentions were not, as the director implied, malicious. Bogie didn't mean to be callous. He didn't want to hurt Betty. But he was a forty-five-year-old, unhappily married man unable to resist keeping company with a nineteen-year-old, single, largely inexperienced woman. He had to be aware of how easily he could lead her on. In her memoir, Betty would offer no concerns or reappraisals of Bogie's actions during that period. But at nineteen, she was dreaming about love, while Bogie had largely given up on the idea. He was, in any scenario, playing with fire.

Of course, by the time she wrote her memoir, Betty was polishing the legend of Bogie and Bacall, and it would not have done their image any good if she'd reflected about any improprieties in Bogie's courtship. It's

not that her version of the Bogart-Bacall love story is necessarily untrue. Age doesn't have to matter in a relationship; love is love. But what Betty never acknowledges is the significant power differential between them. A conflicted, often unstable older man held her heart in his hands. And despite her resilience and survival skills, her entire future would be affected by what he did with it.

To Have and Have Not wrapped on May 10, 1944. Betty wasn't sent to Monogram, and her relationship with Bogie, much as Hawks had predicted, seemingly came to an end. At the wrap party, Bogie gave Betty a gold charm bracelet with her name on one side and THE WHISTLER engraved on the other; a tiny whistle was attached. Giving tokens of gratitude to the cast and crew was standard practice for the star of a picture. But for Betty, the gift was much more than a token. At the end of the day, she walked Bogie to his car and waved as he drove away. "The emptiness when he left!" she recalled. "It was hell." Her resourcefulness usually allowed her to find a way forward, to get what she wanted, but here she had no options, unable to call Bogie at home and unaware of when she might see him again. All she had left was the gold bracelet on her wrist.

OUT AT SEA, BOGIE COULD THINK. MOORED IN NEWPORT BAY OFF THE COAST of Balboa Island, he had the time and the quietude to reflect on his life, both professional and personal. His state of mind at that juncture isn't as transparent as Bacall's. He wrote no memoir, and his interviews are, for the most part, circumspect. What we know was vexing him at the moment was his never-ending battle with Warner Bros. Once again, he'd been assigned a script he felt was inferior—*God Is My Co-pilot*, in which he'd play an army air force bomber pilot—and once again, instead of following orders, he had walked out and taken refuge on his boat. Steve Trilling dashed off a memo to Jack Warner: "Our pal Bogart doesn't think *God Is My Co-pilot* is big enough for him. Apparently, he'd rather play the co-pilot." Warner told Trilling that he was "sick of these ungrateful pups annoying my indigestion."

Bogie's complaints were not, as the studio execs implied, the ravings of an egocentric star. Being directed by Robert Florey, who was known for making B pictures, was unlikely to have enthused him. He may also have had objections to the religiosity of the film, which was based on the spiritually inspiring memoir of a real-life army pilot. Bogie's impatience

with pious sentiment was well known. Finally, he was peeved that the studio had continued to ignore his requests to develop a picture about the USO's efforts to support the troops. Before departing on *Sluggy*, he'd made sure to let the press know that what he really wanted to do that summer was go back overseas for another tour, this time with better material. He just could not see himself committing to another four months on a stuffy soundstage in Burbank, especially in a substandard project.

Bogie's desire for another transatlantic sojourn at that point is significant. If he'd fallen for Bacall the way she'd fallen for him, would he have wanted to spend the next third of a year five thousand miles away from her? Maybe, in fact, he would have, as a way to keep the situation from getting out of hand. His feelings about Betty can be surmised from a letter he sent her during those weeks. "I know what was meant by 'to say goodbye is to die a little,'" he wrote, "because when I walked away from you that last time and saw you standing there so darling, I did die a little in my heart." He signed the note "Steve."

After reading the letter, Betty dashed out a reply and drove it all the way down to Newport Beach to the Coast Guard station where Bogie reported for weekend duty. Bogie's notes to her, charily excerpted in her memoir, sometimes contain professions of love ("Slim darling, you came along and into my heart and all the real true love I have is yours") and other times reveal his deep ambivalence about the relationship ("I feel that I'm not being fair to you. . . . I'd rather die than be the cause of any hurt or harm coming to you").

The truth was that as he wrote those letters, Mayo was with him on the boat, making his meals and fixing his drinks. One columnist noted, "There you will find Mayo busily engaged with a four-burner shipmate preparing meals for Humphrey's fabulous appetite whetted by sea air." Bogart had begun thinking about divorce, but it was still unclear whether he had the stamina to go through with it. It was equally unclear where he saw Betty in his life should he divorce Mayo. Was he consoling himself from his marital unhappiness by leading on a young woman who was besotted with him? Or had he started thinking about a life with her?

It's notable that during that same period Bogie began pushing Vera Peterson to divorce her own mate. Pete replied that she couldn't claim cruelty or desertion in a divorce case against a husband who was serving his country. Still, she wrote, Bogie kept pressing the idea and spent as much time with Pete as he could. If that was all true, was it Pete whom

he imagined himself with post Mayo? Given his insecurities, Pete would have been the safer choice.

In his letters to Betty, or at least in the excerpts she shared, Bogie comes across as a lovesick swain, aching to be with her. But he was also a forty-four-year-old man feeling the encroachment of middle age. The attentions of a teenage beauty must have been gratifying. Humphrey Bogart rarely got the pretty girls in real life. He'd been so faithful to his wives that he'd never really had the experience of sustained sexual flirtation, especially not with a young woman who was poised to be Hollywood's next love goddess. It must have been a heady experience. Understanding this, it's easy to see him as having second thoughts about letting Betty go, the way he had tried to do when their film ended. At the same time, he was conflicted over the ethics of it all. Either way, Betty was in line to have her heart broken, and that was precisely what gave Bogart pause.

If they had been closer in age, the situation might have been very different. Two young people in love, equally wide-eyed and smitten, have a world of possibilities ahead of them, even if one is (unhappily) married. Whatever challenges they face, true love tends to win out. Bacall would do her best in her memoir to present their courtship in exactly that way, as lovers yearning to be together and needing only to be patient until that could happen. In 1978, she may have chosen to downplay the implications of the age difference, but at the time Bogie was very aware of it, and of the risks it entailed. At one point, he wrote to her, "Slim darling, I wish I were your age again—perhaps a few years older—and no ties of any kind, no responsibilities. It would be so lovely, for there would be so many years ahead of us instead of the few possible ones." He understood that they were playing with dynamite, and it scared and confused him.

Bogart's turmoil during the summer of 1944 hadn't just suddenly appeared. From the moment he'd returned from Europe the previous February, he'd been increasingly discontent, finding his adjustment to everyday life difficult after the highs of the trip abroad. Despite his affection for Betty, shooting *To Have and Have Not* hadn't been a happy experience, with his dissatisfaction with the script and his distrust of Hawks rising with every passing week. He remained frustrated by his contract. He'd fully expected the studio brass to hand him a second-rate picture after finishing this one, and they had, right on cue. He'd had enough.

Most of all, however, his distress came from his marriage. The fights,

the drinking, Mayo's resentments (and Bogie's, too) were now out of control. More and more, Bogart was spending his nights, when not on his boat, with Pete Peterson. He was flailing about, looking for a lifeboat, imagining marriage to Pete while yearning for Betty at the same time. He'd possibly never been more conflicted. "For a time there, I had no idea of which way I should go," he said a year later, referring to that period. There was so much left unsaid in that statement. Should he divorce Mayo? Marry Pete? Pursue Betty? With Betty, he seemed damned if he did and damned if he didn't. If he took up with her, he might hurt her, and if he didn't, he would surely wonder about it for the rest of his life.

As usual, he took comfort from a bottle. During this period, as the troubles with Mayo intensified, Bogie was barred from several establishments on the Sunset Strip for getting into fights and drinking until he couldn't stand. The producer Mark Hellinger, a friend of Bogie's, would describe to a journalist how he'd taken the actor to a gambling club. The man at the peephole, spotting them, had immediately locked the door. "Bogart is banned," Hellinger was told. "Creates disturbances." Hellinger relayed the story in a humorous way, one good old boy needling another. Causing disturbances was, after all, what good old boys were supposed to do. The journalist used the anecdote in like fashion as a demonstration of lovable incorrigibility in a fawning profile of Bogart. Such a perspective, however, ignores the harm that Bogie's alcoholism was doing to others, to others' properties—and to himself.

What all this reveals is a deeply conflicted man, one who, even after having achieved so much, still could barely contain the rage and discontent. In her introduction to Joe Hyams's biography of her husband, Bacall would position Bogie's pugnacity as something admirable, insisting that "the balloons he pricked were always overblown." But Pete Peterson, who was usually Bogie's partisan on other topics, had a very different perspective on what she saw as his bullying. "He was either perfectly charming or totally belligerent," she said. His belligerence, she added, "was never against somebody who was either bigger or stronger or more mentally powerful." He might go after Jack Warner, but he always ultimately backed down, which wasn't the case with others who got in his way. Peterson remembered his taunting the actor and screenwriter Allen Vincent, who, she said, was "kind of delicate and homosexual." Bogie teased and goaded him, "becoming frustrated when Vincent wouldn't take the bait."

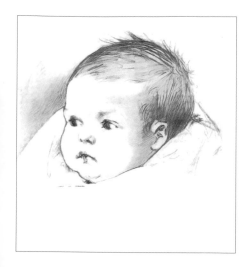

Maud Humphrey Bogart often drew her son and herself, but that was about the extent of their intimacy. *Below*: Maud and Humphrey's father, Belmont DeForest Bogart. *Author's collection*

Humphrey as the upper-class Andover student and the college dropout who joined the Navy during the last months of World War I. *Verita Thompson Collection*

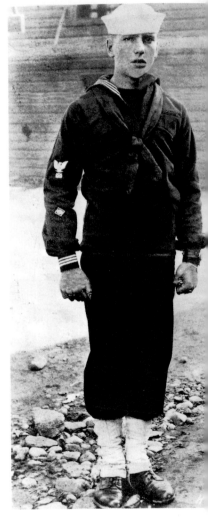

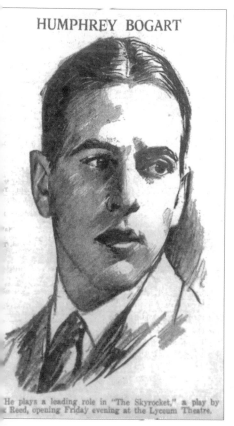

HUMPHREY BOGART

He plays a leading role in "The Skyrocket," a play by
Reed, opening Friday evening at the Lyceum Theatre.

The young Humphrey was a handsome
matinee idol on Broadway. *Author's collection*

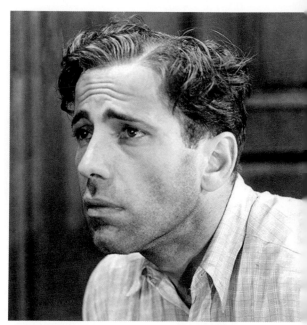

Bogart's breakout role was in *Cradle Snatchers* (1925). He would spend
years living down the part of the suave, flamboyant José Vallejo. *Author's
collection*

Helen Mencken was Bogart's first wife. The newspaper shot of their wedding would seem to dispel notions that Helen was miserable. *Margaret Herrick Library; author's collection*

With his second wife, Mary Philips, Bogart lived through some lean years, when the couple had to resort to vaudeville to survive. *Author's collection*

YONKERS' GREATEST AMUSEMENT VALUE

PROCTORS

'BIG SHOWS LOW PRICES'

TODAY CONTINUOUS 1 TO 11 P.M. A FURORE OF HILARITY

ON THE SCREEN—A PICTURE YOU'LL TALK ABOUT

"The Shopworn Angel"

WITH

NANCY CARROLL
GARY COOPER

A Paramount Picture

PATHE NEWS—SPEAKS

5 BIG VAUDEVILLE ACTS

— PRESENTING —
THE BROADWAY LEGITIMATE STAGE STARS

HUMPHERY MARY

BOGART & PHILLIPS

IN WILLIAM E. BARRY'S "THREE ROUNDS OF LOVE"

THE RADIO AND RECORDING ARTISTS
GLEN & JENKINS
IN "WORKING FOR THE RAILROAD"

WALL & DEEDS | FAYNE & DI COSTA
"SIMPLE SIMON'S SISTER' | "LOTS OF MELODY"

THE SEASON'S OUTSTANDING NOVELTY
BLOMBERG'S ALASKANS
FIRST AND ONLY TROUPE OF TRAINED ALASKAN DOGS

Bogart in the role that made him famous: Duke Mantee in *The Petrified Forest*, first in the Broadway production (1935) and then in the film (1936). *Margaret Herrick Library*

Bogart's first romantic role, opposite Bette Davis in *Dark Victory* (1939). *Author's collection*

Bogie was very happy with his third wife, Mayo Methot, until he wasn't: lots of laughter with friends at the Trocadero in 1938 but forced smiles at the Oscar ceremony in 1943. But Maud Bogart adored her daughter-in-law, leaving her a heart-shaped locket upon her death, along with the note below. *Author's collection; Mayo Methot Collection*

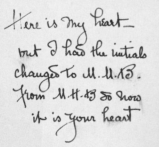

Here is my heart—
but I had the initials
changed to M. M. B.
from M. H. B. So now
it is your heart

Bogie becomes a top-rank star: *High Sierra* and *The Maltese Falcon*, with Peter Lorre, Mary Astor, and Sydney Greenstreet. *Author's collection*

The magic of *Casablanca*: Dooley Wilson, Bogie, and Ingrid Bergman. *Author's collection*

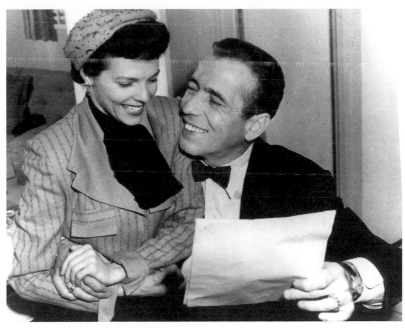

For more than a decade, Bogie's hairstylist Verita "Pete" Thompson offered intimacy and a safe harbor. She was convinced he was going to marry her. *Verita Thompson Collection*

Betty Bacal's high school yearbook photo is adorable but looks nothing like Lauren Bacall. *Author's collection*

For her father, William Perske, Betty had nothing but vilification, and for her mother, Natalie Weinstein-Bacal, nothing but adulation. *Lilly Library, Indiana University*

Harper's BAZAAR

March 1943

AMERICAN RED CROSS

OR SERVI

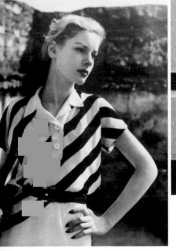

SPRING FASHIONS

Betty Bacall makes a name for herself, first as the winner of the Miss Greenwich Village pageant and then as a model for *Harper's Bazaar. Author's collection*

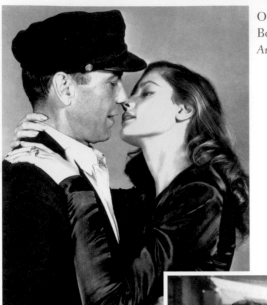

Overnight stardom and a legend is born: Bogie and Bacall in *To Have and Have Not*. *Author's collection*

More than any other director, John Huston (*below*), conferring with Bogart and Bacall on the set of *Key Largo*, was responsible for Bogie's stardom. *Margaret Herrick Library*

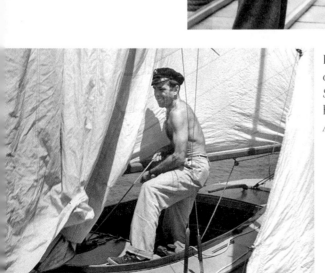

Betty was sometimes jealous of Bogie's attention to his boat, *Santana*, where he was more at home than anywhere else. *Author's collection*

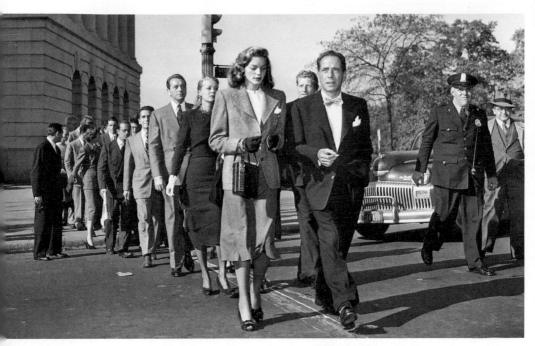

In 1947, Betty and Bogie took a courageous, if professionally risky, trip to Washington, leading a group of fellow actors, writers, and directors in opposition to the House Un-American Activities Committee. *Author's collection*

As Charlie Allnut in *The African Queen*, Bogie won an Oscar and beat back questions about his patriotism. *Margaret Herrick Library*

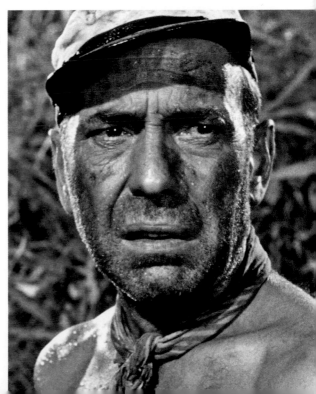

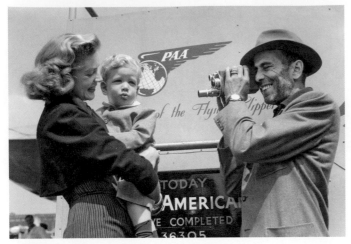

Betty and Bogie are reunited with their son, Stephen, after more than four months, part of which was spent in the Congo making *The African Queen*. *Author's collection*

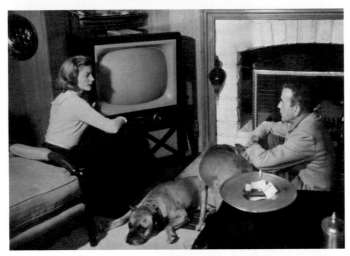

The Bogarts at home with their two boxers and the box that terrified the Hollywood movie studios. *Author's collection*

As leaders of the original Rat Pack, Bogie, Bacall, and Frank Sinatra were often together; after Bogie got sick, Betty was seen with Frank on her own. After Bogie died, Bacall thought she and Sinatra would get married. She was wrong. *Lilly Library, Indiana University*

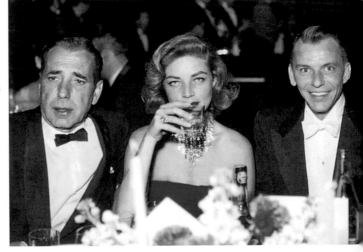

Instead, Betty married
Jason Robards, a brilliant
actor and a tortured man,
not so different from Bogie.
Margaret Herrick Library

Robards and Bacall in their apartment at the Dakota in New York. After
their divorce, much of the wall and floor space were taken over by Bacall's
accumulation of art and tchotchkes. *Author's collection*

Bacall came into her own onstage, in the long-running *Cactus Flower* and in her Tony-winning musical, *Applause*. *Author's collection*

Bacall was thrilled to be awarded a Kennedy Center honor, with all her family there in support (Leslie and Sam are to her right, and Stephen is to her left). *Author's collection*

But she was deeply disappointed to lose out on an Oscar for *The Mirror Has Two Faces*. A scene with Barbra Streisand in the film shows why Bacall should have won. *Author's collection*

Nunnally Johnson also recalled Bogie baiting a man, this time for what he perceived to be nepotism. "Bogie's baiting was always damn near the truth," Johnson said. "I mean, he always picked on somebody whose credentials weren't very good." In that case, he believed the man had gotten as far as he had in the film industry only because he was related to some higher-up. "Well, he drove this fellow livid," Johnson said, so much so that the younger man slugged him. Bogart immediately backed down, which also was part of a pattern Johnson had discerned: if he didn't throw the first punch, he "would withdraw on hands and knees" when struck, Johnson said. "That's what he got out of the bottle. That made him provoke people."

In the 1940s, actors didn't go into rehab. Friends and colleagues didn't perform interventions, forcing alcoholics to acknowledge their addiction. By 1944, Alcoholics Anonymous was getting increased coverage on radio and in newspapers, but no one in Bogie's life seemed to consider that he needed help. Few saw his drinking as a problem. He kept turning in terrific performances, after all, and his pictures made money. But in fact, the more he drank, he was spiraling down farther and farther, his wife just ahead of him.

On May 23, the columnist Harrison Carroll reported that Mayo Methot Bogart's right leg was now in a cast from the knee down. The injury was explained as the result of a fall she'd taken while sailing, in which she'd shattered two bones in her right foot. In Bogart's private legal files, there is an account of a May 1944 accident involving the *Albatross*, a sloop Bogart also owned. The Coast Guard wrote up a report, and Bogie submitted it to the insurance company. The cost of repairs to the boat was more than $500. Knowing the Bogarts and the level of tension between them in the spring of 1944, it's impossible not to consider that it was more than just an accident—especially since, just about three months later, Mayo would again be hospitalized. Louella Parsons reported that she was "only in for a check-up," even if her stay was expected to last several days. In both cases, had her drinking caused the problem? Did she bear some responsibility for the *Albatross* accident? Had Bogie, drunk, lost control of the vessel? Or had Mayo, watching helplessly as her marriage unraveled, made good on her threats of self-harm?

It's impossible to know for sure, but what's clear is that Bogart's private life was imploding and it was having a serious effect on his professional life. That may help explain why his suspension remained unresolved

nearly three months in. Parsons sensed that something was off about the situation. "I am surprised that Humphrey Bogart's suspension at Warners has gone on for this long," she wrote. "Usually Bogey and the bosses kiss and make up by this time. But so far, no armistice." Was he simply in no condition to return? Memos in the Warner Bros. archive show that he was in communication with Steve Trilling about possibly being loaned out to Columbia to work for the director Sam Wood. But he was un- usually indecisive about what he should do, wondering about Howard Hawks's next project, possibly because that could put him opposite the young Miss Bacall again.

While Mayo was recuperating onshore, Bogie invited Betty to join him and some friends down in Newport Beach for a few days. As cover, she'd stay on the yacht of his friend Pat O'Moore and his wife; Bogie would join them during the day. Natalie was furious with Betty for ac- cepting the invitation but her daughter now did things the way she wanted to do them. One afternoon, as the two couples were relaxing at the dock on O'Moore's boat, Pat shouted, "Christ! Mayo's heading this way." Betty was terrified. "Bogie shoved me into the head," she wrote, "where I sat holding on to the door with my heart pounding so loudly, I was sure it could be heard all over the boat." Mayo greeted her friends and suggested that they have a drink. Bogie and O'Moore dissuaded her by saying they needed to go into town and Mayo should come with them. Betty could hear everything. Even after they had gone, she was scared to open the door. O'Moore's wife called down to her that the coast was clear, and so finally she stepped back out onto the deck. The experience was too much for her. "Newport Beach was not the place for me," she wrote. "I didn't want to return until the all-clear was the all-clear for all time."

Bogie was at fault here. He'd been the one to create the drama. He was holding on to both Betty and Pete because he was too insecure to let either go, despite knowing that he was bound to hurt one or both of them. Betty made him feel young; Pete made him feel protected. Mean- while, he was also overwhelmed with feelings of responsibility for Mayo, feelings that may have been exacerbated if she'd caused her hospitaliza- tions herself. "I don't want to break this marriage up," Bogie confided to a friend, but he was miserable in it. He feared what Mayo might do if he left.

All his adult life, Bogart had been the one who had taken respon- sibility for his family. He'd settled his father's debts. He'd cared for his

mother, gotten her a home close to him. He'd taken in his sister and provided her with an income. A sense of responsibility was one of the few lessons of his youth that he'd truly taken to heart. His attitude was noble, admirable. But nobility didn't make his predicament any easier to bear. For now, the only answer remained the bottle.

BETTY MADE HER WAY THROUGH THE FRONT DOORS OF ROMANOFF'S RESTAU-rant on Rodeo Drive, past the famous monogram of two R's below an imperial crown. She'd been to the Hollywood hot spot several times already and knew the proprietor, "Prince" Michael Romanoff, who claimed to be a descendant of the Russian royal family even though everyone knew it wasn't true. (He was actually a Lithuanian immigrant who'd worked as a dry cleaner in Brooklyn not far from where Betty had grown up.) Such was the world Betty now moved in, where no one was quite who or what they seemed. But Betty, too, had her secrets.

Inside the restaurant, she was greeted by the columnist Hedda Hopper, almost certainly wearing one of her (sometimes unintentionally) humorous hats topped by silk flowers and birds. *To Have and Have Not* was nearly ready for release, and Hopper was doing her part to promote its new star. Betty knew Hedda only slightly; the columnist had been at her nineteenth birthday party the previous fall. But Hopper welcomed her to her table as if they were close, longtime friends. The inauthentic intimacy in Hollywood would eventually get to Betty, but for now she played the game. Bogie had surely warned her about Hopper. Her rabid right-wing politics and smear campaigns had led him to swear off any further interviews with her. But a newly discovered star snubbed Hedda Hopper at her peril.

The menu at Romanoff's was the usual screenland fare: Waldorf salad, frog legs, chocolate soufflé, filet mignon. There was also the popular Noodles Romanoff, made of egg noodles and sour cream. What Betty ordered that day has been lost to time. Indeed, the entire lunch faded from her memory, or at least that's the impression she gave to Hopper years later.

"We had a confidential talk," Hedda reminded her, "and I said, 'You've got to hitch your wagon to a star.'"

"There aren't any of them loose," Betty had replied, according to Hopper.

The columnist had pointed to a headline about the marital troubles of Bogart and Methot. "There's your star," she told Betty.

Whether it happened exactly the way Hopper told it or not (she was known for embellishment and self-aggrandizement), what her account does tell us is that by the summer or early fall of 1944, rumors about Betty and Bogie were spreading through the movie colony. Betty's family was uneasy about the situation. Natalie, who was once more living with her daughter on Reeves Drive, made no secret of her distrust of Bogart. Betty would write that her mother "deeply disapproved" of the relationship. Betty's uncles, especially Charlie, remained concerned. But Betty wouldn't listen to anyone. She was convinced that she'd finally found a man who could help her reach the top and, even more important, a man who might be able to give her the love and attention she'd been searching for all her life. Although she would later emphatically deny that her relationship with Bogie had anything to do with seeking a father substitute, she seemed to be complaining too much.

If she'd ever had doubts about Bogie, they were swept away during the trip to Newport Beach, when, before all the drama ensued, she'd told him the secret she'd been carrying. "I had to ask the question that had been so much on my mind," Bacall wrote. "Did it matter to him that I was Jewish?" Bogie was stunned that she had even felt the need to raise the issue. Of course it didn't matter, he told her. "It was a big weight off my shoulders," Betty wrote.

About the rumors swirling around her and Bogart, Betty was far more blasé than her family was. When a fan magazine writer asked how she felt about all the talk, she replied, "The gossip stuff doesn't bother me. If you let it get to you, you'd end up in an asylum. . . . On Shirley Temple it wouldn't be becoming. But on me, considering the type I turn out to be on the screen, it's okay." In other words, she was tough; she could handle it. She was not a child like Temple, who, in fact, was only three and a half years younger than Betty.

In truth, Betty seems to have loved the gossip. She was a young woman, after all, who had spent nearly every waking hour since she was fifteen dreaming of and planning for fame. She now sat for interviews with fan magazines, the same she had read as a starry-eyed teenager. Now the press was talking about her. Now *she* was the femme fatale.

A preview of *To Have and Have Not* had been screened in Huntington Beach for industry insiders, and the consensus was that Betty was a

smash. Jack Warner green-lit a promotional campaign for her. Warners publicists described her as an amalgam of Marlene Dietrich, Katharine Hepburn, Bette Davis, and Tallulah Bankhead, "with overtones of Veronica Lake and Barbara Stanwyck and undertones of Jean Harlow." A little more than a year earlier, Betty had been a walk-on in a failed Broadway show; now she was being compared to just about every great female star of the past decade. She was Cinderella at the ball, and she relished every minute of it.

Natalie noted the change in her daughter, and it worried her. Betty had always taken her mother's advice, trusted her instincts, and followed her suggestions. Now she seemed to believe that she knew better—and given that Betty was the major breadwinner of the household, she was virtually impossible to dissuade. Her success was going to her head even before her film was in wide release. To one reporter, she complained of still not having enough clothes. "I need everything from the skin out," she said. Betty was invited to all the best parties, including a "gay, lavish, and lush" soiree at Cole Porter's house, where each guest received an individual menu. One fan magazine named her amid such top names as Errol Flynn, Joan Blondell, Ann Sothern, Edmund Goulding, and Lena Horne, as if she belonged there; apparently, now she did.

Betty also began turning up at various clubs along the Sunset Strip, where, according to *Life* magazine, "she drinks almost nothing, smokes a great deal and dances conservatively, either leaving the floor or collapsing with mirth when she gets involved with partners who like elaborate steps." All that mattered was that she be seen, mentioned, and photographed.

It's important to remember that Betty was not quite twenty at that point, and despite her cleverness, she was still impressionable. The world she found herself in was like nothing she'd known in New York. It's notable how rarely the press mentioned Betty's age at the time. The fact that she drank almost nothing may have been because she wasn't yet old enough to do so.

For all her diva moments, a part of Betty remained the wide-eyed kid, incredulous at her good luck and how easy it had all been for her, at least in retrospect. She could still show kindness and humility. When Natalie made a visit to New York, Betty was very eager that her mother see Joyce Gates, whose screen test hadn't turned out as successfully as Betty's. "Have you seen Joyce yet?" Betty wrote. "Please don't fail to do that. She's

a sweet girl and I'm very fond of her. Be nice and don't keep talking about me and my career. She feels badly enough."

The release date for *To Have and Have Not* was set for October. In anticipation, Warner Bros. publicists scripted a whole new biography for Betty, one they thought would set the right tone and maximize her appeal. Charles Feldman had a look and suggested to Jack Bacal that he visit the Warner Bros. publicity office in New York; he appears to have wanted to prepare him. "I saw the Warner releases on Betty," Jack wrote to Natalie. "Of course, I did not care too much about the part which makes her a child of American parents of several generations nor the implication that she was from society. Nevertheless, we can do nothing but go along with their publicity line." A veil descended around Betty's past, family, and heritage.

The case of Sylvia Sidney may have provided a cautionary tale. Sidney was the daughter of Romanian and Russian Jewish immigrants, the same heritage as Betty. She'd become a top star with *An American Tragedy* in 1931 and sealed that success with such films as *Street Scene* and *The Miracle Man*. But then, in 1933, her birth father had attempted to invalidate Sidney's adoption, many years earlier, by her stepfather. In so doing, he had revealed the name she'd been born with, Sophia Kosow, as well as her mother's maiden name, Saperstein. Although the courts had ruled against Sidney's father, accusing him of attempted extortion, the headlines had had their effect on the movie chiefs. Sidney abruptly departed Hollywood; it would be several years before she was making first-rate pictures again, and even then she was never able to reclaim the heights of 1931. Sidney would appear with Bogart in both *Dead End* and *The Wagons Roll at Night*, but by the time of the latter picture, she was being billed fourth. By 1944, she hadn't made a film in three years.

The similarities between Sylvia Sidney and Lauren Bacall were uncanny, and no doubt those around Betty took heed of them. Betty had a birth father out there, too, one who, at least in the view of the Bacals, was just as unethical and untrustworthy. Betty believed her father to be fully capable of pulling the same stunt as Sidney's, trying to cash in on the success of a daughter he had abandoned. So for the moment, she and her family made no waves about the publicity.

Practical it might be, but such closeting came with a personal cost. Betty's memoir rings with the guilt and regret she felt for obfuscating her past. As if to underscore her anguish, she and Natalie received word that

Grandmother Sophie was dying. "Mother is not well again," Jack wrote, "and I don't know how long she's going to last." A preview of *To Have and Have Not* was being given in New York, and although Jack had tried to arrange for Sophie to see it, he concluded that "she wouldn't live through it—the emotional strain would be too great." Sturdy old Sophie Weinstein, who'd started out pushing carts with her husband on the Lower East Side, would not survive the glitzy trappings of her granddaughter's new life. "Grandma knew that good things were happening to me, that I was on my way," Betty wrote, "but she could not live long enough for me to share it all with her." Perhaps, in some small way, that was a good thing, as one of the things Betty would have had to share was the erasure of the family's Jewish identity.

Sophie died on September 20, 1944, just a few days after Betty's twentieth birthday. Her daughter and granddaughter did not return for the services. There was no way they could have gotten there in time, as traditionally, Jewish funerals are held within twenty-four hours of death. Besides, Betty had too many responsibilities in Los Angeles with the release of the picture. It was left to Jack to fill his sister and niece in on the details. "The services were simple and moving—just as Mother would have wanted them," he wrote. "There were a great many people there." Except for Betty and Natalie, who now lived in a very different world.

JACK WARNER'S NEW YORK AGENTS COULDN'T WAIT TO SMUDGE THEIR FINGERS riffling through the morning papers. The night before, October 11, *To Have and Have Not* had had its world premiere at the Hollywood Theatre on West 51st Street, the same venue that had given the world *Casablanca*. The house had been packed and the cheers enthusiastic. But as always, the final verdict would come from Bosley Crowther of the *New York Times* and his compatriots. The sun was not yet up when *Times* deliverymen dropped bundles of newspapers at drugstores and newsstands. The Warner publicists were waiting. Within moments, they were wiring word to Jack Warner in Los Angeles.

The reviews were spectacular. "There is much more character than story," Crowther observed, ". . . and much more atmosphere than action," but that was beside the point. Hawks, the critic wrote, had done his characters well. "Mr. Bogart is best when his nature is permitted to smoulder in the gloom," Crowther observed, "and his impulse to movement is

restricted by a caution bred of cynical doubt." But he was most impressed with Bacall, choosing her photo to accompany his review instead of the film's star. "She acts in the quiet way of catnip and sings a song from deep down in her throat . . . in perfect low-down barroom style," he wrote. Despite Jack Warner's concerns, Hawks's gamble of using Betty's own voice had paid off.

During the first week of its run, *To Have and Have Not* pulled in a "sensational" $46,200, according to *Variety*. The second week was nearly as good at $39,000, and the third continued to build on that success. General release was not scheduled until late January. In the two months in between, *To Have and Have Not* needed to keep racking up the cash and the positive reviews. The film would become one of the longest running at the Hollywood Theatre. The excitement built, and virtually every major critic loved the picture when they finally saw it. Los Angeles got its first glimpse on January 19, 1945. The next day, Virginia Wright of the *Los Angeles Daily News* gushed over Bacall, telling her readers, "You haven't seen anything like it since the earliest Dietrich, but the whistles today are a good deal more expressive than they were then."

The praise kept coming as the picture rolled through the rest of the country. Pittsburgh got it in early February. One reviewer there declared that Warner Bros. had found "a young wolverine named Miss Lauren Bacall who's very like to become the feminine Sinatra," an interesting observation given the later friendship that would arise between the two. "Drooping of lip, deep of voice, and a blast-furnace of emotions, Miss Bacall is . . . more the Bogart type than Ingrid Bergman and she smacks her lips lusciously here against dialogue that Miss Bergman could never speak. Very few actresses have ever made such an auspicious debut. Miss Bacall has met the wolf-pack and they are hers."

It was left to *Life* magazine to make the final pronouncement: "Lauren Bacall [is] one of the most meteoric picture successes of recent years. . . . Sober observers consider her one of the great movie discoveries of all time." The reviewers liked Bogie, too, but they'd seen his method before. The film belongs to Bacall, despite the fact that she doesn't do much except sing and simmer. But that was all she needed to do. Betty's belief in herself, even as she had slogged through all those failed auditions and productions, had been justified. When finally given the opportunity, she had delivered. She had *shone*. For all the comparisons to past movie greats, Bacall was something brand new to the screen, a cynical,

confident spell caster who exists in a reality all her own. Marjory Adams in the *Boston Globe* found her "strangely fascinating" with her "three-cornered eyes from which she glances in sideways fashion, a sharply defined chin line, and an intriguing husky voice." She had, Adams wrote, "a haunting charm that grows on you." Audiences felt the same way.

Hawks had been wise to play up her insolence. Her lesson to Bogart on how to whistle went miles past Mae West's cheeky "Come up 'n see me sometime," which some compared it to. There was no joke here. Bacall meant business. That was what made her so appealing. The moment she finally smiles, the immediate reaction of those watching is one of pure joy. It's a powerful moment, revealing that Marie's strength is not a charade.

And then there was the voice. Most reviewers loved it, but there were some doubters. Frances Peck, writing as Mae Tinée for the *Chicago Tribune*, found her "hoarse monosyllables" to be "ridiculous." But another writer was enchanted by her "husky, underslung voice which is ideal for the *double-entendre*," making "her simplest remarks sound like jungle mating cries."

Bogie was delighted at Betty's success. Indeed, her success made her even more desirable to him. Bogie's happiest days with Mary Philips had been when they were working together. Now he could see being part of a similar team with Betty. So could Bacall, who, when she wasn't walking around in dazed wonder over her success, was determined to turn down any other pictures until she heard from Hawks on his planned follow-up for her and Bogie.

"You are a perfect foil for Bogart," Uncle Charlie wrote to her. Along with several members of the family, he'd been among the first to see *To Have and Have Not* at the Hollywood Theatre, arriving early for the 6:22 show on the day of the premiere. "You don't let Bogie breathe. . . . Your voice, its timber, its low register, its rare quality is ideally suited for Bogart roles. . . . This means Warner and Hawks and Feldman need you as much as you need them. . . . The public loves you. Your timing was perfect. . . . I was so pleased and proud." The biggest laugh of the night, Charlie told his niece, came after Betty had delivered the "put your lips together and blow" line. "Your publicity agent should immortalize those lines on the radio, in the columns, among comedians and in song." Her agents were, in fact, already hard at work on doing just that.

The promotional campaign being waged on her behalf left Betty

staggered. The enterprising Marty Weiser came up with a scheme to name a newly discovered volcanic skerry off the coast of Guam "Bacall Island," ostensibly according to the wishes of the randy men in uniform stationed there. Nothing came of the stunt, but plenty of other ideas took off. "I see my name in papers a lot and on the radio a lot," Betty told the columnist Gladys Hall. "It's a little bit hard to believe this is me." "The Look" was now the epitome of Hollywood glamour, replacing Veronica Lake's "Peekaboo." Everyone was talking about Bacall. George Jean Nathan insisted that he'd discovered her long before Hawks had. *Vogue* hired Betty for a photo shoot, which came out in May 1945. *Life* put together another profile that same month. From the covers of *Photoplay, Silver Screen, Screen Stars, Screenland, Picturegoer,* and other fan magazines, Betty's face stared out at the world. She was everywhere.

"I never knew it was going to be like this," she told Gladys Hall. "The phone rings from 75 to 90 times a day. Actual count. My mother, who doesn't know what to make of it, answers and no matter who it is— often it's someone who asks, 'Is *Laur-een* there?'—puts them on. There have been mob scenes. Autographs, you know. When I can give them, I always do." She agreed to be interviewed by a couple of students from her alma mater, Julia Richman, and when she opened the door for them, they were trembling. "Is there something so frightening about me that I make people shake?" she asked Hall. She seemed to be conveniently forgetting her own terror years earlier when she'd knocked on Bette Davis's hotel door. "It's kind of bewildering," she told the writer before adding, "But it's fun."

What wasn't fun, certainly, was the fictions she had to keep pretending were true. One journalist, basing her story on the studio's talking points, described Bacall as being "of Russian, Rumanian, and French descent, though her family had been American for several generations." That was the line the Bacals had agreed to maintain (though "French" appears to have been a publicist's invention). The charade, however, was threatened when the writer of Betty's second *Life* magazine profile, Francis Sill Wickware—unlike the more acquiescent fan magazine writers— dug into her past. Wickware didn't come right out and state that Betty was Jewish, but he revealed that Weinstein was the family's original last name, and most people reading the piece would have drawn that conclusion. That may have been how Hawks found out the truth about his protégée; Betty believed that he felt she had deceived him.

But even more alarming for Betty was the fact that Wickware had located and interviewed her father. William Perske was running a "prosperous medical equipment company" in Charleston, South Carolina. When Wickware found him, Perske expressed great pride in his daughter's success. He added that he was hoping "to arrange a reunion" but so far had not been successful.

Apparently, sometime in mid- to late 1944, Betty's father had opened a newspaper or watched a trailer in a movie theater and recognized his daughter. It had been more than a decade since he'd seen her, but Betty looked so much like him that he would have known it was her even without reading the profiles. According to Betty, Perske, clearly up on the gossip, sent her a wire cautioning her against marrying a man so much older than she was. Betty was livid. "It took fame for me to hear a word from him," she wrote. Her father's reemergence had been inevitable; how Betty and her family had ever thought they could prevent it is a mystery. Perske's looming shadow meant that throughout the premiere of *To Have and Have Not* and its attendant publicity, Betty was constantly looking over her shoulder, worrying that her father might show up, embarrass her, or demand money from her. Her resolve against him only hardened. After all that time, she still had not forgiven him. She clung steadfastly to the view her mother's family had of him.

Fame wasn't all fun, as it turned out. For most people who achieve it, fame creates tension between their public and private lives. Illusions must be sustained, and secrets need to be kept. Betty felt the strain from the start. The other fiction she was expected to uphold, of course, was that she was not romantically interested in Bogie. He was still married; it wouldn't do for Hollywood's "New Girl," as *Screenland* magazine dubbed her, to be a home wrecker. Publicity flacks did their best to deflect the Bogart rumors. Walter Winchell wrote that he'd been told that Betty was "that way" about Brian Aherne, who'd recently separated from Joan Fontaine. But Dorothy Kilgallen speculated that she'd be the next Mrs. Bogart

In Hollywood, Bogie and Bacall were being kept far apart, though he'd sent a dozen roses to her on her birthday signed "Steve." Bogart spent most of his time with Pete during that period. Indeed, they'd likely never been closer, with Bogie pouring out his anxiety over what Mayo might do when he left her. Although he dreaded it, he knew he needed to do it soon. He and Betty had signed on to Hawks's next picture, *The*

Big Sleep, which was scheduled to start production before the end of the year. The studio did not want the shadow of Mayo looming over the promotion of the next teaming of America's new sweethearts.

As Pete would tell it, Bogie kept any feelings he had for Betty a secret from her. Pete's impression was of a girl in over her head with all the publicity, with Bogie trying to protect her. She'd heard the gossip but hadn't put much stock in it. "It could be a publicity gimmick," she reasoned. "Who could believe the columnists anyway?" In fact, the more Bogie spoke of divorce from Mayo, the more Pete believed that he would wait for her to obtain her divorce from Robert Peterson, who would soon be coming home. Pete figured that they should keep apart for a while once Bogie and Mayo separated. "That way," she said, "there would be no chance of me being named as a corespondent in the divorce proceedings." Whether he explicitly promised her that he'd wait for her divorce and eventually marry her or whether he just let her believe that idea is unclear. But Pete was convinced that they both wanted the same thing.

Betty's family, then, might have had some justification in their concern over Bogart's intentions. As the rumors continued to swirl, Uncle Charlie wrote his niece an impassioned letter. "It's not easy to put into words my emotions and mental impressions since you leaped from obscurity to fame," he told her. "I'm happy for you but . . . I worry about your personal happiness. You must make no important decisions until we have talked them over, preferably face-to-face. Experience is an important factor in dealing with life and 20 is too young for experience."

The important decisions Charlie was most worried about weren't about movie contracts but about much more personal matters. His letter was likely prompted by Natalie, who was there watching Betty pine for a much older, married man. As his letter went on, Charlie got more specific, warning Betty about "the gap between 20 and 45." He admonished her, "Remember the precious quality of youth which makes you vital and vibrant is out, extinct, [at] 45." The "topmost age" for a suitor of Betty's should be thirty. "Don't miss the lessons of this simple arithmetic," he pleaded. "I cannot see you professionally apart from your personal life. Remember, you need no one. . . . You can travel the wide distance of life under your own steam." He ended, "Remember Granny and make your mommy proud."

On October 19, a week after *To Have and Have Not* opened, Bogie and Mayo separated. For all Bogart's fears, there had been a minimum of

histrionics. Mayo was exhausted. She'd been fighting so desperately and for so long to hold on to her husband that when the end finally came, she left quietly, making no statements to the press. Dorothy Kilgallen heard that she'd called Bacall "a baby Mae West," but there was nothing on the record. The Battling Bogarts had fought their last battle. The once happy young woman who had dazzled audiences on both coasts was beaten down, unrecognizable. The wife who had done so much to push Bogie's career higher was now as low as she could possibly be.

In Burbank, studio executives were delighted. They could now promote Bogart and Bacall as a romantic couple. Marty Weiser described the moment Bogie takes Bacall into his arms in *To Have and Have Not* as the "most rehearsed kiss in screen history." He had the story all planned out to the press to dutifully report. "Bogart and Bacall rehearse a kiss for 4½ hours straight before the cameras for a kiss which on the screen will last a few seconds," he pitched a colleague in the publicity department. "Story might contain statistics such as the amount of lipstick and Kleenex used." The public would eat it up. Hollywood's greatest love affair was under way.

Los Angeles, Tuesday, May 8, 1945

The news was everywhere. Victory in Europe at last! Germany had sur-
rendered unconditionally, Adolf Hitler was dead, and the troops would
soon be coming home. In New York, thousands of people filled Times
Square. Spontaneous celebrations popped up in other cities as well. In
Los Angeles, however, few people took to the streets; the city, accord-
ing to the *Los Angeles Times*, "paused only briefly to digest the news of
victory in Europe." The eyes of Californians were still trained on Japan,
which was fighting on despite the German surrender. Mayor Fletcher
Bowron announced that schools and businesses would remain open, and,
no surprise, at the movie studios it was business as usual. Humphrey
Bogart, making his latest film, *The Two Mrs. Carrolls* with Barbara Stan-
wyck, had to wait until a break was called to raise a glass of champagne.

Bogie had more reasons to celebrate that day. His divorce from Mayo
was finalized the day before. Coming to terms with his ex-wife had not
been easy. As her attorney, Mayo had chosen Jerry Giesler, the shark
who'd gotten Errol Flynn acquitted of rape and was known for winning
"unwinnable" cases. Giesler had demanded a full accounting of Bogart's
assets beginning in 1938, the year of the marriage, up through the pres-
ent day. According to the ledgers and files of Morgan Maree, Bogie's
income had not increased by all that much—the result of the studio's
parsimony—but in the past six years he'd acquired a significant portfolio
of stocks and bonds. The total value of the portfolio in 1938 had been
$6,252.50; by 1944, the value had jumped to $33,992.25, with significant
investments in General Electric, the Exeter Oil Company, and Warner
Bros. itself. The other increase in his assets was real estate: in addition
to the house on Shoreham Drive, Bogie was also a part owner of two
Safeway supermarket stores, one at Fulton and Ventura and the other on
Hollywood Boulevard. Mayo was included on the deeds of all properties
except for a small lot in the Valley, which was only in Bogart's name.

To win the best terms, Giesler counseled his client to tone down her

rancor, which had only increased in the last few months. Her apparent acceptance of the separation and divorce had masked her true feelings. According to Bacall, Mayo had called her at home one night, probably drunk, and warned her against going after Bogie, reportedly using an anti-Semitic slur in the process. But Mayo heeded her lawyer's advice in the hope of obtaining the best settlement possible. As it turned out, Bogie was quite generous to his wife, giving her more than what was required by community property laws. "It is the intent to vest the said Mayo Bogart all right, title, and interest in and to [1210 North Horn Avenue, i.e., Shoreham Drive] and to divest the undersigned Humphrey Bogart of any community property interest," read the bill of sale. Not only did she get the house, she received two-thirds of Bogie's cash assets and his Safeway investments.

Even with such an advantageous settlement, Mayo's mother, Buffie, had to stay on her to keep her from backing out. As the divorce drew closer, Mayo resisted. "She must make up her mind that her marriage has ended and readjust her life," Buffie told Louella Parsons. Seemingly convinced at last, Mayo boarded a train for Las Vegas to establish the six-week residency requirement for divorce under Nevada law. But then she had second thoughts and returned to Los Angeles. Buffie and Giesler had to persuade her to go back.

Finally, on May 9, Mayo stood before a Clark County clerk and charged Bogart with "great mental suffering," the term they'd agreed upon. She told the newshounds waiting outside the courthouse that she and Bogie remained "the best of friends" and their marriage had been "very pleasant." For all the volatility she was capable of showing, Mayo walked off the public stage with her dignity intact. She planned to go back to New York for a while. The producer Robert Milton had written to her, "I want to bring you back to the theatre, either as a player or co-producer." Gertie Hatch wrote asking her plans: "Would you rent an apartment or what?" Hatch was looking forward to "sliding down some bannisters together and [having] a hell of a time."

While Mayo was left to find a new way in the world, Bogie was free. He'd admitted the previous January that he'd marry Bacall as soon as his divorce was final. That had come to no one's surprise. A letter from the screenwriter Leonard Lee to Elizabeth (Mrs. Charles) Brackett, made light of the open secret the Bogart-Bacall affair had become: "As of noon today," he wrote, "Mr. Bogart was maintaining the sanctity of his home by living with his wife, though the fact that he was lunching

with Miss Bacall in apparent amity would seem to throw some doubt upon how long this sixth or seventh honeymoon—I've lost count— would continue."

Gladys Hall had tried to get Betty to admit what everyone knew. Betty held firm: "There is really nothing more I can say about it now." But in the same interview, she had casually revealed that she'd recently seen *Harvey* on Broadway with Bogie. When Hall expressed surprise that they had gone out in public together, Betty replied, "We're good friends. Not to go out with him would be idiotic. Sheer insanity." On a trip to New York, they dined together at "21," where the waiters referred to the Bogart-Bacall corner table as "the cradle."

The chicanery ended on January 31. Bogie's acknowledgment that he planned to marry Betty was made to Inez Robb, a reporter for International News Service, who'd cornered him in his New York hotel room. "Sure, Baby and I are engaged," Bogart said. "I know that I open my big fat yap too much and maybe this announcement is a little premature. But what the hell? I live in a goldfish bowl. . . . Ever try to keep a secret in a goldfish bowl?" Louella Parsons was not pleased to be scooped by Robb. In her column, she claimed that Bogie had told her weeks earlier that he and Bacall planned to wed but had asked her to keep it secret until the divorce was finalized. If that is true, Bogie had overcome his indecision about remarrying at least by New Year's.

The Bogie-and-Baby bandwagon could now roll full speed ahead. Their prominence suddenly eclipsed everyone else. Although most had seen it coming, one person read the news in disbelief. "It was evident that I had been wasting my time," Pete Peterson recalled. She believed that Bogie had given her every indication that they'd be married after both of their divorces were settled. Robert Peterson's discharge date was fast approaching, and Pete had planned to file for divorce once he was home. Perhaps she had only believed what she'd wanted to believe, but the hurt was nonetheless very real. "I was furious at first," she wrote, "then I cried for days." To friends, she "raged against Bacall," whom she saw as a "Jane-come-lately." She waited to hear from Bogie, but he never called, despite her leaving messages for him at the studio. It was now too risky to have any contact with her. Their three-year relationship ended without a good-bye. It was far from Bogie's finest hour.

Betty was triumphant. "I felt as if I owned the world, and I did," she wrote. "My every dream and hope, and far beyond, were to be realized."

Still only twenty years old, she was a top-ranked movie star, the darling of the critics, and one-half of a Hollywood power couple. Defying her family, her director, and her studio, she was also set to marry the strong, prominent older man she had been seeking her entire life. "I couldn't have wished for a man as incredibly good as this man was," she wrote.

DURING THE PRODUCTION OF *THE BIG SLEEP* WITH HAWKS, WHICH HAD GOTTEN under way at the end of 1944 (during the final negotiations over the divorce) and continued into the first weeks of 1945, Bogart and Bacall had made little secret of their romance. Hawks wasn't happy about that. "Relations were somewhat strained between Howard and me," Betty recalled. "He sensed he had lost. The girl he had invented was no longer his." Hawks later denied that there had been any tension, insisting that his rapport with his stars had been as productive as ever. *The Big Sleep* was what he called a "wheelchair job"—meaning that he rarely needed to get out of his rolling director's chair to manage a scene. "When you get good people and they're working right," he said, "it's easy to make a picture."

What wasn't easy was the dialogue. Once again, William Faulkner had been brought in to polish the script. Bacall described Faulkner as a "very sweet and quiet little Southern gentleman," who'd be "writing and writing and writing away" in Hawks's office before coming to the set with "pages and pages of dialogue, all one speech." Bogie couldn't help but laugh. "He doesn't realize that no one can stand with a camera on your face and just say all of these words," he told Betty. Hawks admitted that Faulkner's "dialogue would be a mouthful for anybody." But "what he was expressing," Hawks said, was exactly what was needed for the film, so they did their best to untangle much of the dialogue while trying to preserve his intent.

The Big Sleep, based on a novel by Raymond Chandler, is the story of a cynical, hard-boiled private eye—a character Bogart knew a few things about—who's hired by a wealthy old man to investigate a disappearance, or perhaps a murder. Philip Marlowe, the detective, is cut from the same cloth as Sam Spade, though he's more unpredictable. The mystery involves the old General Sternwood's two daughters, the elder, Vivian, who's a beautiful, coiled snake, and the younger, Carmen, a rebel who's gotten mixed up with a bunch of shady characters. Eventually Carmen is

killed and Marlowe, it's suggested, becomes involved with Vivian, who's played by Bacall.

The script of *The Big Sleep* was not as carefully plotted out as *The Maltese Falcon* or *Casablanca* (even *To Have and Have Not* has a sturdier story line, and that's saying a great deal). Faulkner's dialogue didn't help matters. What sustained the production—indeed, what made the film—was the crackling chemistry between Bogart and Bacall. There's a moment in the picture where Vivian sits on Marlowe's desk, her crossed legs prominent in front of his face as he sits in the chair. Playing with her skirt, she reveals a tantalizing glimpse of her upper thigh. Marlowe, observing, says, "Go ahead and scratch." She does, shooting him a quick look of annoyance. Bogie had ad-libbed the line during rehearsals to indicate that Marlowe wasn't falling for Vivian's seduction, so he tells her to scratch her leg and be done with it. Hawks kept the line in. "Those things just happen," the director said. "The two of them were good counterparts."

They weren't yet equals, however. Bogie remained her acting teacher. Once, after watching Betty rehearse a scene in which she opened a door, he told her, "You walked out there like a model." She took his advice and changed her stride. "You must always realize you have come from someplace," Bogie went on. "What were you doing before? Were you filing your nails? Were you writing a letter?" Every scene must convey an attitude. "That is a very important part of acting, and I never forgot it," Betty later said.

She watched and absorbed everything he did. In one scene, Marlowe walks into a bookstore looking for clues but needs to hide his identity as a detective. Bogie came up with the idea to disguise himself as a nebbish book collector, pulling his hat down awkwardly on his head and wearing sunglasses. Hawks would describe the characterization as "a little bit of a fairy attitude," though Bogie comes across as a book nerd more than anything else. For a second bookstore scene, Hawks insisted, he needed "to go in as a man." Bogie agreed, according to Hawks, so long as the bookstore proprietor could be a pretty girl. The part was played with smartness and sensuality by Dorothy Malone, who'd soon be a star in her own right.

As production neared its end, things began to unravel. Bacall got a head cold, which meant they had to spend a couple of days shooting only silent footage of her. And again, this was all taking place with Bogart in

the final throes of his divorce, which meant he started showing up late to the set. His drinking had interfered with productions before, but this time it surprised cast and crew since he'd been so cooperative at the start of the shoot. It would appear guilt over the divorce (and possibly over Pete) was getting to him. On the day after Christmas, he didn't show up at all. Unit manager Eric Stacey and a few others went to the Garden of Allah, where Bogie had taken refuge after the separation from Mayo, and found their star drunk and belligerent. "Are we holding a wake?" he snarled as he looked at the men surrounding him. Stacey would report to his higher-ups that the problem was "not only the liquor but also the mental turmoil regarding his domestic life."

According to several who knew him, Bogie's guilt over Mayo was pervasive and it lingered well past the final divorce decree. According to his ex-wife Mary Philips, who saw him on the day it was announced, he was despondent. "The end of the marriage bothered him," Philips recalled, "even though he felt he was doing the right thing." According to one memo, Hawks had no choice but "to straighten him out" about his behavior on the set, a reprimand that Bogart was unlikely to have taken well. But "the Bacall situation," as Hawks called it, was "affecting their performances in the picture."

The "Bacall situation," of course, eventually straightened itself out. By the end of production, they could safely be seen in public and in the pages of fan magazines. Bogie still wrestled with guilt and fear but, turning a page on the past, he told Betty they could now begin to plan their wedding.

SEVEN-YEAR-OLD PENNY SCHETTLER WAS AWAKENED BY VOICES COMING FROM downstairs. Tiptoeing out of bed and sitting on the stairs, she couldn't quite believe what she saw in her family's modest living room. "My mother and father sat talking with Humphrey Bogart and Lauren Bacall," she remembered. She knew that they were "very important people, Hollywood movie stars," but what were they doing in her living room in the little town of Mansfield, Ohio? Penny's father, Herbert Schettler, was a municipal court judge. As it turned out, he was talking with Bogart and Bacall about their wedding, asking for their input on the script he would read. To the little girl, the celebrities seemed ordinary. "I remember thinking that Bogart was awfully short to be a movie star," she said

years later. "Bacall appeared to be much taller." She was also struck by how much older Bogart was than his bride-to-be. "He was the same age as my father," Penny said. In terms of looks, she didn't think he came anywhere near Bacall's level.

At high noon on the warm, clear afternoon of May 21, 1945, Betty, wearing a simple wool dress of rose beige, a brown scarf, and brown suede pumps, with a short, irregular peplum below her waist, descended a red-carpeted staircase into the main hall of Louis Bromfield's Malabar Farm. The strains of *Lohengrin*'s "Wedding March" lilted up from a piano below. Betty and Bogie had chosen to hold the ceremony at Bromfield's farm to avoid a media circus. Still, dozens of newsmen had descended on the bucolic town, some of them sneaking onto the property and some circling in low-flying planes overhead.

Still, inside the house, all was serene, even though Betty had been a bundle of nerves before she started her descent. Bromfield served as Bogie's best man. His secretary, George Hawkins, gave Betty away, accompanying her down the stairs and across an enormous tiger rug in the center of the room. Natalie was waiting there, trying to hold back tears.

Just why Charlie Weinstein, whom Betty considered to be a father figure, did not give her away is curious. For that matter, it wasn't Jack Bacal, either, despite how much he'd done for his niece's career. Neither of them was present at the wedding. Growing up, Betty's uncles had always been there for her, financially supporting her and encouraging her dreams. When *Franklin Street* had closed before making it to Broadway, Charlie had sent a rhyme to console Betty: "Don't be disheartened, you've only just started. I can see from afar, you will be a star." But now she *was* a star, and Charlie was missing from her crowning moment.

A wedding is an important ritual in Jewish culture; the absence of the bride's closest male relatives would have been noticed. Perhaps business kept the two lawyers from making the trip to Ohio. Perhaps they weren't happy that the ceremony was secular, presided over by a Christian judge. (Charlie's own Gentile wife had converted to Judaism.) But there may have been other reasons, too. The fact that Betty's memoir makes no mention of her uncles at her wedding is noteworthy, suggesting their concerns about the marriage had not gone away. Natalie had reached "an armed truce" with Bogart, her daughter said. Natalie had decided to accept the inevitable. Her brothers may have been less willing to do so.

Charlie and Jack had met Bogie only a few months earlier, during his trip to New York with Betty. They were both younger than their future nephew-in-law. Though Betty described Bogie's interactions with her family as largely cordial, she also remarked that Jack seemed "distant" and that ultimately it was not "the best of meetings." It's perhaps worth noting that at the time of the wedding, Jack was writing a piece for *McCall's* warning about the ordeals women were forced to endure in divorce cases—a truth, he wrote, that "many women find too late."

But any strife was put out of Betty's mind as she joined Bogart in front of Judge Schettler. Her husband-to-be was wearing a light gray suit with a maroon tie and a white carnation in his lapel. "We are gathered here in the presence of these witnesses to unite this man and this woman in holy matrimony," Schettler intoned. During their meeting the night before, Betty had asked the judge to excise the vow of "obedience." Instead, husband and wife promised each other the same things: to love, comfort, honor, keep in sickness and in health, and forsake all others. "I charge you both to remember that love and loyalty will serve as the foundation of any enduring and happy home," Schettler said, after which he pronounced them man and wife.

Betty looked over at her husband to see tears sliding down his craggy cheeks. "Bogie shed tears all through the ceremony," she later told an interviewer. "He cries at weddings. He's very cute about it."

After the ceremony, Betty tossed the orchids she'd been carrying to Bromfield's teenage daughter and then joined Bogie for a brief press conference with some carefully selected journalists. One noted of Bacall, "She is tall and seldom smiles." The newlyweds were surprised when suddenly the reporters pushed forward a local man, Saverio Capuano, who, as pictures prove, was the spitting image of Bogart. "I'll be damned," Bogie said. "He does look like me. What do you think about it, Junior?" Capuano, a thirty-three-year-old defense worker, said he was honored. They posed for a photo, and for once, Bogie was taller, by several inches. It's unknown if he was wearing his lifts.

Early the next morning, the Bogarts took the train to Chicago for a "one-day holiday," Bacall explained, before reporting back to the studio. "The honeymoon is ten weeks away," she said. But that, as it turned out, was wishful thinking. There would be no official honeymoon.

The breathless coverage of the wedding established in the public's mind the image of Bogie and his Baby, even if he never really called her

that. "Baby," Bogie told a writer from the *Saturday Evening Post*, was "a stage invention." He always called his wife "Betty." The public loved the epithet, however, and the press made sure to insert it wherever possible. "Baby" evoked affection, a father nurturing a child. But it also conjured sex, in the way that men used the term to flirt, woo, and acquire women, both eroticizing and infantilizing them. That's perhaps why Bogart was uncomfortable with the word.

Meanwhile, the war finally came to an end. During the summer of 1945, the United States dropped two atomic bombs on Japan, inflicting widespread destruction and upwards of 200,000 deaths. Just four days later, the imperial government surrendered, although peace was not formalized until September 2. This time, the citizens of Los Angeles could confidently take to the streets like their East Coast compatriots and celebrate with what the *Times* called "joyous hysteria." A new order was coming for the world, the movies, and the newly married Mr. and Mrs. Humphrey Bogart.

But for Mrs. Bogart, that world seemed almost immediately to fall apart.

THE REVIEWS OF BETTY'S NEW FILM WEREN'T JUST BAD; THEY WERE DREADFUL enough to destroy her career just as it was taking off. Only a few months after she and Bogie had tied the knot, she'd finished her third film, her first without Bogart, which had been rushed into theaters by November. *Confidential Agent*, based on Graham Greene's novel of the same name, was a spy film set in England during the early years of the Spanish Civil War. Charles Boyer played a secret agent and Bacall the jaded daughter of a British peer. Directed by Herman Shumlin, a respected Broadway producer but largely inexperienced as a film director, the picture was a disaster across the board. But critics seemed especially eager to sharpen their knives for Bacall.

"You'd think Warner Bros. had a new comedy team in Charles Boyer and Lauren Bacall the way the audience was whooping at *Confidential Agent*," wrote Jane Corby in the *Brooklyn Eagle*. "The film is not a comedy, however." Corby felt that Bacall's "sultriness [had] given way to woodenness" and that the actress might as well have been "a high school girl giving an impersonation of herself." Not only was Betty unable to deliver a credible English accent, but she came "close to being an

unmitigated bore," Bosley Crowther judged. His opinion mattered more than most, and he declared that "the lady who last year was setting the woods on fire" had fizzled out. "The noise she makes in this picture," Crowther wrote, "is that of a bubble going 'poof!'"

Ironically, higher-ups at the studio had believed Betty to be a "hundred times better" in *Confidential Agent* than she was in *The Big Sleep,* and for that reason had reversed the release dates of the two pictures. As a studio memo stated, getting *Confidential Agent* out to the public first would better assist the company's plan to "keep this woman on top." No doubt there was much Monday-morning quarterbacking at Warner Bros. that November.

Despite being savaged by the critics, *Confidential Agent* opened strong at the box office, with *Variety* calling its first-week take of $69,000 "socko." Still, Betty was stunned and hurt by the reviews; she felt as if the critics had been waiting for her to fail. They probably had been. Her quick success may have left some people envious. It's true that *Confidential Agent* wasn't very good, and neither was Betty, but that's besides the fact. She had received near-unanimous praise and adoration in 1944, feted with a Hollywood coronation rarely, if ever, bestowed upon newcomers. Critics had largely overlooked the flaws in *To Have and Have Not* to write panegyrics about her performance. The reaction to *Confidential Agent* appears to have been a course correction to all that acclaim, an attempt to establish some balance and maybe to let some air out of Bacall's balloon. Whether she would go "poof!" the way Crowther predicted, however, remained to be seen.

The critical pillorying of *Confidential Agent* was only part of Betty's distress during the first six months of her marriage. She no longer had Hawks to guide her and advocate for her. After *The Big Sleep,* he'd sold his share of her contract to Warner Bros.—"Not a nickel of which I ever saw," she complained. At first, she had seemed happy about the change; Bogie was also under contract at Warners, after all. "She was delighted with it," Hawks insisted, adding that he'd asked her permission before he made the sale. "We've more or less done our stuff together," he told her. In fact, each was anxious to be rid of the other. Hawks confided to an associate that he was fed up with his discovery. "When he talked about her, it was in belligerent tones," the associate recalled. "She just got too big for her britches."

It turned out, however, to be a no-win situation. Betty was now a

standard studio employee, without any say in her career. "I had to do what Jack Warner told me to," she said, even when the projects were subpar. That explained *Confidential Agent*.

Charlie Feldman continued to represent her, and he hoped to circumvent his client's looming sophomore slump. Feldman knew that if Betty got the sort of damning reviews for *The Big Sleep* that she'd gotten for *Confidential Agent*, her value to the studio might never recover. The agent had never been happy with what Betty had been given to do in *The Big Sleep*. Martha Vickers, who'd played her nymphomaniac sister, had the much showier part, even if she had less dialogue; it was she whom audiences were likely to remember. Without some strategic promotion of Bacall, the studio stood to lose out on the investment it had made in her.

Feldman knew what was needed. He wrote to Jack Warner suggesting some new scenes be shot between Bacall and Bogart in *The Big Sleep*, heavy on the sexual banter and erotic tension. As Feldman pointed out, Betty's appeal in *To Have and Have Not* had arisen from her being "more insolent than Bogart, and this very insolence endeared her in both the public's and the critics' minds." If the studio didn't promote Bacall in that way, he argued, it "might lose one of [its] most important assets." Warner was persuaded by the agent's argument, and soon after the New Year, Hawks was called back for six days of shooting with the two stars.

The old magic clicked. The scenes, everyone agreed, were crackling and provocative, just what the doctor had ordered. Betty had lost her confidence, however. Feldman tried to reassure her that the revised *Big Sleep* could bring her back. So did Bogie. But Betty knew that the script made even less sense now, as earlier scenes needed to be trimmed to make room for the new ones.

Worst of all, Betty feared that the bigwigs would never fully trust her talent again. She was just a type, not an actress. Indeed, Hawks told Warner, "The way to get the best out of her is not to ask her to do anything past her limitations. I'd much rather have her do less and do it well than to try and give her something she's not capable of doing." Betty felt the withering of the industry's excitement for her. She was not, as it turned out, Davis, Hepburn, Bankhead, and Dietrich all rolled up into one. Rather, she was close to being yesterday's news.

She was also resentful about the money being withheld from her salary, based on an agreement made while she was still a minor. "Lauren's

name may be on a million tongues—and in lights," one journalist wrote after looking into pay inequities in the film industry. "But her paycheck has yet to top that of any one of the press agents who glorify her husky voice and slinky hips." Betty's best shot of upping her income was to petition a judge to overturn the court-mandated salary savings plan and to release the war bonds that were being held in reserve for her. She also asked for the dissolution of the trust fund in the name of her mother. Combined, those deductions took a 20 percent bite out of her earnings. Although she'd turned twenty-one in September, she was also asking the court to retroactively grant her majority status back to May, when, she claimed, "she became a legal adult" upon her marriage to Bogie. The judge granted her petition. It was perhaps the one good thing that happened that fall.

What made those travails even more difficult for Betty was the far more personal distress she faced in her marriage. After the glow of the celebration at Malabar Farm wore off, Betty was faced with the terrifying possibility that the kind, solicitous man who'd courted her might not be the man she married. Just three months after the wedding, Betty was alone at the three-story house she and Bogie were renting on North King's Road above Sunset Boulevard. She called it their "honeymoon house." Bogie, content to remain at the Garden of Allah, hadn't been keen on moving, but he'd given in to his wife's wishes. Old habits were hard to break, however, and Bogie didn't always return home when he said he would. On that August day, he was at the races with Mark Hellinger, one of his most frequent drinking buddies. The two of them, Betty later wrote, egged each other's bad behavior on.

Her description of that moment in her memoir quivers with things left unsaid. It's clear that it was not the first time Bogie had gone out drinking and hadn't returned home on time. In her telling of it, Betty comes across as anxious, maybe a little resentful. Being left alone was new to her; she'd rarely ever been alone at home since the days of sharing an apartment with her mother, uncle, and grandmother. Sitting by herself in a quiet house left her on edge.

That night, Natalie was planning to bring her dinner. Earlier that day, she'd taken Droopy and his pup, Puddle, born the previous February, to the market. When the ring of the phone suddenly cut through the silence, Betty likely expected it to be Bogie, explaining his lateness. But it was her mother. There had been an accident, Natalie told Betty. The

dogs had been struck by a hit-and-run driver. Puddle was badly wounded, and Droopy was dead.

Droopy, who'd been with Betty since she was an unknown actress, traipsing alongside her on walks through Greenwich Village. Droopy, who had consoled her after failed auditions, show closings, and disappointments in love. When Natalie had brought him out to Los Angeles, the little cocker spaniel had bounded across the train platform into Betty's arms. They'd been together since they had both been puppies. Now Droopy was gone, much like the girl Betty had been. When she hung up the phone with her mother, she wrote, "I burst into a flood of tears. Where was Bogie? I needed him!"

It was late when he finally called. He was "crocked," Betty wrote, slurring his words and barely listening to her. Even when she tearfully told him about Droopy, his high spirits did not dim. He wanted her to join him and Hellinger at La Rue, the hip eatery on the Sunset Strip owned by Billy Wilkerson, who also owned the *Hollywood Reporter* and Ciro's nightclub. Betty was not happy. "I should have known that a day with Mark meant a day with Johnnie Walker," she wrote, still peeved about the incident three decades later. "I was furious with Bogie," she said. But she needed to be with him in her grief, so she joined him at the restaurant.

That was a mistake. She "got no sympathy from anyone," she wrote. After La Rue, Bogie and Hellinger took her to "the home of some silent film star." Betty was stuck there until dawn. "Bogie [was] drunker than I'd ever seen him," she described the night. "He didn't know where he was, and only every now and then would he relate to me. I hated what that much liquor did to him." All the while she grieved over Droopy. "It was a night to forget," she said.

Except that she didn't forget. It's telling that in a memoir designed to burnish the great love affair between Bogie and Bacall, Betty made sure to include that unhappy episode. It's one of the rare instances in which she cast Bogart in an unsympathetic light; he comes across as callous and self-centered. It's reasonable to wonder if, a few months into the marriage, she had started to worry that her family had been right all along.

FREE OF MAYO, BOGIE WAS BEHAVING LIKE A BULL SUDDENLY RELEASED FROM its pen. Six months earlier, he'd been trapped, frustrated in his every attempt to escape, yearning over things he couldn't have. Now he was loose

.and living large, often heedless of those around him. He believed that he didn't have to worry about his new wife. She was young and still in some ways in awe of her much older, more successful husband. Besides, her temperament was very different from Mayo's. She wasn't about to cause any scenes.

In the fall and winter of 1945, Bogie's priorities were all about himself. For seven years, he'd had to consider what his wife might say or do. Suddenly unbound, he appears to have reverted to his untamed younger self, the reveler and brawler of whom the studio had despaired. "Bogart didn't think he had to change just because he was married," said Gloria Stuart. "Maybe he was acting out because he thought it was his last chance to do so." One fan magazine item said he "didn't seem to be a devoted newlywed" as he downed whiskies at the Trocadero. A recurrence, perhaps, of the self-sabotage he was known for when things started going well?

Professionally, he remained as dissatisfied as ever. He hadn't enjoyed making *The Two Mrs. Carrolls*, directed by the rather lightweight director Peter Godfrey. So when production ended in June 1945, Bogie was ready to let loose. He would be at liberty for almost a year, although he didn't know that yet. Still, he was prepared to make the most of whatever time he had, which explains his coming home late and the drunken carousing with Hellinger.

That winter, Bogie fulfilled a lifelong dream, buying a boat much larger and more agile than *Sluggy*. His new yacht, *Santana*, was a fifty-five-foot-long, sixteen-ton oceangoing yawl powered by an 85-horsepower engine, with pure white sails and a shiny teak deck. On December 10, he obtained his license to captain *Santana*, which would run for five years before needing to be renewed. "Next to an actor, I'd rather be a sailor than anything," he told Carl Combs, a studio press agent writing a release about the boat. "A sailor has all the best of it. He's a free agent and has to answer to no one except his conscience, his pocketbook [and] his stomach." That was exactly what Bogie was seeking at that point in his life.

Santana had been built in 1935, originally owned by an oil company executive, who had sold her to the actor George Brent. She'd go through two more actors as owners—Ray Milland and Dick Powell—before Bogie bought her for $35,000. He hired a regular skipper, Ted Howard, but remained intimately involved with the care and upkeep of the boat. *Santana* was his pride and joy. He spent nearly all his downtime on the boat, which soon had a well-stocked bar. Within a few years, a reporter would

describe Bogie as "lean, hard, and brown" from his time on *Santana* and "entirely capable of taking care of himself" while at sea.

Of course, Betty was expected to be his sailing partner, much as Mayo had been. "My wife is a good sailor," Bogie told Combs. "Not only that, but she looks cute in dungarees with her hair tied back." Betty did her best to learn the difference between the mizzen and the headsail, but the sea was not her milieu. She was a working-class New Yorker whose only experience with boats had been the Staten Island ferry. She didn't have Mayo's nautical skills. Even Pete Peterson, whom Bogie had sneaked aboard *Sluggy* a few times, was much more adept. One newspaper noted, "Lauren works as part of the crew on the sailboat," and never, unlike her husband and his guests, drank alcohol. Betty wasn't a teetotaler—but on *Santana*, already unsteady on her feet, she apparently wasn't taking any chances.

Betty would admit that she felt a little jealous of *Santana*. "She was trim, sleek, pure, beautiful and she sailed the open sea, the last free place on earth," she wrote in 1966. "Unlike a woman, she never talked back . . . [*Santana*] was my greatest competitor." Bogie treated his boat and his wife similarly—reverently and admiringly—but he spent more time with *Santana*. When Betty declined to join him, he went anyway.

Before their marriage, Betty had seen Bogie as a mentor, a savior, an ardent if sometimes timid lover. He had been devoted to her. When they went long stretches without seeing each other, absence became an aphrodisiac. They had shown only their best sides to each other. Now they lived in the same house, slept in the same bed, worked at the same studio. Gradually Betty discovered what her husband's previous three wives already knew: that according to Bogie, a woman had her place and must never step out of it.

That wasn't just an impression he gave; he told Betty that "a woman should be small enough to fit into a man's pocket, so that when he was in the mood to see her, he could put her in the palm of his hand, allow her to dance and smile and even speak, but when she began to go too far, back in the pocket she would go." In 1966, when Betty told the story as part of her introduction to Joe Hyams's biography, she called Bogie's fantasy "infuriating" but also "enchanting." It was a period when she was actively constructing the Bogart-Bacall legend and when the trope of the dominant husband and the clever but ultimately submissive wife was widespread on television and radio. A decade later, however, when

retelling the story in her memoir during a somewhat more enlightened time, she dropped the "enchanting" and admitted, "There were times when I would have liked to do the same thing to him." Eight months into their marriage, it was clear, at least to Betty, that things were going to have to change.

Washington, DC, Sunday, October 26, 1947

The night was damp and chilly as the four-engine Lockheed Constellation airplane set down just after 10:00 p.m. at National Airport outside Washington, DC. From inside the plane, the delegation of twenty-five Hollywood actors, writers, and producers peered out of the windows at the throngs that had gathered. "We came into an enormous crowd," recalled the producer Jules Buck. "I'd never been in something like that." When the door opened and the passengers debarked, cheers went up and flashbulbs popped as Danny Kaye, Paul Henreid, Evelyn Keyes, John Huston, Marsha Hunt, Jane Wyatt, and others waved to the crowd. But the excitement reached a fever pitch when Humphrey Bogart and Lauren Bacall began making their way down the steps.

"With his actress wife, Lauren Bacall, on his arm," one scribe reported, "Bogart and his associates came as spectators and citizens to buttonhole representatives and urge them to do something about what they called the unfair procedures of the House Committee on Un-American Activities." Many in Hollywood had been horrified at the latest outbreak of congressional anti-Communist fever. Dozens of colleagues were being accused of subversion. The House committee had subpoenaed seventy-nine individuals employed by the film industry and placed forty-three of them on its witness list. Nineteen of those had declared that they would not give evidence. It was a constitutional issue, they argued, an unprecedented assault on the First Amendment.

The crowd of fans followed the celebrities across the tarmac and pressed their faces up against the windows of the terminal to watch reporters pepper them with questions. The travelers were tired, having left Lockheed Air Terminal in Burbank at 7:00 a.m. Along the way they'd made a few stops, where supporters equally as motivated as those in Washington had awaited them. In Pittsburgh, torrential rain hadn't kept the throngs away. Marsha Hunt, shaking hands with the spectators, explained that the point of their trip had nothing to do with communism,

either pro or con. "The point was freedom of thought, of expression, and the public mustn't be taken in," she said. The Hollywood emissaries were calling their organization the Committee for the First Amendment.

Although Huston and the screenwriter Philip Dunne were supposed to be the committee's spokespersons, the media gravitated to Bogart. HUMPHREY BOGART HEADS PARTY OF FILM NOTABLES TO PROTEST ANTI-RED HEARING read one headline. Though Bogie wasn't the best speaker in the group, his marquee value, along with Betty's, was crucial in getting their message out. Before they'd left California, he had made a statement on behalf of the group: "We are against communism and everything it stands for, but we feel the present investigation is a screen to obtain censorship of motion pictures and newspapers."

As the Hollywood contingent was driven to the Statler Hotel on 16th Street, just two blocks north of the White House, Bogie fell asleep in the car. It had been a long day, and they had big plans for the morning. The group would attend the House committee hearing in which Eric Johnston, the president of the Motion Picture Association of America, would be questioned. They also hoped to present a petition to President Harry Truman, and hopefully Bacall's connection to the president would assist them in doing so. Shortly before she'd married Bogie, Betty had been entertaining servicemen at the National Press Club when, urged on by the publicist Charlie Einfeld, she'd jumped on top of a piano being played by then vice president Truman. A photographer had gotten a shot, and the picture had spread like wildfire in newspapers and magazines. The stunt had been good publicity for both Bacall and Truman, but whether it would be enough to get her into the Oval Office remained to be seen.

The members of the Committee for the First Amendment believed that they had right on their side and were convinced they would prevail against the demagogues on the Un-American Activities Committee. A culture war had been brewing since the end of the hostilities with Japan. One side saw an insidious effort to infiltrate Communist propaganda into American novels, newspapers, plays, and movies, using the US-Soviet Union wartime alliance as a cover. The other side saw an infringement of freedom of speech and assembly, comparing the actions of the US Congress to inquisitions under Fascist regimes. In May 1947, Katharine Hepburn, speaking at a rally for former vice president and liberal hero Henry Wallace, had lambasted Truman, who, bowing to the anti-Communist

hysteria, had called for a loyalty test; she compared him to the "thought police of imperial Japan."

The simmering resentments had come to a head when Billy Wilkerson, Bogie's frequent host, had published a column in his *Hollywood Reporter* entitled "A Vote for Joe Stalin" that had named eleven screenwriters, including Dalton Trumbo, Howard Koch, and John Howard Lawson, as Communist sympathizers. It had been followed by similar accusations in the *Chicago Tribune* and the New York *Daily News*, both owned by Robert R. McCormick, a longtime Roosevelt foe who'd been waiting fifteen years to take revenge against a man he believed was a socialist. McCormick had used the 1943 Warner Bros. picture *Mission to Moscow* as evidence of Communist propaganda in American films.

It wasn't long before the Committee on Un-American Activities had pounced on those allegations. The "Unfriendly Nineteen," as the Hollywood holdouts came to be known, were facing jail time for contempt of Congress. Eventually the number was whittled down to ten: the screenwriters Alvah Bessie, Herbert Biberman, Lester Cole, Ring Lardner, Jr., John Howard Lawson, Albert Maltz, Samuel Ornitz, and Dalton Trumbo, the director Edward Dmytryk, and the producer Adrian Scott. That the members of the Committee for the First Amendment had flown to Washington in support of those colleagues was unstated but obvious to everyone.

"Any investigation into the political beliefs of the individual is contrary to the basic principles of our democracy," read the committee's statement of purpose. "Any attempt to curb freedom of expression and to set arbitrary standards of Americanism is in itself disloyal to both the spirit and the letter of the Constitution."

For Bogie, it was becoming personal. Lawson had been one of the writers on *Action in the North Atlantic*. Many others beside the Ten had also been accused, making them vulnerable to blacklisting, including Bogie's old pal John Cromwell, who went all the way back with him to *Drifting* in 1922 and who'd recently finished directing him in the film *Dead Reckoning*. Also smeared was Howard Koch, one of the writers on *Casablanca*.

Everyone on the committee had friends and colleagues who were being singled out for their politics. All liberals were suddenly suspect. The danger to them was real and closer than they knew. The Federal Bureau of Investigation had received a tip about a late-night gathering at director

William Wyler's house on Summit Drive in Beverly Hills, attended by Bogart, Danny Kaye, Judy Garland, Rita Hayworth, Edward G. Robinson, and Gene Kelly. While the actors had talked strategy inside the house, out in the driveway agents had been taking down their license plate numbers, as revealed in Bogie's FBI files.

Riling up the liberals, especially Bogie, was Jack Warner's testimony on October 26, in which he had backed off from his earlier attempts to defend his writers and promised "a pest removal fund [to send] ideological termites" to Russia. The mogul wired Burbank to prevent any bookings of *Mission to Moscow*; the film was withdrawn and not seen for many years. To Bogie and his compatriots, it was clear that there would be no institutional support of their mission.

The same day as Warner's testimony, a couple dozen big Hollywood names were heard on a special radio program called "Hollywood Fights Back." Aired in two parts by the ABC Radio Network, the program cost the Committee for the First Amendment $8,000, but its members believed it was money well spent. Millions of people would hear their favorite stars and directors sound the alarm about what they saw as the threat to American democracy. "We question the right of Congress to ask any man what he thinks on political issues," said Myrna Loy. John Huston called the proceedings in Washington "unconstitutional." Lucille Ball read from the Bill of Rights. Judy Garland, in her best Betsy Booth voice, said that being called bad actors was one thing, but "it's something else again to say we're not good Americans." Bogart intoned seriously, "The committee is not empowered to dictate what Americans shall think."

Jack Warner was furious, but Bogie no longer cared. He'd finally won a measure of freedom from the studio. His new contract was for fifteen years, with one picture a year for Warners and the option of a second picture for another studio. Given the duration of the contract, his lawyers had gone over the terms with a close eye. The studio "could conceivably be willing to find loopholes many years" into the contract, wrote attorney Oliver B. Schwab. He advised that injunctions against Bogart needed to be eliminated, restrictions needed to be placed on the studio's ability to extend the contract, and the morals clause should be dropped. Most important, permission to do unrestricted outside work needed to be expressly stated.

For the first time in his career, Bogie didn't have to back down on any of his demands. When Sam Jaffe presented the terms outlined by

Schwab to Jack Warner, he made clear that Bogart was fully prepared to walk. "The proposition was a matter of take it or leave it," the *New York Herald Tribune* reported. "The studio took it." At last Bogart had control over the direction of his career, being able to choose his scripts and his directors. The contract also made him a very rich man. In 1947, he was paid nearly $300,000 by Warner Bros.; an additional $34,000 came from a television appearance on *The Jack Benny Program*, a series of radio spots on *The Fred Allen Show*, and a product sponsorship with Kraft Foods.

So it was with a sense of impunity that Bogie took a public stand against the same forces that had landed him in front of the Dies Committee seven years earlier. That episode still burned him up. It hadn't silenced him, as some might have hoped; in fact, it had only made him more outspoken. During Franklin Roosevelt's last campaign in the fall of 1944, Bogart had made a radio speech in support of the president. He had been unprepared for the vitriol that had followed. Merely expressing his choice for president—a president who would be elected three times by large pluralities of the American electorate—was enough for some people to call Bogart a Communist.

Agreeing to take part in the mission to Washington was deeply personal for Bogie. Wyler advised them to present themselves soberly, without any movie star trimmings. Philip Dunne warned them that the Un-American Activities Committee could subpoena them. Discussions were held about how to use the Fifth Amendment and the need never to implicate anyone else.

Understanding Bogie's commitment to and passion for the cause is essential, as some later writers, both pro and con toward the House committee, would attempt to minimize his role in the Committee for the First Amendment. He was there just to lend star power, some wrote; he needed convincing to get on the plane; he really hated Communists as much as everyone else did. But Marsha Hunt remembered the fervor that both Bogart and Bacall brought to the effort. They "were angry," she said. "They were there out of conviction, and very strong conviction." Indeed, Betty was still fired up about it thirty years later. "These people saw Communists under every bed," she wrote. "They were convinced that they were the only true Americans—the rest of us were infiltrating films with un-American thoughts."

It was that shared worldview that finally sealed the partnership between Bogie and Bacall. Fired up by a cause larger than themselves, they

were able to move past some of the conflicts they'd faced in the early months of their marriage. Both adapted. For all the fears of Betty's family, the marriage of Bogie and his Baby appeared to be succeeding. Had the young, unseasoned Bacall figured out something her three predecessors had not?

AFTER TWO YEARS OF MARRIAGE, THE BOGARTS HAD SETTLED INTO A PATTERN that worked for them both. There were still occasional miscommunications and bumps in the road. Bogie still drank, but his nights of staying out late and not calling were fewer. He had also made up for his callousness at the time of Droopy's death by surprising Betty with a puppy, the progeny of Louis Bromfield's boxer, Prince, who had memorably trundled up to sit beside them as they'd exchanged their vows at Malabar Farm.

Betty had been enchanted with the new member of the family. They named the pup Harvey, after the first play they'd seen together on Broadway. Harvey "was really smart," Betty recalled. "He knew he wasn't allowed to get on the furniture so he would only put two paws on at a time, and he would sit between us if we had a fight." There would soon be several more dogs in the Bogart household.

By the time of their trip to Washington, Betty, now twenty-three, was much more confident and secure, both as Bogie's wife and as an actress. She had become more experienced in the ways of Hollywood. She and Bogie had made a third picture together, *Dark Passage*, and there was talk of a fourth. It was Betty's newfound confidence, one variable that had changed significantly over the past two years, that anchored the marriage. The couple's political activism became a bond that drew them together. They supported Truman's actions on civil rights and approved of his speech to the National Association for the Advancement of Colored People. The wide-eyed kid who'd been so terrified on movie sets that her body had convulsed with tremors was now a savvy, steady hand strategizing for their mission to Washington. Betty had been the one who had said, "We must go," when the decision was made by the committee to fly east, even before Bogart had agreed.

"Betty was all for it," John Huston said, calling her even more "politically minded than Bogie." She took the initiative to write an op-ed for the *Washington Daily News*, timed for publication as they made their rounds on Capitol Hill. Asking her readers to forget, for the moment, that she

was the girl who'd "said a certain line in a certain picture," she wanted to speak to them as an American citizen. "I think you should be aware of the dangers that arise out of investigations like this. . . . When they start telling you what pictures you can make, what your subjects can be, then it's time to rear up and fight!"

That took courage—reckless, perhaps, but courage nonetheless. Many far more established stars did not speak out as loudly as the young woman with just four pictures under her belt. During that period, Bogie began to see his wife with new eyes. Indeed, his chauvinism must have been challenged by the fact that the delegation of actors who had gone to Washington included as many women as men. Hunt, Keyes, Wyatt—and Bacall—were smart, articulate advocates for freedom of speech. Working shoulder to shoulder with Betty on shared principles was very different from the quarrels over banalities he'd known with Mayo. It may have been his encroaching age as much as anything else, but by 1947, Bogie appears not to have felt the urge to go out on the town with Mark Hellinger and other friends quite as much.

Things had really started looking up for the Bogarts during the summer of 1946, when *The Big Sleep* was finally released. Despite the confusing story line, made worse by the cuts, Jack Warner deemed it "one hundred percent better," and he turned out to be right, at least in terms of the box office. "News of the week is the terrific biz being done by the Strand with *The Big Sleep*," *Variety* reported. "Gigantic from [the] start," the film had set a record for the theater at $86,000 in its first week alone. Critics were mixed in their appraisals, but there was good news for Betty. Hazel Flynn of the North Hollywood *Valley Times* judged: "Baby is still glamorous and she's getting so she can act . . . a little."

What the film did was solidify the Bogart-Bacall brand. *The Big Sleep* might deserve only a "fair rating, but it's great Bogart-Bacall," Flynn wrote. "This, my friends, is a screen team and there's no doubt about it. Born in the news columns, it 'growed' on the fierce white light of notoriety with the result that people want to see them together. The house was packed yesterday with more and more coming. Warners should have a windfall with this one."

The chemistry between Bogie and Baby guaranteed that result. Reviews mattered, but box office mattered more. Any fears that Bacall was fizzling out were gone. She'd become integral to Bogie's stardom, thereby

clinching her own. Their professional success guaranteed their personal success. By 1947, on so many fronts, Bogie and Betty understood they were in this together, the two of them against the world.

In April 1946, the couple moved into a real movie star home at 2707 Benedict Canyon Road, high in the crests of Beverly Hills. The L-shaped ranch house had once been owned by the pioneering producer-director Thomas Ince; later, it had been the home of the sex goddess (and inventor) Hedy Lamarr and her then husband, John Loder, who had called the estate "Hedgerow Farm." After the Loders split up, the Bogarts moved in. The place was sprawling—hardly the small house Betty had once claimed she'd wanted—and isolated. A steep two-mile "driveway" with hairpin curves separated them from the rest of civilization. With its walnut paneling, swimming pool, and "a view of most of California," as one visitor remarked, the house had been Betty's choice, though she'd needed to elbow her husband into agreeing. Even as his fortunes continued to rise, Bogie was still very frugal about spending money.

While Betty set about furnishing and decorating their home, Bogie made the film *Dead Reckoning,* the one with his friend John Cromwell on loan to Columbia. He flew east for location shooting in New York and Florida. Despite his affection for Cromwell, Bogart wasn't impressed with the script, a murder mystery that tried hard, and failed, to be a smart noir thriller. His costar, Lizabeth Scott, told an interviewer that one day Bogie had muttered after a scene, "Isn't this a stupid way to make a living?" Scott was being groomed as the new Bacall, so it's perhaps not surprising that she and Bogie don't ride off together at the end of the picture. Reviewers shared Bogie's discontent when the picture was released in January 1947. Herbert Cohn of the *Brooklyn Eagle* thought that the writers had "fumbled for a way to give the ending an extra twist" and finally given up. But Bogart, opined the *New York Times*, was "beyond criticism"—a telling statement about the status of his stardom at that point.

Dark Passage, the screen reunion of Bogie and Baby, began production in October 1946, with the proficient Delmer Daves both writing and directing. The story of an innocent man framed for murder breaking out of San Quentin, the film was both clever and gimmicky. For the first thirty-seven minutes of the picture, the camera is our eyes; we see mostly from the vantage point of the fugitive. The only time we get a glimpse of

his face is in a photo in a newspaper. Since the camera stood in for the protagonist, other actors had to talk to the lens, which gave the impression that they were looking directly at the audience. As a gimmick, it's effective, but there's also a sense of relief when the subjective perspective ends and we finally see the fugitive's face, bandaged after plastic surgery. It's another twenty-five minutes, however, before the bandages are removed and he's revealed to be Humphrey Bogart. *Dark Passage* would mark the shortest screen time (forty-three minutes) Bogart ever had in his starring pictures.

Daves understood the technical issues he faced. "One of the problems encountered in this unusual camera approach is that the camera at all times had to be kept at Bogart's eye level," the director wrote in his production notes. The doors of the sets therefore had to be heightened to seven feet to accommodate camera magazines with the lens set at eye level. "It was also discovered that it is impossible for a camera to copy the action of a person reclining," Daves explained. Horizontal lines remain horizontal when a subject lies down, but when a camera is turned on its side, they become vertical. The camera had therefore to be lowered rather than turned. Daves made notes about using handheld cameras as well.

Dark Passage broke ground in other ways. Location shooting in San Francisco was not limited to establishing shots. Daves filmed entire scenes on the steep streets of the city, as well as in hotel lobbies and bus stations. In one exciting scene, Bogart and Clifton Young have a brutal fistfight on a bluff at the edge of the Golden Gate Bridge. The crew was also given permission to film exterior shots of San Quentin. Such location shooting would soon become much more common, especially as the studio system declined. "The shots you made in the interior of the hotel lobby are as good photographically as anything you could do at the studio," the film's producer, Jerry Wald, wrote to Daves. "They have more reality, and certainly give a documentary feeling you could never capture at the studio."

The picture also gave Bacall, playing a young woman who assists the fugitive, a different way to shine. "She enacts a loyal and sincere young woman with little of the provocative kind of allure which characterized her first portrayals," the production notes read. Despite the utter implausibility of her story line, she's quite convincing. There's little of the banter

and flirtation of *To Have and Have Not* and *The Big Sleep*, with scenes between her and Bogie instead providing a sense of genuine affection, gratitude, and love. After Betty's three previous cynical, sultry roles, the characterization is refreshing, revealing her softer, more sentimental side. Reviewers took note, treating her much more kindly this time around. It was Bogart who, for a change, Bosley Crowther found, "does not appear at his theatrical best" playing an "uncommonly chastened and reserved" character, while he praised Bacall for generating "quite a lot of pressure as a sharp-eyed, knows-what-she-wants girl." Audiences agreed, turning *Dark Passage* into a gigantic hit, earning $70,000 in its first week at the Strand in New York.

Dark Passage came out just before the Bogarts flew to Washington. It was showing on DC screens while they were there, playing to full houses. Marquees bannered the blockbuster team of Bogart and Bacall. That was the star power they took with them on their mission to the capital. They were Hollywood's premier power couple, and the politicians knew it.

THE MARRIAGE, AFTER A ROUGH START, WAS WORKING. THE ACTRESS EVELYN Keyes, who had recently married John Huston, observed an evenly matched partnership. "We're not talking about love," Keyes said, "that's not an issue." Just as important, she said, was the fact that the couple "respected each other, watched out for each other." Their shared political commitments bonded them. So did the understanding that they were a team, sharing equal billing—above the title, on the same line—and equal press coverage. The one place they weren't equal, of course, remained the payroll; the salary gap between men and women was even more prevalent then than now. But everywhere else there was parity. That meant Bacall was no longer intimidated by her star husband. She could speak her mind; there'd be no more suffering in silence the way she had after Droopy's death. She was a star now, too, and that made all the difference.

Betty was very good for Bogie. He told Gladys Hall that the marriage was "just right," though he admitted that "the others were right, too, but things happened." He said that Betty had come along at the right time. "Things I can give her she wouldn't have had otherwise. Certainly, there

are [also] things she can and does give me." Among them, he told Hall, was laughter. Betty hadn't allowed the fears and resentments she'd felt in the first several months of their marriage to mushroom. She didn't repeat Mayo's mistakes. Her approach to the marriage was twofold. First, she pursued her own career with as much single-minded purpose as Bogie pursued his. Her husband respected her determination, which marked a huge leap forward on his part. "As long as she wishes to go on with her career, it's the better part of valor," he told Hall, "I wouldn't know what to do with a wife who didn't work, who sat around at luncheons, played bridge, canasta." Betty taught him that perhaps women were more than just playthings for him to keep in his pocket.

Betty's second tactic was deployed closer to home. She treated her husband with the respect a daughter tends to show to a father, with the father becoming aware of his responsibility to her and the example he needs to set. Betty's youth and her faith in him had an enormous emotional impact on Bogie. "He saw in her a chance to maybe redeem himself a little bit," said a publicist who worked for Betty occasionally. "This was a young girl [whom] he could guide and help and take care of." His caretaking of his mother and sister had arisen out of a sense of duty. This was different. Bogart, soon to turn forty-eight years old, had never had children; Betty was about the age that a daughter from his marriage to Helen Menken would have been. Possibly some instinctive paternal feeling was awakened in him. "He took care of her," the longtime publicist said. "The idea of hurting her was unbearable. He straightened up because of her."

Howard Hawks agreed that Betty "did a lot of good" for Bogie. "He changed for the better," the director said, "better in all ways." Bacall "was terribly eager to learn, to try things, and she interested him in it." The partnership went beyond career and craft, Hawks said. "His life was broadened and happier and wasn't full of the strife that he found in his early career." Betty motivated him. "I'd probably [just] sit on my boat," Bogart said, "[but] she gooses me."

She also cooled him down. Nunnally Johnson recalled a night when Bogie had hidden out in a restroom because Betty "was giving him hell about his behavior." When he had finally emerged, she had warned him, "Someday, somebody's going to knock your goddamn block off." She'd level those famous eyes at him and hiss, "Humphrey!" when he crossed a line. "Betty would stop him," Johnson said. "She would speak up. She

was a tough dame." Another friend told a *Saturday Evening Post* writer, "Bogie could be difficult to handle when he'd been drinking. But Betty could always handle him, no matter how drunk he got. She was the one person who could."

"He's a complex guy and hard to live with," Betty admitted to one journalist, "but I'm not dazzled anymore. I think I can handle him."

There were fewer benders out on the town. Such incidents upset Betty, and Bogie couldn't bear to see disappointment in his wife's eyes. Nunnally Johnson went so far to say that for the last decade of Bogie's life, his alcoholism was largely an act to maintain the Humphrey Bogart image. "A newspaper person was going to come, a man or a woman to interview him or something like that," Johnson recalled. "[T]he doorbell rang, and he'd go to answer it, and I saw him once come back and pick up a drink and take it with him to the door, because that's the way you ought to meet Bogart, already [with] a drink in his hand." He had also lost one of his most ardent drinking buddies, Mark Hellinger, who had suffered cardiac arrest that some blamed on his heavy drinking. Hellinger had gone in with Bogie on forming an independent production company now that his contract allowed it. Betty recalled Hellinger vowing to cut down on the alcohol after the heart attack to make the new production company work, but it was too late: a second infarction took his life a few months later, in December 1947.

Johnson's contention that Bogie's drinking had become an act, however, is true only as far as it goes. Bogie never stopped drinking entirely; he merely "changed his way of drinking a lot," his wife wrote in her memoir. Although public brawls still occurred, they were fewer, which seemed enough for Betty. Late in life, she even denied that Bogie had qualified as an alcoholic. "Not even close to that," she insisted. "His drinking was all partying and having a great time." She was expressing the shortsighted belief that so long as you kept your job and didn't get into major car accidents, you were not an alcoholic. But in fact, Bogart was still battling to keep his demons at bay, and after his fourth marriage, there were new ones to contend with. His son wrote, "A lot of Dad's fears came to the surface when he drank," and in the early days of his marriage, "one of them . . . was that he would lose Bacall." Bogie saw himself as old and unattractive, while Betty was still in her prime.

But to whatever extent Bogart's drinking moderated, Bacall should share in the credit. "Bogie drank because he was insecure," Bacall told

her son. "Once he realized he had emotional security and professional security, too, he cut back on his drinking."

He mellowed in other ways as well. Bogart no longer felt the need to assert his masculinity around effeminate men, possibly because his wife was friends with so many of them. He enjoyed Truman Capote, for example, then embarking on his literary career and never, ever, disguising his flamboyant affectations. "When they first met," Bacall remembered, Bogie "kind of couldn't believe he was real." But they became "great, great buddies," especially after Capote beat him in arm-wrestling contests. Bacall would also tell a rather improbable story of Noël Coward making a pass at Bogie, who told him, "Noël, if I had my druthers and I liked guys you would be the one I'd want to be with. But unfortunately, I like girls." The anecdote was almost certainly apocryphal, but the sentiment it conveys—that Bogart was no longer as uncomfortable around gay or effeminate men as he had been—seems to be the point.

Clifton Webb was another friend, a former Broadway dancer who became an unlikely movie star after his arch role in *Laura* (1944), despite a Fox studio official warning the director, Otto Preminger, "He doesn't walk, he flies." Like Truman Capote, the effete Webb never attempted to hide his homosexuality. Bogart admired him as an actor, naming him as among the best in Hollywood. He did maintain some delusions about gay men, however, insisting that Webb had been in love with one of his dancing partners early in his career and would have married her if it hadn't been for his mother, who was his constant companion in Hollywood.

Perhaps the most notable expression of his newfound equanimity was his inclusion of his sister in gatherings at his home. Heretofore, not many of his friends had met Pat. But by the mid-1940s, Pat was calm and apparently content, the result of medication and therapy. But the lobotomy—and there may have been more than one—had also left her somewhat vague and absent-minded. When she visited Bogie's house, she tended to peer through the windows before knocking on the door. "Don't pay any attention," Bogie told Richard Brooks on one occasion when the director spotted what he took to be an intruder lurking outside. Bogie told him that Pat always looked in the windows before she came in "to see if everything was all right."

To his credit, Bogie never seemed to resent his sister. Indeed, he grew increasingly fond of her over the years, no matter how many times she showed up dreamily at his door. "He always spoke glowingly of her,"

recalled Joe Hyams. "I always sensed he was kind of proud of her in a way." Pat had taken all that life could throw at her and, despite her problems, was still standing, even if a little worse for the wear. Her brother often felt the same way.

THE OTHER SIGNIFICANT VARIABLE, OF COURSE, THAT HAD CHANGED IN THE previous two years, facilitating a measure of equanimity on Bogart's part, was the fact that he no longer felt like an indentured servant to the studio. The first film on his new contract was *The Treasure of the Sierra Madre*, filmed between March and May of 1947. Bogie had originally planned the film to be his first independent production with Mark Hellinger, and his original choice for director had been Howard Hawks. But *the property* might not be the best choice for the company's first feature, Sam Jaffe argued. If it went over budget, which Hawks usually did, it could "seriously jeopardize future deals." So *The Treasure of the Sierra Madre* became a Warner Bros. picture.

There was also the question of John Huston, who'd been working on the script for a few years with an eye toward repeating his writer-director success on *The Maltese Falcon*. The project came together when Jack Warner agreed to let Huston assume full creative control. Initial production took place on the Warners lot; some location shooting in the mountains outside Sacramento followed. But most of the film was shot in and around the small city of Tampico in the Mexican state of Tamaulipas. At its heart, *The Treasure of the Sierra Madre* is a morality tale, a meditation on greed and character. It was also designed to be a fast-paced, bandit-shooting adventure through the bleak yet beautiful terrain of central Mexico.

Three drifters, one young, one middle-aged, one old, band together to prospect for gold, but their success breeds distrust and paranoia among them. Huston took pains to make sure none of the three was "black and white," entirely bad or entirely good. Although Fred C. Dobbs, the middle-aged fellow, played by Bogart, turns out to be the film's chief villain, Huston didn't want him to be a "thorough rotter"; neither did he want Bob Curtin, the youngest member of the team, played by Tim Holt, to be entirely "goddamn virtuous." So scenes were written to give shading to the characters. Dobbs is at first generous, sharing his lottery earnings with Curtin; Curtin at one point agrees to kill a man who has

discovered their mine (although the bandits get him first). It would be a picture, Huston intended, in which the bad guys and the good guys were one and the same.

The Treasure of the Sierra Madre was an unusual film for a major Hollywood studio in other ways. Not only was there no clear hero, there also wasn't a love story, something that, except for some action films made during the war, usually spelled box-office disaster. We see only two women in the film, both prostitutes; one is played, uncredited and in long shot, by Ann Sheridan in "a good-luck gesture" to Huston. The story eschews romance to focus on the relationships among the three prospectors. The part of the wise old man, Howard, was given to Huston's father, Walter Huston, whose stage and film credits stretched back to 1924. (He'd worked with Bogie on the radio adaptation of *Henry IV* eleven years earlier.) The elder Huston, who'd once played Abraham Lincoln, had a commanding presence that shone through in his performance as the crusty, unshaven old coot. He becomes the film's sage and, in many ways, its protagonist. He's the most consistently likable character in the film.

The prominence of Huston's part appears to have given Bogart some pause. Sam Jaffe recalled his client asking him what he'd thought of the script for *The Treasure of the Sierra Madre*. When Jaffe said he'd liked it, Bogie "made a face." Jaffe quickly figured out his concerns. The character of Dobbs is killed by bandits *thirteen minutes* before the end of the picture, leaving the final resolution to Holt and Huston and the final word to the latter. It had been clear from the first read of the script that the director's father would outshine everyone, even with Bogart getting top billing. "[He] steals the picture," the author of the novel on which the film was based wrote to John Huston. "Don't let Humphry [*sic*] know."

Jaffe wasn't about to let Bogie's ego keep him off the film, however. He told his client, "I don't know if you are considering not doing this. . . . There is nothing wrong with being second in a movie that stars Walter Huston." Dobbs's character was complex, the sort of role Bogie was always looking for, and he got to go mad on-screen, which was always a draw for actors. Jaffe was soon writing to director Huston, praising the script and assuring him that Bogie was "very happy about doing the picture."

On April 6, 1947, accompanied by Bacall, Bogart took a long, bumpy flight to Mexico City. With them was Evelyn Keyes. After many delays, the three arrived, white-faced and staggering. But Huston had no time

to waste. They had mountains to climb, deserts to cross. He cast himself in a cameo at the top of the picture as a white-suited gringo who tosses a few pesos to Dobbs. After that, in a film shot largely in sequence so the actors' beards could grow naturally, Huston stayed behind the camera, pushing his actors ever farther in their endurance.

"We worked as hard, or harder than, we do at the studio," Bogie said. "It was all [Huston's] fault. That guy is an ibex when it comes to climbing mountains, and he expected us to ibex along with him." The director proved to be unrelenting. "If we could get to a location site without fording a couple of streams, walking through a nest of rattlesnakes, or scorching in the sun, then he said it wasn't quite right." Cast and crew called him "Hard Way Huston."

Although the anecdote was lighthearted, there was apparently some tension as the shooting dragged on. Bogart was anxious to be done so he and *Santana* could compete in the famed Los Angeles–to–Honolulu yacht race. At one point, he got right up into Huston's face and ranted about how long it was taking to finish the picture. Reportedly, the director grabbed Bogie's nose and twisted it hard—hard enough for Bogie to turn red and for Betty to cry out. Huston would describe the incident as "our one and only quarrel."

It's a funny, typically Bogart-and-Huston story, but there's a problem with it: Bogie, along with Betty, Tim Holt, and Walter Huston, returned to Los Angeles on May 31; the race was not until July 4. Even with some final studio production, it seems unlikely that Huston would have denied his friend a chance at a trophy when they had more than a month to wrap things up. Much was made of Bogie dropping out of the race due to his "film commitment," but there may have been more to his decision. He was a good sailor, but Honolulu was 2,225 miles from San Pedro, the race's starting point; Bogie had never attempted anything that far. Indeed, when he'd signed up, he'd kept his expectations low. He refused to say definitively that he could win, for "that would be like an amateur coming to Hollywood and announcing he's going to win the Academy Award."

There's also the fact that Bogie was set to start production during the second half of July on *Knock on Any Door*, the first film by his independent company, Santana Productions, named for his boat after the death of Mark Hellinger. The trip across the Pacific from San Pedro to Honolulu would take more than two weeks. The eventual winner of the race,

the character actor Frank Morgan, better known as the Wizard of Oz, made it in sixteen days, sailing into the harbor on July 22, but others kept coming in over the course of a week. Did Bogie really think he could get there fast enough to be able to rush back to the mainland and start work on the new film? As the president and principal stockholder of Santana, he had a lot riding on it. Though he was no doubt disappointed to have to withdraw from the race, it's also possible that he, or his publicists, exaggerated the situation, wanting to imbue the story of the Bogart-Huston tussle with a little high-stakes, transpacific drama.

But the true drama awaited in Washington, DC.

AFTER GETTING SOME MUCH-NEEDED SLEEP, THE DELEGATION FROM THE Committee for the First Amendment stepped out into the bright Washington sunshine and made its way up Independence Avenue toward the Old House Office Building. Directly across the street, the dome of the Capitol gleamed in the morning sun. Bogart and Bacall led the group. Traffic was briefly halted by Metropolitan Police officers as news photographers swarmed around the Hollywood stars.

Once inside the building, however, the fanfare ended. The group quietly took their seats in the back of the hearing room; Betty remembered that the seats had been reserved for them, but news reports at the time said they were the only ones available in the packed room. Banging the gavel was the chairman of the Un-American Activities Committee, J. Parnell Thomas, a Republican from New Jersey. "He was improbable either as hero or villain," recalled the investigative journalist Jack Anderson, who was often in the front row of the hearings. "He was . . . fat, with a bald head and a round face that glowed perpetually in a pink flush. But as it turned out, his flat idiom and disarming corpulence concealed an unsuspected capacity to cultivate unreality, or rather, to parody reality. This was to be his passport to power and fame."

In his ten years in Congress, Thomas had built a reputation as a tough critic of Franklin Roosevelt and his New Deal. He charged that Roosevelt's intention was to sabotage capitalism. He was also a vociferous opponent of government support for the Federal Theatre Project, accusing the project of fostering Communist propaganda. As chair of the Un-American Activities Committee, Thomas finally had his chance to stop all of that.

But for all the authority Thomas wielded at the front of the room, sitting in the back was another man, whose solemn, penetrating observation of the proceedings unnerved some members of Congress. This was Humphrey Bogart, after all, the epitome of rough-hewn masculinity and straight talk, not some frivolous performer who could be dismissed as a dilettante. This was Sam Spade, Rick Blaine, Philip Marlowe, and Mad Dog Earle. This was Hollywood's biggest tough guy, who could play both heroes and villains and win the girl regardless. Jack Anderson observed, "He intimidated them, and they resented it."

Thomas had a plan, however. Very likely because he knew that the Hollywood delegation would be in attendance, he had scheduled a surprise witness for that day. Bogart looked up to see John Howard Lawson, his former screenwriter, being sworn in to give testimony. Lawson was a volatile character, and Thomas knew it. He began by withholding permission for Lawson to read his opening statement, in which he'd planned to denounce the informers as "a parade of stool pigeons, publicity-seeking clowns, [and] Gestapo agents." Lawson became enraged, which was likely what Thomas had counted on. "I'm not on trial here, Mr. Chairman," Lawson shouted as the chairman's gavel echoed throughout the room. He answered the question of whether he was now or ever had been a member of the Communist Party of the United States by accusing Congress of trying "to get control of the screen." Thomas cut him off: "Answer directly!" When Lawson, red in the face by now, kept blustering, the chairman ruled him out of order. "Stand away from the stand," he directed. Lawson refused. Capitol police had to step in.

In the audience, there was shock and disbelief at what they were watching. Bogie got onto his feet. This whole thing, he believed, had been orchestrated by Thomas, who knew that by goading Lawson, he could make everyone else look bad, including the members of the Committee for the First Amendment. Thomas had probably hit his gavel a hundred times during the exchange, making sure he was close enough to the microphone for the sound to obscure whatever Lawson was trying to say. He did the same to other witnesses that day. "I couldn't believe what was going on," Betty wrote in her memoir. "That jerk up there with his title had the power to put these men in jail. I was full of sound and fury, sounding off at the drop of a hat."

Back at the Statler Hotel, the Hollywood cohort, fired up, called a

press conference. It went as badly as the hearing had. Bogie denounced "the censorship of fear by Congress," but the gathered newshounds asked if the Committee for the First Amendment had been hoodwinked into believing that Lawson and the others weren't members of the Party. The larger issue of freedom of speech and the right not to incriminate oneself seemed forgotten, despite how strenuously Bogart, Dunne, Huston, and Bacall tried to argue it. At one point, Betty turned angrily on a reporter and asked him how he'd feel if Congress turned its investigations on the press. She had become a warrior for the cause. But the cause seemed to be crashing down around them.

The CFA hadn't expected that turn of events. Even otherwise sympathetic lawmakers were denouncing Lawson's outburst. The prevailing attitude was that the Hollywood Ten had dug their own graves by being belligerent. And what about the members of the CFA? The reporters gathered at the hotel were not sycophants like the writers from *Photoplay* and *Modern Screen*, whose job was to make the stars look good. The Washington press corps, rather, seemed to be attempting the opposite, heckling Danny Kaye when he tried to make a joke and demanding that the actors and directors prove that they hadn't been duped by devious Communists. Betty wrote that Bogie had been asked point-blank, although she didn't say by whom, to issue a statement affirming that he was not a Communist and that he denounced the Hollywood Ten. "This," Betty recalled, "he refused to do." John Huston was stunned by "how the papers had turned" against them. "We had all kinds of support, up until the testimony. And then—the whole complexion changed. From then on, opinion was against us."

The Hollywood delegation left the press conference crestfallen. Both Truman and the Speaker of the House had refused to meet with them and receive their petitions. Their hope of making a difference had been dashed. "As politicians, we stink," Bogie told a reporter from *Life*.

But did they really? The conventional account of the Committee for the First Amendment has painted them as failures, well-meaning patsies who found themselves in over their heads in the world of high-stakes politics. But this view simply perpetuates the narrative set by Thomas when he charged Lawson, Dalton Trumbo, Albert Maltz, and Alvah Bessie, and others to come, with contempt of Congress. The fierce, indignant response of the Hollywood Ten has been portrayed as an untenable political

strategy that doomed the movie industry's principled stand against congressional overreach. Less has been said about the moral indignation that had caused their belligerence.

For all its perceived failures, the Committee for the First Amendment had stood up when few others were willing to do so. Most public figures continued business as usual, steering clear of the controversy. The members of the CFA may have been neophytes in knowing how to deal with the cutthroat Washington press, but they were not naive amateurs blundering in where they didn't belong, as the coverage then and over the years has portrayed them. They were American citizens whose cogent arguments came to be seen in the clear light of history as moral and just. Marlon Brando, then making a name for himself on Broadway, would face a different, but not entirely dissimilar, moment a couple of decades later, during the Vietnam War and the Watergate investigations. At what point in a national crisis, Brando asked, does business as usual become complicit in the problem? For public figures, staying silent, he said, was "morally wrong." (It's likely no coincidence that Bogart, unlike many in the industry, admired and respected Brando.)

After the hearings, Bogart, Bacall, and their compatriots faced tough headwinds in getting their message out. The press mocked them. "Hollywood's march on Washington [was] conducted with the sedate reserve of a circus parade," wrote the *Kansas City Times*. Right-wing columnists such as Walter Winchell and Hedda Hopper reported on how favorably Soviet newspapers were covering the Hollywood Ten. The *New York Times*, reporting that the Soviets had expressed gratitude to the Committee for the First Amendment for their "complete support" of the accused, made sure to remind its readers that the CFA's mission to Washington had been led by Humphrey Bogart and Lauren Bacall. Even the name of the chartered plane the celebrities had flown on, *Star of the Red Sea*, was used to impugn them.

For some of them, the danger didn't end there. Congressman John Rankin, a Democrat from Mississippi and member of the Un-American Activities Committee, revealed that Danny Kaye's real name was Kaminsky (actually Kaminsky), June Havoc's was Hovick, and Edward G. Robinson's was Goldenberg. Rankin's implication was obvious: that Jews were un-American and supported a Communist takeover. Betty, interestingly, was not included in Rankin's diatribe, even though her family

name of Weinstein had previously been reported in the press. Perhaps her youth kept her off the list. But the whole thing was no doubt still deeply offensive and terrifying for her.

Americans were suddenly fearful of anyone who seemed different from them. The "othering" of Jews, Communists, African Americans, homosexuals, and others would define the next two decades of American politics, with the public growing increasingly paranoid, believing that those "outsiders" threatened the American way of life. It was the same period, after all, when sightings of flying saucers were commonplace. The media knew that stories of surreptitious Communists and their fellow travelers sold newspapers and boosted audiences for radio programs, not unlike the stories of little green Martians landing and intent on taking over the earth.

For a time, the CFA remained defiant. On November 2, the committee bought more radio time, broadcasting objections to the treatment of the Hollywood Ten from various cities; Bogie and Betty headed up the commentary from Los Angeles. "This is Humphrey Bogart," he intoned, the famous clipped, straightforward voice coming into American living rooms across the nation. "We sat in the committee room and heard it happen," he went on, sounding very much like Rick Blaine. "We saw it—and said to ourselves, 'It *can* happen here.'"

But on the same day as the radio broadcast aired, word came that the so-called subversive plays *Awake and Sing* and *Watch on the Rhine* were being banned on Broadway. Whether the films of such outspoken stars as Humphrey Bogart and Katharine Hepburn "also would be banned has not yet been revealed," reported the *New York Times*. The prospect that his films might actually be banned must have made the danger very real to Bogie. But he and Betty were already feeling the repercussions. They were informed by Warner Bros. that the background of their upcoming film *Key Largo* would be switched from the Spanish Civil War, in which Communists had been part of the fight against fascism, to the Italian peninsular campaign during the Second World War, so the heroes could be good, loyal Americans.

A tinge of subversion now stained the public images of Bogie and Baby, who just a few months earlier had been America's sweethearts. Hedda Hopper was gunning for them, particularly Bogart. It was Bogie's name she listed first in her attacks on Communist sympathizers, declaring that she had many letters in her files that answered the question he'd

asked on the radio: What does the public feel about the actions of the Committee on Un-American Activities? Hopper printed a few of them: "We will attend no more movies made by those who are not happy to say they are not Communists but honest-to-goodness Americans." "Why not stop immigration until we clean out the undesirables that have poured into our country for too many years?" She quoted only one letter in support of the Hollywood Ten, making sure to print the correspondent's name, Jules Levine, while keeping all the others anonymous.

In her file of allegations against Bogart, Hopper kept a letter from the singer Florence Crosby, the wife of Bing Crosby's brother and manager Everett, praising her for the "wonderful job" she was doing on "behalf of Americanism." Crosby wondered how soldiers maimed in the war must have felt "when they read that Bogart, Bacall [and the others] went to Washington to protest against a committee that was merely trying to find out who the traitors to our country are."

In January 1948, the Hollywood Ten began their prison sentences. The blacklist against dozens of writers, actors, directors, and producers commenced, with many losing their careers. The film industry was at an inflection point. Voices were silenced. If you wanted to survive, you went along with the line that Communists and their supporters did not deserve to live or work in the United States of America. It was a painful outcome for those who had flown east.

"I don't know now whether the trip to Washington ultimately helped anyone," Betty wrote. "It helped those of us at the time who wanted to fight for what we thought was right and against what we knew was wrong." That's precisely the reason why the sincere and idealistic trip to the nation's capital taken by the Committee for the First Amendment still resonates today. But at the time, its members understood that a reckoning loomed for all of them, and none had more to lose in that reckoning than Bogart and Bacall.

Burbank, California, a Weekday in Early January 1948

Bob Thomas, a reporter for the Associated Press, was treated to quite a show when he visited the Warner Bros. studio where John Huston was shooting *Key Largo*. Walking onto the back lot, Thomas found the picture's two stars, Humphrey Bogart and Edward G. Robinson, eyeing each other like a couple of tomcats. Robinson, Thomas reported, had just discovered that Bogart had burned a hole in the upholstery of his sedan, something the man who'd played Little Caesar wasn't likely to forgive. "All right, you mug," muttered Robinson, "I'm going to get tough, see?" To which Bogart snarled, "Oh, yeah?" They faced off against each other, much as they'd done in *Bullets or Ballots* and *Kid Galahad*. "This repartee continued for ten minutes," Thomas told his readers, "and I'm not sure whether they were kidding."

Of course they were kidding, and Thomas, an obliging collaborator in the studios' mythmaking, knew that. Blurring actors' real selves and the characters they played on-screen was standard Hollywood playbook. Antagonists in their four previous films together, Bogart and Robinson were once again at each other's throats in *Key Largo*, so maintaining the illusion of a rivalry was to everyone's benefit. But the truth was quite different: the two actors, both targets of anti-Communist hysteria, were friends, which meant that Bogie was sensitive to the way their box-office clout had reversed since 1940. In their first four films, Robinson's name had been above the title and Bogart's somewhere down below. Twice they had killed each other at the finish; another time Robinson had offed Bogart; and in the fourth film, Robinson had turned Bogart over to the police.

But now the lay of the land had changed. Bogie was the fifth biggest moneymaking star in 1947. None of his chief rivals of a decade earlier— Robinson, Raft, Cagney—made the list that year or at any time afterward. For *Key Largo*, it would be Bogart's name that came first, and for the first time, he would get to kill Robinson and live to talk about it.

Graciously, he insisted that he and Robinson be called to the set at the same time; he wasn't interested in any grandstanding. The courtesy he showed his costar was evidence of how magnanimous Bogart could be. For all his ambition, he had never been one to care much about star protocol or the trappings of fame. Robinson would write in his memoir how grateful he'd been to Bogie during the making of *Key Largo*.

Huston shot the film between December 1947 and March 1948, at the height of the controversies involving the Committee for the First Amendment. Production was largely confined to the Warner Bros. back lot, although the previous month Huston had shot some location footage of the Florida Keys, particularly the Seven-Mile Bridge, which connects the islands. In the film, Bogie played a decorated army veteran who, according to the director, "has lost faith in humanity" after seeing his buddy killed in the war. The characterization was classic Bogart, the cynical outsider whose essential decency is revealed by the film's end.

Major Frank McCloud arrives in Key Largo to pay a call on a dead friend's widow (Bacall) and father (Lionel Barrymore), who run a hotel on the island. Unbeknown to them, a mob of gangsters has taken up residence at the hotel. The thugs eventually reveal themselves and their leader, Johnny Rocco (Robinson), a onetime mobster nostalgic for the days of Prohibition when he'd ruled the underworld with bootleg liquor. Rocco and his men hold Bogart, Bacall, and Barrymore hostage. But then a hurricane strikes, the gangsters can't leave, and everyone's lives hang in the balance. In many ways, it's *The Petrified Forest*, with Robinson a more megalomaniacal Duke Mantee and Bogart a less dreamy and more cynical Leslie Howard.

Huston intended *Key Largo* as a subtle commentary on the House Un-American Activities Committee and the growing climate of fear and paranoia. Huston and coscreenwriter Richard Brooks "have modernized Maxwell Anderson's great play with a view toward showing the postwar confusion of the disillusioned veteran and the threatened resurgence of American violence," the film's producer, Jerry Wald, wrote in *Variety*. In the film, Robinson stands in for Parnell Thomas, ensnaring and humiliating anyone who stands up to him. Lording over the hotel, the gangsters trample on norms of decency and conscience. Bacall and Barrymore refuse to go along, but Bogart initially capitulates. "I had hopes once," he says, "but gave them up."

It's impossible to watch that scene without considering what Bogart,

in real life, had been through during the past few months. In the days after the trip to Washington, while they'd cooled their heels in New York, Bogie and Betty had remained defiant, refusing to obey Jack Warner's demand for a public apology. Bogie told one newspaperman that he'd spent $2,000 on the radio spot and believed that the principles they'd espoused were "well worth the outlay." He was no Communist, he said, but he refused to apologize for the stand he had taken.

That line would prove increasingly difficult to walk. The columnist Ed Sullivan, a friend of both Bogie (since his William A. Brady days) and FBI director J. Edgar Hoover, placed a call to the Bureau to find out "anything [they] could tell him about Bogart" because he did not want to be duped by the actor "[selling] him a bill of goods." What, if anything, the FBI revealed about Bogart isn't clear—Bogie's file is just circumstance and innuendo—but not long after, Sullivan cornered his old pal at a charity event at Madison Square Garden. "He bawled the life out of me," Bogie recalled. Sullivan told him, "The public is beginning to think you're a Red. Get that through your skull, Bogie!"

More pressure likely came from investors in the first picture being produced by Bogie's production company, to be made in partnership with the producer David O. Selznick. Memos in Selznick's papers suggest his concern about Bogart's position in opposition to the Thomas Committee. Could the future of his independent production career be at stake because of the controversy? Bogie may have thought so. For whatever reasons, by the end of November 1947, Bogart, like Frank McCloud, had made the decision to capitulate.

On a stopover in Chicago during the train ride to Los Angeles, the Bogarts held a news conference. Surrounded by writers from all the major news outlets, a somber Bogie read a prepared statement, one that had the fingerprints of Warner publicists all over it. "I am not a Communist, I am not a Communist sympathizer," he said. "I detest Communism just as any other decent American does." The trip to Washington had been "ill-advised" and "impetuous," he said, "even foolish." But, he added, "At the time it seemed the thing to do." Bacall was at his side, and after Bogie was through, she told the assembled scribes that she agreed "one hundred percent."

In Hollywood, Jack Warner gloated in a telegram to his East Coast office: BOTH BOGART BACALL ARE BENDING BACKWARDS BEYOND THE FLOOR. But the studio chief may have been the only one satisfied by the

recantation. Bogie's critics on the right didn't believe him: the columnist George Sokolsky demanded that Bogart "tell all" he knew about who had sponsored the trip to Washington. Meanwhile, his friends on the left felt betrayed. Paul Henreid never forgave him. "The only man who behaved badly was Bogart," he said. "No character, no nothing. A shit."

A *Washington Post* editorial expressed disappointment in Bogart's statement: "Here is illustrated the terrible danger of [the Un-American Activities] committee's irresponsibility. An actor, dependent for his livelihood upon popular acceptance, could be ruined by Representative Thomas—and without any redress whatever." The Committee for the First Amendment, the *Post* wrote, had "rendered a real service to the industry for which it spoke and the concept of freedom it sought to defend. . . . We feel rather sorry for Mr. Bogart. He had nothing at all to be ashamed of until he began to be ashamed."

Bacall did not mention the episode at all in her memoir. To their son, she tried to explain it away by saying that they'd been misled by the CFA into thinking that none of the Hollywood Ten was, in fact, a Communist, and Bogie had been angry when he had found out that some were. Stephen Bogart wasn't buying the excuse. His father's capitulation would be a legacy he struggled with for much of his life. "It seems to me that if Bogie and the others went to Washington to defend a principle, not the ten accused," the younger Bogart wrote in his memoir, "then that principle didn't change just because some of the ten really were Communists. . . . Maybe he was just trying to save his career. Maybe he was a human being and was expressing the simple human desire for self-preservation." No matter what his reasons, Stephen believed that his father was wrong to have said what he did.

John Huston agreed. "I felt Bogie was out of line," he admitted, although he forgave him after seeing his hangdog face. He may also have given him a bit of redemption in *Key Largo* in the character of Frank McCloud. The ex-serviceman understands what he's given up by becoming cynical. Rocco challenges him about why he'd fought in the war: "Why'd you stick your neck out?" McCloud replies, "No good reason." Except for the fact that he "had believed some words," and then he quotes from Franklin Roosevelt's 1942 State of the Union address: "But we of the United Nations are not making all this sacrifice of human effort and human lives to return to the kind of a world we had after the last world war. . . . We are fighting to cleanse the world of ancient evils, ancient ills."

Toward the end of the film, McCloud has a last-minute change of heart and stands up to, and eventually destroys, Rocco and his men. But in real life, at least so far, Bogart had shown no evidence of a change of heart. For many of his friends who had felt betrayed by his "ill-advised and impetuous" comments, *Key Largo*, and Bogie's portrayal, may have left them cold.

Robinson has the showiest part, with Bogart and Bacall mostly underacting. Claire Trevor steals the show as Rocco's former moll who's devolved into a hopeless alcoholic. The production was filled with bonhomie, with Bacall calling *Key Largo* one of her happiest movie experiences. There are many in-jokes in the film that were not immediately discernible to the moviegoing public. McCloud is a skilled sailor, and the boat he uses in the final scenes is called *Santana*. Another in-joke, however, was deliberately cruel. At one point, Rocco forces his former girlfriend, who's drunk and miserable, to sing a song—the most excruciating scene in the picture. Rocco remarks that she was once a "little wildcat . . . scratched, kicked a bit. A regular hellion. She even stuck a knife in me once. Her name was Maggie Mooney." It seems obvious that Huston intended to evoke Mayo Methot, with the alliterative initials and the mention of a knife. Even three years after Methot had faded gracefully into obscurity, Huston still viewed her as fair game. His concern about scapegoating and defamation of character did not always appear to extend to women.

For Bacall, the camaraderie on the set may have masked some professional discomfort. She's very good in the film: solid, grounded, full of integrity. But it's not much of a role. She does nothing to move the plot forward; she's just there to react to Bogart's moral quandary. There's a hint of romance between them, but nothing is stated. To justify her above-the-title billing, it would have made sense for Bacall to have been the one to smuggle the gun to Bogart, enabling him to overpower the gangsters. But Huston and Brooks had created an entirely separate character to do that. Claire Trevor's part had not been in the Maxwell Anderson play; Huston made her the key to the entire film. After being so sadistically humiliated by her lover, it's fitting that Trevor is the one to get the gun and thereby provide the film with its resolution. Possibly they didn't feel that Bacall was up for the task. Mostly, Betty just glowered and stiffened her back, though the scene where she spits in Robinson's face is a sight to behold.

The problem Betty was facing was that Hollywood no longer seemed

to know what to do with her. She was very good—few were better—at playing the insolent, mysterious femme fatale, but such portrayals weren't going to sustain her forever. Another problem was her resistance to trying new things, especially when Bogie wasn't at her side. She was suspended by Warner Bros. for refusing to appear in the film *Romance in High C*, directed by Michael Curtiz, because she wanted to remain with Bogie in Mexico, where he was making *The Treasure of the Sierra Madre*. "Can't quite understand your reaction," Jack Warner cabled her at her hotel in Mexico. "Come to studio immediately to discuss your part." She didn't and was therefore put on suspension. It's possible that the real reason for her refusal was the fact that she'd be billed second to Janis Paige. In any event, the film, renamed *Romance on the High Seas*, became a breakout hit for the new actress who was put into Bacall's part, Doris Day.

Betty also turned down *Cheyenne, Stallion Road*, and *Whiplash*, two westerns and a noir, none of which was brilliant but might have established her as a more versatile leading lady. Unlike his wife, Bogie had paid his dues, slogging through programmers before appearing in *Dead End* and *High Sierra* and achieving the career he'd always wanted. Betty wrote in her memoir, "My career had not been booming," which was rather an understatement, and some of the blame for that can be laid at her own feet. Her disputes often ended in suspension.

Betty seemed, in fact, to be goading Warners into firing her; Bogie was free, more or less, and she wanted to be, too. Soon after completing *Key Largo*, she got into a shouting match with Jack Warner over the telephone, refusing to be cast in *The Girl from Jones Beach*, a lightweight comedy mystery starring Ronald Reagan in which an intelligent, successful teacher is fired from her job after a photo of her wearing a bathing suit is published in the newspaper. The teacher fights back in court and wins. But Bacall saw nothing redeeming about the project. She told Warner that the script was "vulgar," and she refused to even consider the part if she had to wear a bathing suit. When the studio boss demanded that she cooperate, she snapped that she still regretted having done *Confidential Agent*. Another suspension followed. Two years would go by without Lauren Bacall on the screen.

That was dangerous, given how short moviegoers' memories could be. But Betty wanted out. Five days after the rancorous call with Warner, she sent a formal request to the studio asking to be released from her contract, arguing that her "special, unique, extraordinary, and intellectual"

services were not being used effectively. "Jack Warner kept giving me terrible scripts and I kept going on suspension," she wrote. She was also no longer happy with Charlie Feldman, who couldn't get her contract broken and who, she believed, no longer "gave a damn" about her career. So she took the suspensions and stewed.

The hiatus of Bacall's career may not have been as unintended as it seemed. In the spring of 1948, right around the time of her argument with Jack Warner, she learned that she was pregnant. She'd remarked to Morgan Maree a year earlier, while still in Mexico, that there hadn't been "much 'chica-chica' lately" between husband and wife, "but give us time." That sounds as if she and Bogie may have been trying to have children. Or, possibly, only one of them had been trying. It's notable that Betty's chief concern after getting the news was how her husband would react. As it turned out, the announcement that he was going to be a father would be quite the surprise for the nearly fifty-year-old Bogart.

BOGIE WAS NOT AGING AS WELL AS MOST OF HIS CONTEMPORARY MALE STARS. Cary Grant, Clark Gable, Gary Cooper, Spencer Tracy, all within five years of his age, still turned up at award shows and nightclubs looking debonair and vital despite a sprinkling of silver in their hair and a few lines on their foreheads. James Cagney, a few months older than Bogie, retained a youthful puckishness. Bogie's face had been showing the ravages of alcohol and tobacco since his thirties. Now hundreds of little lines surrounded his lips, etched deeper every time he inhaled on a cigarette.

His smoking may have aged him even more than the booze. He consumed several packs of unfiltered cigarettes a day. His fingertips were brown with tobacco stains, and a persistent cough rattled up from his lungs. In 1948, few people understood the full dangers of cigarette smoke. People were accustomed to the smell of tobacco on the breath when they kissed or talked to each other. They moved through a blue haze of secondhand smoke in restaurants and workplaces without a care. After a night out at a club, people's clothes reeked of tobacco smoke the next morning. On the sets of Bogart's pictures, most everyone was puffing away. Bacall smoked, too, sometimes one cigarette after another when she was anxious or angry. Her husky voice was getting huskier.

The most obvious sign of Bogie's aging, however, was not self-induced

but rather genetic. When *The Treasure of the Sierra Madre* was released, the problem of his hair loss was impossible to ignore. His hair was falling out faster than ever. The producer, Henry Blanke, had asked the makeup director, Perc Westmore, to provide wigs for the star since "he has practically no hair left." In one scene, Dobbs gets a haircut; afterward, his combed-back hair reveals a forehead that extends well over the top of his head. For all his expertise, Westmore lacked the skill to successfully blend the hairpiece into Bogie's own hair. He placed it too far back on his head, which made the seam visible to sharp eyes. Bogart was rarely vain, but like many middle-aged men, he was sensitive about losing his hair. What he needed was someone who could convincingly create the illusion of a full head of hair. Namely, he needed Pete.

Pete had, in fact, made the wigs for *The Treasure of the Sierra Madre*. The problem was that she hadn't been invited to Mexico and so hadn't been there to affix them. She had also made the hairpieces for *Dead Reckoning*. On those films, the former lovers had had little face-to-face interaction. Pete had accepted the job because it paid good money. But with his hair falling out more every month, Bogart realized that Pete was vital in maintaining his image. "After *Sierra Madre*," Pete wrote, "Bogie had need of a full-frontal toupee." She made one for him and would henceforth be the one to put it on.

When he'd returned, hat in hand, asking for her help, Pete had let him have it for deserting her without so much as a phone call. "You don't owe me that much?" she'd recall asking him. "I'm sitting in Burbank, worrying about you . . . and you marry someone who just drifted into your life." Pete would remember Bogie's having squirmed under her words and implying some regret about marrying Bacall. If he said such a thing to Pete, perhaps he was trying to save face. But it's also possible that he retained some nostalgia for his old, untamed ways.

In the end, Pete forgave him. Their friendship resumed after *The Treasure of the Sierra Madre*. Bogie could do things with Pete that he couldn't with Betty. Pete loved to sail and, once on board *Santana*, remembered everything he'd taught her on board *Sluggy*. Betty, meanwhile, rarely joined her husband anymore on the yacht; she finally admitted that she didn't care for sailing. Two of Bogie's favorite pastimes—sailing and drinking—were not shared by his wife, but they were by Pete. So he wanted to keep Pete in his life. Eventually, he'd have her written into his personal agency contract, so that in his new, semifreelance status,

producers, if they wanted him, would have to hire her, too. For *The Bare-foot Contessa*, shot in Italy, Pete received $250 a week, round-trip airfare, living expenses, and a suite at the Excelsior Hotel in Rome, where Bogie was also staying.

Though their renewed friendship is well documented, a renewed sexual relationship is harder to square with everything else we know about Bogie. It would have been completely out of character. He was known for being faithful to his wives even when his marriages were in decline. He'd started cheating on Mayo only after the union had irretrievably broken down, and the marriage with Bacall was currently at its height of success. Pete didn't specifically write that they resumed a sexual affair. It's possible that their friendship was affectionate and companionable without being sexual; a love affair can be conducted without sex. But it's also possible that the relationship was an anomaly in Bogie's life; human beings are inconsistent and unpredictable, which is what makes them human. Maybe Bogart did cheat on Bacall. Even Stephen Bogart wrote that it was possible, if unlikely.

The fact was, Pete filled some part of Bogie's life that was not being filled elsewhere. Their friendship endured until his death. She remained married to Robert Peterson, although they had an understanding. To help them out, Bogie hired Peterson as the regular art director for Santana Productions, their long-ago scuffle in Pete's shower far behind them. For a while, Pete clung to some hope that Bogie might still divorce Bacall and marry her. But those hopes had ended, she wrote, when she'd learned Betty was pregnant.

If Bogie shared his feelings about the pregnancy with Pete, she was decorous enough not to repeat them in her memoir. The truth was, he wasn't happy about welcoming a baby to the family. When Betty told him that she was pregnant, Bogie erupted in anger. "We had the biggest fight we ever had," Bacall wrote. "I was in tears—this moment I'd been hoping for, waiting for, was a disaster. Bogie was full of sound and fury." When he finally calmed down, he said he didn't want to lose her to the baby. Unstated was the truth that he needed his wives to mother him. Over the past few years, Betty had done just that, helping Bogie mature, relax, appreciate what he had; now her attention, he feared, would go to someone else. Heading into his fifth decade of life, he hadn't expected to have to make room for a rival.

Even when he accepted the idea of having a child, it wasn't because

he wanted to be a father but because he wanted to ensure that Betty never forgot him. "I wanted to leave a part of me with her when I died," he said, recognizing the difference in their ages. ". . . I wanted a child, therefore, to stay with her, to remind her of me."

He was also terrified. "He didn't know what kind of a father he'd make," Bacall remembered. Bogie's experience of parenthood had been one of coldness, neglect, and cruelty. He might be able to play the outdoorsman with a child the way Belmont had done with him, teaching the newest Bogart about sailing. But all the other responsibilities of fatherhood—encouragement, compassion, shared wisdom—he feared he was not competent enough to fulfill. The sudden and unexpected demands of fatherhood unnerved him.

But he may have become convinced of their usefulness. "This will be a new Bogart," wrote one columnist, "one who changes diapers instead of changing politics." After the Washington fiasco, the Bogarts' public image was in need of some serious renovation. Whether by coincidence or design, in the midst of the public censure, they announced to the press that they were expecting a visit from the stork.

SIX MONTHS AFTER THE TRIP TO WASHINGTON, THE BLOWBACK AGAINST BOGART and Bacall continued. Hedda Hopper kept up a drumbeat of snide remarks. Conservative papers owned by William Randolph Hearst questioned Bogie's and Betty's patriotism. Communism, the *New York Daily Mirror* wrote, was "the hater of our people, the foe of our way of life, the poisoner of the minds of our children." The paper demanded answers. "Speak, Bogart and Bacall!" Bogie's statement at the train station in Chicago was simply not enough for his critics.

Bogie wrestled with what he had done, especially as it became clear that his recantation hadn't had the desired effect. He knew his friends felt let down. Representative Chet Holifield of California, one of the few legislators who had met with the CFA and offered his support, chastised Bogart in a letter sent to the studio: "I write with the purpose of reassuring you that your trip was not 'ill-advised, even foolish.' It may have been impetuous, but it was a spontaneous action grounded firmly in the desire to protect the basic principles which mean the difference between any form of totalitarianism and our own beloved democracy."

The respect of people such as Holifield mattered to Bogart. The guilt

and shame he felt over losing it tugged at him. Richard Brooks, who'd gotten to know him on the set of *Key Largo*, believed that the Washington trip and its aftermath had left Bogie disillusioned, shattering his belief that there was always a way to work things out. "[He] was never the same again," Brooks said. Bacall, too, after decades of silence on the topic, admitted to her son and others that Bogie had "felt coerced" into making the statement. "He was never proud of it," she said.

Still, he would seesaw in his public statements over the next six months. As the blacklist proliferated through every branch of the film industry, Bogart added his name to a petition decrying the "reign of fear" and the enforced "self-censorship at every level." He told the *Hollywood Citizen-News* that there was no proof that there was "anything wrong with the Committee for the First Amendment" and "until such time it [was] proved to be un-American," he would remain a member. Many on the left saw those statements as half measures, Bogie trying to have it both ways, while on the right, the flip-flops only provided new ammunition. George Sokolsky asked, if the committee had misled him as he'd claimed, why was he still a part of it? Why was he working with two of its key defenders, John Huston and Edward G. Robinson, on *Key Largo*? "Don't try to fox me again—or the public," Sokolsky warned.

Likely in response to such criticism, Bogie rode the pendulum back to the other side, agreeing to put his name on a piece entitled "I'm No Communist" in the March 1948 issue of *Photoplay*. Told in folksy language, a sure sign of the involvement of press agents, the article went much further than Bogart's earlier statement had. "As the guy said to the warden just before he was hanged," he began, "'This will teach me a lesson I'll never forget.'" Some of his friends, he joked, had sent him a mounted fish with the inscription "If I hadn't opened my big mouth, I wouldn't be here." That was the sort of humor *Photoplay* readers had gotten used to from Humphrey Bogart, who they knew talked big and sometimes went too far. His criticisms of the Un-American Activities Committee were just more of that, it was implied. Although he insisted that liberal Americans were loyal citizens, he claimed that the "bulk of the population was on the right." Though he defended the ability of actors to speak out on political matters, he also warned against their being "used as dupes of Commie organizations."

Once again, trying to thread the needle, Bogart pleased no one. For the next few years, Bogie would swing left, then right. A couple

years later, he'd support Helen Gahagan Douglas in her campaign for an open Senate seat against Richard M. Nixon. Douglas had been one of only seventeen legislators to vote against charging the Hollywood Ten with contempt. She lost the election, but it gave Bogie an opportunity to polish his tarnished liberal credentials. But soon afterward he was cozying up to Hedda Hopper, finally granting her an interview and complaining about "pressure groups," a phrase usually associated with leftists during that period.

Yet although Bogie had forfeited the respect of the political establishment, he hadn't lost his box-office appeal, and that was what saved him. When *The Treasure of the Sierra Madre* was released in January 1948, only a couple of months had passed since the Washington brouhaha and only a few weeks since Bogart's mea culpa in Chicago. Audiences flocked to the picture regardless of their politics. Opening in fourteen cities across the country, *The Treasure of the Sierra Madre* made a phenomenal $300,000 in its first week alone. Reviewers were ecstatic. Although the strongest raves, as expected, went to Walter Huston, the critics also hailed Bogie's dark descent as Dobbs.

Indeed, on-screen, he becomes a coiled rattlesnake ready to spring at a moment's notice. His eyes flash, darting back and forth at his partners; he's certain that they're trying to cheat him or do him in. It's an impressive performance of paranoia and madness, reminiscent of his turn as Frank Taylor in *Black Legion*. There are moments, especially when he's playing off the understated, naturalistic style of Tim Holt, when Dobbs seems theatrical, but he's become a monster by this point, and monsters go over the top. Like all monsters, too, he requires a good death scene. Huston shot a grisly demise, with bandits whacking off Dobbs's head, but the Production Code wouldn't allow it, so Dobbs died off-screen, leaving some viewers unsure if he was, in fact, dead.

"Stars of the movies are rarely exposed in such cruel light as that which is thrown on Humphrey Bogart in this new picture," remarked Bosley Crowther in the *New York Times*. ". . . But the fact that this steel-springed outdoor drama transgresses convention . . . is a token of the originality and maturity that you can expect of it." Bogart's performance, he added, was "perhaps the best and most substantial that he has ever done." Edwin Schallert in the *Los Angeles Times* agreed: "The character change of Bogart under the influence of success in finding gold is what really makes the story."

When, a few months later, *Key Largo* made it into theaters, the same thing happened. The picture was a blockbuster from the start, eventually earning $8.1 million, making it the third-highest-grossing film of the year. It was Bogie's (and Bacall's) first top ten movie since *To Have and Have Not.* "You won't find a more exciting movie in town," the *Brooklyn Daily Eagle* promised its readers. While the acting accolades went largely to Robinson and Trevor, critics also liked Bogart and Bacall. The *Eagle* judged Bacall's performance as "her best work to date"; the *Los Angeles Daily News* thought she had revealed "unsuspected warmth." Bosley Crowther called Bogart's characterization "penetrating"; the critic for the *Pittsburgh Press* found him convincing as the "war-weary veteran, cynical and spiritless—until a spark of conscience catches fire." Once again, the basic Bogart formula was magic on the screen.

It seemed, then, that all the political Sturm und Drang of the past several months would have no effect on the viability of the careers of Bogart, Bacall, or Huston. But as new congressional hearings were planned and new investigations loomed, the jury was out on whether their commercial and critical success would be enough to inoculate them from what might still be to come.

ON THE NIGHT OF MARCH 29, 1949, THE BOGARTS HOSTED A SMALL GATHERING of friends at their house in Benedict Canyon after the Oscar ceremony at the Academy Award Theater. Celebrations were in order. John Huston had won both Best Director and Best Screenplay for *The Treasure of the Sierra Madre*; his father, Walter, had won Best Actor in a Supporting Role for the same picture; and Claire Trevor had nabbed Best Actress in a Supporting Role for *Key Largo.* If Bogie was disappointed that he hadn't been nominated for either film, he kept it to himself, even if the snub would eventually be considered among the most egregious in the Academy's history. But seeing his friend Huston, the unapologetic spokesman for the Committee for the First Amendment, walk off with two little gold men in his hands may have been satisfaction enough.

There was more to celebrate. Many of the guests got a peek at little Stephen Humphrey Bogart, born the previous January, asleep in his bassinet. Photos of Bogie changing his son's diapers, holding the pins in his mouth, were published in dozens of newspapers. "Bogart gets a new role," one caption read. "Screen tough guy has his hands—and mouth—full as

he tackles the job of diapering his four-month-old son Stephen." It was a very different look for the screen's hard-boiled antihero and George Sokolsky's suspected fifth columnist, which was, no doubt, exactly what Bogart's publicists wanted. Who could criticize a proud papa?

On the surface, everything appeared happy and high spirited at the Bogart home. Betty would remark, on more than one occasion, how blissful she felt during this period. "We were becoming a more and more popular pair," she wrote. "The word was getting out that it was fun at the Bogarts'." Invitations to their Christmas parties were coveted. "There was always a mixture of East and West coasts," Betty said, "our New York writer friends, any pal who was in town, and some chic and not-so-chic movie folk. And of course, people were brought into the nursery to view the perfection that resided there."

But peel away a couple of layers from that sugarcoated picture, and some nagging unease and restlessness appear. It went beyond the Redbaiting, which Bogie and Bacall had gotten used to by now. It was the bitter realization for Bogie that his new contract had not in fact given him the security and satisfaction he'd hoped for. By 1949, he was supposed to be a big-shot producer. Santana Productions, in partnership with Columbia, had released its first picture, *Knock on Any Door*, to terrible reviews. Bogart had wanted Marlon Brando to star as the troubled young killer, but he'd had to settle for John Derek, a newcomer. He'd been impressed with Nicholas Ray, the exciting young director, but the story had never come together. Bosley Crowther called the whole thing "pretentious." It was a heartbreaking failure, especially since Santana had taken pains to bring the picture in under budget ($849,937 as opposed to $1.17 million).

Mark Hellinger's production expertise was sorely missed. When it came down to it, Bogie knew very little about producing. Even as an actor, in his role as *Knock on Any Door*'s crusading attorney, he failed to impress the critics. He was stiff, as he always was when playing earnest public servants. The film was meant to draw attention to how society fails so-called juvenile delinquents, but Bogart was not good at soaring oratory. He was no Gregory Peck.

After just one film, Santana was struggling. Despite the budgetary savings it had made in the production of *Knock on Any Door*, the company had taken loans of more than half a million dollars before the picture's release, and the sluggish box office wouldn't pay those loans off. The daily management of the company was left to former Warners

screenwriter Robert Lord, who had as little experience at producing as Bogart did. Morgan Maree had come on to guide the financial aspects of the company, but Santana was perpetually undercapitalized and bereft of the sort of creative support—lighting, sound, art direction—that could be found at a studio.

For all the sweetness and light with which Bacall described those years, both old and new resentments were simmering. For Bogie, it was the sense of being cut out, denied, not given a chance or a fair shake, a feeling he'd struggled with most of his life. "Bogie could be very hostile," said his old friend Gloria Stuart. "Everything could be going great for him, such as his life with Betty, but underneath there was always something troubling him, something he needed to prove." He was the highest-paid actor in Hollywood, he had a beautiful wife and baby boy, he owned his own production company, and he had a professional partnership with one of the industry's most celebrated directors, but every once in a while, the little ne'er-do-well he'd long believed himself to be made his presence known.

Much of his resentment was fueled by the control Jack Warner still had over him and Betty. Bogie learned that studio flacks were preparing a summary of all the negative comments he and his wife had made about the studio in the past year, with an eye toward legal action against them. During her pregnancy, Betty had been obliged to send a statement to Warner affirming that once she gave birth, she would resume her services at the studio. Bogie was furious about it. He called Warner, only to be told by his secretary that the studio chief was out. With his "words slurring together," Bogart demanded to be connected to producer Milton Sperling, Jack Warner's son-in-law. "He talked as though he was quite drunk," the secretary wrote to Warner. His language grew increasingly foul, and "he was cut off," the secretary added. "Our operator explained that the telephone company will cut people off who use bad language. Believe this is what happened." That no doubt left a smug grin on Warner's face.

The old corrosive anger that Bogie had lived with for so long—which had seemed to subside following his marriage—was surging up once more, and it did not diminish for some time. Nine months after Stephen's birth, Bogie and Betty were in New York on a promotional tour for Santana, and neither one was very happy. Jack Warner wouldn't allow Betty to appear with her husband in any of the publicity, as she was contracted

exclusively to Warner Bros. They seethed at the restrictions placed upon them.

On Saturday night, September 25, the Bogarts met some friends at "21." Large amounts of alcohol were consumed. Afterward, they stumbled back to the St. Regis New York on East 55th Street at Fifth Avenue, where they were staying. Betty decided to call it a night, but Bogie, still peppy, tagged along with an old friend, Bill Seeman, to the El Morocco nightclub on East 54th Street. The two men had been gadabouts during the speakeasy days. Both were sons of wealthy fathers and products of elite schools (although Seeman, unlike Bogart, had actually graduated). Now Bill was a millionaire grocery magnate and the ex-husband of the movie actress Phyllis Haver. With his old pal at his side, Bogie could imagine that he was twenty again.

On the way to El Morocco, a swank watering hole of the rich and famous known for its blue-and-white zebra-striped booths, the two intoxicated friends purchased a pair of giant-sized stuffed pandas. Carrying them into the club, they positioned the pandas in the booth as if they were their dates. More cocktails were downed. The staff of El Morocco became aware of the increasingly loud and boisterous behavior in the Bogart booth. Just before 3:00 a.m., a twenty-six-year-old model named Robin Roberts spotted the unusual foursome of two middle-aged men and two stuffed animals seated at a nearby table. As she'd tell the story, the club's publicity manager, Leonard McBain, asked if she wanted one of the pandas. The newspaper columnist Lee Mortimer, at McBain's table, told her to take Bogart's. He was certain that Bogie wouldn't mind.

Mortimer's presence suggests that the ensuing fracas was more than just the humorous episode previous chroniclers have presented. Mortimer, the author of anti-Communist tirades, was currently working on a book called *Washington Confidential*, in which he planned to expose subversives in the government. The writer seemed to take pleasure in baiting celebrities; Frank Sinatra had thrown a punch at him a couple of years back.

Bogie was aware of Mortimer and all that he stood for. He "hates my guts," he told a reporter, "and I assure you it's reciprocal." He would always blame Mortimer for what happened next. Encouraged by the two men, Roberts approached the Bogart table. "May I have one of the dolls?" she asked Bill Seeman. According to Roberts's later testimony, Seeman agreed. Roberts took a furry paw into her hand. The small gesture sent

Bogart into a rage. "No, you don't," he said, his voice slurring, "I'm a happily married man." Roberts claimed that he grabbed her wrist and twisted it; Bogart said that he only pushed her away from the panda. In the scuffle, Roberts fell to the floor, hitting an open door as she did so, leaving her with bruises on her chest. Immediately, a couple of her friends, Peggy Rabe and John Jelke, leapt to her defense. They threatened Bogart, who tossed plates and saucers at them. The night ended with everyone getting kicked out of the club.

The situation might have ended there, but early the next morning, when Roberts reported for a modeling session, the photographer, Murray Korman, noticed the black-and-blue marks on her upper chest. Korman, an influential celebrity portraitist whose clients included Clare Boothe Luce, Claudette Colbert, Josephine Baker, Salvador Dalí, Lena Horne, and dozens of up-and-comers, was appalled when Roberts told him the story and encouraged her to get a lawyer and file assault charges. She left the studio and did what Korman had suggested.

In the resulting press frenzy—one headline screamed BOGART ROUGHS UP TWO CUTIES—many insinuations were leveled against Roberts. The press implied that she was a prostitute, reporting that she "models for a living in the daytime." Bacall, in her memoir, would call Roberts "a young woman around town," which drips with innuendo. Bogart's quip that he was a happily married man was used in the press to suggest that Roberts was coming on to him and not as part of the gag that the panda was his date. Roberts as an attention-seeking gold digger became the established narrative.

This view has been perpetuated by subsequent Bogart biographers. Roberts was described, in lurid terms, as pulling down the neckline of her dress to show reporters her bruises, but how else could she have proven she'd been injured? Her friends were tainted, too. One biographer called Jelke "a gangster," when in fact he was nothing more than the idle-rich playboy son of the founder of Good Luck margarine. He was also a war hero and quite popular in New York society circles. So was Peggy Rabe, the vivacious daughter of the millionaire William Rabe of Park Avenue and Palm Beach, a vice president of Manufacturers Hanover Trust. They weren't shadowy underworld figures, as the chroniclers have made them out to be, but society column fixtures, part of the postwar "beautiful people" of New York.

Then and now, a woman often finds her personal life targeted when

she accuses a man, especially a powerful man, of assault. Bogie called Roberts a "screaming, squawking young lady." The press typed her as a floozy. In fact, her life up to that point hadn't been all that different from Betty's before she had found fame in Hollywood. Roberts had been born in Salt Lake City to a working-class family. Her father had either died or abandoned the family when she was just a year old. As the Depression had worsened, her mother had taken her to New York, where Mrs. Roberts had found work as a domestic, much as Natalie Bacal had when she'd needed to support her own daughter. After her mother had remarried, Robin had gone to Seattle to live, but she had never forgotten the possibilities that New York offered. As soon as the war was over, she had returned to Manhattan, age about twenty-one, her heart set on becoming a model and possibly an actress. She found a place to live in Greenwich Village, not far from where Betty had once resided on Bank Street.

There were other parallels as well. Both women sought out high-powered friends who might help them with their ambitions. Betty had Paul Lukas, George Kaufman, Niki de Gunzburg, and numerous other theatrical and publishing figures. Roberts hitched her star to café society glitterati such as Rabe and Jelke, a crowd not dissimilar from the one the young Bogart had run around with after the First World War.

When at last she had her day in court before Judge John R. Starkey, Roberts was described by the newspapers as "dolled up in black broadcloth and white ermine," although in photographs from that day, her clothes don't appear ostentatious. When Starkey asked her if she'd tried to steal the stuffed animal, Roberts said no: "I haven't been brought up that way." Her attorney, Chester S. Mandel, an advocate for disabled veterans and women seeking pay equity, argued that the facts clearly showed that Bogart had caused injury to his client.

Bogart had chosen a lawyer close to home: Betty's uncle Charlie Weinstein, who argued that the case was "a publicity stunt by a Hollywood-stricken female" out to "shake down Mr. Bogart." Weinstein dominated the court proceedings, referencing arcane canons of the professional and judicial ethics of the American Bar Association that confounded even the judge, who nonetheless allowed him to continue despite repeated objections from Mandel. Weinstein was basically arguing that the publicity generated by the case was the plaintiff's real objective.

Clearly, Bogie had decided to fight. He could have simply acknowledged that he might have unintentionally caused the young woman to

fall. That appears to be all that he was guilty of. But Bogie was in no mood for apologies. He had been pushed around by studio bosses, congressmen, newspaper columnists, and witch-hunters for too long. Robin Roberts, justly or not, would have to bear the brunt of his anger.

The "Battle of the Pandas," as the *Saturday Evening Post* dubbed the case, was decided very quickly. "Even according to the complaining witness' statement herself, the facts are that she went over and touched his panda," Starkey ruled. "Naturally Mr. Bogart thought she was going to take his panda away. He was entitled to use enough force to protect his property." The magistrate summarily dismissed the case. The *Post* wrote that he had done so while "trying hard to keep a judicial face." The courtroom erupted into applause. Bogie glad-handed a throng of well-wishers. Meanwhile, Roberts and her attorney slunk out of the building, booed by the noisy crowd of movie fans that had gathered outside.

Over the course of the three days, Roberts's photograph had appeared in dozens of newspapers across the country. She had posed with a giant panda, seeming to enjoy the notoriety. She and her friends were glad to flash some leg for the photographers, and it would be naive to believe that they weren't hoping for a career break now that they had the media's attention. But that does not justify the character assassination Roberts endured. Because the judge dismissed the case so quickly, doctors were unable to vouch for the bruises on her chest. Bacall would allege, on absolutely no evidence, that the black-and-blue marks had been painted on. El Morocco banned both Roberts and Bogart from ever setting foot in the club again, which had a more deleterious impact on the former than the latter. For Bogie, the banning was a bad boy's badge of honor; for Roberts, it was a public declaration that she was a loose woman.

Sadly, the incident seems to have ended Roberts's dream of a modeling career. Although she was still working as a model in 1950, living in the exclusive Mayflower Apartments at 15 Central Park West, there is scant record of her work. She may have done some modeling in Cuba, as she flew there twice over the next couple of years with a promoter, but if so, the work likely never reached the United States. After that, she disappeared from the record.

For Bogie, however, the brouhaha only served to burnish his legend. "The incident, spread over the national press, might have harmed any other actor," wrote the columnist Erskine Johnson, "but as a Bogart gesture, it seemed wry and funny and nobody minded." Asked if he'd been

drunk when the incident had occurred, Bogie quipped, "Isn't everyone drunk at four a.m.?" Pressed on whether he had hit Roberts, he retorted, "I'd never hit a woman—they're too dangerous." (Mayo Methot might have had a different perspective on that.) In the front hall of the Bogarts' home, the celebrated panda was propped on a pedestal for visitors to see, a monument to Bogie's audacity.

"If he hadn't been a hero before," Bacall wrote, "the panda incident made him one." It's a peculiar statement, as if fighting for freedom of speech and rallying the troops in wartime hadn't been quite as heroic as being complicit in the shaming and silencing of a young woman.

Despite Bacall's determination to paint the episode as her husband's triumph rather than his accuser's tragedy, the "Battle of the Pandas" exposed the darkness that still lurked inside Humphrey Bogart. The brief contentment he'd enjoyed after his fourth marriage was now unraveling. Jack Warner, who'd pointedly refused to send studio fixers to assist his defense, remained his bête noire. Santana Productions, Bogie's long-held dream, was floundering. Discontent was also rising once again in his home life. According to Betty's own memoir, Bogie was resentful of the accommodations he'd had to make now that there was a baby in the house. The publicity photos aside, there was very little contact between father and son.

Just as at earlier moments in his life and career, Bogie's stress and resentment made him self-destructive, drinking until dawn, throwing plates at people. At one point during this period, drunk as a skunk, he attempted to eat glass, going "too far with his peculiar humor," the agent Irving "Swifty" Lazar said, and cutting his mouth severely. Bacall did her best to subdue him; she was still the only one who could.

Adding to Bogie's agitation was the looming specter of the blacklist, which every month grew longer. In early 1950, the Hollywood Ten began serving their six-month to one-year sentences, two of them in the same prison as their nemesis, Parnell Thomas, who'd been convicted of payroll fraud, providing a bit of schadenfreude to the men whose lives he'd ruined. But Parnell's downfall did not stem the tide of anti-Communist fervor across the country. The blacklist threatened everyone in the film industry who had ever made pro-labor, pro-socialist, or even pro-Roosevelt statements. Publications such as *Red Channels: The Newsletter of Facts to Combat Communism* printed the names of Hollywood figures suspected of subversion based on their liberal politics. The actresses Jean

Muir and Ireene Wicker, the writer Elmer Rice, and the producer William Sweets, among others, all lost their jobs in this period. The endurance of the blacklist was a constant reminder that no one was safe and even the biggest names, such as Humphrey Bogart, would be wise to keep looking over their shoulders.

Pier 88, New York Harbor, Wednesday, March 14, 1951

At noon, the horns of the SS *Liberté* blew, and the ocean liner began its steady glide into New York Harbor. Seven hundred ninety passengers were on board, including Humphrey Bogart, fifty-one, and Lauren Bacall, twenty-six, who were ensconced in one of the vessel's best staterooms. Before sailing, Bogie had bantered with reporters on the dock about the Senate investigations into organized crime, which were being aired live on television, the rapidly proliferating new medium that was becoming a fixture in American living rooms. He had mused that he might like to play Frank Costello or Joe Adonis, two of the crime bosses being grilled by Senator Estes Kefauver. "The greatest show I ever saw," he declared of the televised hearings.

There were other hearings going on that month, too, but Bogart didn't mention them. Just weeks before the Bogarts sailed on the *Liberté*, the *Los Angeles Times* had bannered NEW RED HEARINGS ON HOLLYWOOD SET. This time, Edward G. Robinson, Larry Parks, Howard Da Silva, and Gale Sondergaard were on the chopping block of the House Un-American Activities Committee, now chaired by Representative John Stephens Wood of Georgia. The danger had not abated. Bogart's transatlantic voyage, it seemed, had come just at the right time.

Bogie and Betty were sailing off for a two-month European holiday before heading south to Kenya and the Belgian Congo to shoot a picture, *The African Queen*, based on a novel by C. S. Forester and directed by John Huston. Betty wasn't in the film; she was going along merely to support her husband and to affirm the couple's vow never to be separated for long stretches. The trip was estimated to last four months; it ended up lasting almost six. "I certainly do not believe in marital separations," Bogie remarked to Gladys Hall before departing. "That is not the way marriage is supposed to be." When the *Liberté* docked in Southampton, Bogie told a British journalist, "We have never been separated for longer than the three hours it takes Lauren to have a beauty treatment."

Yet there *was* someone from whom they'd be separated for the duration: their son, Stephen, now two years old. The child had been left in the care of nursemaids. The wisdom of that decision would be questioned almost immediately. Bogie told Gladys Hall that just before flying to London, there'd been a bit of a "tizzy" and they "didn't know whether to go back or go on." Despite the "tizzy," which he did not identify, they had chosen to continue on their trip. Louella Parsons got the full scoop: "Little Stephen Bogart, two-year-old son of Lauren Bacall and Humphrey Bogart, barely escaped injury when his nurse, Alyce Louise Hartley, who was holding him in her arms, suffered a fatal heart attack." They'd been at the airport, waving as the plane bearing Stephen's parents had taken off for New York. Parsons reported that Natalie had saved the child from hitting the ground, but in fact Natalie hadn't been there; Stephen later gave the credit to the mother of a family friend.

Although he was too young to remember the incident, Stephen was certain, looking back as an adult, that he must have been traumatized. While growing up, seeing newspaper articles about Hartley's death juxtaposed with photos of his parents' carefree travels through Europe and Africa, Stephen had felt a nagging sense of neglect. He learned that his parents had been informed of the incident when they had stopped in Chicago. "What happened next is something that I've thought about all of my life," he wrote in his memoir. "My mother did not come back." He was at a loss to understand her decision. "She didn't *have* to go," he wrote. "There are people who would say that a two-year-old boy needs his mother when his father has gone away and his nurse has just dropped dead while holding him." That abdication of parental responsibility, putting their son into the hands of nursemaids so they could lead their own lives, evokes the same detached approach that had been used by Maud and Belmont toward Stephen's father.

Although Betty would go to great lengths in her memoir to describe how torn she was about leaving her son behind, she also maintained, "Your life with [your husband] cannot stop for your son." She admitted, too, that she wanted to see the "unseen places" that lay ahead of them; she had never been to Europe, and neither of them had ever set foot in Africa. Yet it's hard to imagine Natalie leaving Betty behind at two or even at twelve. Bacall loved her son, but she remained the ambitious careerist she'd been for the last decade. She wasn't about to miss the publicity that came with the momentous journey. So from Chicago she

phoned Natalie, who had by now married her longtime companion Lee Goldberg, and asked her to fly to Los Angeles. Her mother would make sure that Stephen's physical needs were met. That was the rationale Bacall gave to her adult son in defense of her decision to keep on with the trip. "But it's the emotional needs that I have always wondered about," Stephen said in response.

The intense, often symbiotic relationship between Bogart and Bacall during that period left very little room for anyone else, even their own son. His very name reflected his parents' preoccupation with each other: they'd chosen "Stephen" because it would memorialize what Betty had called Bogie in *To Have and Have Not*, during which they had fallen in love. One on one with her child, Betty was loving and attentive. But as soon as her husband got home, her priorities were reset. "He wanted my attention in the evenings, and when he talked to me, he wanted my mind all there," she wrote, adding that she still "hung on his every word."

For his part, Bogie never fully embraced fatherhood. "I don't know what constitutes a good father," he told Gladys Hall. "Just handle him like any other human being," he guessed. In fact, he mostly didn't handle Stephen at all. The year after their African sojourn, Betty told a journalist that Bogie still had "never held his child on his lap, changed his pants, or played horsey with him." He was denying Stephen the tactile intimacy that he himself had been denied.

No doubt, Bogie and Betty missed and worried about their son. But the image they projected on their European tour was one of gaiety. Bogie learned to handle a gondola in Venice. Betty went on a shopping spree in Paris. They had an audience with Pope Pius XII in Rome, even though neither of them was Catholic. Over the years, Stephen would see the home movies his parents had made of visits to the Eiffel Tower and the Arc de Triomphe. Wherever they went, Bogie and Bacall were followed by newsmen and photographers fascinated by their great American love story, and they preserved the clippings in scrapbooks. It was on this trip that Betty first displayed for reporters the bracelet with the gold whistle attached that Bogie had given her, a memento of the classic scene that had brought them together.

"Successful marriage is the infinite capacity for taking pains," Bogart told a reporter in London. "I guess I didn't take quite enough pains for the other three." To which Bacall replied, in a New York accent the English scribe found amusing, "What you mean, de-ah, is you have at last

discovered that we are not the weaker sex, de-ah." Bogart beamed. "What a regular gal she is. I reckon this partnership is really gonna stick." In the press coverage of the trip, no mention was made of their two-year-old son back in California.

While the Bogarts were touring the continent, John Huston was still scouting locations in Kenya. *The African Queen* was an independent production, a combine of Sam Spiegel's Horizon Pictures, in which Huston was a partner, and the British-based Romulus Films. That meant that without a studio backing the enterprise, the money hadn't fully been raised by the time Bogart and Bacall set sail. Abe Lastfogel, the agent for Bogie's costar in the picture, Katharine Hepburn, wired his client in February telling her that she wouldn't be needed until April 1. "They delayed in obtaining escrow money and [are] requesting [an] extension," he explained. Hepburn didn't arrive in London until April 14, exactly one month after Bogart and Bacall.

But once they were all together, Huston and his two stars may have recognized a bond between them, at least on an instinctive level. All three had faced accusations of subversion. The Un-American Activities Committee, once again turning its steely gaze toward Hollywood, could revive accusations against them at any time. Whether deliberately or serendipitously, Bogart, Hepburn, and Huston had been given an opportunity to beat their enemies at their own game.

ON THEIR FIRST NIGHT IN AFRICA, BETTY SPOTTED A SCORPION CRAWLING DOWN the wall while she took a bath. "I was destroyed," she remembered. None of them was prepared for the culture and climate shock. "It was hot as hell," Katharine Hepburn recalled of their train ride through the jungle to their camp at Biondo, which today is located in the Democratic Republic of the Congo. "The roofs of the cars kept catching on fire. The track went right through the jungle. We stopped at several stations and bought bananas." Arriving at Ponthierville after sunset, Hepburn, Bogart, and Bacall transferred to a wooden raft built on pirogues, or canoes made of tree trunks. "Very primitive and very slow," Hepburn recalled of the journey across the Ruiki River toward Biondo in the darkness. "That full-mooned night," she wrote. "The peepers at full blast. The hoot owls. The screech of an occasional monkey."

The three actors had met for the first time only a few weeks earlier in London. Hepburn was not a Warner Bros. star but rather a grande dame of MGM. She was an unlikely leading lady for Humphrey Bogart. As a top star, Bogie had dominated his pictures and his costars, at least in screen time and story points. Even the most memorable of them—Astor, Bergman, Lupino, Bacall herself—had played characters essentially in support of Bogart. That was about to change. Hepburn, as Rose Sayer, would demand equal time and equal agency with her costar. Even as they arrived in their remote jungle outpost, she was already haggling with Huston about script changes she wanted to see. She had as much at stake in the picture as any of them.

Over the past three years, Hepburn had weathered her own opprobrium in the public sphere. Unlike her costar, she'd come close to being subpoenaed by the Thomas Committee. Her appearance at a 1947 fundraiser for Henry Wallace that had raised $87,000 for his presidential campaign had enraged the director Sam Wood, a friendly witness for the Thomas Committee. He had told members of Congress, "You don't think that money is going to the Boy Scouts, do you?" An Associated Press story reported that Hepburn had "appeared [at the fundraiser] on behalf of fellow travelers." Those were even more direct accusations than had been leveled at Bogie.

So the fear remained for both stars of *The African Queen*. Hepburn and Bogart had been prominently featured in the anti-Communist crusader Myron C. Fagan's *Documentation of the Red Stars in Hollywood*, published in 1950 and required reading for movie moguls. Fagan called Bogart and Hepburn "power stormtroopers" for the Soviet Union. In one speech, he said that "Katherine [sic] Hepburn's love for Joe Stalin is no secret." In addition to Hepburn, the list of Hollywood subversives he read off at the microphone included Bogart, Bacall, and Huston.

Fagan, as fringe as he was, represented a dangerous new momentum in the fight to restrict thought. "We don't care whether an individual cannot be proved to be an outright Communist," the frustrated screenwriter said. "As far as we are concerned any man or woman who . . . has come out in open support of the ten branded men who defied the Parnell Thomas Investigation . . . is just as guilty of treason, and is just as much an enemy of America as any outright Communist. In fact, more so!" Humphrey Bogart came in for some of his harshest rhetoric. Bogart,

Fagan declared, was "another example of the individual who may offi-
cially register with only one or two fronts, but whose activities go far
beyond." After all, he had "spearheaded that caravan of glamorous Reds
to Washington to overawe and heckle" the Thomas Committee. The col-
umnist Jimmie Fidler, apparently swayed, asked the government to "thor-
oughly investigate" Fagan's charges.

The danger was metastasizing throughout all branches of govern-
ment. The California State Senate launched its own investigations to
augment the federal probe; one of its targets was Bogie's old friend Gloria
Stuart. The inquisitions were once again getting perilously close. Richard
Brooks, who'd directed Bogie in *Deadline—U.S.A.* shortly before the ac-
tor departed for Europe and Africa, recalled a difficult period. Although
he liked Brooks well enough, having been pleased with his work on the
script for *Key Largo*, he often resisted his direction and was querulous
with just about everyone. "There was an impatience," Brooks said. When
the shoot wrapped on Christmas Eve, Bogie made a hasty retreat without
wishing anyone happy holidays. Brooks thought his star's actions during
the production were out of character. Clearly the stress over the threat of
the blacklist was wearing away at him.

In January 1951, just before Bogie sailed on the *Liberté*, the television
producer John Sinn, interested in offering the actor some small-screen
work, asked Morgan Maree to confirm that his employer was not, in fact,
a Communist. Maree sent off a copy of the Dies transcript and the letter
to Buron Fitts, adding "I rather feel like Bogie does, which is that these
people who so loosely accuse him will never take the time or the trouble
to observe the facts."

Something more than cold, hard facts was needed for full exonera-
tion. The script of *The African Queen*, written by Huston and others, is
about loyalty, faith, and character during the First World War. Charlie
Allnut, the grizzled Canadian captain of a small steam launch on the
Ulanga River, rescues the starchy British missionary Rose Sayer after
the Germans attack her compound. Down the river the couple sails, the
Union Jack flapping in the wind behind them and Rose praying to God
for salvation. Their intent is to fire makeshift torpedoes into the German
gunboat that controls the region. Their crusade is for God and country;
the patriotism of Charlie and Rose cannot be questioned. It remained to
be seen whether the same would rub off on Bogart, Hepburn, and their
director.

OF THE FOUR FILMS BOGART HAD RELEASED IN THE PREVIOUS THREE YEARS, only one had been an unqualified success. Of the two films sans husband Bacall had made during that same period, both had been flops. The invincibility of Hollywood's top power couple was in question.

Tokyo Joe, released in October 1949, was a coproduction of Santana and Columbia, a thriller set in postwar Japan. Considerable photography was shot on location, sometimes making the final film seem like a travelogue, but the actors' scenes were shot on Hollywood soundstages. The director was Stuart Heisler, whose only real claim to fame was helming Susan Hayward's breakout hit, *Smash-up, the Story of a Woman!*, but Bogie liked him well enough. The story was essentially Rick Blaine goes to Tokyo, only this time his name's Joe and the war has ended. Joe returns to his old gin joint and comes up against some secret police who've never accepted the surrender of imperial Japan. Only the arrival of the US Army saves everybody from disaster—except for Joe, who dies heroically while rescuing his daughter from her Japanese kidnappers.

Tokyo Joe seemed to have potential at the box office when it opened at the Capitol Theatre in New York, raking in a respectable $60,000— though how many patrons came mostly to see the stage show headed by Lena Horne, then at the height of her fame, is unknown. The critical reaction, however, was tepid. The film "sputters more than it sizzles," judged Thomas Pryor of the *New York Times*, and "the more involved the story gets the less credible it becomes." Receipts fell off precipitously, with *Variety* noting that *Tokyo Joe* had "hit some air pockets," a reference to its flying scenes.

A few months later, in February 1950, came *Chain Lightning*, again directed by Heisler. This time, Bogie was back on the Warner Bros. lot. The studio gave the picture a tremendous buildup, with ads in the trades heralding "The Biggest Bogart Show Ever!" But the tale of a jet pilot testing out new supersonic aircraft was heavy on technology and light on plot. According to one critic, even its "Buck Rogers costuming" (Bogart in a pointy helmet that was not at all flattering to him) wasn't enough to save the picture. In Chicago, *Chain Lightning* did "mediocre business" during its first week, and by the second week it was "down to dull." At "21" in New York, "for all and sundry to hear," as Jack Warner was to learn, Bogie called the film a "stinker." That made the studio chief "rather upset," and Morgan Maree, in a letter to Bogie, said he didn't blame him.

A year later, *The Enforcer*, directed by Bretaigne Windust, chiefly

known for the Bette Davis comedy *June Bride*, presented Bogart as a district attorney investigating organized crime. Do-gooders were never Bogie's strong suit, but he showed a little more spark than in previous iterations, steely and a little manic, not all that different from the criminals he was pursuing. The film opened "well enough" but then, like *Tokyo Joe*, quickly faded, overwhelmed by stronger competition and its own plodding police procedural. "The sheer accumulation of ugly violence and brutality eventually becomes dull," wrote Bosley Crowther, who reported that the audience had razzed the film on opening night.

Completed but not yet released by the time *The African Queen* got under way was *Sirocco*, set in Syria in the 1920s under French colonial rule. Bogart again plays an American with ties to neither side in a political power struggle, although he does secretly sell weapons to the Syrian rebels fighting against the French colonial rulers. Directed by Curtis Bernhardt as an allegory about conscience and honor, the film, when released, came across as pretentious to Crowther, who called it "slightly platitudinous and conspicuously lacking in charm." The role of the cynical American gunrunner was something Bogart could play in his sleep, and, according to the critic, he pretty much did. On its release in June 1951, *Sirocco* followed the pattern of most of Bogart's recent pictures, opening strong and then falling off. *Sirocco* was another disappointment for Santana Productions.

Part of the problem those films faced, of course, was the growing competition from television. People simply weren't going out to the movies as often as they once had. Since the end of the war, American weekly movie audiences had been in a steep decline, plummeting from about 55 percent of the population in 1944 to about 40 percent in 1947. People were content to stay home and be entertained by Arthur Godfrey, Milton Berle, Jack Benny, Red Skelton, and Lucille Ball on TV. The films that managed to entice people out of their living rooms were largely big spectacles or those made by directors with strong personal imprints: Alfred Hitchcock, George Stevens, and Nicholas Ray, the last of whom justified Bogart's early faith in him by engineering the one bright spot in the actor's recent output: *In a Lonely Place*, released in May 1950, a coproduction of Santana and Columbia.

Bogie plays a struggling screenwriter, Dixon Steele, who hasn't had a hit film in years. In the script, Steele is described as having a "spring-steel tension about him." He's quick to anger, paranoid, and bitter about

his dependence on employers for whom the bottom line is everything and creative integrity is nothing. When a young woman he invites to his home to discuss adapting a book later turns up murdered, Steele is the main suspect. His neighbor Laurel Gray, played with intelligence and spirit by Gloria Grahame (Nicholas Ray's wife), originally gives him an alibi. But as they fall in love, she discovers just how unstable Steele can be, how easily he flies off the handle, and how violent he can sometimes get. Bogart manages to meld confidence, insecurity, paranoia, and finally madness into a fascinating whole.

Louise Brooks, who knew him longer than most, called *In a Lonely Place* the most true-to-life performance of Bogie's career. "[Its] title perfectly defined Humphrey's own isolation among people," she wrote. She believed that her old friend could play the part of Dixon Steele convincingly "because the character's pride in his art, his selfishness, his drunkenness, his lack of energy stabbed with lightning strokes of violence, were shared equally by the real Bogart."

Steele starts out unperturbed when police question him about the young woman's murder. Serene in his innocence, he comes across as indifferent, which raises the suspicions of the detectives. But as more and more elements of his life emerge that make him look guilty, Steele becomes reactive and accusatory. His paranoia and anger grow over what he sees as a frame-up. Anyone who'd been following Bogart's travails with the Un-American Activities Committee and its minions, going back ten years to Martin Dies and continuing to the present with Myron Fagan, would have had no trouble recognizing a similar pattern in Bogie's portrayal of Dixon Steele.

Ray was constantly rewriting the script, sometimes adding lines just hours before shooting. In Ray's papers, the first draft, written by Andrew Solt, reveals changes in the director's handwriting on nearly every page; even the revised "final" script has numerous lines added, deleted, and moved around. Even so, Ray wasn't satisfied with the ending he'd largely written himself. "I just couldn't believe the ending that [Solt] and I had written," he recalled. "I shot it because it was my obligation to do it." Impulsively, he kicked everybody off the set except for Bogie, Grahame, and some of the crew. "We improvised the ending as it is now." In the original ending, everything was tied up in a neat package: Steele's anger and jealousy causes him to kill Laurel just as he is exonerated for the murder that kicked off the film. "And I thought, shit, I can't do it, I just can't do it!"

Ray said. "Romances don't have to end that way. Marriages don't have to end that way, they don't have to end in violence. Let the audience make up its own mind what's going to happen to Bogie when he goes outside the apartment." The ending is far more poetic and tragic than it would have been. Steele is a lost soul, defeated by his own personal demons. It was another echo of his own life. Bogie had gotten close to that point before; he might very well do so again.

In a Lonely Place was a resounding success during its first week in New York, earning "a big" $80,000 and bringing in just as much the second week, which was unusual. Box office was equally robust around the country. In Los Angeles, the queues around the theater "were such as we haven't seen since 1946." Thomas M. Pryor in the *New York Times* raved, "Everybody should be happy this morning. Humphrey Bogart is in top form in his latest independently made production." The star "looms large on the screen . . . and he moves flawlessly through a script which is almost as flinty as the actor himself." *In a Lonely Place* brought Santana Productions, at least for the moment, back into the black.

There was good financial news from another venture as well: *Bold Venture*, in fact, a half-hour syndicated radio drama Bogie and Betty agreed to do for producer Frederic W. Ziv in late 1950. Bogie had previously been heard in such regular series as *Suspense* and *The Jack Benny Program*; he and Betty had performed on *Lux Radio Theatre* as well. But this would be an ongoing series for them, like Dick Powell's *Richard Diamond, Private Detective* mysteries. *Bold Venture* was written by David Friedkin and Morton Fine, seasoned radio veterans who also wrote for *Suspense, Escape, Yours Truly Johnny Dollar,* and the pilot for *Gunsmoke*. Debuting in March 1951, *Bold Venture* was inspired by *To Have and Have Not*, with Bogart playing a salty sea captain who solves crimes in the busy international hub of Havana. Bacall played his ward. It was largely a platonic radio relationship, the sexual tension of the original film needing to be tamped down for the airwaves. But audiences still tuned in.

"*Bold Venture!*" the announcer exclaimed at the start of each episode. "Adventure, intrigue, mystery, romance . . . in the sultry setting of tropical Havana and the mysterious islands of the Caribbean!" Well produced and entertaining, the program supplemented the Bogarts' income now that they had a son to raise. Ziv paid them a fee but also allowed them to share in the profits, money that was free and clear of Warner Bros. (although the studio went over each episode carefully, looking for

copyright infringements). *Bold Venture* was picked up in most of the important markets across the country, distributed by Ziv for the next several years as different markets signed on at different times. This meant revenues continued to flow during the entire period. In all, Bogie and Bacall starred in seventy-eight episodes of *Bold Venture*. Ziv had originally estimated his stars would make $5,000 a week. They ended up with more than double that, raking in nearly half a million dollars.

Bacall was grateful for the income, as her meager film output during that period had been even more dismal than Bogart's. (She also, like so many other women then and now, faced a serious pay inequity. In 1947, for example, Warner Bros. paid her $55,583 and Bogie $297,777. Even a joint appearance on Jack Benny's television show brought in $3,500 for her and $4,500 for him.) Neither did Betty have the advantage of her husband's contract, which allowed him to make his own pictures and approve his directors. She was obliged to take whatever Jack Warner handed her—namely, *Young Man with a Horn*, the story of a jazz musician's rise and fall. To her delight, her costar was her old flame Kirk Douglas. "We worked well together," Betty recalled, "liked each other, talked over old and new times, and flirted—harmlessly." But for all their flirting, Betty wasn't the picture's love interest. That was given to Doris Day, and despite being billed above her, Betty is in fact the film's second female lead.

There's every reason to think that Jack Warner was trying to take her down a few notches by assigning her to such a part. The character of Amy North is utterly unsympathetic, cold, and aloof; she tries to steal the jazzman from his true love (Day). She's also a lesbian, although the Motion Picture Code forbade any mention of the word or any outright depiction of queerness on the screen. Still, the writers, Carl Foreman and Edmund North, got the point across. Watching Day sing, Amy muses, "It must be wonderful to wake up in the morning and know just which door you're going to walk through. She's so terribly normal." Not yet, in 1950, was the ability to walk through different doors something to celebrate; rather, it was something to pathologize, which Douglas's character does when he finally leaves Amy, telling her she's sick and should see a doctor. Betty could have chosen to play Amy with a a sense of wistfulness—she knew enough gay women and men to know that they weren't all self-hating, ruthless schemers—but instead she delivered a one-note performance of degeneracy. She had learned a great deal from her husband

about acting, but how to imbue a villain with a degree of humanity—Bogie's stock in trade—was apparently not one of them.

If she looked for help from her director, she didn't get it. Helming the picture was Michael Curtiz, one of the few directors Bogie was willing to work with, but Betty found him "a tiny bit weak," which seemed odd to her. "There I was being directed by the man who had directed *Casablanca*. . . . Unhappily, the movie was nowhere near as good as it should have been." Thomas M. Pryor in the *New York Times* agreed: "Take away the sound track and all that remains is a hackneyed tale," adding in another article, "Lauren Bacall has the role of the confused, mentally sick wife. It is a heavy, disagreeable part that would tax the ability of a more accomplished actress." *Young Man with a Horn* was a bomb. *Variety* opined that the film needed "considerably more pre-selling" than it had gotten, but Warners had shown little interest in the effort.

The opinion was emerging that Bacall had a limited range as an actress and without Bogie billed above her, her films were doomed to financial failure. That conviction was bolstered by the release of her next picture, *Bright Leaf*, just a few months after *Young Man with a Horn*. Betty's costar was Gary Cooper. There was little love between them, despite her calling him "Coop" and "a pro" in her memoir. They'd been on opposite sides of the political debates for years, Cooper having been a friendly witness for the Thomas Committee. He was one of the charter members of the Motion Picture Alliance for the Preservation of American Ideals, which was diametrically opposed to the Committee for the First Amendment. The two stars have no chemistry in the stale story of tobacco manufacturers (the "bright leaf" of the title) that at its heart is simply a retread of every unrequited love story ever made. *Bright Leaf*, according to *Variety*, was "not big in its New York tee-off," nor was it that anywhere else.

Betty desperately wanted out of her contract. "Jack Warner kept giving me terrible scripts and I kept going on suspension," she said. She believed that the longer she stayed in Burbank, the longer her career would continue its downward slide. "A funny thing happened to my career after the first few years of being Mrs. Bogart," she remembered. "Everyone thought I was terrific personally, but they stopped thinking of me as an actress. I was Bogie's wife, gave great dinners, parties, but work was passed over." Her husband never offered to intervene with producers on her behalf or insist that she be cast in his films, nor did Betty expect him

to. That was something she needed to do herself. "Overjoyed as I was to be Mrs. Bogart, I had no intention of allowing Miss Bacall to slide into oblivion."

The first step in that process came in July 1950, not long after the disaster of *Bright Leaf.* Louella Parsons spotted her in Romanoff's "looking like a strawberry ice cream cone in a pretty pink summer dress," lunching with her agent, Ray Stark, a recent hire by Charlie Feldman. When Parsons asked what they were huddling over, Bacall replied, "Big business." In fact, they were going over the studio's terms for allowing Betty to buy out her contract. Stark, the son-in-law of the stage and radio actress Fanny Brice, was not yet the mover and shaker he'd later become, and at that point, he lacked the clout to push back against most of the studio's demands. If Betty wanted out, he advised her, she'd have to play by its terms.

The fights between Betty and the studio over the last few years had matched and sometimes exceeded the level of acrimony of the fights Bogie had waged. In the summer of 1948, Betty had been suspended yet again for refusing a picture, and although her lawyer agreed that Warners' move had been "hasty and unjustified," her vitriol in her correspondence with the studio had undermined her case. In subsequent letters, she'd tried to tone it down but hadn't always been successful. "I do not wish to rehash any past suspensions or the scripts I have turned down, or the many promises you have made me," she wrote to Jack Warner. "I'm sure you remember and are aware of my reasons. But let me make it absolutely clear to you, Jack, that I have no intention of backing down. I will always refuse to be in pictures that in my opinion are inferior or wrong for me." She ended with a twist of the knife: "I congratulate you, Jack, on your methods of dealing with me and your manner of doing business. It was my mistake to ever believe you when you told me you had confidence in me and my best interests at heart."

In the fall of 1949, Betty put up a fierce fight against appearing in a film to be called *Storm Center* (not the same as the 1956 film). Frustrated, Jack Warner took to the *Hollywood Reporter* to lash out. "I feel that Miss Bacall has no right to question the studio's integrity or purpose in the face of such excellent planning and support," the statement read. "Our record speaks for itself." Betty fired back at the studio: "I have been advised in every contract there exists an implied understanding that each of the parties will act in good faith and deal fairly with the other. Do you

think you are acting in good faith and dealing fairly with me in assigning me to a photoplay for which I am completely unsuited?" In conclusion, she revealed her true motive: "I have repeatedly requested you to release me from my contract. If I have been so much trouble to you, why hasn't this release been forthcoming?"

The reason was Jack Warner's pride: he wasn't about to back down from a woman he felt owed him everything. "We definitely refuse to accord you such a release," Roy Obringer wrote immediately to Betty. "We have at all times fully and faithfully complied with our obligations to you." Warner was being petty, but Betty's argument was legally tenuous. The studio would likely have won in court; even Betty acknowledged that her contract did not give her the right to choose her own films. Ginger Rogers was cast in *Storm Center* (retitled *Storm Warning*) in her place; Betty's salary would be forfeited until Rogers completed the assignment sometime in the spring of 1950, at which time the battles would begin again.

By the middle part of 1951, Jack Warner finally had enough. Bacall could buy out her contract for $50,000, he told Ray Stark. The studio would take 50 percent of all her future earnings until the debt was paid off. Moreover, Betty could accept only film offers that would net Warner Bros. $15,000 at minimum, and if she was more than ten days late in her payments, the full amount of the debt would come due. Swallowing her pride, Betty signed the agreement, which went into effect on July 8, 1950. Four months later, the studio showed it meant business when it demanded half of her compensation for the *Bold Venture* radio deal: "We assume you will make the weekly accountings to us of 50 percent of the monies you receive," Obringer wrote. Whether Betty worked in films, radio, or television or onstage, Jack Warner would be right there with his hand out, waiting to claim his share.

It would be four years before the debt was repaid in full. For Betty, it was worth it to be free of Warner. "He was one of the most ill-at-ease human beings I'd ever encountered," she wrote. "His uneasiness with actors made it impossible to have any reasonable exchange." As for her future, she looked to Santana Productions. Ray Stark was made a partner with an eye to casting Betty in its pictures going forward. But not even with her husband's company was she looking to get tied down again. "As I see it now," she told a reporter, "I would not like to sign another long-term exclusive contract."

Just what a post-Warners career for Lauren Bacall would look like, however, would have to wait. Just as she was negotiating with the studio on the terms of her emancipation, the papers were filled with items about *The African Queen*, an exciting, shot-on-location picture in which John Huston hoped to star Humphrey Bogart opposite Katharine Hepburn. No matter how it played out, Betty knew one thing: she would take advantage of her hard-won freedom to tag along with Bogie and Huston on the adventure of a lifetime.

THEIR CAMP IN BIONDE HAD BEEN BUILT BY HIRED CONGOLESE IN JUST EIGHT days. A semicircle of huts fashioned out of bamboo with palm leaves for roofs greeted the company on their arrival. The windows of the huts, spaces cut into the bamboo, were covered with mosquito netting. Another, larger hut was reserved for dining, and it kept a well-stocked bar. Shooting began on board the nearly forty-year-old, thirty-foot steamboat being used as the *African Queen* of the title, which would sail up and down the river. Cast and crew would occasionally spot crocodiles and hippopotamuses. Giant mosquitos were everywhere.

The Scotch flowed freely. Alcohol was necessary, Bogie said, to make their diet of canned asparagus spears and baked beans palatable. Hepburn didn't drink, so she brought a crate of bottled water that she'd secured in Leopoldville before they'd set out. Bogie later told a reporter that only two moments from the trip lingered in his memory. "Once the party ran out of Scotch for two days and naturally descended into the nadir of despair," he explained. The other memory was the time soldier ants invaded their campground and attacked them in their sleep.

The story of the making of *The African Queen* has been described in detail by Betty, Hepburn, and others. Misfortunes abounded during the six weeks they were on location. A fire on the steamboat left a guide severely burned; Bogie, with his nautical skills, was able to use a fire extinguisher to put the fire out. Another time, the boat sank and needed to be hauled up and righted. Through it all, the company persevered, forging bonds with one another as the ordeal dragged on longer than expected. Except for Bogie, Betty, and Huston, few had known one another before setting out. Hepburn recalled that while she sweated profusely, Bogie never seemed to. She took it as an unhealthy sign. "I anticipated his early collapse in the jungle," she wrote, "for I had heard that he drank quite a

bit." She'd heard right, but to her surprise, the drinking was not a prob-
lem. "He did drink quite a bit," she wrote; both he and Huston "drank
more than plenty." But it had no effect on their work, she wrote, "either
for better or for worse."

As for Betty, Hepburn thought she always looked beautiful, even un-
der the harshest conditions. "I kept looking at her and looking at her. In
the first place, she is young and has lovely tawny skin and she has the
most fabulous sandy hair. In fact, you have never seen her until you've
seen her in her bright green wrapper on the way to the outhouse in the
early morning with her hair piled up on her head and no lipstick or any-
thing else."

Betty was as fascinated with Hepburn as the older actress was with
her. In the beginning, Hepburn "seemed nervous and talked compul-
sively," Betty recalled in her memoir. "She and I didn't know each other
well. I couldn't appraise her." But as the weeks went on, their mutual
admiration society only grew. "The woods was our loo," she wrote, "and
Katie and I would trudge out as the spirit moved us, standing watch for
each other." Bogie was less expressive about his feelings for his costar,
although it's clear that the two very different actors developed a deep
respect for each other, much as Charlie and Rose do in the film. "Inter-
esting girl," Bogart told Gladys Hall after the shoot was finished. "A very
interesting girl."

Still, there were some adjustments to be made. Sharing equal agency
and screen time with a leading lady was something new for Bogart and,
at least in the beginning, rather unnerving. "With his almost aggressive
personality, he had trouble being dominated by a woman," John Huston
told a reporter. One scene called for Charlie and Rose to go shoulder to
shoulder in freeing the steamboat from the muck; they are full partners,
evenly matched. Such a thing had never occurred in any previous Bogart
film, not even the ones with Bacall.

Sometimes the camp would be hit with torrential rain and Huston
would call off shooting for the day. It soon became apparent that rain
was the director's excuse to go off hunting. His hut looked like an armory
with stockpiles of elephant and crocodile guns. What he wanted more
than anything else was to shoot an elephant. One assistant director said
that that goal had been Huston's main reason for insisting that the film
be shot on location.

Hunting, however, was one area in which Bogie departed from his

drinking buddy. The killing of animals for sport was abhorrent to him. When Huston nearly roped Betty into joining him on a hunt, Bogie quickly overruled the idea. On a few occasions, words were exchanged between director and star when Huston wanted to head out with his rifle. Bogie "wanted to be back in civilization," Betty wrote, and the days off that Huston was taking for his quixotic elephant hunt were only prolonging their stay. "Tempers flared," Betty recalled. Her husband "did not love the African location" the way Huston and Hepburn did. Every chance he got, he was saying "Let's get the hell out of here." He wanted to be back in Benedict Canyon with his dogs.

People started getting sick. Only Bogie, Betty, and Huston seemed immune. "We were the only three people who didn't get sick," Bacall remembered. Some got malaria, more got dysentery. Hepburn fell terribly ill. A doctor was brought in who determined that the bottled water she'd lugged all the way into the jungle was loaded with bacteria and amoebas. The irony was not lost that the healthy Hepburn had fallen while the boozy Bogart and Huston had not. By the time all the vomiting and diarrhea was over, Hepburn had lost twenty pounds.

"God, I've had enough of Africa," Betty wrote to Morgan Maree. "Bogie is still wonderful in the part but we're here too damn long." She was restless to get back to her career, typing three-page, single-spaced letters to Maree ruminating over a proposed contract from Fox; she didn't want to get trapped into a situation similar to what she'd endured at Warners. She was also, finally, feeling some maternal pangs. She and Bogie had arranged to have Steve join them when they got to London. "I've missed him so much," she told Maree. "Never again, believe me. It's not worth it to me to be away from him for this length of time."

But the summer dragged on with no end in sight. By early August, Hepburn thought they were finally done and would soon be heading back, but then Huston insisted on getting some shots of Charlie and Rose in the tall reeds. The producer, Sam Spiegel, argued that they "should get out while the getting was good, before everyone collapsed," Hepburn remembered, but Huston insisted on staying behind for a day with his two stars and a cameraman. That "left Bogie and me and Bogie's hairpiece and some makeup, but no makeup man," Hepburn wrote. "I put on my makeup, and I put on Bogie's hairpiece for him. And we got the shots which John wanted."

At last they were free to set out for the city of Entebbe, Uganda, and

from there fly to London—which they called "civilization"—but along the way Hepburn insisted that their caravan stop for a moment so she could have the opportunity to sit in a bamboo forest. Betty traipsed along with her. "I thought Bogie was going to explode," Betty wrote.

Bogart's six weeks in Africa had been physically and emotionally exhausting, and not just because of the mosquitoes, ants, and sinking boats. A week into the shoot, a letter had arrived from Natalie that contained a newspaper clipping. Mayo Methot had died on June 9, 1951, at the age of forty-seven. Betty handed the clipping to her husband, noting his quiet reaction. "Too bad," he said. "Such a waste." She provided no other insights into what Bogie might have been feeling at that moment. But surely beneath his stoic surface his emotions were colliding.

He'd loved Mayo once. He'd felt guilty about leaving her, fearing exactly this, that she wouldn't be able to survive without him. Months after her death, while shooting the film *Beat the Devil*, he'd speak affectionately of his late wife to a visitor. "When he talked about Mayo," the visitor remembered, "his eyes lighted up." But the overriding emotion he felt was sorrow over a life ended too soon.

Since the divorce, Mayo had been living with her mother in Portland. She hadn't hurt for money, with the yearly rentals of the Los Angeles house bringing in $3,000 a year (about $54,000 today) on top of her investments. For a while she had seemed to be getting ready to resume her life. "She wasn't drinking at that point, as everyone thinks," said M. O'Brien, her friend and caregiver. "She was hoping to buy a house and maybe go back on the [Portland] stage."

Her sobriety, however, came too late. She was diagnosed with chronic polyneuritis and hepatic insufficiency, both of which can be caused by alcohol abuse. Those conditions facilitated uterine adenomyosis, for which she was operated on. Two days later, she died at the Portland Hospital. The official cause of death was postoperative shock.

Mayo had been deeply humiliated by the image of the Battling Bogarts and her part in it. Divorce had been the only way to resolve their problems, but each party carried a great sadness over how the marriage had deteriorated. "She never stopped loving Bogart," her friend remembered. "She didn't blame him, but she believed he blamed himself." Bogie never spoke unkindly about Mayo, neither in public nor in his private letters, even if friends such as John Huston continued to malign her. Betty sounded somewhat callous when she wrote to Morgan Maree about how

shocked they had been to hear of Mayo's passing, adding, "This should wind up the alimony payments and settle the matter once and for all."

Yet Bogie, who had retained his affection for his first two wives as well, may have remembered a very different Mayo, the young woman in the stunning red gown he'd spotted at the Biltmore Hotel who had intrigued him so much that he had vaulted up to her box and given her his heart.

AT 11:55 A.M. GREENWICH MEAN TIME ON JULY 21, 1951, THE PAN AMERICAN WORLD Airways aircraft touched down at London Airport. Bogie and Betty had been back from Africa for a couple of days. The plane they were meeting that morning bore a special passenger: their son, Stephen. Arriving at the airport, the Bogarts were treated like royalty. Betty recalled that "the head of the airport" had arranged for Stephen's plane to arrive at the gate reserved for King George VI and his family. Betty was told that the king's grandson, the two-year-old Prince Charles, had come through the same gate just a few days before. Little prince Stephen was the same age.

"The gangway was pushed up, the door opened, and there was Steve," Betty recalled. "The minute he saw me he made a face, the kind he always made at me." He was in the arms of his nursemaid, Ethel King, a British nurse living in the United States whom the Bogarts had recently hired. "I picked him up and I was in heaven," Betty wrote. Bogie was turning the crank of their home movie camera, a phalanx of news photographers catching him as he did so.

The family made their way back to the Dorchester Hotel overlooking Hyde Park. Stephen was talking far more than he had been before they left; it was clear how many of his first words his parents had missed. Now that "the African adventure [was] behind us," Betty wrote in her memoir, "we had to concentrate on being a family."

Given that statement, it's notable that her very next sentence reads "The best thing about those last six weeks in London is that we got to know London itself." Despite the pangs she'd felt in Africa, if we take Betty at her word, the best thing was *not* reconnecting with their son and getting to know him again but rather getting to know the city and some of its most prominent citizens, especially the Oliviers. Betty felt as if they'd been friends with "Larry and Viv" all their lives. There were also Margot Fonteyn, Richard and Sybil Burton, Emlyn Williams, and T. S. Eliot. As

his parents moved through London theatrical society, Steve was left in the care of Ethel King at the Dorchester Hotel.

It's perhaps unfair to push this point too far. The excitement of a first trip to Europe can be intoxicating for someone who's never traveled. Betty was an ardent longtime movie fan, and there she was meeting Scarlett O'Hara and Heathcliff. But it's significant that except for those few sentences about the airport, she provided no details about discovering all the growing up Steve had done or the new skills he'd learned during their five months of separation. Instead, she devoted that section of her memoir to gushing over celebrities. "I still can't believe the people I met," she wrote. "It was incredible to me that at twenty-six I was meeting the best in so many worlds. In all the arts. Such luck."

Bogie, no surprise, was less starstruck and less likely to consider those people friends, no matter how much he liked and respected them. Fame, status, and celebrity had never impressed him. He spent those weeks in London shooting the final scenes of *The African Queen* at Shepperton Studios. That was where the sequence of pulling the boat through the water was filmed, as the river on location had been too hazardous, with all those pesky bacteria and crocodiles. A giant pool at Shepperton stood in for the Ulanga River. Shepperton was also the location of the famous scene where the leeches cling to Charlie after he emerges from the water. Huston originally wanted to use real leeches, but Bogie absolutely refused, understandably.

Finally, on September 7, the Bogarts sailed from Southampton to New York on the *Île de France*, one of the great passenger liners. The crossing took six days. Betty had hoped that Katharine Hepburn would accompany them, but the more time-efficient older actress had chosen to fly. By now Betty was besotted with Hepburn. She was the sort of woman, the sort of star, she wanted to be: independent, forthright, acclaimed, an original. Soon after her arrival back in Los Angeles, she sent flowers to Hepburn for her first day of production on the film *Pat and Mike*. A few months later, she sent another missive: "Katie dear, can imagine how busy you've been so will write you again despite the fact there has been no reply to my last note. . . . Anyway, dear, we think of you and miss you and wish you all the best of everything with the play [*The Millionairess* in Glasgow]. I would give anything to see you."

There's no question that Hepburn liked and admired Betty, but their correspondence gives the impression of the younger actress being the

pursuer in the friendship and Hepburn the never fully attainable prize. Indeed, Betty seemed to grow increasingly infatuated with Hepburn over the years, especially as they both began consciously constructing their individual legends. Hepburn's template was one that Betty would follow.

Soon after their return from Africa, Betty got pregnant again. This time, she did not record her husband's reaction to the news. Indeed, during that period, Bogie was preoccupied with setting up his next film for Santana. There'd been talk of another project with Sam Spiegel, but Bogie wrote to his partner Morgan Maree, "If we do it, I feel [Santana] should get something for doing it, as the S.O.B. [Spiegel] has already gotten many more concessions [on *The African Queen*] than he should have."

Instead, Bogart pressed on with a passion project, *Beat the Devil*, based on the novel by James Helvick, the pen name of the British journalist Claud Cockburn. The book told a tale of international criminals trying to outwit one another in acquiring uranium in British East Africa. Bogart was convinced that he and Huston could re-create the magic of *The Maltese Falcon*, but the director was noncommittal. He didn't share Bogie's enthusiasm for the project. When David O. Selznick pitched his wife, Jennifer Jones, as the female lead of *Beat the Devil*, Huston told him bluntly, "The picture would be more fortunate to get her than she would be in getting it."

Still, Bogart was persistent. In January 1952, Morgan Maree wrote to Huston that Bogie would be content to use Nicholas Ray as director but "would prefer to work with you than any other person." By March, Huston had still not given his answer, arguing that their schedules didn't match up. But then, abruptly, he reversed course and agreed to make the picture sometime late in the year or in early 1953.

Meanwhile, the political harassment continued. Bogart watched as more of his colleagues were called in for questioning and summarily blacklisted. Zero Mostel, who'd appeared with him in *The Enforcer*, was the latest casualty. Bogie was devastated by the death of John Garfield, aged only thirty-nine, felled by a heart attack while the House Un-American Activities Committee was badgering him again. Only after Garfield's death did the committee's investigation exonerate him. There were those, Bogie included, who blamed Garfield's untimely heart attack on the stress he had been put through over the blacklist.

The witch-hunters weren't through with Bogart yet, either. Myron

Fagan's book naming him as a Red appeaser was now in its fifth printing. To sue Fagan would have just drawn more attention to the charges. In May, columnists pounced on an apparently innocuous news story of the Bogarts congratulating the winner of the annual Miss Vie Nuove contest in Italy, sending her an autographed picture. *Vie Nuove*, however, was a magazine published by Italy's Communist Party. The *Daily Worker* called the Bogarts' endorsement of the winner "red hot news," implying that it was a sign of secret support for the Communist cause.

Even worse was the direct question posed by Twentieth Century–Fox president Spyros Skouras during discussions about *Deadline—U.S.A.* about whether Bogart had ever been connected to "certain Hollywood organizations." Skouras defended his question in a letter to the actor. "During the past five years," he wrote, "the consciousness of the American people, our patrons, concerning the world peril of Communism has grown to such dimensions that resentment against American citizens who, in any manner, have given or are now giving aid and comfort to our national enemy, Soviet Russia, must be taken seriously." Skouras requested that Bogart explain his past associations and provide evidence that the studio could release to the public if necessary. No matter how many mea culpas he made, how many investigations exonerated him, that suspicion, that threat to his career, had still not gone away.

In November 1951, Bogie introduced Senator Estes Kefauver at a speech he gave on "Crime in America" at the Los Angeles Philharmonic. After Bogie's praise for the Kefauver Senate committee on his way to shoot *The African Queen*, the senator's office had invited the actor to give the speech. "I think this would be an excellent publicity break," Morgan Maree told Bogart, "and should hit all the newspapers." At the moment, Kefauver was quite popular for his investigation of organized crime. Appearing with Kefauver, "America's number-one racket-buster," as Bogie called him, certainly could be a big break. In his introductory speech, Bogart said the true threat to the American way of life was the "organized, methodical syndicate stretching across our country . . . entrenching itself in our national economy." That was what Congress should be investigating, he implied, not people's political leanings. Bogie was unlikely ever to redeem himself at the political extremes. But what about the majority in the middle? The Kefauver speech was one way of finding out. The picture he'd made in Africa, as it turned out, would be another.

For the past couple of years, the public hadn't been flocking to

Bogart's pictures in the numbers they once had. He'd fallen off the list of top ten of box-office stars. But then came *The African Queen*. Going into wide release in February 1952, the film was the box-office champion for many weeks, eventually pulling in almost $11 million, making it the fourth biggest film of the year. Reviewers were ecstatic. Bogart "had never given a better performance on the screen," wrote Kate Cameron. "You've never seen Humphrey Bogart to better advantage," judged Jane Cody of the *Brooklyn Eagle*. Edwin Schallert noted that people had taken to referring to "Bogart as the new Bogart," indicating that he had redefined himself and was irreplaceable.

There are films that fit the Zeitgeist of their time perfectly: *All Quiet on the Western Front*, *The Grapes of Wrath*, *Casablanca*, *The African Queen*. More than reconfirming his box-office clout, the film gave Bogie a reset of his public image, which had become a little tarnished over the past few years. In the course of the movie, he and Hepburn prove without a doubt their honor and patriotism. "In other words," Rose asks Charlie at one point in the film, "you are refusing to help your country in her hour of need, Mr. Allnut?" Charlie rises to the occasion and, with Rose at his side, obliterates the forces that are intent on destroying freedom and democracy. The characters' eccentricities did not preclude their patriotism, nor should the actors' personal eccentricities, following that logic, be considered evidence of disloyalty. Near the end of the film, Charlie tells Rose, "I'll never forget the way you looked going over the falls. Head up, chin out, hair blowing in the wind—the living picture of a heroine." And Rose replies, "Fancy me . . . a heroine."

Humphrey Bogart had been a hero before, but his heroes had always been flawed. They had been cynical, selfish, out for themselves. They had played both sides for their own advantage, even if they had usually ended up on the side of the good guys. Now, however, Bogart was a defender of the faith, an American lion heart, even if Charlie was actually Canadian and the flag he flew was British. *Parents' Magazine* honored the film with its Special Merit Award for the example it set for children. How much Bogie, Hepburn, and Huston had been aware beforehand of the potential for positive rebranding *The African Queen* offered them is debatable. But they were all savvy enough to at least take advantage of the situation when it presented itself. After the roaring success of *The African Queen*, none of the three was ever accused of subversion again. They became, in fact, American institutions.

Just to confirm that status, Greer Garson walked onto the stage of the RKO Pantages Theatre in Hollywood on the night of March 19, 1953, and announced the name "Humphrey Bogart" as the winner of the Best Actor Academy Award. The auditorium burst into happy applause as Bogart made his way to the stage. He looked drawn and tired when he stepped to the podium, and he flubbed a couple of lines in his thirty-second acceptance speech. He was often uncomfortable when the spotlight was turned directly on him. He managed to thank, awkwardly, Huston and Hepburn, neither of whom had won that night despite being nominated. Yet despite his discomfort, the waves of applause from his peers must have gratified him. The boy called Hump had finally been recognized as doing good.

"He had really wanted to win, for all his bravado," Betty wrote, and "was stunned that it was such a popular victory. He had never felt people in the town liked him much and hadn't expected such universal joy when his name was called." Many members of the Academy did not, in fact, know Bogart all that well; he was stingy about calling industry people friends, a reward granted to only a precious few, such as Nunnally Johnson, Mark Hellinger, and the actor Paul Douglas. But whether the audience was cheering for Charlie Allnut, Rick Blaine, Sam Spade, Philip Marlowe, and Frank McCloud or the actor who'd played them was immaterial; Humphrey Bogart had been enthroned on Mount Olympus. To get there, he'd had to fight, plot, conspire, take stands, rebel, and sometimes betray himself. But there he was, with the little golden man, the highest recognition Hollywood bestowed, in his hands. As Dixon Steele had said in an early scene in *In a Lonely Place*, "There's no sacrifice too great for a chance at immortality."

Manhattan, Thursday, June 24, 1954

Sixty excited movie fans, winners of a contest conducted by New York radio disc jockeys, arrived bright and early at the Hotel Statler, ready to meet the stars. Columbia was going all out to promote its new film, *The Caine Mutiny*, based on Herman Wouk's Pulitzer Prize–winning novel. First came a breakfast, then a parade. Part military adventure and part courtroom drama, *The Caine Mutiny* was expected to be a gigantic hit, but the studio was taking no chances. It was a big, expensive picture, with a stellar cast: José Ferrer, Fred MacMurray, Van Johnson, and, as the commander who is relieved of his authority, Humphrey Bogart.

It was Bogart whom the contest winners most wanted to meet. They had to settle for Johnson, Robert Francis, and May Wynn, the last two providing the picture's romantic subplot. Bogie, according to reports, was resting at the new home he and Betty had purchased in Holmby Hills on the west side of Los Angeles. After a grueling year, during which he'd flown to Europe twice to make pictures, he was exhausted. "Don't expect to see Humphrey Bogart out on the town for some time to come," wrote Jimmie Fidler. "Word is he's flat out."

Still, the contest winners had no time to be disappointed over Bogie's absence. After being treated to a lavish breakfast, they were hustled out to Sixth Avenue to take part in a parade led by Johnson, Francis, and Wynn. Confetti was thrown, horns blared, and placards showing scenes from the film were carried uptown through Times Square to the Capitol Theatre, where the world premiere of *The Caine Mutiny* hit the screen at precisely 9:30 a.m. The line was already around the block by eight. It was Hollywood showmanship at its best.

The hoopla was just one strategy in the film industry's increasingly pitched battle against the upstart medium of television, which just a few years before had been little more than a nuisance but now posed an existential threat. More than half of American households owned television sets by 1954. Popular shows such as *I Love Lucy* and *Dragnet*

were watched by 13 million households every week. That was 13 million households who were not going to the movies on those nights. Movie attendance had continued to drop; by 1955, it would be only about half of what it had been ten years earlier. Television wasn't the only factor keeping audiences away. After the war, movie admission prices had spiked; they were now, on average, double what they had been before the war. All the movie studios were feeling the economic pinch. Warner Bros.' profits were down to $9.4 million in 1951 from $22 million in 1947. Columbia was in even worse straits.

Of course, there were some pictures that managed to break through and lure people back into the theaters. Columbia expected *The Caine Mutiny* to be one of them and believed it would demonstrate staying power. That part was crucial. More than ever, pictures had to have long lives to keep the revenues coming in. For example, one of the brightest successes of the last year was still in theaters eight months after its release: *How to Marry a Millionaire*, made by Twentieth Century–Fox. It was the fifth-highest-grossing picture of 1953. Part of the film's appeal was its wide-screen CinemaScope format, but, like *The Caine Mutiny*, it boasted an all-star cast: Betty Grable, Marilyn Monroe, William Powell, and Lauren Bacall.

For Bacall, being cast in the film had been a dream come true. She'd been off the screen since the fiasco of *Bright Leaf* nearly three years earlier. During that time, she'd been busy with her new daughter, Leslie Howard Bogart, named for the actor Leslie Howard and born on August 23, 1952. By the time Leslie was walking, however, Betty was anxious to be moving around herself, preferably on a soundstage. She'd been somewhat hesitant about signing a one-picture-a-year contract with Darryl Zanuck at Twentieth Century–Fox, as Morgan Maree warned her that the terms were essentially the same as the contract she'd loathed at Warner Bros. He advised her to consider carefully whether she believed Zanuck would give her "the things that you will feel you want to do." If he did not, the penalties would be even more severe than Warners'.

Given that there were no other better offers, Betty decided to take the leap of faith. She believed she'd made the right decision when she learned that Zanuck had hired Nunnally Johnson, a good friend of hers and Bogie's, to write the script of *How to Marry a Millionaire*. Zanuck had the idea of teaming Bacall, Grable, and Monroe in the lighthearted romp about three gold-digging women. Betty was energized about the project

until she had a telephone conversation with Johnson. "I spoke to Betty about it," the screenwriter recalled. "She liked the idea, and then I told her I wanted her to test." The phone went silent for several seconds after his request. "Oh, boy! That burned her up."

Betty asked if Grable was testing. No, she was not, Johnson replied. "She's been playing comedy for years," he said.

"What about Marilyn?" Betty asked.

Monroe had just made *Gentlemen Prefer Blondes*, a very similar sort of comedy. Johnson said he "wouldn't even think" about testing Monroe.

"Then I don't test," Betty told him plainly.

Johnson insisted that it was the only way Zanuck would cast her. She'd never played comedy before. She was "The Look." She was the mysterious, sultry heroine. But Betty absolutely refused. "That's the end of our friendship," she told Johnson before hanging up the phone.

In the end, Bogie convinced her to change her mind, and she had to go back to Johnson, eating humble pie. She aced the test, however, leaving both producer and screenwriter laughing at her delivery. With a shooting schedule set for the spring of 1953, she began costume fittings. But then Bogie announced that he would need to be in Italy during that same period to finally make *Beat the Devil* with Huston, and Betty wanted to go with him, much as she'd done for *The African Queen*. But things were different now. "I would have to make *Millionaire* or forget my career altogether," she wrote. "*Millionaire* was the best part I'd had in years." And so, for the first time in their marriage, the Bogarts were separated for more than a month.

As it turned out, Betty didn't mind being alone. "I enjoyed being able to do as I pleased for a while," she wrote. "It was good to go to sleep when I wanted to, study my lines for the next day without having to worry about dinner for Bogie." On the set she was, for the first time in her career, the main protagonist; although an ensemble, we see the action largely through the eyes of her character, the shrewd Schatze Page, and it's her wedding that serves as the film's climax. In her previous films, Betty had been more of an onlooker than a full participant in the plot. Here, however, she drives the story from the very first scene, when she rents the swank apartment she and her friends will use in their hunt for rich husbands.

For the most part, Betty enjoyed making the film. She was friendly with the director, Jean Negulesco. She found Grable "funny, outgoing . . .

totally professional and easy." Monroe, however, was a different story. Although Betty said that the younger actress was impossible to dislike, she made clear the frustration she felt when shooting scenes with Monroe. "During our scenes she'd look at my forehead instead of my eyes," she wrote, apparently forgetting that Monroe's character was supposed to be extremely nearsighted. What irked Betty was Monroe's habit of turning to her acting coach for approval after each take. If the coach wasn't satisfied, Monroe insisted on doing the scene over; sometimes the do-overs numbered fifteen. "I'd have to be good in all of them," Betty recalled, "as no one knew which one would be used. Not easy—often irritating." She might not have disliked Marilyn, but she clearly felt some resentment toward her. It's also perhaps worth considering that although hers was the central character, Bacall wasn't the film's sex interest, the first time she'd found herself in that position. Schatze, in fact, comes across as the "smart" one, the "plain" one, of the three women.

Upon its opening in November 1953, *How to Marry a Millionaire* shattered box-office records in a dozen American cities. In an unusual move, Fox opened the picture at two theaters in New York at the same time, the Globe and Loew's State, which "attracted outstanding attention," according to *Variety*. Like the rollout Columbia would engineer for *The Caine Mutiny* a few months later, Fox put together a massive promotional campaign for the film, going so far as to make a deal with the enemy, WABC-TV, to provide exclusive coverage.

As only the second CinemaScope production to hit the wide screen, *How to Marry a Millionaire* had a built-in advantage. The first, *The Robe*, had been one of the most profitable pictures of the year. The stars had always been larger than life on the big screen, but now that the screen was bigger, so were they. CinemaScope was, in truth, just a gimmick in the war against home entertainment. Its artistic value was negligible. "In the lingo of merchandising," Bosley Crowther wrote in the *New York Times*, "there is a neat word—'packaging'—for the business of putting up a product in a container of deceptive size and show." That was what Fox had done in this case with "an average portion of very light comedy." Crowther complained that the story felt even "more skimpy and trivial" on a movie screen twice as wide as what audiences were used to. But the gimmick worked. *How to Marry a Millionaire* did not disappoint. Cities around the country reported numbers comparable to New York's: in Los Angeles, the film's first week brought in a new

record of $36,000 for the Fox Wilshire Theatre and "was pointing to a smash season."

Betty was, at last, in a major hit that did not have her husband's name above the title. The satisfaction of that, however, was diminished by the fact that she was largely overlooked by critics, with many ignoring her performance completely. Grable was given the acting honors and Monroe was hailed for revealing new comic depth, but Bacall, according to Crowther, was "cold and waspish." Her final scene was "cheerless," he wrote, and audiences could be grateful that Monroe "does compensate . . . for the truculence of Miss Bacall." Harold Cohen, however, provided perhaps the best assessment: Bacall was "crisp, efficient, and entirely engaging," he judged, and managed to come out of the film intact, "[not] easy in the shadow of MonroeScope."

ACROSS THE OCEAN, HOWEVER, BOGART HAD A VERY DIFFERENT EXPERIENCE making a very different film. He had been determined to make *Beat the Devil* since early 1952. His nearly back-to-back flights to London in the winter and spring of 1953 demonstrated his fervent commitment to the project. British investment, he felt, was the best way to finance a film independent of the established American movie studios. As a Santana production, *Beat the Devil* would be in partnership once again with Romulus Films, and the distribution would be handled by British Lion. In addition, a new agreement had to be drafted with Shepperton Studios for postproduction work.

As a passion project, *Beat the Devil* seems an odd film for Bogart. Perhaps it was the chance to satirize the *Maltese Falcon* formula, yet the uranium thieves in *Beat the Devil* are not nearly as memorable as the jewel thieves in the earlier film, despite Peter Lorre being in the cast. Truman Capote, who was eventually hired to cowrite the script, said that he and Huston had decided to "kid the story"; rather than making another *Maltese Falcon*, they had written a parody of the genre. Such thinking, of course, would have been anathema to studio officials, who tended to green-light pictures that hewed to proven formulas. That may be another reason why Bogie, independent producer and decrier of the studio system, was so drawn to the film. He wouldn't mind sticking it to the system by playing by his own rules, even if the film's subtle, esoteric humor wasn't exactly his own.

Bogart threw himself into every aspect of production, as his correspondence with Huston reveals. He was irate to discover that he could not find enough microphones, sarcastically complaining to Morgan Maree that all "ten thousand and one microphones" in England were unavailable for use. He then asked that replacements be sent from America, much as they had been for *The African Queen*. But RCA refused to ship them to Italy, advising Bogart to contact the RCA subsidiary in Rome. That was the sort of hassle he'd never had to deal with as a contract player. Along with Maree, Bogie negotiated agreements with everyone from union leaders to television marketers, who were eagerly buying up the rights to Hollywood films for their eventual broadcast by TV stations.

Bogie also had to deal with the Production Code Administration, which, at the last minute, refused to approve the script, citing the amorality of the characters, which was unacceptable under the rules of the Production Code. Very few films were successfully released without the PCA's seal of approval, and Huston's first instinct was to scrap the project altogether. Bogart persuaded him otherwise after bringing in Capote as script doctor. David O. Selznick, whose wife, Jennifer Jones, had ended up as the female lead, suggested the diminutive writer, who'd fixed the script for Jones's *Indiscretion of an American Wife*. Bogie called Capote's work on *Beat the Devil* "magnificent." To Joe Hyams, he enthused, "He wrote like fury—has the damnedest and most upside-down slant on humor you've ever seen." Betty recalled that Bogie said that "he'd never seen anyone work so hard or be so professional," which was always a crucial selling point for the actor. As they hoped, the PCA approved Capote's revised script, and the film was back on. Production took place in the spring of 1953 in Ravello on the Amalfi coast of Italy, overlooking the cerulean Mediterranean. Bogie fell in love with the setting, preferring Italy above all other European destinations.

He didn't have the most auspicious introduction to the land of ancient Rome, however. On their way to Ravello, Bogart and Huston were injured in an automobile accident. Their driver got confused and drove into a stone wall. Bogie's head slammed into the front seat, and his teeth—consisting by that point mostly of a bridge—bit straight through his tongue. He had to get the tongue stitched up by a local doctor without anesthetics. He would later joke that the director was possibly hoping that his lead actor's teeth "would fall out so he wouldn't have to go through with the picture," suggesting that Huston had never fully warmed up to

the project. But a new bridge arrived posthaste from Los Angeles, and they were back in business.

For a time, Bogie had considered Betty as the female lead but had deferred to Huston's opinion that she wasn't right for the part. He'd been insistent, however, on Peter Lorre. If *Beat the Devil* was to be a successful homage to *The Maltese Falcon*, Lorre was essential. The film is filled with memorable scenes and lines. There's a bit of marital musical chairs, some comic pathological lying by Jones, cars plummeting off cliffs into the sea, and Lorre's famous speech about the nature of time, ending with "Time is a crook." The action jumps from Italy to the African coast (for which the Italian beaches of Salerno stood in) and then back to Italy, where all the maneuverings, both sinister and comical, are finally resolved. The criminals never get their hands on the uranium. Jennifer Jones goes back to her husband and Bogie goes back to his wife, played by the Italian actress Gina Lollobrigida.

Shooting wrapped by summer, but postproduction turned out to be a nightmare. There was consensus at Santana that Huston's cut was too long. At that point, the director appeared to back away from the film. Hedda Hopper's column reported that Huston wanted his name taken off the picture. "It's not the type with which my name is associated," he was quoted as saying, "and hence may be misleading to the public. It's pure comedy and is never for a moment to be taken seriously." That swiftly brought a telegram from Bogart asking Huston to cable back a denial, which he did. But Hopper refused to print it, according to an assistant, because it had come from Bogart, whom she considered persona non grata. The situation became even more muddied when Huston made similar comments to the Associated Press. The buzz around town was that *Beat the Devil* was a disaster waiting to happen.

HAVE SHOWN PICTURE TO DORE [SCHARY], [DON] HARTMAN, [BILLY] WILDER, AND [WILLIAM] WYLER, Bogart cabled Huston. That trusted group of writer-director-producers FELT CONFUSED [FOR THE] FIRST 10–15 MINUTES, Bogie reported, COULD NOT TELL WHETHER STRAIGHT MELODRAMA OR COMEDY. Everyone agreed that the picture needed "something." Bogie asked Huston if he had any suggestions. By that point, he did not; the director was already on to his next picture. After preview audiences proved to be less than enthusiastic, four more minutes were cut from the film.

Bogart's career was at a crossroads. *Beat the Devil* was his most

personal enterprise yet. He'd been involved in all the behind-the-scenes business, pre- and postproduction, as well as giving his all to the effort of making his character an older, wearier, more cynical Sam Spade. *Beat the Devil*, he hoped, would elevate him to top producer status. That was the goal he'd set for himself since, a short time before, he had finally severed all ties with Warner Bros.

Newspapers had bannered BOGART, WARNERS END 15-YEAR PACT. With eight more years still to go on the contract, the financial security hadn't been easy for Bogie to give up. But the dysfunction had continued. The last picture he'd made for Warner, *Chain Lightning*, three years earlier, had been a complete bust. Both sides agreed that after eighteen years, it was time to part ways. Bogie and the studio were absolved of any obligations to each other. It was a quiet, anticlimactic end to a partnership that had produced some of the greatest motion pictures of Hollywood's Golden Age. Less than a week later, Bogart signed a two-picture contract with Paramount for which he'd be paid $200,000 a year with an additional $20,000 per week for any services in excess of ten weeks. The two films were *Sabrina Fair*, based on the Broadway play, and *Angels' Cooking*, based on the French play *La Cuisine des Anges*.

But first Bogart was hoping for the best with Santana and *Beat the Devil*. His hopes turned out to be in vain. The film was not the success he'd once imagined it would be. Yet neither was it the total box-office disaster that many accounts would claim it was. During its first week, *Beat the Devil* was the fourth highest grosser in New York, and in Chicago and Toronto the revenues were "big," according to *Variety*. Critically, however, it was a dud. Reviewers tended to agree that *Beat the Devil* had moments of brilliance, mostly in the scenes with Lorre and the other criminals. But although Bogie is smart and cunning, he often comes across as dull. The comedy jars the melodrama and vice versa, just as the preview audiences had said. Capote's dialogue is crisp, but Huston's indifference to the project quickly becomes apparent. *Beat the Devil* is one of the few films in which Huston's direction seems uninspired. The *New York Times* delivered the film's eulogy: "A potential treat emerged as a wet firecracker. . . . Beat the Devil ends up beating itself."

Santana Productions lost a great deal of money on the picture, despite Bogie's having waived his salary of $133,333.33. With regret, he and Maree decided to pull the plug on their company. Bogie was exhausted. The idea of going through all of that again for another film in the hope

that it might finally be the one to establish his producing credentials was inconceivable. He sold Santana's assets to Columbia for a reported $1 million. His contract with Paramount meant that from now on, he would be an actor for hire.

Beat the Devil also turned out to be the final Bogart-Huston collaboration. That didn't mean they stopped brainstorming and advising each other. In preparation for *The Caine Mutiny*, Bogie had made sure to send the script to Huston, whose opinion mattered more to him than anyone else's. (Huston's secretary, Jeanie Sims, referred to the director as "God" in the cover letters that accompanied Huston's advice.) *The Caine Mutiny*, rather than *Beat the Devil*, would be Bogie's comeback.

SET IN THE PACIFIC THEATER OF WORLD WAR II, WOUK'S NOVEL TOLD THE STORY of a mutiny on board a navy destroyer and the resulting court-martial of its executive officer. Much of the action is seen through the eyes of a young, idealistic ensign, played by Robert Francis. Bogie starred as Lieutenant Commander Philip Queeg, whose mental instability sets the mutiny into motion. After reading the script, Huston advised that less emphasis be put on the young ensign's troubles with his mother, which seemed "trite." Rather, that time should be spent on the young man's relationship with Queeg. "I think Queeg loses face all too quickly," Huston wrote. "I would like to see him through the boy's eyes." Queeg's psychosis, he counseled, "should be more gradually revealed." When we first meet Queeg, Huston wrote, the commander "should appear to be the perfect and complete officer. Then something ever so slight should make us wonder briefly. Then something else he says or does should cause us to put away our doubts about him." That pattern could be paralleled, Huston suggested to Bogie, in the mutiny trial that provides the film's climax.

Huston's advice wasn't entirely taken by the film's director, Edward Dmytryk. The mother-son story remains a distraction from the compelling main narrative; indeed, the love story between Francis and May Wynn feels extraneous. Bogie wasn't particularly fond of Dmytryk. As one of the Hollywood Ten, the director had gone to prison, but he had also given names to the Un-American Activities Committee, thereby avoiding the blacklist. As far as Bogie was concerned, that was unforgivable. Still, he developed a good enough working relationship with

Dmytryk to get at least some of Huston's ideas incorporated into the picture, although they were presented as his own. Queeg's increasing paranoia is revealed perhaps earlier than Huston would have wanted, but Bogart was still able to present the "perfect, complete officer" at the start. For a chunk of the film, we're not sure if Queeg is just eccentric or dangerously erratic. The commander's progression from competence to insanity followed Huston's outline, however, and was mirrored in the courtroom scenes, much as Huston had advised.

The Caine Mutiny was shot largely on the USS *Thompson* in and around Treasure Island in San Francisco Bay. The *Thompson* had seen action in both World War II and the Korean War. Other scenes were shot around Pearl Harbor, which meant a brief Hawaiian holiday for Betty and Stephen. Obtaining the cooperation of the US Navy had not been easy. The navy was "proud of its record of never having had a mutiny," *Variety* explained, "and in some quarters it has been charged that Wouk's book put the 'system' on trial."

Dmytryk got around that by subtly nudging the blame away from Queeg and onto the subordinates who relieved him of his command; the final big scene seems to suggest that the men got ahead of themselves, despite how dangerous Queeg had become. That way, the system wasn't on trial, but rather the way individuals work within that system. Huston would not have countenanced such a position. But that would have put the film into opposition to the US military, and no one wanted that. (For his part, producer Stanley Kramer would later regret the decision to present the navy as "inviolate.")

For most of the production, Bogie kept to himself, avoiding much camaraderie with his fellow actors. Dmytryk recalled that when he'd worked with Jimmy Stewart, the amiable actor would sit around the set, even when he was through with his scenes. "Not Bogart," Dmytryk told A. M. Sperber. If the director felt that Bogie's coldness toward him might have been the result of his testimony, he did not mention it.

Yet the main reason for Bogie's discomfort on the set was likely his increasing fatigue and shortness of breath. The reports of exhaustion and ill health were true; he seems to have pushed himself too far these past few years. There was no way he could have made it to New York for the gala surrounding *The Caine Mutiny*'s premiere. But surely he was heartened by the news he received. *Motion Picture Daily* reported an opening-week take of $140,000, with the film "hailed by Loew's Theatres

as the greatest grosser for this time of year in the history of the Capitol Theatre." The last week of June was routinely "rated as one of the worst summer weeks in the year," according to *Variety*, and to make matters worse, the city was enduring a stretch of torrential rains. Still, the film's first-week box office was "remarkably big."

The receipts were undoubtedly helped by a bit of unlikely publicity from the televised Army-McCarthy hearings. A week before the premiere, in what appeared to be an off-the-cuff remark, Senator Karl Mundt of South Dakota, a member of the committee investigating Communist infiltration of the US military, had invited his colleagues to a preview of *The Caine Mutiny*, an endorsement that was heard by millions of Americans. Mundt's remark might not have been as spontaneous as it appeared; Columbia's publicity director, Al Rylander, had arranged the preview at the Washington office of the Motion Picture Association of America with the hope of obtaining such a plug. Mundt, who seemed to enjoy the spotlight the small screen gave him, may have wanted some big-screen glamour, too; hence his on-the-air invitation. Mundt was later chastised by Senator Wallace Bennett of Utah, who argued, "The Senate does itself no good to hold the cloaks of those with obviously vested interest in such items." The irony was that a Bogart picture would get a lift from the sort of committee he had been so public in opposing, one that was chaired by the United States' new thought policeman, Senator Joseph McCarthy of Wisconsin.

Critics didn't love the picture as much as the public did, however. Though *Variety* thought that Bogart's performance was "a character portrait that will long be discussed among the pros" and *Time* (which put him on the cover) praised his "instinctive communion with the camera that comes partly from inner fiber, partly from vicissitude and long practice," other critics couldn't get past the clunky subplots and the cowardly ending—much as Huston had predicted. The *Brooklyn Daily Eagle* complained that the "evidence [Queeg] is becoming paranoic is the constant rolling of steel balls [in his hand] but rolling steel balls is no substitute for character development."

Although *The Caine Mutiny* was not quite the sublime achievement of *The African Queen*, Bogie's performance remains unforgettable. He is edgy, desperate, and afraid. As *Time* described his breakdown during the courtroom scene, "Suddenly, he knows he is undone; he stops and stares stricken at the court, during second after ticking second of dramatic and

damning silence." It is an excruciating scene. Once again, Bogart proved his adeptness at portraying madness. When a friend asked him how he did it, Bogie replied, "Easy. I'm nuts, you know."

That was typical Bogart humor, but the actor's inner conflicts had sometimes provided insights into his characters. *Time* described Queeg as "a man who is bottling up a scream," which seems pretty apt in describing Bogart himself during various stretches of his life. *Variety* noted that Queeg was "beginning to crack from the strain of playing hero over the years while he hides his deep inferiority complex." By 1954, Bogart had done a competent job of wrestling down his own sense of inferiority. But his faith in himself was always fragile. And it was about to be challenged by none other than his wife.

THE SOUNDS OF MUSIC AND ROWDY LAUGHTER AND THE OCCASIONAL BARKING of dogs leapt over the walls surrounding the French colonial mansion, shattering the midnight silence of the tony Holmby Hills neighborhood of Los Angeles. The Bogarts were having one of their parties again. "We had kind of an endless open house," Betty remembered fondly. "There was a light above the front door, and when we switched it on, that meant that we were up, drinking, and not averse to having friends join us. So maybe five nights a week, we'd have a crowd in." Some were neighbors, such as Judy Garland and Sid Luft. Others came from all over to sit on the Bogarts' magnificent patio overlooking the swimming pool and do their best to keep up with their hosts' imbibing and merrymaking: Betty Comden, Adolph Green, Mike Romanoff, David Niven, Nunnally Johnson, Jimmy Van Heusen, Swifty Lazar, Noël Coward—"And of course Frank Sinatra was around almost every night," Betty said.

Sometimes the noise got to be too much for some of their more sedate neighbors. The television personality Art Linkletter, who lived directly across the street, along with a few other fed-up, sleep-deprived residents, lodged a complaint with the police, asking that the dogs be muzzled. No action was taken, and the Bogarts never spoke to those neighbors again. Nor did they muzzle their dogs or their parties. They lived as large as their exalted status allowed.

"We were happy people of fame and fortune then," Betty wrote. "For the first time in my life, I didn't have to worry about money. If I liked a pair of shoes, I didn't buy one pair—I bought six. I wanted everything

perfect in our new home, so I bought ashtrays, cigarette boxes, gradually began taking an interest in antiques." The Mapleton Drive house was far bigger than the one in Benedict Canyon; the living room was nearly the size of a tennis court. "It's heavenly," Betty wrote to Katharine Hepburn soon after the purchase. "Of course, we'll never get it furnished—may go bankrupt paying for it—but it's worth it."

They did get it furnished, of course, and they didn't go bankrupt, filling the two-story home with antique armchairs, Chinese vases, and Persian rugs. Betty had once declared that she could never live in a large house: "I like cozy places," she had told Gladys Hall. "Get lost in big ones." But that had been in 1945. Nearly a decade later, the attitude of the woman who had once lived in a two-room apartment with her mother, grandmother, and dog had markedly changed.

"They left behind the lonely hilltop aerie with no neighbors nearer than three whoops and a holler," wrote one interviewer soon after the relocation, "and established themselves overnight on Mapleton Drive, Holmby Hills, in the exclusive center of the movie colony's manor-house community. This represented a thumping victory for Mrs. Bogart." Betty pinned the move on the new baby; the house in the canyon, she said, simply "wasn't big enough when you have a secretary and all that." Everyone understood that the move had been her idea. "Bogie bought it because I fell in love with it," Betty said simply.

The move may also have been prompted by other, more serious concerns. In August 1950, Betty had been startled by a man who had scaled the wall behind the isolated house and stood outside the back door. According to news reports, the man told her, "I've heard that the best way to break into Hollywood is to have a romance with a prominent actress." Betty called the police, who found the prowler and arrested him on a morals charge. The man was Harry Zaharis, a single, thirty-two-year-old clerk in a produce shop. The morals charge was dropped before it went to court. But then, in October of that same year, Zaharis turned up again on the estate. Bogie found him sleeping behind the henhouse. Upon discovery, Zaharis vaulted the wall and fled into the hills, but police picked him up and charged him with vagrancy. "I just want to be an actor," he told the cops. He admitted to having been camping in the hills behind the house "for some time." Police found a stash of oranges, canned vegetables, a blanket, and a hatchet. Zaharis was sentenced to 180 days in jail but had to serve only two weeks, providing he submitted to "periodic

psychiatric study under the direction of the probation officer and that he remain entirely away from the area of the Bogart premises."

In their new neighborhood, Betty did not need to feel vulnerable due to isolation. Mapleton Drive was an exclusive enclave. In addition to Garland and Luft, their neighbors included Bing Crosby, Walter Wanger and Joan Bennett, the composer Sammy Cahn, and Lana Turner, who personified Hollywood glamour and success. Bacall seemed dazzled to be among them, her most extravagant childhood dreams come true, but Bogart was not impressed. He hadn't wanted to leave Benedict Canyon. He'd liked being far away from people, liked people not knowing his business. If the light was burning over their front door, it was almost certainly Betty who'd flipped it on. Bogie wasn't averse to hosting a couple of drinking buddies, such as Nunnally Johnson and Mike Romanoff. But he didn't pay much attention to what else was going on in the house.

"The biggest party-throwers back then were Bogie and Bacall," recalled the agent Dick Clayton. "Bacall would be holding court in the big room while Bogie would be in his den, with one or two of his bourbon-drinking pals. He wasn't the conversationalist she was."

The house had cost $160,000—equivalent to more than $2 million today and perhaps considerably higher, given the spike in Los Angeles real estate prices. Bogie, usually tight with his cash, had spent the money to indulge his wife. Betty, he said, "wouldn't spit on a house that cost less than a hundred thousand." Besides the mansion, the Bogarts owned two Jaguars, a Mark VII for Betty and an XK 120 for Bogie, and of course the yacht. In her memoir, Betty described their married life on Mapleton Drive as "two not-so-normal people . . . beginning to live fairly normal lives." She admitted to not knowing quite what "normal" meant, however. Most people would probably agree that having a living room the size of a tennis court and two Jaguars in the garage and opening one's house five nights a week for entertainment was not the definition of "normal."

Their privilege, however, allowed the Bogarts to become what the conformist decade of the 1950s most prized: the picture-perfect American nuclear family—father, mother, two children, and three blooded boxer dogs. Those were Harvey, his mate, Baby (because of course), and their pup, George; the dogs appeared in photo spreads with the family in numerous magazines. Yet the Bogarts' privilege, to their credit, also enabled them to be generous. Their devoted household staff stayed with them for years. When *Santana*'s skipper, Ted Howard, fell ill with diphtheria and

was too ill to be moved to a hospital, Bogie hired a doctor and nurse to treat him at home. When his gardener, Aurelio Salazar, was involved in an auto crash after drinking, Bogart paid his $50 fine and asked his lawyers if they could get Salazar's one-year license suspension reduced (they were unsuccessful). Bogie and Betty also eventually forgave the debt of the daughter of Alyce Hartley, their nursemaid who'd died unexpectedly; the Bogarts had paid for the ambulance, hospitalization, coroner, storage fees, and burial plot. Bogie did, however, arrange for Betty to keep the mink coat that Hartley had bought just before her death.

Though their lifestyle may not have been exactly normal, it was a period of domesticity for the Bogarts. The addition of Leslie to the family had brought out a more tender side of her father. Bogie was more affectionate to his daughter than to his son, bouncing her on his knee, playing with her on the seesaw. "She was Daddy's little girl," Stephen Bogart would remember, "the baby as well as the female, and he gave to her a quality of love that he never gave to me." What Bogie failed to understand, his son said, was that "a boy needs to be hugged by his father, too." But how could he understand when he himself had never been hugged by either of his parents?

Bogie was flummoxed when it came to his children, especially his son. Adolph Green would remember a time when Stephen, about four or five years old, had become terrified of the hose filling the swimming pool. Green had tried to console the child, but Bogie had kept his distance, shaking his head helplessly. "He had no idea how to handle a hysterical child," Green said. Pete Peterson recalled the "mixture of amusement and bewilderment" with which Bogie looked at his children. "Like Gulliver, one day he awakened and found himself surrounded by little people, whom he couldn't quite figure out," she wrote.

When Stephen was sent to nursery school, his father and mother had the chance one day to observe him through a window. Bogie was struck by how happy his son appeared to be, playing with his friends, and began to cry. Betty took his tears to mean that he was wistful about Stephen growing up and leaving them, but it may have been more than that. Bogie had few happy memories of playtime with other children when he was a boy.

While Bogie could be as distant to Stephen as his own father had been to him, some people were surprised that Betty was more like Maud than she was like Natalie with her children. She wasn't as cold or as

disparaging as Bogie's mother, but she also wasn't the indulgent, nurturing presence Natalie had been with her. Betty had clear ideas about how she wanted Stephen to grow up. Her definition of manhood was the one promulgated by Hollywood: rugged, assertive, self-sufficient—rather like the screen image of Humphrey Bogart, in fact. Betty told a reporter, "I hope [Stephen] does turn out to be rugged. It'll be easier on him if he is. Other children will expect a lot more of Stephen . . . and they're likely to take the attitude that it's up to them to prove that he's no better than anyone else." She said she didn't have a problem with that, although she acknowledged that it would be hard on the boy. "Anyway," she said, "I don't want a pantywaist for a son."

As it turned out, the blissfully happy "normal" family image that was so determinedly projected by the Bogarts and fanned by an obsequious press corps wasn't as ideal as it seemed. In Stephen's book *Bogart: In Search of My Father*, he candidly reflected on the lack of intimacy with which he had grown up, the sense that he was not his parents' top priority. Betty's focus, even more than Bogie's, remained her career. Her children sometimes saw her for only a few minutes a day while she was preoccupied by agents, managers, producers, and columnists. Betty had recently rid herself of Charlie Feldman and his agency after years of feeling neglected. "There is and has been a definite lack of enthusiasm and lackadaisical attitude in your office towards my future as an actress," she wrote Feldman. She did not want her career ever to lay fallow again as it had in the three years before *How to Marry a Millionaire*. It was time for her to get back on top.

She could hear the clock ticking. She had turned thirty. She believed she had no choice but to focus like a laser on her career. To the public, Lauren Bacall seemed to have it all: fame, fortune, a happy marriage, two children. But she knew the fate of women of a certain age in Hollywood. Bette Davis, for all her reputation, hadn't made a film in two years, neither had Katharine Hepburn. If Betty was going to jump-start her career, she had no time to waste.

Inevitably, her efforts in that direction often took precedence over being a wife and mother. She had cooks and housekeepers to fill in for her in those areas; promoting her career and nudging her agents were things she could only do herself. Of course, Betty shouldn't be singled out for this; Bogie's ambition also distracted him from his family, although he had already achieved most of what he'd set out to. Increasingly, Bogie

was content to do his work and come home at night, but Betty was still chasing after the brass ring. The move to Mapleton Drive wasn't just about a bigger house but also a higher profile, one Bogie had little interest in. The move marked a new phase of their marriage.

A tension was growing between the Bogarts. By the spring of 1954, with their social standing in Hollywood at its peak, their problems were becoming apparent. Columnists reported more arguments between them. "Bogie and his Baby had another public spat the other day, with Baby squawking and Bogie pouting," wrote a United Press correspondent. Another reporter observed, more diplomatically, "They have numerous, spirited differences of opinion."

Their problems hadn't appeared out of the blue. They dated, most likely, to the fall of 1952, several months after the move to the new house. That October, Betty had volunteered to work for the Democratic presidential campaign. "Something happened" inside her, she said, as she'd stepped into a world so different from her own. From the moment she first stumped for Governor Adlai Stevenson of Illinois, she wrote, "My life and I myself began to change."

BACALL WOULD RECALL A "VERY WELL-KNOWN PRODUCER" TELLING HER AT the start of the 1952 presidential campaign, "If you're smart, you'll keep your mouth shut and take no sides." Betty understood that Hollywood was "terrorized" (her word) both by the ongoing House Un-American Activities Committee investigations and Joseph McCarthy's Senate hearings. But she wasn't about to sit on the sidelines. She still resented the treatment she and Bogie had endured over the past several years for expressing their political opinions. "I had never considered myself particularly brave," Betty wrote, "but I thought, 'What have things come to if I can't voice my preference for Adlai Stevenson?'"

Bogie, after briefly supporting Dwight D. Eisenhower, shared his wife's partiality for Stevenson. "Delighted to hear . . . that you are willing to make personal appearances for rallies for our great presidential candidate," India Edwards, the vice chair of the Democratic National Committee, wired them. "Your support can mean a great deal because of your popularity." The Bogarts were soon on a plane to San Francisco, where they accompanied the Democratic nominee on campaign stops. "I was insanely caught up in the excitement of campaigning," Betty wrote.

"Crowds waving and screaming—it made me feel I was running for office myself." She admitted to getting "pushy," refusing to allow anyone "who didn't have to be" ahead of her in Stevenson's motorcade, including such fellow campaigners as Tony Curtis and Janet Leigh.

From San Francisco, the Bogarts flew with the candidate to Los Angeles, Betty talking Stevenson's ear off while Bogie slept. On October 16, they led a group of celebrities onto the stage of the Shrine Auditorium in support of Stevenson's speech. In front of seven thousand guests, Bacall and the candidate's sister, Elizabeth "Buffie" Ives, took the stage to solicit contributions; the Associated Press reported that Betty received the louder applause.

After Stevenson and crew flew off to Texas, Betty was restless, still caught up by campaign fever. She immediately began making plans to rejoin Stevenson the following week in Boston. Bogie again accompanied her, though without the same enthusiasm; as much as he admired the candidate, he was exhausted, and frequent air travel "really knocked him out," the Associated Press correspondent observed. After Boston came a giant rally—eighteen thousand people—in Madison Square Garden in New York, where Bogie and Betty were joined onstage by Richard Rodgers, Oscar Hammerstein, Tallulah Bankhead, Carl Sandburg, and none other than Eleanor Roosevelt.

Betty still wasn't ready to go home. So the Bogarts accompanied Stevenson on a special campaign train to Pennsylvania, where Mrs. Bogart quipped to a member of the press accompanying them, "I love that gov," a slogan the campaign then tried to popularize. The reporter remarked on the difference between Stevenson's train and that of the folksier Eisenhower: "Some of the governor's fashionable friends and relatives, not to mention the butler of his administrative assistant . . . give the Stevenson train something of a social tone that is lacking on the other." If anyone was paying attention, they might have worried that such a difference might determine the outcome of the election. The country had moved away from the intellectual, patrician Roosevelt era into something less polished.

By now Betty and Stevenson had become quite close. She was rarely far from his side, with Bogie usually somewhere in the background. "At every speech from the beginning—every platform, breakfast, lunch— Stevenson would catch my eye and wave and smile at me," Bacall wrote. "To my fantasizing mind he seemed so vulnerable." Such intimacy was

bound to cause talk. Stevenson was the first major-party nominee to be divorced. Buffie Ives, who was his hostess in the Illinois State House, did not take kindly to the movie star latching on to her brother. "For glamour, the Democrats have beautiful Lauren Bacall," one newspaper observed. But for Ives, and perhaps for others, glamour led to gossip. Even the merest hint that Stevenson was flirting with Bacall could doom his chances at the polls, confirming many voters' suspicions of divorced men and Hollywood actresses. Ives glared at Betty whenever she saw her and did her best to keep her away from the candidate when photographers were around. "She could see how deeply I felt about him and perhaps felt he might be susceptible," Betty wrote in her memoir.

Stevenson, she believed, "needed a wife, someone to share his life with." She seemed to wish that someone could have been her. "I fantasized that I would be a long-distance partner . . . a good friend he could feel free to talk with about anything." She wrote of her yearning to be "connected with a great man capable of . . . bettering the world." Bogie, apparently, for all his popularity, wasn't capable of such a thing. By the end of the campaign, Betty was thoroughly smitten with Stevenson and didn't want to let him go. "It takes one person . . . who has real passion to unleash one's own comparable passions," she wrote. She was playing with kerosene and matches.

Yet the only scandal regarding the Bogarts the press caught wind of was a nasty editorial in a Boston newspaper about some possibly improper campaign spending. Bogart and Betty, according to a telegram sent to them by their Beverly Hills publicists, were alleged to have "stuck Stevenson fund contributors with $179 one-day hotel bill." The publicists quickly put out a statement claiming that the Bogarts were "paying their own way," but that, in fact, wasn't true. The campaign was taking care of all their accommodations. Campaign insiders suspected that a Republican partisan working at the hotel had leaked the information to the press.

That minor kerfuffle, however, along with Ives's increasing discomfort with Betty's presence, may explain a telegram from Stevenson's scriptwriter, Arthur Schlesinger, Jr., in response to the Bogarts' request to stay involved until the end of the campaign. "The governor has asked me to tell you that he greatly appreciates what you have done," Schlesinger wired them at the St. Regis Hotel, "but in view [of] special nature of last days of the campaign thinks that the job is done."

Betty wouldn't take no for an answer. She and Bogie joined Bette

Davis for a campaign ad on the Manhattan radio station WMCA on October 30. Then they flew back to Los Angeles so they could vote, collapsing "at home with our babies, though, to be truthful, my mind was not on them," as Betty admitted. (Leslie was two months old.) On election morning, the Bogarts were back on an eastbound flight, arriving in Springfield, Illinois, in time to watch the returns from the governor's mansion with the governor himself.

But it was only Betty who showed up at the hoped-for celebration. Bogie had caught a virus and stayed back at the hotel. His wife did not stick around to care for him. "Having come this far," she wrote, "I was not about to miss anything." At the governor's mansion, the expectant jubilation quickly turned into despair as Eisenhower won in a landslide. Betty was overcome as she listened to Stevenson make his concession speech. She wrote, "I sobbed my way back to our room," where she found Bogie more upset about running out of quarters for the pay TV set than he was about the election. Betty seemed to resent being cooped up in the shabby little room with her sick husband. "Until Adlai Stevenson, I was a perfectly happy woman with a husband whom I loved—a beautiful son and daughter—some success in my work—a beautiful home—money—not a care in the world." But Stevenson, she wrote, "shook me up completely."

They flew back to Los Angeles the next day. "On the trip home, I was far away from Bogie, my thoughts on the man I had left behind," Betty said. Among her friends, the gossip swirled. "Everyone kidded me about Adlai," she recalled, "I not having been subtle at all." She wrote that many of her friends hinted that Stevenson had been quite taken with her as well. "I did nothing to dispel the notion," she said. In her memoir, Bacall was remarkably candid about her feelings for Stevenson, making it clear she had fallen in love with him without coming right out and saying it. Post-election, she was determined "not to have [Stevenson] vanish completely" from her life. She searched her calendar for places and times where their paths could cross, even if it meant some rearranging on her part.

It was at that point that Bogie seems to have raised an objection. He was undoubtedly disappointed that Stevenson had lost, which may have been why he exploded at Hedda Hopper on New Year's, creating her grudge against him that lasted the rest of his life. (That was when Bogie became "persona non grata" with the columnist.) But for all that,

he remained uneasy with his wife's fixation on the candidate, and he'd expressed that uneasiness before. "Miss Bacall supports whole-heartedly Governor Stevenson, up to the vomiting point," he'd noted dryly to John Huston. During the campaign, he'd shared an idea with Betty for a cartoon: Bogie, Stephen, and Leslie would be at their front door. Stephen would ask, "Daddy, where's Mommy?" and Bogie would reply forlornly, "With Adlai."

While Bogie was in Italy shooting *Beat the Devil*, Betty flew to New York to see Stevenson. (It's probably not a coincidence that Bogie sent his wife long letters from Rome a couple times a week, the first time he'd done so since their courtship.) At a party being given by two of Stevenson's biggest backers, Ronnie and Marietta Tree, Betty was "not at all sad to be the only Bogart present," she admitted. After the soiree, the governor took Bacall on his arm and escorted her for private after-party drinks at the home of Madeline and Robert Sherwood (the author of *The Petrified Forest* and a longtime friend of Bogart). How Sherwood felt about essentially being on a double date with his friend's wife and another man is unknown.

Eventually Adlai took Betty back to her hotel. In her telling of it, she seems to have been hoping he would come upstairs with her. "I wanted to talk to him alone, to talk personally," she wrote. "Though I wasn't sure he would get that personal with me, the implication was that he would." If she made the offer, Stevenson declined. Betty was left confused and conflicted.

Had she been prepared to begin an extramarital affair with the governor that night? It's impossible to know for sure, but a close read of her memoir gives the impression that's what she wanted. "He did like to flirt," she wrote about Stevenson, "and he did know I was very young and had a solid crush on him." She made all the obligatory qualifications: "It wasn't that I was dissatisfied with Bogie or loved him any less [but] Stevenson could help a different, obviously dormant part of me to grow." In one statement, she had it both ways: "Short of leaving husband and home—which I had no desire or intention of doing—I would see [Stevenson] when I could and keep the thread of my presence alive in his consciousness."

This isn't to suggest that Betty truly wanted to leave Bogie. That would have had career implications for her at a time when Ingrid Bergman had been banished from Hollywood for infidelity. But Betty

appears to have wanted her crush to make some kind of a move, and there was reason to think he might. It was a time when candidates' personal lives were rarely made into campaign issues, which meant that Stevenson could discreetly associate with married women; he'd soon take up with Marietta Tree (who'd also had an affair with John Huston). Betty's infatuation wasn't political or intellectual. Not once in her memoir does she cite any specific policy, position, or vision of Stevenson's as the basis for her obsession. Her emotions had been stirred by him as much as her mind.

While in New York, the pair arranged to meet a few weeks later in California, where Stevenson was giving a speech. At the designated time and place, Betty was right up front, as close to the podium as possible. "Stevenson caught my eye—or I caught his—or we caught each other's," she wrote. They planned a rendezvous in Palm Springs, to which the governor was heading for some rest and recreation. With her "imagination going at full tilt," Betty headed out to the desert, her children left once again with nursemaids. "I was included in all his activities which only fed my fantasy," she wrote. She accompanied Stevenson to lunches and dinners with friends. If a sexual relationship developed between the two, it was likely there, amid the tangy fragrance of desert sage in the shadow of the San Jacinto Mountains, that it began.

Affair or not, Betty was still keen to see Adlai again in Illinois after she finished the New York promotion of *How to Marry a Millionaire*. But by then Bogie was home from Rome and became furious when he learned of her plans. "Absolutely not!" he shouted over the phone. When Betty protested that she'd already accepted the invitation, he hung up on her. "Somewhere in him was anxiety about my feeling for Adlai," Betty wrote in her memoir, implying that, even after all she just revealed, Bogie had no reason to be jealous. His jealousy, she wrote, "had come out before and would again. He held himself in check most of the time, but when it got to be too much, he let loose."

Her husband's fury didn't stop her from going to Illinois. For Bogie, that would have been a sharp slap to his ego. But things didn't turn out the way Betty wanted, either. Any hope for the sort of intimacy she had enjoyed with Stevenson in Palm Springs was dashed. There were always other people in the room. "All very proper," Betty wrote. Buffie Ives was more hostile than ever. Ives asked her "very pointedly" about her husband and children, something Betty seems to have both resented and taken

pleasure in. "I was flattered that she might consider me a threat," she wrote.

But the threat had likely been overestimated. The next day, on her way to the airport, Betty stopped by Stevenson's farm in Libertyville to say goodbye. She found Adlai entertaining a woman, one of his "devoted followers," whose name Betty claimed not to remember. Although they exchanged warm farewells, the Bacall-Stevenson romance of the heart had mostly come to an end. He had many women, and perhaps Betty had realized that. Although she would continue to speak highly of Stevenson and would support him for president again, the intensity of their inter- actions was now in the past. She got onto the plane and returned to her husband and children.

But things had changed. By 1954, the Bogarts frequently led separate lives in private. Betty "started making her own friends and doing her own thing," said Gloria Stuart. "Picture-perfect Hollywood marriages are usually at least one-half public relations." In New York in January of that year, Betty was flying solo, "howling with laughter" at the opening of Dean Martin and Jerry Lewis's act at the Copacabana. Her companions were Paul Douglas, Jan Sterling, Eddie Fisher, Yul Brynner, and others. Having become comfortable making her own decisions, she no longer felt obligated to be her husband's dutiful companion wherever he went. "Betty now refuses to put a foot on his yacht," one writer observed, quot- ing the actress as saying "I spent three years on that so-and-so yacht of his. I had to have my first baby to escape."

Their quarrels increased. Though not quite a return of the Battling Bogarts, as there are no reports of physical altercations, the couple's dis- agreements could still become shrill and heated. Betty described to a reporter her husband's "white-faced anger that cannot be appeased" and how much it terrified her.

Betty's rebellion is not difficult to understand, and it was proba- bly inevitable. After all, as she closed in on thirty, she was entering the prime of her life, while Bogie had long since passed his. He was no longer the vital, dynamic lover he'd been when Betty had fallen in love with him. She'd been nineteen when they had met, twenty when they had married. She'd never had time to explore love and sex or un- derstand her own power. So she was doing that now, making her own decisions and establishing her own relationships. Stevenson was the ob- vious example, but she also forged individual connections with friends

she shared with her husband: Paul Douglas, Nunnally Johnson, Clifton Webb, the designer and former actor William Haines, and Frank Sinatra. She discovered that she liked being Lauren Bacall at least as much as being Betty Bogart.

His wife's newfound independence may have been good for her, but for Bogart it felt like abandonment. Increasingly, he turned to Pete Peterson for companionship. With Pete, he could escape the celebrity-focused world of his wife and talk about ordinary things instead of movies, publicity, and contracts. Pete had finally divorced her husband but no longer harbored any expectation of marriage with Bogie. In January 1954, it was Pete, not Betty, who accompanied Bogie to Paris to make *The Barefoot Contessa* for Joseph Mankiewicz.

Although Bacall arrived a couple of weeks later, Bogart made no attempt to hide his interactions with Pete. At the St. Regis in New York before his transatlantic flight, when Bogie was asked by the columnist Earl Wilson who the pretty brunette was, he quipped, "When people ask me who she is, I generally say, 'Hey, oh, she's my mistress.' That's a conversation stopper." Hiding the truth of their relationship (whatever that truth might have been) in plain sight was classic Bogart. He even authorized an ad in a program for the Make-Up Artists and Hair Stylists Guild in July 1954, a full page that read simply "Bogie and Pete."

Peterson was no longer a secret even from Betty. Photos show her trimming little Stephen Bogart's hair as Bogie and Betty watch. She came to the house, got friendly with Betty's mother, Natalie. One year, she spent Christmas with the family. She was with Bogie on every set and often took Betty's place on *Santana*. Press agents labeled her "Lauren Bacall's good friend" to downplay any suspicions that might arise from reports such as the columnist Herb Stein's, which identified Pete as "Bogart's constant companion . . . meal-fixer, appointment maker or breaker" and someone who "washes and massages his head."

How much Bacall knew of Pete's history with Bogie is unknown, but she was anything but naive. She understood that Bogie was having, if not a sexual affair, then an affair of the heart, and sometimes emotional infidelity is harder to face than its physical expression. According to some reports, she felt hurt but looked the other way. Yet she had done the same thing herself with her intense friendship with Adlai Stevenson. The Bogarts still loved each other, and that love went deep. But the days of being "in love" seemed to have ended, at least for now.

THE BAREFOOT CONTESSA AND SABRINA, BOGART'S TWO FILMS FOLLOWING THE
Caine Mutiny, continued his box-office winning streak. Sabrina came
first. Directed and cowritten by Billy Wilder, it was based on the Broad-
way play Sabrina Fair, which was still running when the film was re-
leased. Critics agreed that Wilder had improved considerably on the
original's rather thin plot. The story of a young woman (Audrey Hepburn)
who is in love with her employer's caddish younger son (William Holden)
but who ends up with his more solid if less exciting older brother (Bo-
gart) was perfect material for Wilder's sly, artful direction. The New York
Times called Sabrina "the most delightful comedy-romance in years."
Much of that was due to the effervescence of Hepburn, then just twenty-
four and fresh off her Oscar win for Roman Holiday. She's both gamine
and elegant. Holden is in rare form as well as Hepburn's devil-may-care,
egotistical object of affection. But Bogie holds his own, projecting a vul-
nerability he didn't often show on-screen, even if it's on the melancholic
side. Critics hailed the "entirely different characterization [from Bogart's]
usual fare." Edwin Schallert thought he was "pleasantly saturnine even
when falling in love."

Production hadn't been as pleasant, however. Bogie was the outsider,
with Wilder close to both Holden and Hepburn. The three of them would
gather to discuss the script in Holden's trailer without inviting Bogart,
who had first billing. Although he'd admired Wilder in the past, Bogie
turned sour on the director soon after production began. "He gave me a
rough time," Wilder admitted. At one point, Bogie taunted him by saying
that John Huston had once revealed his picks for the top ten directors in
Hollywood and Wilder hadn't been on the list. "Isn't that Huston a bum?"
Bogie had asked as innocently as he could. Wilder, like many others,
found the actor's humor "impish and sadistic."

Bogie's costars didn't give him any more satisfaction. He hadn't for-
gotten his conflict with Holden on Invisible Stripes fourteen years earlier.
On the Sabrina set, he blamed Holden for distracting him and causing
him to forget his lines; "It's that fucking Holden," he grumbled. Bogart
also turned out to be one of the very few in Hollywood who didn't care
for Hepburn, who was thirty years younger than he. "She's all right if you
like forty-seven takes," he grumbled.

For all the turmoil, Sabrina was a box-office smash, one of the "gi-
ants" of the fall 1954 season, according to the trades. That was also the
case for The Barefoot Contessa, released around the same time. "Off to

a roaring start," *Variety* raved, noting that the film had brought in a remarkable $87,000 in its first week at the Capitol Theatre in New York. Bogie had approached the project much more enthusiastically than he had *Sabrina*. He'd fallen in love with the script by Joseph Mankiewicz. "The reading of that script was like reading a book," Bacall remembered. "The writing was so good, so interesting. . . . Bogie could be had by that very easily." He liked Mankiewicz and worked well with him, taking on a character he'd played many times before, the once successful professional laid low by his drinking and temperament. He finds rehabilitation in making a star actress out of a Spanish flamenco dancer, played by Ava Gardner. The difference this time was that Bogart, though the nominal lead, was not the romantic interest of the picture. The film belongs to Gardner, who's passionate and heartfelt as she navigates love, desire, and ambition. Bogie's part is basically that of a glorified narrator.

Once again, he didn't warm up to his leading lady. Gardner was the estranged wife of the Bogarts' good friend Frank Sinatra; their furious rows had made headlines. Bogie kept his distance from her except when they were in front of the camera. Despite its Hollywood story line, *The Barefoot Contessa* was produced at Cinecittà Studios in Rome, with exteriors shot at Tivoli, Sanremo, and Portofino. Bogie was happy to be back in his favorite Italian destinations. His performance is likable, decent, sympathetic. "Humphrey Bogart does a superb job," wrote *Philadelphia Inquirer* critic Mildred Martin, "obviously relishing the lines and situations provided by Mankiewicz." The fact that, for the first time since he'd hit top stardom, he was not the focus of the film was driven home when Mankiewicz okayed the poster, which featured only Gardner in a sultry pose. That was a violation of Bogart's contract, which he made sure to point out. He had to settle for a line drawing of his face off to Gardner's side.

Betty also made a picture during that period in which she, too, took a back seat to the stars. She was essentially a supporting character in the all-star ensemble of *Woman's World*, directed by Jean Negulesco (who'd also helmed *How to Marry a Millionaire*). Although Betty's billed fourth, with Clifton Webb, June Allyson, and Van Heflin above her, she delivers a strong performance as the sensible and composed Elizabeth Burns, who sees far more clearly than the other characters in this drama of corporate America. A decade earlier, however, Bacall had personified sex in *To Have and Have Not*, now she was typed as the efficient plain Jane.

On its release in October 1954, *Woman's World* was "sock" in New York, "terrific" in Denver, and "smash" in Chicago, with only *Variety* knowing exactly what the difference was.

The Bogarts had been well represented in the list of the top pictures of 1953–1954. The cumulative, ongoing effect of Bogie's three blockbusters—*The Caine Mutiny, Sabrina, The Barefoot Contessa*—landed him among the top box-office stars for 1955, his last time on the list. But he placed well below William Holden, who personified the brash young leading man so prized at midcentury, and also below John Wayne, who epitomized the conservative, patriotic, even nationalistic mood of the decade. Bogie, for his part, was looking more and more like a man of the past.

His health continued to decline. There were no specific diagnoses for his fatigue, coughing, and stomach troubles. But his symptoms could leave him truculent. At least some of his belligerence on the set of *Sabrina* might be blamed on his physical suffering. He'd always been irascible, but his mood swings in 1953 and 1954 seemed due less to pent-up rage or resentment than to pain, exhaustion, and a creeping fear of becoming obsolete. And it seems quite possible that his wife's attachment to Stevenson added to his malaise.

With every passing month, Bogie felt his age more keenly. Although only fifty-five, he had lived hard. He'd smoked and drunk heavily, brawled in nightclubs, and gotten little exercise other than on his yacht and during an occasional strenuous shoot such as *The African Queen*. "Sometimes I wish I were living back in 1910," he mused to Gladys Hall, recalling the very different world of his boyhood. "Things didn't move so fast. I'm not in such a hurry as most people are."

Humphrey Bogart had accomplished a great deal in his life, much more than anyone could have predicted when he had dropped out of Andover all those decades before. But he sensed that he was nearing the end of his journey, and the limitations imposed on him by his aging and sickly body made him sad. "Pity we haven't the enthusiasm and pep at sixty as at twenty," he told Hall in an unusually reflective moment. "It's too bad we can't be born old and grow young."

Burbank, California, Monday, May 30, 1955

Since departing the stage some twenty years earlier, Humphrey Bogart had been cosseted by "the comfortable 'let's-shoot-it-again' movie business," wrote *TV Guide*, the new bible of the new medium. But there he was, stepping outside his comfort zone, glancing around at the television cameras and broadcasting equipment in the new color studio of the National Broadcasting Company. So many more wires, cords, lights, and microphones than he was used to on a movie set. That night, he would go live, his words and actions beamed out instantaneously to tens of thousands of viewers.

For his first dramatic television appearance, he was re-creating his signature role of Duke Mantee in *The Petrified Forest*. The production was for *Producers' Showcase*, a monthly anthology series that had just scored a ratings bonanza with Mary Martin in *Peter Pan*. The expectations for *The Petrified Forest* were high. Not only was Bogart in the cast but Henry Fonda had taken on the Leslie Howard role and Lauren Bacall was filling in for Bette Davis. But television was largely uncharted territory for the actors. Was Bogart worried, *TV Guide* asked, that he "might freeze up when faced with a live TV camera for ninety on-stage minutes?" Bogie dismissed the question with "the air of Willie Mays facing a mediocre pitcher." No, he told the reporter, he wasn't worried. "Nothin' to it," he said.

That wasn't the truth, however. "Bogart was terrified about going on air live," said the agent Dick Clayton, who spoke to the actor in the weeks leading up to the broadcast. "These big movie stars were thinking they didn't want to get shown up by these small-screen stars who understood the techniques better." Having done a gag appearance on Jack Benny's show and a *Person to Person* interview with Edward R. Murrow, Bogie had concluded, "I look awful on television. Every pore on my face can be seen on those home screens." For a man who often gave the impression of having no personal vanity, the statement is telling. Bogie had aged more

quickly in the last year than he ever had before, and he was sensitive about his lined, gaunt face and bald head.

He wasn't alone in his aversion to TV. For the past five or so years, film stars had largely refused to embrace the movies' upstart rival. But then, almost overnight, TV shows such as *Dragnet*, *The Jackie Gleason Show*, *The George Gobel Show*, and *I Love Lucy* attained more cultural relevance than most current motion pictures had. Americans were suddenly obsessed with TV stars, who came into their homes once a week. By 1955, the Hollywood holdouts had noticed the shift and begun taking their first tentative steps into television studios. Fonda had been busy on the small screen for the past few years, James Stewart had just appeared on *General Electric Theater*, and Barbara Stanwyck would soon appear on *The Ford Television Theatre*. Bogart and Bacall decided that it was their turn.

Of course, the money to be made in television was irresistible. Just one segment aired on Ed Sullivan's *Toast of the Town* had brought in nearly two thousand dollars for Bogie. The Bogarts could also take comfort in the fact that their first dramatic television outing was a prestige project. Their director was Delbert Mann, whose film *Marty*, originally a television production, had just won the Oscar for Best Picture. The *Petrified Forest* actors were, therefore, in good hands with someone who knew both film and TV. For Bogie, who had played the part of Mantee more times than he had any other role, the material was also very familiar. "Pure nostalgia," he replied to a *TV Guide* reporter who asked why he was back at it. "*Petrified Forest* is the show that made me. It also made me a lot of money. It's a real easy role. I just sit there all by myself in a corner and look tough. And it's a great role for Betty."

Bacall's reasons for signing on were likely somewhat different from her husband's. Her most recent picture, *The Cobweb*, had, like *Woman's World*, been an ensemble production in which she had not been the central player. She was no longer under contract to Fox, and producers were no longer sending her scripts built around her character. She had been reduced to writing to Joe Mankiewicz, soon after he'd finished directing Bogie in *The Barefoot Contessa*, asking for a part in his upcoming *Guys and Dolls*. "Dear Joe," Bacall penned in longhand. "Never having done this before I'm not quite sure how to begin. Of course, it's about *Guys and Dolls* and Miss Adelaide. I'd love to play the part and would very much appreciate it if you would give me some thought. And having started off

with one half of the family, don't you think you might [want] to make a stab at the other?" She signed her note simply "Bacall."

The part of Miss Adelaide, a nightclub singer pining for her gambler boyfriend to marry her, had been played onstage by Vivian Blaine with a nasal Bronx accent and a sharp sense of comic timing, winning great acclaim. Bacall was clearly hoping to expand her range, but it's hard to imagine her cultured, husky voice coming out of Adelaide's mouth. Mankiewicz's reply to her is unknown. But he stuck with Blaine, the only one of the Broadway cast to appear in the film.

Betty may actually have felt more pressure to do *Petrified Forest* than did Bogie, whose offhand comment that it was a great role for his wife perhaps reveals his own motives for agreeing to the production. After rehearsing much of the day, Mann's assistant counted down the minutes until showtime. Not even on Broadway was timing so important; curtains often went up a few minutes late. But television had to be precise. At the stroke of 8:00 p.m., they went live. "My heart was pounding so fast I was sure it would be picked up by the mike," Betty wrote.

After a couple of minutes of announcements and a filmed shot of Fonda walking along a desert road, the play began. The camera tracks down to Bacall, slouched forlornly at a bar reading a book. Her body language and irritation with the men at the Black Mesa Bar-BQ telegraphs the disillusionment of the character. Mann then cuts to Bogie as Mantee, being driven by his gang. It might have been 1935 again: he inhabits the part as completely as he did back then, barely moving his mouth or his head, growling out orders and exuding menace, especially when the camera zooms in on a large close up. The pores, wrinkles, and years of hard living are indeed evident on his face as he feared, but they work for the character.

Fonda doesn't appear until almost eleven minutes into the broadcast. But from that moment, the production belongs to him. It's not so much his performance, which is sensitive and competent, but the abundance of screen time he gets. He has more lines than other characters, often dreamy soliloquies. And whereas onstage, and to a lesser degree in the film, he was consistently paired visually with the glowering Mantee, the limitations of television meant that it wasn't easy having the two antagonists in the frame at the same time. In his review of the broadcast, Jack Gould of the *New York Times* wrote, "For maximum effect, Duke Mantee should be seen constantly, so that members of the audience as well as his

prisoners in the restaurant never forget that he represents destiny." As it was, Bogie was usually off-screen as he listened to Fonda's musings about the world. It meant a lessening of the tension that had defined the play and film.

Reviewers were unsure what to think of Bacall. The *Boston Globe* called her "interesting [but] passive, even downright negative at times," which was so unlike the dreamy, wistful way Bette Davis had played the part. In the broadcast, Bacall comes across as already defeated. She's not so much longing for a new life as resenting the one she has. In the original script, Gaby was supposed to be in her late teens or early twenties. Both Davis and Peggy Conklin, who had played Gaby onstage, had been twenty-eight when they had stepped into the role. Bacall, on the other hand, was thirty-one and looked and sounded much older.

The Petrified Forest proved to be a ratings success for NBC, viewed in more than 11 million homes, making it the ninth-highest-rated show for the two-week period ending June 11, 1955. But Bogie had no desire to do any more television. The amount of work and stress wasn't worth it. Betty felt the same, not hiding her disdain for the medium, telling Hedda Hopper a year later that she had no desire to appear on the small screen ever again.

The live broadcast had been a sentimental journey for Bogart. For a few days that spring, he was once again the triumphant young man who'd finally broken through to the top, and he enjoyed his visit to the past. He was part of a generation of stars from what was already being called Hollywood's Golden Age. Bogie had fought hard to get where he was in his career, but he had never been one to kick the ladder out from those who came after him. He saw and recognized a new generation that now waited to succeed him. Among them, he most admired Marlon Brando, another maverick who disregarded norms and niceties. In February 1955, both Bogart and Brando were nominated for Oscars, the first for *The Caine Mutiny* and the second for *On the Waterfront*. "Wrap up all the Oscars, including mine, and send them over to Brando," Bogart announced. In March, Brando won the golden statuette, and Bogie sent his congratulations. Stories that he resented Brando and other young actors are untrue. In 1956, he named Brando, Montgomery Clift, Paul Newman, and Anthony Perkins as the best new actors in Hollywood. All of them played by their own rules, much like the young Humphrey Bogart.

DESPITE HIS AILMENTS AND FATIGUE, BOGIE WORKED HARDER THAN EVER
during 1955, when three major films of his were released. The first was
We're No Angels, the retitled second picture on his Paramount contract,
directed by Michael Curtiz. Although it came out in July, it was a Christ-
mas picture set in French Guiana, a comedy of three escaped convicts
(Bogart, Peter Ustinov, and Aldo Ray) who take over the home of a local
family. The trio is gradually domesticated and, inspired by the Christ-
mas spirit, ends up saving the family from losing their home. *We're No
Angels* was a change of pace for Bogart and somewhat of a trifle in the
Curtiz canon, but, likely because it was shot in both Technicolor and
wide-screen VistaVision, two attributes television could not provide, the
film did well on its release. It also enjoyed some renewed interest during
the holidays.

Bogart's second picture of the year was *The Left Hand of God*, directed
by Edward Dmytryk. Bogie still wasn't overly fond of the director, but
they managed a professional working relationship. During production,
Bogie's costar, Gene Tierney, struggled with recurring mental illness.
According to Dmytryk, Bogart was at first annoyed that she could not
remember her lines, but when he understood her condition, he softened
and helped her out whenever he could. The director thought he might
have been thinking of his sister Pat.

Set in an American mission in China after the end of the war, *The
Left Hand of God* is a far-fetched story of an American war hero (Bogart),
hiding from a villainous Chinese warlord by masquerading as a Catholic
priest. Reviewers were nearly unanimous in their contempt for the pic-
ture. Bosley Crowther sniped that Dmytryk had "not assembled a drama
that conveys either credibility of action or sincerity in mood." As was
usually the case, Bogie mostly got a pass from the critics. Richard Coe of
the *Washington Post* thought he was "far more sure of the part than the
writers, director, and producer seem to be about the rest of the picture."
The picture bombed. Bogie's winning box-office streak was broken.

His third and final film of 1955, *The Desperate Hours*, got him back
on track. (The picture was made before *The Left Hand of God* but re-
leased after.) Reuniting Bogart with his *Dead End* director William Wy-
ler, *The Desperate Hours* was based on the 1954 novel and 1955 play of
the same name, both written by Joseph Hayes, and is loosely built around
actual events. Three escaped convicts invade a private home, but unlike
in *We're No Angels*, the gang is anything but saintly. Bogart's portrayal

of Glenn Griffin is one of his most intense and villainous. Griffin lives only to terrorize, to strike back at those he feels have wronged him. That includes the successful, loving, educated family he takes hostage, who represent everything he has been unable to achieve in his own life. With Fredric March as the solid, fearless patriarch of the family, Griffin has finally met his match; they are reverse images of each other. The two actors, who admired each other and shared the same politics, worked brilliantly in tandem. It was largely a happy shoot, although Wyler was often frustrated with Bogie's contractual right to quit every night at six o'clock.

For the nine-year-old actor Richard Eyer, playing March's son, the experience was sometimes intense. In the course of the film, the boy was repeatedly grabbed, shoved, and put into headlocks by Bogart and his gang. It's agonizing to watch, with Wyler going for as much realism as possible; the fear that the family feels, especially the daughter who is being eyed by the convicts, is palpable for audiences. But for Eyer, Bogart the actor was very different from the terrifying character he played. "I remember [Bogart] as a very sweet man, a nice guy, who smoked a lot," Eyer recalled. As for Bogart's looming, menacing image, Eyer got a glimpse behind the illusion when he observed the actor clomping onto the set in his wooden platform lifts. "When I saw that," Eyer remembered, "I thought, 'What's that about?'" It was about the fact that March stood three inches taller than his costar did.

One day, production became even more intense for the young Eyer. Huge electric lamps, three feet in diameter, were pointed at the actors. "In the middle of shooting a scene," Eyer said, "one of the lights exploded. Hot shards of glass went flying at the actors. Bogart acted instinctively. He took me down with him to the floor, protecting me from any glass. When everyone's nerves had settled down, they said, 'Way to go, Bogie, you saved the kid.' So the guy who tries to kill me in the film saved me in real life."

The Desperate Hours was the first black-and-white VistaVision picture, which certainly didn't hurt its box office. But its compelling, action-packed story was what really brought in the crowds. *Variety* hailed the film's "socko" opening in October 1955, proclaiming it the "standout newcomer" of the week. For whatever reason, however, Bogart was disappointed with the box office, telling a *Time* magazine reporter that receipts would have been even higher if Paramount hadn't promoted the film from a "dignity label," which highlighted March's role, but rather

as a gangster picture, which would have accentuated his own. Three weeks in, *Desperate Hours* was still doing "socko" business in New York and was a "smash" in Philadelphia and Chicago. The reviews were just as enthusiastic. Kate Cameron of the New York *Daily News* praised the "fine individual performances" of the leads; Hortense Morton in the *San Francisco Examiner* was "tied up in knots" by the suspense and singled out Bogart ("drooling freely") and March ("convincing and strong").

Betty also had two films in release during 1955, neither of which had much impact. *The Cobweb* opened in Pittsburgh in June 1955 and was "off to a fancy start," according to *Variety*, but by the second week it had fallen in most markets around the country. A full-color, wide-screen soap opera set in a mental hospital, *The Cobweb* was Betty's first assignment at MGM. Her director was Vincente Minnelli, a former husband of her pal Judy Garland. Once again, Betty had the second female lead (despite her higher billing), yielding screen time to the glamorous, compulsively watchable Gloria Grahame, her husband's costar from *In a Lonely Place*. Once again, Betty was the quiet, intelligent, nice girl in the picture who gets none of the scene-stealing moments of Grahame or even of Lillian Gish, who played a repressed spinster. Howard Thompson of the *New York Times* dismissed the film as "a lurid melodrama," and it quickly faded from prominence.

In October came *Blood Alley*, which found Betty back at Warner Bros. It was a peculiar assignment for her to accept, especially after her fervent campaigning for Stevenson. *Blood Alley* is the story of murderous Communists out to destroy the message of freedom that Americans are trying to spread in postwar China. It bears some similarity to Bogie's *The Left Hand of God*, but the politics are much more explicit. *Blood Alley* was cynically playing into the anti-Communist fervor still roiling the American public; one has to wonder if Betty read the script before signing. Then again, both Bogarts still felt the need to distance themselves from anything resembling tolerance for communism, so it's possible that she took the part precisely for that reason. Certainly, she knew what she was getting into. Her costar was John Wayne, "Hollywood's rough-hewn and indestructible Galahad," as the critic A. H. Weiler called him in the *Times*, who had made very clear his support for the House Un-American Activities Committee. In her memoir, Betty wrote that, to her surprise, Wayne was "warm, likeable, and helpful."

But Warners' opportunistic attempt to cash in on the country's Red-baiting obsession flopped. *Blood Alley* did only "fair" business upon its release, although during its first week it knocked *The Left Hand of God* down from third to fourth place. Both films continued in their free fall after that. For those who felt the Bogarts were guilty of selling out their principles, the failure of the two pictures may have felt like just deserts.

TAKING THE MIKE AT CIRO'S A FEW MINUTES BEFORE MIDNIGHT ON AUGUST 1, 1955, Frank Sinatra, drink in hand, told the packed-house audience, "By now, everybody should be stoned. My whisky has begun to taste like chicken fat." He promised that Ciro's owner, Herman Hover, would buy a drink for every veteran in the room—"Of the Spanish-American war." Sitting at a table up front, Humphrey Bogart immediately raised his hand, insisting that he qualified.

They were all there for the opening night of entertainer extraordinaire Sammy Davis, Jr.'s, stage show. As Davis belted out "Just One of Those Things," "Love Me or Leave Me," and "That Old Black Magic," the crowd complied with Sinatra's command to get stoned, especially those in Sinatra's party, which included Bogart, Bacall, and Sid Luft. "They seem to travel in a little group these days," wrote the columnist Kendis Rochlen, "sort of a Holmby Hills rat pack."

This is the first mention of the "Rat Pack" in the press, so it's unclear if Rochlen coined the term or heard it from one of the group. "Rat pack" referred to juvenile delinquents who went around their communities causing trouble. Canny publicists realized that it was a golden opportunity to sex up and enliven their clients' images, and soon the term came to be used for a certain group of Hollywood troublemakers that included Bogie and Bacall.

The following month, the Holmby Hills Rat Pack made its second appearance, this time at a private party Sinatra threw at the Villa Capri in Hollywood in honor of the restaurant's owners, Rose and Patsy D'Amore. By now Betty was openly promoting the gang, telling a reporter that he ought to join, that its members included her and Bogie, Sid Luft and Judy Garland, "and a few strays." Bogart, however, wasn't with her that night, Betty explained, as he was "taking his annual vacation on his boat, alone." (Pete Peterson later admitted that she'd been with him.) So Betty went to the Villa Capri as Frank's date, sitting at his table, transfixed

by the jam session he spontaneously fell into with Sammy Davis and Nat King Cole. To one reporter present, it was a magical Hollywood moment—"Something like having your record collection come alive." How much more exciting the evening was for Betty than floating around on *Santana*.

It wasn't long before the Rat Pack membership was firmly established: the Bogarts, the Lufts, Betty Comden, Adolph Green, Mike and Gloria Romanoff, David and Hjordis Niven, Nunnally Johnson, Jimmy Van Heusen, Swifty Lazar, Nathaniel Benchley. Betty was called the "den mother" of the group. The Hollywood correspondent Aline Mosby observed, "Some years the movie colony appears to be headed toward being everybody's small town with Tony [Curtis] and Janet [Leigh] posing in aprons in the kitchen. But a handful of senior citizens of the community are keeping some color in the plaster city. They have formed 'the Rat Pack.'" Though Betty might have chafed at being called a "senior citizen" at the age of thirty-one, the average age of the group was forty-four, Bogie and Johnson were in their fifties, and Romanoff was sixty-five. Sinatra was still just thirty-nine, so along with Betty and Judy Garland, he was practically a kid compared to the others.

No matter their ages, however, the Rat Pack understood how to work the brand. Mosby told of their renting a bus, complete with a bar, to take them to Long Beach to see Garland perform, causing a commotion among the citizens there. They'd also flown to Las Vegas to catch Noël Coward. "The club is just for fun, sort of a gag," Bacall told Mosby. "You have to breathe a little life into this old burg now and then." The publicity the group of friends attracted kept them all current. The columnist James Bacon of United Press quipped that New York had its 400 and Hollywood had its Rat Pack, "both exclusive social sets."

Bogart's name always topped the list in press mentions of the Rat Pack, but he wasn't actually present for many of their antics, at least not after the summer of 1955. In October, he began work on what would be his final film, *The Harder They Fall*. Made at Columbia for Jerry Wald, who'd produced *Casablanca* and several other pictures with Bogie. *The Harder They Fall* was based on Budd Schulberg's novel about corruption in prizefighting, which had anticipated his screenplay for *On the Waterfront*. "Bogart was exhausted through most of it," reported Dick Clayton. "[Charlie] Feldman said he barely made it through."

Bogie's diminishing vitality was conspicuous. "The Bogart of today

[has] calmed down a bit," one reporter noted. "Even passes up a drink on occasion, downing a beaker of milk in its place. In fact, you'll find Bogie in the role of a saintly observer when he's relaxing at Romanoff's in Hollywood or '21' in New York." Bogart said, "We're not getting any younger, you know." The columnist Earl Wilson noticed that there hadn't been a report of a Bogart brawl in some time. "You've become boringly respectable," he told the star. Bogie replied that he had retired from fighting. "I'm getting old," he said by way of explanation. Bacall agreed. "He's just turning 56," she said. "When he turns 65—ooooh boy!"

Betty accompanied him to Chicago for some location shooting for *The Harder They Fall*. "Poor Bogie was under the weather in Chicago," she wrote in her memoir. "He'd always been a cougher. Often sitting in a theatre, he would cough when there was silence on the stage or an actor was speaking quietly. It was sometimes irritating." But in Chicago, the coughing was like nothing she'd heard before. To get through shooting, he agreed to have a vitamin shot administered. No one seemed to think to tell him that he ought to knock off the smoking.

The Bogart legend would later insist that the aging star hadn't gotten along with his younger costar, Rod Steiger, one of the blue-jeaned new actors of whom Bogie was supposedly so dismissive. Nunnally Johnson reported that Bogie had expressed some frustration with the way Steiger said his lines, and that may be true. But Steiger would remember only his costar's "independence, his professionalism, and his kindness." Bogart's disdain for the Method—the acting technique many young actors had brought with them from New York—was mostly for show, Steiger thought. He explained, "Here's one generation of actors getting a little upset about this new generation, who were being heralded as maybe being superior." But, in fact, Bogie was patient with Steiger's preparations, even if he didn't understand them. He didn't care how an actor prepared for a scene so long as the acting was good in the end.

With his health issues and his work commitments, Bogart wasn't always able to keep up with the Rat Pack's ramblings. His wife was making a film, too, *Written on the Wind* at Universal, but that didn't keep her away from the merrymaking—or from Sinatra. The relationship between the two was growing more intense and was beginning to resemble Betty's crush on Stevenson.

Bacall's obsession was increasingly clear to her friends. At Sinatra's 1956 New Year's party in Palm Springs, one of the honored guests was

Noël Coward, who'd been named an "honorary rat." In his diary, the British playwright and composer noted a "blonde, cute, and determined" young woman who was hoping to catch Sinatra's eye. But, Coward concluded, "I fear her determination will avail her very little, with Betty Bacall on the warpath."

Coward wasn't the only one to notice Betty's attention to Frank. Not long before, on *Santana*, the Bogarts had entertained Richard Burton, the Welsh actor then making his first splash in Hollywood, as well as other guests, including Sinatra. Bogie had been annoyed when Frank wouldn't stop singing; to Burton, he'd "kept on making cracks about Betty sitting at Sinatra's feet." The cracks were apparently overheard and "really pissed off" Sinatra, Burton said. The next day, according to Burton, the two men "nearly came to blows . . . about the singing the night before." Burton had driven Betty home, because she had been furious with the way Bogie had responded to Frank and refused to ride with him.

Clearly, Bogie was becoming threatened by his wife's friendship with the singer. At the New Year's party in Palm Springs, Sinatra asked the Bogarts to stay a few days longer. Bogie declined. Betty pleaded with him to change his mind, but he was adamant. As they were being driven back to Los Angeles, where their children were waiting, Betty sulked. "We should have stayed," she told her husband, as she recounted in her memoir. Bogie was blunt in his comeback. "You must always remember," he said, "we have a life of our own that has nothing to do with Frank. We have our own road to travel . . . we can't live his life."

Bacall paid no heed. After *Written on the Wind* finished filming and after starring in (despite her earlier disavowal) another live-television event, this time Noël Coward's *Blithe Spirit*, she went right back to Rat Pack business, orchestrating a two-foot-long gag telegram that was sent to the actor David Wayne for a Broadway opening in February. Betty made sure the press knew that she and Frank had sent it. Around the same time, she coaxed Bogie into attending the premiere of Clifton Webb's film *The Man Who Never Was*; Sinatra picked them up in his "hot rod," according to press reports. Bogie, the reports said, appeared "glum." He may have felt like a fifth wheel.

Bogart was more often alone during this time than not. Even Pete Peterson was no longer around. She'd recently married Walter Thompson, an executive at the Cinerama company, who'd been courting her for some time. Thompson had told Bogie of his plans to ask Pete to marry him,

and Bogie had given his blessing. "That Walter's a hell of a good Joe," he advised Pete just before she took off for a flight to New York, where Thompson planned to pop the question. Pete knew that Walter had a surprise for her, but Bogie wouldn't tell her what it was. "It's something you really need" was all he would say. When Thompson proposed, Pete accepted. She'd spent a decade in a loveless marriage and playing second fiddle in Bogie's life. At thirty-eight, it was time for Pete—now mostly called Verita—to find her own happiness. After they tied the knot, the Thompsons celebrated at "21," where they discovered Bogie had picked up the tab.

Back in Los Angeles, Bogart's health continued to decline. Dick Clayton was present at one meeting where Bogie was coughing so hard and so deeply, barely getting a chance to take a breath, that those around him thought he might collapse. But then he caught his wind and seemed to be fine, carrying on the conversation. Betty would write that she had become so used to her husband's cough that she hadn't noticed that it was getting worse. But Bogie did, even if he was loath to admit it.

Soon after Christmas and wrapping *The Harder They Fall*, he was spotted in Romanoff's drinking orange juice by Julius Epstein, the writer of *Casablanca*. Whether it was just orange juice or a screwdriver Bogie was drinking, Epstein didn't say. But the actor complained that the juice hurt his throat. He was also coughing up a storm, as Mike Romanoff recalled.

It was at that point that Bogie made a momentous decision: he would see Maynard Brandsma, a Dutch-born internist at the Beverly Hills Clinic, recommended to him by the actress Greer Garson. Never before had Bogart voluntarily visited a doctor. Bacall was stunned when he told her he'd seen Brandsma. The doctor found his esophagus inflamed and advised him to avoid acidic foods. A few weeks later, when the cough and sore throat continued, Brandsma arranged for a sputum test. "The whole medical scene was foreign to both Bogie and myself," Bacall wrote, "so we didn't pay too much attention." No one appeared to be seriously concerned.

A few days later, the doctor called with the results.

ON THE MORNING OF FEBRUARY 29, 1956, LEAP YEAR DAY, A BLACK LIMOUSINE pulled up in front of the Bogart home on Mapleton Drive. The day was

gray and cloudy and colder than normal. The driver of the limousine opened the door for Bogie and Betty, and they slid into the back seat. They spoke very little.

The news from Brandsma had been concerning. Irregular cells had been found in the sputum sample: cancerous cells. An operation was needed to remove the cancer from Bogie's esophagus. They'd caught it early, Brandsma assured his patient. There was every reason to believe that the malignancy could be removed. But they needed to act quickly.

Bogie hadn't been so sure. Couldn't the surgery wait until he and Betty had finished their first picture together in eight years? They'd agreed to star in *Melville Goodwin, U.S.A.* for their old adversary Jack Warner. Based on a best-selling novel, it was a romantic comedy about a top US Army general carrying on a secret affair with a journalist. In January, Bogart and Bacall had made some costume tests at Warners, Bogie in uniform and Betty in an evening gown. Betty remembered their "sense of play, of bouncing off each other" as they assumed their characters. "We were Slim and Steve all over again," she wrote. The surviving tests corroborate her memory. Although the footage is silent, it's clear that the Bogarts are enjoying themselves. Betty does a little campy flirtation; when Bogie realizes that she's taller than he is, he stands up on his toes, which makes them both laugh.

But the illness is apparent on Bogie's face. He's drawn and thin, with his cheeks appearing wasted. Never heavy, he'd clearly lost weight since *The Harder They Fall.* By the time he finally made his way to Brandsma's office, Bogie was a very sick man. The doctor had looked at him soberly and told him that he needed to postpone the film unless he wanted "a lot of flowers at Forest Lawn." That drove home the urgency of the situation for Bogie, and he scheduled the surgery within days.

No one spoke much about cancer in 1956. When it was mentioned, people's voices often dropped into whispers. The Bogarts had been "totally uninformed about cancer," Betty recalled. That had the effect of keeping them relatively calm. "All I understood was that Bogie needed an operation," she wrote.

The decision to delay the film was deeply disappointing for Bogie, as it was highly unlikely that Warner would hold it for him; the studio was too far along in preproduction. When Bogart pulled out and, not long after, Bacall did as well, the parts went to Kirk Douglas and Susan Hayward. The film ended up being released as *Top Secret Affair.*

But on another front Bogie was more encouraged. In September 1955, he'd formed Mapleton Productions with Morgan Maree. It was less a revival of Santana than a concession to the times: the studios were growing weaker, and independent production was flourishing. As freelancers, Bogie and Bacall would benefit from having their own production company not only for creative reasons but also for tax considerations. With offices at 4376 Sunset Boulevard, Mapleton was considering various projects, including *The Good Shepherd*, the latest work of *African Queen* novelist C. S. Forester, which would be made in collaboration with Columbia. But what had really captured Bogie's attention was "Underworld U.S.A.," a *Saturday Evening Post* feature by the journalist Joseph F. Dinneen. The story of how one young man takes on organized crime fit nicely into Bogart's new crime-stopper image as Estes Kefauver's buddy. Walter Wanger, who had a development deal with Allied Artists, agreed to produce the film. Columbia was on board as well. Mapleton optioned Dinneen's story for $57,000, which was paid in full by January. The company also contracted with a writer, Joel Sayre, to adapt the story for $7,500, which was also fully paid by January.

So Bogie had a good deal of capital already invested in the project. Contracts were executed for Wanger, Bogart, and Bacall, who would co-star. There was every hope that they could start shooting later in the year, after Bogie had recovered and completed *The Good Shepherd* for Columbia, which Harry Cohn promised to keep on the books during his convalescence. Loathed by many in the industry, Cohn had always done well by Bogie. The gesture gave the actor some reassurance as he prepared to go under the knife.

A few nights before going into the hospital, Bogie agreed to accompany Betty to Sinatra's house in Palm Springs, along with "the Nivs, Romanoffs, and Swifty," as Betty called them. No one mentioned the surgery, Betty recalled, but it was there, on everyone's mind.

The gray skies were sprinkling lightly as the limousine delivered the Bogarts to Good Samaritan Hospital. After much consultation, the doctors had determined that the entire esophagus needed to be removed. They would go in through the chest, Brandsma explained, and a rib would have to be cut away. Bogie's stomach would be moved up into his chest and attached directly to the pharynx, meaning that the food he consumed would now drop directly into his stomach. His meals would have to be smaller, and he would feel nauseous until he got used to it.

Brandsma expected him to be in the hospital for three weeks. Betty wrote that Bogie's "drab, impersonal room" was the center of her life for the duration.

She sensed that Bogie was frightened. "I told him I'd be with him, not to worry about anything." It was just the two of them alone in that impersonal, intimidating room. Whatever distance had grown between them evaporated. They sat there in silence, sometimes for long periods, holding each other's hands.

Bogie was on the operating table for nine and a half hours. The doctors needed to slice into his abdomen so they could better access his stomach. But he made it through. This was Charlie Allnut, after all. "Humphrey Bogart is in comparatively good condition after undergoing major surgery for removal of a small swelling in his esophagus," the Associated Press reported. "Dr. Maynard Brandsma said the swelling was of an inflammatory nature and was not cancer."

That was the official line for the public, but even Betty wasn't given the full story. While Brandsma told her that he believed they'd gotten all the cancer, the doctor would later acknowledge that he had realized during the operation that "there was no hope." After Bogie's death, he admitted to a United Press reporter that "he did not want the 56-year-old film veteran to know the worst" and so had "withheld the truth." What appears to be malpractice today was common practice in 1956; patients and sometimes their families were routinely kept in the dark about prognoses. The fear was that the "shock" would exacerbate their condition. The withholding was seen as a kindness, protecting a patient from anxiety and fear during his or her last weeks or months.

When he was wheeled back into the room following surgery, Bogie was pale and wasted, his body traumatized. "Why hadn't anyone prepared me for that sight?" Betty asked decades later, the anguish still fresh. Bogie didn't wake up for several days. Once he did, he coughed nonstop. At one point, he coughed so hard that his stitches came loose. Betty was horrified to observe blood seeping through the bandages on his abdomen. She rushed to the bed and instinctively put her hands against the bandages, "trying to hold everything together," she wrote. It's a far different image than a sultry, glamorous Slim telling Steve to put his lips together and blow, but it's a far more powerful, more intimate expression of love.

Well wishes came from all corners. The director George Cukor sent Bogie a cheery note, saying that he remembered seeing him in *Swifty*

thirty years earlier and being utterly unimpressed. "Never in my born days could I have imagined that you'd turn out to be a beeg, beeg star," he wrote, "and a fine actor besides." John Huston came to visit, surprising his old friend by getting into his bed while Bogie was in the bathroom. Huston told the columnist Mike Connolly that as he'd walked down the corridor toward Bogie's room, he could hear the patient roaring "I'm blankety-blank sick of this pablum you're shoving down my throat! When am I gonna get something I can sink my teeth into?" Never mind that Bogie could barely eat a thing and often got sick when he tried; that was the image his friends wanted out in public. "Bogie, as you can plainly see, is his old self again," wrote Connolly.

Meanwhile, the exhausted Betty, who slept at the hospital all through that period, got by with the help of "hundreds of cups of coffee [and] hundreds of cigarettes." (Smoking was permitted in hospitals in 1956 and incidentally continued to be until 1993.)

In the outside world, *The Harder They Fall* was released at the end of March. Columbia anticipated that it would be "one of the year's major grossers." The studio paid for what *Variety* called a "circus cross-country bus trek" to promote the film, with the "giant" of the picture, Mike Lane, featured at rallies in fifty cities. "Stunt has already paid off in heavy newspaper space and attention," the trade paper noted. But after some initial good numbers in Boston and Philadelphia, *The Harder They Fall* took only sixth place at its New York opening and thereafter quickly declined. Bosley Crowther, in Bogart's last *New York Times* review, called the actor "an old hand at ratting," which made his character of Eddie "thoroughly contemptible" (which was meant as a compliment to his acting). But no one was overly impressed by him or the film. *The Harder They Fall* was an anticlimactic conclusion to Humphrey Bogart's extraordinary film career.

After Bogie was discharged, he didn't quit smoking, only moved on to filtered cigarettes. Even without understanding the full dangers of cigarette smoke, it's unbelievable that doctors permitted a man who no longer had an esophagus to continue inhaling tobacco. He also still drank, though usually only sherry. He began undergoing radiation therapy five days a week; the treatments only made him sicker. The reporter Joe Hyams drove him to the hospital a few times. "How'd it go?" he'd ask Bogie after the radiation was complete. He'd reply, "'Shit,'" Hyams recalled, "and that would be the end of it."

Every night, Stephen and Leslie would come into his room to watch television with him. The dogs came in as well, Harvey instinctively knowing to treat Bogart gently, never jumping on him and sitting protectively at his side. By the middle of April, there was more color in Bogie's face and the nurse thought he'd put on a couple of pounds. He didn't have time to be sick, Bogart believed. He had things to attend to.

For one, his sister Pat, having spent time in the Metropolitan State Hospital in Norwalk, California, was being discharged back to the apartment Bogie had found for her on North Beachwood Drive. To oversee her release, he retained Dr. Warren Jones, a Pasadena psychiatrist. "Plans for her treatment and leave from the hospital I leave in his hands," Bogie wrote to the state hospital. "Dr. Jones will handle problems incident to home visits and leave of absence and such matters as are significant for this and planning for this." Although he was confident that he was going to get well, he was taking no chances where Pat was concerned. After her release, Morgan Maree restarted her $40 weekly checks.

As his strength rose and his nausea declined, Bogie was also eager to return to work. Milton Sperling, who had his own production unit at Warner Bros. and for whom Bogart had made *The Enforcer,* was interested in setting something up. Bogie wrote to Dr. Brandsma, giving him permission to speak freely about his health to Sperling, giving him "all information which you deem pertinent and advisable." Whether Brandsma shared with Sperling more than he'd even told Bogart himself is unknown, but nothing further was heard about any project with Sperling. Bogie was also eager to begin *The Good Shepherd.* Sheilah Graham reported a start date of July 9 for the film. "I hope he will be well enough," she wrote.

By the early summer, Bogie finally had the strength to make a trip to Newport Beach to visit *Santana.* Betty went with him. They didn't sail, just stayed at the mooring. The salty air, the seagulls, and the blue sky lifted Bogie's spirits. Still, Betty wrote, "It was strange seeing Bogie on the *Santana* but not springing around." He just sat in a chair, slender as a reed, a very old man at fifty-six.

FOR MANY CAREGIVERS OF LOVED ONES WITH TERMINAL ILLNESS, THERE OFTEN arises a vigilance that supersedes everything else, including their own self-care. Many develop a sense that only they know how to properly care

for their loved one, which means that they never leave the house. That would describe Bacall during the first months of Bogart's illness. "She hardly ever left his side," said a publicist who worked with Bacall. "She was always afraid he was going to fall or choke. She had nurses, but Betty didn't fully trust them."

Bogie saw what was happening. His wife's career was at a standstill. Their social life was nonexistent, except for when friends came to visit. He knew that Betty needed a break and that she missed the carefree antics of the Rat Pack. "Bogie would make me go to dinner," she recalled. "Because he wasn't up to it, he said, was no reason why I should stay home all the time." Although he had come to depend on her for most everything, "realistically he felt I had to get out once in a while," she wrote. "So I did, once in a while." It was necessary, reinvigorating. No one could blame her for that.

The legend, of course, insisted that she never left his bedside. In one of the very first pieces penned after Bogie's death, Alistair Cooke extolled Betty's constancy and quoted Bogie as saying "She's my wife . . . so she stays home and takes care of me. Maybe that's the way you tell the ladies from the broads in this town." The quote would be recycled in the 1960s and 1970s as Betty's star suddenly became ascendant again, this time on the Broadway stage. But to her credit, Betty eschewed any notion of sainthood in her own memoir, which first came out in 1978. "A man's illness is his private territory," she wrote, incisively and frankly, "and no matter how much he loves you and how close you are, you stay an outsider. You are healthy."

Betty's decision to return to socializing and, later in the year, to her career, was wise, healthy, and essential for both her and Bogie's well-being. Yet the fact remains that her return to society meant a return to Sinatra's society, and that only deepened her attachment to the singer. Bogie had to know that would happen, but he encouraged his wife's respite nonetheless. Sinatra became Betty's sounding board about Bogie's care, his doctors' advice, and whether she should return to work. "There's no question that she became more fixated on Sinatra during Bogie's illness," said the publicist. "Sinatra was young and healthy and vibrant, such a change from bedpans and oxygen machines." For the most part, Betty and Frank avoided being seen in public, tending to socialize with others from the Rat Pack in their homes. They were, however, spotted together ringside at the Art Aragon–Cisco Andrade prizefight at Wrigley Field in August.

As with Stevenson, Betty developed an increasingly proprietary attitude regarding Sinatra. And also, as with the earlier relationship, it has never been fully clear how Frank returned Betty's feelings. That summer, Sinatra was pursuing a young actress who resembled his estranged wife Ava Gardner. "[He was] literally following me," the actress would remember, "and Lauren Bacall kept following him." Bacall, she thought, appeared "very threatened" by her. When the actress ran into Sinatra at Romanoff's not long after, Betty made a point of sitting in Sinatra's lap, even as Bogie, on one of his rare outings, sat beside them. When Sinatra's inamorata finally consented to accompany him to San Francisco, Betty kept tabs on them. As Frank and the actress walked into his hotel suite, the phone was ringing. He picked it up. "Yes, Captain," he said. "Okay, General. Yes, boss." It was Bacall. "Too pushy for words," Sinatra reportedly said after he hung up. The actress remarked, "I hadn't realized the extent of their relationship at the time."

Just how far that relationship went is unknown. "I do not believe she ever slept with Sinatra when Bogie was alive," said the publicist. Of course, just as with Bogie and Pete Peterson, human beings are inconsistent and impulsive; anything is possible when it comes to love and desire. But there's no evidence, not even anecdotal, that Bacall ever physically cheated on Bogie. Emotional infidelity, however, was something they both had experience with.

Shielded from the truth by the doctors, both Bogarts were beginning to reengage with life during the summer of 1956. News reports of Bogie's impending return to the screen proliferated. Bob Thomas of the Associated Press came to visit him and assured his readers that Bogie was "growling again" and would return to work in September. But "he still has little strength or appetite," Thomas added. He quoted Bogie as saying "I've got thirty pounds to gain, but I think I can do it by then."

That summer, Betty appeared on Ed Sullivan's *Toast of the Town* in a tribute to John Huston, along with José Ferrer, Mary Astor, Orson Welles, and Gregory Peck. Bogie had hoped to be there, but despite his improvement, he knew that television could make people appear drawn and wasted even when they were healthy. Huston sent him a note after the show, pleased to hear that he had been putting on some weight. "Bogart has put on five pounds," the director wrote. "His foul-weather friends can now desert him and once again he can breathe in the good clean air of hatred. I am looking forward to my next visit to Mapleton

Drive when you will surely be surrounded by Welsh actors [a reference to Richard Burton], boom boys, and defeated presidential candidates."

Bogart's reply is largely illegible and filled with errors. In an apparent attempt to return Huston's cheekiness, he added an odd last line that makes no sense without the context of what came before: "The trouble with you is that you have no character, no integrity, no sense of obligation, and I have, which accounts for why I am alone." He appears to have been writing from *Santana*. "Miss Bacall is home in bed," he added. Was it simply his dry humor, or had he begun to feel lonely?

Betty did accompany him on the boat for a cruise on Labor Day, although Bogie's skipper did most of the work. Around the same time, he took Stephen out with him on *Santana*, seeming very determined to teach him some seamanship skills. "Bogie was happier on the boat than anywhere," Betty said. How fortunate that his health improved enough for him to have one last summer on the water, even if he was no longer steering his own ship.

The summer also brought disappointment. Given Bogart's illness, Mapleton Productions had stagnated. Wanger had found it necessary to move on to another project and there was not enough money for Mapleton to make *Underworld U.S.A.* on its own. Morgan Maree turned to Columbia. But B. B. Kahane, Cohn's vice president, was firm in his belief that *Underworld U.S.A.* was not right for Bogie. "When Bogie is able to come in for a discussion, we can arrange a meeting and chat about it," Kahane wrote to Maree. "If, however, Bogie would rather dispose of the story rights and not bother to meet on it, this would, of course, be agreeable to us." There's a good deal being said between the lines here. Although Cohn kept *The Good Shepherd* on the books, Columbia wasn't going to gamble with developing a second Bogart picture. Despite the drumbeat of encouraging press emanating from Sam Jaffe's office, word had gotten around that Bogie's rally was already fading. Columbia was telling him to let *Underworld U.S.A.* go. For as long as Bogie lived, Mapleton would remain an incorporated company. But after September 1956, its books are empty.

THE FIFTY-SIX-FOOT-TALL NEON SIGN OF THE SANDS HOTEL AND CASINO LIT UP the Las Vegas Strip on the night of September 12, 1956, with a single name on its marquee that was guaranteed to draw in the crowds. "Frank

Sinatra's Sands opening promises to be a gala affair," reported Louella Parsons. "Reservations have been made for Lauren Bacall, Kim Novak, the Leo Durochers, the Nelson Riddles, Jimmy Van Heusen, and Mr. and Mrs. William Goetz." Sinatra had first played at the Sands in 1953, and every year, the show had gotten bigger and more popular. This year's was billed as his best show yet. No way was Betty going to miss it. At first there was some pretense that Bogie would join her, but it's doubtful that anyone around him took the idea seriously.

It wasn't just that Bogie was too weak to travel. He also, almost certainly, recognized the danger of coming across as a hypocrite if he attended. He'd introduced Estes Kefauver at his rally, after all, and tried to cast himself as tough on organized crime, while the Sands, as everyone knew, had ties to the mob. Crime bosses such as Meyer Lansky and Doc Stacher had acquired shares in the hotel and arranged shares for Sinatra as well, with the intent of establishing him as a Sands headliner. For the past three years, Frank had been bringing in the big cash—some of which made it back into the crime syndicate. It's very possible that Bogie's distancing himself from Sinatra had as much to do with his mob connections as it did with his wife's infatuation. Even if Sinatra's relationship with the mob was more "mutual admiration than affiliation," as his biographer contends, just the perception of impropriety would have been enough to keep Bogie away.

But not Betty. A few nights later, she was back in the audience for Frank's show, knowing that once he sang his last number, the floor would be hers. Around one in the morning, the caterers rolled out a two-tier cake with the words "Happy Birthday Den Mother" inscribed in frosting. An hour earlier, Betty had turned thirty-two, even if she refused to divulge her age to Louella Parsons, who was present. "There were more celebrities at the party than on New Year's Eve," the columnist gushed, among them the "Nivs," the Romanoffs, Swifty Lazar, Cole Porter, and the Goetzes. Sinatra, whom Parsons called "Sands-sational," sang "Happy Birthday" to Betty from the stage. Afterward, as her friends cheered and whistled, Betty embraced Frank and kissed him on the cheek. Bogie reportedly called her backstage to extend his own good wishes.

If that last part was true, and not just publicity hokum, Bogie would have had to call her from the radio on *Santana*, as Betty noted in her memoir that her husband had "decided to withdraw" from the party so he could take Stephen out on the boat again. Bogie was pleased with how

quickly the boy was learning, calling him "responsible, capable." Connecting with his son, which was long overdue, was obviously a better use of his time than taking a trip to Las Vegas. He was also just too worn out, frankly, to travel that far.

Even though Bogie steadfastly maintained that he was going to get better, it's hard to imagine that he never considered what would happen to Betty after he was gone. What crowd would she take up with? Natalie Schafer, with whom he'd appeared in the television adaptation of *The Petrified Forest*, remembered visiting him toward the end. "He turned to me one day when we were talking alone," she told an interviewer, "and he said, 'Keep your eye on Betty. Don't let her get mixed up with those jerks out there.'" Just who he considered "those jerks" to be is unknown. He clearly didn't mean his friends, Niven, Romanoff, or people such as the Durochers and Goetzes. But there were those out there whom he worried about. The Sands was full of them.

Despite his serenade of Betty, Sinatra's date for the week was reported to be Kim Novak, and Earl Wilson reported that he was on the phone regularly with "his beautiful protégé" Peggy Connelly. Wilson revealed that Frank had phoned all his friends back east to go see Connelly's debut at the Blue Angel nightclub. "Results: biggest opening there ever," Wilson wrote. Connelly was seven years younger than Bacall; Novak was nine years younger. Just as with Adlai Stevenson, Betty had a lot of competition for Frank's attention.

When she returned to Los Angeles, Bacall went before the cameras for the first time in nearly a year. The film was *Designing Woman*, made at MGM and costarring Gregory Peck. It proved to be a happy experience. But when she went home at night, the mood was getting bleaker. The weight gains Bogie had achieved dissolved. By the fall of 1956, he weighed less than a hundred pounds. "He just seemed to shrivel up," Nunnally Johnson said. On every visit, Johnson found him "ten pounds smaller, and it was heartbreaking. He just got smaller and smaller." Word leaked of Bogart's decline. On October 7, Dorothy Kilgallen reported, "Sad news for Humphrey Bogart fans: he's been moved to the eighth floor of the Memorial Hospital in Los Angeles." That was untrue; Bogie was still at home, and there was no Memorial Hospital in Los Angeles. Kilgallen's tipster got the details wrong but the seriousness of the situation right.

Still, no one was ready to let the public know the truth. Joe Hyams,

always ready to assist, helped Bogie prepare a statement in response that went out to all the papers denying that he was dying. "All I need now is about thirty pounds of weight, which I'm sure some of you could spare," Bogie was quoted as saying. "Possibly we could start something like a Weight Bank for Bogart and believe me I'm not particular which part of your anatomy it comes from." Classic Bogart. One newspaper editorialized, based on sources unknown, "After enjoining the Hollywood reporters he had called to receive the health bulletin to sin no more, Bogart sprang from his easy chair to the bar and mixed himself a tall one with the toast: 'Here's to Mark Twain. Reports of his death were exaggerated, too.'" The public was relieved by the lie that Bogart was as vital and caustic as ever.

Betty denied that the Rat Pack had disbanded and insisted that Bogie was still the ringmaster. "Our Rat Pack is not dead," she said. "It's all because Bogie, the head rat and director of public relations, has been incapacitated by health problems in past months. He's coming around now but he's not yet quite as ratty as his high office demands." At the same time, the columnist Danton Walker was reporting with certainty that Bogart would begin work on *The Good Shepherd* for Columbia in February 1957.

But Bogie was in no condition to work. He was in increasing pain, which manifested itself mostly in his shoulders and legs. Sometime in October, Brandsma determined that the cancer had metastasized throughout his body. How much of that prognosis he shared with Betty is unknown, but everyone in the house must have realized that something had changed. The doctors suggested that injections of nitrogen mustard might help with the pain, but they clearly saw it as a palliative, or possibly as an attempt to keep Bogie's hopes up. But the nitrogen only made him dizzier and more nauseous. At least once, he fainted when he stood up from bed.

To get around the house, he now had to literally lean on Betty. He apologized for being a burden on her. She wouldn't hear of it. "I love you to lean on me," she told him. "It's the first time in twelve years. Makes me feel needed."

She had resumed her vigil at her husband's side. He was a pale shadow of the man who had changed her life, given her so much, believed in her, and encouraged her. Now she weighed more than he did; now she was the strong one. For all her fascination with Sinatra, she deeply loved

this man. Finally, she could return the support and nurturance he'd once given her. "She was exemplary," Joe Hyams said. "The way she handled his illness, the way she handled the press, the way she handled herself, and the way she handled the children." She had come through for Bogie. This, in the end, no matter what else transpired, is what matters.

Lying in his bed, Bogie's eyes bulged from his wasted face. His bones poked through his skin. He was a tiny, shrinking man, but he hadn't lost his power. That old rage still roiled inside him, and he turned it on himself, angry that he was not getting better. One time he screamed at a nurse, "What do you mean, no improvement? What do you mean, there's no weight gain? That takes time!" The Bogarts went through several nurses during that time.

Morgan Maree made sure that his will and finances were in order. Bogie would leave his family very well off. In addition to his income, real estate, and sponsorship deals, since 1949 he'd been making investments in oil companies. By 1954, his wells in Texas were doing particularly well and were called by an accountant "a very profitable investment." Bogart made sure that his wife, children, and sister would be well taken care of. The trust fund he set up for Betty amounted to $847,540, equivalent to about $7 million today.

Soon after Adlai Stevenson was defeated a second time for the presidency, Bogie was readmitted to the hospital for "treatment of a nerve pressure condition which followed a cancer operation," according to an Associated Press report. That was when the doctors finally told Betty the full truth. "Bogie cannot last much longer," Brandsma said. "We don't know how he's lasted this long." Betty slept in a room adjoining Bogie's after he returned home. Natalie and her husband were there to watch over Stephen and Leslie.

Bogie still shaved every day, with the help of a nurse. His caregivers still wheeled him out to the living room, where he'd sit in his chair and speak, very softly, to visiting friends. Most everyone came by at some point: the Rats (although not Sinatra), Spencer Tracy and Katharine Hepburn, Joan Bennett and Walter Wanger, John Huston. Pete came with her husband, Walter Thompson. Even Jack Warner came, sitting awkwardly and ill at ease opposite the husk of his former top box-office draw. Bogie was touched that he had at least made the effort.

He turned fifty-seven on Christmas Day. What passed for a celebration brought a small smile. By New Year's, Bogie never left his room

and told Betty not to let the children visit him anymore. He could see what he looked like in the mirror. Betty never knew the exact reason he had made the request, but it seems reasonable to believe that he did not want them to remember him that way. Betty held back tears. "I'll never get married again," she vowed to herself, as she revealed in her memoir. "Never."

Bogie said nothing about dying. There was never any talk about his wishes. He never said goodbye. So Betty kept up the game. After all, he had told her. "If you're okay, then I am. If you're upset, then I am." She choked back her emotions and put on a cheerful face.

Their New Year's Eve was very different from the gala of the previous year, with just Natalie and Lee Goldberg sharing champagne and caviar in Bogie's bedroom. On January 3, Betty received a request from the *Star* in London to write a series about her life with Bogart. She declined. That same day, the New York *Daily News* published a piece on Bogie's decline. "The husky-voiced tough guy who has died a dozen times on film is up against the real thing this time," wrote the reporter Kitty Hanson, who added that the actor was down to eighty pounds. Although the story was accurate and likely sourced from someone in the house, possibly a nurse or technician, Morgan Maree turned the lawyers loose on the newspaper. "After the article appeared," one of Bogart's attorneys wrote, "Mr. Bogart and his wife were greatly upset because the untrue statements were given world-wide publicity." But no lawsuit was ever filed. The *News'* reporting was solid.

On the evening of January 12, Hepburn and Tracy came by for a short visit, and then Betty crawled into bed with Bogie to watch a movie on television. "Bogie wanted me on the bed with him, next to him," she wrote in her memoir. After the movie was over, he asked her, "Why don't you stay here tonight?" Bacall replied, "Of course, I will." He was restless most of the night, passing into one of the deep sleeps that had become common, but Betty stayed by his side, sleeping very little, taking some comfort in holding his hand. "Odd how important holding a hand can be, how reassuring," she said.

In the morning, Betty piled the children into the car to drive them to Sunday school. She and Bogart had decided to raise Steve and Leslie as Episcopalian, and both parents considered the rector to be a friend. As Betty left, Bogie said to her, "Goodbye, kid." It wasn't dramatic, just his usual farewell, not a goodbye. But he did say, "Hurry back." Betty did, but

when she returned, he had lapsed again into one of those deep sleeps. He never woke up.

Betty brought little Steve in to see him. They held his hand and kissed him. Later, after she'd thought he'd gone to bed, Betty found Steve back by his father's side. She asked why he'd come back. "Because I wanted to," the boy said.

Betty lay down on her cot. She'd remember praying "Please don't let him die," even though she knew it was inevitable and would mean an end to his suffering. She simply couldn't imagine what life would be like without him. But she would need to start imagining it. In the early-morning hours of January 14, 1957, a nurse gently woke her up. "Mrs. Bogart, it's all over," he said. "Mr. Bogart has died."

Humphrey Bogart had been born into a family that did not know how to show love. He had passed his first moments on Earth, and indeed his entire childhood, untouched, uncomforted, uncared for. His death was just the opposite. His wife lay by his side and held his hand in a way his mother had never done. It's to be hoped that at the end of his life, some of the old demons were at last chased away and Bogie finally understood what it felt like to be loved.

PART V

LAUREN
1957–2014

Los Angeles, the First Week of January 1959

A gaunt, unsmiling Lauren Bacall was waiting in the living room of a rented house on Bellagio Road. It was exactly two years since Bogie had died, and the struggle of the past twenty-four months was plain on her face. Joe Hyams had come to say goodbye.

"There comes a time in everybody's life when they have to move on," Bacall told him. "It's a form of self-protection, I suppose. I feel like a visitor in Hollywood now." She would be leaving for Europe in a matter of days, she told Hyams, and when she returned, she planned to take up residence in New York, severing all ties to the town and industry that had made her a star. The comfortable mansion in Holmby Hills, the epicenter of all those high-flying Rat Pack parties, had been sold. Bacall had moved out long before the sale, selling the furniture and renting a smaller place at 10430 Bellagio Road, where she'd been ensconced now for a year and a half. "There is nothing left for me out here," she told Hyams.

Betty's dark mood at the start of 1959 was stoked by grief for the husband who had made everything possible. But it was more than that. She was also grieving the status she'd once wielded in the film colony. It had become clear, after the past two years, that her status had been dependent on Bogart and would not survive his death. "Being a widow is no picnic," she later said, "you lose your place."

Betty's anger and bitterness simmered just beneath the surface as she spoke to Hyams. She felt abandoned by her friends and colleagues. She felt cast aside by the industry that had once rhapsodized over her. For more than a decade, her entire life, image, and career had hinged on being Mrs. Humphrey Bogart. Now, at thirty-four, she was cast adrift. She had no blueprint for widowhood. She'd known that life without Bogie wouldn't be easy, but she'd had no idea just how devastating the past two years would turn out to be.

In the first weeks after Bogie's death, Betty had existed almost in a fugue state. She was stunned and disoriented. She asked John Huston

to deliver the eulogy at the funeral. Bogie's friend and collaborator could bring an eloquence to the service that she was not capable of summoning at the moment. Huston rose to the occasion. "His life," he intoned in that deep gravelly voice of his, "though not a long one measured in years, was a rich, full life. Yes, Bogie wanted for nothing. He got all that he asked for out of life and more." The awkward boy called Hump, as it turned out, had done very well for himself.

After the church, the mourners had headed over to Mapleton Drive for one final gathering at that storied house. There was no talk of the Rat Pack anymore, but some of them were there: Adolph Green, Betty Comden, Jimmy Van Heusen, and Mike Romanoff, who provided the food, booze, and waiters. There were other, less stellar names, as well: "make-up men, nurses, neighbors," Betty wrote in her memoir, and "Bogie's hairdresser." She apparently couldn't bring herself to name her, but at least she acknowledged that Pete had been there.

The media attention to his death had been overwhelming. Betty put together a scrapbook of clippings as a memento for the children. "It's absolutely fantastic," she told Hedda Hopper, leafing through the pages to reveal dozens of obituaries in foreign languages. "I've never seen such coverage, even for presidents of countries."

Bogie had wanted his ashes to be scattered off *Santana* into the Pacific Ocean. Morgan Maree advised Betty against it, explaining that it was against the law. So the interment took place at Forest Lawn, reportedly with the whistle bracelet Bogie had given Betty some years earlier. It was there, at the columbarium, that the anger first bubbled up inside her. When the cemetery director offered perpetual care of the grave "for a small fee," Betty saw red. She held her tongue, but she was thinking "You're not going to trap me into that, you bastard. These people get you in your grief and misery and sell you whatever they can." An offer of perpetual care is standard in burial packages. But Betty didn't see it that way. The bastard was trying to chisel her, just like Jack Warner and others had been chiseling her since she came to Hollywood. In the months after Bogie's death, his widow saw affronts everywhere. She'd been powerless against Bogie's illnesses and death, but by beating back those she saw as chiselers and exploiters, she may have felt she was regaining some control.

"I will not discuss his illness for publication at all," Betty told Hedda Hopper during her first sit-down interview after Bogart's death and

her first with the despised columnist in some years. "I feel it's very personal. . . . The last year really belongs to us. I just feel very strongly it's something that doesn't concern anyone." Despite repeated attempts by Hopper, Betty wouldn't budge on the topic of Bogie. Sipping Jack Daniel's, she said, "I feel strongly about some things and this is one of them." What she wanted to talk about was her career. "Nothing can stop me from working," she said. "I have ambitions."

That she certainly did. *Written on the Wind* was pulling in the crowds in theaters all across the country, eventually becoming the fourth highest grosser in Universal's history up to that point. The director, Douglas Sirk, in his inimitable style, had assembled a gaudy, spectacular Southern Gothic melodrama with larger-than-life performances from his stars. A dysfunctional Texas oil dynasty fights the world, and itself, over love, profits, greed, and sex. Rock Hudson is his usual stolid, courageous hero; Robert Stack is the scheming, alcoholic heir to the family fortune; and Dorothy Malone is his aggressive, self-destructive sister. Both Stack and Malone would win Oscars for their performances. Bacall played Stack's noble wife, who's really in love with Hudson. Her role is the least showy among the four leads, and once again the siren from *To Have and Have Not* is tamed into the sensible wife. Still, she's quite good, giving the soap opera surrounding her some measure of gravitas. Sirk's brilliance was in the sumptuous, glamorous way he managed to critique the repressed, conformist America of midcentury. Although she's the levelheaded lead, Betty does get some zingers in, as when she says to Malone, brush in hand, "Pardon me if I seem to be brushing you out of my hair."

Reviewers weren't kind to the film, however. "Nothing really happens," complained Bosley Crowther, "the complications within the characters are never clear." Critics tended to be dismissive of Sirk's films during his heyday, considering them to be florid, sappy melodramas aimed at women; the director's reputation has grown considerably in recent years. But at the time, they were considered lowbrow. Bogie had read some early reviews of the film (it was released first in the United Kingdom at the end of 1956) and advised Betty, "I wouldn't do too many of these."

Betty followed that up with *Designing Woman*, which she'd made at MGM the previous fall; the two films would be in theaters at the same time, giving her a high profile in the months after her husband's death. The film was written by George Wells and directed by Vincente Minnelli

as a Tracy-Hepburn–style battle of the sexes. Betty plays a wealthy fashion designer; she's paired with Gregory Peck as a sportswriter. "It's the best part I've ever had," Bacall proclaimed to Hedda Hopper. "I really think this picture is going to do me a lot of good. I have wonderful clothes in it and photograph better than I ever have in color. If this doesn't do it—hara-kari is the next step."

Just what she meant by "do it" is unclear. If she meant achieving security at the box office, *Designing Woman* proved to be another big moneymaker. But if she meant achieving critical acclaim that would lead to more important roles, which seems more likely, there was less consensus. Although critics didn't rave over the picture, most liked it well enough, praising the witty dialogue that crackles between Bacall and Peck. Betty adored her costar, in her mind the epitome of masculinity. She was still gushing over him half a century later, when she accepted an honorary Oscar, leering suggestively as she mentioned his name several times. *Designing Woman* had been enjoyable for Betty to make, no doubt in part because it had allowed her to escape, at least for a few hours, the smell of death at home.

Yet for all her confidence in her performance, *Designing Woman* did not, in the end, "do it" for Betty, despite her solid performance and how good she looked in Metrocolor. The film was a success but it did not kick off a new era for her. There was no rush of new offers. Thankfully, however, there was also no more talk of hara-kiri.

Betty would say that Bogie had had to fight for his success. "He never had it easy," she said, noting his decades-long battle with Jack Warner. "Nothing ever—no part, even after he was a giant star—came to him easily." She'd also say, in contrast, that she *hadn't* had to fight, that everything had been handed to her. That had been true at the start of her career in Hollywood. But in 1959, as the studio system that had created her was taking its last gasps, Betty realized that she, too, would have to fight. New nineteen- and twenty-year-olds were arriving in Hollywood every week. And although male stars were permitted to age on the screen, women were not, unless they obediently moved into character roles once they reached their midthirties. Betty refused to go that route. "My name stays above the title," she told Hopper. She was understandably angry at the double standard she faced and the lack of security the industry was providing her after thirteen years in the business.

She left all estate matters to Morgan Maree and the lawyers. Bogie's

will had provided for his sister Pat's ongoing care. She would receive $300 a month, plus two insurance checks that also totaled $300. Pat seemed happy living at 1909 North Beachwood, where her monthly payments covered her rent and living expenses. Maree also handled the sale of Mapleton Drive and Betty's move to the rental house. Her lease there was set to expire on January 14, 1959; Betty had declined to renew it. She would henceforth, she decided, be an American expatriate, trying to rebuild her life and career across the Atlantic.

If her decision to leave not only Hollywood but the United States seems drastic, that's because it was. To understand Bety's state of mind at that juncture, it's important to know it wasn't just grief and career frustrations driving her. She was also trying to heal from the deepest humiliation she'd ever experienced. Bogie's death had been bad enough, but far worse had awaited her just a few months down the road. More than anything or anyone else, it was Frank Sinatra she was trying to put behind her.

IN THE MONTHS AFTER BOGIE'S DEATH, FRANK HAD BEEN RESPECTFULLY distant. He did not attend the funeral. Yet his presence was still felt. Hedda Hopper noted at the time that his photograph was displayed in Betty's living room. Although his visits were few, he called regularly, and occasionally showed up bearing gifts for the children. Steve liked him, found him always upbeat and smiling. Sinatra loaned them his house in Palm Springs for ten days, where Betty reported they'd had lots of fun. Hopper asked Betty if she'd consider making a picture with Frank. "I'd love to," Bacall replied. "I think we'd be good together."

Four months after Bogie's death, Betty took the train to New York to promote *Designing Woman*. She had put her foot down on any television promotion: "No TV whatever, in any shape or form. I absolutely refuse to do it. It dissipates a star's position." That meant interviews with magazines and newspapers, which she could have done from home. But other reasons propelled her to New York. And certainly, one of them was the chance to reconnect with Adlai Stevenson, who just so happened to be in the city at the same time. Sinatra occupied her thoughts but he was also slippery and unpredictable; Stevenson represented more stability. After a dinner with friends, Adlai accompanied Betty back to her hotel, where they went up to her room for a nightcap. "[He] talked to me about my

life and about life in general," Betty wrote. "He was so full of care and thought—I adored him and felt lucky to have a tiny part in that great heart and mind."

The children had come with her, and on their way back west, they stopped in Chicago. It was Easter Sunday. A car took them out to Stevenson's estate, where the former presidential candidate had planned a holiday dinner and Easter egg hunt for them. "My brain shifted gears when I saw him," Betty wrote. "I reactivated the better part of it." That night, as they sat beside the fire together, Betty marveled at how much at home she and the children felt. "I hadn't known until then that Adlai could do that."

It seems clear that at least in the moment, Bacall was contemplating what married life with Stevenson might be like, something she'd done her best not to think about in the past. But now they were both free, the children were happy in his home, and Adlai made Betty feel better about herself than "almost anyone else." Her feelings for him had receded, but it appears likely that they were rekindled during that trip. Bacall, after all, had never been a woman without a man.

If thoughts of Stevenson filled her mind as the train sped toward Los Angeles, competing thoughts began to intrude as they drew closer to the coast. During her eastern sojourn, Sinatra had called her several times— "To see how I was," she recalled, and to ask when she'd be coming home. "He was the only unattached man I knew," she said, an odd comment seeing that she had just left Stevenson's embrace. But Sinatra represented the world she had lost, the stature she wasn't willing to surrender. As comforting as Stevenson was, he wasn't able to give her that. "I was glad [Frank] was around," Betty wrote. "I suppose that, without realizing it, I was starting to depend on his phone calls."

In the spring of 1957, Sinatra was at the height of his fame, with movies, records, and live performances, but he was also perceived as a bit shady, given his rumored ties to the mob. Never was that truer than at that moment, as he found himself ensnared in what came to be known as the "Wrong Door Raid" scandal. A State Senate committee and grand jury were investigating a 1954 raid on the home of Florence Kotz, a thirty-nine-year-old secretary, whose outside door had been smashed in with an ax. A group of men had barged into her room, terrifying her. She would remember horrible lights flashing as a camera was aimed at her. It was

only then that the intruders realized that they had the wrong apartment. They'd expected to find Marilyn Monroe inside.

The incident went largely unnoticed until *Confidential* magazine headlined it. The scandal was exposed during investigations into *Confidential*'s business practices, in which the full story came out, implicating a couple of big names. Monroe's ex-husband Joe DiMaggio had wanted proof that she was sleeping with someone, so he'd turned to Sinatra, meeting him at the singer's preferred hangout, the Villa Capri. Frank had recommended that he hire Barney Ruditsky, a private eye who'd owned Sherry's Restaurant, where Bugsy Siegel's right-hand man, Mickey Cohen, had been shot and almost killed. Not long afterward, Sinatra and DiMaggio were again at the Villa Capri when they got a call that Ruditsky had located Marilyn's supposed trysting place. Sinatra and DiMaggio hurried to the house on Waring Drive, where the goons they'd directed to do the dirty work blundered into Kotz's apartment, after which they all made a hasty retreat.

Now both Sinatra and DiMaggio faced possible criminal jeopardy. State Attorney General (and later Governor) Pat Brown was leading the investigation. Early one morning, LAPD officers burst into Sinatra's house, waking him up, much the way Ruditsky's men had done to Florence Kotz, and served him with a subpoena to appear before the grand jury. Apparently oblivious to the irony, the irate Sinatra accused Police Chief William Parker of violating his civil rights.

Bacall defended Sinatra vociferously. When the suspicious Hedda Hopper asked her about the Wrong Door Raid, Betty exploded. "When's this mess going to stop? He is completely innocent. I think it's outrageous in this day and age when a man can publicly call you a liar and you've got to sit back and take it." She was referring to one of Ruditsky's henchmen, Phil Irwin, who had refuted Sinatra's testimony to the grand jury that he had not entered the apartment. Irwin claimed that he'd been there with all the rest of them. Kotz's landlady also testified that she was "reasonably certain" she had seen Sinatra rushing out of the apartment that night. Betty wouldn't hear any of it, however. "All he has to do to get into trouble is sleep in his own house," she complained to Hopper. In the end, no one was charged in the case. Kotz later sued DiMaggio and Sinatra for $200,000, equivalent to more than $1 million today. She had to settle for $7,500.

Betty did not appear to consider how her relationship with Sinatra would be perceived. Bogie hadn't always been law abiding, either, but it's impossible to imagine his being involved in a scheme like the raid on Waring Drive. He would never have lied to a grand jury, if we recall how precisely he had chosen his answers to Martin Dies. Indeed, by the end of his life, Humphrey Bogart was a paragon of honor and dignity in the public's mind, lending his name to efforts to fight organized crime. But Betty, yearning for more excitement, may have found the idea of a bad boy appealing. Bogie had been a bad boy in the beginning, too, which had been part of his appeal, but Sinatra was even badder.

Betty seemed to find her proximity to the dangerous elements of Sinatra's life exciting. When Frank was sued by the writer Edward Dunbar O'Brien over alleged copyright infringement, Betty was named as a codefendant, something she certainly would not have welcomed. Yet no matter the sordidness, she seemed to like the association. She'd been current as Bogart's wife for twelve years, but now she was adrift, looking for a way to stay on top. And no one was more current than Frank Sinatra.

It's also true that he was very solicitous toward her at a time when Betty needed some tender loving care. Frank took her for drives down to Palm Springs, showed up at Bellagio Road with flowers in hand, invited her to join him at the Villa Capri. He was sexy, dynamic, vital. He made Betty feel alive after the long ordeal of Bogie's illness and death. She needed someone who could help her shoulder the unhappiness of the past couple of years. Not long after Bogie had died, Betty had also lost her beloved Harvey, "another big piece of my married life gone," she wrote. Her mother had then suffered a serious heart attack, which had sent Betty to New York for a time. She came close to losing Natalie, which terrified her. She longed for the sense of security she'd felt during the first years of her marriage to Bogie. And for a time, Sinatra supplied it.

"I can't really remember how it all began," she wrote about their romance. "There must have always been a special feeling alive between Frank and me from earlier days." That's not difficult to believe when we recall the observations of Noël Coward and the recollections of the actress Sinatra had taken to San Francisco. Betty admitted that she found Frank "wildly attractive, electrifying" and indulged herself with a belief that "behind that swinging façade" lay "a lonely, restless man, one who wants a wife and a home." That was what she had told herself about Adlai Stevenson, too, even if, in both cases, it wasn't really true.

The fact was, Bacall wrote, "I wanted a life. I didn't want to stay home simply waiting for Steve and Leslie to get back from school." No one could blame her for that; few people wouldn't understand her loneliness, her desire to keep living. "I love my kids, but they're not enough for me," she told a reporter at the time. "I like my work, and yet I don't want nothing but getting up at 6 A.M. and coming home exhausted at 7." What she dreaded most, she wrote, was the "large, empty, quiet" bedroom she entered each night, all alone, "to read, to stare out a window or at nothing, to cry." She had dreams, needs, desires. "I was a healthy young woman with tremendous energy," she recalled in her memoir about the period. And so, not yet confident that she could do it on her own, Sinatra became her ticket back into the world. "My dependence on Frank became greater and greater," she admitted.

In August, she was his escort to the Las Vegas premiere of his film *The Joker Is Wild*. Earl Wilson made note of the fact in his column. Shortly afterward, the couple was spotted together at the prizefight between Sugar Ray Robinson and Carmen Basilio. By the end of September, the gossip was everywhere. "A favorite subject of speculation in romance-conscious Hollywood today is whether Frank Sinatra will marry Lauren Bacall, widow of his good friend, Humphrey Bogart," reported the Associated Press. Both parties denied that there were wedding bells in their future, but that didn't stop the talk.

Usually after such rumors appeared, Sinatra withdrew. He'd be fine one night, then disappear for days or weeks. "I couldn't understand it," Betty wrote. "I tried to rationalize it, didn't discuss it with any of our friends, but I was miserable." Soon he'd reappear as if no time had passed. Betty told herself that he was working through his feelings for her and was getting ready to make a commitment. They were seen more often in public. "No promises were made," Betty said. "It was just a fact. We were together. Where he was asked, I was. A couple."

But the relationship was never placid. "We were combustible," remembered Bacall. "Always when we entered a room the feeling was: Are they okay tonight? You could almost hear a sigh of relief when we were both smiling and relaxed." Sinatra had an instinctive resistance against any kind of control over his actions. He resented Betty's making plans for the both of them. "Don't tell me, suggest," he told her many times. "But," Betty admitted, "I didn't know how to suggest."

Her friends were not happy about the relationship. "A few of my

friends were terrified I'd marry him—knew I was riding for a fall," Bacall wrote. "But I had the bit in my teeth and there was no stopping me." So opposed to the match were some friends that they stopped associating with Betty. Perhaps they felt that it was too soon after Bogie; perhaps they felt that Sinatra was a poor successor. By the time she left Hollywood, Betty reported, out of the twenty friends she'd thought she had, only six remained, "narrowed down in the passage of time since Bogie's death," she told Joe Hyams. Just which friends she lost isn't clear, but with the exception of David and Hjordis Niven, Adolph Green, and Betty Comden, the names that had once made up the Rat Pack disappear from Betty's memoir after Bogart's death.

Still, she became ever more attached to Sinatra. James Bacon of the Associated Press was the first to headline, on November 24, 1957, RUMOR HAS WEDDING BELLS FOR LAUREN AND FRANKIE. "As the official mourning period nears an end, Lauren (Betty) Bacall, Bogie's beautiful widow, is linked in marriage talk with Frank Sinatra," Bacon reported. Mike Romanoff, however, denied the story: "I believe Frank and Betty are too close friends to marry." Was the wily restaurateur merely repeating the party line, or was he signaling his disapproval of the match? Notably, Romanoff's is one of the names that fades from Betty's memoir.

During the holiday season, Betty was deliriously happy, as she and Frank acted more and more like a couple, planning to host friends in Palm Springs. Betty reveled in "playing house, going to the market as if I was Mrs. Him." On New Year's Eve, a couple dozen friends joined them for a grand party. Betty had every reason to imagine that 1958 would be her best year yet.

But on New Year's Day, Sinatra asked Betty to leave his house. The other friends could stay, but he wanted her gone. Betty would profess to having been clueless about what had brought about the sudden chill, but it's possible that she had said something offhand about their relationship that Frank had considered presumptuous. Most of our information about the relationship comes from Betty's own memoir; Sinatra would rarely even allude to it. So we have only Betty's reaction, which she describes as utter bewilderment. Maybe she had truly done nothing and it was just Frank, once again, being a scoundrel. She knew one thing, however: to leave the party would be mortifying, and so she refused. For the rest of the weekend, she endured the cold shoulder and silent treatment from the man with whom she had fallen in love.

It wasn't the first such repudiation, nor would it be the last. "I still don't know how he did it," Betty recalled, "but he could behave as though you weren't there." It wasn't so much that Frank would avert his gaze from her but rather that he would look right through her. She had ceased to exist for him. His silences devastated her.

Not long after New Year's, a contrite Sinatra showed up at her door. As Betty would tell it, he asked for forgiveness and explained that he had felt trapped. He'd had a bad breakup with Ava Gardner, which had been terribly painful on both sides, and as a result he was afraid of getting serious again with anyone. What he didn't say, at least in Betty's telling, was that Betty had exacerbated his feelings of being trapped. Since he'd been a kid growing up in Hoboken, Sinatra had always been wary of being caged in. His parents ran a tavern during Prohibition; his father and uncles were arrested several times for various offenses. As a skinny kid, Frank was also perpetually on the lookout for bullies. So, he learned early on the importance of not getting caught.

But then, all at once, he asked her to marry him. According to Betty, Frank said he was finally facing up to his feelings for her. Betty had imagined such a moment many times, and now that it was happening, all her doubts retreated from her mind and she immediately said yes. They called Swifty Lazar to join them in a celebration at the Imperial Gardens, a Japanese restaurant on the Sunset Strip. "I was giddy with joy," Betty remembered, "felt like laughing every time I opened my mouth. My life would go on. The children would have a father. I would have a husband. We'd have a home again."

At first, Lazar was convinced that they were putting him on, but he finally raised a glass to toast them. According to Betty's account, they discussed adding rooms to Sinatra's house in the Hollywood hills to make room for Steve and Leslie. They brainstormed about where they would hold the ceremony. When a fan came up to their table and asked for their autographs, Sinatra told Betty to put down her new name. She wrote, "Betty Sinatra." Still, they agreed to wait awhile before making the announcement.

Not long after that, while Frank was performing in Miami, Betty accompanied Lazar to the theater, where they ran into Louella Parsons. At least, this was the story as Betty would tell it. When she spotted Betty, the columnist pounced, asking the usual question about when she and Sinatra would tie the knot. Betty suggested, a bit brazenly, that Parsons

ask Frank. Before she could spill any more beans, she wrote in her memoir, she made a beeline for the ladies' room. When she emerged, she saw Lazar and Parsons deep in hushed conversation but thought nothing of it. That was, until the next morning, when she spotted a headline in the *Los Angeles Examiner*: LAUREN ANSWERS YES TO SINATRA'S PROPOSAL. It wasn't just an item in Parsons's column; it was a full-fledged news story, syndicated across the country.

Betty panicked. She phoned Frank in Miami and told him she'd had nothing to do with it, blaming it all on Lazar. Sinatra wasn't pleased, Betty recalled, but he didn't seem overly upset.

Bacall had many reasons for insisting, first to Sinatra during that phone call and later in her memoir, that she had not divulged the secret to Parsons. In the immediate aftermath of the report, her prime motivation was to keep Frank from blaming and possibly leaving her. But as events proceeded, there would be further motivation for her to deny any responsibility. The humiliation she endured throughout the rest of 1958 would have been even worse if she'd been perceived as a desperate husband hunter trying to lasso a reluctant bridegroom. It was imperative that she come across as the victim. And it's possible that she was.

But Parsons told a different version of the story. According to the columnist, she didn't run into Bacall at the theater but rather at an after-party thrown by Zsa Zsa Gabor, whose sister Eva was starring with Noël Coward in a production of his play *Present Laughter* at the Huntington Hartford Theatre. In her memoir, Betty wrote that the show had been Emlyn Williams's tribute to Charles Dickens. However, newspapers confirm that it was the Coward show, playing at the Huntington Hartford the night before Parsons published her scoop. That seems to lend more credence to the columnist's version. According to Parsons, there was no encounter at the theater, no mad dash to the ladies' room. Instead, she said, she had posed the question at Zsa Zsa's party, to which Betty had responded, "Why don't you telephone Frank in Florida?" That much, at least, conforms with Bacall's account, but Parsons went on to assert that the actress "finally admitted [that Sinatra] had asked her to marry him." The columnist quickly followed up, "And you'll say yes?" To which Betty answered, "Of course."

It's notable that Parsons did not directly quote Bacall's admission that Frank had popped the question. Had Betty given the confirmation through nonverbal means? Or was she still being evasive, and Parsons

simply presumed the answer she wanted to hear? For all her reputation for skullduggery, Parsons was usually scrupulous about confirming stories, at least the ones she presented as fact and not just as rumors. She was clearly confident about this story, which was why the *Examiner* ran it as news. Parsons backed up her scoop with other sources: she'd gotten a tip from someone who'd overheard the talk of marriage at the Imperial Gardens, possibly the fan for whom Betty had signed her "new name." Parsons also got Lazar to confirm the story. "It's true. They'll marry," he said. Betty would claim that Lazar had made the statement on his own. But Parsons was clear that it was only after Bacall had already confirmed it.

Just who said what and where and when will remain a mystery. In the days after Parsons's report, the story took off like wildfire, with most headlines along the lines of BACALL ADMITS SHE WILL MARRY SINATRA. It's likely that the accretion of reports caused Sinatra to lose his cool and blame Betty. After a few days of silence, he called and asked, "Why did you do it?" She pleaded innocence, insisting that it had all been Lazar's fault. Rightly or wrongly, Frank didn't believe her. The roller coaster finally came to a complete stop.

A story would circulate that Ava Gardner, upon hearing the news of the split, phoned Sinatra from Spain and asked why he had called off the marriage. "What marriage?" Frank reportedly replied. "The marriage to Betty Bacall," Ava said. Frank scoffed, "I was never going to marry that pushy female." For Sinatra's handlers, that was how they wanted the episode viewed: Bacall was a scheming woman who had tried to ground Frank's high-flying ways, and he'd managed to escape her clutches. Here again we see the misogyny of blaming a woman for a man's misconduct. No matter that sometimes Betty may have pushed too far, nothing justified such cruelty from the man who'd supposedly been a good friend, not just to her but also to Bogart. Sinatra "wielded humiliation like a weapon, as payment in kind," wrote James Kaplan, the singer's biographer. Bacall's "sin," Kaplan said, had been to "cut the corners on him . . . in the most public way possible." So he would take out his revenge on her in public as well.

In the ensuing weeks, Betty tried to keep up appearances, but anyone who knew her could see the pain on her face. On a few occasions, she found herself at an event with Sinatra. He'd just look through her as he'd done before without acknowledging her. But other people were looking at

her with pity in their eyes. That may have been even worse. Betty wasn't good enough, apparently, or sexy enough or interesting enough to hold Frank Sinatra, the nation's heartthrob.

Soon the press was reporting that the engagement was off and Frank was turning his attention to the French star and international sex symbol Brigitte Bardot, ten years Betty's junior and known for appearing seminude in her movies. Planning to make a picture with Sinatra, Bardot told reporters that his contract forbade him to bring Bacall to France. "Sinatra and I will make interesting chemistry together," she promised. The picture was never made, but the damage was done. "My humiliation was indescribable," Betty wrote. She plummeted back to the depths of depression she'd felt in the aftermath of Bogie's death.

Making everything worse were the other personal losses she'd endured over the last few months. In January 1958, her uncle Charlie Weinstein had died. Uncle Jack, too, had passed away a few years earlier. Both had been so much a part of Betty's early success. Her family had always given her strength. But the losses kept coming. Just a few months after Charlie's death, his widow, Rosalie, died in a plane crash after visiting Betty in California. Betty's family was dwindling. Natalie remained fragile after her heart attack. With the loss of so many friends, including Sinatra, Betty found herself increasingly on her own.

The personal devastation she experienced during that period was one thing; the professional embarrassment was another. As the Sinatra brouhaha was playing out, Betty's film *The Gift of Love*, made for Fox the previous fall, was in the nation's theaters. The picture reunited Betty with director Jean Negulesco and costar Robert Stack. It was a saccharine CinemaScope tearjerker about a wife, played by Bacall, who, aware that she is going to die, adopts a young girl so her husband, played by Stack, will not be alone. The girl was played by nine-year-old Evelyn Rudie, a television child star who'd appeared in an adaptation of Kay Thompson's *Eloise*. Fox was apparently hoping that Rudie's TV fans would follow her into the movie theaters, but it didn't happen. *The Gift of Love* performed "well below estimate," according to *Variety*, and quickly disappeared. Had it been another box-office hit, another *Written on the Wind* or *Designing Woman*, Betty might have saved some face in the wake of Sinatra's rejection. But as it was, she was seemingly rejected by movie audiences as well.

Bogart had hoped that Mapleton Productions would keep them both

solvent and working. But if Betty still harbored any hope of that, she got bad news when Mapleton's application to join the Motion Picture Association was stalled due to lack of activity. Soon after that, Morgan Maree sold to United Artists the company's rights to *Underworld U.S.A.* Mapleton was quietly dissolved a short time later.

By the summer of 1958, Betty wanted out. She could no longer see a future for herself in Hollywood. She was bitter, angry, embarrassed, heartbroken, and lonely. To start over, however, she would need more cash than she currently had. She petitioned the court to receive a $1,500 increase in her monthly allowance from Bogart's estate, which had been set at $1,000. She argued that she needed the raise to support herself and her two children "in their normal style of living," which she described in her petition as costing about $4,500 a month (the equivalent of more than $40,000 today). The court granted her the increase, and she started making plans.

The first plan was to make a seven-week tour of Europe with Slim Hawks, who was now Mrs. Leland Hayward. "She had been responsible for changing my life," Betty wrote. "Now, some fifteen years later, she was pulling it together for me." Slim had insisted that Betty accompany her after she saw how depressed she was. Betty arranged for the staff to keep an eye on the children and packed her bags.

The two friends flew from New York to Madrid in the second week of October. From there it was on to Paris, Munich, and London. "I discovered there's a whole big world out there filled with people who have something to say, and are willing to listen to what I think," Betty told a reporter. During those seven weeks, she danced the flamenco, was pursued by amorous men, attended theater and opera, drank prodigiously, and dined with aristocrats and theatrical royalty, Sir Laurence and Lady Olivier of course being both. This sojourn in Europe, said Bacall, taught her how to live "positively." In London, she agreed to do a film for the Rank Organisation, Britain's leading film conglomerate. The working title was *North West Frontier*, and part of it would be shot in India. Her new life, she believed, was beginning.

Betty flew back into New York on November 17, 1958. She'd made a decision: she was leaving Hollywood for good. Her abandonment of the movie colony was front-page news in the *Los Angeles Times*. To Vernon Scott of UPI, Betty explained her reasoning: "I didn't have a healthy attitude for the past two years. I couldn't get my thinking straightened

out. My judgment was clouded, and I became a nothing for a while." She never mentioned Sinatra, but he haunted every word she spoke. "There is nothing less attractive than desperation and being too intense," she continued. "Your charm leaves you, and so does your dignity. . . . For a while, I'd given up on myself, feeling I had no future at all, professionally or otherwise. Now I'm happy and confident, confident that I can manage my own life."

Happy, confident, but still a little bitter. To Joe Hyams, her go-to journalist, the one she'd always trusted to make her and Bogie look good in print, she let her feelings about Hollywood flow. "I won't miss the idle chitchat," she said, "the faces that open and close the minute you walk in, the kisses-in-the-air greetings, the scrutiny of one's private life." Her first three complaints could have been directed at herself five years earlier, but now she was publicly repudiating that lifestyle and the friends who'd shared it. The last complaint, however—the public scrutiny and judgment—was what was really propelling her exodus from the West Coast. When all was said and done, she was still humiliated and traumatized by Sinatra's rejection, and that wound to her pride would never fully be healed.

THE LATE 1950S WAS A GOLDEN AGE IN LONDON. UNEMPLOYMENT WAS VIRTUALLY nonexistent; the economy was booming; people appeared to be happy for the first time since before the war. The United Kingdom might have lost its superpower status after the Suez Crisis in 1956, and the country might not be able to afford its sprawling empire anymore, but the trade-off was prosperity and progress at home. A new, young queen sat on the throne. A sense of new beginnings was everywhere. The British "New Wave" in filmmaking was just taking off, with Jack Clayton's *Room at the Top* and Tony Richardson's *Look Back in Anger* raising the profile of British film around the world. Traditional British music was being transformed by rock and roll, with musicians such as Lonnie Donegan and Cliff Richard giving the American phenomenon a uniquely British twist. In Liverpool, four young men were about to become Beatles. It wouldn't be long before "swinging London" and its miniskirts and marijuana would be the epicenter of the coming-of-age baby boomers' social revolution.

During that cultural transformation, Betty said, she "came back to life" in London. "I have a number of close friends in London, people like

Noël Coward, Laurence Olivier, John Gielgud, and Vivien Leigh, and they were all marvelous to me." Those who might have caused her pain or embarrassment to run into back in Los Angeles had been replaced by a new group of friends who didn't pay much heed to American scandal-mongering. Betty decided to settle in London for the forseeable future.

She shot *North West Frontier* in the spring of 1959. Her director was J. Lee Thompson, then on the verge of a successful American career, and her costar was Kenneth More, then at his box-office peak in Britain. The picture was now a coproduction of Rank and Twentieth Century–Fox. For whatever reason, Betty refused to wear a corset for the period picture, Sheilah Graham reported; her waist was apparently still slim enough.

The film concerned a noble Englishman, embodying the trope of the Western savior, who must fight off "Moslem mobs and Hindu hordes," as one reviewer put it, to rescue a baby prince. In late April, the company flew to India for location shooting in the hills behind the pink-walled city of Jaipur. It was Betty's first trip to Asia. Making a a pilgrimage to see the Taj Mahal, she stood barefoot beside the seventeenth-century mausoleum's reflecting pool and mused to a British journalist, "Perhaps this place is so beautiful because of the thought behind it. After all, it was built because a man loved a woman, because he wanted to pay tribute to her love." It was a sentiment to which she would become increasingly attached as she looked to nail down her own legacy.

In India, Betty was once again the teenager who wanted to see the world. "I can't just sit still and watch the world go by," she said. So off she'd go, the British journalist wrote, "into the sweltering bazaars, stacked high with swollen mango fruit, the startling rainbows of silks and cotton, the smell of humanity." But after nearly six months as an American expatriate, Betty was also getting homesick. What would be next for her after the picture was done?

"The real reason I travel so much," she said, "is that I'm a woman without security. Any woman is, outside of marriage. Oh, I have financial security . . . but that's not what I really mean. When a woman has no real home, she is alone."

The second wave of the feminist movement had not yet blossomed, and Betty remained trapped by the idea that a woman was incomplete without a man. She lived with the memory of her mother, who had worked herself ragged without a husband and who, at least from Betty's perspective, had only become happy once she'd married Lee Goldberg.

Bogart, Stevenson, Sinatra—Betty had hoped in succession that they would make her a home that would last all her life, certain that she could never create one all by herself.

Steve and Leslie had not accompanied her to India. They were back in London, attending school. Steve was now ten, and Leslie was seven. Bacall admitted to Lorna Thomson of the London *Daily Herald* that she refused to live solely for her children. While she was in India, she learned that Steve had come down with measles. Concerned, she tried numerous times to get a phone connection to England, but it was frustrating and time consuming. "Lauren Bacall was doing something she rarely does, and resents doing," Thomson reported. "She was mixing work with motherhood." She defended her decision to leave the children behind and not to rush back after word had come that her son was sick. "I will not have my life organized around my children," she said, "sit at home with them every night, wash their clothes, and wait on them."

Bacall certainly had every right to insist, in the same interview, that "a woman needs a life of her own." Men were rarely criticized for leaving their children behind to take work trips, and no one expected a man to give up his career once he had children. But there's a coldness to Betty's defense of herself. "Stephen always seems to get ill—as with the measles—or break something or cut himself badly the minute I'm out of reach," she told Thomson. That was a complaint she'd had since he was an infant and his nursemaid had dropped dead of a heart attack while holding him in her arms. The child always seemed to interfere with his mother's plans.

When Betty was with him, Steve could become clingy, and if she wasn't entirely indulgent, he could turn resentful. "I wish Daddy were here instead of you," he told her more than once. The child had not been given the support and encouragement to process the loss of his father. At one point, Steve suggested that they all shoot themselves so they could "be with Daddy on Valentine's Day." Betty was horrified. "What had been going on in that young mind?" she wanted to know, but she never did much to find out, even after his school reports revealed that he would sometimes stand up in the middle of class and scream. It wouldn't be until he was an adult that Stephen Bogart finally faced his childhood trauma. Visiting the house on Mapleton Drive in his forties, he shook as he entered. He realized then how he'd felt: "My father, the

house, and my childhood were all wrenched away from me in a single violent moment."

It was only natural, then, that as a child he would want to have his mother around for a sense of security. Steve had it harder than Leslie, as he could remember his father and their previous way of life more clearly. "He really would like me to be a stay-at-home mother," Betty said soon after her arrival in London from India. She predicted that in a few years' time, "when he's ready to go out every evening for his own pleasure," he would be glad that his mother had friends to be with when he couldn't be with her. "He will understand then why I'm determined to be a working mother." Her son was ten at the time. Betty's presumption appears to have been that Stephen would grow out of those childish feelings by the time he was in his early teens.

Despite her hands-off mothering, Bacall's children never doubted that she loved them, though that love seemed to flow from some distant mountaintop. "Though she might not have always shown the love, Leslie and I always knew it was there," Steve wrote. ". . . When the chips are down she's always there. Unfortunately," he added, "it takes the chips being down for her to get to that point. She is not a fair-weather friend; she is a foul-weather friend."

By the fall, Betty sensed that her self-imposed exile in Europe was coming to an end. *North West Frontier* did well at the British box office. "This is pure, unabashed escapist entertainment, ably directed and beautifully photographed," declared Wendy Newlands, who wrote for several London newspapers. Bacall was once again less an actress than a movie star, lending some Hollywood glamour to the proceedings but little else. The film did not kindle a European film career for her, nor did it do her any good back home. For its American premiere in the spring of 1960, Fox retitled the picture *Flame Over India*, likely because audiences might otherwise think it was a tale of lumberjacks in Oregon. The film bombed stateside.

THE QUESTION OF WHAT CAME NEXT FOR HER WAS NOW AT THE FRONT OF Bacall's mind. She had lost her foothold in the film industry, so another idea suddenly became quite appealing. During their time together the previous summer in Spain, Leland Hayward had showed Betty a script;

not a movie script but a play. *Goodbye Charlie* had been written by George Axelrod, who'd once told Bacall that whenever she wanted to try Broadway, he'd write her a play. He had modeled Charlie, the central character, on Betty's husky voice, mannerisms, and expressions.

"It's a funny thing," Bacall mused. "When I was ushering, pounding doors and producers' offices, and modeling fashions, I dreamed of only one thing—to be a star on Broadway." Movies had never been her dream, although she'd pounced on the opportunity when it was offered to her. But somewhere down deep, the plucky girl passing out *Actors Cues* remained, and her dream, for all of her other successes, was still unfulfilled. By the spring of 1959, Hayward needed an answer about the play. "I couldn't resist it any longer," Betty recalled. Hollywood didn't appear to want her, but Broadway was beckoning with open arms.

When she signed her contract with Hayward on June 18, 1959, she was given the full star treatment: guaranteed top billing with no other name printed the same size, transportation to and from the theater by limousine, a star's dressing room, and a dresser of her choosing. She would also receive 10 percent of the weekly gross box-office receipts, with a guarantee of at least $1,500 per week. If the show proved to be a long-running hit, she would become a very wealthy woman in her own right, no longer dependent on Bogie's estate. Her contract term was one year, or until June 30, 1960, after which Hayward could option to renew. The contract was a great relief for Betty. "I felt good to know definitely what the future would be," she wrote. "A new chapter. And I was ready."

Betty was going home. But first she needed a place to live. Before leaving London, she arranged to sublet an apartment at the Beresford at 211 Central Park West, an exclusive high-rise co-op between 81st and 82nd Streets. Joan Axelrod, the wife of the playwright and an influential interior designer, secured the place for her. When Betty and the children flew into New York on September 3, they already listed their address on the airline manifest as the Beresford. To the children, the building, with its three octagonal copper-crowned towers and magisterial Georgian architecture, may have reminded them of the castles they'd seen in England. But apartment living was a very different environment for the children from the green lawns, swimming pool, and fruit trees they'd known on Mapleton Drive. Steve dearly missed that house and that life. For Betty, however, being back in the city was invigorating.

So was rehearsing the part of Charlie. As her leading man, Betty

was grateful to have Sydney Chaplin, with whom she developed a good rapport. He had considerably more experience on the stage than Betty, and she was counting on his support. For Betty, the idea of performing live in front of an audience was both thrilling and terrifying. She'd acted live in her television roles, but there she had been performing for the camera, not a theater full of spectators. The last time she had performed on a theatrical stage had been seventeen years earlier in *Franklin Street*, when she'd just turned eighteen. The trembling she'd known back then suddenly reappeared, causing her hands to shake as she held the script during rehearsals. Her jitters would continue straight up until opening night. Daily lessons on how to project from the diaphragm made her feel self-conscious. "I was one nervous actress," she remembered, "shaking all the way."

But her nerves did not deter her. One of her gifts had always been her steely determination, her refusal to give up. Her tenacity had ensured her early success and was sustaining her now. That was crucial. The part of Charlie was never going to be easy. As it turned out, there was a reason that Bacall's husky voice fit the character so well: Charlie is a man reincarnated in the body of a woman. And not just any man, but a selfish, sexist womanizer. Divine intervention has decided to teach him the errors of his ways by making him live as a woman. Axelrod, the author and director of the phenomenally successful play *The Seven Year Itch*, fearlessly went all in on the concept. The 1950s were a time of strict gender and sexual policing; anything that deviated from the norm was considered degenerate. Yet Axelrod was blurring the contours of gender and sexuality, two of the decade's greatest taboos. The first drafts of *Goodbye Charlie* pushed every envelope and pulled no punches.

Take, for example, the scene in which Charlie's boss, a movie executive played by Bert Thorn, hits on the reincarnated Bacall, unaware she is his deceased screenwriter. Thorn's persistence in trying to get Charlie into bed seems deliberately written to raise the specter of homosexuality, both as a laugh and as a commentary on the fluidity of gender and desire. Just a few years earlier, around the time Axelrod had begun work on the play, Christine Jorgensen, a World War II veteran, had returned to the United States after undergoing sex reassignment surgery in Denmark. In the beginning, Jorgensen was treated respectably enough by the press and public, with some straight male reporters admitting that they wouldn't mind dating her. That may have been too much for the moralists

to countenance, and it didn't take long before Jorgensen was being disparaged as a "castrated man" and turned into the butt of jokes by Bob Hope and other comedians.

Like Jorgensen, however, Charlie is quite pleased with his gender transformation. "I'm really stacked," he says to his best friend, George Tracy (Chaplin), the only one who knows his secret. "I mean, I'm really built. Front and back. Did you notice?" George, uncomfortably, says, "No," even though he clearly *has* noticed. At one point, Charlie, with his back to the audience, opens his trench coat to George, revealing that he's wearing nothing underneath. Charlie's easy acceptance of his new body and identity was quite subversive in an era of unexamined sexism. A real man should be horrified at losing his power and status, "reduced" to being a woman. But Charlie's quite content. Axelrod pushes the subversion even further than that. Charlie had "always liked the ladies," he tells George. "What's going to happen to me if I still do?" The allusion to lesbians was what had gotten *The Captive* banned on Broadway thirty years earlier and Bogart's first wife sent to jail.

But still Axelrod doesn't stop. The only taboo greater than lesbianism was gay male sexuality, and, as it turns out, Charlie is surprisingly sanguine about the prospect of sleeping with men. "If fellas are going to be the action, I'll just teach myself, that's all," he tells George. "I'm really a very adjustable person." The 1950s were not, however, a very adjustable decade. A real man was expected to recoil at the idea of sex with another man. But Charlie's fine with the idea, which leads to Axelrod's most subversive twist of all: Charlie and George fall in love. The playwright had to know he was potentially risking an outcry from church and civic groups.

Of course, onstage, it was a man and a woman, Sydney Chaplin and Lauren Bacall, who were falling in love. Both actors, but especially the novice Bacall, faced some real challenges in getting the characterizations right. Betty would have to embody the sort of male gaze that had been directed at her since she had first asked Bogie if he knew how to whistle. She would have to think like a man. The script demanded it: Charlie is consistently referred to with "he/him" pronouns. When Charlie spoke, it was in a man's voice. Betty was given such lines to say as "Neither of us knew the other was banging her until we met." But she had to project maleness without any overtly "unladylike" behavior, which even Axelrod seemed to understand would be a third rail for audiences.

Rehearsals began in October, and the problems in the script quickly

became apparent. "Sydney and I found some things that didn't work as well as they might," Bacall remembered in her memoir. They began to meet in secret to mull over "the problem of the play." Just what that was, she did not specify. It's likely that they were thinking more about the audience reaction than Axelrod was and wanted to tamp down some of the script's more subversive elements. The actors presented their ideas to Axelrod, who was the director as well as the writer. He listened to them. But ultimately he refused, telling them that they would have to "play it the way he wrote it."

Axelrod may have been right from a perspective of artistic integrity. But Bacall and Chaplin may have recognized the dangers he refused to see. If the reviews of the play during its first tryouts are any indication, "the problem of the play" was its very premise. "*Goodbye Charlie* has a curious kind of ambivalence, and between the lighthearted and the serious, Mr. Axelrod is at least momentarily at loose ends," the critic Harold Cohen remarked in Pittsburgh. The scene with Thorn as the lecherous movie exec didn't elicit laughs, only discomfort. Cohen explicitly referenced Christine Jorgensen in his review, exposing what was perceived as degenerate about the play.

In Detroit, one critic wrote that *Charlie* "skirt[s] the blasphemous." In neighboring Windsor, Ontario, the drama editor declared that the play would appeal only to "those who would be artificially world-wise as to lose sight of any sense of morals." The humor was described as "vulgar." Such opprobrium followed the play from town to town, and after each preview, Axelrod grew more frantic. The salty language was toned down. Scenes were cut. Bert Thorn's part was scrapped. "Poor George was a wreck," Betty remembered, "rewriting constantly." Leland Hayward was now concerned that they wouldn't make it to Broadway.

In Detroit, promoting the show on Shirley Eder's radio show, Betty reacted negatively when the host compared her part in *Charlie* to Christine Jorgensen. "It was really blow-up time," Dorothy Kilgallen reported. The interview ended on an icy note.

Yet for all that, there was one aspect of the play that reviewers unanimously praised, and that was Betty. In every city, her reviews were glowing. "Miss Bacall is wonderful as Charlie," one critic wrote after the Baltimore premiere. "She is tops, couldn't be better. Her husky voice and expressive eyes express more than there is to express [in the script]. She manages to be beautiful even when she is pretending that she doesn't know how to be."

Just before opening night in Philadelphia, their last tryout before

Broadway, Axelrod showed up with "a big last scene," Betty recalled. It
was his last-ditch hope to save the play. His stars liked the idea. Charlie
and George still fall in love and speak of getting married, but in a sudden
shift of perspective, the whole play is revealed to have been a dream, or
at least some sort of alternate reality. The moment George admits that he
loves Charlie, they both fade into a strange sleep. The light goes down.
Covered by darkness, Betty moves across the stage. When the lights go
up, she's revealed as a "real" woman, come to pay her respects to the de-
ceased Charlie, with whom she'd had an affair. Charlie and George can
now be together without any whiff of perversion. Betty hurriedly learned
the several pages of new dialogue for the Philadelphia performance. "We
all felt very confident," she wrote.

But the reviews were no better. Enough degeneracy remained in the
script to upset critics, as well as audiences, which had dropped off pre-
cipitously after each opening night. But now the play had cannibalized
itself with its new ending, which satisfied exactly no one. The critic for
the *Philadelphia Inquirer* criticized the "philosophical conclusion" as
"ephemeral."

The play was frozen, however, as the company limped back to New
York. The company was smaller now; most of the supporting cast had
been eliminated during Axelrod's revisions. One character who could not
be cut, however, was the one played by Cara Williams; it's she who finally
enables Charlie to see how his promiscuity hurt the women he was in-
volved with. Williams, who'd appeared in *Knock on Any Door* with Bogie,
was a fiery, curvy redhead who won praise all along the tour. "Funny as
well as eye-catching," one critic described her. Several reviewers thought
that Williams stole the show. But in Philadelphia, items suddenly ap-
peared that the actress was being "difficult." Williams's name, third billed
below Bacall's and Chaplin's, had already begun appearing in newspaper
ads for the Broadway premiere. But by the time the show opened at the
Lyceum Theatre on December 16, Williams had been replaced by an
understudy. Knowing Betty's behavior toward a prominent female sup-
porting player in her next play, one can't help considering whether there
was a similar strife here, driven by the older actress's insecurity about a
supporting player getting the raves. In her memoir, Betty would single out
the understudy for praise, calling her a "first-rate actress." The only thing
she said about Williams was that she had been replaced.

Opening night on Broadway brought out the crowds. New York

audiences seemed more comfortable with the gender and sexual politics, but the critics were as disdainful as their provincial counterparts had been. Brooks Atkinson called the play "an expanded vaudeville sketch" and "inherently hopeless as a story." He liked Bacall, though: he wrote that she played "the part like a cross between a female impersonator and Tallulah Bankhead," which he meant as a compliment. "Miss Bacall gives a good, slam-bang performance," Atkinson went on, "—broad and subtle by turns, full of horseplay and guile . . . she can take satisfaction in realizing that she is playing it as well as anyone could, Lon Chaney and Mae West not excepted."

Betty had done it. Her first Broadway show might not be a hit, but she was. By the end of the year, she was a bona fide Broadway star, accepted into an exclusive theatrical world she'd never been a part of before. For the first time in a long while, she felt happy. "I'm not frantic anymore," she told an interviewer. "I'm not looking for a husband. I'm not looking for anything but the day-to-day pleasure of doing what I want and being with amiable people." *Goodbye Charlie*, she said, had freed her from the "false security" of clinging to the past. "I was liking my life in my old town a lot," she later wrote. "I felt no yearning for California."

On New Year's Eve, she was invited to a party at Lee and Paula Strasberg's home, "where everyone in New York theatre would be." In the "sardine crush" of the apartment, Betty spied an up-and-coming actor she'd met briefly backstage at his play, *The Disenchanted*. The actor's name was Jason Robards, Jr., and "he was feeling no pain," Betty recalled. "We hit it off instantly. He stayed with me until I left." Throughout the night, he kept burning her shoulder with his cigar. It should have been a warning.

A LITTLE PAST 3:30 IN THE MORNING OF OCTOBER 2, 1960, A RED STATION WAGON swerved up Central Park West, frequently crossing the divider and careening through red lights. Busy in the daytime, the street was mostly trafficless at that hour, which was a good thing, given the driver's performance. At 3:40, the station wagon crashed into a parked car near 68th Street, but the driver kept on going. He was apprehended at 70th Street and taken to a police station, where he failed a sobriety test. He'd had "several" Scotches, he admitted.

The officers examined his wallet. The man's name was Jason Robards, Jr. He explained to the police that he'd been on his way to a parking

lot on 72nd Street, just off Central Park West. When reporters got hold
of the story the next day, they noted the proximity to Lauren Bacall's
apartment. Betty's photo would appear alongside Robards's in the *Daily
News*' report of the accident and arrest. The piece reminded readers that
just days earlier, Robards's wife had named Bacall in her separation law-
suit from the actor. Robards was charged with drunk driving and leaving
the scene of an accident and released on $100 bail. Gossip columnists
had a field day with the scandalous Bacall-Robards romance.

Just a few months earlier, Betty had happily proclaimed that she was
no longer looking for a husband. But after the Strasbergs' party, she'd
been unable to resist Robards. "From that moment on, well, one thing led
to another." She accepted all his invitations, even when he'd call on her
"at odd hours of the morning, slightly looped." They'd meet at the Palace
Bar near the Lyceum after Betty had wiped off the stage makeup from
Goodbye Charlie. "My need for someone having been denied for so long,
it was impossible for me to turn away," she wrote. When Robards went
to Boston for tryouts of a new play, *Toys in the Attic*, he called Betty late
at night and they spoke for hours. He was often drunk. It didn't matter.

"I was being drawn deeper and deeper into a relationship with him,"
Betty said. "I was in desperate need for someone to love, someone to
belong to." Now thirty-six, Betty was once again driven by the need for a
man that had defined her for most of her life.

Robards was a magnetic figure. He was being hailed as a great talent,
one of the greatest of his generation, in fact. He'd awed the critics with
his performance as James Tyrone, Jr., in Eugene O'Neill's posthumous
Long Day's Journey into Night, which had run on Broadway from 1956 to
1958. The story, inspired by O'Neill's relationship with his father, the ac-
tor James O'Neill, evoked Robards's own backstory as well. Born on July
26, 1922, in Chicago, Jason had grown up in Los Angeles, where he had
watched his father's acting career, after peaking in silent films, steadily
slide downhill. His parents' divorce when he was quite young had left
him traumatized and guarded; his mother's early death had been a blow.
He had also watched his father's decline into bitterness. No wonder he
later said of appearing in *Long Day's Journey into Night* that he had felt as
if he were reliving his younger years.

In 1940, freshly graduated from high school, Jason enlisted as a ra-
dioman third class in the US Navy. Serving on the USS *Northampton*,
he was only about a hundred miles from Pearl Harbor when the Japanese

attacked, bringing the United States into World War II. Later myths claimed that Robards had been an eyewitness to the attack, but in truth the *Northampton* had arrived in Hawaii days afterward. He did serve in the Guadalcanal campaign, seeing active duty in the Battle of the Santa Cruz Islands, and was forced to tread water all night after the *Northampton* was sunk by Japanese torpedoes. He also survived a kamikaze aircraft assault on the USS *Nashville* in the Philippines. An undeniable war hero, Jason was awarded several medals.

The experience had come with some personal cost. "He was twenty-four and had seen too much," his father told the writer Neil Hickey. "Buddies being killed around him, the strain of prolonged attacks. You know what it does. It made him brittle, nervy, alert. He wasn't a youngster anymore." There were many things Jason drank to forget. The war was one of them.

During his time on board the ship, Robards read several plays and began thinking about a career as an actor. His father had been badly treated by the Hollywood studios, but maybe the theater would be more supportive of actors. Robards Sr. encouraged his son to enroll in the American Academy of Dramatic Arts, the same place where, just a couple years earlier, Betty had spent some time. Unlike Betty, Jason graduated from the academy in 1948, when he was twenty-five. "It was the best thing I ever did," he recalled. "I had never gone to college. I learned theater and music and art, ballet, history. I loved it."

At first he worked mostly in radio and television. He distinguished himself in dramas for *Studio One*, *Philco Television Playhouse*, *Magnavox Theatre*, and other anthology series. He played Harry Hotspur in *Henry IV*, a role Bogie had done on radio, in a regional production in Stratford, Ontario. Robards's Broadway debut came with a brief replacement run in *Stalag 17* in June 1952, after which he was cast by José Quintero as the lead in an off-Broadway revival of O'Neill's *The Iceman Cometh* in May 1956. Robards received terrific notices as the unstable salesman "Hickey" Hickman, with the critic Mark Barron judging that he "ably handled" the complex part (the play ran four and three-quarter hours) and Brooks Atkinson praising his "aura of good fellowship" that gave "Hickey a feeling of evil mischief" that had not been apparent in earlier interpretations.

When Quintero was chosen to direct the original Broadway production of *Long Day's Journey*, he knew that Robards would make the

perfect Jamie. He had all the charisma, bitterness, anger, and insecurity the character had been written with. The play was a resounding success, and Robards's arrival as a first-class actor was assured. Atkinson wrote that he gave "another remarkable performance that has tremendous force and truth." Robards played well against the two seasoned actors, Fredric March and Florence Eldridge, who played his parents. He was nominated for a Tony, although he did not win. He did receive the award for *The Disenchanted*, however, which followed *Long Day's Journey into Night*.

Jason's ascent had been impressive but hardly meteoric. He was thirty-five by the time he appeared as Jamie Tyrone. He was beginning to drink heavily; he missed auditions and casting calls. He was always broke. He was now married with three small children. "That was a terrible period, very, very difficult, very tough," he said. "We lived in a cold-water flat over in the West Village. We rented from people who owned a meat and dairy company. When we were short, they saw that we had enough to eat." He divorced his first wife in 1958 and married his second, Rachel Taylor, the following year. Only a few months later, he began his affair with Bacall.

The failure of his marriages weighed on him. "You really feel guilty," he said. "You feel as if you've taken another soul and crushed it. And guilt and drinking go hand in hand." He wasn't getting drunk for fun. "I drank to erase things in my life," he said. His alcoholism became worse after the divorce from his first wife and marriage to his second. Nearly his entire income went to his first wife and children, but that didn't assuage the guilt. By the time he encountered Betty Bacall on New Year's Eve 1959, he was a serious binge drinker, one who gets behind the wheel of a car even though he can't see straight and crashes into other cars on the road.

All sorts of warning signs should have been flashing for Betty, but if they were, she ignored them. For much of 1960, the couple fought, separated, kissed, and made up in a tedious, terrible cycle. In July, Walter Winchell spotted "Lauren Bacall forgetting Adlai with Jason Robards Jr. at the Dubonnet." At the same time, a columnist for the *Daily News* noted, "Those were harsh, harsh words tossed back and forth by Lauren Bacall and Jason Robards at Frankie and Johnnie's the other 2 a.m." In September, Mike Connolly wrote, "It must be love for Lauren Bacall and Jason Robards Jr. I hear they've been having battles-royal in the 'grand' old tradition of Humphrey Bogart and Mayo Methot, and in public at

that." Betty had always looked down on Mayo for her public brawling. Maybe she understood it a bit better now.

That same month, Earl Wilson remarked on "the Lauren Bacall– Jason Robards palship" causing "fireworks." The pyrotechnics may have been ignited by an item in Dorothy Kilgallen's column hinting that Jason was two-timing Betty with Faith Dane, the bugle-blowing stripper Mazeppa from the musical *Gypsy,* currently running on Broadway. Kilgallen also reported that Jason's play, *Toys in the Attic,* was seeing a spike in audiences; "his romance with Lauren Bacall," Kilgallen wrote, was causing "the box-office stir."

Despite all the turmoil, Betty grew increasingly attached to Jason. *Goodbye Charlie* had closed in March 1960, just a little over three months after it had opened. "Audiences did not like the play," Bacall admitted. She could sense the audiences, especially the men, recoiling at what they saw on the stage. The closure of *Charlie* caused her to cling ever more tightly to Jason. No other jobs—and no other men, for that matter— beckoned on the horizon. Once again, despite her supposed awakening in Europe, she convinced herself that she couldn't succeed on her own.

And then one day in April 1961, she discovered that she was pregnant.

28

Danny Kaye, with his impish grin, graciously acknowledged the applause of the small studio audience gathered for his weekly variety hour on CBS television. "Welcome to the show, ladies and gentlemen," he trilled in his slightly high-pitched, Brooklyn-accented voice. "Tonight, we have probably some of the most exciting guests we've had the entire season. One of the motion picture's most illustrious stars, Miss Lauren Bacall—"

The camera followed Kaye's gesture to reveal Bacall, wearing a sleeveless dress and a flippy hairdo, standing off to the side, smiling broadly as she accepted the audience's applause.

"And," Kaye went on, "the very distinguished actor, Jason Robards." Another camera cut, this time to Robards in a dark suit, who also acknowledged the applause, although more awkwardly and less grandly than Bacall. "Oh, and incidentally," Kaye added, "Lauren and Jason are a set." When the audience tittered, the host replied, "Well, they are. They're married, you know."

Just a little over three years earlier, Betty, four months pregnant, had married Jason in a simple ceremony in Ensenada, Mexico, the only place that would give them a license. They'd attempted to wed in Vienna while Robards was in Europe making *Tender Is the Night*, his first starring picture, but Viennese authorities would not recognize the quickie Mexican divorce obtained by Jason's second wife. Neither was the divorce recognized in Paris, nor in Las Vegas, where Betty had hoped for a fun ceremony at the Sands, poetic justice given the hotel's association with Sinatra. The delays had caused her considerable distress. No one except Jason—not even her mother—knew about the pregnancy, and every day her waistline kept expanding. Finally, Betty and Jason motored down to Ensenada, where, on the Fourth of July 1961, they married in the shabby chamber of a local judge—quite a change from Betty's first wedding at the bucolic Malabar Farm. Betty was thirty-six; Jason was almost thirty-nine. The ceremony was conducted entirely in Spanish, which Betty

didn't understand. They were getting a quickie Mexican marriage following a quickie Mexican divorce, but, if not elegant, it was at least legal, and when their son, Samuel, was born on December 16, his parents were husband and wife. The baby was premature, the Robardses' publicists insisted.

Most of Betty's friends had either warned her or distanced themselves from her in the lead-up to the marriage. Robards's drinking alarmed them. Adlai Stevenson had cautioned, "It's not going to get better after you're married. It's going to get worse." Notably, it was David Selznick and Jennifer Jones, the latter of whom was costarring with Jason in *Tender Is the Night*, who hosted the Robardses' wedding party, not any of Betty's old pals. During their sojourn in California, Bacall's first time back since she'd exiled herself after Sinatra's rejection, there were few, if any, happy reunions with friends from her time with Bogie—at least, she mentioned none in her memoir and newspaper reports give no evidence of it. There were no parties with Judy Garland, Jimmy Van Heusen, the Romanoffs, or Swifty Lazar. There was a new Rat Pack in town, led by Sinatra and composed of Dean Martin, Sammy Davis, Jr., and Peter Lawford, of which Betty was conspicuously not a part. The women who hung around the Pack these days, such as Shirley MacLaine and Angie Dickinson, were a decade younger than she was.

Betty gave the impression of finally being happy again, as photographs were published with her holding her new son. By all accounts, she was more hands-on with Sam than she'd been with Steve or Leslie. That was partly because there were no distractions for her. During the first years of her marriage, she had hardly worked. She was now hoping to change that.

Much as she had done with George Kaufman and Joseph Mankiewicz, she penned a plaintive letter to the playwright Garson Kanin, asking if there were a part for her in his new play, *Come On Strong*. He told her in the kindest possible terms, "No." All that was left for her was a couple of one-shots on television series (*The DuPont Show of the Week*, *Dr. Kildare*, the sort of thing she'd once refused to do) and one truly horrible movie, *Shock Treatment*. In the era of "Grande Dame Guignol," in which Bette Davis, Joan Crawford, Olivia de Havilland, Barbara Stanwyck, and Tallulah Bankhead, among other movie queens, starred in low-budget horror thrillers, Betty accepted the part of a sadistic, psychotic doctor in the Aaron Rosenberg–produced picture. *Shock Treatment* opens with Roddy McDowall taking an ax to an old woman's head and ends with Bacall

muttering to herself in a mental hospital. She'd agreed to do the picture for the same reason her contemporaries had signed up for their own gorefests: no other offers were coming her way. *Shock Treatment* turned out to be a bust at the box office. Betty never saw the film. "I mean, it was bad enough making it without having to see it," she said. She'd later call the picture the worst of her career. Few disagreed, although they might not have seen *Bright Leaf*.

In public, Betty put on a great show of happiness and contentment. "Some people think I'm bitter about Hollywood," she told Bob Thomas of the Associated Press. "I'm not bitter. I'm realistic. I was in quicksand before I left. If I was to continue to function as an actress, as a woman, and as a mother, I had to leave. I did, and it was the greatest thing that ever happened to me." Now she had a loving husband and three children. When Thomas pointed out that Robards was a "boozer," Betty replied, "Aren't all the good ones?" Yes, he liked to drink and sometimes drank too much, she admitted. But, she added, "I have a pretty good background with boozers."

Part of the reason Jason drank, Betty believed, was the inevitable comparisons with Bogie. Erskine Johnson said that Robards's physical resemblance to Betty's first husband was "the talk of everyone." There's some superficial resemblance, especially in the long oval of the face, but it's hard to see why Henry King, who directed *Tender Is the Night*, called Jason "Bogie" on the set several times. "It's strange," King said. "He even thinks like Bogart." Columnists and talk-show hosts were always making the comparison, which Jason did his best to ignore. "I just don't see it," he told Johnson. Betty was sensitive to his feelings. "Jason and Bogie have only two things in common," she insisted. "Talent and me." Once, when the "editor of a high-brow magazine" monopolized her and Jason's time by extolling Bogart's talents as an actor while not once mentioning Robards, Betty had a curt response: "Bug off, buster."

But for all her public presentation of contentment, Betty was not happy. "I knew I wasn't functioning well," she told an interviewer a couple of years later. "I became rundown physically. When you have the responsibility of a husband and children, you also have a responsibility to yourself. If you neglect yourself, you actually are neglecting them. It's unfair to all."

She was, of course, 100 percent right about that. But her lack of maternal interest comes through clearly in her interviews and memoirs,

and it meant the problems with her two older children would continue. "Steve has had nothing but school trouble," she lamented to Katharine Hepburn. Now sixteen, the boy had almost been booted out of school, his mother reported, "but talked his way back in." To judge by his own memoir, Stephen Bogart seems to have felt penned up in the schools his mother had insisted he attend. Betty was pushing him toward the same sort of upper-class education that Bogie's parents had tried to push on him, and Bogart *fils* was just as resistant as Bogart *père* had been.

Steve had graduated from the prestigious Buckley School, but it hadn't been easy. Now he was at Milton Academy outside Boston, which functioned as a feeder school for Harvard. "Four years of living away from home," Betty remembered, "which we felt would be a happy, healthy experience for him." The press reported that Steve wanted to be a scientist and that he'd become an expert chess player like his father, but that may have been part of Betty's spin. Like Bogie, Steve had little patience for traditional academics. His attitude was maddening to Betty. "To survive one's children is really the thing," she complained to Hepburn. "It seems as though they're out to get you in one way or another from the beginning." Her words make it sound as if she viewed her children as adversaries, who were "out to get" her the way Jack Warner had once been. The answer, apparently, was to keep her distance as much as possible. During his time at Milton, Steve saw his mother, stepfather, and siblings only a handful of times each year.

Meanwhile, Leslie was attending the Lycée Français de New York, where the curriculum was based on the academic program of the French Ministry of National Education. At fourteen, Leslie was quiet, shy, and self-possessed, and her mother encouraged her to spend as much time at the lycée as possible to soak up French culture and become the sort of debutante she herself had once dreamed of being during her brief time at Highland Manor. Whether Leslie's dream was the same as her mother's remained to be seen, however. Betty never inquired.

It was with Sam, now almost four, that Betty was the most maternal. She had nannies to take care of him, to make sure he ate and brushed his teeth, which meant she could just play with him and laugh at his antics. Hepburn was the boy's godmother, an honor she'd initially resisted because of her unease with little children, but Betty had won her over. It would formalize their connection, give them a bond that couldn't be broken, something Betty seemed to desire very much. Hepburn remained

her role model; she still wrote her dozens of letters a year, ensuring that the bond forged in Africa was not broken. "Your godson is heaven," she told Hepburn. "Seems to enjoy school, loves football and basketball. . . . A very sporty, funny, and sensitive boy." In other words, quite different from his older brother.

So without much professional work and largely free of family responsibilities, Betty spent most of her time on decorating. After her sublet at the Beresford had expired, she'd found a place at an even more exclusive address on Central Park West. The Dakota was built in the late nineteenth century in the Renaissance Revival style; its brick and sandstone rise dramatically on the west side of the park, its windows reflecting the morning sun. Located between 72nd and 73rd Streets, the Dakota has a central courtyard that is accessed through the oversized arched entrance on 72nd Street. Notable residents when Betty moved in included Robert Ryan, Judy Holliday, Boris Karloff, and the artist Charles Henri Ford.

Bacall's apartment, four thousand square feet of marble floors and deep-toned mahogany woodwork, overlooked Central Park thirty feet above the tree line. A seventy-foot gallery led to the great room, dining room, and library. Nineteenth-century architectural features abounded: pocket doors, plaster molding, a Juliet balcony off the library. But the Dakota apartment's three bedrooms and three and a half baths remained largely bare for the first few months of Betty's residence. Once she was a married lady, however, she purchased the apartment for $48,000. It was the best investment she ever made, given the exponential growth of its real estate value over the decades.

To fill all those big, empty rooms, Betty sent for some of the furniture and objects from the Mapleton Drive house, which had been in storage for the last four years. Bogie's black granite games table made its way into the Dakota library along with a set of books on yachting that had once held pride of place on board *Santana*. A Bernard Buffet expressionist painting, for the longest time propped against a wall in their living room in Holmby Hills, now adorned the long gallery. But Betty also wanted to leave her own imprint on her new home. She launched into a series of antique-buying sprees, acquiring English majolica garden seats, Louis XV giltwood tables, and Chippendale mahogany armchairs. Betty also began acquiring an eclectic assembly of art: *American White*

Pelican, a hand-colored engraving by John James Audubon from 1836; landscapes by Albert York; and *Jamaican Hillside Road*, an oil painting by Noël Coward.

"Not a square millimeter of those tall walls was left uncovered," recalled Jamie Bernstein, daughter of the composer Leonard Bernstein, one of Bacall's closest friends, "and every horizontal surface was covered with tchotchkes from her world travels. It was charming but exhausting—not unlike Betty herself."

Betty's husband, however, didn't leave as much of an imprint on the place. Jason was working nearly all the time. He reprised his role as Jamie Tyrone in the film version of *Long Day's Journey into Night*, in which Katharine Hepburn played his mother. The picture was shot in New York, which made it easier on him, but the script was still draining. Another film, *Act One*, the life of the composer Moss Hart, in which Jason played his wife's onetime booster George S. Kaufman, was also shot in New York. Then came a year's run in *A Thousand Clowns* on Broadway, after which he signed on to Arthur Miller's *After the Fall*, directed by Elia Kazan. The play was intended to launch a new repertory company and therefore did not pay its actors well; Robards took the part because he believed in the mission and the men behind it. He would be disillusioned by the end of the run.

Most nights Jason returned to the Dakota after 2:00 a.m., if at all. "He's around Manhattan at all hours of the night," the columnist Alex Freeman reported, "and if Lauren wants him, she has to telephone his haunts until she finds him." When Sam would ask where Daddy was, Betty decided not to lie. "I don't know," she said. Would he be home for dinner? "I don't know."

Almost immediately after she married, Betty began to wrestle with the idea that she'd made a mistake. She'd thought the same about Bogie, too, in the very beginning, when he and Mark Hellinger would stay out all night drinking. But this was different. Jason had been at the hospital when Sam was born but rarely afterward. On the morning he was to take her home, Betty couldn't reach him; when she finally got him on the phone, he was drunk. The fact that he then showed up in a Rolls-Royce palliated her anger for only a moment. "This had not been marriage as I'd ever conceived of it or known it," she wrote in her memoir. "The first months [of the marriage] had been more down than up." Jason could be

charming with the children, all of whom liked him well enough when he was present, but much of the time he was sleeping off a hangover or at the theater.

Betty blamed herself, as women in such situations often do. "Jason had not promised to change into another person," she mused. "Yet somewhere in me—not somewhere, everywhere—I'd expected him to." It had been one thing, she said, for him to pop up unexpectedly when they were dating, but it was quite another "not to know when your husband would be turning up."

As unwilling as Betty was to recognize it, the truth was that Jason had not wanted to be married. He had just ended two marriages in the space of a couple years. He'd tried to back out of his third several times, even with Betty being pregnant. She'd had to coax him back. "I wasn't interested in marrying [again], but it happened," Robards said, looking back years later. "I still had hangovers from my first marriage." For all his problems, Jason understood his emotional limits, and now here he was, with another wife and another child whom he'd likely disappoint.

Katharine Hepburn had gotten an up-close look at Robards while making *Long Day's Journey into Night*. She had seen the weariness, the guilt, the self-destruction—the qualities that made him so powerful in the part but severely handicapped him as a husband. At some point afterward, she made it a point to see Betty. Sam was now three, and Betty, almost forty, was looking much older than her years. "You're too thin, a wreck," Hepburn scolded in her inimitable style. "The marriage is no good for you—get out, forget it. Think of yourself again."

But Betty wasn't ready to take that step. "I'm not saying this because I'm married to him, but because it's the complete, unvarnished truth," she told Joe Hyams. "Jason is the best American actor around. In addition to that, he has virility—something lacking in most movie males today. He doesn't keep saying he's a man all the time—he is!" Her words could be interpreted as slaps against Rock Hudson, Tony Curtis, Jack Lemmon, Anthony Perkins, and Warren Beatty, then riding high on the list of "movie males." But Betty seemed convinced that she needed a virile man if she was to remain the sexy siren of her youth in the public's mind.

When Jason was sober, he was fun, attentive, and loving. Betty didn't want to be a single woman again. And how could she think of depriving Sam of his father's presence—even if that presence was rare? Still, she

knew she needed to get back to work for her own sanity. She flew to Hollywood to make a film, *Sex and the Single Girl*, costarring Natalie Wood, Tony Curtis, and Henry Fonda and suggested by the best-selling book by Helen Gurley Brown. Betty thought the separation would be good for her and Jason. And unlike *Shock Treatment*, it was a major Hollywood release, directed by Richard Quine with a screenplay by Joseph Heller. If the picture did well, she hoped to be cast in other prominent features. When *Sex and the Single Girl* was released in late 1964, the picture was indeed a hit, although critics weren't overly enthusiastic about it. For the first time, Bacall was playing the older character actress to the nubile young lead; she was billed fourth and had the least screen time. Some reviews didn't even mention her; those that did mostly commented on the loud, jealous wife she portrayed.

Returning to New York, Betty found the problems with Jason multiplying. He'd begun performing in *Hughie*, a one-act O'Neill play staged by José Quintero, and Betty girded for the worst. Her husband had "more than a tendency to take on the personality of the character he was playing," and Erie Smith, the lead figure in *Hughie*, was a drunken, desperate braggart and liar. True to form, Jason spiraled down. "Drink took over more and more with *Hughie*," Betty wrote, "[and] I became more of a shrew." One columnist reported, "There is trouble in Lauren Bacall's four-year marriage to Jason Robards, Jr. The Robards are warring over Jason's drinking and late-night running around with the boys."

Many years later, reflecting on his union with Bacall, Robards said, "It's kind of hard to review a marriage. Betty is a wonderful person. But I was drinking. We had personality conflicts. She had a strength I wasn't prepared for. I can't be that strong. My modus operandi was different from hers. I was trying to escape."

In early 1965, Betty complained to Hepburn, "At the moment, he is out, submerged in booze, I fear. It's all nerve-wracking as hell. Wish he'd pull himself together. His being out of work for even a few weeks is tough for him. I just keep taking Valium and cursing under my breath." She added, "Doesn't look as though I'll be working again soon, if ever."

But Betty was not one to give up. When *Hughie* closed after five weeks and Jason accepted an offer to do the show in Los Angeles at the Huntington Hartford Theatre, Betty decided to go with him, bringing Sam with her. That was how Mr. and Mrs. Robards ended up on *The Danny Kaye Show*. On the highly rated variety series, Betty could

promote *Sex and the Single Girl* and prove to movie execs that she was still vital—and available.

On the air, Kaye, Bacall, and Robards made a gag out of the way the word "sex" was bleeped by the censors every time one of them said it. Kaye reminisced about Betty's ushering days when she'd knocked on his dressing room door looking for an autograph. The bonhomie obscured the tension between the Robards. The show ended with a medley of silly songs, and it's here that the hostility in the Robards marriage becomes discernible. Sitting between Kaye and her husband, Betty never looks at Jason. Nor does she touch him, even as she's all over Kaye, grabbing his arm, leaning in to him. When she's supposed to sing a lyric to her husband, she does, but without eye contact. There's none of the affectionate interplay that viewers might have expected between a husband and wife. It's as if Jason is just another guest on the show. When the trio moves forward, Betty takes Kaye's arm but deftly evades Jason's; when he manages to touch her, she breaks contact by moving toward Kaye.

It was all there for anyone to see—that is, if they knew to look for it. To the press, Betty insisted she had no intention of divorce but admitted, "Jason isn't the easiest guy to live with." That was why, once Robards finished *Hughie* and went back to New York, Bacall stayed behind, taking a beach house in Malibu to think things over. Three thousand miles away from her husband and two of her children, Betty apparently found her bitter memories of Hollywood easier to cope with than the current reality of her life in New York.

JOE HYAMS WAS WRITING A BOOK. A BOOK ABOUT BOGIE. HYAMS, THE TEETOTAL-ing Purple Heart recipient who covered Hollywood for the *New York Herald Tribune*, had long been a sympathetic chronicler of all things Bogart and Bacall. "My press intermediary" Betty affectionately called him for the way he had helped disseminate whatever message the Bogarts wanted to get out there. During Bogie's last months, Hyams had been a godsend for Betty, managing the media frenzy. Now he was writing a book. What would be Bacall's reaction to the news?

She was, surprisingly, all for it. "He wanted my blessing," Betty recalled, "wanted me to write an introduction. Knowing Joe's attachment to Bogie, I agreed." It was a bit of an about-face. After insisting for much of the eight years since Bogie's death that she would not play "the widow

Bogart," she appeared to be reconsidering. What had happened in the meantime was something that no one could have predicted: Bogie had become relevant again, as big a star as he'd been in his heyday.

For the young baby boomers who wanted to challenge the status quo of their parents, Humphrey Bogart was the perfect hero. Most of those young people had not seen Bogart's pictures during their first runs. The Brattle Theatre in Cambridge, Massachusetts, around the corner from Harvard, had begun showing several weeks of Bogart films around final exam time. The first sustained festival was in 1958, just a year after Bogie's death, with screenings of *The Big Sleep, To Have and Have Not,* and *The African Queen.* In the years since, something of a Bogart "cult" (a word dreamed up by the press, not the young moviegoers) developed, with the Brattle's springtime Bogart festival growing ever more popular and the trend spreading to other campuses and theaters.

"These nights," the critic Michael Iachetta wrote in 1965, "on TV and in the so-called art movie houses, the top attraction is a casually cynical and tough actor who has been dead a little more than eight years. The object of this posthumous interest is Humphrey Bogart, whose films— good, bad, or indifferent—are a new 'in' cult." In Cambridge, "the Harvard guys and their Radcliffe dolls" frequented hangouts dedicated to Bogart: the Club Casablanca bar and a coffeehouse adorned with framed photos of Bogie, Bacall, and Peter Lorre. Rarely a week went by that local television stations didn't program a Bogart film or two or three. In New York, the manager of the 8th Street Playhouse explained his reasons for reviving Bogart's pictures: "Hollywood just doesn't have anybody like Bogart making pictures anymore. Bogart has become a legend. . . . The smart set always is on the lookout for somebody to latch on to." In this case, it was somebody who fit the growing anti-establishment mood among young people.

A Brattle Theatre manager recalled the time the sound had cut out during a screening, "but everybody just kept saying the lines anyway." In the balcony, young men proposed to their girlfriends during *Casablanca,* which became a Valentine's Day tradition. Moviegoers showed up in trench coats and fedoras for *The Maltese Falcon* and a week's stubble for *The African Queen.* To be clear, the Bogie "cult" was primarily a male preoccupation, and white male at that. But with the deluge of Bogie's pictures airing on television, the racial and gender demographics of his newfound fandom expanded. Bogie's face was instantly recognizable to

young people; the only other star of their parents' generation who enjoyed such recognition was Marilyn Monroe.

The Bogie cult was part of a larger generational shift in cinema appreciation. International in scope, the period saw the rise of the British Film Institute's *Sight and Sound*, the French *Cahiers du Cinéma*, and other influential film journals that made the case for film as art, the work of auteurs with singular visions of society and the world. It was the era of François Truffaut's *400 Blows*, Karel Reisz's *Saturday Night and Sunday Morning*, John Schlesinger's *Billy Liar*, and Jean-Luc Godard's *Breathless*, in which a young thief (Jean-Paul Belmondo) models himself on Bogart's screen character, staring at his photo as he smokes a cigarette. Europe—France, Britain, Sweden, Italy—was changing the structure and influence of film, and the young, hip, film-savvy European moviegoers and critics had embraced the very American Bogie as one of their heroes. Suddenly Bogart was avant-garde. His cult would ensure that his legacy would be more exalted than that of just about any of his peers.

Betty was keenly aware of the renewed burst of appreciation for her first husband. The press coverage of it could sometimes be uncomfortable to her, as she worried about Jason's feelings. But mostly she welcomed the phenomenon. "I think the whole thing proves that Bogie had something each generation could identify with," she told Bob Thomas of the Associated Press. "For all the great work that Gable and Cooper did, their style hasn't lived on. Bogie's has." She was pleased that through this revived interest, her children could "appreciate what a contribution their father made to the screen."

She may have embraced the Bogie cult for other reasons as well. A renewed interest in Bogart could mean the same for Bacall. Their stories were inextricably intertwined. Signing on to Hyams's book and endorsing it with her introduction would be the first steps in establishing an enduring Bogie-and-Bacall legend. Betty provided the author with papers, correspondence, and anecdotes. In the introduction, she told Hyams's readers, "There is hardly a day that passes that I don't remember something [Bogie] said to me. He used to say, 'Long after I'm gone, you'll remember this.' And I do. I remember it all. . . . He taught me that we all choose our way to live and no matter what direction the lives of our friends might take—however attractive or romantic they might seem—we must never lose sight of our own."

And so the legend was launched. Hyams's book established the

worldly, cynical integrity. It codified the defiance of authority. It provided the template for how the great romance with Bacall should be told. Nothing that Hyams wrote, of course, was a complete fabrication; Bogie had really had all those qualities and beliefs. But the quotes and anecdotes that Hyams shared were polished in such a way to make Bogart always appear to be the wisest person in the room—to justify, in fact, his anti-establishment credentials and popularity among the younger generation. When *Bogie: The Biography of Humphrey Bogart* was published in late 1966, the *New York Times* liked the effort, but other critics quibbled: Otto Dekom at the Wilmington, Delaware, *Morning News*, called it an "adulating biography . . . authorized by the widow."

Still, despite Hyams's foundational role in the Bogart legend, Betty wasn't pleased with the result. "I had written what I thought was a hell of an introduction," she said, "but I found the book disappointing." She didn't give any reasons for her disappointment. Perhaps she felt that there was too much about Bogie and Mayo and their battles, too little condemnation of Jack Warner, too little about her. To do the job right, she wanted the acclaimed short-story writer John O'Hara to write the next Bogie biography—with her oversight, of course.

This is what we might today call controlling the brand. After all, the Bogart brand was also Betty's brand, and she needed to take direct charge of its promotion if it was going to be sold the way she wanted. When Betty learned that Hyams had negotiated with ABC for an hour-long documentary on Bogart's life without involving her, she was livid. "Lauren Bacall seems as interested in preserving the legend of her late husband Humphrey Bogart as Mrs. Jacqueline Kennedy has been for the late President," one columnist observed. Even as Charlton Heston was attached to the project as narrator, Bacall continued to speak out against it. She refused to be interviewed for it and seems to have convinced Bogie's friends to boycott the project as well. The only three celebrities to appear on camera were Joan Blondell (who told off-brand stories about Bogie's fights with Mayo), Ingrid Bergman, and Ida Lupino, all of whom were outside of Betty's control. But there was no John Huston, Katharine Hepburn, Howard Hawks, Mary Astor, or David Niven.

By the mid-1960s, Bacall was more protective of Bogie's image than she'd been before his death. "I paid total attention to everything to do with him," she admitted in her memoir. "Those horrible people who write books," she believed, could say anything they wanted if they had control

of the narrative. To Hepburn, she complained about "some fool named Larry Swindell" who'd asked to interview her for a biography about Spencer Tracy. Betty had rebuffed Swindell's request, quipping to Hepburn that his last name "might be a clue about him." To Betty, those swindlers were out to steal the stories that she wanted told her way or not at all. It's possible that, in the back of her mind, she worried that one of them might get in touch with Verita "Pete" Thompson.

Her reasons for wanting to control the Bogart legend weren't entirely selfish. Betty's efforts were fueled by the perfectly understandable desire to protect the legacy of a departed loved one, even if that sometimes meant telling less than the full truth. But there were practical reasons as well. If Bogart was current, she could be, too.

Indeed, during the first bloom of the Bogart cult, Betty was offered a major prestige picture for the first time in nearly eight years. It was *Harper*, produced by Elliott Kastner and released through Warner Bros., directed by Jack Smight, and written by the novelist William Goldman. (The film would turn Goldman into one of Hollywood's major screenwriters.) The star was Paul Newman, and the cast was impressive: in addition to Betty, there were Robert Wagner, Julie Harris, Janet Leigh, Shelley Winters, and Arthur Hill. *Harper* was an homage to the noir mysteries of the 1940s, particularly Bogie's. In a nod to *The Big Sleep*, Betty played a wealthy woman searching for her missing husband. Her part wasn't the biggest or showiest, and the forty-year-old actress had to endure cracks about her age and wrinkles from the twenty-two-year-old Pamela Tiffin, who played her stepdaughter. But Betty was the one to set the plot into motion, much as she'd done in *The Big Sleep*. She liked Newman, but the production of the film was not happy for her. Though Goldman's script was quite good, evoking the mood of Bogie's noir films, Betty considered it "not reminiscent enough, unfortunately," lacking what had made Bogie's films so special. Still, *Harper* was a major picture, and Betty would benefit if it turned out to be a box-office success.

"Lauren Bacall has 'movie star' written all over her," read a UPI story that bore the fingerprints of a press agent. "The tawny, lynx-eyed beauty with the smokey voice just completed a new movie and is thinking of remaining in Hollywood to pursue a film career again." Betty was quoted: "Broadway is in terrible shape, and European movies have had it. Hollywood is once more the center of the entertainment world, and I have never felt more like working in my life."

But nothing came of her hopes. No new offers came in. Betty felt thwarted at every turn. Her only other gig was an episode of the CBS television series *Mr. Broadway* entitled "Something to Sing About," scripted by Garson Kanin, perhaps as a consolation prize for *Come On Strong*. Betty played a nightclub singer and sang her own songs. Not long afterward, she learned that the producers had dubbed her voice with another singer. Embarrassed, Betty filed a $3 million lawsuit against Talent Associates–Paramount Ltd., complaining that the action "would cause irreparable injury to her reputation as an actress and a singer." The producers eventually backed down, and it was Bacall's throaty voice that warbled into Americans' living rooms when the show was broadcast.

Betty was particularly sensitive to professional slights at the moment because she was eyeing a property that the producer M. J. Frankovich was setting up at Columbia, *Cactus Flower*, a comedy based on a French play. Betty saw herself as the devoted nurse of the handsome dentist who masquerades as his wife to deceive the dentist's young girlfriend, until the ruse turns into love. But Frankovich didn't see Betty in the part. "He is evidently envisioning a twenty-year-old girl for it which God knows kills the only point the play had," she griped to Hepburn. "Back to the idiot world on their terms, I suppose."

That was her attitude by the end of her West Coast residency in the fall of 1965. When her Malibu lease was up, there was no point in staying any longer. Without fanfare, she left Hollywood again and returned to New York, her husband, her children, and her antiques. Her future, she now understood, would be on the East Coast, for better or worse.

THERE WAS A REASON WHY NEW YORK WAS HOME, A REASON WHY BETTY KEPT returning: New York had never turned its back on her. And New York, as it turned out, had its own plans for *Cactus Flower*, which were very different from Hollywood's. The legendary producer David Merrick and the playwright Abe Burrows wanted *Cactus Flower* to be a Broadway show, and they'd contacted Betty in Malibu to offer her the part Frankovich had refused to even consider her for. She wasn't their first choice, however. They'd wanted Rosalind Russell, who'd proven her Broadway box-office appeal in *Auntie Mame* and *Wonderful Town*. But when Russell wasn't available, they turned to Betty. It didn't take her long to say yes.

"Lauren Bacall will have to retract those 'I could never live in New

York again' interviews she just gave in Hollywood," the columnist Leonard Lyons wrote. "She's returning to Broadway in Abe Burrows' *Cactus Flower*." If Betty had to eat a little crow for the opportunity, she was willing to do so. Rehearsals began on October 4, soon after she arrived from Los Angeles. "I'm a little nervous since I haven't done anything on stage since *Goodbye Charlie*," she told Hedda Hopper just a few months before the old warhorse died, "but I have to keep working to keep my juices flowing."

Cactus Flower was the farcical story of a philandering dentist, played by Joseph Campanella, who's carrying on an affair with a woman much younger than he is. To keep her from demanding marriage, he concocts a story that he's married and his wife won't give him a divorce. Comes a plot twist, and he suddenly decides he's in love with the young woman and wants to marry her. He asks his nurse, played by Bacall, to pretend to be his wife and obligingly consent to a divorce. But as it turns out, the young woman has never wanted to marry the dentist, while his nurse has carried the torch for him for years. Through a series of misadventures, both women get what they want.

Abe Burrows was one of America's most acclaimed humorists, and over the past decade he'd brought his singular wit to such Broadway smashes as *Guys and Dolls* and *How to Succeed in Business Without Really Trying*. He was both jocular and intense, with a penchant for blinking his eyes rapidly behind his round spectacles, especially when he was anxious. As he had not only written the script but was also directing, Betty had every reason to believe that the show would be a hit.

The first tryouts were held at the National Theatre in Washington, DC, starting on November 4. The company remained in the capital for two weeks. Merrick spared no expense on the show and accommodations for the company. "David Merrick, God bless him, knew he had a hit on his hands," recalled Brenda Vaccaro, who, at age twenty-five, was playing the dentist's young inamorata. The fact that the preview period was short and included only two cities reflected the producer's confidence in the material. Vaccaro had only praise for Burrows. "What a great opportunity to be in a comedy that worked every single night," she said.

Local critics agreed. Louis Cedrone of the Baltimore *Evening Sun* wrote, "While *Cactus Flower* may not have a very novel plot and may not have many surprises, it is rife with laughs, many of them of yock caliber, and those, after all, are what make a solid comedy." Bacall did "rather

well as a comedienne," he said, but he reserved his effusive praise for the younger actress in the show. "Miss Vaccaro has an offbeat kooky charm and her facial expressions are something to see," he noted, such as "her clowning behind Campanella's back when he tells her his 'wife' no longer wants the 'divorce.'" R. H. Gardner of the *Baltimore Sun* thought that "Without Toni [the part played by Vaccaro] the show would be in a spot. She gives *Cactus Flower* the freshness and warmth needed to make it a success."

Reviewers at the show's next stop in Philadelphia went a step further. The *Philadelphia Inquirer* headlined its review BURROWS, BACALL FACE SHOW-STEALER IN "CACTUS FLOWER." "Lauren Bacall is fascinating as the cactus who flowers in a dazzling outburst," Henry T. Murdock wrote. But it was Brenda Vaccaro, he said, who was "this year's discovery as the pretty, soft-hearted, hard-headed, whimsical, and betrayed ingenue of the play. . . . She is a scene-stealer, abetted in her larceny by some of Burrows' brighter quips to which she adds one of the sunniest personalities seen in a long time."

That, of course, was a problem. *Cactus Flower* was supposed to be Bacall's show. One day in Philadelphia, Burrows asked Vaccaro to take a walk with him before that day's rehearsal. "He started talking to me about Betty," Vaccaro recalled. "She was a major Hollywood star, and we had to show her some consideration. I stopped and asked what he meant." Burrows looked at her. "You're walking away with the show, and we can't let that happen," he explained. "I'm telling you now, we're not walking onto Broadway without Betty being the star of the show."

Vaccaro asked what he was proposing that she do. "Well," he said, "you know the chop-chop-chop you do behind [Campanella's] neck, which the audience can see but he can't? We've got to cut that."

"No," the young actress told him categorically.

Burrows's eye tic started blinking out of control. "Did I hear a no?"

"You heard a no," Vaccaro replied. "It's the biggest laugh of the show." Modulating her performance would hurt the entire production, she said. "I just refused to do it," she remembered. "I don't know where my audacity came from. I could have lost my job." She understood Burrows's position, and he was "within his rights as writer and director" to change the performance. "He was really concerned to walk onto Broadway and have me outshine Betty," she said. "He knew it could be damaging to her." Still she remained intransigent.

At last Burrows backed down. "I think our meeting is over," he said. Vaccaro knew he hadn't really wanted her to make the changes. "So he said just 'Fuck it' and went on with it."

She didn't know whether Bacall had put Burrows up to it. Throughout the show's run, Betty was always pleasant and professional with her, albeit from a certain distance. "I definitely felt a competitive edge from her," Vaccaro said. But one night, while the show was still in Philadelphia, Betty suggested that the two of them go out for a drink at the RDA Club, a members-only nightclub run by the father of one of the show's supporting players, Marjorie Battles. There, sipping Jack Daniel's, Bacall grew reminiscent, and her thoughts turned to Frank Sinatra. She told Vaccaro that she regretted her "fatal mistake" of talking to the press that had ended their engagement. "I didn't get the sense that she was bitter, just deeply, deeply disappointed. I don't think she'd gotten over Sinatra. He was still on her mind."

Whatever made Betty let her down her guard with a woman who nightly eclipsed her on the stage is puzzling. "I found it interesting for her to confide in me that way," Vaccaro said. Possibly she wanted to demonstrate to the young filly that in her day she'd attracted America's heartthrob, that she hadn't always been the prim and proper character she played on the stage. But perhaps more likely, she was simply lonely. Her marriage was continuing to decline. Bogie had tempered his drinking by a similar point in their marriage; Jason's had gotten worse. Betty admitted to Vaccaro how often she had to pick up her unconscious husband from bars. "But she was so loyal to Jason," Vaccaro said. "She had no desire to be divorced."

As the company prepared for their Broadway opening at the Royale Theatre, where Betty had once ushered people to their seats, Merrick and Burrows made their final adjustments to the show. Bacall's failure to outshine her younger costar had perhaps been inevitable, given the nature of their roles. But it appears that some of the blame was shifted to Joseph Campanella. Betty had never fully warmed up to him, and the thinking went that she might shine brighter if she had better chemistry with her leading man. Campanella was summarily fired and replaced with Barry Nelson, whom Betty adored. Their chemistry on the Royale stage was apparent. As hoped, Betty's performance benefited. Howard Taubman in the *New York Times* praised her above her costars, especially the scene in which "she lets go [of] her inhibitions" with "spirit

and humor," changing from her starchy nurse's uniform to a clingy, side-slitted gown. In response to the critical raves in New York, the show racked up $600,000 in advance ticket sales. Betty was on top of the world. "She is the season's reigning Broadway female star in the town's biggest new hit," one interviewer noted.

"I've waited for this for 40,000 years," Betty exclaimed. "It was my teen-age dream." *Cactus Flower* ran its full two years on Broadway. Bus-loads of people came over the bridges and through the tunnels to keep the house sold out nearly every night. Betty had a ball. "It's been one of the nicest experiences of my life," she said six months in. "I can hardly wait to get to the theatre. All that damned adulation, I love it. It almost seems as though my entire life has been a trip to get to this point."

It's important to recognize Bacall's accomplishment. Unlike so many of her contemporaries, she hadn't gone gently into the uncharted night of postmovie stardom. The two options for older actresses were to slide into character parts and episodic television or retire. Betty rejected that choice. Instead, she challenged herself to conquer a new medium, and she did so magnificently, thanks to her fierce determination and willing-ness for hard work.

Brenda Vaccaro recalled that every night before a show, Bacall would exercise her voice, using an ascending scale of notes. "We'd hear her in her dressing room going 'ma-ma-ma-ma-ma-ma-ma-ma-ma.' It drove us crazy. But to be fair, she was a very dedicated lady to her work." Betty was self-conscious about her voice, understanding that the stage required an ability to project that hadn't been necessary on Warner Bros.' sound-stages. She was also taking singing lessons for "a future show," Earl Wilson reported, "a musical, she hopes."

Time put her on its cover for an issue celebrating middle-aged achiev-ers. "Although she barely qualifies," the magazine's editor wrote, "Lauren Bacall at forty-one" was "a fitting (and certainly comely) personification" of what the magazine was calling the "command" generation. "What is fascinating about Bacall," *Time* observed, "is not so much her kinetic sea-green eyes or her svelte-as-sin 129-lb. body, but the distillation of glamour into poise, inner amusement, and enriched femininity that no 20-year-old sex kitten has lived long enough to acquire."

Betty may not have been pleased at being called "middle-aged," but she took the praise. Careerwise, she was back on top of her game, and she relished every minute of it, the trials of the last nine years never far

from her mind. About her renewed success, she mused, "I sure took the long way around, a long detour, on a roller coaster where the highs were as high as anyone could ever hope to go, and the lows . . . were ten degrees below hell." Now she was riding high once more. *Harper* had just been released and was doing smashing business; it would become one of the top twenty highest-grossing pictures of the year.

Bacall was once again part of a smart set of film and theater people. She received a coveted invitation to Truman Capote's Black and White Ball, held on November 28, 1966, at the Plaza Hotel, a glittering assembly of New York's posh and pretentious. "Everyone stood back when Jerry Robbins danced with Betty Bacall," remembered Lee Radziwill, the sister of Jacqueline Kennedy. "When they started out, people were dancing everywhere, but the two of them were so superb the dance floor just cleared." Betty's profile hadn't been so high since her film debut.

Yet in her personal life, the roller coaster was on a runaway course to the bottom. "Lauren Bacall's intimates say the true test of her shaky marriage to Jason Robards" will come from how they deal with their frequent separations, one reporter disclosed. Jason was doing more film work in California while Betty was appearing in *Cactus Flower*. "If the marriage stands the strain of the separation, it'll stay together, but it's a big 'if.'"

To that end, she was looking for a project they could do together. "We just haven't found a script," she told Earl Wilson. Movies might be a safer choice than a play. Jason didn't drink quite as much when he was making a film as he did while working on the stage. "There was something about theatre life," Betty mused. "'Let's have a drink after the show.' 'Stop by for a drink' . . . and the endless bars and favorite hangouts." She no longer attempted to police her husband; it was pointless. "I did tell Jason that if he had to drink, I didn't want him doing it at home. I was not going to have Sam or Leslie see him like that."

There was other personal distress as well. One night during the run of *Cactus Flower*, Burrows told Betty that someone named William Perske had called the theater, claiming to be the star's father and requesting twelve house seats. Betty was outraged. "I haven't seen him since I was eight years old," she told Burrows. "He had a hell of a nerve calling you— and twelve seats is ridiculous." She didn't care if he came, but Burrows shouldn't feel obligated to give him tickets. How Burrows handled the request, Betty was never sure. Nor did she know whether her father came to see the show. "One night I saw the outline of a man in the audience

who might be him," she wrote in her memoir. If it had been Perske, she was thankful he hadn't tried to come backstage. "I'd never be prepared for that meeting," she said. Her wounds might be decades old, but they remained as fresh and painful as when she was eight.

ON SATURDAY NIGHT, NOVEMBER 18, 1967, LAUREN BACALL TOOK HER FINAL bows in *Cactus Flower*. The audience gave her a standing ovation. The cast presented her with cards and a silver mirror for her bag. Jason sent bushels of flowers. Starring in a successful Broadway show may have been Bacall's dream, but she'd come to loathe it, as well as her costar, whom she'd once liked. "I am slaving and absolutely going mad in this show," she wrote to Hepburn. "I hate Barry Nelson, hate the confinement." In her memoir, she'd express annoyance at Nelson for milking the laughs, which she saw as damaging to her performance. "Two years is sheer drudgery," she wrote. "To keep a part fresh for that length of time gives ulcers and leads to exhaustion."

She hoped she'd quickly land a new part in another play, but that was far from certain. "I guess I'll miss the work in a way," she admitted to Hepburn. "I'm terrified I'll never get another job." She had never been good at being idle. The frenetic schedule of eight shows a week had worn her down, but it had also kept her focused and engaged. By the spring of 1968, she was feeling out of sorts again, dissatisfied, directionless. After promising that she'd star in the film version of *Cactus Flower*, M. J. Frankovich went back on his word and decided to hire a whole new cast: Ingrid Bergman would play Betty's part on-screen. "I had created that part and I wasn't crazy about anyone else claiming it as hers," Betty told Hepburn.

Betty's ennui was exacerbated by the assassination that June of Robert Kennedy, whose presidential campaign had fired up her enthusiasm in much the same way Adlai Stevenson's had done. Adlai, too, was gone, having succumbed to a massive heart attack a few years before. Betty's support network was getting smaller, and her marriage continued to deteriorate. "Certainly [Jason's] drinking had been a large part of it," Betty wrote, "but beyond that it seemed we had less and less to share, with the great exception of Sam, who unequivocally adored his father and vice versa." However, she believed that Jason ultimately failed his son, neglecting to show up when he'd promised, forgetting Christmas gifts.

"Jason was not a good father," Bacall said plainly. "Jason, unfortunately, was not good enough. I wish he had been."

One day in late 1968, while they were in California, Jason disappeared. For two days, he didn't show up and didn't call. "I was upset, angry, disgusted," Betty wrote, but "there was no point in threats anymore." In her memoir, she claimed to have been looking for a stamp when she opened Jason's desk drawer. What she found instead was a romantic letter penned to her husband by a woman. There was also a statement from Jason's accountant verifying money that had been transferred to the woman's account. At that moment, Betty knew the marriage was over. "It had been for some time," she wrote, "and this fact was something I had no intention of dealing with." When Jason finally returned, Betty asked him about the woman. He didn't deny it. "It's over," Betty said, "so let's end it. Now, with dignity and like grown-ups."

To his credit, "Jason recognized the finality and accepted it," Betty wrote. He hadn't been happy in the marriage, either. The fault for its dissolution was primarily his, but Betty accepted her part in it. "It was clear that I had always wanted it more than he had," she wrote, "that I had taken on something that I didn't understand."

Things were clearer for her now. In the months after the separation from Robards, she came to accept that her life, her career, her happiness, did not require a man. At the age of forty-four, it was rather late to learn the lesson, and she was never all that happy about it, but the realization finally set her free. Henceforth, her life, whatever happened, would be her own.

New York City, Sunday, April 19, 1970

The day couldn't have been more auspicious. Bright blue skies and torrents of sunshine crowned the city that morning, a change from all the clouds of the week before. The dispersing of the gray skies and the triumphant return of the sun could only have brightened Betty's mood and raised her hopes on that momentous day. The actress whose only previous award had been Miss Greenwich Village 1942 had been nominated for the theater's highest honor, the Antoinette Perry Award, known in common parlance as a Tony. And not just any Tony but Best Actress in a Musical. Lauren Bacall—whose voice Warner Bros. and CBS had considered dubbing—was competing for an award previously won by Mary Martin, Ethel Merman, and Gwen Verdon. The show was called *Applause* and had been an immediate smash upon its opening just weeks before.

What a year of ups and downs it had been. In August 1969, Betty's mother had died, taken by another heart attack. Natalie had been sixty-eight. She had always been Betty's biggest cheerleader. She'd worked so hard to make her daughter's dreams come true. How unfair, Bacall told friends, that she should not live to see that moment, when Betty's Broadway dream was finally realized, when she was finally getting the recognition that she'd sought for so long.

A little more than a week after Natalie's death, Betty's divorce from Robards was finalized by a Mexican judge. The marriage had begun in Mexico, and it ended there as well. Freeing herself of Jason was right and necessary, but it did not make Betty happy. She was more depressed than ever.

"I've had fourteen years of bad luck, and I mean pretty desperately bad luck," she said in 1970. She had made similar comments before, with the duration of her bad luck increasing with each passing year. The beginning of her nadir, by her reckoning, had been Bogie's diagnosis of cancer, from which so much unhappiness had flowed: Bogie's death, the

Sinatra debacle, the loss of friends, the cratering of her movie career, the problems with Steve, the problems with Jason, and finally her mother's death.

Certainly, all those events were difficult and heartbreaking. But it's hard to back up Bacall's claim of "desperate bad luck." She was living comfortably at one of New York's most fashionable addresses. She never had to worry about money. She'd traveled throughout Europe several times, always hosted by the glitterati. She'd starred in two Broadway shows, one of them a long-running hit. Other actresses of her era also faced career uncertainty as television upended the entertainment industry; she was hardly alone in that. "Desperately bad luck" might be better applied to Veronica Lake, who'd been discovered while working as a waitress and living in cheap hotels, or Montgomery Clift, whose automobile accident had left him disfigured, or Patricia Neal, whose infant son had suffered brain damage in an accident, whose seven-year-old daughter had died of measles, and who herself had suffered a debilitating stroke that had forced her to relearn how to walk and talk. Against their stories, Bacall's self-pity rings hollow, but that's how depression works. Others can point out positive things that you should feel good about, but when you're clinically depressed, which Betty likely was during her last few years with Robards, none of that matters.

Applause was what helped bring her back to life. "It's like a second chance, as if my life is beginning again," she gushed to an interviewer from *Life*. "I'm counting on this for a lot, because believe me, I'm due. I'm overdue." Her contract stated that she would stay with the show no longer than a year—she did not want a repeat of the drudgery of *Cactus Flower*—although she did have the option to head companies in Los Angeles and London.

The idea for the show had come from the composer Charles Strouse and the lyricist Lee Adams, who'd had a hit with *Bye Bye Birdie*. They envisioned *Applause* as a musical version of *All About Eve*, the Academy Award–winning 1950 film that had starred, so memorably, Bette Davis. Fox, however, refused to grant rights to the film, so Strouse and Adams obtained the rights to Mary Orr's short story "The Wisdom of Eve," on which the film had been based. That meant that none of the dialogue from the film could be used, a decision eventually revoked by Fox, which allowed a musical number based on the movie's most famous line, "Fasten Your Seat Belts." The producers were Lawrence Kasha and Joseph

Kipness, who attached Bacall to the project. She would play the lead, the glamorous Margo Channing.

"The Margo Channing of *Applause* and myself were ideally suited," Betty wrote in her memoir. "She was approaching middle age. So was I. She was being forced to face the fact that her career would have to move into another phase as younger women came along to do younger parts. So was I. And she constantly felt that the man she was in love with was going to go off with someone else, someone younger of course, and I, too, had had those feelings." By embracing middle age, much as Davis had done in the film, Bacall's career was given new life.

The book for the musical was written by Betty's close friends Betty Comden and Adolph Green, who set the story in 1970 instead of 1950 and created new characters since, at first, Fox wouldn't allow them to use any character in the film that hadn't been in the original short story. Among the new characters was Margo's wry hairstylist, Duane, played by Lee Roy Reams. Duane was the first, or one of the first, likable gay characters on the stage. At one point, he takes Margo to a gay bar, where the patrons welcome her with song and dance, which was undoubtedly a first. Diane McAfee, a rising young actress and singer, was cast as Eve Harrington, the conniving fan who aims to eclipse Margo on Broadway.

The flaw in the story of Margo Channing, however, has always been that she is presented with only two choices: career or marriage. In 1950, when the film was made, Margo's conundrum reflected the prevailing wisdom, but twenty years later, things had changed. The second wave of feminism had launched the women's liberation movement; TV commercials sang about women bringing home the bacon and frying it up in a pan. The choice Margo faced was no choice at all.

Comden and Green understood that the story needed modernizing. Eve's imaginary husband, supposedly killed in World War II in the film, now was said to have been killed in Vietnam. The inclusion of Duane and the gay bar scene was done specifically to make the show appear "with it," the Stonewall uprising having taken place the previous June, engendering a surge in gay activism and visibility. Girls in bell-bottoms swung their hips across the stage, and the word "groovy" was sprinkled liberally throughout. A couple of bare bottoms were flashed, and at one point the dancers gave the audience the finger.

But that was just window dressing. Comden and Green did not seem to know how to adjust Margo's story to the new reality. The ending, as

Joseph Mankiewicz had written it for the film, required Margo to retire from the stage so she could "go back to being a woman." The first draft of the *Applause* script concurs, with Margo saying "I was calling myself a woman, when all I've been is an eight-by-ten glossy with a scrapbook full of clippings. I've still got a chance at something better. . . . But I've got to give it the same kind of monster single-mindedness I've been giving my career." She then launches into her eleven o'clock number, "Love Comes First," in which she sings, "No more breaking my back for wealth and fame,/I've been trying to win the wrong ball game."

The ending rang hollow to Larry Kasha after the first rehearsal. In a memo to the writers and the director-choreographer, Ron Field, he advised, "Margo's decision at the end of the play that 'Love Comes First' still bothers me. It's really hard for me to accept the fact that a Margo, a Lauren Bacall in life, would so quickly decide to give it up." He recommended a more nuanced ending, with Margo saying that she'd give marriage a try but making clear that she'd still have some ambitions of her own. He was clearly met with some resistance, as the change was not made.

That faulty dichotomy also bothered some critics when the show opened for its first previews in Baltimore on January 28. Richard Lebherz of the Frederick, Maryland, *News* titled his review of the show THE SOUND OF ONE HAND CLAPPING, and he lamented Comden and Green's failure to convincingly bring the original film into the counterculture 1970s. "Either the character of Margo Channing has to be updated to fit in with the contemporary setting or the Ron Field version ought to be adjusted to the 1950 film concept," he wrote. He pinned the problem on the book writers, not Bacall, whom he hailed for her "magic and allure, not to mention a terrific figure and talent that cries out to her fingertips." When Margo is "in the present tense," the critic wrote, "she shimmers." But when she becomes the 1950 version, "she has a tendency to fade." Other critics made similar points.

There's no indication of how the woman playing Margo felt about all of that. But Kasha was right: Bacall had never forfeited her professional ambitions, not for Bogie, Sinatra, or Robards. She'd epitomized "monster single-mindedness" when it came to her career. Her entire life had been predicated on the idea that she could have both a career and a family. In practice, of course, that hadn't always worked out. There had been ups and downs for both, and coming so soon after the divorce, Betty's

portrayal of Margo likely felt very personal. After all she'd been through, she may even have agreed that there could be no middle ground in Margo's decision. The difference was that if Betty had to choose between family and career, she was going with the latter.

The show's run in Baltimore lasted two weeks, so Field and his writers had time to make changes "in what seemed like the spirit of market research," according to one reporter. Despite Lebherz's saying that McAfee was "so perfect [as Eve] that you wonder how they were ever so lucky to find her," the actress was replaced by Penny Fuller, another rising star. More critically, the writers attempted to solve the Margo problem. "Love Comes First" was dropped, but its replacement, "Something Greater," essentially conveyed the same message, though it's a little more ambiguous about whether Margo will ever work again. The dialogue suggests that she won't: at one point, she asks her friend Karen Richards if she has a recipe for lasagna, telegraphing a retreat into domesticity. Comden and Green, both in their midfifties, appeared unwilling to fully divest from Mankiewicz's midcentury conception of Margo Channing.

Bacall seemed to understand instinctively that *Applause* would succeed less on its story than on her own star power. So she threw herself body and soul into the show. "We were rewriting like mad in Baltimore and Detroit," Betty Comden remembered. ". . . Betty was tireless. We were always asking, 'When is she going to explode?' She never did." In rehearsals and tryouts, Betty danced until her legs ached and sang until her throat hurt. Ron Field cagily gave her numbers surrounded by male dancers, who could cover for her when her kicks failed to go off as planned.

Given her anxiety over her first musical, Betty understood she'd need allies in the cast. When Lee Roy Reams referred to her as Miss Bacall on the first day of rehearsals, she told him, "My friends call me Betty." To her, gay men often represented safety and support. As the rehearsal went on, with repeated stops and starts, Reams grew exasperated waiting in a wardrobe closet to deliver his one line. Finally, he called, "Excuse me, but when does this character get out of the closet?" Betty burst out laughing. Reams said, "That was the beginning of a beautiful friendship."

During a run-through of the show for some high-powered invited guests, including David Merrick and Hal Prince, Betty's old shakes returned. Reams noticed her standing in a corner waiting to go on. She was visibly trembling, and everyone was afraid to approach her. "I went over, and I took her hands in mine," Reams remembered. He asked her, "Why

are you so nervous? The show only depends entirely on you." That made Betty laugh. "You son of a bitch," she said. From that moment through the end of the show's run, Reams said, they would meet at the five-minute call each night and hold hands until she made her entrance.

Betty felt enormous pressure to get it right. "She always believed she had to prove herself," said the critic Rex Reed, who was both an adversary and a close friend. "She was self-conscious about the limitations of her talent. But she just kept pushing ahead." Bogie's old friend Gloria Stuart said that Betty's attitude was "Damn the torpedoes. Let me in, or I'll smash my way in." As Bacall told Barry Farrell of *Life* on the day of the Detroit premiere, "What the hell, I've made an ass of myself before." In many ways, she remained the teenager who, recognizing she was outclassed at an audition for George Abbott, still danced her heart out, hoping that someone would notice her anyway.

In Detroit, Betty rehearsed yet another revision to the finale, but the pianist was having difficulty transposing the new music to her key. "It was a circumstance in which even a small star might feel entitled to a tantrum," wrote Farrell, "but Bacall waited patiently, dancing idly by herself, cool and loose. She was wearing a turtleneck shirt, yellow slacks, and what appeared to be suede tennis shoes." When the pianist finally got the key right, Bacall "started singing along in half-voice," Farrell said, "clowning with the lyrics and smiling out at the dozen listeners sprawled out in the first few rows. Everyone beamed back at her until all were caught up in a theatrical lovefest, with winks and jokes and extravagant whoops and embraces."

Betty was feeling the love. She told Farrell that she got "the greatest kind of soaring feeling" from the work. It was her moment, and she knew it. "Would-be shows have been saved before from the fate they deserved by a performance of the sort Miss Bacall gives here," opined one reviewer in Baltimore. "Her familiar, throaty voice," he judged, worked surprisingly well for the character, even if Lawrence DeVine, reviewing the show in Detroit, thought she was often "inaudible"—but, he quickly added, "never unnoticeable."

The show was also helped enormously by a young actress by the name of Bonnie Franklin, who had been born the same month Betty had been signed for *To Have and Have Not*. Playing a theatrical gypsy who belts out the title track, "Applause," Franklin has nothing to do with the show's plot; she functions merely to provide context and atmosphere.

Some reviewers wondered why the song, a showstopper every night, had been given to a minor character and not to Margo or Eve. But Franklin made the number the catchiest in the show, and her warm embrace by audiences and critics ensured she would not get cut like McAfee, even though her vocals outclassed Bacall's. The show's producers agreed to release the song as a single, with Franklin recording it with an orchestra. On the B side, Bacall and her costar, Len Cariou, sang "Something Greater." Whether the stars were irked that the A side was given to a neophyte isn't known. But the single became the most successful of any Broadway song released that season.

Cariou proved to be another ally, one even more intimate than Lee Roy Reams. One night while still in Detroit, Betty invited Lee Roy to join her for dinner, and to his surprise, Cariou was there as well. After dinner, Betty's limo waited to take her back to her hotel (she stayed separately from the rest of the cast) and Reams noticed Cariou went with her. "You sly puss," Betty purred at Reams the next night when he turned up for their regular after-show cocktail in her dressing room. "I knew you knew about Len and me. That's why I invited you to dinner with us." Reams hadn't known, but the affair was soon an open secret among the cast. Once in New York, however, the relationship ended, and Betty was fine with that. "She had a great deal of respect for Len," Reams said. Getting her leading man on her side had been a wise move after the tension she'd felt with Barry Nelson during *Cactus Flower*.

As the show prepared to open on Broadway, the receipts from the previews were encouraging, rising from $46,000 a week to $100,000 during their last week in Detroit. On March 30, *Applause* opened at the Palace Theatre ("At last, I'm playing the Palace!" Betty exulted) and the city's theatrical elite turned out to welcome their native daughter. Clive Barnes of the *Times* loved the show but loved Bacall even more: "The cast as a whole was superior, the look of the show proved sweet and glossy, but it was Miss Bacall's night. She is a good lady, and New York is going to love her and love her—we take her to our brittle hearts." *Life* put her on its cover, her head back, laughing uproariously.

It was Bacall's apotheosis. She had never been this loved, this valued. Her success was entirely her own. It had nothing to do with Bogie. It was about her drive, her determination, her hard work, her commitment. The box office for *Applause* was tremendous: $109,231 for the first week and then never below $102,000, with most weeks pulling in over $109,000.

The cherry on top of the outpouring of love was the Tony nomination, announced on March 31, just one day after the show opened, based only on previews.

Bacall desperately wanted to win. A Tony would symbolize her rebirth, her transformation from Baby into Lauren, a star on her own at last. But first, she'd have to beat her main competition for the award, none other than Katharine Hepburn, who, as the star of *Coco*, had also reinvented herself in musical comedy that season. Betty's well-known devotion to Hepburn required that she tamp down her excitement and desire to win, at least in her letters to Kate. "This bloody thing will do until the real thing comes along," she said about the nomination, appearing to play down the Tony compared to the Oscar, of which Hepburn had three. "After it's over and you win, we have to have a meeting," Betty said. Only with her idol would she be so modest.

In truth, Bacall wanted that award "more than anything," one of her managers said. "The Tony would be tangible proof of her success on her own." The award ceremony was held at the Mark Hellinger Theatre, which Betty may have taken as a good omen, given Hellinger's close friendship with Bogie. She looked incredible, svelte in a fashionable burgundy pantsuit, flowing scarves, and a long metallic necklace that came to her waist. Her hair was full and bouncy, and her smile was frequent and genuine, the joy impossible to contain.

As Walter Matthau read the nominations from the stage, the television camera cut to Betty in the audience, coiled in her seat. Lawrence Kasha was to her right; Adolph Green was directly behind her. When Matthau announced her name as the winner, Bacall leapt to her feet like a jack-in-the-box and, without acknowledging the congratulations around her, bolted down the aisle toward the stage. At first she could make only deep, primal sounds of triumph that she'd later compare to the wail of a foghorn; words literally failed her at that moment. Finally composing herself, she gushed, "I just can't believe it. I've never held one of these things before. It's the first prize I've ever gotten." She dispensed with the usual thanking of producers and writers and costars and family except to say "I do feel that everyone connected to *Applause* owns a little piece of it"—although astonishingly, as she said it, she rolled her eyes a bit, hinting perhaps at some reluctance to share her victory with anyone.

Though graciousness was never one of Bacall's best qualities, we can perhaps indulge her somewhat here. Until this moment, in her work and

in her personal life, she had always been defined by a man: her husbands, her costars, her directors. Although she had help from her composers, writers, and choreographers on *Applause*, on some deep level Betty had done this entirely on her own. She had made the show a smash despite its anachronistic story line, and she hadn't needed a man to make it happen. She had done it all through the sheer force of her performance. At long last, Uncle Charlie's long-ago words made sense: "You can travel the wide distance of life under your own steam."

The sheer joy Betty felt in her triumph as she practically danced across the stage is touching to watch. "I remember her in bud and in blossom," John Huston said in a statement. "Now it is my joy to behold her in full glorious bloom." Hepburn sent her one of her stream-of-consciousness notes: "Deserved—warranted—all that pure simplicity— quartz and modesty and boyish courage." Later that year, Betty would win a Drama Desk Award for *Applause*, presented to her by New York mayor John Lindsay at Sardi's. The little girl who had once stationed herself outside that very same restaurant passing out theatrical tip sheets had done herself proud.

ON APRIL 11, 1970, JUST A WEEK BEFORE THE TONY AWARDS, BETTY HAD BECOME a grandmother. She was not yet forty-six. Stephen had married Dale Gemelli in October; their son, named James Stephen Humphrey Bogart and always called Jamie, weighed in at five pounds, ten ounces. "He's beautiful!" his mother exclaimed to an Associated Press stringer who'd found them in the rural northwest corner of Connecticut. "He looks just like his father." Jamie's father, in turn, had looked just like *his* father. Bogie's bloodline endured.

Steve was only twenty when he married and freshly twenty-one when his son was born. Betty could hardly object to the age, as she'd been twenty when she married Steve's father. But she objected to other things. It was not the life she had imagined for her son. After graduating from Milton Academy in 1967, Steve had entered the University of Pennsylvania, where he had begun experimenting with marijuana and psychedelics. Although she didn't know about the drugs, Betty was aware that her son was having a hard time. "Steve is a worry at the moment," she wrote to Hepburn, "doing almost everything to get kicked out of Penn." She feared that he'd flunk out "and end up in the Army." With flag-draped

coffins coming home from the war in Vietnam every week, her fears were not unreasonable.

But Bacall knew nothing about her son's life or why he was struggling so much at school. She simply never inquired. "I had been so preoccupied with my marriage, with travel, with being out of work, with Leslie and Sam, that I hadn't realized Steve was in trouble," she later admitted. It took Natalie, not long before she died, to track down her grandson after he hadn't come home from school or even called in many months. He agreed to meet her on a street corner in Philadelphia. Natalie made him promise to check in with her regularly. Afterward, she chastised her daughter. "How could you let any time go by, not knowing where he was living?" she demanded. "He has to know that you care what happens to him!"

That was the problem. For much of his life, Steve had felt that his mother did not care. She certainly didn't understand him or indulge him in even the slightest way. Much like his father, he could never win his mother's approval. Everything he did seemed wrong.

Steve transferred to Boston University, where he met his future wife. When Dale became pregnant and they decided to marry, Steve made the trek to New York to tell his mother he was leaving school. To support the baby, he would get a job in Dale's hometown of Torrington, Connecticut, a working-class factory town. Betty was furious, but this time, Steve responded with as much fury. She had never been a real mother, he charged. She'd always been away, never at home, more concerned about her work than she had been about him. Betty called him immature. "I was faced with a young man who had apparently never understood what I was about at all," she wrote in her memoir, "nor I him."

Steve wanted a world as different from his parents' as possible. He wanted to live with real people, not celebrities or press agents, people who worked and then went home and took care of their kids. Dale's father was a foreman at a grocery warehouse. Steve found a job at the Fitzgerald Manufacturing Company, which made metal gaskets for automobiles as well as electric ranges, toasters, and percolators. Fitzgerald employed eight hundred people at its main factory in Torrington. On the assembly line, Steve was his own man. No one paid much attention to who his parents were, even when his mother and his siblings showed up for the wedding at the local United Methodist church. In his mother's world,

Steve said, "It was always your father this, and your father that." In Tor-
rington, he could be himself.

A hundred miles and a world away, *Applause* closed on Broadway in
July 1971. But Betty was having so much fun with it that she went on
tour, taking the show across the United States and Canada. After that,
she took it to London, where, at Pinewood Studios, she also did it for
television, receiving an Emmy nomination for the effort. For more than
a year, she was away from New York. Sam was with her for much of her
time away, but Steve and Leslie were now living their own lives. Leslie,
whom her mother described as "generous of spirit and very independent,"
was now studying at the Art Institute in Boston. Betty had hoped that
she'd go to France for college, but Leslie had had enough of French in
high school. "I'm an American girl," she told her mother. "I want to go to
an American school." So she did.

It wasn't until late 1973 that Betty finally put away Margo Chan-
ning's shoes for good. Immediately she lapsed into the old panic over
what would come next. Nunnally Johnson teased her about her fears of
never working again. "This is the end!" he wrote in jest. "Not one soul has
asked for me! Which way to the Motion Picture Home?"

But to Betty, the fear was no laughing matter. She couldn't be idle.
She couldn't be alone. "I have been unable to adjust to what is laughingly
called real life," she told Hepburn. "I've forgotten how to behave, how
to make evening small talk." There were fewer and fewer close friends
around, and spending time with her children, sadly, had never been all
that fulfilling for her, not even with the addition of a new grandson. "I
would never fit the grandmother mold," she admitted. Occasionally, she
went out with men, such as the newscaster David Brinkley, whom she'd
begun seeing even before her divorce from Robards was final, and later,
according to one report, with his rival newscaster, Eric Sevareid. But
neither relationship was serious.

In late 1973, Betty accepted a part in the all-star film production of
Agatha Christie's *Murder on the Orient Express*, to be directed by Sidney
Lumet in England. "The part in itself is not staggering," Betty admitted
to Hepburn, "but important to the whole." She would be playing oppo-
site Albert Finney, Ingrid Bergman, Sean Connery, John Gielgud, and
Michael York, among others. "I'm terrified again, of course," she wrote.
"Haven't had my face in front of a camera since 1966. And with that

formidable group!" She needn't have worried about the competition. "With such a large cast and everyone so well-known," Michael York recalled, "no one really misbehaved. We enjoyed going to work every day." The only downside, he said, was that most of the film was shot on a closed set and few of the actors ever got to set foot on a real train. The only location shooting was in Paris for the opening scenes of the film, when everyone boards the Orient Express. York thought that Betty had been quite happy making the picture, laughing a great deal. As neighbors in Belgravia, they shared a cab to and from the set.

Betty was fifty years old when *Murder on the Orient Express* finally made it to theaters. The milestone seemed to prompt some reflection on her part. Her movie parts were fewer and farther between, and, despite the phenomenal success of *Applause,* no one had come along with another idea for a musical starring a middle-aged actress. Most of the top box-office shows reflected the "youthquake" of the 1960s and 1970s: *Grease, Company, Jesus Christ Superstar, Godspell, A Chorus Line, The Wiz.* The slowdown of professional activity caused her fears to rise once more, and she had to contend with the uncertainty of her life's meaning without work.

Yet it wasn't just fear and doubt she grappled with this time. Her focus had turned to thoughts of her legacy. She had lived quite a life and had quite a story to tell, but she resolved that it would have to be told her way. Nobody else had gotten it right. She resented those people who were merchandising off her life. Her present and future might be out of her hands, but she could at least take control of her past.

BETTY SAT IN HER LIBRARY OVERLOOKING CENTRAL PARK WITH A PAD OF yellow legal paper in front of her. Deep in thought for some time, she suddenly began furiously scribbling words on the paper. Mostly she wrote in sentence fragments connected by lots of dashes in the style of Hepburn. She was undertaking something she'd vowed never to do: she was writing her memoir. She'd been signed to a contract with Alfred A. Knopf by its editor in chief, Robert Gottlieb, arranged by her old friend (and sometime nemesis) Swifty Lazar.

Betty had reasons for breaking her vow. "I do not usually dwell on the past," she explained, "but every now and then these moments—and more than moments—that have had an impact on me pop up. They resonate

with me clearly and loudly. All of the events big and small—all the people close or not so close—have shaped me."

The other reason for writing was less grandiose. "If you want to make Lauren Bacall hopping mad, here's how," one reporter quipped after interviewing her. "You open a disco called Bogart's. Or write a quickie book called *Bogey's Bride*. Or bring out a line of T-shirts with the faces of Bogart and Bacall on them." Woody Allen's successful 1969 play, *Play It Again, Sam*, about a Bogart fan who receives ghostly visits from his idol, had recently been made into a successful film, with Jerry Lacy an uncanny doppelgänger, in both face and voice, of Betty's late husband. The Bogart image was now making money for other people.

"It never stops," Bacall wailed. "And it's outrageous! There ought to be some way people in public life can copyright their personas."

She was particularly peeved at Joe Hyams, who was coming out with a second treatise on the Bogarts, for which he didn't have the same collaboration with Bacall as he'd had the first time. "I'm very upset with Joe," she said. She accused him of making capital out of what she now called "his slim friendship" with Bogie. If someone was making bank off her story, she felt, it ought to be her. "I think it's terrible that our life has become public property," she complained. "But I'm told there's nothing that can be done about it." Except, that was, to write her own book.

Nathaniel Benchley had also written about Bogie. Though Benchley, with his family's long and close connection with Bogart, wasn't likely to upend the basic tenets of the legend, he'd failed to reach out to Betty for her approval, which annoyed her. He'd contacted others, however. "I got a letter from Nat Benchley about Bogey's biography," Nunnally Johnson had informed Betty. "If I can't remember anything about him, Nat and I will cook up something just as good." This seems to suggest that Benchley intended his book to be another hagiography, if he was, in fact, open to "cooking up" stories with Bogart's closest friends. Indeed, Johnson told Betty, "I don't think even you will have any cause to complain. We are all lucky that Bogey got such a superior biographer." Benchley dedicated the book "To Betty. Who else?"

Yet Betty was still dissatisfied. No one, she felt, could tell the story but her. Curled up on her couch with her legs tucked under her, she scrawled down her memories—the way *she* remembered events, not the way Hyams or Benchley or anyone else remembered them.

As a primer on how to build a legend, she had only to look as far as her

hero, Kate Hepburn, who'd spent the years after Spencer Tracy's death in 1968 transforming their twenty-seven-year friendship into a romantic, star-crossed love story. People in the know, such as George Cukor and Irene Selznick, understood that Hepburn was engaged in mythologizing. In truth, for the nearly thirty years of their relationship, Hepburn and Tracy had been more often apart than together, sometimes on different continents, and both had been involved with others during that time.

Hepburn's aversion to marriage and children could be obscured by the fact that Tracy never divorced his wife and so supposedly remained out of reach. And by implying that she had had romantic intimacy with Tracy, she could divert suspicion from her long and close association with other unmarried women.

Whether Betty knew about those fundamental truths about "Spence and Katie," as she called them, is unknown. What Betty did understand was that the Tracy-Hepburn legend could assist hers and Bogie's. The love story between Bogart and Bacall, of course, was different and more authentic than that of Tracy and Hepburn. But Betty realized that by aligning her life with Hepburn's and Bogie's with Tracy's, she might earn dividends similar to what Kate had received from the public over the past decade.

"I do love what you do and the way you think," Betty wrote to Hepburn at one point. Her letters to her idol are solicitous, congratulatory, inquiring, modest. She had been modeling Kate for some time now: the way she pronounced certain words, such as "hurricun" for hurricane, copying, as did Hepburn, the British articulation; the way she wrote, with all her dashes, phrases, one-word sentences, rarely ever a period. Hepburn's two memoirs would retain the phrases and dashes, sometimes confusingly so. So would Betty's.

Most surprisingly, Bacall became more conservative, again following Hepburn's lead: Kate had demurred a few years earlier when the National Organization for Women had asked for a public statement from her in support of abortion rights. During the national debate over the Equal Rights Amendment, Bacall told the journalist Sally Quinn, "Forget women's lib. I don't particularly believe in it. I don't believe in extremism." She added, "[Feminists] want to get rid of men," a comment Quinn called "incredulous." (A few years later, she appeared to have changed her mind, showing up at a fundraiser for the ERA with Marlo Thomas and Richard Dreyfuss.)

During this period, she also made another movie with John Wayne. Hepburn had made *Rooster Cogburn* with Wayne a few years earlier, waxing poetic about working with Hollywood's leading pro-war, pro-gun activist. "It was like leaning against a great tree," she said. "A man's body. Rare in these gay times." Betty responded similarly when she made *The Shootist* with Wayne in early 1976. "He is the epitome of what a man should be," she told a reporter. *The Shootist* was a critical hit. Wayne gives one of his all-time greatest performances, his real-life battle with cancer informing his character's fortitude, and Betty's had reviewers comparing her to Hepburn, which may have been her goal.

IN THE FALL OF 1976, WORK ON HER MEMOIR WAS PUT ON PAUSE WHEN BETTY accepted an invitation to the fifth annual Tehran Film Festival, where she would be the guest of honor. The official hostess would be the shah's wife, Empress Farah Pahlavi. Betty flew first to Paris, where she spent a few days, then on to Tehran. When she arrived in the Iranian capital, she and her fellow festival attendees were met not by the expected limousines but by "dilapidated buses reeking of carbon monoxide fumes," according to an American reporter covering the event. They were soon stuck in the dense Tehran traffic. Once they arrived at the Hilton hotel, things got even worse. The hotel was overbooked, and Betty had to cool her heels while a bed was found for her. Although she was accommodated, others, such as the director Arthur Hiller, had to sleep in the lobby.

But it appears that the problems went both ways. The behavior of some of the Americans was boorish. Otto Preminger, when denied seating in the Hilton lounge because not everyone in his party was wearing a jacket and tie, exploded at the maître d': "Shut up and seat us or I will take off all my clothes." Betty complained loudly to reporters about the food served at one reception—soda pop, sweet rolls, and pistachio nuts—despite other nights being served lobster, pheasant, champagne, and caviar, most notably at the gala reception with the empress. "La Bacall," as she was being called, made a scene in the lobby "spewing obscenities because the caviar she had purchased wasn't being refrigerated fast enough," recalled one writer.

To keep her sanity, Betty got away from the festival whenever she could with the journalist Roderick Mann, touring the ancient ruins at Persepolis and some of Iran's cultural hubs. She bought several carpets

to be sent back home to the Dakota. "Persepolis was fascinating and marvelous," she wrote to Katharine Hepburn, "Shiraz and Isfahan beautiful, Tehran the bottom." With Mann, she also visited the crown jewels, her jaw dropping at the sight of the famous Sea of Light diamond, more than triple the size of the Hope diamond, which she'd laid eyes on at the outset of her Hollywood career. She lifted her hand to show Mann a diamond ring on her finger, a gift from Frank Sinatra, and called it "a miserable peanut of a thing."

The fifth annual Tehran Film Festival would be the last. Within the year, student protests against the shah's government were heralding revolution. Little support was left for continuing to host ungrateful Western guests demanding caviar. Betty was relieved to fly out of Tehran and spend a few days in London, where her hotel rooms were always sumptuous and ready for her on arrival. From London, she flew to Barbados, where she was the houseguest of the media mogul Lord Sidney Bernstein for the New Year celebrations. "Barbados is perfect," Bacall wrote to Hepburn. "Sun strong but it's never too hot and Caribbean swimming is the best." Sunbathing on the beach, she was regularly spotted by tourists on passing boats who would "train their field glasses" on her. She got a pair of her own and stared right back.

If she got any writing done on her memoir once she returned to New York, it was interrupted again in the spring of 1977, when she accepted the lead in a twelve-week summer touring production of *Wonderful Town*, the Comden–Green–Leonard Bernstein musical that had won Rosalind Russell a Tony in 1953. The show opened at the Dallas Music Fair, then rolled through the Valley Forge Music Fair in Pennsylvania, the Westbury Music Fair on Long Island, and the famed Muny amphitheater in St. Louis before closing in Miami in August. "Her dancing isn't going to steal anything away from *A Chorus Line*," a Miami reviewer wrote about Bacall's performance, "and her singing isn't going to win her the lead in the next Stephen Sondheim musical, but her charm and magnetism, her elegance and indomitability" ensured "excitement and mystique." At every stop, that was the general critical consensus.

Betty found the tour difficult, both physically and emotionally. It had been just a few months since her trip to Iran, and she'd had barely any time to see family and friends since she'd gotten back. "The road can be very lonely," she wrote. "Strange cities, hotels, impersonal rooms." She could get through the nights, as she had a show to do and afterward the

cast and crew would go for dinner or drinks. But the days were hard. She spent the time trying to read or reach people on the phone. She wished that Sam was with her. After traveling around with his mother in his youth, Sam, now fifteen, was increasingly off on his own; he went to camp that summer, which kept him away. Betty missed the boy terribly. "He filled so many empty spaces in my life and was the best company in the world," she lamented.

For the first time, Betty's private letters and public comments reflected a growing loneliness and desire for belonging. When the *Wonderful Town* tour was over, she returned to an empty apartment in New York. "I feel so estranged from everyone when I come home," she wrote. "It's hard for me to call and say, 'I'm back'—it always sounds to me as though I'm waiting for an invitation, and in a way, I suppose I am."

Perhaps to create a sense of belonging somewhere, she had purchased a house in Amagansett, Long Island, a charming two-floor Cape Cod with gabled windows not far from the beach. "I was excited about the prospect of living in a house again," she wrote, remembering the now halcyon days on Mapleton Drive, when she had had a yard and trees and a driveway. "What a marvelous feeling that was! Sam would love it. Steve and Leslie would have a place to come to in the country when they could—they all hated city life. A perfect family picture flashed before my eyes." Betty had friends living nearby, too: the writer Peter Stone and his wife, Mary; Alistair Cooke; Adolph Green and his wife, Phyllis Newman. Maybe it would be like living on Mapleton Drive again.

But it wasn't. Betty owned the house for more than a decade, but her restlessness, her traveling for work, her inability to stay at home, her terror of being alone—which only increased in the country—meant that happy gatherings of friends and family were infrequent. She often spent holidays away from New York, as she'd done in Barbados, with acquaintances rather than close friends, her children, or her grandson. Jamie Bogart grasped early on the divide between his family's life and the world of the woman he called "grandmama" (the accent on the last syllable). "Her expectations for what us regular folks could achieve weren't always realistic to us," he said. "She lived a unique life that not many people get to live."

By the end of 1977, Bacall turned her full attention to writing about that unique life. She was having a difficult time concentrating. "It is hard to go through one's life and try to revive it all, and it's not terribly

pleasant, a lot of it," she told an interviewer. She was not a writer, but what she needed wasn't a collaborator ("and in any case would never have put up with one," said Robert Gottlieb, her editor). Rather, she needed structure and discipline. "After a month or two she told me she just couldn't write at home," Gottlieb recalled, "too many distractions. So I gave her an office at Knopf, and every day she was in town—*every* day— she turned up and got down to work, writing in longhand on long yellow pads, wandering around the office in her stockinged feet, getting coffee for herself, and chatting with the gang. . . . And at the end of every day, little elves out at the front desk would type up what she'd written for me to look over."

She wasn't the formidable diva Gottlieb had expected. She was a middle-aged lady who often brought boxes of doughnuts for those little elves. "Although she was notorious in the theater and in Hollywood for being difficult," Gottlieb wrote, "with us she was relaxed and generous." He came to realize that despite her fame, glamour, and Tony Award, Bacall was deeply insecure about her talent. She was "a star, yes," he wrote, "but not taken seriously the way Bogart was, or for that matter, her second husband, Jason Robards—so that she still needed the kind of validating support she had from her studio in her salad days."

Despite all her success, Betty had lost the defiant belief in herself that had defined her youth, the chutzpah that had taken her to the top by the time she was nineteen. Now, deep down, she often felt like a fraud, not as good as her husbands, not as good as Hepburn, not as good as the younger actresses nipping at her heels. The Tony felt like a fluke. Today, psychologists call the complex "imposter syndrome." And the only balm for it, at least at the moment, was to write.

Gottlieb took Betty's cat scratches and fashioned them together into a compelling, cohesive whole. "Although it needed a good deal of stan-dard editing, it never needed rethinking or restructuring," the editor said. "The crucial thing was there on the page: Betty Bacall." She took the most beloved aspects of her and Bogie's story and built around them, highlighting the challenges and the triumphs while also obscuring and sometimes obliterating anything that contradicted them. So readers got the excitement and romance of *To Have and Have Not*; the taming of Bogie's wild ways, at least to some degree, by his Baby; the outings on *Santana*; and the wisecracking antics and irreverent camaraderie of the Rat Pack.

About her extramarital pursuits, Betty was more forthcoming than many expected. "It's a catharsis, I suppose," she said about memoir writing. "I find out things about myself I didn't realize before." Her goal was "to face the truth." Although she handled Sinatra and Stevenson delicately so as not to damage the central love story of Bogie and Baby, she was surprisingly candid about her feelings for them, admitting that her fixation on Stevenson had bothered Bogie. With Sinatra, she was careful, for the most part, to confine their relationship to after Bogie's death, but she disclosed details about what had happened afterward with unusual forthrightness. Most Hollywood memoirs in 1978 did not name names or provide such details.

By Myself established a framework for the Bogie-and-Bacall mythos. Bacall's version of it was taken up quickly by the Bogart cultists, entertainment writers, budding biographers, and filmmakers. A year after *By Myself* was published, the film *The Man with Bogart's Face*, with Robert Sacchi playing a private investigator named Sam Marlow (get it?) who has plastic surgery to look like Bogart, proved to be a successful homage to the magic of *The Maltese Falcon*. The filmmakers even lured the seventy-nine-year-old George Raft out of retirement to play a small part, ironic given his contentious relationship with Bogie.

Even songwriters got into the act. Within the next few years, Bertie Higgins's "Key Largo" would reach number 8 on the *Billboard* Hot 100 chart and be certified gold by the Recording Industry Association of America. The catchy song was propelled by such lyrics as "Just like Bogie and Bacall / Starring in our old late, late show." The song also evokes *Casablanca* with the lines "Here's looking at you, kid" and "Play it again." The Bogie-and-Bacall legend was now firmly in place.

Betty codified the cynical, decent, honorable, irascible, and pugnacious Bogart, without the self-doubt, insecurity, self-sabotage, and mean streak that had been just as much parts of him. Indeed, if Bacall modeled herself on Hepburn, then Bogie had to be Tracy, pure in talent and integrity. As Hepburn would do with Spence, Betty pushed back against the idea that Bogie was an alcoholic (although she pulled no punches in describing Robards as such). Rather, just like Tracy, Bogart had been an artist and a red-blooded American male for whom drinking was a defense against the mercenary, emasculating world of Hollywood.

Soon after its release in December 1978, *By Myself* soared to the top of the best-seller lists, selling more than 300,000 copies, and that just in

hardcover. "Betty was thrilled, but not surprised," Gottlieb remembered. "I was thrilled by the extent of the success, too, but somewhat surprised." What he hadn't counted on was the large Jewish readership, which didn't normally buy the memoirs of movie stars. Among the many previously off-limits topics Betty discussed in *By Myself* was her Jewish heritage; it was one of the first times, in fact, that she had publicly acknowledged being Jewish. She revealed her grandparents' struggles, the anti-Semitism in the modeling and filmmaking industries, and her pervasive fear of being discovered and rejected during her first years in Hollywood. Gottlieb realized that Betty's success had meant a great deal "to tens of thousands of the Jewish women of her day." From that point on, Betty was invited to speak to various Jewish organizations, where she always received a tumultuous welcome.

In November 1980, *By Myself* won the American Book Award for Autobiography—Hardcover. The honor, which had been previously called the National Book Award and would later resume that name, was handed out at the Seventh Regiment Armory in New York. Some critics complained that the new management of the awards was attempting to commercialize the ceremony along the lines of the Oscars, and the win by a movie actress seemed suspiciously in tune with that goal. The mean-spiritedness of the chatter may have triggered some of Betty's insecurities, but she didn't let them show as she accepted the award, posing with such other winners as William Styron, Tom Wolfe, John Irving, William F. Buckley, Jr., A. Scott Berg, and Philip Levine.

Betty had triumphed again. She'd put her mind to becoming a movie star, and she'd won worldwide acclaim. She'd decided to become a stage actress and found herself in a long-running hit. She'd upped her game to become a musical comedy actress and won a Tony for her efforts. Now she'd conquered the literary world, not just in terms of profits but in terms of prestige. Would it finally make her happy, content, satisfied? Would it finally dispel the malaise she'd felt since Bogie's death?

If her previous successes were any guide, most likely not. She would grow only more embittered and aggrieved during the last three decades of her life. Betty's anger and resentment went back very far. That becomes clear reading the pages of *By Myself*. She pulled no punches in telling the story of her father. She gave us William Perske as she saw him, abusive, irresponsible, exploitative. Though Perske was certainly no saint, there

was another side of the story, and after some forty years, upset over Betty's public vilification, he decided to tell it.

That was the period in which he spoke to reporters, defending himself and producing the canceled checks he'd sent for years for Betty's support. That was when he implored his daughter to consider the possibility that the estrangement between them had not happened exactly as she had been told it had. There is no evidence that Perske ever tried to cash in on his daughter's success beyond asking for some tickets to see her perform onstage. But Betty was not willing to see both sides. She never responded to his public appeal to meet with him.

Her grudge is not difficult to understand. But if they had met, perhaps Betty would have found some closure. Perhaps some of the heartache could have been alleviated, some of the anger released. Father and daughter looked so much alike; for Betty, looking into his eyes would have been like looking into her own. She might not have forgiven him, but perhaps she could have allowed some healing to take place, enough to temper the bitterness she lived with. But her anger against him had become a form of self-protection; to give that up would have left her vulnerable, and that was one thing she was unwilling to be. William Perske died three years later, on November 15, 1982, at the age of ninety-three.

30

Rex Reed, the handsome, sardonic, influential film critic for the New York *Daily News* and a neighbor of Lauren Bacall in the Dakota, answered his phone a little before 11:00 p.m. It was a friend who lived downstairs. She'd just heard what she described as a loud explosion, and she was worried that something had gone wrong with the furnace. Would Reed mind going down into the basement to check? He told her he would.

On another floor, Bacall heard the sound as well. "I was in my bedroom with my dog, of course," she told the broadcaster Larry King some years later. ". . . And I heard this—it was a shot, but it sounded like a backfire . . . but something kind of different about it. So I went to my kitchen and opened the window and looked in the courtyard. And I saw other people doing the same thing. Looking. Couldn't see anything. So I thought, well, . . . it must have been a backfire."

But Reed, now on the ground floor, had discovered the truth. Through the front gate he could see crowds of people rushing down 72nd Street toward the Dakota. News crews were arriving, Police were swarming. Stepping outside, he saw the bleeding body of a man on the sidewalk. To his horror, he realized that it was another neighbor: John Lennon. He had been shot. Lennon's wife, Yoko Ono, having witnessed the attack, was wailing at his side. The severely wounded man was close to death. Reed hurried forward to assist a police officer in getting Lennon into the back of a police car, as no ambulance had yet arrived. Lennon died on the way to Roosevelt Hospital, where he was pronounced dead at 11:15 p.m.

The Dakota immediately became an armed camp. "The gates were locked," Reed recalled. "No one could get in or out of the building. You had to get a special pass. For days, you couldn't even get your mail delivered to your door. You had to go down to the concierge's desk to get it yourself. Every person in the building was doing what they could to assist, taking over the duties at the desk, answering phones, letting people in or out." All but one. "The only one who disregarded all that, who was

openly hostile to any suggestion that she pitch in, was Lauren Bacall," said Reed. "She demanded that mail still be delivered to her door. She demanded she be able to come and go without barriers."

To do so, Bacall kept a limousine in the alley between the Dakota and the building next door, which had become the only access point for residents to enter, given that 72nd Street and Central Park West were closed off. "Nobody could get in or out because of her limousine, which took up the whole alley," said Reed. "That caused some hard feelings. Her behavior ticked off everyone in the building. She was very unpopular."

Bacall argued that she needed easy access to the limousine because it took her downtown every day for rehearsals of a new musical she was rehearsing, *Woman of the Year*. "She was very unnerved by Lennon's murder," said a manager who worked with her during that period. "So many celebrities were. No one wanted to be seen on the street. And for Betty, there was the added fear that she would soon be on stage, exposed, six days of the week."

That might explain, though hardly excuse, what happened next. On the morning after the murder, Reed got a call from his friend the film critic Pat Collins to meet him outside the Dakota to do an interview on *Good Morning America*. He reluctantly agreed, throwing a tan winter coat over his pajamas. To Collins, he described how safe the building was and how the killer had exploited an opportunity when Lennon and Ono were entering. "I don't know if I'm supposed to name names or not," he said, "but I think the whole country knows that Lauren Bacall, Rudolph Nureyev, Leonard Bernstein, Roberta Flack, and many other famous people live here. So we're all security conscious living in a city where you're so easily accessible."

When Reed got back upstairs, his phone was ringing off the hook. It went to his answering machine. "Call me back," came a voice. "It's Betty." Reed picked up the phone. "Betty who?" he asked. ("I knew lots of Bettys," he explained forty years later.) "Bacall!" rasped the voice at the other end of the line. "You named me! How dare you? Nobody knows where I live, and I am much more famous than you. You had no right!"

Reed tried to point out that her residence at the Dakota was no secret, that where she lived was known by lots of people, many of whom gathered outside every day hoping for autographs. Just months earlier, Betty had permitted the *Daily News* to photograph inside her apartment, and not long before that, the *News* had written, "A list of Dakota

residents reads like a who's who of show business," naming Bacall first on the list. Reed attempted to tell her all that, but she wasn't listening. "Frank was right," she shouted at him. "You're all just sons of bitches," meaning the press. Then she slammed the phone down.

Bacall confirmed Reed's account in an interview several weeks later. "Because my profession is acting, why does that mean the world must know everything about me?" she complained. "And the John Lennon thing! I live in the Dakota, I was there when Lennon was shot, and I can't believe what they did on television, a sideshow, a disgrace! Sure, I know what Rex Reed did, all that ghoulish stuff just because he lives in the Dakota. Lenny [Bernstein] was ready to kill him. You bet your ass I called Rex Reed! I screamed at him what Frank once said"—though, at that point, she, or the news editor, changed the "sons of bitches" to simply "no damn good." Missing from Bacall's diatribe was any sadness about or tribute to the man who had been killed.

"I was so shocked that she would take this very tragic incident and make it all about her," Reed said. But Bacall's truculence was nothing new. She was known for bossing around those who worked at the Dakota. She had, rather infamously, placed a sign on her door reading NO TIPS so deliverymen wouldn't expect any. Once, while Betty had been in London, Reed had told a doorman that he was heading there himself. "Will you see Miss Bacall?" the doorman had asked. "You never know," Reed had replied. "Well, if you do," the doorman had told him, "give her our worst."

Many people were struck by the sense of entitlement Bacall displayed during that phase of her life. "When she was in the mood, Betty could seduce a stone," wrote Jamie Bernstein, the daughter of Leonard, "but she was also notoriously imperious and cruel. Waiters shrank from her; maids quit; doormen held their breath as she strode past them with her coddled King Charles spaniel, Blenheim." Betty's former manager said, "She thought she deserved more than she got. She thought she'd been cheated out of the opportunities Bogart had, or Kate." More than ever, status mattered to Betty. She was entitled to more consideration than Reed, she'd said, because she was "much more famous than" he was. Her fame was so great, in fact, that she believed she shouldn't be expected to play by the rules that her mortal neighbors followed. Rudolph Nureyev and Roberta Flack could pick up their own mail. Not Lauren Bacall.

There is no avoiding this unpleasant chapter in Betty's story. She was angry, resentful, and rarely nice when she didn't have to be. Of course,

it's not as if she had become that way overnight. Her sense of entitlement can be discerned all the way back in her letters to her mother demanding clothes and shoes during her first weeks in Hollywood, before she was even a star. Earl Wilson had noted her lack of generosity to homeless people on the street in 1961, revealing that she would shout, "I'm broke!" even before she was asked for a handout. With the great unwashed public, she had minimal patience. When, in 1970, she was approached in a restaurant by a shy man whose father had known Bogie's family, she responded to his nervous, halting introduction of himself with an icy lack of expression. "She did not say a word," said the *Life* reporter with her. "She did not sigh or frown." Instead, she smiled tightly, her eyes stubbornly averted, until the man's friends tugged him away.

Steven Boggs, director of global guest relations at the Beverly Hills Hotel, recalled an incident involving Bacall one day as she sat with Kirk Douglas, Roddy McDowall, and Gregory Peck beside the pool. Betty wasn't happy with the lemonade being served and bawled out the waiter for bringing her such a substandard beverage. Boggs came out to see what the trouble was, but Betty was in no mood to be appeased. The hotel's standards were falling, she declared, and what was he going to do about it? "Meanwhile," Boggs recalled, "Roddy was apologizing to me in a whisper for her behavior, and Kirk was drinking the lemonade and exclaiming how much he liked it." Without her friends to back her up, Betty finally and reluctantly quieted down.

She simply could not tolerate most people. "Why do you ask me about Marilyn?" she snapped at an oral historian from Columbia University, as the unedited transcript reveals. "Why is that question in there?" Then she argued about the tape recorder and questioned the interviewer's competence: "I don't know what you're doing. What a sheltered life you must lead." When she was irritable, she seemed unable to refrain from insults like that. Previewing *Goodbye Charlie* in Detroit, she'd listened as the columnist Shirley Eder reported that she was now on the radio five times a day. Completely unfiltered, Betty replied, "I can't think of anything more loathsome."

Her tetchy behavior intensified during periods of professional dissatisfaction. When Hepburn was fifty-five, the same age Betty was now, she had made *Long Day's Journey into Night*. Helen Hayes at fifty-five had played in *The Glass Menagerie* on Broadway. Shelley Winters had been nominated for an Academy Award when she was in her midfifties for *The*

Poseidon Adventure after having already won two of them. "She just didn't understand why not her," said her manager. Why, Bacall demanded, was she not given the same chances?

Part of the answer, of course, was that the three actresses had more impressive résumés. Bacall was self-conscious about her lack of a literary pedigree. "She was never going to do Shakespeare," her manager said. "She hadn't even yet done Tennessee Williams. What she really wanted was the respect of the theater. She had given up on Hollywood, but she still hoped to be considered a stage actress with range. It's what she'd wanted in her youth."

Despite the terrific publicity following the publication of her memoir, Betty's output since had been minimal. She was in Robert Altman's *HealtH*, an all-star ensemble that was supposed to be a follow-up to the director's successful *Nashville* but wasn't. Bacall played an eccentric spinster with narcolepsy running for president of a health care association against an Adlai Stevenson–quoting Glenda Jackson. The script wasn't very funny or even very logical, but the shoot was a happy one. Paul Dooley, who acted in the film and was also one of the writers, remembered that there was some trepidation when Bacall arrived. "She had a very bad reputation around New York as a diva," he recalled. "The rumors were she'd run through fifteen to twenty hairdressers and make-up women already in the dressing room." But she quickly responded to Altman's egalitarian treatment of the company, which Dooley likened to "one big happy family." The lack of competition among the actors "mellowed Bacall," he believed. "She behaved herself. She was fun, in fact."

HealtH bombed with the critics and at the box office, but Betty at least gained a new beau from it, James Garner. The relationship never appeared to be serious, but a long-term friendship was established. Garner persuaded her to appear as his romantic interest in a two-part episode of his highly rated television series *The Rockford Files*, which aired on October 12 and October 19, 1979.

But it was Betty's part in the film *The Fan*, shot in the spring of 1980, that would have been most on her mind when, six months later, John Lennon was shot outside their apartment building. A psychological thriller, *The Fan* is the story of an obsessed admirer who stalks and tries to kill his celebrity crush. When the producer, Robert Stigwood (*Saturday Night Fever, Grease*), green-lit the movie, he had no idea how relevant the

film would be upon its release, especially to the actress who was playing the intended victim.

The Fan tells the story of Sally Ross, an icon of both stage and screen. Betty is essentially playing herself. Photos from *To Have and Have Not* and other Bacall films are used as glimpses of Sally's past. She looks great in the film, wearing her signature shoulder-length hair and showing off her trim figure. Sally is supposed to be forty-nine but passes for forty-two, which Betty also manages to do at fifty-six. In the film, she's rehearsing a musical that's a thinly disguised version of *Applause*, meaning that she had to learn a couple of songs as well as the steps that went with them. Audiences clearly understood that she was playing Lauren Bacall.

John Lennon was still very much alive when the film was shot on the streets and subways of New York, but the script uncannily predicted some of his killer's behavior. The twenty-five-year-old actor Michael Biehn, in his first major role, plays the psychotic title character, who has worshipped Sally Ross his whole life, believing that they are in an intimate relationship. Stalking Sally from a distance, he sits outside her apartment building and follows her to rehearsals for the musical. When his letters to Sally are repeatedly intercepted by her secretary, the fan goes on a murder spree, eventually turning his rage against Sally herself.

The director, Edward Bianchi, set up an effectively suspenseful premise. The film certainly had potential. The script Betty read was a character study of a woman of a certain age, unlucky in love, who finally finds her power by standing up to her crazed fan. The fundamental story line is still there in the film, but in the final cut, *The Fan* seems more influenced by the recent success of the slasher film genre: *Halloween*, *Friday the 13th*, *Prom Night*. The film becomes a catalog of bloody murders, each one maximized for gruesomeness. The beating Sally endures at the end of the film is difficult to watch, not so much for the physical violence, which is only glimpsed, but for the injury being done to the dignity of both Sally and the actress playing her.

"*The Fan* is much more graphic and violent than when I read the script," Betty said upon its release. "The movie I wanted to make had more to do with what happens to the life of the woman—and less blood and gore." Cast alongside Betty was James Garner, who called *The Fan* one of the worst pictures he ever made; its "only saving grace was working with Betty Bacall." The film was a box-office and critical disaster when it was released in May 1981, just six months after Lennon's murder.

The making of the film lingered in Betty's consciousness. Shortly before the *The Fan* opened, the newly elected president, Ronald Reagan, was shot by another deranged man. Betty's fear of being in the public eye is therefore understandable, especially as she rehearsed for a real-life musical that would put her front and center six nights a week. Accordingly, she was not in very good spirits as she began the process of learning her lines and dance steps for *Woman of the Year*. She was angry, frightened, and highly strung. Her cast and crew would need to watch out.

"YOU ARE STILL THE ONE AND ONLY TESS," BACALL WROTE TO KATHARINE Hepburn before starting her new musical, which, like *Applause*, was based on a classic American film. *Woman of the Year* (1942) had starred Katharine Hepburn in her first pairing with Spencer Tracy. Betty had long wanted to be Hepburn. She was getting that much closer to her goal.

The show's threadbare plot concerned Tess Harding, a haughty, high-powered newscaster (modeled less on Hepburn than on Barbara Walters) who falls for a cartoonist who brings her down from her high horse. As Sam, Tess's love interest, Harry Guardino did his best Tracy impression, crusty, irreverent, and stubbornly chauvinistic. During the run of the play, Guardino succeeded Garner as Betty's escort, although, once again, the relationship never became serious.

Woman of the Year had a score by John Kander and Fred Ebb, and it was directed by Robert Moore, who, as an actor, had worked with Betty in *Cactus Flower*. "As I always do," said Bacall, "I started to train like a prizefighter." Still as tenacious as ever, she worked out at a gym to get into shape for the dancing and trained with a vocal coach to strengthen her voice. "You have to be in physical shape to be in a musical," she wrote. "No one who hasn't had the experience can possibly know the amount of energy and stamina required."

After a five-week tryout in Boston, the show opened at the Palace Theatre on March 29, 1981. Increased security was visible both inside and outside the theater. The day after the premiere, reviewers unanimously gave thumbs down to the book for its creaky gender politics, essentially the same criticism they'd had for *Applause*. Once again, a woman aspires too high and isn't submissive enough to a man, which barely flew in 1942 but here was a dead weight dragging down critical assessment of the musical. Allan Wallach of *Newsday* identified lots of

groan-worthy moments in the show, but "we may groan even louder," he wrote, "at Sam's angry exit line that the 'Woman of the Year' isn't much of a woman." According to Wallach, the attempt by the book writer, Peter Stone, Betty's neighbor on Long Island, to update the story to the 1980s amounted merely to name-dropping current public figures as a way to get some easy laughs: Henry Kissinger, Indira Gandhi, Björn Borg, Jean-Paul Sartre, G. Gordon Liddy, Marie Osmond.

Yet both Wallach and Frank Rich at the *New York Times* had nothing but raves for the elegant, glamorous leading lady at the center of the nonsense, who had the "incandescence . . . to light up Times Square." Bacall, Rich declared, was "a natural musical comedy star" and "embodies the very spirit of the carefree American musical."

But one critic had a decidedly different take on the star and the show. "The question is as irritating as an ingrown toenail, but here it is again," Rex Reed wrote. "Can you take a bankrupt idea, fashion it into a ragged vehicle for a big-name star, weld together the pieces like broken pipes until they more or less fit that star's capabilities, and expect the public to pay for the mess you make?" Perhaps still stung by Bacall's abusive early-morning phone call, Reed had waited a couple of weeks before publishing his review. According to him, word of mouth on the show was "already dreadful, and for good reasons." He pulled no punches: "*Woman of the Year* is a disaster. Now the question remains: How long can Lauren Bacall sell tickets with nothing going for her but charisma?" He predicted that her star power would keep audiences coming "until the shine wears off and the tarnish shows."

Reed was in league with his fellow critics, who likewise considered the book, the direction, and the choreography to be substandard. Where he parted with them was in his judgment of the performance of the lead actress. To Reed, Lauren Bacall was the antithesis, not the epitome, of the American musical. "Bacall constantly makes it look like she's knocking herself out," he wrote, "even when all she's doing is being lifted uncomfortably by a group of chorus boys." And just as Bonnie Franklin had stolen *Applause* from her, Reed argued, so did Marilyn Cooper, "a moon-faced miracle" playing Tess's first husband's ex-wife, who "stops the show cold and steals it right out from under the star again."

Reed was correct that audiences would keep coming through the summer, lured by the chance to see a glamorous movie star in person. Bacall's win of a second Tony on June 7 kept the momentum going. (Mel

Gussow in the *New York Times* wrote that the show's four wins had been awarded "by default in a weak season," except for Marilyn Cooper's featured award.) But eventually, as Reed predicted, the crowds began to thin out and the show played to increasing numbers of empty seats. To forestall burnout, Betty had made sure that her contract guaranteed her two weeks of vacation, which she scheduled for the first two weeks of December. She assumed that an understudy would fill in for her. She was wrong.

Lawrence Kasha, once again producing, decided to go with Raquel Welch, who was best known as a 1970s sex symbol but who'd recently made a name for herself in Las Vegas as a singer and dancer. The announcement of Welch's casting was made in late October, giving Betty plenty of time before she left to hear how well her replacement was performing in rehearsals. "I must have more guts than brains to come in and follow Bacall," Welch told the Associated Press. "She won a Tony Award, she's a distinctive personality and a tough act to follow." She paused. "But I'll give it my best shot."

Word got out that Betty wasn't pleased by the casting of a woman sixteen years younger than herself, and, "very oddly," according to one report, "no provision was made for press coverage" of Welch's debut, which went unheralded. James Brady in the *New York Post* wrote that Kasha was "putting the lid on Raquel Welch" so as not to offend Bacall. Kasha denied it and demanded that Brady recant his story, but the journalist refused. Many other sources reported on Bacall's hostility toward Welch, including her refusal to pose with her for publicity photos. *Life* revealed that she had wanted "an older woman," possibly Dina Merrill, to fill in for her.

All of that might be written off as so much theatrical backstage gossip, but sadly it fits a pattern we've seen from Bacall before. Two Tonys hadn't palliated her insecurity. She appeared incapable of taking the high road in such a situation, rising above her doubts and fears to be gracious. To be sure, her deep-seated insecurities were triggered further when the raves for Welch started rolling in once the press got in to see her, a week into her two-week run. Critics didn't usually flock to see temporary replacements in a show, but as word got around that the new cast (which included Jamie Ross, filling in for Guardino) was reinvigorating the show, they hustled over to the Palace. Welch's performance "has generated more old-fashioned showbiz excitement than the Great White Way has seen all season long," one critic declared.

Mel Gussow wrote, "[Welch] is a show-stopper." In the number "One of the Boys," Bacall had been lifted and carried around the stage by the male chorus "as if she were a fragile sculpture," but Welch, in contrast, "kicks her leg—nice leg—as high as her ear. The lady can move and she can dance." He thought she could sing, too, despite the overmiking in the theater. Betty's voice, of course, needed overmiking. Perhaps the technicians had failed to adjust it after she went on vacation. "If an attempt was made to squelch Welch," a reviewer for the Gannett News Service reported, "it has certainly backfired. Her brief stay at the Palace Theatre has generated enormous and well-deserved attention in the media."

Critics thought that every aspect of the musical was improved during Welch's run. "The show itself begins to glow in her presence, looking less like a tailor-made vehicle and more like a work of reasonably respectable Broadway craftsmanship," judged the Gannett reviewer. "Peter Stone's book seems brisker somehow . . . and the score by Kander and Ebb sounds perkier." Box-office receipts surged during Welch's two weeks. Lawrence Kasha told a reporter that when Bacall left the show at the end of her contract, they might hire Welch as her permanent replacement. "If she's interested, we're interested," the producer said.

Betty stayed with the show until June, and Welch was indeed hired to replace her. A critic from the *Hartford Courant* saw the new show and wrote that Welch "has not only revitalized *Woman of the Year*; she has made it sing and dance as it never did when Lauren Bacall was headlining the show." One of Betty's managers at the time recalled that painful period for the star. "That whole experience with *Woman of the Year* really depressed her," he said. "She got the Tony, but Raquel Welch stole the spotlight away. She was angry at the producers, angry at the press, and angry against her team."

Scott Henderson, one of her agents, recalled, "When we worked on a project or discussed a script, she was a pro. But as she got older, when she wasn't working all the time and she thought all these people were against her, she was quite hard to work with."

Betty might be forgiven for feeling paranoid. The rapturous welcomes she had once gotten from the public and the press had dimmed. Taking *Women of the Year* on the road, she was disappointed by the lackluster ticket sales in many places. In Los Angeles, she was blasted by the *Herald Examiner* critic Jack Viertel for "a lack of grace and humility" during her opening-night curtain call at the Ahmanson Theatre. Apparently, she

had come across a bit too grand or less than generous to the rest of the cast for Viertel's liking. The director, Joe Layton, who'd restaged and rechoreographed the show, sent an irate letter to Viertel saying that Betty had just been following his direction. But as with Brady, there was no retraction.

"By this point," said Rex Reed, "people knew that she was difficult and totally self-absorbed. Her reputation now preceded her." Betty still had her die-hard fans, especially the ones who stayed up late to watch Bogart and Bacall movies on television, but many newspaper and television reporters, privy to her temper and cutting remarks, had begun to harden against her. On one level, it was clearly gender bias; men got away with being caustic and hot-tempered all the time. Otto Preminger and Stanley Kubrick were both known for their short fuses and roughshod treatment of their colleagues, but they never wanted for work. Still, the response to Bacall wasn't entirely sexist. "She was very, very hard on people, especially those who were doing things for her, dressers and the like," recalled Rosemary Harris, who considered Bacall a colleague and a friend. "And people could see that. She was rather known for it." Stories abound of Bacall berating assistants and camera people in full view of everyone. For many reporters, it became a class issue. No one likes to see the little guy bossed around.

So it's probably no surprise that much of the media leapt on the publication of a book called *Bogie and Me: A Love Story* in the summer of 1982, just as Betty was starting her tour of *Woman of the Year*. The book was by Verita Thompson. Pete had become a prominent restaurateur in Los Angeles, opening La Cantina, a Mexican eatery, and then the New England Village complex on Santa Monica Boulevard near Century City. Her husband, Walter, had died in 1975, leaving her well off from his years with Cinerama, so money was not the motivator for her to write the book. She moved with a high-profile crowd that included the Harold Robbinses, with whom she regularly spent holidays in Europe; the Russian émigré Prince Nicholas Toumanoff; and fellow restaurateur Tony Roma. Her friends had been encouraging her to write a memoir for some time. "She'd loved Bogie," said her companion Dean Shapiro. "If she didn't tell their story, their love would be forgotten."

Dozens of newspapers across the country reviewed *Bogie and Me*. The *Los Angeles Times* featured the book prominently. Reviewers were unanimous in their criticism of the amateur writing and the dubious

re-creation of exact dialogue from forty years earlier. But few thought that Verita was making things up. "In terms of the Bogart myth," the *Times* wrote, "you can only say it's a good thing Ingrid Bergman went off with Paul Henreid in that movie. . . . Feelings will be hurt by *Bogie and Me*. [But] can it be news that men carry on with their secretaries? If a typist or a toupee fixer chronicled a chaste relationship with a celebrated boss, now that would be news."

When, in the late 1980s, A. M. Sperber began work on her biography of Bogart, she clearly felt obliged to acknowledge that Thompson existed and to at least remain open to the possibility that what she had revealed was true. By 1994, Jack Martin in *Beverly Hills Magazine* could write that *Santana*, then up for sale by its new owners, had been "the great love of Humphrey Bogart's life (next to Lauren Bacall and Verita Thompson, of course)."

Bacall made no public comment on *Bogie and Me*. But that didn't mean the book hadn't affected her or that she wasn't already thinking how she might regain control of the legend of Bogie and his Baby.

FOR THE NEXT DECADE, BETTY WAS RARELY OUT OF WORK. AFTER THE TOUR of *Woman of the Year* ended, she accepted an offer to play the faded screen star Alexandra del Lago in a West End production of Tennessee Williams's *Sweet Bird of Youth*. Her return to London was triumphant, with her name in lights at the 265-year-old Haymarket Theatre, where John Gielgud, Ralph Richardson, Peggy Ashcroft, and other greats had once trod the boards. Harold Pinter directed. It was Betty's first time in a literary play. After a successful tryout in Manchester, the play opened in the West End on July 8, 1985. Michael Billington in the *Guardian* praised Bacall's "self-aware monster." John Barber in the *Daily Telegraph* wrote that she seized the part "like a hungry dog with a bone (a ham bone)" and though she might not be "the greatest actress in the world," there was "no denying her loping, lynx-eyed, imperious charisma." No two reviews together ever described Betty onstage better.

To Hepburn, Bacall wrote, "The play is going very well—audience excellent—loved working with Pinter—and saying Tennessee's words is a joy." In early 1986, she took the show to Australia, where Hepburn had toured so happily in the 1950s. *Sweet Bird of Youth* opened in Melbourne, then moved on to Brisbane and Adelaide. While in Australia, Betty saw

Kate's friends, the dancer and choreographer Robert Helpmann and the journalist Pat Jarrett. Once more she was walking in the steps of her idol.

Although she never quite gets around to saying so in her second memoir, it seems clear that Betty saw the parallels between herself and Alexandra del Lago—"The fear not to be left alone to think and to face her faded or finishing career, her age, her empty, lonely life," as she wrote in her memoir. Though her life could not be called empty, as she still had friends and rewarding work opportunities, she was certainly becoming lonelier as the years passed, especially when on the road. But not to be on the road, to be idle, would have been far worse. She was sixty-two when she returned from Australia.

Sweet Bird of Youth had kept her away from home for fourteen months. She'd squeezed in a brief Christmas holiday with her family in New York between the English and Australian runs. Every time she saw her grandson, Jamie, he was a couple of years older; he was now sixteen.

She made, on average, two films or television shows a year. There was *Appointment with Death*, another all-star Agatha Christie whodunit, made in Britain with Peter Ustinov, Carrie Fisher, and John Gielgud. There was *Mr. North*, based on Thornton Wilder's *Theophilus North*, written by John Huston (shortly before his death), and directed by Huston's son Danny in his directorial debut. Neither film was particularly liked by critics, and both were box-office busts.

Betty got some good reviews for her next film, *Tree of Hands*, made in Great Britain, a dark story about an eccentric grandmother (Bacall) who kidnaps a child to replace the child her daughter lost. The director, Giles Foster, flew to Los Angeles to meet with his leading lady before production began. He found her sitting all alone in the hotel lobby, perfectly positioned on a couch "where she was lit very nicely," he recalled. "She looked sensational." The director was pleased with her performance as well, which he described as "ballsy." The British critics were in rapture over her: "Bacall is a tour de force," exulted the *Daily Mail*. But the film was barely released in the United States, where its title was changed to *Innocent Victim*.

The parts kept coming, many of them on television, the medium she'd once professed to loathe, such as her turn as Carlotta Vance in the TV movie *Dinner at Eight* in 1989. The next year, she signed on for a few days of work for the director Rob Reiner in his adaptation of Stephen King's *Misery*, playing James Caan's agent. The film was a giant hit, winning an

Oscar for Kathy Bates, but in truth, Betty's part could have been played by any middle-aged woman from central casting. There were also travelogues with her pal Roddy McDowall, holiday TV movies, appearances on talk shows, voice-overs for cartoons, and television commercials for High Point instant decaffeinated coffee and Fancy Feast cat food. Anything to keep working and not be alone.

In the spring of 1994, Betty signed up for another Robert Altman all-star comedy ensemble, this one called *Prêt-à-Porter* (in the United States it was released as *Ready to Wear* with the French title in parentheses) and set during Paris Fashion Week. Betty was always happy for any chance to work in Paris. Her costars included Sophia Loren, Julia Roberts, Tim Robbins, and Marcello Mastroianni. In her earlier film for Altman, *HealtH*, Betty's part had been integral to the story; in this one, she was on hand primarily to lend a note of glamour, playing a fashion icon, Slim Chrysler, modeled on Slim Hawks Hayward, who had recently died. *Prêt-à-Porter* was another critical and box-office disappointment on its release in late 1994.

"She started to realize that people wanted her because of who she was but they didn't really value her as an actress," said Scott Henderson. She'd accepted Altman's offer of "not very much money" because she'd wanted the work and wanted to remain current by working with the esteemed director. But the relationship was unbalanced, as it was with most of her latter-day directors. "She was getting jobs because she was iconic," Henderson said. "She was lending her name and image to these filmmakers to sell and promote their films, and that was worth a lot more than what they were paying her." Betty was always welcomed to sets with much fanfare and lavished with all the star trappings, but at the end of the day, she was under no illusions that she was anything other than a celebrated outsider.

Things promised to be different, however, with her next picture, made in late 1995 and early 1996. The film was *The Mirror Has Two Faces*, for which Barbra Streisand would be producer, director, and star. Betty was playing the mother of Streisand's character. She was now seventy-one and Streisand was fifty-three, but both were playing younger. Streisand had specifically requested her for the part. Betty was tough, self-absorbed, glamorous, and Jewish—exactly the qualities the director needed for the character of the mother to work. Betty had nothing but praise for the way Streisand directed the picture. "If not for her, I would not have been

cast in this part," she said. It was her first time working with a woman director.

The Mirror Has Two Faces is the story of an ugly duckling who lives in the shadow of her more glamorous mother until one day she gives herself a makeover and wins her man. The critics hated it. When the film was released in November 1996, Rita Kempley of the *Washington Post* wrote, "Although meant to be a bubbly romantic comedy, the movie is actually a very public tragedy for Streisand, who still can't quite believe that she's not Michelle Pfeiffer." What saved the film, judged Desson Howe in the same issue, was the "comic relief" supplied by Bacall: "Her withering lines counteract some of the ubiquitous narcissism."

Right from the start, everyone involved had realized that the film was Bacall's chance for an Academy Award. Howe was correct that Betty is the saving grace of an overlong, predictable movie with a dubious message. Bacall is phenomenal in the film. She lights up every scene in which she appears, and the audience looks forward to her next appearance. She's tough, cutting, and sarcastic, but she's also poignant, especially in a beautiful stretch of acting at the breakfast table with Streisand. The lines she speaks in that scene carry autobiography for both Streisand and herself. "It's an awful thing to do to a woman of my age," she says. "Leave her alone with her thoughts." Betty punctuates her lines with small gestures, barely perceptible sighs. "Parents don't have plans to hurt their children," she says, apologizing to Streisand for not having been a good mother. "I never wanted to hurt you." The line surely resonated for Betty. "The problem was," she tells Streisand, "I always thought I had more time. Inside, I feel young, like a kid, that it's just the beginning, that I have everything ahead of me. But I don't." Bacall's performance was quiet, reflective, and emotionally powerful.

Oscar prognosticators called her a sure win for Best Supporting Actress. The signs were in her favor. In January 1997, she bounded up to the stage to accept a Golden Globe, a frequent predictor of the upcoming Academy Awards. "Oy, I can't believe this," Betty said. "I'm in a state of shock. I honestly did not expect to win this. I was so thrilled to be nominated for the first time for any performance in a movie in my entire career." She ended by throwing up her arms, fully releasing her joy, gushing "I'm hysterical!"

Maybe, at long last, she'd be able to chase away those feelings of being a fraud, an imposter. On February 12, she received her Academy

Award nomination, and ten days later, she won a Screen Actors Guild award, another predictor. An Oscar now seemed a lock. Betty attended the awards ceremony on March 24 at the Shrine Auditorium. Steve, Leslie, and Sam were with her. She looked fabulous in a low-cut black ensemble. Photos taken of her on the red carpet caught a playful, exuberant woman who thought her time had finally arrived.

But then Kevin Spacey read the names of the nominees. The camera caught Bacall with an expression that can only be described as expectant. Opening the envelope, Spacey announced the winner, and it wasn't Bacall. Instead, the Oscar went to Juliette Binoche for *The English Patient*. In the collective memory of that moment, Bacall was halfway out of her seat when Binoche's name was called, or else she scowled on camera when she realized that she hadn't won. None of that is true. She remained calmly in her seat, applauding for Binoche as she accepted her award. What people might be remembering was the look in Betty's eyes, reflecting a shattering sense of disappointment despite the wan smile on her face. When Binoche, attempting to be gracious, acknowledged Betty's performance, Bacall did not appear happy. She seemed to just want to melt into her seat. "I felt very alone," she later said, looking back on that night. "No matter how you slice it, this is a ball for winners."

"I was very disappointed for her," recalled Scott Henderson. "She was devastated. [Losing the Oscar] really killed her." Her disappointment wasn't just because she had wanted, at last, some recognition from the film industry. What hurt even more was the realization of how little affection her peers held for her. When Bogie had won his Oscar for *The African Queen*, Betty had marveled over the love being expressed for him in that room. But there was no love for her at the Shrine Auditorium. "I think she knew that a lot of people didn't like her and didn't vote for her because of that," said Henderson. "And that was really, really painful for her."

She had brought some of it on herself, of course. The scorn some people felt for her might have been deserved. But one can't separate the irascible Bacall from the wounded, lonely Betty, who heard the clock ticking and knew she had very little time left to turn things around.

DURING THE PERIOD WHEN SHE WAS IN LOS ANGELES TO MAKE *MISERY*, BETTY had the chance to meet her new grandson, Jasper Robards, the son of

Sam and his wife, Suzy Amis. She was enchanted by what she saw. "It was so fabulous to see my baby swinging his baby in his car seat, handling him with total ease," she wrote. When she spotted Sam staring at his sleeping son, Betty asked what he was thinking. "I just can't believe it," he told her. "Nor could I," Betty wrote. "This child of mine, with whom I'd spent so much time alone, watching him from year to year. There I was watching him again, as he held a baby straight out in front of him in his two hands, only it was not *a* baby—it was *his* baby." Her experience of fathers—Perske, Bogie, and Jason—had always been one of reserve, distance, and a lack of affection. Her son had broken that pattern, and it touched her. Bacall, the careerist, was thinking more about her family than ever before.

She would have six grandchildren in total. The first was Steve's son Jamie. After Steve divorced his first wife and married Barbara Bruchmann, he had two more children: Richard, born in 1986, and Brooke, born in 1989. Sam followed his brother's pattern: his first marriage produced Jasper in 1990 and, after divorce and a second marriage to Sidsel Jensen, he had two more sons: Calvin, born in 1999, and Sebastian, born in 2001.

Leslie had earned a degree in nursing. At the age of thirty-seven, she married Erich Schiffmann, a prominent yoga instructor and author. Betty gave them a grand wedding party in Los Angeles. "I toasted my daughter, telling all present . . . what a wonder she was, and how proud her father would have been to see her this day," she recalled in her memoir.

As she looked out at her growing family, Betty appears to have experienced a bit of an epiphany. So many of her friends had died: Leonard Bernstein in 1990; Harry Guardino in 1995; Joyce Gates Buck, her pal since *Franklin Street*, in 1996; Roddy McDowall in 1998. Frank Sinatra died that year as well, which no doubt brought back a rush of painful memories. Betty was grieved by how much Katharine Hepburn had slowed down as she struggled with tremors and memory loss. Their correspondence dwindled. Betty's life was contracting.

The most difficult loss, however, was Jason, who died the day after Christmas 2000 of lung cancer, an eerie, final echo of Bogie. Betty had softened toward her second husband, both for Sam's sake and because she still clung to their happier times. Jason had been the last man she had loved. After his death, she told an interviewer that her marriage to Robards had always been unfairly compared to her marriage to Bogart, as

if "one guy was the great guy and the other guy was no damn good." She wanted to refute that idea. When Jason wasn't drinking, she said, "we had a marvelous time together." She paused. "We did the best we could."

The loss of Jason and the loss of her friends seemed to steer Betty's attention back to her family—the people she had sometimes gone a year without seeing. "It was almost as if she suddenly noticed them," said her former manager. "Oh, look, I have a family." In the stretches between jobs, she began to reflect on her relationships with that family of hers.

She was always closest with Sam, whom she still called her baby. Rex Reed remembered seeing Sam around the Dakota but never Steve or Leslie. "She never talked about the Bogart children at all," he said. He and Betty had long since buried the hatchet, and she had started confiding in him. "She only talked about Sam. I never saw the older children. They may have visited. But they never went with her to the Dakota parties, which Sam sometimes did."

She'd had the most difficult relationship with Steve. In 1995, he had published his own memoir, *Bogart: In Search of My Father*. Like Betty's, Steve's memoir is honest and straightforward, but unlike his mother, he wasn't interested in constructing a legend; he had no patience for myths and fairy tales. He was trying to understand the ups and downs of his life since his father had died. Neither parent is let off easily in the book. Steve refused to downplay his father's alcoholism, as his mother had done. He also didn't shy away from writing honestly about his issues with Betty.

Betty's response to the book was twofold. On the issue of Bogie's drinking, she pushed back against her son. "He doesn't know what the hell he's talking about," she told Matt Tyrnauer of *Vanity Fair*. But she also tried to see his side of things. Writing the book "made him feel good," she said, and that was what was important. "Steve, who was the first child, has been trying to find an identity for himself besides being Humphrey Bogart's son," she said. "It's a terrible thing to have to rise above that."

Bacall had always resisted being alone because it would leave her with her thoughts. But after Steve's book was published, she was alone more and more, and she was taking stock. She'd read a draft of *Bogart: In Search of My Father* as she was writing her second memoir, *Now*. It's hard not to think of Steve's grievances when reading *Now*. Betty was clearly trying—how successfully it remained to be seen—to understand her strengths and weaknesses as a mother. Her own mother, she realized, had been "an unselfish woman, a so much better person than her

daughter." Natalie had accepted Betty's determination to be an actress, even if she hadn't wanted that for her; she had understood and respected her daughter's determination. But in her own relationship with Leslie, Betty had been resistant to her ambitions. "I won't pretend I always understood her goals, her needs," Betty said. "She did her best to enlighten me, but it didn't always work."

Betty acknowledged that she hadn't said "I love you" often enough to her children—or, for that matter, to her mother or to Bogie. "I don't want Steve or Leslie or Sam to have those same regrets," she wrote. "I hope Steve tells Barbara how he feels about her. I hope he tells his children all through their growing up years how much he loves them and has faith in them and is proud of them." Neither she nor Bogie nor Jason had done that with their own children. Betty felt regret about that. Steve's book had clearly had an impact on her.

With Leslie, too, she seemed to be trying for a reset. Betty realized how often she'd asked her daughter to be a sounding board for her. That had started when Leslie was very young. "An awful burden to have placed on her," Betty wrote in her memoir. "I apologize to you publicly, my darling daughter." In her own way, which meant through the written page and not the spoken word, she was trying to make amends with her children.

Those who worked for her noticed the change. "I don't know if the disappointment over losing the Oscar had anything to do with it," said her former manager, "but it was after that she suddenly became much more interested in her family. She'd call them, try to see them." It's not as if she suddenly became a cuddly grandma baking cookies. But she talked about them more often and was unusually excited when they visited. There appeared to be a sudden longing for family. They were all she had left.

Still, the patterns of a lifetime remained. After all those years of apparent disinterest on her part, her children had made lives of their own. It wasn't easy to get together, so gatherings were rare. "She was lonely," said her agent Scott Henderson. Brenda Vaccaro, who appeared with her in *The Mirror Has Two Faces* three decades after *Cactus Flower*, said, "She seemed so alone, always in her own thoughts." Betty's former manager summed it up succinctly: "She'd always fought against being alone. And now she was."

After Leslie got married, Betty fell into a sort of depression. "The reality of my being the last and only one left hit me so hard," she wrote. "It

was my fury at myself for feeling so lost, at needing so much more than I thought I did. Wondering how much future lies ahead."

At Leslie's wedding, Steve had joked, "Well, Mom, she's the last one. Now you're next." They'd all laughed it off, but was the idea that outrageous? Betty still had her health; why couldn't she find someone to share her life with? "Recently I have experienced a new awakening," she wrote in 1994. "A sense of it being possible, of there being someone for me to love. Somewhere. I want to have somebody's hand to hold. . . . Only lately have I realized how long, for how many years, I've been closed to that emotion." She had distracted herself with movies, plays, lectures: "I'd get on a plane to Paris, to London, for some drummed-up reason." But now she was ready to claim the happiness that was supposed to come at the fade-out of a life, or at least the fade-out of a movie. "I don't want to be alone anymore," she wrote plaintively.

Her words are heartbreaking to read, especially since we know how the story turns out. She never found someone to share her last years with. Her closest companions were her dogs, who gave her much joy, but dogs can provide only so much. She was alone in an apartment overstuffed with memories. All those tchotchkes collected over the past fifty-plus years might have offered some solace. But they were also constant reminders of all she had lost.

In 1997, Bacall was feted by President Bill Clinton at the Kennedy Center Honors, with all three of her children and their spouses at her side. The award may have taken some of the sting out of her Oscar loss. "I guess I've had three enormous career highs, each in a different medium," she told an interviewer at the time. "*To Have and Have Not, Applause,* and my autobiography. Well, you can't ask for much more than that."

Nonetheless, she did. "I still want more," she admitted. "I'm greedy."

TWO YEARS LATER, AGAINST ALL ODDS AND AT THE AGE OF SEVENTY-FIVE, BETTY was back on Broadway. To celebrate Noël Coward's one hundredth birthday, the producer Alexander H. Cohen signed her to costar, along with Rosemary Harris, in *Waiting in the Wings,* one of Coward's last plays. Betty was thrilled to be going back to work, especially in honor of the friend she'd always called "Noëly," as she made sure to tell interviewers. Months of inactivity had left her climbing the walls. "Doing eight shows a week will be a blessing," she declared. And it was time that Noëly got his

due, she said. "It took them years to give him a knighthood because he was gay and lived in Switzerland. Please. There are very few great talents, and he was a great talent. He was a composer, an author, a director, a playwright. Excuse me, how many more things can you be?"

The play opened on December 16, 1999, at the Walter Kerr Theatre. *Waiting in the Wings* is set in a charity home for retired actresses. The queen bee, played by Rosemary Harris, is upset when her longtime rival, played by Bacall, moves in. Their onstage antagonism was not, however, carried offstage, despite the gossip. The two actresses became friends, phoning each other for years during their shared birthday month of September. "Betty loved being in the play," Harris recalled. "She loved being with all us actresses." In addition to the two stars, the cast included Dana Ivey, Helen Stenborg, Patricia Conolly, Rosemary Murphy, and Elizabeth Wilson, all esteemed veterans of the stage.

Reviewers generally liked the play, although largely because of Harris's performance. "When she is offended, and she often has reason to be," wrote Ben Brantley of the *New York Times*, "she expresses her displeasure with fractional shifts of her chin or her eyebrows, delicate gestures that nonetheless register like thunderclaps." Against Harris, Brantley wrote, Bacall's "own theatrical weapons are useless." The critic observed that Bacall, "a fabled Hollywood siren, is radioactive with nostalgic associations, but not of the sort demanded here."

So yet again there was that sense of being out of her league. But according to Harris, her fellow players didn't feel that way. Though they each had considerably more theatrical experience than Betty had, they accepted her as one of their own. Feeling a part of a company mattered to her. *Waiting in the Wings* turned out to be a happy experience for Betty, despite a sore knee that Rosemary Harris remembered her keeping elevated on a stool in her dressing room. The play ran for six months, and there was discussion of taking it to London, where it had never played the West End and where Harris thought it would have been successful. But Alexander Cohen's death shortly before the play closed scotched that idea.

Betty was in Los Angeles on September 11, 2001, awakened in her hotel room before dawn by a phone call from the desk. She'd asked for a 9:00 call, as she was due to fly back to New York that afternoon. But the phone was jangling considerably earlier. "Why are you calling me now?" she barked into the receiver. She was told to put on the news. She

watched in horror as the second tower fell. "And I couldn't, obviously, get away," she said. It took her five days to get a flight back to New York. "And even then, security was very, very tight. Horrible." Upon her return, she found the city she loved devastated and shell shocked.

For the next four months, she rarely left her apartment. But in January, she flew to Sweden to make *Dogville*, directed by the acclaimed if controversial Lars von Trier. The film is essentially a black-box theater production with cameras rolling. The spartan staging is intended to focus the audience on the actors and the story. There are very few props, no scenes set outdoors, no enclosed structures. Chalk drawings on the set stand in for gooseberry bushes and landscapes. *Dogville* was shot not on film but on high-definition video. Bacall played a character called Ma Ginger, one of the town elders. The frequently moving camera meant that she was often only glimpsed and some of her dialogue came from off camera. *Dogville* was another example of a director wanting to capitalize on Bacall's cachet but not using her for anything significant. But Betty apparently hoped to absorb some of von Trier's cachet as well, as she also appeared in *Manderlay*, the sequel to *Dogville*, in 2005, in another very small part.

During the making of the first film, Betty had gotten to know and like its star, Nicole Kidman. That was partly why she agreed to play her mother in Jonathan Glazer's *Birth*, the strange story of a woman (Kidman) who becomes convinced that her dead husband has been reincarnated as a ten-year-old boy. Betty had a bit more to do in that one, but she's still just a face in the ensemble. Critics were polarized over the film, many of them unnerved by Kidman's kissing the boy on the mouth. Some found the film confusing, others thought-provoking.

Betty inadvertently added to the controversy when, at the Venice Film Festival in September 2004, she got into a bit of a tussle with Jenni Falconer, the host of the British morning show *Entertainment Today*. When Falconer referred to both Bacall and Kidman as "legends," Betty cut her off in midsentence. "She's a beginner," she snapped. "What is this 'legend'? She can't be a legend at whatever age she is. She can't be a legend! You have to be older." Reporters immediately sought out Kidman for a response. She kept mum.

Betty's off-the-cuff remark drew bigger headlines for her than she'd seen in years: BACALL BRISTLES AT KIDMAN LEGEND TALK. SHE CAN STILL SPIT AS NICOLE KIDMAN DISCOVERED. Most damning of all was David

Thomson's piece in the *Independent,* THE SOURING OF A HOLLYWOOD LEGEND. "These days, alas," wrote Thomson, one of the most highly regarded film critics on both sides of the Atlantic, "'The Look' is better known for her huffs and her hissy fits." The latest huff, he said, was "one of her worst numbers." Most actresses approaching eighty—Bacall would hit that milestone in a week's time—"would be grateful for being there, and having work," he opined. "The real sadness of that soured ego is that sixty years after her own debut, she still doesn't get it. . . . Lauren Bacall is famous forever." Her performances in *To Have and Have Not* and *The Big Sleep,* he averred, had provided "such natural learning material for actresses to come, including Nicole Kidman." She had enough laurels to be gracious and generous to other actors. But apparently she still felt she had something to prove.

A few months later, Betty told Larry King that she hadn't intended to insult Kidman, whom she respected. Her comments, she insisted to the talk-show host, had been taken out of context. She'd meant to support Kidman, not offend her. "Why do you have to burden her with the category?" Betty claimed she'd said to Falconer. "She's a young woman. She's got her whole career ahead of her. Why does she have to be pegged as an icon or as anything? Let her enjoy her time. Don't put her in a slot." Perhaps that was how Betty remembered it, but those words are nowhere in the transcript of the interview. The media kerfuffle bothered her. "My only interest," she told King, "was that she was not hurt or that she did not misunderstand." Kidman downplayed her costar's words. "I certainly don't feel like a big star in Hollywood," she said, although she most definitely was. That was how graciousness worked.

Bacall made nine more films and three television appearances after *Birth,* but five of them were short films or cartoons. In 2008, she lent her voice to the direct-to-video *Scooby Doo and the Grand Witch* as the titular villain who's exposed by Scooby and his gang. The rest were barely released in the United States, with *The Walker* (2007) going direct to DVD. Her most seen work during that period was a cameo in the popular HBO series *The Sopranos.* She played herself, getting mugged and slugged by series regular Michael Imperioli.

Betty had no interest in retiring, so she harangued her agents, Scott Henderson in Los Angeles and Johnnie Planco in New York, to find her better work. But she'd become harder and harder to sell to producers and directors. "You didn't always want to tell her the truth when she asked

about a certain project because it would hurt," Henderson said. "People were telling us 'She's too difficult' or 'She's too old.' So you did your best to keep that from her." But Betty was too shrewd not to figure it out.

WITHOUT WORK, THE ONLY THING LEFT WAS TO KEEP BURNISHING THE LEGEND. By now, however, the public had changed; fewer book buyers remembered Bogie and Bacall in their heyday. Bacall's second memoir, *Now*, had been published in 1994, although she corrected anyone who called it a memoir. "It was just a book that I wrote about different things in life that I thought about," she told Larry King. Still, it was filled with reflection, some thoughtful, some facile. Many reviewers found the book pretentious. "Why did Lauren Bacall write *Now*?" one critic asked. "Aside from the fact she got a hefty advance from her publisher, that is." The answer the critic came up with was, in so many words, that she had wanted to come across as wise and philosophical in order to tidy up her story but instead she had produced an "autobiographical mishmash" of experiences that were neither remarkable nor extensive. *Now* did not sell anywhere near as many copies as *By Myself*. Betty blamed the marketing department at Knopf. "It was unfortunately sold in a very peculiar way," she said.

In 2004, in the midst of the drama surrounding her comments about Kidman, Betty took one last stab at the legend, one final attempt to seize the last word. Verita Thompson's book was now forgotten. (Pete was ill and would pass away in 2008. She'd moved to New Orleans, where she opened a piano bar called Bogie and Me. During Hurricane Katrina, she made headlines by staying put, telling an interviewer, "Lauren Bacall failed to chase me out of Hollywood. Katrina won't force me out of New Orleans.") Betty now had the stage all to herself.

By Myself would get a polish and an update. "I was told and I was convinced that it was a good idea to celebrate the 25th anniversary of *By Myself* . . . and then to add to it," Betty said. (It had actually been twenty-seven years by the time the new book came out.) She also claimed that she was being inundated with letters from fans wanting to know more about her life. The result was *By Myself and Then Some*, published in 2005 by HarperCollins. Knopf, her original publisher, had apparently passed on it.

Ten years after *Now*, book-buying readers, as well as critics, were even

younger, even more savvy to the tropes of celebrity, and far less suscep-
tible to mythmaking. The response to Betty's latest memoir—two-thirds
of which was essentially the same as what had been published a gener-
ation earlier—was very different this time around. What had seemed
honest, brave, and insightful twenty-five years earlier now seemed safe
and sometimes shallow. By 2005, hundreds of celebrities had openly dis-
cussed their addictions, affairs, divorces, and problems with their chil-
dren with Oprah Winfrey, Barbara Walters, and Larry King. Sex tapes of
Rob Lowe, Pamela Anderson, Paris Hilton, Colin Farrell, and others had
been leaked, sometimes deliberately. Consequently, *By Myself and Then
Some*, the majority of which had won the American Book Award for 1979,
was pretty tame stuff by the time it made its way to bookstores again.

Betty shouldn't be faulted for refusing to go the salacious route; she
should be admired. But her twentieth-century ways meant that her book
wasn't going to grab new readers. "I'm afraid this book is an awful con,"
wrote Rachel Cooke in the *Guardian*, noting that "the postscript-cum-
second-volume" of her memoirs "is a mere 77 pages long and must have
taken all of hours to write." Cooke had been born in 1969; she had been
ten when the book had first come out, and its latest incarnation failed to
impress her the way it had impressed the previous generation. "By rights,
By Myself should be a wonderful read," she wrote. "Bacall is known for
her acid tongue, and this, combined with her quite immense address
book, should, you'd imagine, make for some pretty juicy stuff. But open it
up and you quickly realize that the diaries of Truman Capote these ain't."
Cooke thought that Betty's adoration of Bogie tended "to blur the man
himself." She wrote, "For a woman with balls, Bacall is adept at making
excuses on his behalf. Is there self-knowledge here? Hardly." As a mem-
oirist, she said, Betty was "as flat as day-old champagne."

Betty could have written an update to *By Myself* that went deeper,
acknowledging Bogie's alcoholism and her own obsessive nature. She
might have confronted the moments and individuals she had previously
tried to gloss over, such as Verita Thompson. She might have challenged
the narrative given to her by her family about her father and faced up to
the fact that her refusal to meet him had meant that some wounds would
never be closed. Although she'd acknowledged her failings as a parent,
she had never really looked at her ambivalence toward motherhood it-
self, expressed so tellingly when she'd dedicated *Now* to her friends, not
her children, citing friendships as the relationships she valued most in

life. She might also have been more honest about Adlai and Frank; what had seemed candid in 1978 now seemed like obfuscation. It should be noted that she had the ability to do all that. She had proven herself a strong enough writer to explore the depths. Her final memoir, if she had wanted, could have rocked the critics and the public.

But that wouldn't have enshrined the memory of Bogie and Bacall in the public's mind the way she wanted it to be. It's probably unfair to have expected her to do anything differently. She was eighty-one when the revised memoir came out. Why would she want to open old wounds at that late stage of the game? It was easier, safer to simply carry on as she had.

The imperiousness and entitlement remained. During her book tour, Betty met with Bob Thomas, the longtime correspondent for the Associated Press, in the outdoor dining area of a West Los Angeles hotel. Thomas recalled that when she ordered a pot of tea, she also asked for "a thermos of boiling water." The waiter brought the teapot but not the thermos. Betty requested it again. When another waiter brought a cozied teapot, which would help keep the water hot, Betty was not pleased. "What is the problem?" she growled. "There's no thermos in this hotel? I have a thermos of hot water every single morning. Go to the kitchen and ask for a thermos!" After a while, a thermos was located, and a terrified waiter brought it over to her. Bacall made no apologies for her behavior. She told Thomas, "For good or ill, I'm honest."

Honesty or rudeness? Standing up for oneself or asserting privilege? "It was always with the little people, so to speak, with whom she was ill tempered," said Rosemary Harris, who'd witnessed her behavior during *Waiting in the Wings* and since. Bacall's arrogance wasn't all that different from the way Katharine Hepburn would step out of character and break the fourth wall onstage to lambaste an audience member for taking a photo or coughing. People needed to be confronted when they did not behave the way they were supposed to behave, both Hepburn and Bacall believed. It was simply too late to rethink that philosophy now.

DURING THE LAST DECADE OF HER LIFE, BETTY LARGELY REMAINED AT THE DAKOTA with her "dearest companion," her papillon, Sophie. On the wall was a portrait of her last companion, her King Charles spaniel, Blenheim. Dogs were her "companions for life," she wrote. They were always happy to be with her, never contradicting her, without histories of their own or any

unresolved issues. In Betty's last years, Sophie brought her great happiness. A delightful video taken by the actress Glenn Close and since posted online reveals the sheer joy Betty felt with Sophie, the unguarded way she interacted with her, the easy laughter, the sustaining companionship.

She made her last film in 2008, when she was eighty-four. The independently produced *Carmel-by-the-Sea* was a gentle, thoughtful, and ultimately uplifting picture shot mostly along the Monterey coast in California. It's the story of a teenager abandoned by his drug-addicted mother. An instinctive artist, the boy gets caught up in the world of art forgery, producing paintings that are passed off as the work of masters. Betty, as a retired art forger, helps him get out of the business and set his life straight. The first film for director Lawrence Roeck, *Carmel-by-the-Sea* starred the up-and-coming young actor Josh Hutcherson, then sixteen. Bacall and Alfred Molina were included to give the project gravitas.

As often happens with independent films, money became an issue, and the picture languished until acquired by the Abu Dhabi–based Experience Media Studios, which shot some additional scenes in Monterey in late 2010. *Carmel-by-the-Sea* finally premiered in Los Angeles in March 2011, with a second premiere in Carmel a week later. The distribution deal fell through, however, which meant no one outside those two locations got to see the film. The following year, Hutcherson's stock in Hollywood skyrocketed after he played the lead in the highly successful *The Hunger Games*. So the little film begun four years earlier, now renamed *The Forger*, was finally released on DVD in the hope of cashing in on Hutcherson's fame. The ordeal of Bacall's last film symbolized the changes in the industry she'd once known.

It's unfortunate that *The Forger* was seen by so few people. Betty's quite good. She's direct, confident, even showing some humility and wistfulness. Unlike her other post-1990 films, her part was pivotal to the plot, enabling the boy to see what a life of forgery does to a person. She also looks fantastic, her white hair and crystal blue-green eyes giving her a glow we hadn't seen since *The Mirror Has Two Faces*, and she's far more likable here. *The Forger* is not a great film by any means, but as our final glimpse of Lauren Bacall on-screen, it offers some small satisfaction.

The Academy of Motion Picture Arts and Sciences finally got around to honoring her in 2010. After basking in the applause as she held her

honorary award, she launched into a rambling, unscripted, rather hyper speech in which she seemed to be channeling Betty White in the way she leeringly described her attractions to men, especially the late Gregory Peck. It was all a bit embarrassing, and Betty came to agree. A few years later, she told Matt Tyrnauer that she didn't display her Oscar because it made her feel terrible. "I'm ready to throw it out the window," she said. "I hate it now. Every time I look at it, I remember that day, and I think it was probably the worst thing I have ever done." When Tyrnauer asked what she meant, Bacall replied, "Because I only talked about Bogie. . . . I never talked about Jason, and Sam was sitting right there. . . . I just kind of went blank. And I knew it, and I tried to get back on, and I couldn't. . . . I think it scarred my son terribly, and there's no excuse for that, especially in view that I so adore him." Not only Jason, not only Sam, but Steve and Leslie had also been there, and she didn't mention either of them. There wasn't even that much about Bogie; it was mostly herself. But it was her Oscar, after all.

In late 2010, Betty fell in her bathroom and fractured her hip. She was taken away by ambulance. "It's the only time I have been in the hospital except for the times when I gave birth," she said. Thankfully the hip was not broken. She was released from the hospital with a walker, which she called "my friend." Tennis balls were attached to its feet.

She didn't let her disability keep her from the sidewalks of New York. Pushing her walker ahead of her, a leash secured to her wrist, she still took Sophie out for her walks. She also made her own way to physical therapy appointments. "People don't pay any attention to me or the walker," she said. "The other night I was going into a doctor's office, and some son of a bitch came out of the building, almost knocked me over. I said, 'You're a fucking ape!'—*screaming* at him. He never even turned around. Couldn't care less, this big horse of a man."

She was never able to walk on her own again, which eventually confined her to her apartment. "She hated therapy and refused to go," Rex Reed said. "That of course meant that she didn't work." Betty's loneliness became a way of life. "Sometimes," she admitted to one interviewer, "when I want to go to a play and I don't have someone to go with, that can be difficult." The losses had continued, which was especially hard for a woman whose closest friends had mostly been older than she was. Katharine Hepburn had died in 2003. The last correspondence Betty had had from her was signed by her secretary, thanking Betty for little gifts she

had sent. Toward the end, she went to visit Hepburn at her summer home in Fenwick, Connecticut, where Kate's first reaction upon seeing her— "What are you doing here?"—left Betty shattered. But Hepburn, deep in the grip of dementia, didn't really know her. Adolph Green died in 2002. "The worst [loss] was Adolph Green," Betty told a reporter. "Anyone who knew Adolph could never forget him. He had such an incredible brain."

"Her friends were all gone," said Rex Reed. "Leonard Bernstein, Adolph Green. She was friendless." She turned to Reed, her onetime adversary, for companionship. Once, when both were being driven to a charity fundraiser, the chauffeur mistook her for Reed's wife. Betty got a big kick out of that and forever after signed her name "Mrs. Reed" when she sent a note to Rex.

By 2011, she was in a wheelchair. The loss of mobility mellowed her. "I never saw such a transformation," Reed said. "She became a very warm but also very needy person." She would continue attending the Dakota's annual party, she said, only if Reed went with her and never left her side. "We'd sit at our table while everybody came by to pay homage to her," he said.

At one point, Reed said to her, "If I can ever do anything for you, just let me know." Her reply reflected just how lonely she felt. "Yes, there is something," Betty said. "You can invite me to dinner." Reed did. She'd arrive in her wheelchair, and he'd wheel her to the table. Afterward, he would take her to the elevator so she could return to her apartment. Reed also made her pies and sorbet, which she loved.

When writing Betty's story, there's a yearning to give her a happier ending than this. Some people said she was reaping what she'd sowed. Karma, they say, can be a bitch. But Betty wasn't, no matter how many times she may have seemed to be. She was a woman with an ego that needed to be colossal if she was going to find her way out of a fourth-floor, two-room walk-up to Hollywood, Broadway, and beyond. She was a woman who, in the face of her father's rejection, had sought the acclaim of the world and gotten it: the fact that she never fully believed she had done so doesn't negate her accomplishment. She was often consumed with contempt and resentment for others, but she was also capable of growth and reflection and regret. Human beings are complicated creatures. Like most of us, she had her successes and she had her failures.

When Bogart died, there was a sense of his having completed the

circle. From the day of his birth, he'd been unloved and undervalued. Yet by the time he died, he was surrounded by love—from his family, his friends, the entire world. Many of those who loved him, such as his wife, were constantly at his bedside, tending to his every need, exactly the opposite of what he'd experienced as a baby, when he had been left alone in a cradle to cry, rarely picked up or held.

Betty's story, however, doesn't fully complete her circle. At the end, she still lived with a sense of being an imposter, unworthy of what she'd been given, while at the same time convinced that she deserved more. She was still the little girl whose father didn't love her.

But one thing is certain: she held her own. She wouldn't let herself be defeated or turned into a victim. There's a photo of her, one of the last ever taken, by the British photographer Andy Gotts, in which she stares directly into the camera, with barely any makeup, without any Botox or fillers. Her face is a road map of wrinkles. Her jowls sag. Her hair is wispy and gray. But her sea-green eyes are defiant. It's a face that has lived. It's a face that tells the viewer: *This is who I am.*

Bacall was a survivor. "So, I'm not the most adored person on the face of the earth," she said in one of her last interviews. "There are a lot of people who don't like me at all, I'm very sure of that. But I wasn't put on earth to be liked. I have my own reasons for being and my own sense of what is important and what isn't, and I'm not going to change that."

On Tuesday, August 12, 2014, in her apartment, Betty suffered a massive stroke. Her children were notified. Steve phoned his son, Jamie, and told him "to prepare for the worst." The next day, August 13, at New York–Presbyterian Hospital, Betty Bacall died. She was a month short of her ninetieth birthday. In her will, she had divided her $26.6 million estate among her three children, with some money carved out for her loyal employees and for college for Sam's younger sons. There was also a $10,000 trust fund set up for Sophie, so that Betty's cherished companion could live out her life in the luxury to which she was accustomed.

Television, newspapers, and the Internet were flooded with images of the sex siren of *To Have and Have Not* and *The Big Sleep*. But few were still alive who had known Bacall at her peak, who had traveled the long road with her, leaving published tributes to people such as Streisand and Seth MacFarlane, for whom Betty had done her last professional work, a voice-over on *Family Guy*. Only a few were present to watch as

Betty's ashes were deposited beside Bogie's at Forest Lawn in Glendale, California, in the Garden of Memories in the Columbarium of Eternal Light. There they rest together in perpetuity, Steve and Slim, Bogie and Baby, Hollywood's greatest love story, complicated, devoted, passionate, contradictory, genuine, and everlasting.

ACKNOWLEDGMENTS

My gratitude to my editor, Jonathan Jao, for all his support, guidance, and advice; David Howe and David Koral of Harper for all their expert work; Elina Cohen and Joanne O'Neill for the elegant designs of the book and the cover; my agent, Malaga Baldi, for her tireless efforts on my behalf; and my husband, Timothy Huber. Thanks also to those who shared their memories and insights: Steven Boggs, Paul Dooley, Richard Eyer, Giles Foster, Rosemary Harris, Scott Henderson, M. O'Brien, Lee Roy Reams, Rex Reed, Nita Rodrigues, Dean Shapiro, Brenda Vaccaro, Michael York, and the late Dick Clayton, Gloria Stuart, and Miles White, as well as those agents, managers, and friends who asked to remain anonymous.

I'd also like to thank Leslie Bogart for her good wishes and encouragement, while also respecting and understanding her decision, made with her brothers, not to grant interviews for this project. They've spent their lives being asked about their parents, even as they have carved out rewarding lives of their own. I hope they feel that I have done justice to the story of Bogie and Bacall.

Special gratitude to those archivists and historians who worked with me before, during, and after the pandemic to keep the research for this book going. These include Kristine Krueger at the Margaret Herrick Library of the Academy of Motion Picture Arts and Sciences; Sarah McElroy Mitchell at the Lilly Library, Indiana University, Bloomington; Nailah Holmes and Sharon Rork at the New York Public Library for the Performing Arts; Jane Parr and J. C. Johnson at the Howard Gotlieb Archive, Boston University; Karl Schadow, radio historian, who shared considerable material on *Bold Venture* and helped me track down a recording of *Let's Playwright* so I could hear the voice of the teenage Bacall, and Greg Bell, host and program director of Sirius XM's Radio Classics channel, for putting me in touch with Schadow; Tim Noakes at Special Collections, Stanford University; Mary Huelsbeck

ACKNOWLEDGMENTS

at the Wisconsin Center for Film and Theatre Research; David Olson at the Oral History Archives, Columbia University; and Randy Sullivan at the University of Oregon Libraries. Finally, I greatly appreciate the invaluable research assistance provided by Jesse Balzer, Milton Landes, and Ted Gostin.

SOURCES AND NOTES

Archival Collections

Mary Astor Collection, Howard Gotlieb Archival Research Center, Boston University

Lauren Bacall Collection, Howard Gotlieb Archival Research Center, Boston University

Lloyd Bacon Papers, Margaret Herrick Library, Academy of Motion Picture Arts and Sciences

Rudy Behlmer Papers, Margaret Herrick Library, Academy of Motion Picture Arts and Sciences

Nathaniel Benchley Collection, Howard Gotlieb Archival Research Center, Boston University

Humphrey Bogart Collection, Howard Gotlieb Archival Research Center, Boston University

Bogart/Bacall mss., Lilly Library, Indiana University, Bloomington

Charles Brackett Collection, Margaret Herrick Library, Academy of Motion Picture Arts and Sciences

Abe Burrows Collection, Billy Rose Theatre Division, New York Public Library for the Performing Arts

Alexander Cohen Collection, Billy Rose Theatre Division, New York Public Library for the Performing Arts

Betty Comden–Adolph Green Collection, Billy Rose Theatre Division, New York Public Library for the Performing Arts

George Cukor Papers, Margaret Herrick Library, Academy of Motion Picture Arts and Sciences

Daves (Delmer) Papers, Special Collections and University Archives Department, Stanford University

Fred Ebb Collection, Billy Rose Theatre Division, New York Public Library for the Performing Arts

Charles K. Feldman Collection, Special Collections, Brigham Young University

Gladys Hall Papers, Margaret Herrick Library, Academy of Motion Picture Arts and Sciences

Howard Hawks Papers, Special Collections, Brigham Young University

Leland Hayward Collection, Billy Rose Theatre Division, New York Public Library for the Performing Arts

Katharine Hepburn Papers, Margaret Herrick Library, Academy of Motion Picture Arts and Sciences

Hedda Hopper Papers, Margaret Herrick Library, Academy of Motion Picture Arts and Sciences

John Huston Papers, Margaret Herrick Library, Academy of Motion Picture Arts and Sciences

Garson Kanin Papers, Library of Congress

Howard Koch Papers, Wisconsin Center for Film and Theatre Research

Joseph Mankiewicz Papers, Margaret Herrick Library, Academy of Motion Picture Arts and Sciences

Mayo Methot Bogart Memorabilia, Special Collections and University Archives, University of Oregon Libraries

Paramount Collection, Margaret Herrick Library, Academy of Motion Picture Arts and Sciences

Nicholas Ray Papers, Harry Ransom Center, University of Texas at Austin

David O. Selznick Collection, Harry Ransom Center, University of Texas at Austin

Sidney Skolsky Papers, Margaret Herrick Library, Academy of Motion Picture Arts and Sciences

Warner Bros. Archives, University of Southern California

Preface

xi **"Let's have the Café Flore"**: Ginia Bellafante, "To Have and Have Not," *New York Times*, February 24, 2005.

xi **"What the fuck"**: Interview, name withheld by request, August 7, 2021.

xi **"She could be lovely"**: Interview, Scott Henderson, January 12, 2022.

xii **"With all the great luck"**: *Daily Telegraph* (London), February 5, 2005.

xiv **"blur the man himself"**: *Guardian* (London), March 19, 2005.

xvi **"Immortality is a difficult subject"**: Alyssa Rosenberg, "Did Humphrey Bogart Become Immortal?," *Atlantic*, February 1, 2011.

xvi **"As an actor"**: *Guardian* (London), January 1, 1999. For an astute and fascinating consideration of Bogart's image, see Stefan Kanfer, *Tough Without a Gun: The Life and Extraordinary Afterlife of Humphrey Bogart* (New York: Alfred A. Knopf, 2011).

xvii **"In a sense, his talent"**: "Cinema: The Survivor," *Time*, June 7, 1954.

Chapter 1

3 **Braving the cold**: On December 4, 1920, the *Montclair* [NJ] *Times* reported that *The Ruined Lady* would be "starting this coming Monday night." On December 11, the same paper advertised Marilyn Miller and Leon Errol in *Sally*, a Ziegfeld production, set to play at the Broad following the current show. Newspaper advertisements for *The Ruined Lady* announced matinees on Wednesdays and Saturdays. It's clear from a search of newspaper archives that the tour was ending that night. Grace George immediately went into rehearsals for *The New Morality*, which opened on Broadway on January 30, 1921. The *Montclair Times* reported on the extremely windy conditions that day.

3 **"I never had a birthday"**: Stephen Humphrey Bogart, *Bogart: In Search of My Father* (New York: Dutton, 1995).

3 **When the Broad St. Theatre**: *Montclair* [NJ] *Times*, December 4, 1920; *Passaic Daily News*, December 4, 1920.

4 **"I tossed lines to actors"**: *St. Louis Star and Times*, April 23, 1937.

4 **At some point that afternoon**: Conflicting accounts have Hamilton either being sick or daring Bogart to go on in his place. In an interview with the *Los Angeles Times* (October 19, 1930), Bogart said the performance had been for a matinee; whether or not Hamilton

had then gone on to do the evening performance is unclear. Hamilton had joined the company just a month or so earlier, during its run in Washington. Previous to this, including on Broadway, the role of Dallis Mortimer had been played by Richard Farrell. Hamilton would go on to have a fairly prominent silent film career but is probably best known for portraying Commissioner James Gordon on the 1966–1968 television series *Batman*.

4 **"After getting out"**: *St. Louis Star and Times*, April 23, 1937.

4 **As the studio's story went**: Joe Hyams, in *Bogie: The Biography of Humphrey Bogart* (New York: New American Library, 1966), referred to a Warner Bros. press bio that included the railroad company anecdote. Even Hyams, who largely adhered to the Bogart legend the way Bacall, who wrote the prologue for his book, wanted it told, doubted the veracity of the quote and questioned whether Bogart had ever worked for the railroad at all.

5 **didn't last long**: *St. Louis Star and Times*, April 23, 1937.

5 **the son of Irish immigrants**: A. M. Sperber and Eric Lax, in their *Bogart* (New York: William Morrow, 1997) (hereafter Sperber and Lax), state that Brady was Jewish, but in fact he was the son of Terence and Catherine Brady, immigrants from County Limerick, Ireland, and his funeral in 1950 was held at St. Malachy's Roman Catholic church in New York.

5 **"A fine racket"**: William A. Brady, *Showman: My Life Story* (New York: E. P. Dutton, 1937).

5 **"inseparable from the time"**: *Modern Screen*, December 1936.

5 **"There was [an] axiom"**: "W.A. Brady, 86, Dies of Heart Ailment," *New York Times*, January 8, 1950.

6 **"picked up all [she] could find"**: *Modern Screen*, December 1936. Rankin told this story again in *Photoplay*, September 1938. The two versions differ as to when the event occurred, either just before or just after Bogart's service in World War I.

6 **One narrative**: The escaping prisoner story comes from Bogart's friend and brother-in-law Stuart Rose, quoted in Sperber and Lax, *Bogart*.

6 **"Why, it was all part"**: *Photoplay*, July 1937.

6 **Despite an extensive inventory**: U.S. Navy, National Personnel Records Center, June 18, 1919.

6 **"He carried a souvenir"**: *Modern Screen*, December 1936.

6 **When he was Hump's age**: *Montclair* [NJ] *Times*, March 30, 1878.

7 **"A marvelous English actress"**: *Photoplay*, July 1937. Bogart's heartthrob may have been Eleanor Robson, an English actress who played the title role in *Merely Mary Ann* opposite Warner in 1907, when Bogart was eight.

7 **By the time he was thirteen**: Joe Hyams, *Bogie: The Biography of Humphrey Bogart* (New York: New American Library, 1966).

8 **"Surgery I couldn't see"**: *Photoplay*, July 1937.

8 **"shooting the globes"**: *Modern Screen*, December 1940.

8 **"Fortunately," Hyams assured his readers**: Hyams went on to claim that Bogart and Brady had smashed a light bulb as an alibi in case anyone had heard the shot and then sought out another doctor, not his father, to "patch up" his wrist.

9 **"loved sleeping late"**: *St. Louis Star and Times*, April 23, 1937.

9 **"beset from two sides"**: Sperber and Lax, *Bogart*.

9 **"so thoroughly pleasant"**: *Variety*, January 24, 1920.

10 **"Always keep working"**: This quote has been cited in various accounts, including

Jeffrey Meyers, *Bogart: A Life in Hollywood* (New York: Houghton Mifflin, 1997), but I have been unable to locate the original source.

11 **One account called the performance**: Hyams, *Bogie*. Stephen Bogart, in his book on his father, repeats this story. Possibly this account of an afternoon performance grew out of Bogart's early descriptions of his stage debut being in a matinee. None of the later accounts of Bogart's first theatrical performance seems to have any awareness that there was a matinee on the last night of *The Ruined Lady*'s run.

11 **"which occur with a vengeance"**: *New York Clipper*, January 7, 1920.

11 **"leading Dallis to tell Bill"**: *Variety*, January 24, 1920.

11 **"In one scene"**: *Modern Screen*, December 1940.

11 **"[He'd] never been"**: Nathaniel Benchley, *Humphrey Bogart* (Boston: Little, Brown, 1975).

11 **"all the lines"**: Hyams, *Bogie*.

Chapter 2

13 **"We were not an affectionate"**: *McCall's*, July 1949. In several accounts of Bogart's life, this source has been misidentified as *Ladies' Home Journal*.

14 **"Our mother and father"**: *Modern Screen*, June 1938.

14 **"We lived in a three-story"**: *McCall's*, July 1949.

14 **At their Canandaigua lake house**: 1900 and 1910 censuses for Canandaigua, New York.

14 **His practice was successful enough**: Belmont purchased the property from Martha L. Ash on September 21, 1905, for $14,000 (*New York Times*, September 25, 1905).

15 **"For over forty years"**: *McCall's*, July 1949.

15 **After a few years**: Sailing from Liverpool, Maud arrived in New York on September 10, 1894, onboard the *Etruria*.

15 **"devotedly attached"**: *Pittsburgh Press*, May 12, 1901. Curiously, when this observation was made, Frances Humphrey had been dead for four years (she died on May 17, 1897).

15 **"Her children are natural"**: Ibid.

15 **"the children of the tenements"**: *Critic*, May 1900.

16 **"a well-known young"**: *Democrat and Chronicle* (Rochester, NY), May 30, 1898.

16 **"She was working"**: *McCall's*, July 1949.

16 **"as if there were a disposition"**: *Critic*, May 1900.

16 **"a laboring Tory"**: *McCall's*, July 1949.

16 **"I admire her more"**: Ibid.

17 **"She was essentially"**: *Modern Screen*, June 1938.

17 **"It was always easier"**: *McCall's*, July 1949.

17 **"an ideal family"**: *Democrat and Chronicle* (Rochester, NY), May 18, 1897.

17 **"But," he said, "I can't"**: *McCall's*, July 1949.

18 **"classes for small boys"**: See the advertisements for the De Lancey School for Girls in *New York Tribune*, for instance on September 6, 1907.

18 **"pretty discouraged"**: *Photoplay*, July 1937.

18 **"Prepares for all colleges"**: See, e.g., *New-York Tribune*, September 21, 1909.

18 **Adam Bogart's father**: *New-York Commercial Advertiser*, October 25, 1843.

18 **"a great deal of money"**: *McCall's*, July 1949.

18 **Adam increased his worth**: In the 1860 census, Julia's personal worth was stated as being more than $2,000; the money was held by her, not her husband. See also the probate records of her father, Philomen Stiles.

19 **After his mother's death**: New York state death records; 1850, 1860, 1870, and 1880 censuses.

19 **a shop on Park Place**: New York city directories, 1875–1880, 1882.

19 **"My father made a great deal"**: *Photoplay*, July 1937.

19 **"loved talking with truck drivers"**: *McCall's*, July 1949.

19 **"My father liked to get away"**: Ibid.

19 **Instead, studio publicists**: The story of the drowned man was reported in the *Los Angeles Daily News*, January 28, 1938.

19 **His father, he'd say**: *Modern Screen*, June 1938.

20 **"I used to putt-putt"**: Warner Bros. press release, [n.d.], 1948, Lauren Bacall Collection.

20 **"while far from perfect"**: Stephen Bogart, *Bogart: In Search of My Father* (New York: Dutton, 1995) (hereafter Bogart, *Bogart*). Unless otherwise indicated, all quotes from Stephen Bogart come from this source.

20 **"Maud and Father swept off"**: *McCall's*, July 1949.

20 **Belmont would also inject Maud**: See Sperber and Lax, *Bogart*, for interviews with neighbors who witnessed the Bogarts' substance abuse.

21 **"We kids would pull"**: *Photoplay*, July 1937.

21 **In 1910, they employed**: 1910, 1915, and 1920 censuses.

21 **"Our maids would invariably quit"**: *McCall's*, July 1949.

22 **One childhood friend**: Sperber and Lax, *Bogart*.

22 **"wasn't happy at home"**: *Pictorial Living*, August 15, 1965.

23 **ended his second year**: I am indebted to Sperber and Lax, who obtained Bogart's transcripts from Trinity.

24 **"Military training is being taken"**: *Boston Post*, March 13, 1917. Also see *Boston Globe*, September 16, 1917.

24 **A few months before**: *Boston Post*, April 7, 1917.

24 **"one of the richest blessings"**: *Boston Globe*, March 26, 1917.

25 **"sullen" and "spoiled"**: Charles Yardley Chittick, quoted in Hyams, *Bogie*.

25 **"indifference and lack of effort"**: Hyams, *Bogie*. See also Sperber and Lax, *Bogart*.

25 **"a good boy"**: Sperber and Lax, *Bogart*, quoting Phillips Andover Academy archives.

25 **"He lived a life of his own"**: Arthur Sircom to Nathaniel Benchley, December 31, 1973, Nathaniel Benchley Collection, Howard Gotlieb Archival Research Center, Boston University (hereafter NBC). Sircom was an actor and director on Broadway between 1924 and 1944, directing Anne Baxter, Nigel Bruce, ZaSu Pitts, and Billie Burke, among others.

26 **"caught coming in"**: Benchley, *Humphrey Bogart*.

26 **one fan magazine insisted**: *Modern Screen*, December 1940.

26 **"My father"**: Bogart, *Bogart*.

26 **"He claimed he was"**: Nunnally Johnson, oral history, June 10, 1971, Columbia Center for Oral History, Columbia University.

26 **"I'm leaving this fucking place"**: Arthur Sircom to Nathaniel Benchley, December 31, 1973, NBC. In his book, Benchley changed "fucking" to "goddamned."

27 **"Because I loved boats"**: *Photoplay*, July 1937

27 **"hell bent"**: Hyams, *Bogie*.

27 **"the leading marine engineer"**: *Yonkers* [NY] *Herald*, July 17, 1914.

28 **"They didn't know"**: *Photoplay*, July 1937.

28 **"I joined the navy"**: *Modern Screen*, June 1938.

29 **"no nearer to an understanding"**: *Photoplay*, July 1937.

30 **"You can't buy it"**: Hyams, *Bogie*.

30 **"old Hartford and very socially OK"**: *Vogue*, September 1991.

30 **"His body was coordinated beautifully"**: Sperber and Lax, *Bogart*.

30 **In the newspapers the next day**: *Brooklyn Daily Times*, May 4, 1919.

31 **"two beads and a buckle"**: *Modern Screen*, December 1936.

31 **"just to the point"**: Benchley, *Humphrey Bogart*.

31 **"I have a mean streak"**: *Los Angeles Daily News*, January 29, 1938.

31 **"There are still those"**: Benchley, *Humphrey Bogart*.

32 **"flounced out"**: Ibid.

32 **"Everyone dislikes me"**: *Modern Screen*, March 1939.

32 **"It didn't look as if"**: *Modern Screen*, December 1936.

33 **"He had the beginning"**: Ibid.

Chapter 3

34 **William Brady knew that something**: Sperber and Lax, in *Bogart*, do not name this play and erroneously cite Alice Brady as its star. They also placed the premiere at the Fulton Theatre, not the Majestic. That was likely an instance of Stuart Rose, their source of the story, misremembering details more than half a century later. Bogart is listed in the cast of the *Dreamy Eyes* premiere in *Brooklyn Daily Eagle*, May 31, 1921, as well as other papers.

34 **Earlier, Rose had marched**: Sperber and Lax, *Bogart*; details of the parade come from *New York Times*, May 31, 1921.

35 **"The boy's good"**: Sperber and Lax, *Bogart*.

35 **By the time the show**: Allen Atwell had played a Japanese valet in Brady's 1909 hit *Paid in Full* (*San Francisco Dramatic Review*, August 14, 1909). The show was revived in 1921 and renamed *Bought and Paid For*, with Atwell once again in the cast. "Allen Atwell, as the Jap servant, repeated his former success" (*Variety*, December 16, 1921).

35 **But as it turned out**: *Asbury Park* [NJ] *Press*, July 21, 1921.

35 **The show had been struggling**: *New York Times*, August 7, 1921.

35 **In Atlantic City, he didn't like**: Hyams, *Bogie*.

35 **"pleasantly remember"**: *Times Leader* (Wilkes-Barre, PA), October 15, 1923.

36 **he'd later recall**: *Modern Screen*, December 1940.

36 **"fussy"**: Ibid.

36 **On January 2, 1922**: Hyams, in *Bogie*, incorrectly wrote that Menken had joined the cast while it was touring.

36 **"one of life's derelicts"**: *Evening World* (New York), December 29, 1921.

36 **"the best acted melodrama"**: *Evening World* (New York), January 3, 1922. Curiously, chronicles of Bogart's career have often claimed that *Drifting* was a critical and commercial failure, but contemporary reports do not bear that out.

36 **"I guess I shouldn't have"**: Hyams, *Bogie*.

37 **"turned loose" her "fine, fiery temper"**: *Saturday Evening Post*, August 2, 1952.

37 **"relentless"**: Benchley, *Humphrey Bogart*.

38 **"Denial was made"**: *Evening World* (New York), April 5, 1922.

38 **"A romance of the stage"**: *New York Herald*, April 5, 1922.

38 **"both well-known stage folk"**: *Daily News* (New York), April 25, 1922.

38 **"one of the greatest"**: *Missoulian* (Missoula, MT), March 19, 1922.

39 **"Helen didn't want to marry"**: *Photoplay*, July 1937.

39 **"a slim boy with charming manners"**: Louise Brooks, *Lulu in Hollywood* (New York: Alfred A. Knopf, 1982).

39 **"the younger generation's"**: Syndicated column, as in *St. Louis Globe-Democrat*, March 12, 1922.

40 **"tipsy youngsters and dubious scheming"**: Charles Darnton, *Evening World* (New York), March 9, 1922.

40 **"Money?" Humphrey asked**: *Photoplay*, July 1937.

40 **He was appearing**: *New-York Tribune*, January 22, 1922.

40 **"Mr. Bogart, as the cad"**: *Boston Globe*, September 5, 1922.

41 **She was fast becoming**: "a sure-fire dramatic success" (*Star-Gazette* [Elmira, NY], August 2, 1922); "a certain success" (*New York Times*, September 17, 1922).

41 **"a young roué"**: *Brooklyn Daily Times*, October 17, 1922.

41 **"three heavy-fisted acts"**: *New York Herald*, October 17, 1922.

41 **"full praise" for a "fine performance"**: *Brooklyn Daily Times*, October 17, 1922.

41 **"excellent bit of work"**: *New-York Tribune*, October 17, 1922.

42 **"a young sprig"**: *New York Herald*, October 17, 1922.

42 **"taking each of the big scenes"**: *Daily News* (New York), October 31, 1922.

42 **"Not since Duse"**: *New York Times*, October 31, 1922.

42 **"irradiated by the dazzling performance"**: *New York Herald*, November 5, 1922.

42 **"So, you wanted"**: *McCall's*, July 1949.

42 **So when, that fall**: Maud sold the house on November 23 to Israel Liebowitz (*New-York Tribune*, November 29, 1922).

43 **"The breakup of the Bogarts"**: *McCall's*, July 1949.

Chapter 4

44 **At the conclusion**: *Brooklyn Citizen*, August 23, 1925; *Brooklyn Daily Eagle*, August 30, 1925.

45 **"He fired me forty times"**: *St. Louis Star and Times*, April 26, 1937.

45 **"the younger set, intoxicated"**: *Yonkers* [NY] *Statesman*, November 28, 1922.

45 **"Humphrey Bogart does well"**: *Hartford* [CT] *Courant*, January 23, 1923.

46 **"Mr. Bogart is most attractive"**: *Buffalo* [NY] *Times*, April 1, 1923.

46 **"the usual youthful lover"**: *Brooklyn Daily Eagle*, November 27, 1923.

46 **"a pleasing young chap"**: *Wilkes-Barre* [PA] *Record*, October 16, 1923.

47 **"the sort newspapermen"**: *Daily News* (New York), November 30, 1923.

47 **"Get this, Bogart"**: Hyams, *Bogie*.

47 **"think tall"**: Bogart, *Bogart*.

47 **"the latest heartthrob"**: Unsourced clip, December 1923, New York Public Library.

47 **"The needling I got"**: Bogart, *Bogart*.

48 **"both dry and fresh"**: Stark Young, "The English War Play," *New York Times*, September 2, 1924.

48 **"stood out"**: *Brooklyn Times-Union*, September 2, 1924.

48 **"the most effective performance"**: *New York World*, September 3, 1924.

48 **"You can't just make faces"**: Hyams, *Bogie*.

48 **Mary Boland, who'd also returned**: Various chroniclers have reported, without any sourcing, Boland's supposed concession to the producers at the start of *The Cradle Snatchers* in July 1925: "Oh, all right then, get Bogart. I know it's what you have in mind." Yet that seems highly unlikely, since by that time she had been on tour with him in *Meet the Wife* for several months. If Boland said anything of the sort, it would have been for the *Meet the Wife* tour, not *The Cradle Snatchers*. Benchley, in *Humphrey Bogart*, called their feud a "two-year banishment," but that was clearly not the case, as only six months transpired between the end of the *Meet the Wife* tour and the first tryouts of *The Cradle Snatchers*.

48 **"Humphrey Bogart, the juvenile"**: *Daily News* (New York), February 8, 1925.

49 **"I had a choice between"**: *Modern Screen*, December 1940.

49 **"young lounge lizard"**: *Lima* [OH] *Daily News and Times-Democrat*, September 20, 1925.

49 **"The first night audience"**: "'Cradle Snatchers' Brings Laughter," *New York Times*, September 8, 1925.

49 **"freshly played"**: *Daily News* (New York), September 9, 1925.

49 **"as young and handsome"**: *Chicago Daily News*, September 9, 1925.

50 **"All the old women"**: *Photoplay*, July 1937.

50 **"to show what a romantic"**: Nunnally Johnson, oral history, July 2, 1971, Columbia Center for Oral History, Columbia University.

50 **"I'm allergic to glamour"**: *Modern Screen*, December 1940.

Chapter 5

51 **"Everybody in the theatre"**: Sperber and Lax, *Bogart*.

51 **Missing from the ceremony was Belmont**: Passenger and crew lists, SS *Santa Ana*, departing from Peru, arrived into New York on April 5, 1926. Belmont left again for Peru on June 6, 1926, two weeks *after* Humphrey's marriage, according to a later passenger manifest (July 26, 1926).

51 **"She got hysterics"**: Sperber and Lax, *Bogart*.

51 **"hastily . . . summoned"**: *Daily News* (New York), May 21, 1926.

52 **"I've been so frightfully occupied"**: Ibid.

52 **Her only theatrical prospect**: It was written by Vincent Lawrence and scheduled to play at the Palace (*Daily News* [New York], May 9, 1926).

52 **"against his wishes"**: Benchley, *Humphrey Bogart*.

53 **"I tried to make my marriage"**: United Press, as in *Brooklyn Times-Union*, November 13, 1927.

53 **"We quarreled over"**: Hyams, *Bogie*.

53 **"Women's organizations and"**: *Morning Telegraph* (New York), August 28, 1926.

53 **"prevent such an affront"**: *New York World*, August 20, 1926.

54 **"the clinical laboratory"**: *Brooklyn Daily Times*, September 30, 1926.

54 **"the province of pathologists"**: *New York Commercial Advertiser*, September 30, 1926.

54 **"Lesbian love walked out"**: *Morning Telegraph* (New York), September 30, 1926.

54 **"a collection of sins"**: *Theatre Arts Magazine*, February 1927.

54 **"girls like Irene"**: *Brooklyn Daily Times*, October 15, 1926.

54 **"Groups of unescorted girls"**: *New York Times*, March 9, 1927.

54 **"To believe that such stuff"**: *American Mercury*, March 1927.

54 **Newspapers owned by**: *New York American*, January 26, 1927.

55 **"What sort of woman"**: *New York American*, February 5, 1927.

56 **"the husband of Helen Menken"**: *Daily News* (New York), August 1, 1927.

56 **"I hate the idea"**: United Syndicate, as in *Morning Call* (Allentown, PA), November 19, 1927.

56 **"an old meany"**: Benchley, *Humphrey Bogart*.

56 **With the aristocratic**: *Brooklyn Citizen*, September 14, 1927.

57 **"I had had enough women"**: Hyams, *Bogie*.

57 **"actors trying to be gentlemen"**: Earl Wilson, *Earl Wilson's New York* (New York: Simon & Schuster, 1964).

57 **"Philips was putting"**: Bogart, *Bogart*.

57 **Sometime in the spring**: Sperber and Lax, in *Bogart*, apparently from an interview with Kenneth MacKenna, reported that Bogart ran into Philips after a showing of the film *The Jazz Singer* in the fall of 1927. However, for most of the fall he was touring with *Saturday's Children* in Detroit, Pittsburgh, and elsewhere. I feel it's more likely that MacKenna's memory was a bit faulty and it was after seeing the stage version of *The Jazz Singer*, which had a one-month revival in the spring of 1927, that the two met again. Bogart was definitively in New York at that point, and the timing fits with Menken's description of their official separation.

58 **"Humphrey Bogart gives"**: *Daily News* (New York), June 11, 1927.

59 **"excellent"**: *Detroit Free Press*, December 12, 1927.

59 **"exquisite and credible"**: *Chicago Tribune*, October 25, 1927.

59 **"Men hate to have women"**: *Detroit Free Press*, December 18, 1927.

Chapter 6

60 **Charles Farrell, then one**: United Press, as in *Sandusky* [OH] *Register*, April 27, 1930; *Hollywood Filmograph*, May 10, 1930.

61 **"There is no juvenile"**: Louella Parsons column, April 4, 1930, as in the *St. Petersburg* [FL] *Times*.

61 **"What the hell"**: Hyams, *Bogie*. Rose may have, yet again, been embellishing here to Hyams; whether the biographer actually saw the letter is unclear. However, it has the ring of authenticity, knowing Bogart's petulance when it came to his career.

62 **"There was no formal separation"**: *McCall's*, July 1949.

62 **"Love is very warming"**: *Modern Screen*, June 1938.

63 **FOOTLIGHTS DRAW SOCIETY GIRLS**: *Hartford* [CT] *Courant*, September 9, 1928.

63 **"a determined young lady"**: *Brooklyn Daily Eagle*, February 21, 1931.

63 **She had been born**: Details of Mary Philips's birth and family were discovered in New London and New Haven vital records, the 1880 and 1900 censuses for Connecticut, and the newspaper account of her father's death published in the *Morning Journal and Courier* (New Haven, CT), October 24, 1907.

63 **At age eight**: *Morning Journal and Courier* (New Haven, CT), December 24, 1908.

63 **"learning about the theatre"**: *Brooklyn Times-Union*, November 16, 1935.

63 **at the tender age of eighteen**: Some publicity (*New Haven* [CT] *Register*, January 1, 1929) put her age as early twenties when she went to New York, although her first play, *The Canary*, ran from November 1918 to March 1919, when she was eighteen. She turned nineteen before the play closed. The intent perhaps was to make her seem less a

wild child heading to the big city at eighteen; a similar spin was put on her background when she was referred to as a debutante.

63	**"With the intrepidity"**: *New Haven* [CT] *Register*, January 1, 1929.

64	**"and such other masculine tomfoolery"**: Syndicated column, as in *Hartford* [CT] *Courant*, July 22, 1934.

64	**"Mary is a mixture"**: Hyams, *Bogie*. The source of the quote is not clear. It did not turn up in newspaper database searches.

64	**"a strangely puritanical"**: Hyams, *Bogie*, from an interview with Philips.

64	**He and Mary were signed**: *Brooklyn Times-Union*, May 27, 1928.

65	**In August, Bogart and Philips**: *Bangor* [ME] *Daily News*, August 15, August 24, 1928; *Daily News* (New York), August 19, 1928.

65	**They also optioned a comedy**: *Brooklyn Daily Eagle*, April 12, 1928. The notice identified the playwrights as Maxwell Nurnberg and Harold Clarke; a few years later, a play written by them called *Chalk Dust* opened at New York's Experimental Theatre, a division of the Federal Theatre.

65	**"Mary Philips is a delight"**: *New Britain* [CT] *Herald*, April 29, 1930. The review is from the tour after the Broadway run.

65	**"legit business"**: *Variety*, March 6, 1929.

66	**Stuart Rose told a story**: Sperber and Lax, *Bogart*.

66	**"life was one extended hangover"**: Hyams, *Bogie*.

67	**"the heat and the humidity"**: *New York Times*, August 25, 1929.

67	**Winfield Sheehan**: *Variety*, April 18, 1930.

68	**"We were so modern"**: *Photoplay*, July 1937.

68	**"Nothing could make him leave"**: *Los Angeles Times*, October 19, 1930.

69	**He was paid $200**: Vitaphone Corporation contract, [n.d.] 1930, Humphrey Bogart Collection, Howard Gotlieb Archival Research Center, Boston University (hereafter HBC).

69	**The director, Arthur Hurley**: *Motion Picture News*, February 8, 1930.

69	**Production began in early August**: Bogart did not make *A Devil with Women* and *Up the River* simultaneously, as some sources have alleged. According to *Variety*, the first film began shooting the first week of June; Ford did not sign his Fox contract for *Up the River* until the second week. In July, the new name of *Sez You* was announced, suggesting that the film was completed by that point. The star of *Up the River*, Spencer Tracy, did not arrive in Hollywood until the first week of August, whereupon the film was shot in three weeks, as Tracy had a stage obligation starting September 1.

70	**"To me it was a wise move"**: *Los Angeles Times*, October 19, 1930.

71	**"for many years a summer"**: *Daily Messenger* (Canandaigua, NY), November 5, 1930.

71	**"roused no end of mirth"**: *Los Angeles Times*, October 17, 1930.

71	**"This film, made some time ago"**: *Variety*, October 22, 1930.

72	**"the many nights"**: *Los Angeles Herald*, November 8, 1947.

72	**One boisterous party**: *Los Angeles Times*, August 3, 1930.

72	**"Where are the wild"**: Consolidated Press Association, as in *Green Bay* [WI] *Press-Gazette*, November 24, 1930.

73	**Scaramouche, the impish character**: Benchley, *Humphrey Bogart*.

73	**"He was a disputatious fellow"**: Nunnally Johnson, oral history, June 10, 1971, Columbia Center for Oral History, Columbia University.

73 **"I can lick you"**: Hyams, *Bogie*. Hyams claimed that afterward Bogart and Farrell became good friends, but there's no real evidence of it.

74 **"My name is Humphrey Bogart"**: Benchley, *Humphrey Bogart*.

Chapter 7

75 **After seeing Mary in her hit**: *Daily News* (New York), June 11, 1931.

75 **"an extended vacation"**: *Los Angeles Times*, June 11, 1931.

76 **"welcomed back after"**: *Bangor* [ME] *Daily News*, July 7, 1931.

76 **"others in the cast"**: *Bangor* [ME] *Daily News*, September 8, 1931. I have relied on the *Daily News* for information on Lakewood's summer season. There was a notice that the company would end with *It's a Wild Child*, which Bogart had performed in on Broadway, and the company may have given him another substantial part that summer. But it appears that the play was replaced by *The Last Warning*.

76 **The local newspaper reported**: *Bangor* [ME] *Daily News*, July 30, 1931.

77 **"earnest"**: Mordaunt Hall, "Romantic War Fliers," *New York Times*, March 14, 1931.

77 **Then came a small part**: It's possible that the film, on first release, included Bogart's scenes, as he was listed in some cast lists published in newspapers. But I have so far not found a review that mentions his work in the film.

78 **"I was too short"**: Hyams, *Bogie*.

78 **"an unconscionable time"**: Brooks Atkinson, "Thicker than Water," *New York Times*, December 4, 1931. The Internet Broadway Database lists *After All* as opening on November 3, instead of the correct December 3.

79 **Good thing Mary**: The Internet Broadway Database credits Philips as appearing in Ed Wynn's *The Laugh Parade*, which ran from November 1931 until the spring of 1932, playing the part of a "winsome dancing girl." I could find no evidence of Philips appearing in the show; instead, she was still on tour with *House Beautiful* in February 1932. However, *The Laugh Parade* was choreographed by Albertina Rasch, whose party the Bogarts had attended a few months earlier in Hollywood.

79 **"Following telegraphic negotiations"**: Syndicated column, as in the *Tampa Tribune*, December 28, 1931.

79 **"a royal welcome"**: *Sacramento Bee*, December 23, 1931.

79 **"champeens"**: *Silver Screen*, April 1932.

79 **"perfect image of a stalwart"**: Press clipping, unsourced, Humphrey Bogart file, New York Public Library.

80 **"The increasing prominence"**: *Standard Union* (Brooklyn), March 31, 1931.

80 **"Cupiding"**: Walter Winchell column, as in the *Dayton Herald*, January 21, 1932.

80 **"got up too soon"**: *Fresno Bee*, January 20, 1932.

81 **"There he was, bandages"**: *Modern Screen*, December 1936.

81 ***Big City Blues***: Some Bogart filmographies have erroneously listed another Warner Bros. loan called *New York Town*. But that was the original name of *Big City Blues*.

81 **"I like Harry Cohn"**: *St. Louis Star and Times*, April 26, 1937.

81 **"who arrives for a visit"**: *Hollywood Citizen-News*, May 24, 1932.

81 **"the smart set of Hollywood"**: *Hollywood Filmograph*, May 24, 1932.

81 **"Humphrey Bogart was competent"**: *Los Angeles Times*, May 25, 1932.

83 **On September 3**: *Brooklyn Times-Union*, September 8, 1932.

83 **"impressively sinister"**: *Hollywood Filmograph*, n.d.

83 **"impressive in a brief role"**: *Brooklyn Daily Eagle*, October 31, 1932.

Chapter 8

84 **But it was Gilbert's coproducer**: Hyams, *Bogie*, gave the credit for Bogart's casting to Leslie Howard, asserting that the British star, when he had heard Humphrey's voice booming from the audition stage, declared that they had found their Duke Mantee. But it does not appear that Bogart had to audition; Sherwood suggested him to Hopkins, and the producer was sold. Besides, Howard wasn't even in the United States until the third day of rehearsals, when Bogart had already been cast. What Howard recommended him for was the film, a gesture for which Humphrey was always grateful.

84 **Hopkins had seen Humphrey**: *Silver Screen*, February 1941.

84 **"He thought of more than"**: John Mason Brown, *The Worlds of Robert E. Sherwood, Mirror to His Times* (New York: Harper & Row, 1965).

85 **"lean and hungry period"**: *St. Louis Star and Times*, April 26, 1937.

85 **"I thought I'd gone as far"**: *Silver Screen*, February 1941.

85 **"there were ten people"**: *Photoplay*, July 1937.

86 **"when sometimes he didn't"**: *Photoplay*, March 1941.

86 **"I have not been paying"**: Players Club archives, [n.d.], quoted in Sperber and Lax, *Bogart*.

87 **"he was drunk a good deal"**: Benchley, *Humphrey Bogart*.

87 **"worried about money"**: Hyams, *Bogie*.

88 **"A white thigh and tails evening"**: Benchley, *Humphrey Bogart*. His sources for this anecdote were Mary Philips and Mary Baker.

89 **In August, toward the end**: *Bangor* [ME] *Daily News*, August 21, 1934.

89 **On the night of *Mary Tudor*'s closing**: *Boston Globe*, August 30, 1934.

91 **"It was only in that moment"**: Hyams, *Bogie*.

91 **"She doubled up"**: *McCall's*, July 1949.

91 **"I thought my career was over"**: *Photoplay*, July 1937.

93 **"I just started thinking"**: *Picture Play*, ca. 1939.

93 **"baiting of the gangster"**: *Daily News* (New York), January 8, 1935.

93 **"he went about contriving it"**: Brooks, *Lulu in Hollywood*.

93 **"an excellent $14,000"**: *Variety*, January 1, 1935.

94 **"the best in town"**: *Variety*, January 8, 1935.

94 **"a roaring Western melodrama"**: *New York Times*, January 8, 1935.

94 **"Bogart's Beard"**: *Variety*, January 15, 1935.

94 **"that rare phenomenon"**: *Brooklyn Times-Union*, January 20, 1935.

94 **"There is something authoritative"**: *Variety*, January 15, 1935.

95 **He'd become Bogie**: The first use of "Bogie" as a nickname for Bogart that I could find was in the *Chicago Tribune*, August 26, 1936. It was during the making of *Black Legion*, with director Archie Mayo quoted as calling him Bogie. The name had likely been in use for some time before that, and there may be earlier examples, but it was only after that point that the media and the public began thinking of him as "Bogie" or sometimes "Bogey."

95 **"drinking steadily"**: Brooks, *Lulu in Hollywood*.

Chapter 9

99 **"The reaction of the chosen few"**: *St. Louis Globe-Democrat*, February 2, 1936.

99 **"The colony literally stormed"**: *Los Angeles Times*, January 12, 1936.

99 **"the striking performance"**: *Los Angeles Citizen-News*, January 7, 1936.

100 **"round-trip railroad transportation"**: Warner Bros. contract, October 2, 1935, HBC.

100 **Once the film was shot**: The contract, dated December 10, 1935, is in the Warner Bros. Archive at the University of Southern California (hereafter WBA).

100 **Although plans were immediately made**: According to *Film Daily*, December 16, 1935, Bogart's "first role under the new set of papers will be in James Cagney's next starring vehicle, *Over the Wall*."

101 **"like a bride"**: *Daily News* (New York), July 21, 1935.

102 **Perhaps to counter such talk**: See *Pittsburgh Post-Gazette*, July 30, 1935, and *Oakland [CA] Tribune*, August 15, 1935.

102 **"Bogie was devastated"**: Interview with Blanche Sweet, June 25, 1984.

103 **"I always knew one day"**: Hyams, *Bogie*.

103 **"He was quite plastered"**: Sperber and Lax, *Bogart*.

103 **Whether Robinson backed out**: "Humphrey Bogart steps into the role passed up by Edward G. Robinson," *Variety* reported on October 9, 1935, suggesting that it was Robinson who had withdrawn first. Louella Parsons maintained that Robinson had never been sold on the idea and had passed on the film because he saw it as a "Leslie Howard starring vehicle" in which he'd have to provide support (*San Francisco Examiner*, October 1, 1935).

103 NO BOGART NO DEAL: Bogart's various contracts, along with the studio's communications with Howard, are in WBA.

104 **"Humphrey Bogart is returning"**: *San Francisco Examiner*, October 1, 1935.

104 **"save Jack Warner some embarrassment"**: Sperber and Lax, *Bogart*.

104 **"staged with all the trimmings"**: *St. Louis Globe-Democrat*, January 27, 1936.

104 **"a line a block long"**: *Film Daily*, February 3, 1936.

105 **"more like Dillinger"**: Frank S. Nugent, "Heralding the Warner Brothers Film Version of 'The Petrified Forest,' at the Music Hall," *New York Times*, February 7, 1936.

105 **"just right for Bonaparte"**: *Los Angeles Times*, November 29, 1935.

105 **Then came an idea**: *Film Daily*, January 13, 1936.

105 **"quantity over quality"**: *New York Times*, July 11, 1936.

106 **"screen's three baddest 'bad men'"**: "News of the Week in Photo-Review," *Film Daily*, January 31, 1936.

106 **"easily one of the most"**: "Reviews of the New Films," *Film Daily*, May 18, 1936.

106 **"the blackest menace"**: *San Francisco Examiner*, May 29, 1936.

106 **The *Film Daily* had named**: *Film Daily*, March 17, 1936.

106 **"Probably more gangsters"**: *Los Angeles Daily News*, January 25, 1936.

107 **"knew the score"**: Mary Astor, draft of article, "Bogie Was for Real," which appeared in the *New York Times* on April 23, 1967, original in the Mary Astor Collection, Howard Gotlieb Archival Research Center, Boston University.

107 **"wasted in a role"**: *Brooklyn Daily Eagle*, August 12, 1936.

107 **"Humphrey Bogart has been"**: Lee Hugunin to T. C. Wright, July 7 and July 8, 1936, WBA.

108 **"I'll be damned"**: Wolfe to Fitzgerald, July 26, 1937, published in *Time*, July 27, 1959.

109 **"leaning against a sofa"**: Brooks, *Lulu in Hollywood*; also syndicated excerpts in various newspapers, 1982.

110 **Bogart had made the Hatches' acquaintance**: *Los Angeles Times*, February 25, 1936.

111 **"He found her at a time"**: Brooks, *Lulu in Hollywood*.

111 **"They were irresistible"**: Interview, M. O'Brien, August 15, 2020. O'Brien was a caregiver to Methot in her last years.

112 **Her first name was Isabel**: *Oregon Daily Journal* (Portland), May 5, 1916.

112 **"the wistful little waif David"**: *Oregon Daily Journal* (Portland), August 4, 1912.

112 **"I was very much charmed"**: *Oregon Daily Journal* (Portland), June 29, 1913.

112 **"If I can't be a second"**: *Capital Journal* (Topeka, KS), May 1, 1912.

113 **"lots of fighting"**: Interview, M. O'Brien, August 15, 2020.

113 **When she was fourteen**: *Oregon Daily Journal* (Portland), February 26, 1918.

113 **"It is her ambition"**: *Oregon Daily Journal* (Portland), November 26, 1922.

113 **Mayo's only offer**: *Salt Lake Tribune*, July 22, 1923.

114 **"almost exclusively with"**: *Daily News* (New York), January 6, 1924.

114 **In the fall of 1924**: *Daily News* (New York), October 13, 1924.

114 **"Mayo Methot handles"**: *Standard Union* (Brooklyn), February 5, 1929.

114 **"vital person with yellow hair"**: *Modern Screen*, March 1939.

115 **"In a part that would tax"**: *Los Angeles Evening Post-Record*, February 3, 1931.

115 **"Reservations have been made"**: *Los Angeles Express*, February 2, 1931.

Chapter 10

118 **"Hollywood is afraid"**: *Californian* (Salinas, CA), August 14, 1936.

118 **"renewed proof"**: *Daily News* (New York), February 27, 1936.

118 **"not up to expectations"**: Details of the run of *The Postman Always Rings Twice* come from the *Daily News* (New York), April 24, 1936, and *Variety*, March 4, 11, April 1, 29, 1936.

118 **"Mary Philips is leaving"**: *Brooklyn Times-Union*, April 22, 1936.

119 **"This is the first time"**: Hyams, *Bogie*.

120 **"Three hits in three times up"**: *Film Daily*, August 14, 1936.

120 **In October, a syndicated**: *Oakland* [CA] *Tribune*, October 23, 1936.

120 **The couple attended dinner parties**: *Los Angeles Times*, September 6, 20, 1936.

121 **In November 1936**: Syndicated column, as in the *Gaffney* [SC] *Ledger*, November 13, 1936.

121 **"distinctly American-looking actor"**: Robert Lord to Hal Wallis, [n.d.], 1936, WBA.

122 **"perfectly rounded character study"**: *New York Times*, January 18, 1937.

122 **"gradual disintegration of character"**: Ada Hanifin, *San Francisco Examiner*, January 22, 1937.

122 **"Bogart, an extremely fine actor"**: *Los Angeles Citizen-News*, February 19, 1937.

122 **"Despite that"**: *Variety*, January 20, 1937.

122 **"Very disappointing"**: *Variety*, January 27, 1937.

123 **"It is ironic and tragic"**: Frank Nugent, *New York Times*, January 24, 1937.

123 **"sinister fascist forces"**: *San Francisco Chronicle*, September 23, 1936.

124 **That association was made clear**: *Daily Worker*, October 5, 1936, listed the donors, in addition to Bogart, as Herbert Marshall, Gary Cooper, Gale Sondergaard, James and Lucile Gleason, Fred Keating, Lionel Stander, Edward Arnold, Eddie Cantor, Robert Montgomery, Melvyn Douglas, Brian Aherne, J. Edward Bromberg, Jean Muir, Fredric March, Florence Eldridge, Boris Karloff, and James Cagney.

125 **"an amicable separation"**: *Pittsburgh Post*, January 30, 1937.

125 **The divorce was finalized**: Divorce decree, Frances Rose v. Stuart Rose, June 21,

1937, Pat Bogart Rose file, Bogart/Bacall mss., Lilly Library, Indiana University, Bloomington (hereafter BBM).

126 **Her husband, Geoffrey Harper Bonnell**: Abstracts of World War I Military Experience; *Brooklyn Daily Eagle*, June 28, 1935; *Daily News* (New York), December 6, 12, 1936.

126 **"Nobody came to work"**: *McCall's*, July 1949.

127 **"She was parading down"**: Ibid.

127 **"pipe down"**: Sperber and Lax, *Bogart*.

128 **"In fact, I like to play"**: *Los Angeles Daily News*, January 29, 1938.

128 **"faded to poor"**: *Variety*, April 14, 1937.

129 **"not as big as expected"**: *Variety*, June 2, 1937.

129 **"Undoubtedly, the best"**: *Chattanooga* [TN] *Daily Times*, February 14, 1937.

130 **"Although both have confided"**: Read Kendall, *Los Angeles Times*, February 14, 1937.

130 **"Humphrey Bogart, being unraveled"**: Walter Winchell column, as in the *Courier-Post* (Camden, NJ), February 8, 1937, although it would have appeared a day or two before in his flagship paper, the *New York Daily Mirror*.

130 **Not for another couple**: *St. Louis Star and Times*, April 26, 1937.

131 **"sensational role in *Black Legion*"**: Ibid.

131 **"who wanted to have"**: Ibid.

131 **"was cast to advantage"**: Ada Hanifin, *San Francisco Examiner*, August 24, 1937.

Chapter 11

133 **The dark gray smoke rolling**: *Variety*, November 30, 1938.

133 **"Bette Davis and Humphrey Bogart"**: Paul Harrison column, as in the *Hastings* [NE] *Daily Tribune*, November 29, 1938.

134 **"But if I do"**: Alexander Kahn column, United Press, as in the *Clinton* [IL] *Daily Journal and Public*, November 23, 1938.

135 **"killed from every possible"**: International News Service, as in the *Salt Lake Tribune*, June 26, 1937.

135 **"dominates the scene"**: Kate Cameron, *Daily News* (New York), September 5, 1937.

135 **"the most striking performance"**: Norbert Lusk, *Los Angeles Times*, September 5, 1937.

135 **"the finest performance"**: Graham Greene, *Night and Day*, November 25, 1937.

135 **Although it would become**: *Variety*, September 3, 1937.

136 **Bogart's new, powerful agents**: Correspondence, production files, September 1937, WBA.

136 **"Humphrey Bogart, gun shooting"**: *Chicago Tribune*, August 10, 1937.

137 **As a sign of those feelings**: Myron Selznick to Humphrey Bogart, March 10, 1938, Philips divorce file, BBM.

137 **"Humphrey Bogart will marry"**: Sheilah Graham column, as in the *Kansas City Star*, August 13, 1937.

138 **"Why can't the best actor"**: Tay Garnett to Nathaniel Benchley, NBC.

138 **"Mayo is a frail-looking person"**: *Modern Screen*, February 1939.

139 **"Are you looking"**: Sheilah Graham column, as in the *St. Louis Globe-Democrat*, August 10, 1938.

140 **"My darling angel"**: Mayo Methot Collection (hereafter MMC); interview with M. O'Brien, August 15, 2020.

140 **"jittery . . . a little out of it"**: Sperber and Lax, *Bogart*.

140 **"couldn't agree on anything"**: *Modern Screen*, March 1939.

141 **"to do everything"**: Acro Associates, New York, to Morgan Maree, May 8, 1940, Kay Bonnell file, BBM.

141 **"She was a victim"**: Benchley, *Humphrey Bogart*.

141 **Bogie wired his brother-in-law**: The back-and-forth over Kay's hospital bill is documented in letters between Bogart and Bonnell as well as Morgan Maree and Gotham Hospital and its collectors, October 3, 5, November 29, 1938; January 20, February 4, September 13, 1939; April 24, May, 8, 31, 1940, Kay Bonnell file, BBM.

142 **He had finally been signed**: Warner Bros. contract summary, January 2, 1938, LBA.

143 **"It's pleasant here"**: *Modern Screen*, February 1939.

143 **"a refusal to conform"**: *Los Angeles Daily News*, January 29, 1939.

144 **"to play golf in the lower 70s"**: *St. Louis Star and Times*, April 26, 1937.

144 **"There are heavies"**: *Motion Picture*, May 1939.

145 **"There's a disturbing male element"**: *Motion Picture*, June 1939.

145 **"Humphrey, according to his biographers"**: Brooks, *Lulu in Hollywood*.

145 **"The Hollywoodsmen vowed"**: *Motion Picture*, February 1939.

145 **"frankly sexy"**: *Los Angeles Daily News*, May 19, 1939.

146 **"with a thick but not phony"**: *New York Post*, April 21, 1939.

146 **Hal Wallis announced**: Hal Wallis to Steve Trilling, February 22, 1939, Rudy Behlmer Papers, Margaret Herrick Library, Academy of Motion Picture Arts and Sciences (hereafter RBP).

146 **"Humphrey Bogart is wearing"**: United Press, as in *Oroville* [CA] *Mercury-Register*, April 4, 1939.

146 **A studio memo**: Al Alleborn, memo to T. C. Wright, March 20, 1939; Alleborn, memo to Wright, March 22, 1939, RBP.

147 **According to the testimony**: Sperber and Lax, *Bogart*.

147 **"If I feel like going"**: *Modern Screen*, June 1938.

148 **a curious profile**: "Bogey Man" appeared in the April 1940 issue of *Motion Picture*; I have drawn on her notes from the interview as well, located in the Gladys Hall Collection at the Margaret Herrick Library.

150 **"this stinking movie"**: Richard Gehman, *Bogart: An Intimate Biography* (New York: Gold Medal Books, 1965).

150 **"a no-dicer"**: *Variety*, December 27, 1939.

150 **"different strata"**: *Los Angeles Times*, November 10, 1939, and elsewhere.

151 **"He was ambitious"**: Sperber and Lax, *Bogart*.

151 **"Humphrey Bogart is only"**: *Philadelphia Inquirer*, October 28, 1939.

151 **He called him an "S.O.B"**: William Holden to Nathaniel Benchley, [n.d.], NBC.

152 **"purposely destroyed property"**: *Bakersfield* [CA] *Californian*, May 15, 1940.

152 **"the best part in the picture"**: Steve Trilling to Hal Wallis, October 19, 1939, RBP.

152 **"plans for Bogart"**: Ibid.

153 **"Humphrey Bogart parts"**: George Raft to Jack Warner, October 17, 1939, RBP.

154 **"Humphrey Bogart, Warners'"**: *Los Angeles Daily News*, April 5, 1940.

154 **"Bogart's role is to be imbued"**: *Los Angeles Times*, April 8, 1940.

154 **"Until *They Drive By Night*"**: *Whittier* [CA] *News*, September 17, 1940.

155 I NEVER RECEIVED: Humphrey Bogart to Hal Wallis, May 4, 1940, WBA.

156 **"Suddenly Warners have discovered"**: Louella Parsons column, as in *Deseret News* (Salt Lake City, UT), July 19, 1940.

156 **"I want you to give"**: S. Charles Einfeld to Martin Weiser, July 17, 1940, Martin Weiser Papers.

156 **"Now that Humphrey Bogart"**: Louella Parsons column, as in *Fresno Bee*, August 4, 1940.

157 **"Bogart, having apparently"**: *Motion Picture*, November 1940.

157 **"Now that he is a star"**: *Hollywood*, November 1940.

Chapter 12

159 **As the Communist candidate**: Information on John L. Leech comes from various issues of the *Los Angeles Times*, *Los Angeles Daily News*, and *Hollywood Citizen-News*, as well as Los Angeles city directories and voting lists, on which Leech is identified as a Communist.

160 **"professional witness"**: *Daily Worker*, June 25, 1953.

160 **"liberal Democrat"**: *Modern Screen*, June 1938.

160 HOLLYWOOD NAMES CITED: The headlines and subsequent quotes come from *Los Angeles Times*, August 15, 1940.

162 **"Very grave charges"**: *Hollywood Citizen-News*, August 16, 1940.

162 **"possible espionage"**: *Long Beach* [CA] *Press-Telegram*, August 16, 1940.

162 **"Bogart absent this morning"**: Production log, *High Sierra*, August 16, 1940, WBA.

162 **"strong CP leanings"**: Humphrey Bogart file, August–December 1940, Federal Bureau of Investigation.

162 **"read the doctrines"**: Ibid.

163 **"I'd say they were"**: This and other quotes following are taken from the transcript of the hearing, published in *Investigation of Un-American Propaganda Activities in the United States*, August 16, 1940 (Washington, DC: U.S. Government Printing Office, 1940).

166 **"Snarling in his best 'menace' manner"**: *Hollywood Citizen-News*, August 16, 1940.

166 **"Why, they were getting wires"**: *Los Angeles Times*, August 17, 1940.

166 **"the worst blow"**: *Modern Screen*, December 1940.

167 **"cooperate with us"**: Martin Gang to Buron Fitts, August 19, 1940, Dies file, BBM.

167 **"It's good enough"**: Sperber and Lax, *Bogart*.

168 **"Don't you think"**: Hal Wallis, memo to Jack Warner, September 18, 1940, WBA.

168 **"absolutely heaven and peaceful"**: Sperber and Lax, *Bogart*.

168 **In 1945, she'd reveal**: *Screenland*, November 1945. Lupino said that she and Bogart had since made up.

168 **"plenty of temperament"**: Louella Parsons column, as in *San Francisco Examiner*, September 29, 1940.

168 **"the problem of convincing"**: Henry Blanke to Jack Warner, January 31, 1941, RBP.

168 **"casting pictures"**: Steve Trilling to Roy Obringer, March 17, 1941, RBP.

169 **To Sheilah Graham later**: Sheilah Graham column, as in *St. Louis Globe-Democrat*, June 18, 1941.

169 **"a verbal battering"**: Quoted in Sperber and Lax, *Bogart*, unsourced clipping bylined Thomas Wood, [n.d.] 1943.

169 **Production records reveal**: Production log, *High Sierra*, WBA.

169 **"building up Humphrey Bogart"**: *Variety*, November 5, 1940.

170 **"any and all claims"**: Court receipt, Humphrey Bogart to Margaret Beaulieu, April 13, 1938, Frances Rose file, BBM.

170 **"It's my idea of heaven"**: Pat Rose to Humphrey Bogart and Mayo Methot, [n.d.], 1939, Frances Rose file, BBM.

170 **"As you know, Pat relies"**: Humphrey Bogart to Stuart Rose, March 16, 1939, Frances Rose file, BBM.

171 **"A very heavy expense"**: Noll Gurney to Jack Warner, April 13, 1937, WBA.

171 **"I cannot and never will"**: Humphrey Bogart to Martha Allen, October 27, 1939, Frances Bogart file, BBM.

171 **"private and very pleasant"**: Humphrey Bogart to Stuart Rose, October 27, 1939, Frances Bogart file, BBM.

172 **Bogie threatened legal action**: Humphrey Bogart to Arthur Brennan, July 10, 1940, Legal file, BBM. Rose reported on the 1940 census form that he had made $5,000 in the previous forty-nine weeks, although many people underreported their income on the form.

172 **"died as she lived"**: *McCall's*, July 1949. Although Stephen Bogart wrote that Maud had gone into the hospital to die, her death certificate reports both her place of death and her residence as 8221 Sunset Boulevard.

172 **"Here is my heart"**: Maud Bogart to Mayo Methot Bogart, [n.d.], MMC.

173 **The same scene was repeated**: *Film Daily*, January 27, 1941; *Los Angeles Daily News*, January 29, 1941.

173 **"strange sense of inevitability"**: John Huston to Hal Wallis, March 21, 1940, RBP.

174 **"plays the lead role"**: *New York Times*, January 27, 1941.

174 **"*High Sierra* reinstates"**: *Los Angeles Times*, January 22, 1941.

174 **Zero was not**: *Philadelphia Inquirer* and others, January 31, 1941. (Hat tip to P. M. Bryant's blog, *Let Yourself Go . . . to Old Hollywood*.)

175 **"He was quite irritated"**: Sperber and Lax, *Bogart*.

175 **"killer-diller roles"**: *Brooklyn Daily Eagle*, December 10, 1940.

176 **"Remember *Private Lives*"**: *Modern Screen*, March 1939.

176 SEEMS LIKE A GOOD IDEA: Humphrey Bogart, cable to Henry Blanke, December 15, 1940, RBP.

177 IT SEEMS TO ME: Humphrey Bogart, cable to Jack Warner, January 16, 1941, RBP.

177 **"one-punch feud"**: Louella Parsons column, as in *San Francisco Examiner*, April 13, 1941.

177 DEAR HAL, I AM SENDING: Humphrey Bogart to Hal Wallis, March 6, 1940, RBP.

178 **"Humphrey Bogart has a sense"**: Louella Parsons column, as in *San Francisco Examiner*, April 13, 1941.

179 **"Are you kidding"**: Quoted in Steve Trilling, memo to Roy Obringer, March 17, 1941, RBP. The following quotes also come from this source.

180 **"Morgan will not finish"**: Roy Obringer to Jack Warner, April 18, 1941, RBP.

181 **"Mr. Bogart is badly hampered"**: *New York Times*, May 10, 1941.

181 **"not an important picture"**: George Raft to Jack Warner, June 6, 1941, RBP.

182 **"I've been on a little suspension"**: Sheilah Graham column, as in the *St. Louis Globe-Democrat*, June 18, 1951.

182 **"He has been on his boat"**: *Philadelphia Inquirer*, June 9, 1941.

Chapter 13

184 **"Practically no direction"**: Sperber and Lax, *Bogart*.

184 **"no movie hero"**: Astor, "Bogie Was for Real."

184 **"not particularly impressive"**: John Huston, *An Open Book* (New York: Alfred A. Knopf, 1980).

184 **"adopted a leisurely"**: Hal Wallis to Henry Blanke, June 12, 1941, WBA; John Huston to Hal Wallis, June 13, 1941, RBP.

185 "**the whip-cracking speed**": Astor, "Bogie Was for Real."

185 **"He'd had theatre experience"**: Mary Astor, oral history, June 7, 1971, Columbia Center for Oral History, Columbia University.

185 **"One solid sequence"**: Henry Blanke to Hal Wallis, June 30, 1941, RBP.

186 **"You put this in somebody"**: Astor, "Bogie Was for Real."

186 **"an old-timer can fend"**: Robbin Coons column, as in *News-Pilot* (San Pedro, CA), July 15, 1941.

186 **"the same that George Raft"**: Robbin Coons column, as in *Pensacola* [FL] *News Journal*, July 21, 1941.

186 **"first detective role"**: Virginia Vale column, as in *Charlotte* [NC] *News*, August 6, 1941.

187 **That was pure PR hokum**: Astor, "Bogie Was for Real." See also Mary Astor, *A Life on Film* (New York: Delacorte Press, 1971).

187 **"A story should be prepared"**: Sam Jaffe to Steve Trilling, August 4, 1941, RBP.

188 **"Bogart picked fights"**: Interview, Vincent Sherman, May 5, 1999.

188 **"When he was drunk"**: Astor, "Bogie Was for Real."

188 **"a slight goose"**: [Hal Wallis?] to Jack Warner, October 8, 1941, RBP. New York publicists were described as being "not sufficiently sold on the picture to get behind it importantly."

188 ***"The Maltese Falcon," declared***: *New York Times*, October 4, 1941.

189 **"enjoyed a powerful weekend"**: *Variety*, October 8, 1941. Other box-office details come from *Motion Picture Daily*, October 10, 14, 1941.

189 **"very good guy"**: *Chicago Tribune*, December 13, 1941. Chicago box-office receipts come from *Variety*, December 17, 1941.

189 ***"The Maltese Falcon, I venture"***: *Los Angeles Times*, November 21, 1941.

190 **"pulled a boner"**: Ed Sullivan column, *Los Angeles Times*, December 1, 1941.

191 **"with equal doses"**: *St. Louis Post-Dispatch*, December 11, 1941.

191 **When the Bogarts arrived**: Information on the rally comes from *St. Louis Globe-Democrat*, December 9, 10, 1941; *St. Louis Star and Times*, December 11, 1941; and *St. Louis Post-Dispatch*, December 11, 1941.

192 **The press kept up its coverage**: The nickname "Sluggy" likely referenced both Mayo's and Bogie's fists. There are references to the name being used for Mayo as early as 1939, and "Sluggy Hollow" is mentioned in *Modern Screen*, December 1940, both before the Raft incident.

192 **"He never troubles himself"**: *Life*, June 12, 1944.

192 **Warner Bros. had rewarded him**: Warner Bros. contract summary, January 5, 1942, HBC.

193 **"When Mayo Methot speaks"**: *Hartford Courant*, November 17, 1943.

193 **"gave up her career"**: Quote from Jaik Rosenstein in Hyams, *Bogie*.

193 **"made him contemptuous and bitter"**: Astor, "Bogie Was for Real."

194 **"morbidly faithful"**: Sperber and Lax, *Bogart*.

194 **"sex was low"**: Benchley, *Humphrey Bogart*.

194 **"a gold necklace that must"**: Jimmie Fidler column, as in *Tampa Bay Times*, March 15, 1942.

195 **The scene had taken**: The description of the first day's shoot comes from production records for *Casablanca*, WBA, as well as from correspondence in WBA and RBP.

195 **"to get over to the audience"**: Casey Robinson in a note attached to a memo from Hal Wallis to Michael Curtiz, May 25, 1942, WBA.

196 **"to sacrifice a little"**: Hal Wallis to Arthur Edeson, May 26, 1942, RBP.

196 **"sheer hokum melodrama"**: Robert Buckner to Hal Wallis, January 6, 1942, WBA.

196 **"They thought the dialogue"**: Aljean Harmetz, *Round Up the Usual Subjects* (New York: Hyperion, 1992).

196 **"I kissed him, but"**: Bergman said this in the 1967 television documentary *Bogart*, quoted in *El Paso Herald-Post*, April 24, 1967.

197 **"that ever-resourceful facer"**: *New York Times*, January 24, 1942.

197 *All Through the Night* **racked up**: *Variety*, January 21, 1942.

197 **"the Golden Age of crime"**: *New York Times*, July 18, 1942.

197 **"Let's hurry up and get"**: Astor, "Bogie Was for Real."

197 **REACTION OF AUDIENCE**: Jack Warner, cable to S. Charles Einfeld et al., May 22, 1942, WBA.

198 **"How can I play"**: Sperber and Lax, *Bogart*.

198 **"There is a danger"**: "Suggestions for Revised Story," [n.d.], Howard Koch Papers, Wisconsin Center for Film and Theatre Research (hereafter HKP).

198 **Before the cameras started rolling**: Al Alleborn to T. C. Wright, July 18, 1942, RBP.

199 **Koch, whose script doctoring**: "Suggestions for Revised Story," HKP. The Howard Koch Collection also provided various versions of the *Casablanca* script for comparison, including the original play, *Everybody Comes to Rick's*.

199 **"not just solving"**: "Notes on *Casablanca*," May 20, 1942, WBA.

199 **"story conference between"**: Production records, *Casablanca*, May 25, 1942, WBA.

199 **"Louis, I think this is"**: Hal Wallis to Owen Marks, August 7, 1942.

200 **"Their neighbors were lulled"**: The quote appears to have originated in Peter Bogdanovich, *Pieces of Time* (New York: Arbor House, 1973).

200 **A Warners publicist**: Sperber and Lax, *Bogart*.

Chapter 14

201 **Ann Sheridan had just left**: In her memoir, *Bogie and Me: A Love Story* (New York, St. Martin's Press, 1982, with Donald Shepherd), Verita Peterson Thompson placed the *Casablanca* wrap party in winter 1942. The film was actually finished in August. But she also remembered that at the time, Sheridan was working on *King's Row*, which was produced in the summer of 1942. The overlap of the two suggests that Thompson's memory was correct on the details but off on the month.

201 **"Warners ground out so many"**: Thompson, *Bogie and Me*.

203 **"They were holding hands"**: Interview, Nita Rodrigues, January 15, 2022.

203 **She had been born**: Birth and family information comes from Arizona vital records and the 1920, 1930, and 1940 censuses. The documents sometime conflict with Peterson's memories of the past. She said that both her parents had died, when in fact

her father had lived to 1957. He may, however, have abandoned his daughter to his parents.

203 **Pete would try to upgrade**: Pete wrote that her grandfather was a surgeon who had spent much of his time "lecturing at medical facilities like Johns Hopkins." Richard Ellis was, in fact, called a physician in some of his obituaries, but census records going back to 1900 refer to him as either the manager of an ice company or a cattle rancher. If he had been a medical practitioner, he'd been out of that field for at least a couple of decades by the time his granddaughter was born.

204 **"a week's trip to Los Angeles"**: *Arizona Daily Star*, June 26, 1934.

204 **Vera didn't win**: *Tucson Citizen*, July 12, 1934.

204 **The last notice of her**: *Arizona Daily Star*, July 25, 1935.

205 **"She could trade cuss word"**: Interview, Dean Shapiro, December 1, 2021.

207 **"take advantage of this"**: Hal Wallis to Charles Einfeld, November 11, 1942, RBP

207 **"beyond belief"**: Hal Wallis to Jack Warner, November 12, 1942, RBP.

207 **"The highest ever scored"**: *Variety*, December 2, 1942.

208 **"a goldmine"**: Hal Wallis to Benjamin Kalmenson, February 22, 1943, RBP.

208 **"rich, suave, exciting"**: *New York Times*, November 27, 1942.

208 **The crew filming a scene**: Sidney Skolsky column, as in the *St. Louis Post-Dispatch*, August 10, 1943; Paul Harrison column, as in the *New Haven* [CT] *Register*, September 7, 1943.

209 **"I'll make the rest"**: Draft script of *Conflict*, April 1943, WBA.

210 **"something to do"**: Sperber and Lax, *Bogart*.

210 **"I love a good fight"**: *Modern Screen*, March 1939.

210 **The screenwriter Allen Rivkin**: Sperber and Lax, *Bogart*.

211 **"Aboard the cruiser"**: *Life*, June 12, 1944.

211 **"We miss you both"**: Louis Bromfield to the Bogarts, January 5, 1943, MMC.

212 **"She was fetching"**: United Press, as in the *Hobart* [OK] *Democrat-Chief*, August 22, 1943.

212 **"a very injurious effect"**: *Richmond* [VA] *Times-Dispatch*, November 17, 1943.

213 **"ice-cold martinis"**: The story was told by the actor Kurt Krueger to Michael Flam for his article in the *New York Post*, July 30, 1992.

213 **"Where are we going today?"**: Sperber and Lax, *Bogart*.

213 **"little idiosyncrasies"**: Thompson, *Bogie and Me*.

213 **"self-indulgence [for] knocking"**: Associated Press, as in the *Argus* [SD] *Leader*, March 3, 1942.

214 **"She was a talented actress"**: Sperber and Lax, *Bogart*.

214 **"This is personal"**: Transcription of telephone call between Humphrey Bogart and Jack Warner, May 17, 1943, WBA.

214 **"It is my opinion"**: Martin Gang to Sam Jaffe, May 13, 1943, Legal file, BBM.

215 **"He came back into"**: *Life*, June 12, 1944.

215 **"subjective melodrama"**: *Los Angeles Times*, June 23, 1945.

216 **"cool and calculated"**: *New York Times*, June 16, 1945.

216 **"the largest single audience"**: *Brooklyn Daily Eagle*, September 1, 1943.

216 **"a smash," earning a "dandy"**: *Variety*, October 20, 1943.

217 **"rat-a-tat-tat"**: United Press, as in *Fresno* [CA] *Bee*, December 19, 1943.

217 **"a blankety blank gangster"**: Ibid.

218 **"Allegations that the Subject"**: Humphrey Bogart file, December 7, 1943, Federal Bureau of Investigation.

218 **"more mileage abroad"**: Wire report, as in *Brookville* [IN] *Democrat*, December 23, 1943.

218 **"We have good warm clothes"**: Mayo Methot to Evelyn Wood Methot, [n.d.], MMC.

219 **"She had no voice"**: Sperber and Lax, *Bogart*.

220 **"distilling themselves"**: *Saturday Evening Post*, August 2, 1952.

220 **"It has been quite"**: Mayo Methot to Evelyn Wood Methot, January 29, 1944, MMO.

220 HE ABSOLUTELY REFUSES: Mort Blumenstock to Steve Trilling, February 9, 1944, WBA.

Chapter 15

225 **In the basement**: *Daily News* (New York), October 21, 1941; *Pittsburgh Press*, October 14, 1941. Leo Shull would later go on to publish the influential trade weekly *Show Business*.

225 **"so desperately to be someone"**: Lauren Bacall, *By Myself and Then Some* (New York: HarperCollins, 2006).

225 **"Show me Max Gordon"**: *Screenland*, January 1945.

225 **It was outside Sardi's**: I have placed the meeting between Bacall and Lukas, undated in *By Myself*, in October 1941, due to the fact that the first issue of *Actors Cues* was published on September 30, 1941, and that the tip sheet was "banished from the Walgreen's basement" toward the end of the month. (*Pittsburgh Press*, October 31, 1941.)

226 **"I brazenly cornered him"**: Bacall, *By Myself*.

226 **The marriage was not**: Louella Parsons column, as in the *San Francisco Examiner*, March 1, 1950; Dorothy Kilgallen column, as in *Mercury* (Pottstown, PA), May 15, 1950; Erskine Johnson column, as in the *Salt Lake Telegram*, June 7, 1950. The Lukases did not end up divorcing.

226 **"the Windmill"**: *Life*, May 7, 1945.

226 **"My dream was to star"**: *Saturday Evening Post*, May 21, 1966.

226 **"He remembered me"**: Bacall, *By Myself*.

227 **Spooner had managed the publicity**: *Box Office*, November 11, 1939; *Variety*, September 20, 1939, November 8, 1941.

227 **Forty years old**: 1930 and 1940 censuses. In his 1942 draft registration, he did not give his wife as the person who would know how to reach him; city directories reveal that she was living in Milwaukee. Like Lukas, however, Spooner remained married to his wife.

227 **"I made Fred laugh"**: Bacall, *By Myself*.

229 **"you could squeeze in 495"**: Ibid.

230 **"a large cast of young people"**: *Brooklyn Citizen*, August 19, 1941.

230 **"Naturally, I thought"**: Bacall, *By Myself*.

230 **"I recall her audition"**: Interview, Miles White, June 11, 1997.

230 **"My audition was no good"**: Bacall, *By Myself*.

231 **"a Dead End kid"**: *Life*, May 7, 1945.

232 **"Bogie didn't believe him"**: *Vanity Fair*, March 2011.

232 **"The prettiest theatre usher"**: *Esquire*, July 1942.

232 **"A world I knew nothing about"**: Bacall, *By Myself*.

232 **"personable New York Communist"**: *Life,* May 7, 1945.

232 **"blitzkrieged"**: Ibid.

Chapter 16

234 **Betty Bacal made her first**: In her memoir, Bacall gave the Grand Concourse
Hospital as her place of birth, but that was a colloquial description of the hospital
because it was located on the Grand Concourse.

234 **Betty's father was William Persky**: Information on Bacall's father comes from
census records, including the New York State census of 1915. His occupation as a
druggist comes from his World War I draft registration of 1917 and has not previously
been reported; Bacall does not describe him as such in *By Myself.* This is possibly
because of his arrest and the ensuing scandal, which forced him out of the profession.
He seems to have adopted the affectation "Perske" at a later point, perhaps to obscure
his history to investigative reporters. The physical description of William Persky comes
from his draft registration.

235 **"I fell in love with her"**: *Los Angeles Times,* February 19, 1979.

235 **An active member**: *Chat* (Brooklyn), June 3, 1922.

235 **They were both arrested**: *Brooklyn Daily Eagle,* July 14, 1923; *Standard Union*
(Brooklyn), July 15, 1923; *Brooklyn Times-Union,* July 15, 1923.

236 **If his family was hoping**: *Brooklyn Daily Eagle,* October 10, 1923.

236 **Everett Winter, the doctor**: AMA Deceased Physician file, June 27, 1938, *Brooklyn
Times-Union,* March 15, 1935, April 22, 1935; *Brooklyn Daily Eagle,* February 2, 1936.
Winter was sentenced to Leavenworth on April 28, 1935, and was discharged from the
prison hospital in September 1937. His license was revoked on November 9, 1937. He
died just seven months later.

237 **"The wheat is suffering"**: Wire report, *Fremont* [NE] *Tribune,* April 1, 1903.

238 **"The tenements grow taller"**: Jacob Riis, *How the Other Half Lives: Studies Among
the Tenements of New York* (New York: Scribner's, 1890).

238 **"One family fact"**: Bacall, *By Myself.*

238 **At 1512 Washington Avenue**: New York City directory, 1906; 1910 census; 1915 New
York State census.

238 **By 1920, they'd moved**: 1920 census; 1925 New York State census.

239 **"I get anything I want"**: *Life,* May 7, 1945.

239 **"She liked nothing more"**: *Daily Times-News* (Burlington, NC), April 3, 1946.

240 **"Everything that Betty"**: *Los Angeles Times,* February 19, 1979.

242 **"correct English and how"**: *New York Tribune,* December 26, 1920.

243 **"climbed trees, fell out"**: Notes, [n.d.], 1944, Gladys Hall Collection (hereafter GHC).

243 **"took [Betty] in"**: Charles Weinstein to Betty Bacall, October 12, 1944, Lauren Bacall
Collection, Howard Gotlieb Archival Research Center, Boston University (hereafter
LBC).

244 **"a tiny room for me"**: Bacall, *By Myself.*

244 **Fighting against racketeering**: *Daily News* (New York), October 23, 1934.

245 **"the teaching of poise"**: *Brooklyn Daily Eagle,* August 17, 1939.

245 **When she graduated**: Francis Sill Wickware obtained her official school records for
his article in *Life,* May 7, 1945.

246 **"the day came"**: Bacall, *By Myself.*

246 **"I'd rather have you"**: *Screenland,* January 1945.

247 **"I, too, am an American"**: *Daily News* (New York), December 22, 1939.
247 **"Wars and rumors of war!"**: *Spotlight*, yearbook of Julia Richman High School, 1940.

Chapter 17

249 **"practically dog-trotting"**: *Screenland,* January 1945.
249 **She'd read that Gordon**: Various newspapers in late November carried reports of
 Gordon looking to put together a third company of *My Sister Eileen*, such as *Brooklyn
 Daily Eagle*, November 30, 1941.
249 **"Hopes rose"**: Bacall, *By Myself.*
250 **"read the lines hanging"**: *Screenland,* January 1945.
250 **Fortunately, the Walter Thornton Agency**: Betty would later quibble about
 Thornton's involvement in the gig. In 1954, while he was being investigated for false
 advertising and after he'd been using her name to promote his client list, she told a
 court investigator: "As far as I can recall, he did not get me more than one modeling job,
 if that." Lauren Bacall to William Kerwik, Queens County Courthouse, May 17, 1954,
 Bogart general file, BBM.
250 **"Betty must have done"**: Charles Weinstein to Natalie Bacal, January 7, 1942, LBC.
250 **"I really loved it"**: Lauren Bacall, interview notes, [n.d.] 1944, GHC.
252 **"I was to dance with"**: Bacall, *By Myself.*
253 **"the sea of extras"**: United Press, as in the *New London* [CT] *Day*, March 3, 1942.
253 **"looked like rush hour"**: *Billboard*, March 28, 1942.
253 **Brown was hiring**: *Daily News* (New York), February 25, 1942. He married Karen Van
 Ryn, who played Maxine in *Johnny 2×4* four months later.
254 **"He regards them"**: *Variety*, February 18, 1942. A notice had appeared in the *Boston
 Globe* on January 23 reporting that *Johnny 2×4* would begin tryouts in Boston on
 February 16, but a close examination of *Globe* issues from that date until the New York
 opening revealed the show never previewed there.
254 **"with extravagant care"**: *Daily News* (New York), March 29, 1942.
254 **"on Saturday night"**: Contract between Betty Bacall and Rowland Presentations,
 March 12, 1942, LBC.
254 **"Headlines in the near future"**: Betty Kalb to Betty Bacall, March 16, 1942, LBC.
254 **"that being an actress"**: Bacall, *By Myself.*
254 **"A hack's dream"**: *New York Times*, March 17, 1942.
254 **"a tawdry and rather dated"**: *Variety*, March 18, 1942.
254 **"It must be pretty disappointing"**: *Daily News* (New York), March 29, 1942.
255 **"The Battle of the Sexes"**: Wire report, as in the *Shreveport* [LA] *Times*, June 9, 1942.
256 **"Max Gordon always gave me"**: Bacall, *By Myself.*
257 **"He chased them around"**: Note, unknown author, attached to a letter from Betty
 Bacall to Natalie Bacal, postmarked April 7, 1943. The note mentioned that the
 incident took place at the Waldorf. Dorothy Kilgallen reported on March 6, 1942,
 that Pidgeon was staying at the Waldorf as part of the Defense Savings Bond drive.
 The report "leaving a trail of swooning females" comes from Kilgallen's column of
 March 2, 1942, as in *Star-Gazette* (Elmira, NY). Pidgeon was apparently a bit of a
 sexual adventurer. Scotty Bowers, the well-known bartender and procurer for the stars,
 reported that Pidgeon picked him up for sex on Bowers's first day in Hollywood after
 getting out of the war in 1945. Interview, Scotty Bowers, May 2, 2002. Also reported in
 Bowers, *Full Service* (New York: Grove Atlantic, 2012).

258 **By the time rehearsals**: *Daily News* (New York), August 26, 1942. This Sam Jaffe was not the same Sam Jaffe who served as Bogart's agent.

258 **"She was darling"**: Sperber and Lax, *Bogart*.

259 **"All I cared about"**: Bacall, *By Myself*.

259 **"Just continue as you are"**: Charles and Rosalie Weinstein to Betty Bacall, September 16, 1942, LBC.

259 **"May this be one"**: Natalie Bacal to Betty Bacall, September 16, 1942, LBC.

259 **"In as few words"**: *News Journal* (Wilmington, DE), September 19, 1942.

259 **"The comic pranks"**: *Evening Star* (Washington, DC), September 22, 1942.

260 **"Dear Betty Bacall"**: George Kaufman to Betty Bacall, [n.d.] 1942.

261 **"a good deal older than I"**: Bacall, *By Myself*.

261 **Gunzburg, born in Paris**: *Vanity Fair*, August 18, 2014.

262 **"[Why don't you]"**: Diana Vreeland, *D.V.* (New York: Knopf, 1984).

262 **"Very direct in manner"**: Bacall, *By Myself*.

263 **"I was never terribly good"**: Lauren Bacall, oral history, June 29, 1971, Columbia Center for Oral History, Columbia University.

Chapter 18

264 **Around 8:30 a.m., the *Chief* steamed**: Atchison, Topeka and Santa Fe Railway System timetable, 1943.

266 **"a scene straight out"**: *Saturday Evening Post*, May 21, 1966.

266 **"My secretary made"**: Howard Hawks, oral history, July 7, 1971, Columbia Center for Oral History, Columbia University.

266 **"arranged transportation"**: Interview notes, 1944, GHC.

267 **"I entrust Betty"**: Bacall, *By Myself*.

267 **"Oh, how boring"**: Lauren Bacall, oral history, June 29, 1971, Columbia Center for Oral History, Columbia University.

267 **"Just a note, Betty"**: George Kaufman to Betty Bacall, [n.d.], LBC.

268 **"It's clean, and kind of cute"**: Betty Bacall to Natalie Bacal, April 7, 1943, LBC.

269 **Hawks had a different memory**: Sperber and Lax, in *Bogart*, dismissed Hawks's version of events, pointing out that Feldman's records indicate the money laid out for Bacall's trip to Los Angeles. Yet that was Feldman, not Hawks. Hawks would say essentially the same thing in several different interviews: he hadn't intended for Betty to come west, and once she was there, he had no plans to use her. It's possible that Hawks's account was colored by his subsequent conflict with Bogart and Bacall, but his statements about that period are otherwise remarkably consistent.

269 **"This very eager girl arrived"**: The quotes in this paragraph come from Howard Hawks, oral history, July 7, 1971, Columbia Center for Oral History, Columbia University, and the Howard Hawks Papers, July 27, 1977, Brigham Young University (hereafter HHP).

270 **"The only women I have"**: Howard Hawks, oral history, July 7, 1971, Columbia Center for Oral History, Columbia University.

270 **"She only has about"**: Betty Bacall to Natalie Bacal, May 3, 1943, LBC.

270 **"A real Passover dinner"**: Betty Bacall to Natalie Bacal, April 21, 1943, LBC.

271 **"How do you feel?"**: Bacall, *By Myself*.

271 **"My test was more fun"**: Betty Bacall to Natalie Bacal, May 3, 1943, LBC.

272 **"cold and ruthless"**: Sperber and Lax, *Bogart*.

272 **wouldn't want to be a dog**: Ibid.

272 **"He'd like it"**: Bacall, *By Myself*.

272 **"I was so frightened"**: *Vanity Fair*, March 2011.

273 **"She had a dilemma"**: Sperber and Lax, *Bogart*.

273 **"What did he really think?"**: Bacall, *By Myself*.

273 **"and if it's good enough"**: Betty Bacall to Natalie Bacal, May 7, 1943, LBC.

273 **"Svengali-ing"**: Lauren Bacall, oral history, June 29, 1971, Columbia Center for Oral History, Columbia University.

274 **"If and when something"**: Betty Bacall to Natalie Bacal, May 3, 1943, LBC.

274 **Records in Feldman's file**: Charles K. Feldman Collection, Special Collections, Brigham Young University (hereafter CFC).

274 **"Please without fail"**: Betty Bacall to Natalie Bacal, May 7, 1943, LBC.

274 **"one or two summer prints"**: Betty Bacall to Natalie Bacal, May 3, 1943, LBC.

275 **"Haven't met June Vincent"**: Betty Bacall to Natalie Bacal, May 3, May 7, 1943, LBC.

275 **For a brief period, Slim**: *Variety*, September 3, 1941.

275 **"She had great personal style"**: Bacall, *By Myself*.

276 **"Betty really emulated Slim"**: Sperber and Lax, *Bogart*.

277 **Judge Joseph W. Vickers**: The details of Bacall's court case come from her legal file, WBA; United Press reports, June 9, 16, 1943; and *Los Angeles Times*, June 16, 1943.

278 **"I must have been born"**: Lauren Bacall, *Look*, November 3, 1953.

278 **"soldiers who had no place"**: Bacall, *By Myself*.

279 **"the delightful child"**: Hedda Hopper column, as in *Daily News* (New York), September 21, 1943.

279 **"There was no clap"**: Bacall, *By Myself*.

Chapter 19

281 **Their night had begun**: Although her letter to Natalie describing these events (and the weather) is not dated, the only Los Angeles–area theater showing *Casablanca* between September and December 1943 was the Elite in Beverly Hills, less than a mile from Betty's apartment on South Reeves Drive. On the first night of *Casablanca*'s run, the city was pounded by torrential rains, along with hail and flurries of snow (*Los Angeles Times*, December 6, 1943). I've been unable to place the restaurant None-Such, but it was likely part of the None-Such Cafeteria chain founded by Charles H. Stillwell in Los Angeles in 1911.

282 **"I thought he was a good"**: Lauren Bacall, oral history, June 29, 1971, Columbia Center for Oral History, Columbia University.

282 **"Saw Dennis at the commissary"**: Betty Bacall to Natalie Bacal, December [n.d.], 1943, LBC.

283 **"Be sure that we get"**: Steve Trilling to Leo Forbstein, February 22, 1944, RBP.

283 **"Please buy me some"**: Betty Bacall to Natalie Bacal, December [n.d.], 1943, LBC.

283 **"When producer Howard Hawks"**: *Times-Tribune* (Scranton, PA), March 7, 1944.

283 **"newcomer Lauren Bacall"**: *Deseret News* (Salt Lake City, UT), March 31, 1944.

284 **"First-day jitters"**: Harold Heffernan column, as in *Record* (Hackensack, NJ), March 10, 1944.

284 **"We noticed a kind"**: Howard Hawks, oral history, July 7, 1971, Columbia Center for Oral History, Columbia University.

284 **"I don't do too well"**: Howard Hawks, oral history, July 27, 1977, Howard Hawks Papers, Special Collections, Brigham Young University.

285 **"had very little to do"**: *Life*, May 7, 1945.

285 **"It worked," she recalled**: Bacall, *By Myself.*

285 **"An insinuating pose"**: *Life*, May 7, 1945.

285 **"He wanted me in"**: Bacall, *By Myself.*

286 **"We rolled our eyes"**: Associated Press, as in *New Haven* [CT] *Register*, June 12, 1966.

286 **"He addresses men"**: *Life*, June 12, 1944.

287 **"He looks wonderful"**: Betty Bacall to Natalie Bacal, April 5, 1944, LBC.

287 **"We were joking"**: Bacall, *By Myself.*

Chapter 20

293 **"Bogie had a lot"**: Sperber and Lax, *Bogart.*

293 **"Howard, you've got"**: Howard Hawks Papers, July 27, 1977, BYU.

294 **"The way they did"**: Sperber and Lax, *Bogart.*

295 **"Bogie always said"**: Thompson, *Bogie and Me.*

295 **"Bogie's approach to work"**: Lauren Bacall, oral history, June 29, 1971, Columbia Center for Oral History, Columbia University.

296 **"There's an awful lot"**: *Time*, June 7, 1954.

296 **"There are just two moods"**: Jimmie Fidler column, as in *Sioux City* [SD] *Journal*, March 9, 1944.

297 **"scrappily enduring"**: Jimmie Fidler column, as in *Sioux City* [SD] *Journal*, April 1, 1944.

297 **"Both are unpretentious"**: *Life*, June 12, 1944.

297 **"Take her downtown"**: *Vanity Fair*, March 2011. The quote comes from Bacall.

299 **"Our pal Bogart"**: Steve Trilling to Jack Warner, May 29, 1944, WBA.

299 **"sick of these ungrateful"**: Jack Warner to Steve Trilling, May 25, 1944, WBA.

300 **"I know what was meant"**: Humphrey Bogart to Betty Bacall, 1944. Bacall included excerpts of Bogart's letters in her memoir, although not all of them are dated. The originals of the letters, however, are not part of her collection at Boston University, unlike the letters to her mother and from her uncles.

300 **"There you will find"**: Wire report, as in *Indianapolis Star*, May 29, 1944.

302 **"For a time there"**: Wire report, as in *New Haven* [CT] *Register*, October 30, 1945. He was speaking in general, not specifically about the women in his life, but those situations would have factored into his confusion.

302 **"Bogart is banned"**: *Saturday Evening Post*, August 2, 1952.

302 **"He was either perfectly"**: Thompson, *Bogie and Me.*

303 **"Bogie's baiting was"**: Nunnally Johnson, oral history, June 10, 1971, Columbia Center for Oral History, Columbia University.

303 **In Bogart's private legal files**: Hubbard's South Coast Company work order, May 27, 1944. The Coast Guard submitted its report to the insurance company on August 11, 1944.

303 **"only in for a check-up"**: Louella Parsons column, as in *Pittsburgh Sun-Telegraph*, September 20, 1944.

304 **"I am surprised"**: Louella Parsons column, as in *Tampa Daily Times*, July 11, 1944.

304 **Memos in the Warner Bros.**: Transcript, phone call, Humphrey Bogart and Steve Trilling, July 27, 1944, WBA.

304 **"Christ! Mayo's heading"**: Bacall, *By Myself*.

305 **"We had a confidential talk"**: Hedda Hopper notes, March 25, 1957, HHPH.

306 **"I had to ask"**: Bacall, *By Myself*.

306 **"The gossip stuff"**: *Screenland*, May 1945.

307 **"with overtones of Veronica Lake"**: The quote is given in the *Saturday Evening Post*, May 21, 1966, although the original source is not cited.

307 **"gay, lavish, and lush"**: *Screenland*, September 1944.

307 **"she drinks almost nothing"**: *Life*, June 12, 1944.

307 **"Have you seen Joyce yet?"**: Betty Bacall to Natalie Bacal, April 5, 1944, LBC.

308 **"I saw the Warner releases"**: Jacques Bacal to Natalie Bacal, September 25, 1944.

309 **"Mother is not well again"**: Jacques Bacal to Natalie Bacal, September 15, 1944, LBC.

309 **"she wouldn't live through it"**: Jacques Bacal to Natalie Bacal, September 25, 1944, LBC.

309 **"Grandma knew that good things"**: Bacall, *By Myself*.

309 **"The services were simple"**: Jacques Bacal to Natalie Bacal, September 25, 1944, LBC.

309 **"There is much more"**: *New York Times*, October 12, 1944.

310 **"You haven't seen"**: *Los Angeles Daily News*, January 20, 1945.

310 **"a young wolverine"**: *Pittsburgh Post-Gazette*, February 2, 1945.

310 **"Lauren Bacall [is]"**: *Life*, June 12, 1944.

311 **"strangely fascinating"**: *Boston Globe*, February 23, 1945.

311 **"hoarse monosyllables"**: *Chicago Tribune*, May 1, 1945.

311 **"husky, underslung voice"**: *Life,* June 12, 1944.

311 **"You are a perfect foil"**: Charles Weinstein to Betty Bacall, October 12,

312 **The enterprising Marty Weiser**: Marty Weiser to Alex Evelove, October 18, 1944, RBC.

312 **"I see my name"**: Interview notes, early 1945, GHC.

312 **"I never knew"**: *Screenland*, May 1945.

313 **"It took fame for me"**: Bacall, *By Myself*.

313 **"that way"**: Walter Winchell column, as in the *Shamokin* [PA] *News-Dispatch*, October 20, 1944.

314 **"It could be"**: Thompson, *Bogie and Me*.

314 **"It's not easy to put"**: Charles Weinstein to Betty Bacall, October 12, 1944, LBC.

315 **"a baby Mae West"**: Dorothy Kilgallen column, as in *Pittsburgh Post-Gazette*, October 25, 1944.

315 **"most rehearsed kiss"**: Marty Weiser to Alex Evelove, November 1, 1944, RBC.

Chapter 21

316 **According to the ledgers**: Methot divorce files, Morgan Maree, September 27, 1944; Morgan Maree to Jerry Geisler, October 30, 1944; and other dates, BBM.

317 **"It is the intent"**: Bill of sale, Humphrey Bogart to Mayo Bogart, April 15, 1945, BBM.

317 **"She must make up"**: Louella Parsons column, *Los Angeles Examiner*, March 16, 1945.

317 **"I want to bring you"**: Robert Milton to Mayo Methot, May 20, 1945, MMC.

317 **"Would you rent"**: Gertrude Hatch to Mayo Methot, July 3, 1945. MMC.

317 **"As of noon today"**: Leonard Lee to Elizabeth Fletcher Brackett, January 5, 1945, Charles Brackett Papers.

318 **"There is really nothing"**: *Screenland*, May 1945.

318 **corner table as "the cradle"**: *Life*, June 12, 1944.

318 **"Sure, Baby and I"**: INS wire report, as in *Courier-Post* (Camden, NJ), January 31, 1945.

318 **"It was evident"**: Thompson, *Bogie and Me*.

318 **"I felt as if I owned"**: Bacall, *By Myself*.

319 **"Relations were somewhat strained"**: Ibid.

319 **"wheelchair job"**: Howard Hawks, oral history, July 7, 1971, Columbia Center for Oral History, Columbia University.

320 **"Those things just happen"**: Ibid.

320 **"You walked out there"**: Lauren Bacall, oral history, June 29, 1971, Columbia Center for Oral History, Columbia University.

320 **"a little bit of a fairy"**: Howard Hawks, oral history, July 7, 1971, Columbia Center for Oral History, Columbia University.

321 **"Are we holding a wake?"**: Eric Stacey to T. C. Wright, December 26, 1944, RBP.

321 **"The end of the marriage"**: Hyams, *Bogie*.

321 **"to straighten him out"**: T. C. Wright to Roy Obringer, December 26, 1944, RBP.

321 **"My mother and father"**: *Heart of Ohio*, May–June 2012.

322 **Betty and Bogie had chosen**: Details of the wedding ceremony come from the exclusive access given to reporters from *Mansfield* [OH] *News-Journal* and *Advocate* (Newark, OH), May 22, 1945.

322 **"Don't be disheartened"**: Bacall, *By Myself*.

323 **"many women find too late"**: *McCall's*, December 1945.

323 **"We are gathered here"**: Wedding script on Municipal Court letterhead, May 21, 1945, LBC. Bacall would later claim that they had changed "obey" to "cherish," but neither word is found in the script.

323 **"Bogie shed tears"**: *Time*, June 7, 1954.

324 **"You'd think Warner Bros."**: *Brooklyn Eagle*, November 3, 1945.

324 **"close to being"**: *New York Times*, November 3, 1945.

325 **"hundred times better"**: [Hal Wallis?] to Benjamin Kalmenson, August 23, 1945, RBP.

325 **Despite being savaged**: *Variety*, November 14, 1945.

325 **"Not a nickel of which"**: *Saturday Evening Post*, May 21, 1966.

325 **"She was delighted with it"**: Howard Hawks, oral history, July 7, 1971, Columbia Center for Oral History, Columbia University.

325 **"When he talked about her"**: Sperber and Lax, *Bogart*.

326 **"more insolent than Bogart"**: Charles Feldman to Jack Warner, November 16, 1945; Jack Warner to Charles Feldman, November 21, 1945, WBA.

326 **"The way to get"**: Howard Hawks to Jack Warner, December 18, 1945, HHP.

326 **"Lauren's name may be"**: Central Press wire report, as in *Star Press* (Muncie, IN), July 8, 1945.

327 **"she became a legal adult"**: Associated Press, as in *Gazette* (Cedar Rapids, IA), November 26, 1945.

329 **"didn't seem to be a devoted"**: *Silver Screen*, October 1945.

329 **On December 10, he**: Master's Oath for License of Vessel, License No. 26, December 10, 1945, BBM.

329 **"Next to an actor"**: Warner Bros. press release, [n.d.], 1948, HBC.

330 **"lean, hard, and brown"**: *Saturday Evening Post*, August 2, 1952.

330 **"Lauren works as part"**: North American Newspaper Alliance wire report, as in *Kansas City Star*, November 25, 1945.

330 **"She was trim, sleek"**: Original draft to the introduction to Joe Hyams's *Bogie*, LBC.

331 **"There were times"**: Bacall, *By Myself*.

Chapter 22

332 **"We came into"**: Sperber and Lax, *Bogart*.

332 **"With his actress wife"**: *Los Angeles Herald-Express*, October 26, 1947.

333 **"The point was freedom"**: Patrick McGilligan and Paul Buhle, *Tender Comrades: A Backstory of the Hollywood Blacklist* (New York: St. Martin's Press, 1997).

333 **"We are against communism"**: *Los Angeles Herald-Express*, October 26, 1947.

334 **"thought police of imperial Japan"**: Katharine Hepburn, recording, May 19, 1947, Gilmore Stadium, Wisconsin Center for Film and Television Research.

334 **"Any investigation into"**: Bacall, *By Myself*.

335 **"a pest removal fund"**: *Hearings Regarding the Communist Infiltration of the Motion Picture Industry*, October 20, 1947, Library of Congress.

335 **"could conceivably be willing"**: Oliver Schwab to Jennings Lang, Jaffe Agency, September 28, 1946, Humphrey Bogart contract file, BBM.

336 **"The proposition was"**: *New York Herald Tribune*, September 29, 1946.

336 **In 1947, he was paid**: Humphrey Bogart taxable income, 1947, Federal income tax file, BCC.

336 **"were angry"**: Sperber and Lax, *Bogart*.

336 **"These people saw Communists"**: Bacall, *By Myself*.

337 **"Betty was all for it"**: Sperber and Lax, *Bogart*.

338 **"one hundred percent better"**: Jack Warner to Benjamin Kalmenson, February 9, 1946, RBP.

338 **"News of the week"**: *Variety*, August 28, 1946.

338 **"Baby is still glamorous"**: *Valley Times* (North Hollywood, CA), September 19, 1946.

339 **"Isn't this a stupid way"**: Sperber and Lax, *Bogart*.

339 **"fumbled for a way"**: *Brooklyn Eagle*, January 23, 1947.

339 **"beyond criticism"**: *New York Times*, January 23, 1947.

340 **"One of the problems"**: Production notes, [n.d.] 1946, Daves (Delmer) Papers, Special Collections and University Archives Department, Stanford University (hereafter DDP).

340 **"The shots you made"**: Jerry Wald to Delmer Daves, November 19, 1946, DDP.

341 **"does not appear"**: *New York Times*, September 6, 1947.

341 **Audiences agreed**: *Variety*, September 10, 1947.

341 **"We're not talking"**: Sperber and Lax, *Bogart*.

341 **He told Gladys Hall**: Gladys Hall, notes, [n.d.], 1951, GHC.

342 **"did a lot of good"**: Howard Hawks, oral history, July 7, 1971, Columbia Center for Oral History, Columbia University

342 **"I'd probably [just] sit"**: Gladys Hall, notes, [n.d.], 1951, GHC.

342 **"was giving him hell"**: Nunnally Johnson, oral history, June 10, 1971, Columbia Center for Oral History, Columbia University.

343 **"Bogie could be difficult"**: *Saturday Evening Post*, May 21, 1966.

343 **"He's a complex guy"**: *Saturday Evening Post*, August 2, 1952.

343 **"A newspaper person"**: Nunnally Johnson, oral history, June 10, 1971, Columbia Center for Oral History, Columbia University.

343 **"Not even close to that"**: *Vanity Fair*, March 2011.

343 **"A lot of Dad's fears"**: Bogart, *Bogart*.

344 **"When they first met"**: Lauren Bacall, oral history, June 29, 1971, Columbia Center for Oral History, Columbia University.

344 **"Noël, if I had"**: *Vanity Fair*, March 2011.

344 **"He doesn't walk, he flies"**: Otto Preminger, *Preminger: An Autobiography* (Garden City, NY: Doubleday, 1977).

344 **"Don't pay any attention"**: Sperber and Lax, *Bogart*. Although Gloria Stuart told Sperber that Pat's troubles had been reported in newspapers identifying her as Bogart's sister, a search of thousands of digital newspapers did not turn up any mention of her.

344 **"He always spoke"**: Hyams, *Bogie*.

345 **"seriously jeopardize future deals"**: Sam Jaffe to Humphrey Bogart, February 6, 1947, Legal file, BBM.

346 **"a good-luck gesture"**: Don Page to Roy Obringer, March 20, 1947, RBP.

346 **"[He] steals the picture"**: H.C. (Hal Croves, aka B. Traven) to John Huston, February 2, 1947, JHP.

346 **"I don't know if"**: Bogart, *Bogart*.

346 **"very happy about doing"**: Sam Jaffe to John Huston, September 11, 1946, JHP.

347 **"We worked as hard"**: United Press, as in the *Charlotte* [NC] *News*, June 28, 1947.

347 **"our one and only quarrel"**: Bogart, *Bogart*.

347 **"that would be like"**: Associated Press, as in the *Asheville* [NC] *Citizen-Times*, February 3, 1947.

347 **The eventual winner**: Associated Press, as in the *Spokesman-Review* (Spokane, WA), July 22, 1947.

348 **"He was improbable"**: Jack Anderson, *Confessions of a Muckraker: The Inside Story of Life in Washington During the Truman, Eisenhower, Kennedy and Johnson Years* (New York: Random House, 1979).

349 "**a parade of stool pigeons**": Committee on Un-American Activities, *Hearings Regarding the Communist Infiltration of the Motion Picture Industry*, 80th Congress, 1st Session, October 1947 (Washington, DC: Government Printing Office, 1947); "A Statement by John Howard Lawson," published in Gordon Kahn, *Hollywood on Trial* (New York, 1948).

350 **"how the papers had turned"**: Huston, *An Open Book*.

351 **"Hollywood's march on Washington"**: *Kansas City Times*, October 27, 1947.

351 **"complete support"**: *New York Times*, October 30, 1947.

352 **"also would be banned"**: *New York Times*, November 2, 1947.

353 **"We will attend no more"**: Hedda Hopper column, as in *Daily News* (New York), November 7, 1947.

353 **"wonderful job"**: Florence George Crosby to Hedda Hopper, November 7, 1947, HHPH.

353 **"I don't know now"**: Bacall, *By Myself*.

Chapter 23

354 **"All right, you mug"**: Associated Press, as in the *Denton* [TX] *Record-Chronicle*, January 6, 1948.

354 **sensitive to the way**: Edward G. Robinson, *All My Yesterdays* (New York: W. H. Allen, 1974).

355 **"has lost faith"**: John Huston to Margaret Chase, February 10, 1948, RBP.

355 **"have modernized"**: *Variety*, January 7, 1948.

356 **"well worth the outlay"**: *New York Herald Tribune*, November 23, 1947.

356 **"anything [they] could tell him"**: Sullivan's call is reported in a memo in Bogart's FBI files, November 24, 1947. Who he spoke with at the Bureau is unknown.

356 **"He bawled the life out"**: *Photoplay*, March 1948. The charity event was likely for the New York University–Bellevue Medical Center, which Sullivan wrote about in his column in *Daily News* (New York) on November 5, 1947. The event was televised.

356 **"I am not a Communist"**: Many papers, including *Times Leader* (Wilkes-Barre, PA), ran the statement in full on December 4, 1947.

356 **BOTH BOGART BACALL**: Jack Warner to Mort Blumenstock, December 11, 1947, WBA.

357 **"tell all"**: George Sokolsky column, as in *Marion* [OH] *Star*, December 22, 1947.

357 **"The only man who behaved"**: Sperber and Lax, *Bogart*.

357 **"Here is illustrated"**: *Washington Post*, December 4, 1947.

359 **She was suspended**: Bacall, *By Myself*; Louella Parsons column, as in the *Tampa Bay Times*, May 12, 1947.

359 **"Can't quite understand"**: Jack Warner to Lauren Bacall, April 28, 1947, Jack Warner file, BBM.

359 **she snapped**: Transcript of telephone call between Lauren Bacall and Jack Warner, April 15, 1948, RBP.

359 **"special, unique"**: Lauren Bacall to Jack Warner et al., April 20, 1948, RBP.

360 **"Jack Warner kept giving"**: Bacall, *By Myself*.

360 **"much 'chica-chica' lately"**: Lauren Bacall to Morgan Maree, April [n.d.], 1947, Lauren Bacall file, BBM.

361 **"he has practically"**: Henry Blanke to Don Page, February 4, 1947, RBP.

361 **"You don't owe me"**: Thompson, *Bogie and Me*.

362 **For *The Barefoot Contessa***: Sam Jaffe to Humphrey Bogart, December 8, 1953, courtesy Estate of Verita Thompson.

362 **"We had the biggest fight"**: Bacall, *By Myself*.

363 **"I wanted to leave"**: Bogart, *Bogart*.

363 **"the hater of our people"**: *New York Daily Mirror*, October 29, 1947.

363 **"I write with the purpose"**: Chet Holifield to Humphrey Bogart, December 9, 1947, John Huston Papers, Margaret Herrick Library, Academy of Motion Picture Arts and Sciences (hereafter JHP).

364 **"felt coerced"**: Bogart, *Bogart*.

364 **"reign of fear"**: *Christian Science Monitor*, December 22, 1947.

364 **"anything wrong with"**: *Hollywood Citizen-News*, January 29, 1948.

364 **"Don't try to fox"**: George Sokolsky column, as in the *Winona* [MN] *Daily News*, February 6, 1948.

365 **"pressure groups"**: Hedda Hopper column, as in the *Fort Worth Star-Telegram*, June 22, 1949.

365 **Opening in fourteen cities**: *Variety*, February 4, 1948.

365 **"Stars of the movies"**: *New York Times*, January 24, 1948.

365 **"The character change"**: *Los Angeles Times*, January 15, 1948.

366 **"You won't find a more"**: *Brooklyn Eagle*, July 25, 1948.

366 **"unsuspected warmth"**: *Los Angeles Daily News*, July 17, 1948.

366 **"war-weary veteran"**: *Pittsburgh Press*, July 23, 1948.

366 "Bogart gets a new role": United Press, as in *Lubbock* [TX] *Evening Journal*, May 24, 1949.

367 **After just one film**: Santana's finances are documented in its balance sheets and financial statements, September 11, 1948, Santana Production files, BBM.

368 **"Bogie could be very hostile"**: Interview, Gloria Stuart, May 5, 2000.

368 **"words slurring together"**: Memo to Jack Warner, October 11, 1948, WBA.

369 **On Saturday night**: My account is culled from Bacall, *By Myself*; Joe Hyams, *Bogie*; Nathaniel Benchley, *Humphrey Bogart*; *Time*, October 10, 1949; *New York World-Telegram*, September 28, 1949; *Daily News* (New York), September 28, 29, October 1, 2, 1949; *New York Post*, September 29, 1949; and several other wire reports.

369 **On the way to El Morocco**: My account of the "panda" fracas is pieced together as accurately as possible using many different sources, including contemporary news articles, court reports, and recollections of some of those involved. These sources include: *Hollywood Citizen-News*, September 30, 1949; *Time*, October 10, 1949; *Los Angeles Daily News*, September 28, 1949; *Daily News* (New York), September 28, 29, 30, 1949; *New York World-Telegram*, September 28, 1949; *New York Post*, September 29, 1949, October 1, 1949; Lee Mortimer's column, as in the *Post-Star* (Glens Falls, NY), February 6, 1957; and the court transcript, September 30, 1949, Legal file, BBM. Also see Bacall's account in *By Myself*.

369 **"hates my guts"**: United Press, as in *Times* (Shreveport, LA), September 30, 1949.

370 **"a gangster"**: A. M. Sperber may have confused John Jelke with his younger brother Mickey, who served a prison sentence for running a high-class prostitution ring. Though the police also investigated John, they never found any evidence to link him to his brother's activities.

372 **"Even according to"**: Court transcript, September 30, 1949, Legal file, BBM.

372 **"The incident, spread"**: Erskine Johnson column, as in *Bakersfield* [CA] *Californian*, November 3, 1949.

373 **"too far"**: Irving Lazar to John Huston, June 26, 1953, JHP.

Chapter 24

375 **"The greatest show"**: *Daily News* (New York), March 15, 1951.

375 **NEW RED HEARINGS**: *Los Angeles Times*, February 17, 1951.

375 **"I certainly do not"**: Gladys Hall, notes, [n.d.], 1951, GHC.

375 **"We have never been"**: *Daily Mirror* (London), March 21, 1951.

376 **a bit of a "tizzy"**: Gladys Hall, notes, [n.d.], 1951, GHC.

376 **"Little Stephen Bogart"**: Louella Parsons column, as in *Cincinnati Enquirer*, March 12, 1951. The Bogarts took care of Hartley's medical and burial bills, purchasing a plot for $140 at Inglewood Park Cemetery (deed of sale, July 20, 1951, Bogart general file, BBM).

376 **"What happened next"**: Bogart, *Bogart*.

377 **"He wanted my attention"**: Bacall, *By Myself*.

377 **"I don't know what"**: Gladys Hall, notes, [n.d.], 1951, GHC.

377 **"never held his child"**: *Saturday Evening Post*, August 2, 1952.

377 **"Successful marriage"**: *Daily Mirror* (London), March 21, 1951.

378 **"They delayed in obtaining"**: Abe Lastfogel to Katharine Hepburn, February [n.d.], 1951, Katharine Hepburn Papers, Margaret Herrick Library, Academy of Motion Picture Arts and Sciences (hereafter KHP). The telegram must have been sent in February, as the address was Minneapolis; Hepburn was performing in *As You Like It* at the Lyceum Theatre there from February 12 to 17.

378 **"It was hot as hell"**: Katharine Hepburn, *The Making of* The African Queen (New York: Knopf, 1987).

379 **"You don't think that money"**: *Time*, October 27, 1947.

379 **"appeared [at the fundraiser]"**: Associated Press, as in the *Zanesville* [OH] *Times Recorder*, October 21, 1947.

380 **"I rather feel like"**: Morgan Maree to John Sinn, February 6, 1951, Dies file, BBM.

381 *Tokyo Joe* **seemed to have**: *Motion Picture Daily*, November 2, 1949.

381 **"sputters more than it sizzles"**: *New York Times*, October 27, 1949.

381 **"hit some air pockets"**: *Variety*, November 2, 1949.

381 **"mediocre business"**: *Variety*, March 1, 1950.

381 **"for all and sundry"**: Morgan Maree to Humphrey Bogart, October 16, 1950, Legal file, BBM.

382 **"The sheer accumulation"**: *New York Times*, January 26, 1951.

382 **"slightly platitudinous"**: *New York Times*, June 14, 1951.

383 **"[Its] title perfectly defined"**: Louise Brooks, *Sight and Sound*, Winter 1966–67.

383 **In Ray's papers**: Scripts for *In a Lonely Place* are located in the Nicholas Ray Papers, Harry Ransom Center, University of Texas at Austin.

383 **"I just couldn't believe"**: Quoted in Bernard Eisenschitz, *Nicholas Ray: An American Journey* (Minneapolis: University of Minnesota Press, 2011).

384 **"a big" $80,000**: *Variety*, May 24, 31, 1950.

384 **"were such as we"**: *Los Angeles Times*, May 25, 1950.

384 **"Everybody should be happy"**: *New York Times*, May 18, 1950.

384 **Ziv paid them a fee**: Morgan Maree, Business files, various dates 1951–1953, BBM.

385 **In 1947, for example**: Bogart and Bacall, taxable income, 1947, Federal income tax file, BBM.

385 **"We worked well together"**: Bacall, *By Myself*.

386 **"Take away the sound track"**: *New York Times*, February 12, 1950.

386 **"Lauren Bacall has"**: *New York Times*, February 12, 1950.

386 **"considerably more pre-selling"**: *Variety*, March 29, 1950.

386 **"not big"**: *Variety*, June 21, 1950.

386 **"Jack Warner kept giving me"**: Bacall, *By Myself*.

387 **"looking like a strawberry"**: Louella Parsons column, as in *Times-Tribune* (Scranton, PA), July 13, 1950.

387 **In fact, they were**: "Cancellation of Contract and Mutual Release," July 12, 1950, Bacall legal file, WBA.

387 **"hasty and unjustified"**: David Tannenbaum, Swarts Ziffren & Steinberg, to Lauren Bacall, July 21, 1948, Bacall legal file, BBM.

387 **"I do not wish to rehash"**: Lauren Bacall to Jack Warner, July 27, 1948, Bacall legal file, BBM.

387 **"I feel that Miss Bacall"**: *Hollywood Reporter*, October 20, 1949.

387 **"I have been advised"**: Lauren Bacall to Warner Bros., October 20, 1949, Warner Bros. file, BBM.

388 **"We definitely refuse"**: Roy Obringer to Lauren Bacall, October 20, 1949, Warner Bros. file, BBM.

388 **"We assume you will"**: Roy Obringer to Lauren Bacall, November 22, 1950, Bacall legal file, BBM.

388 **"He was one of the most"**: Bacall, *By Myself*.

388 **"As I see it now"**: *Los Angeles Times*, July 12, 1950.

389 **"Once the party ran"**: *Saturday Evening Post*, August 2, 1952.

389 **"I anticipated his early collapse"**: Hepburn, *The Making of* The African Queen.

390 **"Interesting girl"**: Transcript of interview [n.d.] 1952, GHC.

390 **"With his almost aggressive personality"**: *Time*, May 1, 1954.

390 **One assistant director said**: Lawrence Grobel, *The Hustons* (New York: Charles Scribner's Sons, 1989).

391 **When Huston nearly roped**: Bacall, *By Myself*.

391 **"did not love the African"**: Lauren Bacall, oral history, June 29, 1971, Columbia Center for Oral History, Columbia University.

391 **"God, I've had enough"**: Lauren Bacall to Morgan Maree, July 4, 1951, Lauren Bacall file, BBM.

391 **"should get out"**: Hepburn, *The Making of* The African Queen.

392 **"When he talked about Mayo"**: Sperber and Lax, *Bogart*.

392 **She hadn't hurt for money**: United Press, as in the *Albany* [OR] *Democrat-Herald*, August 2, 1951.

392 **She was diagnosed**: Death certificate, Mayo Methot Bogart, June 27, 1951, State of Oregon.

393 **"This should wind up"**: Lauren Bacall to Morgan Maree, June 30, 1951, Lauren Bacall file, BBM.

393 **"The gangway was pushed up"**: Bacall, *By Myself*.

394 **"Katie dear, can imagine"**: Lauren Bacall to Katharine Hepburn, May [n.d.] 1952, KHP.

395 **"If we do it"**: Humphrey Bogart to Morgan Maree, July 4, 1951, Lauren Bacall file, BBM.

395 **"The picture would be"**: John Huston to David O. Selznick, February 8, 1952, David O. Selznick Collection, Harry Ransom Center, University of Texas at Austin.

395 **"would prefer to work"**: Morgan Maree to John Huston, January 29, 1952, JHP.

396 **"red hot news"**: *Daily Worker*, July 11, 1951.

396 **"certain Hollywood organizations"**: Humphrey Bogart to Spyros Skouras, April 3, 1952, Dies file, BBM.

396 **"During the past five years"**: Spyros Skouras to Humphrey Bogart, March 28, 1952, Dies file, BBM.

396 **"I think this would be"**: Morgan Maree to Humphrey Bogart, August 1, 1951, Legal file, BBM.

396 **"organized, methodical syndicate"**: Kefauver introduction, November 27, 1951, Legal file, BBM.

397 **"had never given"**: Kate Cameron, *Daily News* (New York), February 21, 1952.

397 **"You've never seen"**: Jane Cody, *Brooklyn Eagle*, February 21, 1952.

397 **"Bogart as the new Bogart"**: *Los Angeles Times*, January 25, 1952.

398 **"He had really wanted"**: Bacall, *By Myself*.

Chapter 25

399 **Sixty excited movie fans**: *Variety*, June 16, 23, 1954; *Motion Picture Daily*, June 24, 1954; *Daily News* (New York), June 23, 1954.

400 **"the things that you"**: Morgan Maree to Lauren Bacall, June 22, 1951, Legal file, BBM.

401 **"I spoke to Betty"**: Nunnally Johnson, oral history, June 10, 1971, Columbia Center for Oral History, Columbia University.

401 **"I would have to make"**: Bacall, *By Myself*.

402 **"attracted outstanding attention"**: *Variety*, November 11, 1953.

402 **"In the lingo of merchandising"**: *New York Times*, November 11, 1953.

403 **"was pointing to a smash season"**: *Variety*, November 11, 1953.

403 **"cold and waspish"**: *New York Times*, November 11, 1953.

403 **"crisp, efficient, and entirely engaging"**: *Pittsburgh Post-Gazette*, November 12, 1953.

404 **Bogart threw himself**: For a detailed account of Bogart's producer role, see JHC; see also Grobel, *The Hustons*.

404 **"ten thousand and one microphones"**: Humphrey Bogart to Morgan Maree, March 16, 1953, Humphrey Bogart file, BCC.

404 **But RCA refused**: Jess Morgan to Humphrey Bogart, March 16, 1953, Humphrey Bogart file, BCC.

404 **"He wrote like fury"**: Joe Hyams, *Cue*, August 16, 1954.

404 **"he'd never seen anyone"**: Lauren Bacall, oral history, June 29, 1971, Columbia Center for Oral History, Columbia University.

404 **"would fall out so"**: Hyams, *Bogie*.

405 **"It's not the type"**: Hedda Hopper column, as in *Hartford Courant*, August 27, 1953.

405 **That swiftly brought a telegram**: Humphrey Bogart to Jeanie Sims, August 27, 1953, JHC.

405 **But Hopper refused**: The unknown assistant actually used the phrase "non persona gratis," which is incorrect, in a letter to Huston on August 28, 1953, JHC.

405 **HAVE SHOWN PICTURE**: Humphrey Bogart to John Huston, November 24, 1953, JHC.

406 **Less than a week later**: Bogart's contract is dated September 28, 1953. Paramount Collection, Margaret Herrick Library, Academy of Motion Picture Arts and Sciences.

406 **During its first week**: *Variety*, March 10, 1954; *Motion Picture Daily*, March 10, 1954.

406 **"A potential treat"**: *New York Times*, March 13, 1954.

406 **Santana Productions lost**: Financial statements; J. M. Blankley of Columbia to Jess Morgan of Santana, August 22, 1956, Santana Productions file, BBM.

407 **Huston's secretary**: Jeanie Sims to Humphrey Bogart, June 23, 1952, JHC.

407 **"I think Queeg loses"**: John Huston to Humphrey Bogart, June 10, 1953, JHC.

408 **"proud of its record"**: *Variety*, June 9, 1954.

408 **For his part, Kramer**: Sperber and Lax, *Bogart*.

408 **"hailed by Loew's Theatres"**: *Motion Picture Daily*, June 23, 1954.

409 **"rated as one of"**: *Variety*, June 30, 1954.

409 **"The Senate does itself"**: *Variety*, June 23, 1954.

409 **"a character portrait"**: *Variety*, June 9, 1954.

409 **"instinctive communion"**: *Time*, June 7, 1954.

409 **"evidence [Queeg] is becoming"**: *Brooklyn Eagle*, June 25, 1954.

410 **"Easy. I'm nuts, you know."**: *American Weekly*, June 27, 1954.

410 **"a man who is"**: "Cinema: The Survivor," *Time*, June 7, 1954.

410 **"beginning to crack"**: *Variety*, June 9, 1954.

410 **"We had kind of"**: *Saturday Evening Post*, May 21, 1966.

410 **"We were happy people"**: Bacall, *By Myself*.

411 **"It's heavenly"**: Lauren Bacall to Katharine Hepburn, May [n.d.] 1952, KHP.

411 **"I like cozy places"**: *Screenland*, May 1945.

411 **"They left behind"**: *Saturday Evening Post*, August 2, 1952.

411 **"wasn't big enough"**: Hedda Hopper, notes, March 25, 1957, HHPH.

411 **"I've heard that the best"**: *Los Angeles Mirror*, October 31, 1950; also *Los Angeles Times*, October 31, 1950.

411 **"periodic psychiatric study"**: Memo from "PMJ" to Morgan Maree, October 31, 1950, Legal file, BBM.

412 **"wouldn't spit on"**: *Saturday Evening Post*, August 2, 1952

412 **When *Santana*'s skipper**: Hedda Hopper column, as in *Detroit Free Press*, December 14, 1946.

413 **When his gardener**: Various memos and reports including Paul M. Jones, Bogart's attorney, to A. H. Henderson, Department of Motor Vehicles, May 25, 1950; Paul M. Jones to Humphrey Bogart, July 26, 1950; Paul Mason, Department of Motor Vehicles, to Paul M. Jones, July 17, 1950; C. H. McCarty, Stores Collection Bureau, to Paul M. Jones, July 28, 1950; and memo to Bogart from Morgan Maree that the fine has been paid, October 14, 1950, Legal file, BBM.

413 **"She was Daddy's"**: Bogart, *Bogart*.

413 **"mixture of amusement"**: Thompson, *Bogie and Me*.

413 **Bogie was struck**: *Saturday Evening Post*, May 21, 1966.

414 **"I hope [Stephen]"**: United Press, as in *Knoxville* [TN] *Journal*, September 25, 1949.

414 **"There is and has been"**: Lauren Bacall to Charles Feldman, January 13, 1954, Bacall contracts, BBM.

415 **"Bogie and his Baby"**: United Press, as in *Hartford* [CT] *Times*, April 17, 1954.

415 **"They have numerous"**: *Saturday Evening Post*, August 2, 1952.

415 **"Something happened"**: Bacall, *By Myself*.

415 **"Delighted to hear"**: India Edwards to Bogart and Bacall, October 3, 1952, LBC.

416 **"I love that gov"**: *Chattanooga* [TN] *Daily Times*, October 28, 1952.

417 **"stuck Stevenson fund"**: Unnamed publicist to Bogart and Bacall, October 30, 1952.

417 **"The governor has asked"**: Arthur Schlesinger to Bogart and Bacall, October 30, 1952.

419 **"Miss Bacall supports"**: Humphrey Bogart to John Huston, October 8, 1952, JHP.

421 **"started making her own"**: Interview, Gloria Stuart, May 5, 2000.

421 **"howling with laughter"**: Louis Sobel column, as in *Tacoma Press*, January 29, 1954.

421 **"Betty now refuses"**: *Saturday Evening Post*, May 2, 1952.

422 **"When people ask me"**: Earl Wilson column, *Washington Post*, January 12, 1954. After running in Wilson's flagship paper, the piece was syndicated, and the word "mistress" was replaced with "girl," perhaps a cautionary gesture or perhaps in response to a complaint from Bogart or Bacall.

422 **"Bogie and Pete"**: Ad sheet, Local 706, July 24, 1954, courtesy of the Estate of Verita Thompson.

422 **"Lauren Bacall's good friend"**: Herb Klein column, as in *Philadelphia Inquirer*, November 16, 1953.

423 **"the most delightful"**: *New York Times*, September 23, 1954.

423 **"entirely different"**: *Los Angeles Daily News*, September 22, 1954.

423 **"pleasantly saturnine"**: *Los Angeles Times*, September 23, 1954.

423 **"He gave me a rough time"**: *Time*, April 29, 1954.

423 **"It's that fucking Holden"**: William Holden to Nathaniel Benchley, [n.d.], NBC.

423 **"She's all right"**: Maurice Zolotow, *Billy Wilder in Hollywood* (New York: Putnam, 1977).

423 **"Off to a roaring start"**: *Variety*, October 6, 1954.

424 **"The reading of that script"**: Lauren Bacall, oral history, June 29, 1971, Columbia Center for Oral History, Columbia University.

424 **"Humphrey Bogart does"**: *Philadelphia Inquirer*, October 27, 1954.

425 **"Sometimes I wish"**: Gladys Hall, notes, [n.d.], 1951, GHC.

Chapter 26

426 **"the comfortable 'let's-shoot-it-again'"**: *TV Guide*, May 28, 1955.

426 **"Bogart was terrified"**: Interview, Dick Clayton, May 3, 2007.

426 "**I look awful"**: *New York Herald Tribune*, November 6, 1955.

427 **Just one segment**: Statement of earnings of $1,969.90, January 10, 1052, Legal file, BBM.

427 **"Pure nostalgia"**: *TV Guide*, May 28, 1955.

427 **"Dear Joe"**: Lauren Bacall to Joseph Mankiewicz, August 20, 1954, Mankiewicz Papers.

428 **"My heart was pounding"**: Bacall, *By Myself*.

429 **"interesting [but] passive"**: *Boston Globe*, May 31, 1955.

429 *The Petrified Forest* **proved**: *Broadcasting Telecasting*, July 11, 1955.

429 **"Wrap up all the Oscars"**: *Variety*, July 14, 1954.

429 **In 1956, he named**: Associated Press, as in *Green Bay* [WI] *Press-Gazette*, July 10, 1956.

430 **"not assembled a drama"**: *New York Times*, September 22, 1955.

430 **"far more sure"**: *Washington Post*, September 23, 1955.

431 **"I remember [Bogart]"**: Interview, Richard Eyer, May 21, 2020.

431 *Variety* **hailed the film's**: *Variety*, October 12, 1955.

431 **"dignity label"**: *Time*, December 19, 1955.

432 **Three weeks in**: *Variety*, October 26, 1955.

432 **"fine individual performances"**: *Daily News* (New York), October 23, 1955.

432 **"tied up in knots"**: *San Francisco Examiner*, October 27, 1955.

432 **"off to a fancy start"**: *Variety*, June 22, July 6, 1955.

432 **"a lurid melodrama"**: *New York Times*, August 5, 1955.

432 **"Hollywood's rough-hewn"**: *New York Times*, October 6, 1955.

433 **did only "fair" business**: *Variety*, October 5, 1955.

433 **"By now, everybody"**: *Mirror News* (Los Angeles), August 3, 1955.

433 **"They seem to travel"**: *Los Angeles Mirror*, August 3, 1955.

433 **"and a few strays"**: *Hollywood Citizen-News*, September 16, 1955.

434 **"Some years the movie"**: Aline Mosby column, as in *Cincinnati Post*, January 16, 1956.

434 **"both exclusive social sets"**: James Bacon, United Press, as in *Charlotte* [NC] *Observer*, October 28, 1956.

434 **"Bogart was exhausted"**: Interview, Dick Clayton, May 3, 2007.

435 **"The Bogart of today"**: Howard McClay column, as in *Los Angeles Daily News*, September 22, 1954.

435 **"You've become boringly respectable"**: Earl Wilson column, as in *Charlotte* [NC] *News*, October 10, 1955.

435 **"independence"**: Sperber and Lax, *Bogart*.

436 **"blonde, cute, and determined"**: Diary entry, January 1, 1956, in Noël Coward, *The Noël Coward Diaries*, edited by Graham Payn and Sheridan Morley (Boston: Little, Brown and Company, 1982).

436 **"kept on making cracks"**: Richard Burton, *The Richard Burton Diaries*, edited by Chris Williams (New Haven, CT: Yale University Press, 2012).

437 **Soon after Christmas**: Bogart, *Bogart*.

437 **"The whole medical scene"**: Bacall, *By Myself*.

439 **With offices at 4376 Sunset Boulevard**: Associated Press, as in *Berkshire Evening Eagle* (Pittsfield, MA), September 29, 1955.

439 **Mapleton optioned Dinneen's story**: Jess Morgan of Mapleton Productions to Ed Carter, representing Joseph Dinneen, January 16, 1956, Mapleton Productions file, BBM.

439 **The company also contracted**: Contract, Joel Sayre, December 22, 1955; final payment statement, January 31, 1956, Mapleton Productions file, BBM.

439 **"the Nivs, Romanoffs"**: Bacall, *By Myself*.

440 **"Humphrey Bogart is in"**: Associated Press, as in *Fort Worth Star-Telegram*, March 3, 1956.

440 **"there was no hope"**: United Press, as in *Miami* [OK] *News-Record*, January 15, 1957.

441 **"Never in my born days"**: George Cukor to Humphrey Bogart, March 14, 1956, HBC.

441 **"I'm blankety-blank sick"**: Mike Connolly column, as in *Desert Sun* (Palm Springs, CA), March 22, 1956.

441 **"one of the year's"**: *Variety*, March 27, 1956.

441 **"circus cross-country bus trek"**: *Variety*, April 3, 1956.

441 **"an old hand at ratting"**: *New York Times*, May 10, 1956.

441 **"How'd it go?"**: Sperber and Lax, *Bogart*.

442 **"Plans for her treatment"**: Humphrey Bogart to Robert Wyers, Metropolitan State Hospital, September 19, 1956; Robert Wyers to Humphrey Bogart, September 20, 1956.

442 **"all information which"**: Humphrey Bogart to Maynard Brandsma, April 16, 1956, Humphrey Bogart file, BBM.

442 **"I hope he will be"**: Sheilah Graham column, as in *Deseret News* (Salt Lake City, UT), May 30, 1956.

443 **"She hardly ever left"**: Interview, name withheld, July 15, 2021.

443 **"Bogie would make"**: Bacall, *By Myself*.

443 **"She's my wife"**: *Atlantic*, May 1957.

443 **They were, however**: Bill Hollohan column, as in the *News-Pilot* (San Pedro, CA), August 30, 1956.

444 **"[He was] literally following me"**: Kitty Kelley, *His Way: The Unauthorized Biography of Frank Sinatra* (New York: Bantam, 2015).

444 **"growling again"**: Associated Press, as in *Green Bay* [WI] *Press-Gazette*, July 10, 1956.

444 **"Bogart has put on"**: John Huston to Humphrey Bogart, July 27, 1956, JHC.

445 **"The trouble with you"**: Humphrey Bogart to John Huston, summer 1956, JHC.

445 **"When Bogie is able"**: B. B. Kahane to Morgan Maree, August 3, 1956, Legal file, BBM.

445 **"Frank Sinatra's Sands opening"**: Louella Parsons column, as in *Philadelphia Inquirer*, September 12, 1956.

446 **"mutual admiration"**: James Kaplan, *Sinatra: The Chairman* (New York: Doubleday, 2015).

446 **"There were more celebrities"**: Louella Parsons column, as in *Record* (Hackensack, NJ), September 18, 1956.

447 **"He turned to me"**: Sperber and Lax, *Bogart*.

447 **"Sad news for Humphrey"**: Dorothy Kilgallen column, as in *Knoxville* [TN] *Journal*, October 7, 1956.

448 **"After enjoining the Hollywood reporters"**: *Montgomery* [AL] *Advertiser*, October 14, 1956.

448 **"Our Rat Pack is not dead"**: *Mirror News* (Los Angeles), November 20, 1956.

448 **At the same time**: *Daily News* (New York), November 20, 1956.

448 **Sometime in October**: Humphrey Bogart death certificate, January 14, 1957, registered January 18. "Generalized carcinoma," which had lasted for three months, was listed as the immediate cause of death, with the antecedent cause being carcinoma of the esophagus.

448 **"I love you to lean"**: Bacall, *By Myself*.

449 **"She was exemplary"**: Sperber and Lax, *Bogart*.

449 **"a very profitable investment"**: Paul M. Jones to Humphrey Bogart, February 11, 1954, Oil file, BBM. Among the oil companies Bogart invested in were the Bardsdale Oil Company in Ventura County, California, from which he made 2.5 percent of net profits from Elkins No. 2 well, and the Capricorn Oil Company, in which Morgan Maree and John Huston were also investors.

449 **"treatment of a nerve"**: Associated Press, as in *Belleville* [IL] *Daily Advocate*, November 27, 1956.

449 **"Bogie cannot last"**: Bacall, *By Myself*.

450 **"The husky-voiced tough guy"**: *Daily News* (New York), January 3, 1957.

450 **"After the article appeared"**: Martin Gang to Michael Halperin, January 10, 1957, Legal file, BBM.

450 **On the evening of January 12**: In her memoir, Bacall wrote that the film was *Anchors Aweigh* with Gene Kelly. This could not be confirmed through television listings for that week.

Chapter 27

455 **"There comes a time"**: *New York Herald Tribune*, January 11, 1959.

455 **"Being a widow"**: *Time*, July 29, 1966.

456 **"His life," Huston intoned**: John Huston, eulogy, January 17, 1957, HBC.

456 **"make-up men, nurses"**: Bacall, *By Myself*.

456 **"It's absolutely fantastic"**: Hedda Hopper, notes, March 25, 1957, HHPH.

456 **"I will not discuss"**: Ibid.

457 **"Nothing really happens"**: *New York Times*, January 12, 1957.

458 **"It's the best part"**: Hedda Hopper, notes, March 25, 1957, HHPH.

458 **"He never had it easy"**: Lauren Bacall, oral history, June 29, 1971, Columbia Center for Oral History, Columbia University.

458 **Bogie's will had provided**: "Helen" to Speed L. Post, Maree Associates, June 13, 1957; Speed L. Post to Frances Rose, October 14, 17, 1957, Legal file, BBM.

459 **Her lease there was set**: Leila M. Chappell, realtor, to Jess Morgan, April 23, 1958, Legal file, BBM.

459 **"I'd love to"**: Hedda Hopper, notes, March 25, 1957, HHPH.

459 **"No TV whatever"**: Ibid.

459 **"[He] talked to me"**: Bacall, *By Myself*.

460 **A State Senate committee**: My account of the "Wrong Door" scandal comes from various issues of the *Los Angeles Times*, February–August 1957, as well as Henry E. Scott, *Shocking True Story: The Rise and Fall of* Confidential, *"America's Most Scandalous Scandal Magazine"* (New York: Pantheon, 2010).

461 **"When's this mess"**: Hedda Hopper notes, March 25, 1957, HHPH.

462 **When Frank was sued**: Complaint, March 19, 1958, Legal file, BBM. It's unclear why O'Brien sued Bacall, along with thirty others, except that he alleged plagiarism of his private letters in *Designing Woman*. The case was dismissed as frivolous.

462 **"I can't really remember"**: Bacall, *By Myself*.

463 **"I love my kids"**: Mel Heimer's column, as in the *Kane* [PA] *Republican*, March 6, 1958.

463 **"A favorite subject"**: Associated Press, as in *Sunday News* (Lancaster, PA), September 29, 1957.

463 **"I couldn't understand it"**: Bacall, *By Myself*.

464 **"narrowed down"**: *New York Herald Tribune*, January 11, 1959.

464 **"playing house"**: Bacall, *By Myself*.

466 LAUREN ANSWERS YES: *Los Angeles Examiner*, March 12, 1958.

466 **But Parsons told a different**: Parsons's story was picked up by many papers through the International News Service. Not all of them carried the full story, which included the Noël Coward reference, but some did, such as *Province* (Vancouver), March 12, 1958.

467 **"What marriage?"**: Kelley, *His Way*.

467 **"wielded humiliation"**: James Kaplan, *Sinatra: The Chairman* (New York: Doubleday, 2015).

468 **"Sinatra and I will make"**: International News Service, as in *Fort Worth Star-Telegram*, April 11, 1958.

468 **"well below estimate"**: *Variety*, March 5, 1958.

468 **Bogart had hoped that Mapleton**: Morgan Maree to United Artists, April 2, 1958, Legal file, BBM; Associated Press, as in *Kansas City Times*, January 31, 1958; *Sedalia* [MO] *Democrat*, February 2, 1958.

469 **"in their normal style"**: United Press International, as in *Shreveport* [LA] *Journal*, August 22, 1958; Associated Press, as in *Tallahassee* [FL] *Democrat*, September 14, 1958.

469 **"I didn't have a healthy"**: United Press International, as in *Corsicana* [TX] *Daily Sun*, December 5, 1958.

470 **"came back to life"**: *Saturday Evening Post*, May 21, 1966.

471 **"Perhaps this place"**: *Boston Globe*, May 3, 1959.

472 **"Lauren Bacall was doing"**: *Daily Herald* (London), May 9, 1959.

472 **"I wish Daddy were here"**: Bacall, *By Myself*.

472 **"My father, the house"**: Bogart, *Bogart*.

473 **"He really would like"**: *Daily Herald* (London), May 9, 1959.

473 **"This is pure, unabashed"**: *Westminster & Pimlico News* (London), October 23, 1959.

474 **"It's a funny thing"**: *Baltimore Sun*, November 8, 1959.

474 **"I couldn't resist it"**: Associated Press, as in *Birmingham* [AL] *Post-Herald*, June 22, 1959.

474 **When she signed her contract**: Rider to standard Equity run-of-the-play contract, June 18, 1959, Leland Hayward Collection, Billy Rose Theatre Division, New York Public Library for the Performing Arts (hereafter LHC).

474 **"I felt good to know"**: Bacall, *By Myself*.

475 **"I was one nervous actress"**: Ibid.

476 **Charlie is consistently referred to**: Script for *Goodbye Charlie* by George Axelrod, November 10, 1959, LHC.

477 **"*Goodbye Charlie* has a curious"**: Harold Cohen, *Pittsburgh Post-Gazette*, October 20, 1959.

477 **"skirt[s] the blasphemous"**: *Detroit Free Press*, October 27, 1959.

477 **"those who would be artificially"**: *Windsor* [ON] *Star*, October 27, 1959.

477 **"It was really blow-up time"**: Dorothy Kilgallen column, as in *Lima* [OH] *Citizen*, December 16, 1959.

477 **"Miss Bacall is wonderful"**: *Evening Sun* (Baltimore), November 24, 1959.

478 **"philosophical conclusion"**: *Philadelphia Inquirer*, December 1, 1959.

478 **"Funny as well as eye-catching"**: *Pittsburgh Press*, October 20, 1959.

479 **"an expanded vaudeville sketch"**: *New York Times*, December 17, 1959.

479 **"I'm not frantic anymore"**: Associated Press, as in *Fresno* [CA] *Bee*, January 10, 1960.

479 **"I was liking my life"**: Bacall, *By Myself*.

479 **A little past 3:30**: *Daily News* (New York), October 4, 1960.

480 **"From that moment on"**: *Saturday Evening Post*, May 21, 1966.

480 **"at odd hours"**: Bacall, *By Myself*.

480 **His parents' divorce**: The account of Robards's early life comes from Boyd Martin's column, as in the *Courier-Journal* (Louisville, KY), February 3, 1959; various profiles in *Time*, *Life*, and others; and Steven A. Black et al., eds., *Jason Robards Remembered: Essays and Reconstructions* (Jefferson, NC: McFarland, 2002).

481 **"He was twenty-four"**: *Pittsburgh Post-Gazette*, August 20, 1961.

481 **"It was the best thing"**: *Washington Post*, November 16, 1977.

481 **"ably handled"**: Mark Barron column, as in *Richmond* [VA] *News Leader*, May 10, 1956.

481 **"aura of good fellowship"**: *New York Times*, May 9, 1956.

482 **"another remarkable performance"**: *New York Times*, November 8, 1956.

482 **"That was a terrible period"**: *Washington Post*, November 16, 1977.

482 **"Lauren Bacall forgetting Adlai"**: Walter Winchell column, as in *Times Leader* (Wilkes-Barre, PA), July 27, 1960.

482 **"Those were harsh, harsh words"**: *Daily News* (New York), July 25, 1960.

482 **"It must be love for Lauren"**: Mike Connolly column, as in *Valley Times* (North Hollywood, CA), September 14, 1960.

483 **"the Lauren Bacall–Jason Robards palship"**: Earl Wilson column, as in *Detroit Free Press*, September 15, 1960.

483 **The pyrotechnics may have been**: Dorothy Kilgallen column, as in *Greenville* [OH] *Daily Advocate*, September 15, 1960.

483 **"Audiences did not like"**: Bacall, *By Myself.*

Chapter 28

485 **"It's not going to get better"**: Ibid.

485 **He told her in the kindest**: Garson Kanin to Lauren Bacall, July 29, 1961, Garson Kanin Papers, Library of Congress.

486 **"I mean, it was bad"**: *Saturday Evening Post*, May 21, 1966.

486 **"the talk of everyone"**: Newspaper Enterprise Service, as in *Evening Herald* (Rock Hill, SC), June 13, 1961.

486 **"Jason and Bogie have"**: *Saturday Evening Post*, May 21, 1966.

486 **"I knew I wasn't"**: "The Pleasures and Perils of Middle Age," *Time*, July 29, 1966.

487 **"Steve has had nothing"**: Lauren Bacall to Katharine Hepburn, January 24, 1965, KHP.

487 **"Four years of living"**: Bacall, *By Myself.*

487 **"To survive one's children"**: Lauren Bacall to Katharine Hepburn, January 24, 1965, KHP.

488 **"Your godson is heaven"**: Ibid.

489 **"Not a square millimeter"**: Jamie Bernstein, *Famous Father Girl: A Memoir of Growing Up Bernstein* (New York: Harper, 2018).

489 **"He's around Manhattan"**: Alex Freeman column, as in *Hartford Courant*, June 7, 1965.

490 **"I wasn't interested"**: *Washington Post*, November 16, 1977.

490 **"You're too thin"**: Bacall, *By Myself.*

490 **"I'm not saying this because"**: *Philadelphia Inquirer*, August 13, 1961.

491 **"more than a tendency"**: Bacall, *By Myself.*

491 **"There is trouble"**: Alex Freeman column, as in *Hartford Courant*, March 24, 1965.

491 **"It's kind of hard"**: *Washington Post*, November 16, 1977.

491 **"At the moment"**: Lauren Bacall to Katharine Hepburn, January 27, 1965, KHP.

492 **"Jason isn't the easiest guy"**: Alex Freeman column, as in *Hartford Courant*, June 7, 1965.

493 **"These nights"**: *Daily News* (New York), April 25, 1965.

493 **"but everybody just"**: *Crimson*, February 14, 2013.

494 **"I think the whole thing"**: Associated Press, as in *Brattleboro* [VT] *Reformer*, March 15, 1965.

494 **"There is hardly a day"**: Draft, introduction to Hyams, *Bogie*, LBC.

495 **"adulating biography"**: Otto Dekom, *Morning News* (Wilmington, DE), May 31, 1967.

495 **"Lauren Bacall seems as interested"**: *Hollywood Citizen-News*, February 11, 1967.

496 **"some fool named Larry Swindell"**: Lauren Bacall to Katharine Hepburn, January 27, 1965.

496 **"Lauren Bacall has 'movie star'"**: UPI, as in *El Paso Herald-Post*, August 7, 1965.

497 **"would cause irreparable injury"**: *Daily News* (New York), October 10, 1964.

498 **"I'm a little nervous"**: Hedda Hopper, *Daily News* (New York), September 10, 1965.

498 *Cactus Flower* **was**: Working scripts for the show can be found in the Abe Burrows Collection, Billy Rose Theatre Division, New York Public Library for the Performing Arts.

498 **"David Merrick, God bless him"**: Interview, Brenda Vaccaro, June 19, 2020.

498 **"While** *Cactus Flower* **may"**: *Evening Sun* (Baltimore), November 8, 1965.

499 **"Without Toni"**: *Baltimore Sun*, November 8, 1965.

499 **"Lauren Bacall is fascinating"**: *Philadelphia Inquirer*, November 28, 1965.

499 **"He started talking"**: Interview, Brenda Vaccaro, June 19, 2020.

500 **"she lets go"**: *New York Times*, December 9, 1965.

501 **"She is the season's"**: *Saturday Evening Post*, May 21, 1966.

501 **"I've waited for this"**: *Time*, July 29, 1966.

501 **"It's been one of the nicest"**: *Saturday Evening Post*, May 21, 1966.

501 **"We'd hear her"**: Interview, Brenda Vaccaro, June 19, 2020.

501 **"a future show"**: Earl Wilson column, as in the *Port Clinton* [OH] *News Herald*, November 2, 1965.

501 **"Although she barely qualifies"**: *Time*, July 29, 1966.

502 **"I sure took"**: *Saturday Evening Post*, May 21, 1966.

502 **"Everyone stood back"**: *Esquire*, June 29, 2020.

502 **"Lauren Bacall's intimates say"**: Wire report, as in *Macon* [GA] *News*, September 13, 1965.

502 **"We just haven't found"**: Earl Wilson column, as in *Indianapolis Star*, December 14, 1965.

502 **"There was something"**: Bacall, *By Myself*.

503 **"I am slaving"**: Lauren Bacall to Katharine Hepburn, February [n.d.], 1967, KHP.

503 **"I guess I'll miss"**: Lauren Bacall to Katharine Hepburn, December [n.d.], 1967, KHP.

Chapter 29

505 **"I've had fourteen years"**: *Life*, April 3, 1970.

508 **"I was calling myself"**: Draft script, January [n.d.] 1970, Comden-Green Collection [hereafter CGC].

508 **"Margo's decision"**: Lawrence Kasha to Betty Comden, Adolph Green, Charles Strouse, Lee Adams, [n.d.] late 1969, CGC.

508 **"Either the character"**: *News* (Frederick, MD), January 30, 1970.

509 **"in what seemed like"**: *Life*, April 3, 1970.

509 **"We were rewriting"**: *New York Times*, April 1, 1970.

509 **"My friends call me Betty"**: Interview, Lee Roy Reams, September 9, 2022.

510 **"She always believed"**: Interview, Rex Reed, May 1, 2022.

510 **"Damn the torpedoes"**: Interview, Gloria Stuart, May 5, 2000.

510 **"What the hell"**: *Life*, April 3, 1970.

510 **"Would-be shows have been saved"**: *Baltimore Sun*, March 18, 1970.

510 **she was often "inaudible"**: *Detroit Free Press*, April 19, 1970.

511 **"You sly puss"**: Interview, Lee Roy Reams, September 9, 2022.

511 **rising from $46,000**: Richard Wincor to Betty Comden and Adolph Green, April 3, 1970, CGC.

511 **"The cast as a whole"**: *New York Times*, March 31, 1970.

511 **$109,231 for the first week**: Box-office receipts, March–June 1970, CGC.

512 **"This bloody thing"**: Lauren Bacall to Katharine Hepburn, March–April 1970, KHP.

512 **"more than anything"**: Interview, name withheld, October 19, 2020.

513 **"I remember her"**: John Huston, statement, April [n.d.] 1970, JHP.

513 **"Deserved—warranted"**: Draft, Katharine Hepburn to Lauren Bacall, April [n.d.], 1970, KHP.

513 **"He's beautiful!"**: Associated Press, as in *Bridgeport* [CT] *Post*, April 14, 1970.

513 **"Steve is a worry"**: Lauren Bacall to Katharine Hepburn, January [n.d.], 1968, KHP.

513 **"and end up in the Army"**: Lauren Bacall to Katharine Hepburn, March 8, 1968, KHP.

514 **"I had been so preoccupied"**: Bacall, *By Myself*.

515 **"generous of spirit"**: Lauren Bacall, *Now* (New York: Knopf, 1994).

515 **"This is the end!"**: Nunnally Johnson to Lauren Bacall, November 2, 1973, LBC.

515 **"I have been unable"**: Lauren Bacall to Katharine Hepburn, December 1972–January 1973, KHP.

515 **"I would never fit"**: Bacall, *Now*.

515 **"The part in itself"**: Lauren Bacall to Katharine Hepburn, February 22, 1974, KHP.

516 **"With such a large cast"**: Interview, Michael York, August 6, 2020.

516 **"I do not usually"**: Bacall, *By Myself*.

517 **"If you want to make"**: *San Francisco Examiner*, August 27, 1978. I have been unable to locate a book called *Bogey's Bride*. I believe the writer was referring to *Bogie's Baby*, which was the original title of Joe Hyams's second book on the Bogarts, published as *Bogie and Bacall: A Love Story*.

517 **"I'm very upset with Joe"**: Associated Press, as in *Shreveport* [LA] *Journal*, February 19, 1975.

517 **"I got a letter from Nat"**: Nunnally Johnson to Lauren Bacall, June 12, 1973, LBC.

517 **"I don't think even you"**: Nunnally Johnson to Lauren Bacall, March 10, 1975, LBC.

518 **"I do love what you do"**: Lauren Bacall to Katharine Hepburn, October [n.d.], 1970, KHP.

518 **"Forget women's lib"**: *Washington Post*, February 1, 1975.

519 **"It was like leaning"**: *TV Guide*, September 17, 1977.

519 **"He is the epitome"**: *New Haven* [CT] *Register*, September 11, 1976.

519 **"dilapidated buses"**: Dick Kleiner, Huffington Post, August 19, 2016.

519 **"Shut up and seat us"**: Marilyn Beck column, as in *Democrat and Chronicle* (Rochester, NY), November 30, 1976.

519 **Betty complained loudly**: *Boston Globe*, December 21, 1976; *Evening Standard* (London), December 10, 1976.

519 **"spewing obscenities"**: *Son of the Cucumber King* (blog), http://sonofthecucumberking.blogspot.com, April 28, 2009.

520 **"Persepolis was fascinating"**: Lauren Bacall to Katharine Hepburn, February 2, 1977, KHP.

520 **"a miserable peanut"**: *Los Angeles Times*, December 19, 1976.

520 **"Barbados is perfect"**: Lauren Bacall to Katharine Hepburn, February 2, 1977, KHP.

520 **"train their field glasses"**: *Daily News* (New York), January 12, 1977.

520 **"Her dancing isn't going"**: *Miami News*, August 3, 1977.

520 **"The road can be"**: Bacall, *Now*.

521 **"Her expectations"**: *Standard-Times* (New Bedford, MA), August 14, 2014.

521 **"It is hard to go"**: Knight Ridder, as in *Lexington* [KY] *Herald*, July 5, 1977.

522 **"and in any case"**: Robert Gottlieb, *Avid Reader: A Life* (New York: Macmillan, 2016).

523 **"It's a catharsis"**: *Miami News*, August 3, 1977.

524 **In November 1980**: *Pittsburgh Press*, May 3, 1980, and other newspaper accounts.

Chapter 30

526 **Rex Reed, the handsome**: Interview, Rex Reed, May 1, 2022.

526 **"I was in my bedroom"**: *Larry King Live*, CNN transcript, May 6, 2005, https://transcripts.cnn.com/show/lkl/date/2005-05-06/segment/01.

526 **"The gates were locked"**: Interview, Rex Reed, May 1, 2022.

527 **"I don't know if"**. *Good Morning America*, December 9, 1980.

527 **"A list of Dakota residents"**: *Daily News* (New York), October 2, 1979. Other news articles that reference Bacall living at the Dakota are *Daily News* (New York), October 18, 1962, January 20, 1980; *Newsday*, January 28, 1979; and many others.

528 **"Because my profession is acting"**: Syndicated piece by Kevin Kelly of the *Boston Globe*, as in *Indianapolis News*, February 9, 1981.

528 **"I was so shocked"**: Interview, Rex Reed, May 1, 2022.

528 **"When she was in"**: Bernstein, *Famous Father Girl*.

529 **"I'm broke!"**: Earl Wilson column, as in *San Francisco Examiner*, September 27, 1961.

529 **"She did not say"**: *Life*, April 3, 1970.

529 **"Meanwhile," Boggs recalled**: Interview, Steven Boggs, October 12, 2022.

529 **"I can't think of"**: Dorothy Kilgallen column, as in *Journal Herald* (Dayton, OH), December 15, 1959.

530 **"She had a very bad"**: Interview, Paul Dooley, August 28, 2020.

531 **"*The Fan* is much more"**: *People*, June 8, 1981.

531 **"only saving grace"**: James Garner, *The Garner Files: A Memoir* (New York: Simon & Schuster, 2011).

532 **"As I always do"**: Bacall, *Now*.

533 **"we may groan even louder"**: *Newsday*, March 30, 1981.

533 **"incandescence"**: Ibid.

533 **"a natural musical comedy star"**: *New York Times*, March 30, 1981.

533 **"The question is as irritating"**: *San Francisco Examiner*, April 19, 1981.

534 **"by default"**: *New York Times*, December 11, 1981.

534 **"I must have more"**: Associated Press, as in *Asbury Park* [NJ] *Press*, November 29, 1981.

534 **"very oddly"**: Gannett News Service, as in *Tennessean* (Nashville), December 13, 1981.

534 **"putting the lid on"**: *New York Post*, December 12, 1981; Lawrence Kasha and David Landay to James Brady, December 14, 1981, LBC.

534 **"has generated more"**: Gannett News Service, as in *Tennessean* (Nashville), December 13, 1981.

535 **"[Welch] is a show-stopper"**: *New York Times*, December 11, 1981.

535 **"If an attempt was made"**: Gannett News Service, as in *Journal News* (White Plains, NY), December 7, 1981.

535 **"If she's interested"**: *Newsday*, December 9, 1981.

535 **"has not only revitalized"**: *Hartford Courant*, July 25, 1982.

535 **"When we worked on"**: Interview, Scott Henderson, January 13, 2022.

535 **"a lack of grace"**: Joe Layton to Jack Viertel, July 7, 1983, LBC.

536 **"She was very, very hard"**: Interview, Rosemary Harris, June 29, 2020.

536 **"She'd loved Bogie"**: Interview, Dean Shapiro, December 1, 2021.

537 **"In terms of the Bogart myth"**: *Los Angeles Times*, August 30, 1982.

537 **"the great love of Humphrey"**: Jack Martin, *Beverly Hills Magazine*, April 13, 1994.

537 **"self-aware monster"**: Michael Billington, *Guardian* (London), July 11, 1985.

537 **"like a hungry dog"**: John Barber, *Daily Telegraph* (London), July 11, 1985.

537 **"The play is going very well"**: Lauren Bacall to Katharine Hepburn, [n.d.] 1985, KHP.

538 **"where she was lit"**: Interview, Giles Foster, July 21, 2020.

539 **"She started to realize"**: Interview, Scott Henderson, January 13, 2022.

539 **"If not for her"**: Lauren Bacall, acceptance speech, Golden Globes, January 19, 1997.

540 **"Although meant to be"**: Rita Kempley, *Washington Post*, November 15, 1996.

541 **"I felt very alone"**: Bacall, *By Myself.*

541 **"I was very disappointed"**: Interview, Scott Henderson, January 13, 2022.

542 **"It was so fabulous"**: Bacall, *Now.*

543 **"one guy was the great"**: *Vanity Fair*, March 2011.

543 **"we had a marvelous time"**: *Larry King Live*, CNN transcript, May 6, 2005.

543 **"She never talked about"**: Interview, Rex Reed, May 1, 2022.

543 **"He doesn't know"**: *Vanity Fair*, March 2011.

543 **"an unselfish woman"**: Bacall, *Now.*

545 **"I guess I've had three"**: *Washington Post*, December 7, 1997.

545 **"Doing eight shows a week"**: *New York Times*, August 11, 1999.

546 **"Betty loved being"**: Interview, Rosemary Harris, June 29, 2020.

546 **"When she is offended"**: *New York Times*, December 17, 1999.

546 **"Why are you calling"**: *Larry King Live*, CNN transcript, May 6, 2005,

547 **"She's a beginner"**: Associated Press, as in *Burlington* [LA] *Free Press*, September 9, 2004.

548 **"These days, alas"**: *Independent* (London), September 11, 2004.

548 **"Why do you have to"**: *Larry King Live*, CNN transcript, May 6, 2005.

548 **"I certainly don't feel"**: *Daily Telegraph* (London), September 9, 2004.

548 **"You didn't always want"**: Interview, Scott Henderson, January 13, 2022.

549 **"It was just a book"**: *Larry King Live*, CNN transcript, May 6, 2005.

549 **"Why did Lauren Bacall"**: *Detroit Free Press*, October 15, 1994.

549 **"It was unfortunately sold"**: *Larry King Live*, CNN transcript, May 6, 2005.

549 **"Lauren Bacall failed"**: *Guardian* (London), February 8, 2008; also interview with Dean Shapiro.

549 **"I was told"**: *Larry King Live*, CNN transcript, May 6, 2005.

550 **"I'm afraid this book"**: *Guardian* (London), March 19, 2005.

551 **"a thermos of boiling water"**: Associated Press, as in *Albuquerque Journal*, April 4, 2005.

553 **"I'm ready to throw it"**: *Vanity Fair*, March 2011.

553 **"It's the only time"**: Ibid.

553 **"Sometimes," she admitted**: *New York Times*, February 24, 2005.

555 **"So, I'm not the most adored"**: *Vanity Fair*, March 2011.

555 **"to prepare for the worst"**: *Standard-Times* (New Bedford, MA), August 14, 2014.

INDEX

ABOUT THE AUTHOR

WILLIAM J. MANN is the *New York Times* bestselling author of *The Contender: The Story of Marlon Brando*; *Kate: The Woman Who Was Hepburn*; *How to Be a Movie Star: Elizabeth Taylor in Hollywood*; *Hello, Gorgeous: Becoming Barbra Streisand*; *Wisecracker: The Life and Times of William Haines*; and *Tinseltown: Murder, Morphine, and Madness at the Dawn of Hollywood*, winner of the Edgar Allan Poe Award. He divides his time between Connecticut and Cape Cod.